JAPAN AND THE WEST

AN ARCHITECTURAL DIALOGUE

NEIL JACKSON

LUND
HUMPHRIES

First published in 2019 by Lund Humphries

Lund Humphries
Office 3, Book House
261A City Road
London EC1V 1JX
UK

www.lundhumphries.com

ISBN: 978-1-84822-296-0

A Cataloguing-in-Publication record for this book is
available from the British Library

Cover: The Kimura Manufacturing Laboratory at Hirosaki,
designed by Maekawa Kunio, 1934.

Photograph: Neil Jackson.

Copy edited by Pamela Bertram
Designed by Jacqui Cornish
Set in Arnhem Pro and BrownStd
Printed in China

The Great Britain
SASAKAWA
FOUNDATION
グレイトブリテン・ササカワ財団

The publishers gratefully acknowledge the support of the
Great Britain Sasakawa Foundation.

CONTENTS

INTRODUCTION AND ACKNOWLEDGEMENTS

James Bond's introduction to Japan, as descried by Ian Fleming in *You Only Live Twice* (1965), demonstrates clearly and in architectural terms, the dichotomy between that country and the West. Before Tiger Tanaka, the head of the Japanese Secret Service, briefed Bond on his mission, he had pulled back the *shōji* and the *fusuma* surrounding the room in which they sat. 'In the West,' he said, 'when you have secrets to discuss, you shut all the doors and windows. In Japan, we throw everything open to make sure than no one can listen at the thin walls.'[1]

This present book, which is neither a history of Japanese architecture, nor one of Western architecture, is about how such architectural and spatial differences were adopted by each opposing culture and how, in a relatively short period of some one-hundred-and-fifty years, an architecture inter-dependant, one upon the other, emerged. The book is, inevitably for a Western author, written from a Western perspective, but as a journey of discovery it allows Japan to take the lead. Thus the sections are arranged chronologically by Emperor, rather than by periods of Western history, and people's names are given as they would be in their own countries – in Japan, the family name comes first. Japanese place names can take on a variety of spellings when Romanised, so here the most usual versions are adopted. And rather than using, for Japan, the year of the emperor, all dates follow the Gregorian calendar, which was introduced three years before this story begins.

Following my earlier monograph on *The Modern Steel House* (1996), this book began in 2005, with the support of a grant from the Japan Foundation Endowment Committee, as part of a planned study of the modern concrete house. However, a Research Trust Award, given by the Royal Institute of British Architects (RIBA) in 2007, allowed me to shift my focus towards a broader investigation of tradition and modernity in post-war Japanese architecture. Then, in 2009, a Major Research Fellowship awarded by the Leverhulme Trust encouraged me to extend the work to its present horizons. During the following nine years I was fortunate enough to have an honorary Professorial Research Associateship at the Japan Research Centre in the School of Oriental and African Studies (SOAS) in London. Without their support and the opportunity, on a number of occasions, to offer my ideas for discussion, the project could not have advanced as it did. The eventual publication of this book has been made possible by awards received from the Great Britain Sasakawa Foundation, from both the David Foster Wicks Endowment and the Research Development Initiative Fund at the University of Liverpool, and from the Society of Architectural Historians of Great Britain. My thanks goes to those who first saw a future in this project, those who facilitated its development and those who saw the need to publish it.

Such a cross-cultural study as this could only have been possible with the help of many people to all of whom I am enormously grateful. But to start with Japan: no-one has done as much as Murayama Kazuhiro who has been my architectural guide, translator, travel agent, copy editor and much more besides. Asako Yakuwa Brown helped me early on as a translator and has been a constant source of reference, guidance and support. Mizuta Susumu has helped with many textual and reference questions; Fujioka Hiroyasu, Izumida Hideo, Kimura Hiraoki, Suzuki Hiroyuki and Christian Polak have shared with me their knowledge of Japanese architecture; Takaki Ayaka has helped with translations; Kimura Junko first introduced me to Tokyo as did Brian Burke-Gaffney, to Nagasaki; and Keigo Okada walked me through the Mitsubishi Heavy Industries' Kobe shipyards to the Wadamasaki Battery. Not least, in this Japanese

context, is David Stewart, whose book, *The Making of Modern Japanese Architecture from the Founders to Shinohara and Isozaki*, has been a model to follow and whose friendship has been a privilege.

In 2010 I first made contact with Meg Vivers, in Australia, who, without hesitation, sent me copies of letters which she had found between Thomas James Waters and his sister Lucy, which became, at the invitation of the late Sir Hugh Cortazzi, the basis of my first publication on Japanese architecture; later, they were central to Meg's own and much more comprehensive book, *An Irish Engineer*. Those letters were, of course, in English, but many of my sources were not. Translations of foreign-language texts were frequently needed: Sophie Richard helped with French; Manuel Cresciani, Marco Iuliano and Francesca Leibowitz with Italian; Richard Koeck, Luise Rellensmann, Torsten Schmiedeknecht and Saija Singer with German. As well as those keepers of drawings collections who are acknowledged elsewhere, many librarians and archivists have dealt pleasantly and efficiently with my enquiries, often offering me space in which to work: Susan Augustine, at the Art Institute of Chicago; Michael Bartolic and Michael Dolgushkin, at the California State Library, Sacramento; Arnaud Dercelles and Delphine Struder at the Fondation Le Corbusier, Paris; Sally Eastgate at Broughton House, Kirkcudbright; Nancy Hadley, at the American Institute of Architects, Washington DC; Miranda Hambro, at the College of Environmental Design, University of California, Berkeley; Judy and Fred Porta, of the Friends of First Church, Berkeley, at that building; Christopher Pugh, at the Royal Society of Arts, London; Wim de Wit, at the Getty Research Institute, Los Angeles; Rita Wolters at the Werkbundarchiv-Museum der Dinge, Berlin; and the ever-accommodating staff of the British Library, the National Art Library, the RIBA library and the library at SOAS.

My meetings with Kikutake Kiyonori and Maki Fumihiko were, respectively, too early and too late to have any impact on my understanding of Metabolism. However, Simon Sadler shared his knowledge of Archigram and Margaret MacDonald, hers of Whistler, while Ken Tadashi Oshima and Jonathan Reynolds answered many questions about early modernism in Japan. The Japanese influence on the Pacific Rim was the subject of conversations with Philip Goad and Jenny Mitchelhill, in Melbourne, and Grant Hildebrand and Jeffrey Karl Ochsner in Seattle. In Ireland, Ann Martha and Alistair Rowan, and latterly Anne O'Leary, followed up leads for me while in England, Sally Haden told me all about early glass-making in Meiji Japan.

Dinners with Simon Pepper, Christine Stevenson and Mark Swenarton led to many interesting discussions while, in diverse contexts, others similarly offered help, advice, encouragement and direction. They include Alejandra Armendariz-Hernandez, John Arthur, Simon de Boinville, Marco Capitanio, Nigel Coates, Andrew Cobbing, Jeff Cody, Alex Craik, Thomas Croft, Elizabeth Darling, Wolfgang Dokonal, Murray Fraser, Henry Gibson, Colin Houston, Kameda Motoko, Peter Kornicki, Barbara Lamprecht, Irwin Lavenberg, June Lawrence, Angus Lockyer, Laura MacCulloch, Maeta Reiko, Charlotte Myhrum, Steve Osgood, Jonathan Plunkett, Heidi Potter, Pamela Robertson, Jordan Sand, Timon Screech, Marc Treib, Julian Treuherz, Thomas Underhill, Liz Walder, Richard Guy Wilson, Robert Winter and last but not least, Paul Wynn, who drew all the plans shown in the text.

Finally, thanks are due to the team at Lund Humphries who have brought his book into existence: Val Rose, who commissioned it, Pamela Bertram, Jacqui Cornish, Tom Furness and Sarah Thorowgood.

Dedications are, I think, important and this book is, as always, dedicated to my daughter, Elizabeth. But, throughout these past thirteen years, it is Woodstock who has been my constant, uncomplaining companion.

Neil Jackson
Westminster, London
December 2018

PRELUDE

On a day in early July,[1] one hot Italian summer, four Japanese teenagers went to the theatre in Vicenza. There would be nothing remarkable about this were the year not 1585, the theatre Andrea Palladio's recently completed Teatro Olimpico, and the young tourists the first ever Japanese emissaries to Europe [Plate 1]. There they sat in the front row, attired not in Japanese but in Western costume, and were honoured with a musical performance and a public oration which celebrated their arrival and praised both Japan and its people.[2] Their names were Nakaura Julião, Itō Mancio, Hara Martino and Chijiwa Miguel, and their presence is recorded in a fresco high up on the wall of the theatre's entrance chamber.

The Tenshō Embassy, as it was called, was now mid-way through a triumphal progress which had begun in Lisbon on 11 August the previous year and had taken them to Toledo, Madrid, Pisa, Florence, Siena, Rome, Assisi, Bologna, Ferrara, Venice and many other cities along the way. There they had had audiences with Philip II of Spain and his sister, the Empress Maria of Austria, Francesco dei Medici (the Grand Duke of Tuscany), Pope Gregory XIII, as well as his successor, Pope Sixtus V, and the Doge of Venice. They were still to meet the Duke of Terranova at Milan and the Doge at Genoa, and to be given a second audience with Philip of Spain at Monzón before departing from Lisbon, on 8 April 1586, for the long journey home. When they eventually arrived back at Nagasaki on 21 July 1590, they had been away for eight years and five months.

The four young men, all relatives and vassals of the *daimyo*, were Jesuit converts; the intention of the Tenshō Embassy, conceived in Japan by Father Alessandro Valignano, was therefore both to demonstrate the work of his Jesuit mission and to engender greater support in Europe. With this in mind, they were, as instructed by Valignano, closely chaperoned by a young Japanese friar, Jorge de Loyola. They were also accompanied by Father Diogo de Mesquita, who acted as an interpreter, and

by Kazariya Constantino (or Constantino Douardo) a *dōjuku* or lay catechist. Although they did witness Philip II's great Armada being assembled at Alicante, they were kept unaware of the divisions within the Christian church and ignorant of the Protestantism which proliferated in northern Europe, although Elizabethan State Papers show that the English government certainly knew of and followed their progress.[3] Apart from the resounding success of their tour in social terms, their political goals were achieved with the issuing of a papal bull recognising the exclusive rights of the Jesuits to continue their missionary work in Japan.

The party was under strict instructions to record all their experiences and to note down whatever they saw so that they could bring back to their own country a full account of the distant lands which they were visiting. These records are now lost but their existence is verified by the clear account which the Jesuit missionary Father Luís Fróis (who did not accompany the expedition) wrote in his *Tradado dos Embaixadores Iapões que Forão de Iapão à Roma no Anno de 1582*. Although probably compiled in 1590–92,[4] the book remained unpublished until 1942.[5] During the embassy's lengthy sojourn, many books and pamphlets were published in Europe, including Guido Gualtieri's *Relationi della Venuta degli Ambasciatori Giaponesi a Roma fino alla partita di Lisbona*,[6] which described parts of their journey, and it is likely that Fróis relied upon these as well when writing his report.[7] Nevertheless, there are passages in Fróis's book, attributed to Kazariya and others, most likely to be by Diogo de Mesquita, which give first-hand descriptions of what they saw.[8] Mesquita, who was Portuguese,[9] had left Europe for Goa in 1574 aged 21, so it is unlikely that he viewed European architecture with the same sense of overwhelming novelty as might have his travelling companions, although that is not to say that he could not admire or be impressed by what he saw at the

Escorial Palace or along the Grand Canal in Venice. Kazariya,[10] who, like Jorge de Loyola, was born in Isahaya, Kyushu,[11] is credited with this description of Toledo Cathedral:

> The building ... has eight doors; there are seventy-four beautifully carved wooden stalls in the choir, each worth a thousand crowns; as well as many silver lamps. Each nave has eleven arches or columns. The cathedral has twenty chapels, some of which are 50 by 30 paces large ... The tower has seven storeys and eleven bells, one of which is 46 spans in circumference.[12]

It is likely that it was Kazariya, as the comment about language might suggest, who also wrote of their reaction to the Escorial Palace in Spain:

> It is impossible to describe in writing its splendour, magnificence and great size, for even people skilled and learned in the language would hesitate and falter in many things. For truly they cannot be described to anyone who has not seen them ... It is not possible to descend into detail concerning these magnificent and spacious works, so we will deal briefly and succinctly about what we saw.[13]

The descriptions, when they come, tend towards the statistical rather than offering any stylistic or constructional observations. Yet for one whose native architecture had neither windows nor stairways, the 2,600 windows and 86 stairways of the Escorial Palace must have seemed extraordinary. Such magnificence, whether they could comprehend it or not, clearly had a visceral effect upon the visitors which, to them, justified their presence. While at the Escorial, Jorge de Loyola wrote this tribute:

> We came to see this house of San Lorenzo el Real del Escoril by order of the great Lord Don Philip, King of Spain, and we all greatly admire and are happy to see a work so magnificent. So far we have not seen or dreamed of seeing anything like this, and we consider the hardships and perils we have undergone in our journey of three years to have been well worthwhile for we have finally seen such a marvellous work.[14]

What the Japanese ambassadors saw and experienced would have been the envy of any northern European on the Grand Tour two centuries later. In Florence they stayed at the Palazzo Vecchio and visited the Pitti Palace, the cathedral and the Laurentian Library, as well as the Villa Pratolino located outside the town; in Ferrara they were guests of Duke Alfonso at the Castello Estense, took Mass at the cathedral and were taken on a tour of the city's churches and palaces; and in Venice they toured the Grand Canal in a cavalcade of boats, visited the Doge, Nicolò da Ponte, in his palace and celebrated Mass at St Mark's Cathedral. At Milan, where they attended the first public Mass of the new Archbishop, Gaspare Visconte, they were entertained by the Duke of Terranova at both his palace and his castle. 'Milan is one of the loveliest places we saw in Italy,' they wrote. 'It is two-and-a-half leagues in circumference, and is surrounded by lakes and strong walls, and many high towers around it ... The City is situated on flat ground in the form of a circle. There are many noble houses of 3,000 or 4,000 crowns in value; others are of greater worth.'[15]

The ambassadors' longest stay in any one European city, from 22 March until 3 June 1585, was in Rome where they hoped to engender greater support from the Pope for the Jesuit mission in Japan. Their procession through Rome was recorded by the linguist John Eliot in his *Ortho-epia Gallica*:[16]

> In the yeare eightie-foure or five *Xistus quintus* being Pope of Rome, there were foure yong princes or kings, or sonnes of the kings of Iapan, which came from these contries of the Orient to Rome with the Iesuist Mesquite an Italian who had conuerted them, and brought them thether to do homage and to take the oth of obedience to the Pope. I heard them speake in passing along thorow the streetes: their words are almost all of one sillable, their speech princely, thundering, proud, glorious, and marvellous loftie.[17]

The day after their arrival in Rome, three of the ambassadors (Nakaura being unwell) had an audience with the elderly and infirm Pope Gregory XIII who ordered that a celebratory medal be struck bearing the abbreviated inscription, 'Ab Regibus Iaponio Prima ad Roma Pont legatio et obedienta 1585.' But within three weeks the Pope had died. The ambassadors, however, remained in Rome and on 1 May participated in Pope Sixtus V's coronation procession as pole-bearers for the papal canopy (together with the French and Venetian ambassadors and the senior senator); Mancio was even allowed to enter the sanctuary, during the ceremony, bearing water for the Pope to wash his hands.[18]

The giving (and also receiving) of gifts had been constant throughout the tour, the choice of gifts, much like the whole itinerary, having been conceived by Valignano. What he had failed to anticipate was the extraordinary success of the tour and, long before it was over, the supply of suitable presents had run out. In the event this mattered little, for the offerings were so unusual and unfamiliar that they were always well received. But in Rome, the gifts presented to Pope Gregory XIII were special and for this story, significant. Besides an ebony writing desk, there were two decorated screens or *byōbu* which had been commissioned by the great war-lord Oda Nobunaga. These same folding screens were famous in Japan, not just for their great artistic skill,[19] but for the fact that Nobunaga had, in an unprecedented action, given them to Valignano. Thus the Pope received what would have been regarded in Japan as great treasures. They are now lost but two sketches of the screens made by the Louvain antiquarian, Philips van Winghe, who was then in Rome, survive.[20] What the paintings on the screens showed were two views of Azuchi Castle on the shore of Lake Biwa, near Kyoto. One was of the main tower with a tall, open central space or atrium, and the other was of the castle gateway with some figures entering. Built between 1576 and 1580, this was the first castle of its kind and it was greatly admired by the various guests to whom Nobunaga showed it with pride. But, within months of the four ambassadors departure from Japan, Nobunaga was dead and, long before they returned, his castle was in ruins. Nevertheless, in bringing these screens to Rome, the young ambassadors, who themselves were to experience much of the finest architecture of the Italian Renaissance, also brought the first direct representation of Japanese architecture ever to reach the West.

PART 1

SHOGUN

1 THE CHAINED COUNTRY

Looking West

Sakoku: a locked or chained country. For over 230 years, the equivalent then of some 10 generations,[1] no foreigner was allowed to enter Japan and no Japanese were allowed to leave, both on pain of death. This policy, introduced in the 1630s by the *Shogun* Tokugawa Iemitsu, remained in force until it was rescinded in 1866, 13 years after the arrival of Commodore Perry's black ships which effectively began the opening up of Japan. During that time the West experienced enormous political, social, scientific and cultural change: in England, America and France, a series of revolutions resulted in two regicides and, briefly, three republics; industrialisation and agricultural reform brought about vast population shifts and mass emigration; the invention of the steam engine and, later, the electric telegraph transformed transportation and communication;[2] and the art of architecture, the subject of this book, moved from the Baroque to Neo-Classicism and the revival of the Gothic. Meanwhile Japan changed hardly at all.

Despite the banning of Christianity in 1612 and the introduction of *sakoku* two decades later, the Japanese kept an eye on what was happening beyond their shores. This was achieved through the trade links to China and Europe, although trade with the latter became increasingly tenuous.[3] Westerners and Chinese arriving in Nagasaki, the one port kept open to them for the duration,[4] were interviewed by interpreters and what was learned of the outside world was recorded in a *fūsetsugaki*, a 'Report of Current Hearsay', and sent on to the *Shogun* in Edo[5] (now Tokyo), the centre of political power and *de facto* capital. During this time the only Western power permitted to retain a foothold in Japan, and thus maintain trade relations, were the Dutch. The Vereenigde Oostindische Compagnie (VOC) had established a trading post or factory (as it was called) at Hirado Bay, about 50 miles to the north-west of Nagasaki, on Hirado, in 1609. Here, if one is to believe the 1669 engraving published by Arnoldus Montanus, they built, alongside other structures, a stone store-house with stepped gables in the traditional Dutch manner and an imposing, three-storey structure with, again, stepped gables and an arcaded elevation.[6] The British equivalent, the East India Company, had also set up a factory there in 1613 under Richard Cocks, but remained only 10 years. The Portuguese had traded freely between Nagasaki and Macao since 1571 but in 1634 Tokugawa Iemitsu instructed the local merchants that an artificial island, called Dejima, be built in Nagasaki Bay and the Portuguese were contained there, in accommodation built by the Japanese, from 1636. However, the unsuccessful rebellion the following year of Japanese peasants in nearby Shimabara,

an area associated with Christianity,[7] led to the expulsion of the Portuguese in 1639 and the further persecution of Christians whose Jesuit missionaries had been so successful in their work. The Dutch, being Protestant and having lent artillery support to help crush the Shimabara rebellion, were tolerated.[8] In 1641 they were instructed to move their factory to Dejima, for them a far more convenient location, where they took over the Portuguese trading base. But once there, they were closely supervised, Christian worship was banned and access to and from the island was strictly limited.[9]

Dejima, meaning 'protruding island' (and written as *Desjima* or *Deshima* in Dutch), was fan-shaped, embanked with polygonal cut stone, and measured 120 by 75 metres [Plate 2]. It was connected to the mainland by a single, gated bridge bearing the sign: 'Whores only, but no other women shall be suffer'd to go in.'[10] The current signage is somewhat more tempered, simply listing women, other than courtesans, amongst those to whom entry is banned. A curving central street ran the length of the island while a shorter cross-street terminated at the gateway to the bridge. A second gateway, located at the west end of the island, served as a sea gate and was opened only when Dutch traders were in harbour. Because the houses and warehouses had been constructed by the Nagasaki landlords, they were built, at least initially, in the Japanese manner – timber-framed and of one or two storeys with *tatami* and *shōji*. Yet at Dejima the Dutch, who by the end of the eighteenth century numbered but a dozen, managed to largely preserve their European lifestyle. They introduced Western furniture, including, in 1794, a billiard table, as well as incorporating glass windows into their houses in place of the usual Japanese paper screens. These merchants, there only for profit, took no interest in their host country, a situation nevertheless made no easier by the many restrictions placed on their movement by the Japanese. As the Russian hydrographer, Admiral Adam Ivan Krusenstern, said of the Dutch, 'Europe owes nothing to this nation with respect to a knowledge of the Japanese empire …'[11] Yet there were exceptions amongst the community on Dejima, although they were not necessarily Dutch. One was the German physician and naturalist Engelbert Kaempfer who came to Dejima in 1690–92. Among his manuscript papers, purchased on his death by Sir Hans Sloane and brought to England, was his *Heutiges Japan* (*History of Japan*), which was subsequently translated by Johann Gaspar Scheuchzer, a physician and Fellow of the Royal Society, and published in London in 1727. Another naturalist was Carl Peter Thunberg, a Swede who was head surgeon on Dejima in 1776–77. His *Flora Japonica* was published in 1784. And there was Isaac Titsingh, also a surgeon, who was the Dutch *opperhoofd* or chief agent on Dejima in the early 1780s and whose *Mémoires et anecdotes sur la dynastie régnante des Djogouns, souverains du Japon* was published in Paris in 1820, the English edition appearing in London two years later.[12] Despite the Japanese ban on all maps or representations of towns and cities, Titsingh managed to include in his book a bird's-eye view of the Dutch compound at Dejima, as he had known it in the 1780s, as well as the Chinese compound which lay close by. These were amongst the first visual representations of Nagasaki to be seen in the West.[13]

Two years before Titsingh's *Mémoires* were published in Paris, a model of the Dutch settlement at Dejima arrived in Holland and was put on show at the Royal Cabinet of Antiquities in The Hague. It caused a sensation. This model had been built, soon after his arrival at the factory, by Jan Cock Blomhoff, *opperhoofd* at Dejima from 1817 to 1823. Much of the excitement over the model must have been due to the fact that, until very recently, Dejima was the only place in the world which flew the Dutch flag. From 1810, when Napoleon annexed the Kingdom of Holland, until 1813, when his defeat at Leipzig (at the Battle of the Nations) led to the establishment of the United Netherlands and, in 1815, the United Kingdom of the Netherlands, Dejima exhibited the only national demonstration of this once great trading power. The model was a curious device and highly didactic. Every building extant at that time was laid out, on plan, at a scale of 1:30. Thus the model measured about 8 by 2.5 metres. But in elevation, each building was shown, in whole or in part, at a scale of 1:15, so that the interiors could be examined

more carefully. This must have had the curious effect of distorting each building so that its proportions were quite misleading. But, no matter, it served its purpose of displaying, to the West, how the Dutch and Japanese lived and worked in Nagasaki.

The Japanese, when they could, took a great interest in the small Dutch community on Dejima, although initially not so much for the value this might offer but for the curiosity it aroused. A much greater influence at this time, in terms of both architecture and culture in general, came from the Chinese who, from 1689, had resided in great number in the *tōjin yashiki* or Chinese Quarter, located on the mainland just above Dejima.[14] Nevertheless, there developed, towards the end of the eighteenth century, *rangaku* – the study of Dutch and, by extension, of Western learning.[15] It further transmogrified to become part of the alternative culture of *ukiyo*, the 'floating world', signifying notions of leisure and escape beyond the control of *sakoku* and the *Shoguns*. Although no Japanese scholar dared to profess an interest in Christianity, there nevertheless developed a Dutch mania, *ranpeki*, causing some to adopt Dutch names, to

write prose and even compose poetry in Dutch, and to draw supposedly Dutch landscapes complete with windmills.[16]

Central to *rangaku* was the understanding of medicine and science which frequently resulted in the interrogation by the Japanese of the surgeon on Dejima although, with the exception of Kaempfer, Thunberg and a few others, these surgeons were often little better than horse-leeches or barber-surgeons.[17] It was through Dejima that scientific and medical texts found their way into Japan and it was, in turn, through their illustrations – such as the hexagonal base or pedestal for a sextant shown in Shiba Kōkan's *Oranda Tensetsu*, published in Edo in 1796[18] – that notions of Western architecture were exposed to Japanese scrutiny. Perhaps the most striking example of this is the title page of Sugita Genpaku's anatomical study, *Kaitai Shinsho*, printed in Edo in 1774 [1.01]; this was the first book to be translated from the Dutch and published in Japan. *Kaitai Shinsho* reemployed the title page of Juan de Valverde's *Vivae Imagines Partium Corporis Humani Aereis Formis Expressae*, published in Antwerp in 1566. In Juan de Valverde's image figures

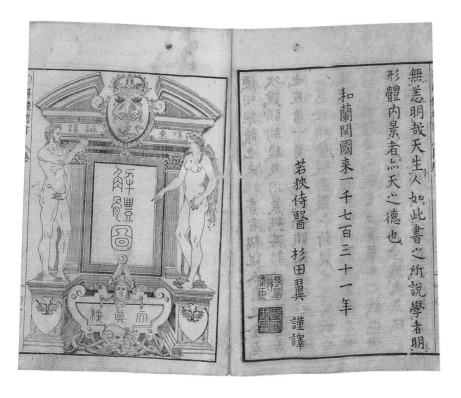

1.01 Title page from Sugita Genpaku, *Kaitai Shinsho*, 1774.

representing Adam and Eve stand on a plinth in front of Corinthian columns and beneath an open, segmental pediment. To the rear Corinthian pilasters frame the title panel while between the figures a pair of dividers surmount a strap-work cartouche. A similar aedicular composition was employed just four years later by Andrea Palladio in the title page of his *Quattro Libri dell'Architettura* and in its subsequent English editions.[19]

An equally architectural frontispiece, a pedimented Corinthian triumphal arch with flanking statuary and the figure of Atlas, can be seen in the copy of Nicholas Sanson's *Atlas nouveau contenant toutes les parties du monde ...* (1692)[20] which Isaac Titsingh presented to his close friend Kutsuki Masatsuna. The value of this book, for Masatsuna, was in the maps which contained information on the outside world which would normally be restricted, but Masatsuna, the son and inheritor of the *daimyo* (lord) of Fukuchiyama, could have got away with it. This would have been known to Titsingh and the presentation of this book on the day he sailed from Japan, 6 November 1780, would have been a meaningful parting gift.[21]

It was thus through the Dutch factory at Dejima that Western publications made their way into Japan. And this served to feed the increasing demand for *rangaku*. The Edo artist Shiba Kōkan, who stayed in Nagasaki for six weeks in 1788, was a student of *rangaku* and the first person to adopt the characteristics and techniques of Western art in his work. It was probably here that he obtained a copy of Gérard de Lairesse's *Het Groot Schilderboek* (*Great Book of Painting*), first published in 1707 and with many subsequent editions, the influence of which can be seen in his work.[22] This too had an architectural frontispiece, this time an interior.

When in Nagasaki, Kōkan (as he was known) visited and drew the interior of the *opperhoofd*'s quarters, which he described thus:

> There was a row of chairs, next to each of which was a silver spittoon standing about two feet high, looking like a flower-vase. On the floor matting was a rug with a flowered pattern, and a glass chandelier hung from the ceiling.[23]

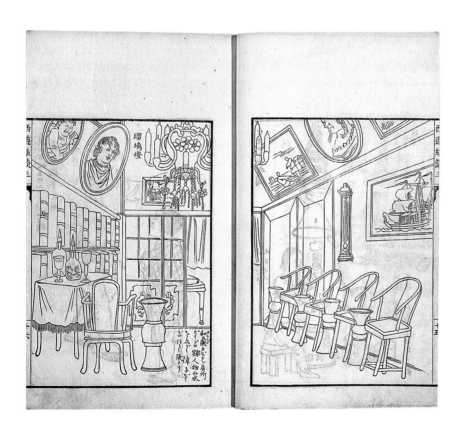

1.02 The interior of the *opperhoofd*'s house at Dejima, from Shiba Kōkan, *Saiyū ryodan*, 1790.

Whereas he does not include the rug, his drawing, published as a pair of wood-block prints in *Saiyū ryodan* (*Account of a Western Journey*) in 1790, shows heavy volumes lining the bookshelves while a barometer, sea-views and portraits in oval frames hang on the walls or lean forward from above the picture rail [1.02]. Although apparently a very European scene, its Japanese context is betrayed by a half-open *shōji* which allows a glimpse, beneath a demi-length *noren*, into the next room.[24]

In the same way that wood-block prints were later to bring images of Japan to the West, so it was that copper-plate prints first exposed the Japanese to Western architecture and landscape design. These came with *kiki* (strange devices), such as peep-boxes and *optiques*, which were imported into Nagasaki either directly from Europe or through China. In 1746, the VOC presented a peep-box to the *Shogun* Ieshige; referred to as *gokurakubako* (paradise box), it was an immediate success.[25] These devices contained painted scenes where visual depth or perspective, enhanced by mirrors, could make an interior, such as seen in a painting by Jan Vermeer or Emmanuel de Witte, appear real. If mirrors were not employed, then prints made from copper-plate etchings showing perspective views would be supplied, often in sets, so that the scenes could change for narrative or simply pictorial effect. It was also copper-plate prints which were used, as reversed images, in *optiques*, which the Japanese called *karakuri*. Here through lenses and mirrors, known as *Oranda megane* (Dutch glasses), these *vues d'optique* or *megane-e*, showing European cities or landscapes, could be seen enlarged and enhanced.

Imported copper-plate prints were initially both rare and expensive but in 1783 Kōkan, who was to build his own *Oranda megane*, started making copper-plate prints.[26] Kōkan believed that Europeans viewed everything in the form of these 'perspective views', or *verdute*, and so their adoption and production was a further indication of *rangaku*. In about 1787 he made a copy of George Bickham's *A View to the Grotto of the Serpentine River in the Alder Grove in the Gardens of Earl Temple at Stow, in Buckinghamshire*.[27] Although Kōkan's *megane-e* is a reverse print, as his original would have been,

William Kent's grotto[28] and flanking *tempietti* (one ornamented with shells and the other with broken flint and pebbles) are still recognisable, but the Cold Bath,[29] set within the trees to the side, is no longer arcuated and pedimented, but now appears to resemble a Japanese farmhouse (such as that built at the 1878 Exposition Universelle in Paris) with a lean-to roof across the front [Plate 7].

As well as producing copper-plate and wood-block prints based upon European sources, Kōkan adopted European painting techniques and subject matter, an art form which became known as *yōga*. His oil paintings, whether on paper or silk, were, not surprisingly, Dutch in both composition and method. Copper-plate etchings of genre scenes showing *De Kuiper* and *De Mandemaaker*,[30] taken from Johannes and Caspaares Luiken's *Het Menselyk Bedryf* (1694), provided the source for both his paintings and wood-block prints. In his painting of *The Coopers*, Kōkan borrows only the figures working on the barrel while composing, in the background, a scene of buildings with a seascape beyond. Although the joints in the stonework and the voussoirs around the windows of these two-storey buildings are clearly delineated, there is something unconvincing in the form of the openings and the manner in which the upper storeys appear to be corbelled out. Similarly, in his wood-block print of Luiken's *De Mandemaaker* (The Basketmaker), the crispness and detail of Luiken's Dutch house has been lost and a simple Japanese frame-and-plaster building, albeit of over two storeys, has been substituted. For all his interest in Western art – and Kōkan published *Seiyō gadan*, a book on Western art appreciation, in 1799 – his representation of Western architecture is, at best, loose.

A far more accurate architectural representation of Western architecture was found in the wood-block prints of Utagawa Toyoharu who copied, from imported copper-plate prints, celebrated scenes of Europe including the Roman forum [Plate 5]. Although the print is entitled *A Dutch View of a Franciscan Monastery* (*Oranda Furansukano garan no zu*), the great Roman monuments, copied from a *capriccio* most probably by Giovanni Paolo Panini, are immediately recognisable: from the right,

the Colosseum, Trajan's Column, the Basilica of Constantine, the Arch of Titus, and the Temples of Antoninus and Faustina and of Saturn, all (re)arranged, however improbably, around the equestrian statue of Marcus Aurelius, which some thought once stood in the Forum. However, as with Kōkan's view of Stowe, Toyoharu's view of Rome, when compared with Panini's original, is in reverse.

The archaeological inaccuracy was of no concern. Indeed, whether this was Rome or Amsterdam probably mattered little. This was *rangaku* and all-encompassing. Another wood-block print by Toyoharu entitled *The Bell Which Rings for Ten-thousand Leagues in the Dutch Port of Frankai* shows, in fact, a view of the Grand Canal in Venice [Plate 6]. The copper-plate etching upon which this was based was *The Canal Grande from Sante Croce to the East* by Antonio Visentini. This was published as part of a series of *vedute* in 'Prospectus Magni Canalis Venetiarum' in 1735–42. It was based, in turn, upon a contemporary painting developed from a sketch by Canaletto, and probably by his nephew Bernardo Bellotto, called *Venice: The Upper Reaches of the Grand Canal Facing Santa Croce*. Once again, the location was not important but the demonstration of Western learning, *rangaku*, was.

The first known Japanese to adopt Western architecture as a lifestyle during *sakoku* was the *rangaku* scholar Yoshio Kōsaku (or Kōgyū). As well as dealing in Western medicines, much of which he had learned from Carl Peter Thunberg, Yoshio was for many years the head translator at Dejima. With the wealth accrued from his medical ventures (and quite possibly other dealings at Dejima, for he was eventually sacked and imprisoned[31]) he built a two-storey house in the Dutch style, complete with stairs to the upper floor, as opposed to a ladder, and a bath-tub in which he could lie down. Tachibana Nankei, the diarist and physician who visited Nagasaki from Edo in 1781, described it as being 'exactly like entering a real Dutch house ... all very awkward'.[32] The illustration of the interior, drawn by Ichiyanagi Kagen, which he included in his book *Hokusō sadan*, published in 1829, shows a stylised Classical Order, possibly Ionic, framing loggia windows, with square tiles rather than *tatami* on the floor and heavy-looking ornate chairs which he says Nankei found 'gruelling' [1.03].[33] Perhaps they were, for when Kōkan visited it in 1788, he showed his gratitude by painting a portrait of Kōsaku, holding a Western book, beneath a pair of Westernised, cloud-borne, trumpeting *putti*. But despite these

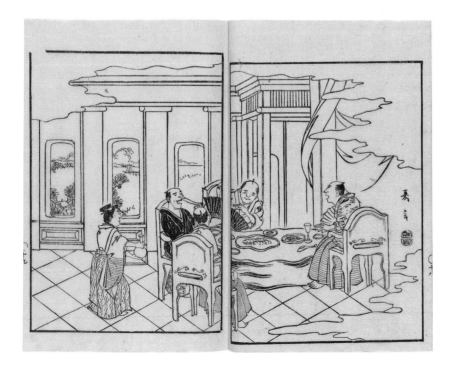

1.03 The interior of Yoshio Kōsaku's house in Nagasaki, from Ichiyanagi Kagen, *Hokusō sadan*, 1829.

occidental references, Kōsaku is shown sitting on the floor.[34]

The best if not the only source of first-hand knowledge of the West was through the Dutch community on Dejima, although occasionally, as did happen, Japanese sailors who had been shipwrecked or had lost their way at sea came back to Japan. When found, they would be relentlessly questioned before being imprisoned, or relocated far from their home, lest what they knew of the other world leaked out.[35] Daikokuya Kōdayū was a ship's captain from Ise who in 1783, having lost his way, landed in the Aleutian Islands from where he made his way to Kamchatka and eventually Irkutsk in Siberia. In 1791 he travelled to Moscow and St Petersburg to petition Catherine the Great to allow him and the remnants of his crew to return to Japan, which she did. Daikokuya arrived back in Japan in 1792 and was soon summoned before the *Shogun* in Edo. There he was interrogated about his life in Russia and his account was to provide the most comprehensive description of a Western country yet obtained. This was written up as *Hokusa Bunryaku* (*Tales of a Northern Raft*), in 1793, by the *rangaku* scholar, Katsuragawa Hoshū, but remained unprinted since it dealt with matters of state and was therefore taboo. Nevertheless, *Hokusa Bunryaku* was widely read in manuscript form and from this considerable detail of the architecture of Russia could be gleaned.

In his attempt to gain an audience with the Empress, Daikokuya had arrived first in Moscow. There he thought that the Kremlin was 'a vast, beautiful and prosperous place'[36] and he was impressed by the large clock above the gate to the Starodevichy, the Ascension or Old Maiden's Convent, the dial of which he thought was more than two *hiro* in diameter. 'It can be seen,' he said, 'from several *ri* away.'[37] Outside the Kremlin walls was the Spassky Bridge, rebuilt in stone in the seventeenth century and used for royal entrances:

> It is over 40 *ken* long and six or seven wide and, on both sides, stone balustrades which have been engraved in reliefs of many varied designs, one of the most perfect archived. But these balustrades are very low. It was once fashionable, it seems.

Recently, they are all made of iron, at a height of about three or four *shaku*, with up to date carved designs and borders of fine golden inlays.[38]

The Empress, it turned out, was not in Moscow but in St Petersburg, to where Daikokuya next went, the journey taking three days and nights. 'It's the new town-castle of the emperors of Russia,' he later told Katsuragawa, 'very nicely built.'[39] In Moscow, he recalled, 'the brick houses mingle with those of wood, there are some large ones and some small, they are not more than one or two stories'.[40] In St Petersburg, by comparison, 'the houses are brick and rise to three or four floors. The houses of ordinary people are scarcely different from those of officials.'[41] 'Moscow,' he concluded, 'does not live up to Petersburg.'[42]

Meanwhile the Empress was residing at the Winter Palace:

> Covering an area of two square *chō*, it has been laid out without a fence or wall around it and does not cut through the ordinary houses ... The main building, built of brick, has four floors. Its construction is of a subtle beauty that one cannot imagine ... Beside the castle, a stone building. It is *mura-mura* (a kind of marble) and of three floors. It is 60 *ken* long and of an architecture developed to the highest degree.[43]

Beyond the Winter Palace was Peter the Great's Summer Palace (built by the Swiss-Italian architect Domenico Trezzin in 1710–14) and its garden. It was the garden, more than the Summer Palace, which remained in Daikokuya's memory and was described to Hoshū:

> About two *chō* east of the palace of the emperors, there is a garden. It is about seven *chō* long and three wide (according to our measurements). On the inside have been erected high buildings and gazebos, statues of men and of women sculpted in beautiful stone close to either side of the road, and a number of fountains have been built to relieve the landscape.[44]

Once the *Shogun* had heard what Daikokuya had to say, and Hoshū had recorded it, the unfortunate sailor had served his useful purpose and had to be secluded. So he was given a generous pension and ordered to retire to the *Shogun*'s herbary where he remained, a virtual prisoner, until his death 35 years later.[45]

There were, in the eighteenth century, few significant Japanese translations of Dutch texts, for the risk of state censorship made the effort involved unappealing.[46] Although Sugita Genpaku's *Kaitai Shinsho* was published, Katsuragawa Hoshū's *Hokusa Bunryaku*, as has been noted, remained in manuscript form. The extensive writings of Honda Toshiaki, best known for his economic theories, were familiar to only a few friends and students. Written in 1798, but not published for 90 years, his *Seiiki Monogatari* (*Tales of the West* — that is, areas to the west of Japan) conjures up powerful images.[47]

In Europe and Africa there are huge edifices known as the Seven Wonders, consisting of the most remarkable sights of the world. The pyramids of Egypt and the tower of Babylon were both built for worshiping God. The latter, constructed of stone and ornamented with sculptures, was round in shape, and of a splendour difficult to describe. A spiral staircase ascends to the summit, at which point the tower was very broad, with balconies on every side from which the mountains and oceans can be seen. There one was truly above the clouds …[48]

Despite the confusion in the name, this description, including the mountains and ocean, neatly fits Maarten van Heemskerck's engraving of the Tower of Babel, published in Haarlem in 1572 as one of an eight-part series of the Seven Wonders of the World: the eighth was a view of the Colosseum combined with a self-portrait.

Toshiaki must also have read Hoshū's *Hokusa Bunryaku* for he mentions Daikokuya's account of the 'Great Bell of Muscovy', which he lists as one of the extant (or modern) Wonders, together with 'the Stone Bridge of London':

In the capital city of London there is a broad river called the Thames. A stone bridge spans its width of about three *ri*, and at both ends there are markets and temples. Large ships with sails raised can pass under the bridge. The construction of the stone embankment along the river and of the bridge itself is so magnificent that one doubts it was accomplished by human labour. When it comes to grand edifices, no country in the world can compare with England.[49]

One might speculate upon what evidence he based this assessment. The enthusiasm for England is perhaps surprising but, at this time, not unexpected.

There is no country comparable to England in the manufacture of very fine things. Among the articles imported into Japan by the Dutch, there have been none more precious than the watches. Some of them are so exquisite that hairs are split to make them. London is thought to produce the finest such workmanship in the world. Next comes Paris in France, and then Amsterdam in Holland. In these capitals live people virtually without peer in the world, who are the handsomest of men. The houses in these towns and cities, even in the outskirts, are built of stone. They are from two to five storeys high and surpassingly beautiful.[50]

While there might seem to have been a range of sources available to inform the Japanese about Western architecture, it must not be thought that they were of any great influence. Books, most of which were medical or scientific, which found their way in through Dejima were prized but of limited circulation. Expatriated Japanese who returned to their country were put into some sort of purdah, if allowed to live at all; their accounts, although circulated privately in manuscript form, were, like maps, taboo. The *Shogun* or *daimyo* would receive imported gifts from the VOC but consider them as curios and nothing more, only to be put away and brought out again, maybe years later, and viewed with the same quizzical interest. Peep-boxes, which eventually became commonplace in fairgrounds, did generate a great deal of attention but perhaps more for the pictorial effect and the thrill they imparted than for their actual subject

matter. Indeed, Kōkan, who took them much more seriously than that and even produced series of Japanese *vedute*, albeit with Roman lettering, charged 32 *mon* for a peep.[51] Furthermore, Western architecture was Christian architecture and Christianity was absolutely forbidden. When the Dutch had erected a warehouse at Hirado with a Christian date inscribed on the cornerstone, the building had to be torn down.[52] A Japanese person would never have made the same mistake.

Looking East

Although Japan was a country closed to the West, it was not as if there was no outside knowledge of its architecture. Indeed, the fact that so little changed in that time would suggest that what was known of Japan's architecture from before *sakoku* still held good until the mid-nineteenth century. The decorated screens, given to Pope Gregory XIII by the Tenshō emissary in 1585, had provided the West with its first likeness of Japanese buildings, but the first-hand accounts, written by the Jesuit Father Luís Fróis, give a much better impression of the scale and magnificence of these buildings. In 1569 Oda Nobunaga, whose Azuchi Castle was shown on the Tenshō screens, invited Fróis to Miyako (now Kyoto) to witness the building, in stone, of Nijō Castle for the puppet *Shogun*, Yoshiaki Ashikaga. It was a prodigious effort involving 15,000 to 25,000 men. 'The most marvelous thing about the whole operation,' Fróis wrote, 'was the incredible speed with which the work was carried out. It looked as if four or five years would be needed to complete the masonry work, yet he had it finished within 70 days.'[53]

In 1567 Nobunaga seized Gifu Castle, to the north of Nagoya, and subsequently rebuilt it, remaining there until 1576 when he moved his base to his new Azuchi Castle. When Fróis saw Gifu Castle it was still incomplete and he records how Nobunaga 'remarked that although he would like to show us his palace, he was reluctant to do so because it would be considered very inferior to what I had

seen in Europe and India; however, he added, as we had come such a long way, he himself would be our guide and show us around ...'[54] As Fróis was to find, this hesitation, on Nobunaga's part, was misplaced modesty. 'I wish I were a skilled architect,' he continued, 'or had the gift of describing places well, because I sincerely assure you that of all the palaces and houses I have seen in Portugal, India and Japan, there has been nothing to compare with this as regards luxury, wealth and cleanliness ...'[55] It was an opinion shared by another Jesuit, Father João Rodrigues, who wrote in his *História da Igreja do Japão* that 'The architecture, the style (both inside and out), the decoration of the roofs and the symmetry of these buildings are wonderful to behold in every detail.'[56]

But although the symmetry of the exterior was noticeable, it was not extended to the interior. As Fróis wrote, 'The halls and compartments within are like the labyrinth of Crete and are deliberately constructed thus with no little ingenuity.'[57] As someone brought up in Lisbon at the time that Portugal was reaching its political and cultural zenith, Fróis would have been sensitive to the formalities of Classical architecture – the Hospital Real de Todos os Santos, where the Jesuit Order was based, was arranged symmetrically around a centrally positioned chapel[58] – and he would have expected, intuitively, such organisation in a building of the scale and importance of Gifu Castle. Yet the sense of procession and order, characteristic of Classical architecture and suggested by the symmetrical exterior, was missing. 'Just at the place where you think there is nothing more,' he wrote, 'you find a luxurious chamber (which they call *zashiki*) and behind it another room, and then yet another, all designed for special purposes.'[59] This was not a series of rooms set *enfilade*, but a maze, each successive room indistinguishable from the last: 'Leading off from the first gallery there would be about 15 or 20 *zashiki*, all decorated with *byōbu*, or screens painted with gold, with locks and fittings of pure gold.'[60]

Fróis was impressed by the castle's broad stone wall, 'so well constructed of enormous blocks of stone that there is no need for any mortar'.[61] He

commented upon the size of the entrance hall, approached up a long flight of steps, and by the views of the city and the houses of the 'principal nobles and gentlemen' visible from the balconies. Nobunaga showed him the women's apartments on the second floor and, on the floor above, the rooms intended for the tea ceremony whose perfection amazed him. 'These rooms are very quiet and not a sound is to be heard in them; their exquisiteness, perfection and arrangement are quite beyond my powers of description,' he wrote, 'or I simply do not possess the necessary vocabulary as I have never seen their like before.'[62]

When Fróis wrote of his visit to Nobunaga's newly completed Azuchi Castle in 1581, he chose to contrast what he saw with what he remembered of Western architecture:

On top of the hill in the middle of the city Nobunaga built his palace and castle, which as regards architecture, strength, wealth and grandeur may well be compared with the greatest buildings of Europe. They seem to reach the acme of human elegance. And in the middle there is a sort of tower, which they call *tenshu* and it, indeed, has a far more noble and splendid appearance than our towers. It consists of seven floors, all of which, both inside and out, have been fashioned to a wonderful architectural design ... This *tenshu* and all the other houses are covered with bluish tiles which are stronger and lovelier than any we use in Europe; the corners of the gables are rounded and glided, while the roofs have fine spouts of a very noble and clever design. In a word the whole edifice is beautiful, excellent and brilliant.[63]

Fróis's enthusiasm, however, must, to some extent, have been a reaction to the paucity of the common housing all around. Of this he wrote, once again offering a comparison: 'Our roofs are covered with tiles; the Japanese mostly with boards, straw, and bamboo.'[64]

In the same way that Japanese sailors were cast up or shipwrecked upon foreign shores, so Europeans found their way into Japan. William Adams, the first Briton to come to Japan, arrived in 1600 upon the Dutch ship *De Liefde* with a sick and depleted crew, and was soon taken to Osaka to be interviewed by the *daimyo* and future *Shogun* Tokugawa Ieyasu:[65]

The twelfth of May 1600, I came to the king's great citie, who caused me to be brought into the court, being a wonderfull costly house guilded with gold in abundance. Coming before the king, he viewed me well, and seemed to be wonderfull favourable ...[66]

Rodrigo de Vivero y Velasco was a Spanish colonial officer and governor of the Philippines who, on his way to take up a position in Mexico in 1609, was shipwrecked on the east coast of Japan. He was to spend nine months in the country and, with the help of a Franciscan friar, Luis Sotelo[67] and probably also Adams,[68] was received in Edo by the *Shogun* Tokugawa Hidetada, the son of Ieyasu. In his *Relacion y noticias del reino del Japon*, written in 1609, Velasco described the palace but this account was not published until much later, in 1855.[69] However, he outlived his detention in Japan by over 25 years and had ample time to recount what he saw.

It is not easy to describe the grandeur I saw there, both as regards the material structure of the royal house and buildings, and also the multitude of courtiers and soldiers who thronged the palace that day ...

The first and principal wall is made up of huge square blocks of hewn stone, without mortar or any other mixture but simply set in the wall. The wall itself is very broad and has openings through which to fire artillery, of which they have some but not a great deal. Below this wall there is a moat through which flows a river, and the biggest drawbridge I have ever seen.[70]

His impression of the palace's interior takes on a description which, due to the architecture's novelty, became commonplace amongst nineteenth-century writers:

Next we came to the first apartment of the palace. Nothing could be seen of the floor, the walls or the ceiling. On the floor they have what is called *tatami*, a sort of beautiful matting trimmed with cloth of gold, satin and velvet, embroidered with many flowers. These mats are square like a small table and fit together so well that their appearance is most pleasing. The walls and ceilings are covered with wooden panelling and decorated with various paintings of hunting scenes, done in gold, silver and other colours, so that the wood itself is not visible. Although in our opinion, this first compartment left nothing to be desired, the second chamber was finer, while the third was even more splendid; and the further we proceeded, the greater the wealth and novelty that met our eyes ...[71]

Like Velasco's almost contemporaneous account, the detailed diary kept by Richard Cocks, the director of the East India Company's factory at Hirado, remained unpublished until late in the nineteenth century.[72] Had Cocks not died at sea on the return journey to England in 1624, it might have come to light sooner. Nevertheless, it is worth quoting here for it shows what most moved a yeoman's son from England.

Cocks had been raised in Seighford, Staffordshire, about 50 miles – or a two-day ride – from the walled cathedral city of Coventry. When, on 1 September 1616, he was received by Tokugawa Hidetada in Edo, he thought the *Shogun*'s palace to be 'much more in compass than the citty of Coventry'.[73]

It is a place very strong, duble diched and ston walled about, and a league over each way. The Emperours pallis is a huge thing, all the rums being gilded with gould, both over head and upon the walls, except som mixture of paynting amonst of lyons, tigers, onces, panthers, eagles, and other beastes and fowles, very lyvely drawne and more esteemed [than] the guilding

... I forgot to note downe that all the rowmes in his pallis under foote are covered with mattes edged with damask or cloth of gould, and lye so close joyned on to an other that yow canot put the point of a knife betwixt them.[74]

Beyond the stone-built palaces, all the buildings were of timber. Francesco Carletti, a Florentine merchant who visited Japan in 1597–98 while circumnavigating the globe, recorded his observations in the *Ragiomenti di Francesco Carletti*, published posthumously in 1701. His writings suggest a keener eye than Fróis's, and perhaps his mercantile background and his considerable fortune accrued from slave trading left him less in awe of the richness of the gilded Japanese interiors. He noticed the construction process, the use of materials, the structural system and the techniques employed for protection against damp and water penetration:

The houses in the city of Nagasaki are all built of timber cleverly fitted together, and all the materials used in their construction are carefully wrought, in accordance with designs and measurements. It is possible to erect a house in two days, the upright posts which support it standing on large stones, by way of foundation. These as to one-half of their height are buried in the earth, and as to the other half rise above it, their purpose to prevent the wood from touching the earth and so becoming rotten. Next they place the transverse beams which are mortised into the upright posts, and on these they nail the planks which form the walls of the room. They then cover the whole with a kind of shingles, formed by splitting wood, such as that of the pine, and these, being fixed with pegs, take the place of flat or pantiles, being so laid as to overlap one another and thus cover any gaps through which the water might leak.[75]

Carletti's account might not be totally original, which is not to say that it was not accurate – including the comment about the use of nails, for contrary to some thinking, the Japanese did use nails.[76] By his own admission, he lost the notes he made on his visit to Japan and had to rely on his memory, or perhaps other sources, when assembling his *Ragiomenti*.

Another Jesuit who knew Japan well was Father João Rodrigues who had arrived there as a teenager in 1577 and then mastered the language so well that he became known as Tçuzzi or Rodrigues the Interpreter.[77] He was eventually expelled from Japan in 1610 and retreated to Macao where he wrote his *História da Igreja do Japão* which was published in 1620–33. Here he explains how in the houses of the nobles all the frame-posts (or pillars) are made of expensive woods, often a good-quality cedar which gives a fine lustre, while the ordinary houses use inferior timbers such as pine. He also points out that, even if the principal house is built of cheaper timber, the guest house would be built of cedar. In his description of the Japanese house, he identifies the importance of the *tatami* as a basic design module for the timber frame, as well as the inherent flexibility and resilience of this type of post-and-beam construction:

The houses are built according to fixed measurements because the mats, or *tatami*, with which the floors are covered, are of a standard size; each one is eight spans in length, four in width and with their stuffing three fingers thick. They always see to it that the mats in the halls and rooms are closely fitted together without any space or gap between them, just as if they were planks. The houses in which they dwell are generally of one story with the floor raised up four or five spans off the ground so that the house may be fresh and well-aired underneath because of the humidity; however, there are also houses of more than one storey, as we have already mentioned. The walls are made of wooden pillars, equally spaced out and resting on stone supports, instead of foundations in the ground, so that the wood will not rot. Each pillar is joined to the corresponding one in the opposite wall by a wooden beam which rests in a hole which they make on the top of the pillar. In this way the house is stronger and firmer against the winds, storms and earthquakes than it would be if it were made of stone, brick or mud. Although there are a great many storms and earthquakes, the houses rarely collapse (unless they were already rotten) because the pillars are so strongly joined and fixed to each other. Thus they can move an entire house of this sort to another place nearby without dismantling it, apart from removing the roof from on top because of its weight, and this we have seen them do many times.[78]

The majority of these early impressions of Japan date from before the introduction of *sakoku* in the 1630s. After that time interaction between Westerners and the Japanese was limited to business arrangements with the Dutch on Dejima and the annual pilgrimage from there to Edo, known as the 'viewings', when the *opperhoofd*, given the status of a *daimyo*, was required to show his fealty to the *Shogun*. This, in itself, was a very curious relationship because, in Japan, the merchant class were regarded with disdain: it was the *samurai* or soldier class which, outside the gentry and nobility, held the greatest respect, as François Caron, the *opperhoofd* from 1639 to 1641, implied. 'The Souldiers and Gentry,' he wrote, 'have their houses divided, one side for their Wives, the other for them, for their Friends and their ordinary vocation. The Merchants and Citizens Wives dwell promiscuously with their Husbands, governing and ordering their families as with us ...'[79]

Such viewings are referred to in the title of Arnoldus Montanus's *Atlas Japannensis Being the Remarkable Addresses by way of Embassy from the East-India Company of the United Provinces to the Emperor of Japan ...* which was first published in Dutch in 1669. An English edition was printed in London the following year, and a French version appeared in 1680.[80] Montanus was actually Arnold van den Berghe, a Dutch theologian, historian and rector of the Latin School at Schoonhoven, who never travelled to Japan but rather assembled his book, he claimed, based on information brought by sailors and returning employees of the VOC. The book is remarkable for the amount of engraved illustrations which it contains, something which previous accounts of Japan had failed to do. Yet the illustrations were prepared by Dutch engravers and cannot be relied upon. The costumes often appear to be more Chinese than Japanese and the

physiognomy is not characteristic of the Japanese people. Indeed, in some illustrations a similarity to native Americans, the subject of a later book by Montanus, is perceptible.[81]

If some of the imagery was fanciful, there was also a noticeable disparity between the illustrations and the text. As already noted, the view of the Dutch factory on Hirado, which Montanus calls Firando, shows a number of stone buildings with stepped gables and one with an arcaded elevation. Yet the text does not altogether support this. Montanus writes of the store-house at Hirado:

> being built of Wood, which in short time grew dry and rotten, it could not preserve their Merchandise either from Fire, foul Weather, or Thieves. Therefore, in *Anno* 1641, they began to build one more large, of Stone; which the Emperor, not rellishing, supposing they might convert it into a Fort of Defiance, commanded them to desist, and at the same time remov'd them to *Nangesaque*.[82]

It is unclear from Montanus's account whether the stone store-house was ever finished and, if so, how it might have appeared. But it is unlikely that it looked like the cluster of mercantile buildings shown in his illustration, for there was probably neither the time and certainly not the building skill to achieve this. As with the costumes and the characteristics of the Japanese people, Montanus's Dutch engravers had allowed their imagination to run away with them. Having said that, however, almost nobody in Europe was in a position to challenge the authenticity of Montanus's illustrations, yet readers must have wondered at their detail and accuracy. The German surgeon, Engelbert Kaempfer, who took the book with him when he was posted to Dejima from 1690 to 1692, noticed the shortcomings of Montanus's account.[83] This was confirmed by Johann Caspar Scheuchzer, who in his introduction to his translation of Kaempfer's *The History of Japan*, published in London in 1727, wrote that 'This work doth by no means answer, neither the expence bestowed on the impression, nor the promises made in the very Title-page, nor doth it deserve

the favourable reception it hath met with.'[84] He is, however, most critical of the engravings, or 'Cuts', as he calls them:

> But what is most material, most of the Cuts, which are the greatest embellishments, and, as it were, the Soul of performances of this kind, do greatly deviate from truth, representing things not as they were, but as the Painter fancied them to be.[85]

Be that as it may, this was the impression of Japan with which European readers were confronted. The images, which are not lacking in detail, often revert to what might be regarded as a generic description of a similar European building type. For example, the castle on Hirado which, Montanus says, 'is all that *Firando* boasts',[86] is shown as being of a symmetrical design around a central axis leading from the access bridge and embellished gateway to the castle, a seven-storey, stepped structure on raised ground.[87] Both the use of symmetry and the axial route, if not the detail of the castle itself, are uncharacteristic of Japanese design. The description further enforces the European perception:

> The Castle stands amidst a pleasant Mead, to which they pass over a Bridge of blue Slate, which leads to the Base Court, guarded on each side with a File of Musquetiers. The Gate is cover'd with a double Penthouse, one a good distance beneath the other: The opposite Jaumes are adorn'd with the Emperors Arms, and those of their Noble Family.[88]

There are also, arranged symmetrically at each corner of the courtyard, 'four Arbours of Pleasure, or Banquetting-houses, standing on square Pillars, built round with Galleries, and a *Cupiloe* on the top'.[89] If there was any accuracy in Montanus's illustration, it was restricted to the polygonal stonework of the encompassing wall which does recall Fróis's description.

In a similar way, the description of the university at Kyoto, here called Meaco, conjures up an European image of 'several Halls, Colledges,

Cloisters, surrounded by a pleasant Stream: near which are many Chappels'.[90] But any notion of it being a place of Christian learning is quickly crushed when we read that in some of the chapels 'they worship a horrible Image, representing, as we suppose, the Devil'.[91] The frequent inclusion of pagan imagery in the illustrations supports Scheuchzer's assertion that Montanus's account was not 'collected from the Journals and Memoirs of the Ambassadors' but 'transcribed from the Letters of the Jesuits';[92] yet Montanus, as a Calvinist, would have been against imagery of any sort.[93] As if to emphasise the heathen nature of Japanese society, monkeys are shown as the object of worship: 'And how far this shameful Worshipping of Apes is spread over *Asia*, may hereby appear: for it is not onely usual in *Japan* and *China*, but also in the Territory of the *Malabaers*, and the *Wild Countrey*, between *Macaw* and *Pegu*, and the *Island Cylore*, where they set up Apes for their gods.'[94]

These pagan shrines are often shown within the context of Western, Christian architecture – not the pointed arches of the medieval Gothic churches but the simple classicism of the Dutch Renaissance. In the illustration of an unnamed but 'very stately Temple with a thousand Images near *Meaco*', the giant Buddha below which the Japanese, here recognisable with their top-knots and twin samurai swords, prostrate themselves, is surrounded by Classical plinths upon which dance or perform a range of idolatrous or pagan characters which Montanus describes as '*Morisco* Dancers, Exotick Wizards, and other dreadful figures, with antick Gestures: Their Wind and Thunder also are personated in terrible Figures.'[95] Yet the whole scene is set within a great Renaissance hall with niches along the walls, leaded lights in the windows,[96] a vaulted and coved timber roof and crested doorways [1.04]. The view is probably based upon the depiction of the 1618–19 Synod of Dort (or Dordrecht) by Franck (or François) Schillemans, published in Amsterdam soon after the event.[97] In Schillemans's engraving, the position of the viewer, the arrangement of the space, the vaulting of the

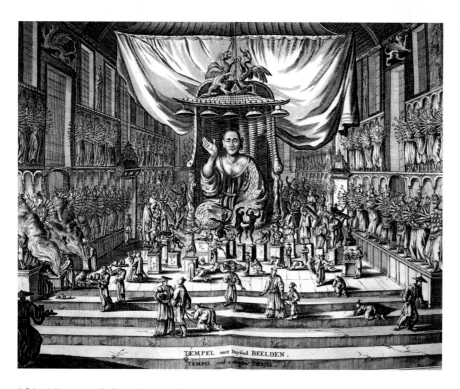

1.04 A 'very stately Temple with a thousand Images near Meaco', from Arnoldus Montanus's *Atlas Japannensis ...*, 1670.

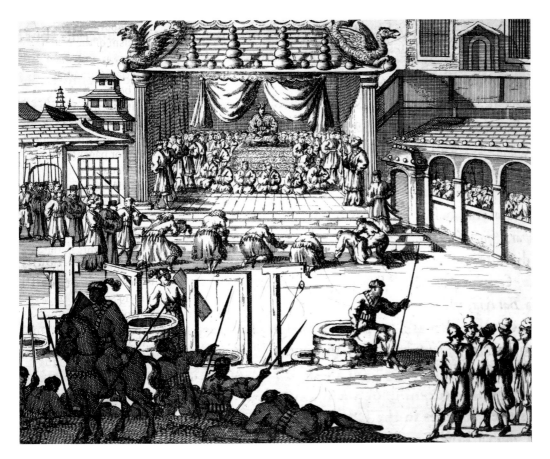

1.05 Captain Hendrick Schaep and his crew are brought before the Grand Inquisitor Inoue Masashige, from Arnoldus Montanus's *Atlas Japannensis* ..., 1670.

roof and the disposition of the windows are all similar to Montanus's later view of the temple at Meaco. But perhaps most significantly, the setting of the giant Buddha between two columns and beneath a hanging or canopy almost replicates that of the moderator's chair in Schillemans's drawing. Since it was at the Synod of Dort that the Five Points of Calvinism were set out and adopted, it could be inferred that Montanus's depiction of this space as a scene of pagan worship was an implicit criticism of the Dutch Reformed Church; conversely, it could suggest that the importance which the Dutch Reformed Church gave to the Synod of Dort was similar to that which the Japanese gave to their worship of the Buddha.

One illustration which does take on a sense of rapportage shows the appearance of Captain Hendrick Cornelisz Schaep and nine of his crew from the VOC ship *The Breskens*, together with some Italian Jesuits, before Inoue Masashige, the Grand Inquisitor for the *shogunate* [1.05].[98] The Dutchmen had been arrested while on a foraging mission on the north-east coast of Honshu and taken to Edo but unfortunately for them, their arrival on Honshu had coincided with that of a group of Jesuits who had come to 'rescue' Cristóvão Ferreira, the apostate former head of the Jesuit mission in Japan who was now working for the Japanese. The unfortunate Dutchmen had to convince the Japanese that they were not Roman

Catholics which, only with the help of Johan van Elserack, the *opperhoofd* at Dejima, did they succeed in doing. The Jesuits, meanwhile, were tortured and apostatised. In the foreground of the picture are the gallows and pits for *ana-tsurushi* or reverse hanging. This much is rapportage and probably, as Scheuchzer suggests, based on letters from Jesuit priests. However, the surrounding buildings, with the exception of two pagoda-like structures in the background, are uniformly Western: Doric columns, a round-arched arcade, round-arched doorways and load-bearing masonry construction.

The 'viewings', or the annual tribute mission to Edo on which the Dutch at Dejima were required to embark, took place in the spring and would last three months. The Dutch party, which usually comprised the *opperhoofd*, the surgeon and a few assistants, as well as a retinue of servants and guards, travelled by both land and sea. The journey from Nagasaki to Edo, along the *kaidō*, took about

five weeks in either direction.[99] The distance was, as Kaempfer explained, 'at least of three hundred and twenty three Japanese Leagues of different length … The Japanese Leagues, or miles are not equally long.'[100] His illustrated account of the viewings, before the *Shogun*, which he included in *The History of Japan*, provided, in contrast to Montanus, reasonably accurate descriptions of Japanese architecture. Indeed, Kaempfer himself observed that, 'The hall of audience, otherwise the *hall of hundred mats*, is not in the least like that which hath been describ'd and figur'd by *Montanus* …'[101] Although much of the account is concerned with the events which comprised the viewings – including the humiliating performances which the Dutch merchants were obliged to put on for their hosts[102] – it included detailed descriptions of the spaces in which they were received. During these audiences with the *Shogun*, the Dutchmen were usually face-down upon the floor in a position of obeisance, making it hard for them

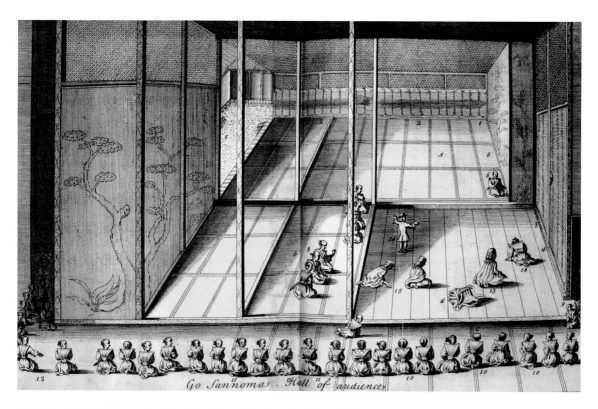

1.06 The Hall of Audience, from Englebert Kaempfer, *Heutiges Japan*, 1727.

to take in their surroundings. But following their second such audience, the Governor of Nagasaki allowed them to see the Hall of Audience, which afforded Kaempfer the opportunity of making a drawing of it. 'Every thing indeed is curious and rich,' he wrote, 'but not otherwise than my draught represents it.'[103]

Kaempfer 's drawing of the Hall of Audience in which the Dutch were required to perform demonstrates the great flexibility of this architecture [1.06]. Painted screens and hanging bamboo blinds, behind which the *Shogun* sat, subdivided the framed interior, resulting in a volume which appears irregular and open-ended. This effect was enhanced by the varied floor levels resulting from the positioning (or not) of the *tatami* mats: the greater the number of layers of mat, the more important the occupant of that space, the zones themselves being defined by the positioning of the columns. But, as Kaempfer notes, 'The middle place had no mats at all, they having been taken away, and was consequently the lowest, on whose floor, cover'd with neat and varnish'd boards, we were commanded to sit down.'[104]

Kaempfer's illustrations can be regarded as being reasonably accurate since all he had to do, as he said, was to count or 'tell over the number of mats, posts, skreens, and windows';[105] these mats were 'all of the same size, to wit, one fathom long, and half a fathom broad'[106] or 6 by 3 feet. However, the posts or columns were not, as might be expected, arranged on a regular grid. In the part of the palace where the Dutch were required to put on their performance, the area was divided into two bays of 18 by 9 feet (3 by 3 mats), and one bay, where the performance took place, of 18 by 18 feet (3 by 6 mats). Beyond that was a further area subdivided in the same manner. However, so as not to obstruct his drawing of the performance, Kaempfer might have omitted the columns which, if included, would have subdivided the larger bay into two smaller bays of 18 by 9 feet each. Indeed, there is, in the distance, a column on that imagined grid line but there is also, at the same time, a column set off the grid-line which subdivides the two smaller spaces.

Three things in particular are noticeable in Kaempfer's description of the palace interiors: the scale, the flexibility of the spaces and the quality of the light.

The palace itself hath but one story, which however is of a fine height. It takes in a large spot of ground, and hath several long galleries and spatious rooms, which upon putting on or removing of skreens, may be enlarged or brought into a narrower compass, as occasion requires, and are contriv'd so, as to receive at all times a convenient and sufficient light.[107]

The waiting room where Kaempfer and his companions were first taken was, as he said, 'a large and lofty room, but when all the skreens are put on, pretty dark, receiving but a sparing light from the upper windows of an adjoining room'.[108] The contrast in light levels added to the mystery if not the confusion of the building which the flexibility of the architecture and the circuitous routes must have brought about. They were taken 'thro' several apartments into a gallery curiously carv'd and gilt ... and were then, through several other walks and galleries, carried further into a large room ...'[109] Fróis's comparison of Gifu Castle to the labyrinth of Crete should not be forgotten.

What is striking about these interiors is that, contrary to all Western conceptions of hierarchy and ceremony, there is no notion of procession about these spaces. The *Shogun* did not sit at the end of an axial route, gazing down upon all who approach him: rather, he placed himself to one side and in the gloom. Furthermore, there is no sense of permanence in either the space in which he sits – the mats and screens could be repositioned at the flick of a finger – or in the materials, paper and bamboo, which define it. Yet the deference which his acolytes and servants show, as they lie prostrate on the floor before him, suggest a more powerful presence than this lightweight architecture would imply.

Nevertheless, the scale and volume of the space is not to be underestimated and, being devoid of furniture and always viewed, if actually viewed at all,

from a seated position upon the floor, it must have been impressive. In his illustration of the Hall of Audience, the posts appear slender, as do the beams. But when compared to the diminutive figure of the dancing Dutchman (which is Kaempfer himself) or to the seated Japanese, the size of the room might seem to be exaggerated. The relative plainness of the principal rooms was perhaps unexpected, but therein lay their architectural value. As Kaempfer observed:

> The structure of all these several apartments is exquisitely fine, according to the architecture of the country. The ceiling, beams, and pillars are of cedar, or camphire, or *Jeseriwood*, the grain whereof naturally runs into flowers and other curious figures, and is therefore in some apartments cover'd only with a thin transparent layer of varnish, in others japan'd, or curiously carved with birds and branched work neatly gilt. The floor is cover'd with the finest white mats, border'd with gold fringes or bands; and this is all the furniture to be seen in the palaces of the Emperor and Princes of the Empire.[110]

Yet to someone even as well-educated and as widely travelled as Kaempfer, whose home town of Lemgo in Westfalia boasted fine stone buildings with tall, pitched roofs, Japanese architecture was, in the end, inherently inferior. 'It may be observed in general,' he wrote, 'that all the buildings of this country, either Ecclesiastical or Civil, publick or private, are by no means to be compar'd to ours in Europe, neither in largeness nor magnificence, they being commonly low and built of wood.'[111] Kaempfer's disappointment must have been due to both the simplicity and the insubstantiality of the architecture. By contrast, Montanus's illustration of The Emperors Throne[112] at Edo (by which he meant the *Shogun*'s[113]) suggests something much more magnificent and robust. His illustration shows the *Shogun* seated beneath a great canopy at the top of a broad flight of steps which 'are all cover'd with rich Tapestry'.[114] 'Four thick Columns, no less beautiful than marvellous', and in a sort of Doric Order, support the canopy's tiled roof 'which is cover'd

with Plates of Gold: At each of the two Corners lies a great Dragon Couchant, of massie Gold. The Cieling represents all manner of Imagery, wrought in Gold, and in some places adorn'd with Precious Stones.'[115] Kaempfer, as has been noted, dismissed such invention:

> The elevated throne, the steps leading up to it, the carpets pendent from it, the stately columns supporting the building which contains the throne, the columns between which the Princes of the Emperor are said to prostrate themselves before the Emperor, and the like, have all no manner of foundation, but in that author's fancy.[116]

Yet, to the Western eye, Montanus provided a much more familiar description of power and grandeur and, with the exotic costumes and prostrate figures, exactly what might be expected from Japan.

It was almost 100 years before there appeared another book which offered any real advance on Kaempfer's descriptions of the Japanese interior. This was Isaac Titsingh's *Illustrations of Japan; Consisting of Private Memoirs and Anecdotes …*, published in London, posthumously, in 1822. Whereas Kaempfer's was the product of a relatively short stay in Japan, albeit including two viewings in Edo, Titsingh's showed the benefit of his two terms as *opperhoofd* on Dejima (1779–1780, 1781–1783, and 1784) as well as a slightly more relaxed attitude towards the Dutch on the part of the Japanese. As his friend and co-founder of the Asiatic Society, the British philologist Sir William Jones, said in 1790:

> Kaempfer has taken from Mr Titsingh the honour of being the first, and he from Kaempfer that of being the only European, who, by a long residence in Japan, and a familiar intercourse with the principal natives of it, has been able to collect authentick materials for the natural and civil history of a country secluded, as the Romans used to say of our own island, from the rest of the world.[117]

Titsingh's book offers the first really informative visualisation of the interior of the Japanese house.[118] Together with a bird's-eye view of the Dutch houses and factory on Dejima, Titsingh provided a number of axonometric views showing the interior of Japanese houses at certain times during the marriage ceremony. There is little commentary but the illustrations demonstrate in detail the construction of the timber framing, the positioning of the *shōji* and *fusuma*, and the arrangement of the *tatami*. More importantly, these illustrations were in colour and so the sometimes murky impression of the Japanese domestic interior conveyed through Kaempfer's engravings was now replaced with very clear, explicit renderings.

One of Titsingh's scenes of the marriage ceremony shows the area around the *tokonoma* where the bride's parents entertain the bridegroom [Plate 3]. The arrangement of the columns and beams shows no use of a grid, but rather an irregular, orthogonal assemblage of rooms which, in contrast to Western architecture, are neither contained by solid walls nor shown with any windows. Anyone examining these drawings with a Western eye will see no apparent order between the size and shape of the rooms, and will probably take a while to realise that these are really not rooms at all, in the Western sense, but rather one large and irregular space subdivided and subdivided again. The *fusama*, decorated with a variety of painted silk coverings, slide quietly between low *uwabuchi* (top rails) and *shitabuchi* (bottom rails) set flush with the *tatami* which cover the floor. The translucent *shōji* are positioned not only on the outside wall, opening on to the *engawa*, but also between the interior spaces, where there too hangs a *noren*. Other walls are made of slatted wooden screens and there is a screen box in which they can be stored.

As well as displaying clearly and in three dimensions the interior of the Japanese house, Titsingh's drawings also demonstrated the benefits of axonometric projection where, unlike in perspective drawing, every dimension was correct and free from optical distortion. It is perhaps no more than a coincidence that Titsingh's book was published in the same year as the Cambridge University Professor William Farish published his paper 'On Isometrical Perspective'. Here he observed that 'Buildings may be exhibited by this perspective, as correctly, in point of measurement, as by plans and elevations, under the advantage of having the full effect of a picture.'[119] It was a technique which had been used in China for many centuries and consequently adopted by Japanese artists for the decoration of, amongst other things, *byōbu*. In the few years before *sakoku* there developed a booming trade in folding screens and other works of art between Japan, the Philippines and Mexico. In the Museo de América in Madrid there is an eight-panel Japanese folding screen or *biombo* (as they call it) showing, in axonometric projection, the Palace of the Viceroy in Mexico City prior to its firing in the riots of 1692.[120] Dating from about 1660, it shows the influence, if not the evidence, of Japanese craftwork and, like others, found its way to Europe. One such eight-panel screen, which shows in axonometric projection and remarkable detail the cityscape of Osaka in the time of the great unifier Toyotomi Hideyoshi, was purchased by Johann Seyfried von Eggenberg, between 1660 and 1680, and installed at his castle, Schloss Eggenberg, near Graz in Austria.

The axonometric projection adopted by the Japanese *byōbu* artists rarely, if ever, explored the interior of the buildings as Titsingh's drawings did. Farish here offered a warning: '... in thus exhibiting a building transparent, and their interior laid open, there is a danger of being confused by a multiplicity of lines; which is a difficulty in a building containing many rooms ...'[121] Yet as a means of architectural drawing, the axonometric was soon taken up by engineers in the nineteenth century, and by architects of the Modern Movement in the early twentieth century. It was perhaps with more than a look over their shoulder that in 1977 Alison and Peter Smithson adopted, as will be shown, not just axonometric projection but Titsingh's style – and, indeed, a Japanese scenario – for their Riverside Apartments competition drawings. Unfortunately for the Smithsons, they did not win.

2 THE JAPANESE AMBASSADORS

Early Japanese exploration of the West was very much an ordered affair. With the exception of the few students who illegally made their way to London, and the few who were sent there by the *bakufu* government, it was largely through the facility of ambassadorial delegations that the Japanese began to discover the West. These parties were not small. The most famous of them, the Iwakura Embassy of 1871–73, comprised over 100 people, ranging from high-level government officials to students.[1] With Japan being so distant, and travel so slow, they were away from their home country for months, if not years, at a time. These ambassadorial delegations had an agenda, as did the students, and this was, in broad terms, to study and report on the industrial and military advances made by the Western powers. Thus, their role was less that of tourists or even goodwill ambassadors, although there was always the need to renegotiate the Unequal Treaties, but that of undisguised spies. Even so, the Western governments, each in their turn, welcomed the foreigners and received them with great kindness and hospitality, but always with an eye for trade opportunities.

It is from the accounts written by the early Japanese embassies to the West that can be gathered the best understanding of how this new world appeared to them. Many of these accounts are simply reactive but, as the novelty wore off and the West became better known in Japan, the accounts, particularly those of Kume Kutinake, are both inquisitive and descriptive.

Against these can be set the reactions of the Western newspapers, such as *The Times*, *The Illustrated London News* and *Harper's Weekly*, which reported on both what the ambassadors saw and, sometimes, on how they reacted. By describing how the Japanese ambassadors reacted to the buildings and cities which they visited, this chapter seeks both to demonstrate the unfamiliarity of Western architecture while at the same time drawing out the things to which they could relate.

The Embassies

The first Japanese embassy to the West, led by Masaoki Shinmi, landed at San Francisco on 30 March 1860.[2] Sent by the *bakufu* government at the instigation of Townsend Harris, the first American minister in Japan, they travelled, via the Panama isthmus, to Washington, Baltimore, Philadelphia and New York. Muragaki Norimasa, the embassy's second envoy, kept a diary of the expedition but it was not published until 1920. On their return to Japan, they found that Ii Naosuke, the *shogunal* official who had signed the Treaty of Friendship, Commerce and Navigation with Harris in 1858 (and similar Unequal Treaties with the British, Dutch, French and Russians) and had subsequently supported their mission, had been assassinated and the expedition had consequently lost its credibility.

Amongst the Shinmi Embassy's 77 delegates was Fukuzawa Yukichi who was to be a member of the next *bakufu* embassy, the Takenouchi Embassy of 1862 (under Takenouchi Yasunori). This time they went to Europe, arriving first in France and then travelling on to England, where their progress was well recorded in *The Times*, before moving on to the Netherlands, Prussia, Russia and Portugal.[3] Fukuzawa's accounts of these expeditions, *Seiyō Jijō* (Things Western) and *Seiyo Tabiannai* (Guide to Travel in the Western World), were published between 1866 and 1870. Another member of the Takenouchi Embassy, Ichikawa Wataru, published his diary of the trip, *Biyo Oko Manroku*, in 1863. This was translated in 1865 by Ernest Satow, then a young consular official in Japan, as *A Confused Account of a Trip to Europe, Like a Fly on a Horse's Tail*. These accounts proved to be enormously popular.

In 1864, a second European delegation, this one under Ikeda Nagaoki, travelled to France, and the following year, the Shibata Embassy (under Shibata Takenaka) visited France and England. In 1867, a small delegation was sent to Russia, and another, under Tokugawa Akitake, the *Shogun* Tokugawa Yoshinobu's younger brother, toured France, England, the Netherlands, Belgium, Switzerland and Italy. Following the Meiji Restoration in 1868 and the Boshin War of 1868–69, there was not another embassy until 1871. In that year two left Japan. The first, comprising 23 delegates from 17 different *han*, visited the United States, Britain, France and Germany. The second, and the most extensive of all the Japanese embassies, was the Iwakura Embassy, which visited America, Britain, France, Belgium, the Netherlands, Germany, Russia, Denmark, Sweden, Italy, Austria and Switzerland.[4] Kume Kunitake recorded this lengthy progress in five volumes published in 1878.

The students who left Japan illegally to study in London were known as *mikkōsha* or stowaways; those who were sent by the *bakufu* were called *ryugakū-sei*. The most famous of *mikkōsha*, not least because they were the first to go, were known as the Chōshū Five: they were Endō Kinsuke, Inoue Monta, Itō Shunsuke, Nomura Yakichi and Yamao Yōzō. The escape of these young, educated *samurai* was engineered by Samuel John Gower, the Jardine Matheson and Co.

representative in Yokohama, in 1863.[5] Two years later another group of *samurai*, the Satsuma Nineteen, a group including three senior officials and an interpreter, left Kagoshima, through the facility of Thomas Glover, also destined for London.[6] In London these students were received by Alexander Williamson, the Professor of Chemistry at University College, where the majority of them registered to study physics, chemistry and engineering. It was the three most powerful *han*, located in the south-west of Japan – Satsuma, Chōshū and Hizen – who were threatening the *Shogun*'s authority and the *bakufu* who sent their young *samurai* abroad. Before the ban on overseas travel was lifted on 21 May 1866, over 80 *mikkōsha* had left the country – 43 to Britain, 19 to America, 10 to Germany, 10 to France and one each to Holland and Russia.[7]

From the moment of their arrival in San Francisco in March 1860, the Shinmi Embassy's three-month tour caused a huge amount of popular interest. In anticipation of their arrival in New York, *The New York Times Illustrated News* published an ode of the most awful doggerel:

Oh, Japanese,
You're welcome to this shore!
We greet you as we greet the Orient breeze
Whose rustling robes have swept the perfumed seas;
You come as welcome as the earliest peas –
Can soul of man say more?[8]

In Washington, *The Herald* did at least recognise that the Americans might appear as strange to the Japanese as they did to them:

The half shaven heads of several other of his countrymen were visible at the different windows of the steamer, and by their words and laughter were evidently passing some, to us, no doubt, very original opinions on what they saw.[9]

Although Muragaki Norimasa was fairly reticent when it came to commenting in his diary on Western architecture, members of the party took a keen interest. As their ship steamed up the Potomac towards Washington, it slowed down to allow the

Japanese artists an opportunity to sketch Mount Vernon.[10] 'One in particular,' *The Herald* reported, 'who stationed himself on the upper deck guards, with a number of sheets of colored paper, and without loss of time commenced sketching the whole scene before him, succeeded in making himself "the observed of all observers." Those who satisfied their curiosity by glancing over his shoulder reported that his drawings were very life-like, and that he took particular notice of the Japanese flag, and touched it off with photographic nicety.'[11] Meanwhile Muragaki could note: 'The capital now came in view. It is really a picturesque sight; the tall tower of congress in the distance, the flags flying from the tops of buildings, just visible through the dull mist.'[12]

This was before Thomas Ustick Walter had added his great cast-iron dome to the Capitol, which Muragaki was to describe as 'a large building of white marble with a high tower in the centre'.[13] Muragaki would never have seen a building as large as the Capitol, even without its dome. Indeed, the size of the buildings was often commented upon. The Willard Hotel in Washington, where the rooms were 'large and comfortable', was four-storeyed but the Metropolitan Hotel in New York was 'large, handsome building six stories high'.[14] As well as the size of the buildings, it was the scale of the cities which most often drew a response from Muragaki. As the embassy progressed from San Francisco to Washington and onwards, each city seemed bigger than the last. 'Philadelphia is not as large a port as New York,' he noted, adding, 'The streets are wider and the buildings finer than those of Washington ...'[15] On arriving at New York, he could write: 'As we entered the bay we could see the large buildings and towers of the city ... street after street of large buildings, enabled us easily to realise that this is the largest city in America.'[16]

Yet it was more than just the scale of the city and the size of the buildings which distinguished the West from Japan. It was the whole infrastructure, from the trains to the carriages in the streets and the lighting which kept the cities awake at night. In San Francisco, Muragaki had written in his diary: 'I noticed a large round structure at a street corner;

this I was told, is used to store gas, an inflammable air made from coal and now utilised all over the country for lighting purposes. Gas, in this part of the world, is taking the place of oil.'[17]

The effect of gas lighting, seen for the first time, must have been extraordinary. In Washington Muragaki could venture out unimpeded after dark. 'This was the first time we had been out in the streets at night,' he wrote. 'Every street is well lighted with gas lamps, so that it is not necessary to carry a lantern.'[18] And in New York, he wrote:

From the roof of the hotel there is a good view of the city. We see from there the two busiest thoroughfares, where the principal shops, theatres and restaurants are. The traffic is great. Pedestrians and carriages of all sorts pass from early morning until late at night, and, as the streets are brilliantly illuminated at night with innumerable gas lamps, they are as light then as in the day time.[19]

Muragaki, together with the Shinmi Embassy, was also the first Japanese to travel on a railway train. Although he had heard of this invention, he found the journey across the Panama isthmus noisy but exhilarating:

This was our first experience of railway travelling, about which we had heard so much, and we eagerly awaited the time of departure. Presently the train began to move forward, rolling along two lines of iron. As the speed increased, the shaking of the cars becomes excessive and the noise is so great that we cannot hear ourselves speak, and the train goes so quickly that it is almost impossible to form an idea of the country immediately around us; it is like riding on a galloping horse ... We arrived at Aspinwall at 11 a.m., having done the 47½ miles from Panama in 3 hours. What marvellous speed![20]

There were, however, to be no further reports on the efficacy of the Panama to Aspinwall line, for throughout the next decade, the embassies, and the *ryugakū-sei* and *mikkōsha* students who made

their way to the West, travelled westward across the Indian Ocean[21] and, before the Suez Canal was completed in 1871, had to take the train from Port Said, via Cairo, to Alexandria. This was a distance of about 180 miles (288 km), which took almost eight hours – nevertheless it was faster than Muragaki's journey across the Panama isthmus. Ichiki Kanjuro, one of the *mikkōsha* who came from Satsuma in 1865, could not help but be impressed:

> Railways like this apparently stretch along every long-distance route in the countries of Europe. The steam engine itself is about three *ken* long and one and a half *ken* wide; this is placed at the front, and it pulls coaches which are all the same size and can hold between sixteen and twenty-four passengers each. The train runs along the top of iron bars laid on the ground, and forty, fifty or maybe even a hundred of these coaches are coupled together in a long line … The train is as fast as the rushing wind.[22]

Although they might have been momentarily distracted by such things, there was probably very little which the Japanese visitors missed. *The Times* correspondent in Alexandria reported how the Takenouchi Embassy of 1862 took every opportunity to record what they had seen:

> They arrived from Cairo last night by rail, a mode of travelling which seems to excite their warm approval … Their voluminous notebooks are already filled with a mass of information, and the greater part of a most practical kind – such, among others, as the commerce and shipping trade of the ports they have visited, Custom-house duties and regulations and harbour dues. Everything, however, of whatever nature, is minutely inquired into and minutely noted down. Among the officers of the Mission is a Japanese artist, whose pencil is not more idle than the pens of his companions. Before leaving Cairo he added sketches of the Egyptian locomotives and railway carriages to his collection … The Ambassadors, I may add, did not leave Egypt without visiting the Great pyramid, and taking due note of it.[23]

For the many delegations travelling west, their first experience of Western architecture, other than what they might have seen at Dejima, was when the ship stopped at Hong Kong; '… it would be no mistake to think of Hong Kong as first and foremost part of Europe,' wrote Kawaji Tarō, the director of *bakufu* students in Britain in 1867–68.[24] In their desire to see examples of civil and military engineering, they would almost certainly have seen, and might have been entertained at, Murray House (1846), the officers' mess at Murray Barracks, built when Sir William Murray was Master-General of Ordnance.[25] This long, three-storey building, comprised two levels of verandah set above a rusticated stone base. Here the Classical Orders were exhibited in their correct relationship, for both verandahs were colonnaded, the lower one Doric and the upper one Ionic. It would have been quite unlike anything they would ever have seen before.

If the first impressions of the West were gained in Hong Kong and Egypt, they would have been unrepresentative of what they were eventually to find in Europe. This is something which *The Times*, reporting on the Takenouchi Embassy in 1862, was not slow to point out:

> … we hope they did not form a general estimate of the populations of the West from the Arabs who must have beset them there. The bleary-eyed, ophthalmic Egyptians, were not a pleasant study even to Japanese, nor could they have much regretted the speed with which the splendid *Himalaya* bore them away to Malta and to France. France has had the opportunity of first impressing these inquirers with the greatness of an European nation … but in the dirty quays and crowded Canobière of Marseilles, and further on in the thronged and busty city of Lyons, noisy with its clattering shuttles, they had for the first time an idea of the industrial life of Europe …[26]

However dirty and crowded Marseilles might have been, when *HMS Himalaya* docked, 'the Japanese flag – white with a red spot in the centre – at the main',[27] the ambassadors were received by the Marquis de Trévise and Count de Maupas with

military honours.[28] On arriving, over three weeks later, at the Bricklayers' Arms railway station in London, carriages were sent to meet them but they were afforded no formal reception or military escort. As *The Times* explained, it 'is understood that an application was made on their behalf to the Foreign-office for an escort, but it was not complied with, the reason assigned being that it was desirable to avoid such a display at this particular time when the Court is in mourning'.[29]

London, on being approached by sea, would have been very different to Marseilles. Nomura Fumio, who arrived in England in 1866, described the journey up the Thames estuary:

> The river looked very much like the Yodogawa river in Japan. One warship was so magnificent as to surely have no equal throughout the five oceans. The houses slowly became grander in size and more densely packed as we passed through Greenwich. Here there were tall imposing houses of five or six storeys, all in a line like the teeth of a comb. Huge sawmills, shipyards and other buildings stood together like trees in a forest, chimneys rose above them stretching to the heavens, the whistle of a steam train could be heard, and although we had not reached the port yet, I was already certain that no city in the world could rival such prosperity.[30]

Nire Kagenori, arriving in London the same year, felt the same. 'This must indeed be ranked as the greatest metropolis in the World,'[31] he wrote, adding, '... trains actually run through tunnels carved out underneath the city, and one cannot help but marvel at such ingenuity.'[32] In 1862, Mashizu Shunjirō commented that 'The city is on flat land and the sheer density of housing is extraordinary ... there are several wide open spaces called parks where people often gather for recreation.'[33] He was a member of the Takenouchi Embassy and, having come to London from Paris, was perhaps less impressed than Nomura or Nire were to be. 'The townhouses are three or four storey's high, and much lower than those in Paris. There are some houses with seven or eight storey's but these are mostly inferior [*sic*].'[34]

Another member of the Takenouchi Embassy less impressed with London was the *shogunal* official Nozawa Ikuta. 'Neither the town,' he noted, 'nor the house construction matches Paris, and can even be said to pale in comparison with Edo.'[35] The contrast between London and Paris was something which their colleague Matsuki Kōan (later known as Terashima Munenori) could understand. 'Everybody says how much Paris is like Kyoto,' he observed, 'and how much London is like Edo.'[36] Others saw this too, for in 1867 Kawaji Tarō commented that 'Charing Cross is like the Nihonbashi of Edo. The buildings on both sides of the street are lit up and they are paned with glass so that, at night, the general effect is quite breathtaking, and simply too beautiful to describe on paper.'[37]

Yet with this beauty came the chaos of the nineteenth-century city. On arriving in England, Taro had noted that 'there are many houses here in Southampton, all of them most beautiful, and the criss-cross network of railways and telegraphs are truly the height of progress'.[38] But soon he would write that 'the busy thoroughfare in the streets is just like Edo Boulevard at New Year or in the twelfth month [January]. Carriages go back and forth endlessly throughout the day, and it can be really quite dangerous to walk in the middle of the road.'[39] Thomas Waters had not yet built Bricktown in Tokyo so the notion of pavements or sidewalks was still alien to the Japanese. Nakai Hiroshi, like Kawaji, was soon alerted to the dangers of the city streets and how to avoid them. 'People walk,' he wrote, 'on slightly raised places on either side of the street. Carriages use the lower area in the middle, and anyone foolish enough to walk there will be assailed on all sides by carriages at great personal risk.'[40]

If the unfamiliarity of the Western city presented the Japanese visitors with difficulties, their domestic arrangements must have made their acclimatisation no less easy. In April 1862, when the Takenouchi Embassy arrived in Lyons at the start of their European tour, it was reported that 'They appear astonished at the princely luxury of the hotel at which they have alighted, and where they occupy the splendid apartments on the first floor.'[41]

As an official and high-powered foreign delegation, they were afforded the best accommodation which their status allowed. On arriving in Paris on 7 April, they stayed at the Hôtel de Louvre on the rue de Rivoli, a six or seven-storey Second Empire style stone building, designed by Charles-Hubert Rohault de Fleury and completed just six years earlier. Here, the entrance on the side facing the Place du Palais Royal was reserved for their use and the Japanese flag, 'white with a red moon', floated from the balcony above the ground floor arcade.[42] In an editorial written in anticipation of their arrival in England, and whose message was as much about the French as it was the Japanese, *The Times* said:

> No doubt the minds of these men must have been deeply impressed with all they have seen in France, but we shall be very much surprised if the effect upon them be any other than to make them love their own country better, and to think slightingly of the luxury their habits do not allow them to enjoy ...[43]

For in Paris, the ambassadors had been received at the Tuileries by the Emperor Napoleon III, who reminded them, somewhat gauchely, that 'hospitality to foreigners is one of the virtues of civilization'.[44]

The Takenouchi Embassy arrived in London on 30 April, and stayed at William Claridge's hotel in Mayfair, then still Georgian townhouses, where they occupied some 30 or 40 rooms, including the State Rooms which had previously been occupied, at different times, by Eugénie de Montijo, the Empress of France, Sophie von Württemburg, the Queen of the Netherlands, and Crown Prince Oscar of Sweden.[45] Outside the hotel, as *The Times* reported, 'a very handsome flag now floats, and which has been displayed at their special request. The material is of white silk, with a large red disc in the centre, intended to represent the rising sun, their national emblem ...'[46] By now, almost a month into their visit, the richness and presumed luxury of these rooms would no longer have surprised them, nor the use of Western furniture. In fact, there was, for

the Japanese ambassadors, no escaping it. When they reached St Petersburg on 10 August, they were accommodated, in no less grandeur, in the Palais de Reserves on the Quai de la Cour,[47] and on coming to Lisbon on 16 October, were taken to the Braganza Hotel.[48]

The *mikkōsha* and *ryugakū-sei* student parties often stayed, to begin with, at the Charing Cross Hotel or at the less expensive South Kensington Hotel.[49] The size and complexity of these buildings confused them: '... there are corridors up, down and across, and I am frequently losing my way,'[50] wrote Ichiki Kanjurō. 'This lodging house is a very beautiful place. I eventually managed to find my room on the seventh floor as it had the number 72 on the door.'[51] The planning of these large buildings would have been hard to comprehend and the vertical circulation quite unimagined, as Ichiki observed:

> Another curiosity is a small room on one side of the dining room large enough for three or four people to enter at once. On the command to a servant, this rises of its own accord and, before you know, it has arrived on the fourth floor.[52]

Even more humble lodgings on Bayswater Road were quite alien, as he later noted:

> This place is not as beautiful as our previous lodgings, but it is still quite unlike any house in Japan. My room is on the sixth floor and the windows are paned with glass. They command a panoramic view over the city and suburbs.[53]

The Japanese visitors, whether ambassadors or students, were themselves objects of huge interest. Crowds would gather, out of curiosity, just to look at them. The *Salut Public* of Lyons offered a portrait of the Takenouchi Embassy which reflected the novelty of their appearance and customs:

> The Japanese have an intelligent physiognomy, although their countenances are not very prepossessing; the nose is large and flat, the lips thick, the eyes oblique, the complexion sallow,

and the head large. Their hair, of a jet black, is raised up on the head, which gives the younger portion of them a rather feminine appearance when seen from behind. Several of them have the head completely shaved, but none have the slightest appearance of a beard on the face. They are generally dressed simply in garments of dark colours, and with little ornament. They wear a silk tunic, trousers of white muslin, and sandals of yellow leather. They all wear in their waistbelt a dagger more or less richly chased, according to their rank or dignity. They have on their heads a kind of Chinese hat of straw, those of the Ambassadors being gilded on the inside. The Japanese are very sober. They usually drink liqueurs and rice water; and as regards food they prefer boiled poultry. They sit at table, use knives and forks, and season everything they eat with pepper and spice. They are remarkably clean in their manner of eating, as well as their daily habits. They do not appear to be at all annoyed at the curiosity which they excite.[54]

Their presence had no less an effect when they arrived in London, as *The Times* reported:

The Japanese Ambassadors, who arrived just about noon, were of course objects of unmeasured curiosity ... Their dresses were plain and almost sombre in colour, but rich in material. They wore the two swords which in their land are the highest insignia of aristocracy. The *nil admirari* spirit which we are told is one of the chief characteristics of this extraordinary nation was displayed yesterday in a marked manner by the two senior Ambassadors.[55]

In Marseilles, where policemen had to be stationed at the hotel door to keep the inquisitive crowds away, the Japanese ambassadors showed their gratitude as they best knew how:

... it is said that they presented a cigar to each of the policemen placed at the door of the hotel to keep off the crowd. The cigars were composed of tobacco and opium, and they made the smokers quite drowsy. The next police inspector who passed was surprised to find his men asleep at their post.[56]

In anticipation of the arrival of the Takenouchi Embassy in April 1862, *The Times* observed, in an editorial, that 'These interesting people, who exist in the East, under very much the same conditions of climate, territory, and population under which we live in the West, are now coming to examine us as we a short time since went to examine them.'[57] This was true, as far as it went, but the fact was that, whereas the Japanese were intent upon emulating the industrial prowess of the West, many in the industrialised West wished for the simple, pre-industrialised world of Japan.

From the moment of their arrival in Europe or America, if not, as has been suggested, in Hong Kong, the Japanese were confronted with Western architecture. The architectural styles might have appeared familiar, either from illustrations or even from the increasing quantity of Western and *giyōfū* architecture appearing in Japan in the 1860s, but the size of the buildings and the materials employed would have been unfamiliar. Although there was some use of masonry in traditional Japanese architecture, such as in castle fortifications, the use of brick was not known. In 1862, Nozawa Ikuta was so unimpressed with London's brick buildings that he wrote, 'the exteriors are made up of cornered blocks like pillows piled on top of each other'.[58] Frame structures in cast-iron, on the other hand, whether they be exhibition buildings, railway stations or conservatories, offered an approach to construction with which the Japanese would have been familiar. In this type of architecture, there was arguably something which their country could achieve.

Cast-iron and Glass

The first cast-iron and glass building which the Takenouchi Embassy saw was the Palais d'Industrie in Paris, built for the 1855 Exposition Universelle.

With a masonry shell designed by the architect Jean-Marie-Victor Viel, it had a glazed, cast-iron interior created by the engineer Alexis Barrault. The Japanese, as *The Times* reported, were 'astonished by the size of the central nave'[59] which was 650 feet (195 metres) long with a central span of 80 feet (24 metres). The 1862 International Exhibition building in Kensington, London, was similarly a cast-iron and glass gallery contained within a masonry shell. Designed by Francis Fowke, a captain in the Royal Engineers, it was regarded by William Burges, who reviewed the exhibition for the *Gentleman's Magazine*, as a 'bad and ugly building' and he condemned it for 'its utter deficiency in all artistic matters'.[60] The Takenouchi Embassy arrived in England just in time for Takenouchi to attend the opening of the Exhibition on 1 May. Seated in front of the orchestra, under the cast-iron and glass eastern dome, 'The Haitian Embassy and the Japanese Ambassadors,' *The Times* reported, 'were objects of greatest interest to the spectators. The latter, especially, differed from all their brethren of the Corps Diplomatique in bringing with them an elaborate armament, which seemed rather out of place in a temple of Peace, though, *de rigueur*, according to Japanese etiquette ...'[61] There was, amongst the senior ambassadors as they walked down the aisle, an indifference to their surroundings although the youngest of them, as *The Times* observed, appeared 'anything but insensible to the forms of beauty through which he moved'.[62]

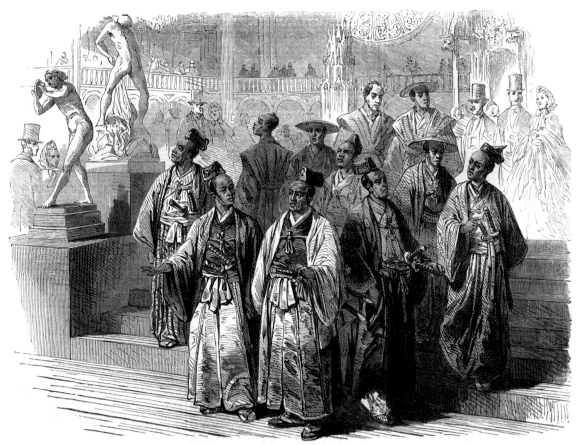

THE JAPANESE AMBASSADORS AT THE INTERNATIONAL EXHIBITION.

2.01 The Japanese Ambassadors at the 1862 International Exhibition in London, from *The Illustrated London News*, 24 May 1862.

2.02 The Japanese Court at the 1862 International Exhibition in London, from *The Illustrated London News*, 20 September 1862.

The Japanese display at the Exhibition had largely been assembled by Sir Rutherford Alcock, from 1859 to 1864 the British minister plenipotentiary in Edo, 'to exhibit', as he said, 'as far as limits of space and means will allow, a fair sample of the industrial arts of the Japanese, and their capabilities of production in rivalry with the nations of the West ...'[63] Located alongside the central avenue on the ground floor and close to exhibits from China and Siam, the display comprised 614 listed items, which included lacquer-ware, china, porcelain and inlaid woods; there were also two cabinet models of Japanese tea-houses as well as a stereoscopic view of one [2.01].[64] However, Fuchibe Tokuzō, a *shogunal* official who joined the Takenouchi Embassy in London, was quite unimpressed with what he saw, writing that

'... it was such a ramshackle assortment of artefacts that it looked just like an old antique shop, and I could not bear to look'.[65]

Although unimpressed with the quality of the Japanese exhibits, the ambassadors nevertheless returned to the International Exhibition on a number of occasions [2.02]. As *The Times* observed, even at the end of the first week, it was still Captain Fowke's cast-iron structure which held their attention:

The same *insouciant* air of quiet languor which seems habitual to them was remarkable yesterday as on other occasions. Nothing appeared to excite their admiration, and very few things attracted even their notice. A glance to the right and left,

as they passed through the courts, was about the utmost they vouchsafed to anything, except, perhaps, the roof of the building itself, at which they were constantly looking ...[66]

What must have held the ambassadors' attention was the scale of the building. The nave reached a height of 100 feet while each dome, set on its octagonal bases of 160 feet in diameter, soared to over 250 feet. The efficacy of the glazed roof following the torrential rain-storm of the previous night might have impressed them as well. 'Of course,' noted *The Times* in the same article, 'it has not proved water-tight throughout, though the leakages were much fewer than was generally expected. Some few of these were caused by trifling defects in sashes or glazing; many by the stoppages of gutters, which never would have been discovered but for the sudden and heavy downpour.'[67]

Compared to the Crystal Palace at Sydenham (1852–54), Fowke's brick-clad exhibition building was more than a little lumpen. What the Takenouchi Embassy saw at Sydenham, as *The Times* reported, thrilled them:

On Saturday they drove to the Crystal Palace which they had not seen before, and where they spent several hours. They were received by Sir Joseph Paxton, Mr. Farquhar, and Mr. Bowley, and by them conducted over the building. There everything they saw was to them so entirely novel and unique that they have talked of little else since their visit. Their delight at the structure itself, as they saw it for the first time glistening in the sunlight, knew no bounds. With all the various courts, especially that of the Alhambra, they were profoundly interested, as they were charmed with the internal display of plants and flowers. From the entire balcony they were afforded a sight of the grounds and of the landscape of marvellous beauty stretching beyond on all hands.[68]

When the Iwakura Embassy visited the Crystal Palace exactly 10 years later, Kume Kunitake carefully recorded what they had seen:

The structure consisted of an iron frame supporting walls and a roof entirely of glass, which kept out the wind but did not exclude the daylight. Its length was 1,608 feet (equal to 168 *ken*). Its width was not uniform: the ground plan included transepts. The highest point of the roof was 110 feet. At either end were towers 240 feet high, and in front of the building spacious gardens in a series of terraces ... The Palace had a wooden floor. Because the walls and roof did not obstruct the light it was as bright inside as out. The nave was over a thousand feet long: one strained one's eyes and still could not make out the end.[69]

As much as the use of cast-iron impressed the Japanese, it was use of glass in such quantities and proportion which impressed them more. 'In Japan,' Kume wrote, 'everyone regards glass as a precious material because of its transparency and delicate beauty, but it is not, in fact, particularly costly. *The use of glass in the West may be likened to the use of pottery in Japan.* Glass is even used in the cottage of the poorest farm labourer; chinaware, conversely, is counted as a valuable possession.'[70] In San Francisco, where the Iwakura Embassy had first made footfall in the West, Kume had visited Woodward's Gardens, a pleasure park with an art gallery and a zoo. Opened in 1866, it comprised a series of inter-linked, glazed pavilions, the central one of which, with an ogee dome, was referred to as The Mosque. This was the first use of cast-iron and glass construction which Kume would have seen: 'The building was surrounded by a conservatory, with glass set in iron frames so that the roof and walls were made entirely of glass.'[71]

On reaching New York, the embassy stopped at Alexander Stewart's department store on Broadway, an Italianate cast-iron building of 1862 designed by John Kellum and referred to as the 'iron palace'. 'Mr Stewart's store, which occupies an entire block in this bustling area,' Kume wrote, 'is a five-storey building constructed mainly of iron. The rows of big windows give it a light and airy appearance. Inside the building is an atrium with glass roof enclosed by four walls ...'[72]

As the Iwakura Embassy's progress continued, few buildings offered anything to compare with the Crystal Palace. In Amsterdam, the cruciform and domical Hall of Glass, 'with its gigantic central tower and ... entire structure consisting of an iron framework glazed with clear, shining glass', was no more than 'a scaled-down version of the Crystal Palace in Britain'.[73] The only other cast-iron and glass building which Kume recorded was the rotunda built for the Vienna Universal Exposition in 1873. Although Sydney Smirke's 140-foot diameter cast-iron reading room at the British Museum in London had impressed him – '... a magnificent structure ... extraordinary engineering skill ... its sheer size dazzles the eye' – the rotunda at Vienna, designed by Karl Freiherr von Hasenauer, exceeded anything Kume had seen before:

> The dome of this structure, however, was 250 feet in diameter and 370 feet in height (that is, 42 *ken* in diameter and 45 *ken* in height). An iron frame supported the dome itself, which presents a balanced appearance. The apex was so high that one could not see it clearly. The intervening doors and windows were glazed ... From the summit to the base of the Rotunda was a three-storeyed, empty, cage-like structure. The solidity of its inter-locking components revealed a profound knowledge of mechanics, and the precision of the moulding represented the highest level of craftsmanship ... The Rotunda was enclosed by four galleries, each 670 feet long (111.5 *ken*) and 80 feet wide.[74]

In 1862, the Takenouchi Embassy had shown considerable interest in the manufacture of cast-iron. Accompanied by the chief engineer of Her Majesty's Dockyard at Woolwich,[75] they had visited the great boiler and engine factories of Messrs. John Penn and Son near Greenwich. 'The vast machines in this factory,' *The Times* reported, 'they inspected with much intelligent interest. They seemed particularly struck with the immense steam hammers of Nasmyth's patent, which were in full operation. A wish having been expressed to witness the process of melting iron and running it in its liquid state, this was speedily accomplished ...'[76] From there they went to the firm's works at Deptford Green where the planning and riveting machines held their attention. 'The various processes carried on in the different works,' *The Times* continued, 'were eagerly and closely examined by the Japanese, and they made copious notes and drawings of all that particularly struck them.'[77]

The manufacture of cast iron was not possible without the use of coal. So, towards the end of their third week in England, the ambassadors departed from London's Kings Cross station on the Great North Railway. Once again, *The Times* kept its readership informed:

> The principal object of their visit to Northumberland is to see a coal-mine in full operation. It is said their own country, among other mineral products, contains coal, but that the people know little or nothing of the proper modes of working and rendering it available for use. Hence the trip of the Ambassadors to Newcastle ...[78]

Their destination was the North Seaton Colliery[79] at Newbiggin-by-the-Sea where six of the party actually descended in the cage and, in a stooping position, followed the line of a seam. 'On their return to the bottom of the shaft,' *The Times* reported, 'and while waiting for the descent of the cage in which they were to ascend, the atmosphere being rather warm, the Japanese began to fan themselves with great industry, to the astonishment of the pit lads, who stood around with wonder-struck countenances.'[80]

Although exhibition buildings, railway stations or conservatories could be replicated, in terms of framed structures, this type of architecture was impossible without window glass. The seismic instability of the country had never encouraged its use. The Dutch, for their buildings at Dejima, had imported it in small amounts, but it was not until 1873 that any attempt was made to manufacture glass in Japan.[81] It was not a success. Nevertheless, the desire to build Western architecture, if not cast-iron architecture, demanded the use of glazing and soon the importation of sheet glass was expanding

rapidly. In 1868, 10,144 sheets were imported; 42,586 in 1872 and 101,337 in 1873. By 1901 the importation of sheet glass ranked 25th in import value, exceeding 1 million Yen in value.[82]

During the time of the Iwakura Embassy, Kume's observation on relative cost came from a good understanding of the manufacturing process and the awareness of the almost universal use of glass in the West. Kume recorded the Iwakura Embassy's visit to a number of glassworks, both in Britain and in continental Europe. In October 1872 they were at the Sutton Oak factory of the London and Manchester Plate Glass Company at St Helens, where plate glass was rolled, and a month later, at Chance Brothers' factory in Spon Lane, Birmingham, where cylinder glass was blown. In Belgium, the following February, they visited, first, the Val-Saint-Lambert glass works at Seraing and then the recently opened sheet glass factory at Courcelles, and the following May, the Murano glassworks in Venice. But no matter what lessons could be learned, the difficulty which the Japanese nascent glass manufacturers were to have during the Meiji era was both technical and commercial, for with the flood of imported glass, they could not compete with either the quality or the price.

Civic Buildings

After the Meiji Restoration of 1868, the new government seized upon Western architecture both as a way of connecting with the West and of disassociating themselves from the *Shogun* tradition. Nevertheless, for the *bakufu* visitors who comprised the Shinmi Embassy, there was no ignoring the great monuments of Western architecture. Muragaki Norimasa's comments on the incomplete Capitol building in Washington, then under the architectural direction of Thomas Ustick Walter, have already been noted. The Shinmi Embassy also saw the Patent Office (1846), designed by Robert Mills, which Muragaki described as 'a large marble building'.[83] When in London in 1867, Hanabusa Yoshimoto drew the plans of both the House of

Commons and the House of Lords and noted that it took about 16 *ri* (nearly 40 miles) of steam-filled iron piping to heat the Houses of Parliament. On their official visit in 1862, the Takenouchi Embassy had been invited to the building 'where they remained for some time, occupying seats in the Peers' and Ambassadors' Gallery, and then went to the House of Lords, with the magnificence of which they were amazed and delighted'.[84]

Sir Charles Barry and Augustus Welby Pugin's Houses of Parliament (1837–c. 1860) represented London's newest architecture and was one of its largest buildings. Hampton Court Palace,[85] and the Royal Naval Hospital at Greenwich which the Takenouchi Embassy also visited, would have appeared different but not necessarily, to their eyes, that much older. Although at Greenwich, 'Two of the visitors,' *The Times* reported, 'took notes relative to those objects which appeared to excite special interest',[86] it is quite possible that the ambassadors found it hard to distinguish between so much large and stylistically varied architecture and were even numbed by the experience. But where there was something familiar, such as the frame construction of the cast-iron buildings, or something of immediate practical benefit, they appeared to show the greatest interest. *The Times* reported that while in Liverpool 'they went to the Huskisson and Sandon docks, and also to the Sandon graving docks, with all of which, particularly the latter, they expressed obvious satisfaction and evinced no small amount of curiosity'.[87]

For Kume, recording the experience of the Iwakura Embassy while in London in 1872, it was the size of the buildings and the use of stone which he most frequently noted. Whitehall, he wrote, 'consists of huge buildings in white stone'[88] and Buckingham Palace was also 'built entirely of white stone',[89] while the Royal Naval Hospital at Greenwich was '… a long range of buildings, all of white stone'.[90] At the Houses of Parliament he observed that 'The ornamental stonework of the exterior walls is extremely fine, and among the richly-decorated rooms inside none fails to dazzle the eye … The whole building covers an area of eight acres (the equivalent of about 10,000 *tsubo*) and is divided into

1,100 rooms.'[91] To this statistic he added the width and height of the Victoria and clock towers – 80 feet square by 340 feet high and 40 feet square by 320 feet high, respectively. Outside London, he could mention that St George's Hall, Liverpool, 'was built of stone, and the walls and pillars were very finely carved';[92] that the Assize Court in Manchester was 'the handsomest and most well-found court building in Britain. The whole structure was of granite, and although it was a single-storey building the rooms were very high and the main entrance wide and very imposing';[93] but at Windsor Castle, where he documented that 'The length of the principal corridor is 500 feet and the diameter of the tower 200 feet',[94] there is no mention of the stonework.

While Kume observes and records dimensions (which were probably supplied to him), he is rarely critical or analytical. However, on viewing the government buildings along Whitehall, he wrote that 'The grandeur of their character made Washington and New York seem mean in comparison.'[95] There had, indeed, been little in the architecture of New York to attract Kume's attention – only Mr Stewart's cast-iron store and the Stock Exchange, whose dimensions, but nothing else, he recorded.[96] In Washington, he had noted:

> Commercial life in Washington is not very lively. There are no bustling markets even on the streets and quays along the river. The atmosphere is elegant and quiet. The many fine buildings, some of them architectural masterpieces, attract attention. Chief among these is the Capitol, then comes the president's residence ... [97]

Muragaki Norimasa, who had visited Washington 12 years earlier, also found the city quiet. When he arrived in New York, he was able to write retrospectively, 'Washington is the capital of America, but compared with Baltimore, Philadelphia and New York, it is quite a small town.'[98] The dome at the Capitol had been completed by the time Kume saw the building in 1872. 'For sheer elegance,' he wrote, 'the Capitol has few peers, even in Europe.' But then he qualified his praise:

Its architecture, however, is rather plain, with little decorative carving, and the interior displays no glittering gilded surfaces to dazzle the eyes. Nothing here compares with the elaborate decoration in French or Italian palaces, with their intricate carving and scattered jewels and gilding. Painting, of course, is not one of the great talents of the Americans or British.[99]

This was a prejudice which seems to have been confirmed by the guide at Buckingham Palace who, on leading the ambassadors around the interior, stated that none of it could stand comparison with the magnificence of the Tuileries in Paris.[100]

What struck Kume about the Palais des Tuileries, once the Iwakura Embassy arrived in Paris, was not the building itself but its position in the urban layout. The axial arrangement of this part of Paris, running from the Louvre, through the Place de la Concorde, along the Avenue des Champs-Elysées and terminating at the Arc de Triomphe, and the consequent alignment of the buildings, was an effect quite unknown in Japanese cities. 'Looking out from inside the palace,' he wrote, 'is a scene so delightful as to defy description, with the Obelisk in the Place de la Concorde bisecting the Arc de Triomphe far off in the distance.'[101]

The Arc de Triomphe, designed by Jean Chalgrin and Jean-Nicolas Huyot in 1806–36, probably received as much attention from Kume as any other building he saw, for the ambassadors were lodged at 10 rue de Presbourg which looked out onto the south-east side of the arch. This afforded him the opportunity to study the origin and construction of the triumphal arch, many of which, he said, 'were built by piling stones on top of one another the shape of a bow so that they converged in a cruciform junction at the top to form a vaulted roof. This method followed the principal of uniform weight-distribution to create a robust and beautiful structure, which became known as the "cruciform arch"'.[102] In his account, he describes the building in detail, concluding that 'The arch is an extraordinarily grand work of architecture, standing on an area of high ground within the city and rising above the countless rooftops, overlapping like scales on a fish, to form a

focal landmark for the whole of Paris.'[103] The greater part of Baron Georges-Eugène Haussmann's plan for Paris had been completed by 1872 and what Kume saw must have appeared pristine and glittering. 'Rows,' he wrote, 'of superb white stone buildings soaring to the clouds were built along twelve broad new avenues radiating in all directions from a focal point at the Arc de Triomphe.'[104] His account of London had made no such mention of either Marble Arch or the Wellington Arch, neither of which have a strong urban role, but in Berlin he called the Brandenburg Gate, designed by Carl Gotthard Langhans in 1789–91, 'the finest sight in the city',[105] adding that it was 'surpassed only by the Arc de Triomphe in Paris'.[106]

Churches

Although Christianity had made some considerable impact in the south-west of Japan before the years of *sakoku*, the ensuing suppression of the religion would have meant that for most Japanese, churches were, in the early Meiji years, still an unfamiliar building type. Early on, Kume, who was probably unaware of the current Anglican revival, realised that the more elaborate churches in the West were the Roman Catholic ones. In Washington DC he had noted, 'Because there are no large cathedrals in Washington and even the Catholics have not built impressive churches, I will not describe any of them.'[107] The weeks which he spent in Britain seemed to have done little to change his opinion. Only Chester Cathedral seems to have been visited – 'We went inside to inspect its architecture. Before leaving, we signed the visitors' book.'[108] – but there are no further comments. Much of Kume's account would have been written retrospectively as the comparisons which he makes indicate. In a short summary paragraph inserted under Paris, 2 January 1873, he positions the Buddhist Honganji temple[109] in Kyoto in the context of Western church building:

> There are few magnificent cathedrals in Protestant countries. In London there is only

St Paul's in addition to the sublime grandeur of Westminster Abbey, which may be thought of as foremost among all Protestant churches. In Catholic countries, however, a city's outward beauty invariably lies in its magnificent church buildings. In Italy, the basilica of St Peter's in Rome and the cathedrals of Sta Maria in Milan and Florence all took hundreds of years to build and they astonished the world with their height and scale. St Stephen's in Vienna, the towering churches of Strasburg and Antwerp and the old church in Brussels are all among the leading works of religious architecture in Europe, and to compare their beauty with Honganji temple in Japan would be like comparing a grand mansion with a straw hut.[110]

When Kume reached Rome in May 1873, he could write of St Peter's Basilica with conviction:

> The church is so constructed that it is without peer among all the churches of Europe for sheer size, beauty and dignity. It is a huge structure with an overall area of 222,321 square feet (in other words, converting it to our measurements, 5,895 *tsubo*). Although St Paul's in London is large, it is no more than half the size ...[111]

The larger the building, the more Kume is given to quoting statistics. For St Peter's he gives the number, height, diameter, cubic volume and weight of the columns, but places the value of each one 'beyond calculation'. He also quotes the number of windows, statues and chandeliers, adding, 'Above the high altar there is a round tower 429 feet high (in other words, 71.5 *ken*). One's head swims when looking up at it from below.'[112]

Kume's perception of the buildings was not always as might be expected. Orientation is often a difficulty and whereas he has St Peter's Basilica facing east, as it does, he has Florence Cathedral facing south when it actually faces west. Indeed, his reading of the Cathedral of Sta Maria del Fiore is unorthodox; '... [O]n the left there,' he writes, 'the great dome and on the right there is a tall square tower. In between and adjoining them both is a tall

structure, the entire interior of which is taken up by a large hall, which is attached to the lower part of the dome.'[113] Rather than reading the cathedral's plan as a longitudinal, Latin cross, with a dome above the crossing and a free-standing campanile to the side, he sees it in elemental, almost platonic, terms – a rounded or spherical dome, a square tower and an open, rectangular hall. This suggests not just a lack of understanding of the homogeneous components of a Christian church, but more the notion that buildings are the cumulative accretion of separate elements.

Unphased by the complexity of the building, Kume soon launches into a descriptive analysis of the structure:

> Under the dome, three sides are supported by great domed structures, which are known as 'arches'.[114] These are divided into lesser vaults, and each of these reaches to at least half the height of the interior. They are huge when compared to vaults found in ordinary churches. Each of these lesser vaults is subdivided into five smaller vaults, which themselves are as much as thirty-three yards high. Each of the fifteen minor vaults is adorned with its own altar. That is the shape of the area under the dome.

> The open hall in front of the dome is one hundred and forty feet in width and is dominated by two rows of giant columns. The arches come together in cruciform fashion to form the ceiling. The base of each column is fifteen feet square, and even the smaller ones are more than three feet square. That is how big this church is, and although it is one of the largest in Europe, we understand that it is nevertheless barely half the size of St Peter's in Rome.[115]

Whereas the homogeneity of the building might have escaped him, the complexity of its structural system did not. Here his eyes could follow the lines, as they would in a framed building, and what might have appeared as a massive form from the outside became clear once the internal skeleton was exposed.

Neither the recognition nor discussion of architectural styles play much of a part in Kume's account of Western architecture. To his understanding, there were probably just two principal Western styles, the Classical, whether Greek, Roman or Renaissance, and the Gothic. Girard College, built in Philadelphia by Thomas Ustick Walter in 1848, he identified as being 'in the Grecian style';[116] when describing the Smolny Convent in St Petersburg as 'being constructed in the Greek style, topped with a number of cupolas,'[117] he probably just meant Classical: it is Russian Baroque, pilastered and pedimented, in blue and white. His stylistic attribution of St Nicholas in Hamburg, however, was the product of some confusion. Designed by George Gilbert Scott in 1844, and constructed between 1846 and 1882, it was still incomplete when Kume saw it. Combining elements of English, French and German medieval architecture, it was very much a Gothic Revival church, but Kume, probably transliterating the architect's name, confidently described this church by Scott as being 'built in the Scottish style'.[118]

Prisons

As well as needing to protect themselves against encroaching foreign powers, the young Meiji government was very aware of the necessity of strong internal control. The British, who were beginning to see themselves as Japan's primary Western ally, had a strong interest in helping the Meiji government enforce social order so, in 1871, John Carey Hall, then a young consular official and translator in Edo, and Ohara Shigechika, the Head of the Office of Jails, sailed to Hong Kong and Singapore on an inspection of colonial prisons and the British prison system. Ohara, a loyalist, had himself been imprisoned in the 1860s under the Takugawa *shogunate* and was now pushing for prison reform. The Hong Kong prison had been the subject of a brief but enthusiastic report published by Shibusawa Eiichi, a member of the 1867 *bakufu* embassy to France. 'We understand that the

Japanese government intend sending an officer to Hongkong to inspect the jail,' the English-language *Japan Weekly News* wrote. 'The Hongkong jail is very extensive, being capable of containing eight or nine hundred prisoners, and it seldom has less than four hundred occupants. The system on which it is conducted is much eulogized by those who have studied the matter.'[119] Although the efficacy of the colonial prisons was as much as anything to do with the even and spacious distribution of the inmates, it was while in Singapore that Ohara learned, from the colonial officers, of the Benthamite panopticon or radial plan for prison design. This was the model which he promoted, in 1872, in his resulting publication, *Prison Rules and Charts*.

Consequently, when the Iwakura Embassy visited prisons in America, Britain and continental Europe that same year, it was the Benthamite prisons which they saw, the first being the Eastern State Penitentiary in Philadelphia (1836) designed by John Haviland. As Kume indefatigably recorded:

> The front of the prison is kept secure by means of a fortress-like gate-house with enormous iron doors. The prison itself is located in the centre of the compound and consists of stone buildings two storeys high and several hundred feet long. There are seven wings in all, which converge on one central hub, rather like rays around the sun. A large room at the centre serves as the watch-tower, from where guards can easily oversee the seven radiating blocks. Each cell block has a long central corridor, with cells along either side. One criminal is allotted to each cell, and all cells have iron doors ... The size of a cell is about three *tatami* mats.[120]

On arriving in England, the ambassadors visited Alfred Waterhouse's Strangeways Prison (1869) in Manchester, where, as Kume said, 'The arrangement of the prison in the form of six wings radiating like spokes from a central hub was the same as that of the prison at Philadelphia, in the United States.'[121] Kume noted that Haviland's prison had been the model for Waterhouse's, the only difference being that whereas the former was of two storeys and built in stone, the latter was four storeys and of brick. Otherwise, as he said, 'Everything, including the provision of a Bible in each cell, was just as it had been in Philadelphia.'[122] In Paris they visited la Santé Prison (1867), designed as an panopticon by Emile Vaudremer: 'Three storeys high with seven converging wings, it is constructed in much the same way as the prison in Manchester in England ...'[123] By the time that the ambassadors reached Berlin, it had become apparent to Kume that the originator of this prison type was Moabit Prison (1849), designed by Auguste Busse and Heinrich Herrmann:

> The buildings are all of five storeys, including a basement level, and are constructed in the same style as the prison buildings we saw in Philadelphia in America and Manchester in Britain ... The prison in Berlin ... has won such fame around the world that the people of Philadelphia in America imitated and added to its design when they constructed their own penal institution. Since then Britain, France and other countries have followed suit ...[124]

Kume, however, was poorly informed. The first model of this type was indeed Haviland's Eastern State Penitentiary in Philadelphia, which was begun in 1823.

Prison design, as Kume observed on visiting the court-house and prison at Chester, 'has in recent years become a subject of scientific study'.[125] In Geneva, the ambassadors visited

> the house of a learned gentleman who had spent many years studying the construction of prisons. During the past few years he had collected the plans of prisons in many countries and had written a book which discussed their various advantages and disadvantages. He presented us with a copy. Afterwards, he accompanied us to the city's prison. This had been built in the early part of the nineteenth century and was of very solid construction. But since it was no longer fit for its purpose, we were told, plans had recently been drawn up for its reconstruction.[126]

The learned gentleman is likely to have been Gustave Moynier who, in 1859, had become Chairman of the Geneva Society for Public Welfare, in which capacity he was involved with prison reform.[127] The Geneva prison, a semi-circular panopticon design built in 1825, was demolished in 1862.

The evidence which the Iwakura Embassy gathered on prison design complemented Ohara Shigechika's recommendations contained in *Prison Rules and Charts*. The prisons, he said, would be built of stone or brick, and barred with iron. The basic panoptical design would be a cross with four arms extending from a central watch-tower, with the interiors free of all obstructions to allow for clear sight-lines and, ideally, each prisoner would have a separate cell.[128] This was the plan adopted at the Kajibashi gaol in Tokyo, completed in 1874, although budgetary restraints meant that it was constructed from timber rather than masonry. Narushima Ryūhoku, a former *shogunal* official and journalist who was imprisoned there in 1876, later wrote: 'The design follows that of a Western jail and forms a cross shape. There are two stories, divided into a total of eight sections. Each section has ten cells, making for a total of eighty cells. On both the top and bottom stories there is a guard in the middle who keeps watch in all four directions.'[129]

It was a lesson well learned and soon applied.

Houses

While in Britain and France, Kume had commented frequently on the use of stone in the architecture, but in the Netherlands, it was the use of brick which he noticed. This was probably due, as much as anything, to the Netherlands' general absence, in Kume's perception, of grand, public buildings: 'small and cramped in scale' was how he described the Royal Palace in Amsterdam, adding, 'it is built in an unusual style unlike the royal palaces of Britain or France'.[130] 'Most of the buildings in Amsterdam,' he wrote of its neighbours, 'are constructed in brick, and the occasional stone structure to be seen is always some distinguished house of the city ... The average house in the city is narrow but has large windows, and none are more than five storeys high. The way they stand shoulder to shoulder at varying heights overlooking the canals is just like the view from Edobashi of the warehouses along the river-bank there.'[131] In The Hague, the houses were similarly 'built of red brick with large windows all over the façades, and although few of them are constructed in stone, there are nevertheless a great number of beautiful residences'.[132] Rotterdam, on the other hand, pleased him less: 'There is nothing singular about the style of buildings here, which are constructed of red brick in rows of tall but narrow houses five or six storeys high, with each one just wide enough to have three or four windows across the front.'[133]

Kume, as has been observed, is rarely given to the contemplation of Western architecture; more often his writing is descriptive and statistical. But in a short paragraph written, in all likelihood, following his return to Japan, he lays out the case for the use of brick and stone in architecture. That this was written at just the time that Thomas Waters was completing the controversial Bricktown residential development in Tokyo's Ginza district is significant.

Architecture in the West places great emphasis on admitting fresh air into buildings through a careful choice of clay for bricks and the quality of the stone. There is no need for papers and books to be taken outdoors and exposed to the breeze once a year to protect them from the effects of damp. This is due not only to the fact that the air in Europe is dry, unlike that in Japan, but also because of the precision employed in construction. With earthen walls like ours, the damp may be dispelled when the weather is fine but it accumulates on rainy days, which inevitably raises the level of humidity inside. As a result, the furniture kept in a storehouse built outdoors will be prone to rot for lack of exposure to dry air. In Japan, not only is the air damp, but no care at all is taken to keep the air indoors fresh. The great

advantage of structures with walls of brick and stone is that they prevent fire and at the same time keep out the damp.[134]

The irony, however, is that one of the reasons why Bricktown proved unsuccessful was that the buildings were found to be damp. Their benefit, as Kume suggests, was that they were to some extent resistant to fire and it had been the Ginza fire of 1872 which brought about their construction. In America, the Boston fire of October 1872, just two months after the Iwakura Embassy had sailed from Boston to Liverpool, and the Chicago fire of the previous October, illustrated the problem, common to both the United States and Japan, of timber construction. In another short contemplative passage, he notes: 'The building of Western houses with bricks and stone derives from … ancient custom. They are not built this way with any particular intent to prevent fires. Some methods of construction, such as those involving opening up windows and doorways, do not help prevent conflagrations. Because large fires are numerous in America, building methods may need to be changed.'[135]

In London, as in the Netherlands, it was the unfamiliar vertical arrangement of the houses which Kume noted, relating the design of the buildings, as he might have done in Amsterdam or The Hague, to the cost of the land.

In London's wealthiest districts, the price of land is extraordinarily high … Throughout the city, therefore, buildings seek to make the most economical use of the land they occupy. Basements are dug below them to a depth of six feet or more, and above ground the buildings rise to a height of several storeys – sometimes as many as eight or nine. The upper storeys — the seventh, eighth and ninth – are where the poorest classes live: they are like the back-streets of Tokyo. The people who live on the middle floors are of a slightly better class than this – craftsmen, tradesmen, shopkeepers, the employees of merchant houses and the like. The ground floors house shops selling goods of all kinds.[136]

Similar densities were noticed in Berlin and Vienna, where 'the closely-jammed houses are five or six storeys high'.[137]

Whereas the housing in the cities was unfamiliar to Kume, the rural housing, especially in the Alpine regions, with their 'broad eaves projecting on both sides to protect the walls',[138] frequently brought back memories of his own country. In Sarnen, Switzerland, the houses were 'built in an unusual style and closely resemble Japanese houses in structure. They are two-storeyed, with the upper storey projecting somewhat, and have eaves and beams. Every house has its vegetable garden, surrounded by a wattle fence, just like houses in the Japanese countryside.'[139] And between Tracht and the Brünig Pass, the houses were built of logs 'placed one on top of another; their roofs consisted of branches laid parallel to one another and weighted down with stones. Some were rather more attractive in appearance than the rest. Their walls were decorated with ornamental singles, like fish scales, and they had upper storeys and broad eaves. They greatly resembled the houses seen in the gorges on our own [river] Kiso.'[140] If there was a familiarity to be seen in Western architecture, it was not in the cities but in the humble country dwellings where this was to be found.

The City and the Countryside

After arriving first in San Francisco, Kume soon became aware of the benefits of the modern Western city. 'City life offers many amenities,' he wrote, 'such as the laying of underground pipes to supply gas and water, and for sewage disposal. These pipes are led into each house, in every town, as branches of the main system. Rooms are all lit by lamps, and there is no need to haul water because pure water is delivered from a tap.'[141]

The infrastructure of Western cities interested Kume greatly. In Sacramento, California, he noted that the shopping areas were paved with brick;[142] in Lyons, that the streets were paved with flagstones;[143] and in Leiden, that although the streets were not

spacious, they were immaculately kept.[144] In San Francisco, where he thought that the maintenance of the streets was still inadequate, he took time to note down the manner in which streets were laid out and the order of construction: 'Before the houses were constructed, pedestrian footpaths were laid using flagstones. Gas pipes and pipes for drinking water and sewers were buried underground. Only then did they lay the carriage road. And not until the road construction was advanced did they build the houses.'[145]

In Paris, the quietness of the newly metalled road surface was appreciated, and the construction described:

> Gravel is heated together with a kind of tar, and it sets as hard as stone to form a perfectly seamless road surface from one end to the other. All the streets there are paved in this way, and the wheels of the carriage make no sound as they pass by. In London the clattering din of carriage wheels rang in one's ears with such a deafening noise that the horses could not be heard at all. In the streets of Paris the carriage wheels are muted, and all one hears is the sound of hooves.[146]

If London was bad, the older parts of Vienna, where the houses were closely packed and the streets paved with stone, were worse. 'No city surpasses it,' Kume wrote, 'for the din made by pedestrians and carriages.'[147] He was, however, greatly impressed by the Ringstrasse, which was then under construction, although, as he said, 'paving is so poorly laid that in dry weather dust flies everywhere, while after a rainfall there is a morass of mud'.[148] He compared its avenues of trees to Unter den Linden in Berlin, its tram-car tracks to American cities, and the manner in which the road was laid to what he had seen in London and Edinburgh:

> First, the ground is levelled and then sand is laid to a depth of three inches. On top of that paving stones are laid. Recently, however, it often happens that pipes have to be laid underground, so now hard-core is apparently laid to a depth of five inches followed by the layer of sand and then the paving.[149]

To the members of the Iwakura Embassy, the modern Western city was, despite its clamour, something at which to wonder. On arriving in London, Kume described the vibrancy of the city:

> Trains fly across the river from above the housetops to arrive at stations on the other side. The tracks are supported from below by huge iron pillars. Stone 'arches' have been built over the main roadways. (Our 'spectacle bridge' uses the same method of construction: blocks of stone fitted together to form a self-supporting arc.) The wheels of the trains rumble like thunder as they pass overhead, entering and leaving the stations. Passengers boarding the trains swarm together like bees to the hive and those alighting scatter like ants from the nest.

> A railway also runs underground alongside the river ... It circles a third of London, running for the most part through tunnels excavated under built-up areas. The tunnels, being made of brick or stone and arched in section, are as strong as a solid block of stone buried in the earth. Anyone sitting or lying in a house in one of the streets beneath which the railway runs hears a constant rumbling all day, like thunder under the ground. Throughout London trains are constantly passing overhead and continually running underfoot. The construction of these railways is a most remarkable feat of engineering.[150]

Ultimately, it seems that Kume grew weary of the noise and bustle of the industrial metropolis, for on arriving in Paris, he was able to write:

> In the streets of London there are railway lines underground, roads at ground level and railway lines overhead, and the people rush around on three different levels as they go about their daily business. Smoke from coal fires pervaded the sunlight, and even the rain, too, seemed black. This is not the case in Paris, however, for the citizens all live in the midst of parkland, and wherever one goes there are celebrated sites for recreation. Neither are the people in the streets in

any hurry as they walk, and the fresh air around them contains little smoke as they burn fire-wood rather than coal. While London makes people diligent, Paris fills them with delight.[151]

Although the Iwakura Embassy's journey took them through many hundreds of miles of open countryside, their destinations, in their pursuit of knowledge, were most often urban. It was in the mountainous regions that Kume was most moved to comment on the scenery, for Japan is a mountainous country and such scenery would have been familiar. At the pass of Killicrankie in Scotland, Kume wrote how 'Picturesque mountain peaks towered before us; at their foot ran a river … Among the trees were green pines and phoenix-tail pines. No two trees had leaves of the same colour. The scene looked exactly like a painting executed in the *tentai* style, but using a full palette.'[152]

In 1862, when the Takenouchi Embassy had visited Hampton Court, they expressed, as *The Times* reported, 'a great hankering to see the country, and they were much refreshed by the glimpses which they were afforded of it'.[153] On seeing the famous avenue of chestnut trees at Bushey Park, 'their admiration was excited to the highest pitch'.[154] From there they went to Richmond-on-Thames to take lunch at the Star and Garter where, as *The Times* reported, 'they were captivated by the view from Richmond-hill, and lingered over the enjoyment of it for some time'.[155] This, as it turns out, is not surprising, for it was a view which the British diplomat, Laurence Oliphant, had recalled in his *Narrative of the Earl of Elgin's Mission to China and Japan*, published three years earlier in 1859.

Leaving Hojee, we rode up to the brow or the hill behind the village … The prospect upon which we feasted our gaze more nearly resembled that from Richmond Hill than any other with which I am acquainted. Beneath us was a winding river,

now hidden among thick woods, now shining in the broad light of day as it emerged upon grassy fields. Beyond, as far as the eye could reach, the country was richly divided cultivated and charmingly diversified, while here and there smoke of a town or hamlet imparted an air of animation to the view.[156]

Whereas the similarities between Japan and the British landscape was something which did not go unnoticed – on another occasion Oliphant compared the Japan countryside to the lanes of Derbyshire[157] – the dissimilarities were extreme. In 1872, the Iwakura Embassy, like the Takenouchi Embassy before them, visited Liverpool. There Kume saw how 'the smoke of coal fires billowed up in dense clouds to a height of two or three hundred feet, permanently darkening the blue sky'.[158] A sense of displacement was common to all the early embassies and it would be not until some years into the Meiji reign that the architecture and cityscape of Japan had changed sufficiently for the Japanese not to feel out of place when visiting Western cities. This feeling was well summarised by Muragaki Norimasa when the Shinmi Embassy were entertained at a *Fête Champêtre* hosted in their honour by Mr and Mrs James Gordon Bennett at Fort Washington on Washington Heights, New York, in June 1860:

In the city we cannot help feeling that we are strangers in a strange land, as the manners and customs are unlike those of Japan. As soon, however, as we get into the country, it is quite different; the fact that we are far from our native land is not brought so vividly before us. The hills, valleys and rivers, carved by nature, are much more homelike; the vegetation is similar to that which we are accustomed to. The very birds in the trees around us, sing the same melodies as their oriental sisters. All these things combine to make us feel more at home.[159]

3 THE HOUSES OF THE PEOPLE

Laurence Oliphant, the secretary to Lord Elgin, arrived at Dejima on 2 August 1858. 'The distance from Shanghai to Nagasaki,' he wrote, 'is not above 450 miles; but if oceans rolled between the two empires, Japan could not be more thoroughly isolated than it is from the rest of the world.'[1] What he saw in that colonial outpost, 'where some Dutch soldiers were lounging under an open shed',[2] was a soft introduction to Japan. 'The houses were substantial little two-storied edifices, with green shutters and blinds, from behind which peeped sun-dry pretty-looking female Japanese faces; for the Dutch here are not allowed the companionship of their own countrywomen.'[3] On crossing into Nagasaki to present their credentials to the Governor, Lord Elgin's party entered an unforeseen world:

> I find it difficult, in attempting to convey our first impressions of Japan, to avoid presenting a too highly coloured picture to the mind of the reader. The contrast with China was so striking, the evidence of a high state of civilisation so unexpected, the circumstances of our visit were so full of novelty and interest, that we abandoned ourselves to the excitement and enthusiasm they produced. There exists not a single disagreeable association to cloud our reminiscences of that delightful country.[4]

Oliphant's *Narrative of the Earl of Elgin's Mission to China and Japan ...* is as much a diary of events as it is a detailed account of the people and the architecture that he saw. Using his descriptions and those of many other early visitors to Japan, this chapter looks at Japanese building and, in particular, the ordinary Japanese houses known as *minka* or, literally, the 'houses of the people'. For here are found all the characteristics of Japanese architecture which so immediately distinguished it from that in the West while, at the same time, providing a source of inspiration which is still drawn upon today.

Oliphant's account of Lord Elgin's mission was not the first such record of foreign interference with nineteenth-century Japan. Francis Lister Hawks's *Narrative of the Expedition of an American Squadron to the China Seas and Japan Performed in the Years 1852, 1853, and 1854*, which recorded Commodore Matthew Perry's earlier visits, had been published in Washington in 1856, three years before Oliphant's book appeared. However, two earlier accounts of Perry's voyage had been published in 1855: *A Visit to India, China and Japan in the Year 1853* by Bayard Taylor who had joined Perry's first Japanese expedition in Shanghai, and *Japan and Around the World* by J. Willett Spalding, the Captain's clerk on that expedition's flagship, *USS Mississippi.*

In the early 1850s there was, in fact, a large amount of printed material available on Japan, as the Scottish writer Charles MacFarlane intimated in the preface to his timely book of 1852, *Japan: An*

Account Geographical and Historical ... Down to the Present Time, and the Expedition Fitted Out in the United States:

> It appears to me erroneous to say – though it very commonly *is* said – that we know next to nothing of Japan and the Japanese ... We may safely be said to know more of the Japanese than we knew of the Turks a hundred years ago.[5]

MacFarlane listed many of his sources, as did Spalding three years later. These ranged from the printed accounts of the Jesuits, to the books by the medical officers and *opperhoofds* at Dejima, to the diaries and memoirs of merchant adventurers who returned from Japan. Indeed, Spalding comments rather caustically that, 'With such sources of information as these, it would be a piece of affectation to suppose the majority of the reading community without some knowledge of the early and past history of Japan.'[6] But with the arrival of Perry's black ships, the *kurofune*, in July 1853 and the opening up over the following few years of the treaty ports, the amount of available information on how the Japanese lived and built soon became prolific. Initially, these accounts came, as indicated above, from the pens of Western government or military representatives, they being the only people allowed to venture into the hinterland, but by the 1880s such restrictions had been lifted and a wide range of published material was in circulation. The earlier publications, by independent travellers, commented very much on what Hawks and Oliphant had observed: these would include books such as Kinahan Cornwallis's *Two Journeys to Japan 1856–57*, published in 1859, or Robert Fortune's *Yedo and Peking: A Narrative of a Journey to the Capitals of Japan and China*, published four years later. As the country opened up, the travellers went further: *Unbeaten Tracks in Japan* (1880) is the telling title of the intrepid Isabella Bird's solo journey to Hokkaido where, in 1878, she met the Yezo peoples,[7] a journey matched in fortitude only by that told in Mrs Brassey's *A Voyage in the 'Sunbeam', Our Home on the Ocean for Eleven Months* (1881). Such was the interest in Japan that Henry Faulds, who had

travelled to Japan to be a surgeon at the Tsukiji Hospital in Tokyo, could write in the introduction to his *Nine Years in Nipon: Sketches of Japanese Life and Manners* (1885) that 'So many works have of late been written on Japan that perhaps the best apology for publishing a new one is that the public seem to wish for more.'[8] Faulds's account, it appears, was written in or about 1873[9] and by the time it was published commentators had begun to analyse and stratify what they saw.

The first significant account of Japan derived from an extended stay in the country was *The Capital of the Tycoon: A Narrative of Three Years' Residence in Japan*, written by Sir Rutherford Alcock, the first British minister plenipotentiary to Japan, and published in two volumes in 1863. It was, however, limited in scope due to the travel restrictions imposed upon foreigners, but met the growing interest in Japan which the 1862 International Exhibition in Kensington, to which he had greatly contributed, generated. In the year following Alcock's book, the first folio of Albert Berg's ten-part *Ansichten aus Japan China und Siam* was published in Berlin.[10] The product of Friedrich Albrecht Count zu Eulenberg's mission of 1860–61, which had resulted in the signing of the Prussian–Japanese Treaty of Friendship, Commerce and Navigation in February 1861, it was a collection of 60 photolithographs and printed in a limited edition of 750. Although only half the selection was of Japan, they nevertheless presented a broad range of views, from 'Yeddo', 'Ikegami' (now in Tokyo), 'Yokuhama–Kanagava' and 'Nangasaki'. With lengthy descriptive captions in both German and English, these plates showed everything from a peasant's cottage to a temple gateway, and from views along the Tōkaidō, the Imperial Highway, to ones overlooking Nagasaki harbour.

Berg's ten-part production, however, took nine years to be published, its final folio being issued in 1873, the year the Prussian government sent Johannes Justus Rein, a Professor of Geography at Marburg University, to Japan to undertake a study of the country and its peoples. There he remained for two years. His comprehensive findings were published in two volumes under the title *Japan*

nach Reisen und Studien im Auftrage der Königlich Preussischen Regierung dargestellt in 1881 and 1886; English language editions, entitled *Japan: Travels and Researches, Undertaken at the Cost of the Prussian Government*, followed in London in 1883, and the next year, in New York. Rein's observations were the product of much, sometimes wearisome, travel:

> As the Japanese build in pretty much the same fashion throughout the whole country, the interest which the visit to the first town secures us, through the charm of novelty, is not preserved to the same extent as in other countries. He who has seen one Japanese town has seen them all; the only difference being that one appears somewhat cleaner, less poverty-stricken and less smoky than another.[11]

Kyoto, however, was different:

> Kyōto is of a much more regular architectural construction than most of the towns in the country. Its streets are indeed not very broad, but they are perfectly straight, and they usually cross each other at right angles, running parallel to the axes of the elliptical plane from north to south and from east to west.[12]

A few paragraphs later he identifies the 12 'most remarkable temples' which he marks on a 'Plan of Kiōto', but provides no architectural description to support this.[13]

Coincident with Rein's study were two books which more directly addressed Japanese architecture. The first of these was Christopher Dresser's *Japan: Its Architecture, Art, and Art Manufactures* which appeared in 1882 and was followed, three years later, by Edward Sylvester Morse's *Japanese Homes and Their Surroundings*. Between them, these two books, one by a British writer and the other by an American, told Western readers almost everything they needed to know about traditional Japanese architecture.

Most of these commentators remained only briefly in Japan or enjoyed, as Morse put it

disparagingly, 'a few weeks at some treaty port'.[14] Some, however, such as Dresser, who travelled about 1,700 miles[15] during his four-month sojourn of 1876–77, saw a great deal of the country. Although working as a designer and, while in Japan, the official representative of the South Kensington Museum in London, Dresser had trained as both a designer and a botanist. His articles on 'Botany as Adapted to the Arts and Art Manufactures', published in 1857 in the *Art Journal*, had, in 1859, earned him a doctorate, *in absentia*, from the University of Jena, one of the oldest universities in Germany and a centre of evolutionary theory.[16] It was probably this early recognition which encouraged him in 1860, at the age of 26, to apply for the Chair of Botany at University College, London: being unsuccessful, he turned his attention to design. Morse, like Henry Faulds, was an *o-yatoi gaikokujin* – one of the foreigners hired in the late *bakufu* and Meiji eras, usually on short-term contracts, to assist in the modernisation of Japan. And, like Dresser, he was first a scientist. Having come to Japan in 1877 to study coastal brachiopods, Morse was appointed Professor of Zoology at the newly opened University of Tokyo in April 1878,[17] a position he retained until 1880. His study, *The Shell-Mounds of Omori*, was published first in English, and then in Japanese (Ōmori Kaikyo Kobutsu-hen) by the Science Department of the University in 1879. Both Dresser and Morse were Darwinists and their attention to detail and difference, and their ability to categorise, which characterised their work as scientists, gave them the skill to analyse Japanese architecture as few lay-persons could do. The one Western architect who did do this was Josiah Conder, the young Englishman who, as another *o-yatoi gaikokujin*, took up the position of the first Professor of Architecture at the Imperial College of Engineering[18] in Tokyo in January 1877. Conder and Morse, one thinks, must have known each other but there is no indication in their writings that they did. Indeed, Morse dedicates *Japanese Homes and Their Surroundings* to Dr William Sturgis Bigelow, with whom he had travelled around Japan looking at the architecture in 1882–83 and thanks both him,

and Ernest Fenollosa (whom he had attracted to the Imperial University to teach political economy and philosophy in 1878) in the Preface: there is no mention of Conder.

It was Conder, in fact, who wrote the first significant text in English on Japanese architecture. His paper, 'Notes on Japanese Architecture', was read, in his absence, by Thomas Roger Smith[19] at the Royal Institute of British Architects' rooms on Conduit Street, London, in March 1878. When Conder wrote the paper, he had been in Japan barely a year and he felt it necessary to apologise for his 'scanty notes, hoping for a future opportunity of enlarging upon them after longer and closer observation and more extended travel in the country'.[20] Although he thought temples to be 'by far the most interesting and instructive',[21] he drew attention to the Japanese house which, up to that point, had received very little serious consideration from commentators. It was a subject to which he returned in much greater detail almost a decade later with his paper on 'Domestic Architecture in Japan'.[22] By now he was styled Architect to the Japanese Government and was the architect of many houses and public buildings in Japan – but all were in the Western manner.[23]

The Ryukyu or 'Loo Choo' House and Temple

When Commodore Perry's squadron arrived in 1853, the Ryukyu Islands (then the Loo Choo Islands), at the very south-west of the Japanese archipelago, were controlled by the Satsuma *han*. Although the kings of Ryukyu were tributaries, through Satsuma, of the Japanese *Shogun*, they were also tributaries of the Emperor of China. It was not until the signing of the Treaty of Shimonoseki in 1895, following China's defeat in the First Sino-Japanese War, that China abandoned its claims to the islands.[24] In contrast to the rest of Japan, Christian missionary work was tolerated in the Loo Choos, although reluctantly, and since 1846, a Hungarian-born medical-missionary called Bernard (or Bernát)

Jean Bettelheim had been living on Great Loo Choo (now Okinawa), much to the displeasure of the islanders.[25] Bettelheim had been sent there by the British Loo Choo Missionary Society but, as Bayard Taylor was to write, 'After seven years' labor, all the impression which Dr. Bettelheim appears to have produced upon the natives is expressed in their request, touching from its very earnestness: "take this man away from among us!"'[26]

The first Western visitor to report on the architecture of the Loo Choos was the Bishop of Victoria (Hong Kong), the Revd George Smith.[27] He had gone there in 1850 to try to mediate in Bettelheim's difficulties with the Loo Choo government and, in his book, *Lewchew and the Lewchewans: Being a Narrative of a Visit to Lewchew or Loo Choo, in October, 1850* (1853), he described Bettelheim's residence:

> The house itself was previously a Buddhist temple ... The house was in almost the same state as before its present appropriation. The images only had been removed; the open halls had slender partitions of boards around the sides; a few paper windows were inserted to keep out the cold of winter ...[28]

A view of the house, or temple, was included as the frontispiece to the book but elicited no further comments [3.01]. On arriving with Commodore Perry three years later, Bayard Taylor noted that Bettelheim lived in 'a very neat cottage furnished him by the authorities of Loo Choo, on a slope behind Capstan Rock ... The house was plain but comfortable, and the view from the neighbouring rock enchanting, yet I could not but doubt whether any thing can atone for such a complete removal from the world of civilized man.'[29] Taylor, it appears, was unaware of its previous use.

Unlike the house, or temple, the street architecture of Naha (which Taylor called Napa[30]), the main town on Great Loo Choo, appears to have been built of masonry – not stone, as such, but coral. The streets, Smith noted, 'generally consisted of neat walls on either side, built of coral fitted compactly together, and apparently

RESIDENCE OF DR. BETTELHEIM, LOO CHOO.

(From a Sketch by Captain P. Cracroft, R.N.)

3.01 Dr Bernard Bettelheim's house on Great Loo Choo, from George Smith, *Lewchew and the Lewchewans* ..., 1853.

without mortar',[31] and 'the houses and the walls around the enclosures are exceedingly well built'.[32] As a defence against the weather, perhaps, or against infiltrators, and in contrast to what was to be found on mainland Japan, the houses and the temple complexes were contained, as Smith put it, behind 'a firmly constructed enclosure built of stone, and presenting, from the sea, the appearance of a fortified wall'.[33] In describing the streets of Naha, where he had walked with Bettelheim,[34] he wrote:

> The outer walls enclose little courts, which had a few shrubs and flowers, the houses themselves lying a few feet further back from the street. The houses of the poorest classes, and the few shops which we saw were generally without a court, and opened directly upon the thoroughfares.[35]

A careful examination of Willet Spalding's lithograph of 'Loo Choo – a scene showing two elders and a young man by a house on a hill overlooking the sea'[36] will show, as well as the pitched roof and glazed tiles of the dwelling, a coral block wall extending around the building's demesne.

If the use of coral blocks to form the walls was a local (or Polynesian) tradition, the use of more conventional Japanese building techniques at Loo Choo was also in evidence. Bettelheim's house appears to be a frame structure, as was the house of the royal Regent where Perry, accompanied by Taylor and a number of officers, was entertained:

> The Regent's house ... was rather larger than usual, but not distinguished by any appearance of wealth, or insignia of office. It consisted of a central hall with wings, open toward the court-yard, from which it was only separated

by a narrow verandah, approached by a flight of stone steps. The building was of wood, and the pillars supporting it, with the beams of the ceilings, were painted of a dark colour. The floor was covered with thick, fine matting, each mat being rigorously made according to the legal dimensions.[37]

Interpreting the Japanese House

It was not until 1854 that the unpopular Dr Bettelheim eventually left the Loo Choos on board Commodore Perry's flagship, the *USS Powhatan*, at the end of Perry's second visit to Japan. It was on that second visit that Perry and representatives of the *Shogun* Tokugawa Ieyoshi signed the Convention of Kanagawa, the 'American-Japan Treaty of Peace and Amity', which opened the Japanese ports of Simoda and Hakodate to the Americans. This one action signalled the end of Japan's isolation.

On his first visit to Japan, Perry had presented the *Shogun* with a letter from President Millard Fillmore demanding trading rights for America. This had been handed over ceremonially, following threats of violence from the Americans, in a hall which the Japanese had quickly erected for the purpose at Gorihama (Kurihama), near Uraga. Willet Spalding accompanied Perry to the ceremony and, with great observation and perspicacity, noted the building's construction:

> The place of audience was a room in a thatched building, limited in space, and entirely open in the direction of the court, ornamented with gauze curtains as drapery ... Overhead you looked up to thatching, and each rafter was marked with Japanese characters, as if the building had been originally constructed at some other place, probably at Yedo, and sent down for erection.[38]

The Treaty was signed eight months later, on the shoreline at Yokohama, in a hall also specially erected for the purpose and, as Hawks was to observe, 'arranged in a similar manner to that at Gori-hama'.[39] As work progressed, he noted it in his journal:

> The Japanese now commenced constructing at once a wooden building for the proposed conference, and a great number of workmen were seen busily engaged in bringing materials and putting them together in the form of a large and irregular structure ... As the building on the shore was in progress, the details of its erection, and the prospective interview ashore, were naturally topics of conversation ... The eighth of March had been appointed by the Commodore as the day for the conference ashore; and, as crowds of Japanese labourers kept busily at work upon the building, there seemed every prospect of it being ready in time.[40]

The building, when it was completed, appeared, to both Hawks and Spalding, unfamiliar or possibly just unfinished. Both men commented on the unpainted pine wood and the use of oiled paper, in place of glass, in the windows; on the *tatami* on the floor and on the heating braziers set in lacquered wooden stands aligned down the centre of the space.[41] But it was an architecture which was to prove to be exceedingly common, for Perry and his officers, on venturing soon after into a small town, were invited into the home of the mayor or chief magistrate (Hawks is unsure which) where 'The interior was quite unpretending, consisting of a large room, spread with soft mats, lighted with oiled paper windows, hung with rudely executed cartoons, and furnished with the usual red-colored benches.'[42] The benches, quite clearly, had been brought in, and quickly, as at the hall in Yokohama, for the foreigners' comfort.

The domestic architecture which these Americans, and those who followed them, were to see differed little if at all from what Cocks, Kaempfer and other Westerners had previously observed. Yet they were able to study it at greater leisure and with increasing freedom, as well as to record it in print and pictures which received far wider distribution than before. The rather startling assertion made in

1863 by Rutherford Alcock that the Japanese 'have no architecture'[43] demonstrates his Western prejudices as much as it belies his understanding of Japanese building. Alcock, a native of London, an Anglican, a medical doctor and a diplomat, would have thought of architecture in terms of the late-Georgian or early- to high-Victorian Gothic masonry buildings of his own country, and not in terms of what he saw in Japan:

> Houses for dwelling in seldom consist of more than one story, those of the wealthy never, I fancy, and those of the busy and commercial classes in large cities where land is valuable – more valuable than life in Japan – consist of a ground-floor and garret above. These are all constructed of solid wooden frames strongly knit together, the walls being merely a thin layer of mud and laths to keep out the cold and heat; the whole surmounted in the better class by rather ponderous and overhanging roofs ...[44]

His dismissiveness is based as much upon the method of construction employed in Japan as it is the appearance of the buildings. This he ascribes to the 'tertian ague' (a form of malaria) found in the volcanic soil, 'thus denying,' as he says, 'the first conditions of a builder, a stable foundation, and imposing a law of construction fatal to all architectural pretensions or excellence'.[45] Alcock even rejects the perceived advantages of timber-frame construction, writing that 'once in about every seven years, according to Japanese report, the inhabitants of Yeddo must lay their account for seeing their wooden city reduced to a heap of ruins by an earthquake, too violent, even, for such constructions to resist, and completed by fire, which inevitably follows'.[46] Only the temples, he acknowledges, have any sort of architectural pretension, and that was because people did not live under their roofs.[47]

Be that as it may, the interchangeability of the temple and the house, in the context of Bernard Bettelheim's residence on Great Loo Choo, has already been noticed. What is significant here, and what Alcock fails to recognise, is that the everyday architecture of Japan at this time could not be categorised and understood in terms of usage or building type, but rather had to be considered in a more holistic way – in terms of construction, space and enclosure. For what served as *minka* or the people's houses – and here the word is used most loosely – was an infinitely variable and flexible affair, which could be reduced, on the one hand, to volumes as small as two or three *tatami*, as in a tea house, or expanded into a multiplicity of rooms as in the Imperial or *shogunal* palaces. It was also a building in which rooms frequently had no designated functions but would change their usage throughout the day, or even, by the removal of all the external walls, dematerialise. In the same way, the halls which were erected for Perry's meetings with the *Shogun*'s representatives were flexible and therefore as characteristic of Japanese domestic architecture as was the home of the mayor or chief magistrate whom Perry later visited.

The clearest analysis of the Japanese house was made by Christopher Dresser when he said that 'the Japanese may be said almost to live an out-of-door life, the house being rather a floor raised above the ground with a substantial roof than a series of rooms properly enclosed by substantial side walls'.[48] This interpretation of the Japanese house as a raised floor with a roof suspended above suggested a significant departure from Western norms but one which, less than a century later, had become a trope in Modern architecture.

Minka

Johannes Rein and Edward Morse did not agree about Japanese architecture. Rein, rarely being sentimental about the country, drew comparisons and made assessments based upon a European lifestyle. Morse, much more the Japanophile, took him to task over this:

> Rein, in his really admirable book on Japan says 'the Japanese house lacks solidity and comfort.' If he means comfort for himself and his people, one

can understand him; if he means comfort for the Japanese, then he has not the faintest conception of the solid comfort a Japanese gets out of his house.[49]

Rein describes the Japanese house as being ill-adapted to the climate. Although he concedes that it might be cool and airy in the heat of the summer, he states that, during the long winter months, 'it affords no adequate protection against the cold air which everywhere penetrates through the joints and chinks' and that therefore 'even the more hardened natives can hardly find it comfortable to live in ...'[50] His solution was in the modernisation of Japan and the consequent provision of what he regarded as 'a more solid style of building, accommodating itself in a rational way to the various requirements of a dwelling house'.[51] Morse, on the other hand, believed that 'Whether the Japanese house is right or wrong in its plan and construction, it answers admirably the purpose for which it was intended.'[52] Rein, like other Western writers, was also critical of the want of privacy in Japanese houses but, as Morse put it, 'privacy is only necessary in the midst of vulgar and impertinent people, – a class of which Japan has the minimum, and the so-called civilized races – the English and the American particularly – have the maximum'.[53]

The difference in analysis was clear: while Rein was forward-looking and saw the benefits of development and modernisation – 'Japan,' he wrote, 'exhibits these transitions in abundance'[54] – Morse saw the real value of the way in which the Japanese traditionally lived. While he conceded, in the Preface to *Japanese Homes and Their Surroundings*, that 'Profound changes have already taken place in Japan, and other changes are still in progress',[55] it is clear that he valued the quiet lifestyle embodied in the Japanese house above the clamour of the modern, Western world:

Within are no slamming doors or rattling latches; one admires the quaint and noiseless way in which the *fusuma* are gently pushed back and forth; and the soft mats yielding to the pressure of still softer feet, as the inmates like cats step lightly about, are soothing conditions to overstrained nerves, and one cannot help contrasting them with the clatter of heavy boots on our wood floors, or the clouds of filthy dust kicked out of our carpets in any rough play of children. All these miseries are happily avoided in a Japanese house.[56]

Minka: The Timber Frame

Understanding the Japanese house as both Morse and Dresser did meant understanding not just how it was used, but also its purpose or intention. When threatened by fire, as so often happened, the house could be quickly dismantled and carted off: 'Mats, screen-partitions, and even the board ceilings,' Morse explained, 'can be quickly packed up and carried away. The roof is rapidly denuded of its tiles and boards, and the skeleton frame-work left makes but slow fuel for the flames.'[57] In this way the additive process of house construction is reversed until all that remains is the basic form – the timber frame.

The Japanese house was a modular structure controlled by the standardised dimensions of the *tatami*. 'Once you have prepared your foundations and woodwork, of the dimensions of so many mats,' Mrs Brassey wrote, 'it is the easiest thing in the world to go to a shop and buy a house, ready made, which you can then set up and furnish in the scanty Japanese fashion in a couple of days.'[58] The dimensions of all the components which were used in the house consequently related to the *tatami*. This point was picked up upon by Morse who noted that, 'As the rooms are made in sizes corresponding to the number of mats they are to contain, the beams, uprights, rafters, flooring-boards, boards for the ceiling, and all strips are got out in sizes to accommodate these various dimensions.'[59] This, in turn, as Morse pointed out, controlled the way in which the house was designed and constructed, the benefits of which were to him immediately apparent:

The architect marks on his plan the number of mats each room is to contain, – this number defining the size of the room; hence the lumber used must be of definite lengths, and the carpenter is sure to find these lengths at the lumber-yard. It follows from this that but little waste occurs in the construction of a Japanese house. Far different is it with us in our extravagant and senseless methods of house-building.[60]

However, Henry Faulds saw similarities between Japanese house construction and traditional timber-frame building in England. Citing the *History of the Preston Guild*[61] as his somewhat unlikely architectural reference, he explained that 'English houses, like those in Japan, were formed of a wooden framework, the interstices of which were formed of clay mixed with straw. Each piece of wood in the framework,' he continued, 'was usually tenoned fitted into a mortice, and fixed by a wooden peg. The framework was put together by the builder before it was taken to the site. The corresponding parts were all numbered, just as we find them in Japan at the present day, and the rest of the description fits almost word for word.'[62] The process of pre-fabrication which Faulds recognised here reflected Bayard Taylor's earlier observation made at Gorihama. Faulds further offered an explanation for the universal use of pegged mortice and tenon joints:

> The carpenters are reputed to be afraid of the god of metal. Certainly, they use his products rather badly. We could never, for instance, get them to put in a screw-nail by any other process than driving it in by main force with a hammer ... and so right smash went the biggest screw-nail into the finest piece of wood-work.[63]

Francis Hawks's experience of Japan was largely limited to the treaty ports of Shimoda and Hakodate (which he calls Simoda and Hakodadi). In Shimoda, on the Izu peninsula on the south coast of Honshu, 'The shops and dwelling houses,' he wrote, 'are but slightly built, many of them being merely thatched huts. A few of the houses of the better classes are of stone, but most are constructed of a framework of bamboo or laths, covered with a tenacious mud.'[64] At Hakodate, on the northern island of Hokkaido, a more sturdy architecture was to be seen:

> The buildings of Hakodadi are mostly of one storey, with attics of varying heights ... The height of the roofs is seldom more than twenty-five feet from the ground. They slope down from the top, projecting with their eaves beyond the wall, are supported by joints and tie-beams, and are mostly covered with small wooden shingles of about the size of the hand. These shingles are fastened by means of pegs made of bamboo, or kept in their place by long slips of board, which have large rows of cobble stones put upon them to prevent their removal. The stones are, however, said to have the additional advantage of hastening the melting of the snow, which during the winter season is quite abundant in Hakodadi.[65]

Morse, in turning his attention to the peculiarities of Japanese structural framing, refers to Ralph Waldo Emerson's sixth essay on *English Traits* (1856), 'Manners', and invokes the caricature of the Englishman to demonstrate the apparently incomprehensible nature, to some, of the Japanese house:

> An Englishman particularly, whom Emerson says he finds 'to be him of all men who stands firmest in his shoes,' recognizes but little merit in the apparently frail and perishable nature of these structures. He naturally dislikes the anomaly of a house of the lightest description often-times sustaining a roof of the most ponderous character, and fairly loathes a structure that has no king-post, or at least a queen-post truss; while the glaring absurdity of a house that persists in remaining upright without a foundation, makes him furious.[66]

The pitched roofs of the Japanese houses were constructed with a framing system that knew

3.02 Sōshirō Hoshino, Prefectural Assembly Hall, Niigata, 1883.

nothing of triangulation. The structure consisted of a series of cross-beams of decreasing length supported one upon another by timber struts. Morse, not being an architect, saw no real need to adopt the Western convention of king- or queen-post trusses, rafters and purlins. 'When one of these foreign critical writers contemplates the framework of a Japanese house,' he writes, 'and particularly the cross-beams of the roof, and finds no attempt at trussing and bracing, he is seized with an eager desire to go among these people as a missionary of trusses and braces, – it is so obvious that much wood might be saved! In regard to the Japanese house-frame, however, it is probable that the extra labour of constructing braces and trusses would not compensate for the difference saved in the wood.'[67] By the time that Morse made his observation in 1886, Japanese carpenters and builders were already adopting the European triangulated truss, one of the first examples being the Prefectural Assembly Hall built by Sōshirō Hoshino at Niigata in 1883 [3.02]. Although this building was Western in appearance and therefore *giyōfū* architecture, the adoption of

the triangulated truss was novel, for the use of the traditional stepped frame to support the roof would have been more normal [3.03].

Internally, as Morse says, 'The frame-work of a building is often revealed in the room in a way which would delight the heart of an Eastlake.'[68] Although the eponymous British architect Charles Locke Eastlake's book, *Hints on Household Taste*,[69] had less to do with architecture than his next book, *A History*

3.03 Triangulated Western roof trusses and traditional Japanese roof construction compared.

59

of the Gothic Revival (1872), it nevertheless promoted a certain aesthetic, delivered mostly in furniture but popularised in American housebuilding, which Morse recognised here.[70] 'Irregularities in the form of a stick,' Morse wrote of Japanese houses but with the Eastlake style in mind, 'are not looked upon as a hindrance in the construction of a building. From the way such crooked beams are brought into use, one is led to believe that the builder prefers them. The desire for rustic effects leads to the selection of odd-shaped timber.'[71]

Morse's observation that 'Diagonal bracing in the frame-work of a building is never seen'[72] was correct. The result of this was that the structural timbers were often weighty and the interior walls were divided, for stability, into small, almost square bays. The moment joints created at the pegged mortice-and-tenon junctions needed to be strong to withstand the lateral forces generated by earthquakes and typhoons and, rather than by introducing a diagonal brace, this was achieved by the use of the *kamoi* or lintel, a second and lower beam spanning between the uprights. The effect was similar to that of inserting a deep beam between the posts except that there was no structural web to provide load-bearing strength. Instead, this void space, which was essentially a frieze, was either filled with plaster or, if kept open to allow for cross-ventilation, given a decorative grille. The effect of this, in terms of how the houses were used, was commented upon by Josiah Conder in his paper on 'Domestic Architecture in Japan' presented to the RIBA in 1887. Here he described how the 'the light and flimsy nature of internal partitions, and the use of perforated friezes in such divisions for purposes of ventilation, has led to the almost total disregard of privacy as an element of domestic comfort'.[73]

Minka: The Raised Floor

The Japanese house, Dresser explained, 'is in no way built upon foundations, or fixed to the ground on which it rests. It stands upon a series of legs, and these legs usually rest upon round-topped stones of such a height as will, during the rainy season, support the timber uprights above any water that may lie upon the ground ...'[74] The raising of the floor, to increase ventilation beneath the house, as well as to avoid flooding, was something which Hawks had noticed in 1854, observing that 'previous to building the house the ground is beaten smooth, and the floor is raised about two feet above it'.[75] Rather than disturbing the flattened earth with foundations, the frame of the house was rested upon it, so as to further mitigate against the transfer of seismic shocks. The American painter and stained-glass artist, John La Farge, who arrived in Yokohama in 1886, commented upon this when writing *An Artist's Letters From Japan* (1897):

> Like all true art, the architecture of Japan has found in the necessities imposed upon it the motives for realizing beauty, and has adorned the means by which it has conquered the difficulties to be surmounted. Hence no foundations, which would compromise the super-imposed building by making it participate in the shock given to its base. Hence solid pedestals, if I may so call

3.04 'Paved space under eaves of thatched roof', showing the raised floor, from Edward Morse, *Japanese Homes and their Surroundings*, 1886.

them, or great bases, upon which are placed only, not built in, the posts which support the edifice, leaving a space between this base and the horizontal beams or floors of the building. The building is thus rendered elastic, and resumes its place after the trembling of the earthquake, and the waters of bad weather can escape without flooding any foundations.[76]

The absence of rainwater gutters on the overhanging thatched or tiled roofs also necessitated the raising of the floor to avoid splashing, and sometimes, as Morse showed, the inclusion of a pebble bed beneath the eaves to catch the drips [3.04].[77]

The raising of the floor, however, also served the purpose of separating one activity from another while co-existing under the same roof. It was an arrangement which led Hawks, who clearly saw a house as being defined by the walls rather than, as Dresser did, by the floor and the roof, to describe the arrangement as a house within a house. 'In the interior of the houses there is a large frame work, raised two feet above the ground. It is spread with stuffed mats, and is divided into several compartments by means of sliding panels.'[78] Here, at the raised level, the domestic functions of eating, sleeping, receiving company and trading, as well as skilled craft-work such as lacquer varnishing, were performed, while heavier work of, for example, the blacksmith or the stonecutter, could be carried out on the ground.

Minka: The Great Roof

The adoption, in Japanese architecture, of the timber frame as a remedy against earthquakes, as had been noticed almost 250 years earlier by Father João Rodrigues in his *História*, was recognised by the Scottish botanist Robert Fortune, in *Yedo and Peking: A Narrative of a Journey to the Capitals of Japan and China* (1863):

On carefully examining the structure of one of these buildings, one soon sees the principles on which it is put up, and the reasons for its peculiar construction. Buildings such as we erect in England would be very unsafe in a country like Japan, where earthquakes are so common and so violent. Hence the main part of a Japanese house is a sort of skeleton framework; every beam is tied or fastened to its neighbour; so that, when the earth is convulsed by those fearful commotions, the whole building may rock and sway together without tumbling down. In order to render these buildings more secure, it seems necessary to have the roof of great strength and weight, and this accounts for their heavy and massive structure.[79]

Fortune also saw the importance of the roof, rather than the walls, as the stabilising medium in Japanese house construction. 'The walls were formed of a framework of wood nicely fitted and joined,' he wrote, 'but apparently not very massive in construction. This was rather extraordinary, owing to the great thickness and weight of the framework of the roof. No doubt, however, the sides were strong enough to support the roof, heavy though it was.'[80] It was a point also noted by La Farge in his book of letters:

The great, heavy, curved roof, far overhanging, weighs down upon this structure, and keeps it straight. An apparently unreasonable quantity of adjusted timbers and beams supports the ceiling and the roof. Complicated, tremendous corbelling, brackets grooved and dovetailed, fill the cornices as with a network; but all these play an important practical part, and keep the whole construction elastic, as their many small divisions spread the shock.[81]

These great roofs, however, were pitched at some 30 to 40 degrees and extended beyond the eaves to shelter the raised *engawa* which surrounded the house. The result was that the upper portions of the rooms, shielded from any direct sunlight, remained dark, confining, as Conder explained, 'the only direct illumination to the floors of the different chambers. This was no disadvantage in the old

mode of life, when all writing, reading, and painting was executed upon the floor ...'[82] It was this gloomy condition that was so admired by Tanizaki Jun'ichirō in his short book of 1933, *In Praise of Shadows*:

> The quality that we call beauty, however, must always grow from the realities of life, and our ancestors, forced to live in dark rooms, presently came to discover beauty in shadows, ultimately to guide shadows towards beauty's ends.

> And so it has come to be that the beauty of a Japanese room depends on a variation of shadows, heavy shadows against light shadows – it has nothing else.[83]

Minka: The Moveable Wall

It is in the treatment of the external walls, the building's principal enclosing element or envelope, that the essential difference between the Japanese house and those in the West, as suggested by Dresser, was apparent. Indeed, he was to reinforce the point when he wrote: 'We have already noticed that the sides of a Japanese house are generally removable, and that the building consists of uprights, a floor, and a roof.'[84] The openness of the Japanese house was a response to the heat and humidity of the summer but in winter proved very ineffective against the sometimes severe temperatures. In Hakodate, where the Siberian weather makes the winters very cold, John M. Tronson, a surgeon who sailed there with Admiral James Stirling's squadron in 1854, wrote that 'The fronts of the houses are open to the street; deep projecting eaves keep off the rain or strong sunbeams. At night the fronts are closed by folding doors, or rather sliding shutters, which run in a groove to the end of the house, where they are received in a box-like receptacle ...'[85] When, in the same year, Perry's squadron arrived at Hakodate to survey the harbour, Francis Hawks had ample opportunity to note the house construction. There he observed how the effect of the harsh weather on

the unpainted pine boards caused them to shrink, mould and rot, with the result that the town had 'a more rusty, ruined appearance than its age should indicate'.[86] Although the winters in Hokkaido were cold, the hot, humid summers still necessitated the removing of the external walls:

> The walls of the buildings are generally constructed of pine boards, fastened lengthwise, with a layer inside and out, to the framework, which is jointed with admirable skill. The boards in front and rear are made to slide horizontally in grooves like shutters. At night they are barred fast, and in the day-time entirely removed, to allow the light to pass freely through the paper screens behind them.[87]

In Nagasaki, on the southern island of Kyushu where the summers are even hotter, Laurence Oliphant was similarly struck by the open nature of the houses whose interiors were exposed, without either shame or modesty, to all passing by:

> Light wooden screens, neatly papered, and running on slides, are for the most part pushed back in the daytime, and the passer looks through the house, to where the waving shrubs or a cool-looking back-garden invite him to extend his investigations. Between the observer and this retreat there are probably one or two rooms, raised about two feet off the ground; and upon the scrupulously clean and well-wadded matting, which is stretched upon the wooden floor, semi-nude men and women loll and lounge, and their altogether nude progeny crawl and feast themselves luxuriously at ever-present fountains. The women seldom wear anything above their waists, the men only a scanty loin cloth.[88]

In his early stereoscopic photo-essay, *The Japanese; Their Manners and Customs* (1862), Thomas Clark Westfield made similar observations of houses in Nagasaki. Being of two-storeys, they would have resembled those along the Tōkaidō or Imperial Highway in Kanagawa, illustrated by Fortune:[89]

The front and back of the basement [the lower floor] can be removed at pleasure, leaving it quite open, through the premises, for air and light, except where the posts supporting the first floor intervene. Usually the front panels are removed during the daytime, and the back panels, formed of a light, graceful, wood framework, covered with translucent paper, are left to screen the cooking departments and back premises. The floor of the basement is raised about three feet above the level of the ground, and is neatly boarded, and then laid over with a series of stuffed grass mats, on which the inmates walk, sit, feed, and sleep ... The story overhead [the upper floor] serves as a place of abode for their wives and families, and those we visited are in height, and ventilation, and cleanliness, vastly superior to the majority of up-stairs rooms in the East.[90]

Fifteen years later, Mrs Brassey, who arrived in Yokohama on board the *Sunbeam* in January 1877, was still able to comment on the openness of the Japanese houses on the island of Enoshima in Sagami Bay, where the 'screens were all thrown back, to admit the morning air, cold as it was. We could consequently see all that was going on within, in the sitting-room in front, and even in the bedrooms and kitchen.' Travelling in 'a funny little shaky carriage', Annie Brassey had, as she said, 'a bird's-eye view of the ground plan of the houses, the method of cooking food, &c.'[91] Being able, apparently, to distinguish the sitting-room from the bedroom, however, suggests that her bird's-eye view allowed her little understanding of how the Japanese actually lived.

Annie Brassey and Josiah Conder had both arrived in Yokohama, but independently, in January 1877. Conder's 'Notes on Japanese Architecture',[92] which was read to the Royal Institute of British Architects in March the following year by Thomas Roger Smith, a relative and both his former employer and university teacher, similarly dwelt upon the moveable walls. 'In the ordinary houses,' Conder wrote, 'one external wall or more, and most of the internal walls, are not covered with plaster, but are open between the uprights, being filled in merely with light wooden screens sliding past one another in grooves ...'[93] The flexibility of the plan which this implied is not commented upon here, either because it was not yet apparent to this newcomer or, if it was, not appropriate (or useful) for explanation. However, in the paper of 1887 on 'Domestic Architecture in Japan', Conder seemed at pains to explain the open-plan domestic arrangement, so misunderstood by Annie Brassey, which the moveable *fusuma* and *shōji* facilitated. 'The absence of internal thoroughfares,' he wrote, 'and the use of every room as a passage to the next renders strict privacy impossible. The bedroom, as a distinct apartment, can hardly be said to exist ... As a general rule, any room is converted into a bed-chamber by spreading sleeping quilts and pillows upon the matted floor.'[94] To accompany this explanation, a plan and elevation of a middle-class house, drawn by his brother Roger, were provided which, through the delineation of the *tatami* and the (closed) *fusuma*, demonstrated the homogeneous nature of the Japanese interior [3.05]. Conder's paper, or at least his subject, was not received well by Richard Phené Spiers, the Master of the Architecture School at the Royal Academy of Arts. Spiers, who, like Conder, had both worked for Burges and won the RIBA Soane Medal, might be presumed to have known him. Nevertheless, his opinion was not supportive:

I am afraid that with regard to the architecture of Japan, there is no architecture, as we understand it: that is, whatever there may be in decoration, in dress, in objects of art, and in other works in Japan, from the architecture of the country we shall learn scarcely anything.[95]

Charles Barry Jnr, the President, tried from the Chair to redeem the situation:

It occurs to me that if, as Mr Spiers has said, there is no architecture in Japan, there is at all events a great deal of fancy and imagination displayed in the uses of their wood.[96]

The openness of the Japanese house meant, paradoxically, that in terms of Western architectural

TRANSACTIONS OF THE ROYAL INSTITUTE OF BRITISH ARCHITECTS VOL. III, NEW SERIES.

XXXI. DOMESTIC ARCHITECTURE IN JAPAN. (XXVII).

ELEVATION.

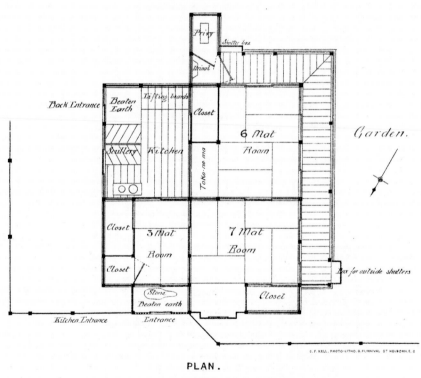

PLAN.

Scale of [10 5 0 10] feet

R T Conder del.

MIDDLE-CLASS JAPANESE DWELLING.

(Page 107.)

3.05 'Middle-class Japanese dwelling', from Josiah Conder, 'Domestic Architecture in Japan',
Transactions of the Royal Institute of British Architects, 1877–78, 1878.

appreciation, there was no great demonstration of façade design or, as Spiers said, 'architecture, as we understand it'. Morse shows two illustrations of 'a city house of one of the better classes' – a view from the street [3.06] and another from the garden [3.07]. 'The house,' he writes, 'stands on a new street, and the lot on one side is vacant; nevertheless, the house is surrounded on all sides by a high board-fence, – since, with the open character of a Japanese house, privacy, if desired, can be secured only by high fences or thick hedges ... There is no display of an architectural front; indeed, there is no display anywhere. The largest and best rooms are in the back of the house ... Here all the rooms open directly on the garden. Along the verandah are three rooms *en suite*.'[97]

The flexibility of the envelope which surrounded the Japanese house is what gave the interior its character. La Farge saw the house almost as a metaphor for life. 'The domestic architecture is as

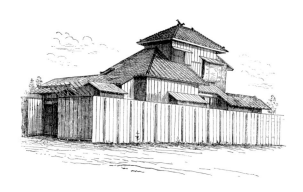

3.06 'Street view of dwelling in Tokio', from Edward Morse, *Japanese Homes and their Surroundings*, 1886.

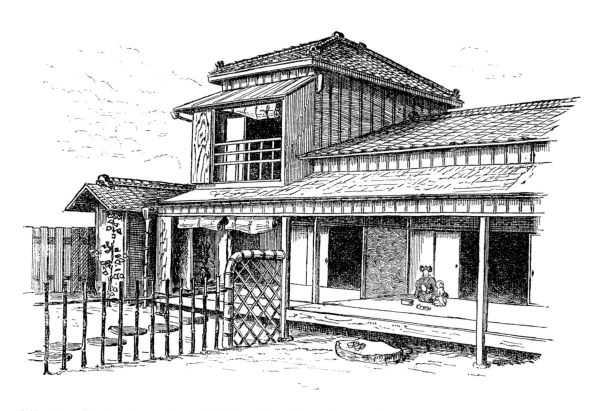

3.07 'View of dwelling from garden, in Tokio', from Edward Morse, *Japanese Homes and their Surroundings*, 1886.

simple, as transitory, as if it symbolized the life of man ... Within, the Japanese house is simplicity itself; all is framework, and moving screens instead of wall ... The woodwork is as simple as it can be – occasionally, some beautiful joinery; and above all, exquisite cleanliness.'[98] The moving screens, the *fusuma* and *shōji*, precluded the accumulation of ornament and thus effected, in the absence of any bric-a-brac, a sense of social levelling. 'And this,' La Farge noted, 'is all the same for all, from the emperor's palace to little tradesman's cottage. There is nothing, apparently but what is necessary, and refinement in disposing of that. The result is sometimes cold and bare. There is the set look of insisting upon an idea – the idea of doing with little ...'[99]

Minka: The Verandah or *Engawa*

As Morse showed in his illustration and also suggested in his description of the city house, the verandah was a constituent part of the Japanese house. Known as the *engawa* (Morse calls it the *Yen-gawa*), it was contained between *shōji* on the inside, *amado* or rain doors on the outside, and often covered with a *hisashi* or canopy roof separate from the building's main roof. It was an intermediate zone between public and private space, between house and garden or street. 'In the Japanese house,' Morse wrote, 'it is almost a continuation of the floor of the room, being but slightly below its level. The verandah is something more than a luxury; it is a necessity arising from the peculiar construction of the house.'[100] As an intermediate zone, neither inside nor outside the house, the *engawa* served to separate and thus protect the *shōji* and *tatami* from the weather.

Morse's cross-section shows the *engawa* to be constructionally independent of the house, the main posts being aligned with the *shōji* screens and supporting the *kamoi* or lintel above [3.08]. The alignment of the *engawa* with the eaves, however, was not a pre-requisite and sometimes, as Captain Bernard Whittingham of the Royal Engineers wrote of the houses in Hakodate in 1856, 'the gables are generally towards the street, and have rustic

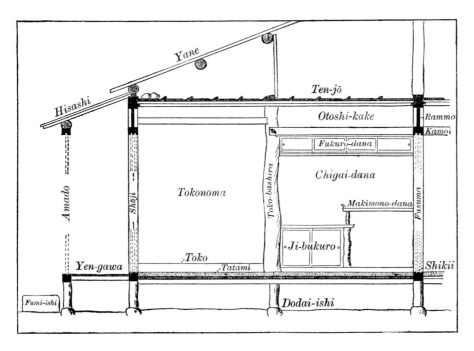

3.08 A cross-section through the '*Yen-gawa*' showing the '*Tokonoma*' and '*Chigai-dana*', from Edward Morse, *Japanese Homes and their Surroundings*, 1886.

verandahs in front'.[101] In Niigata, where the winter conditions were similar, Isabella Bird noticed in 1878 that 'The houses ... all turn the steep gables of the upper stories streetwards', and that 'The deep verandah are connected all along the streets, so as to form a sheltered promenade when the snow lies deep in winter.'[102]

The fact that the *engawa* usually extended the whole length or breadth of the house made the point of entry into the house somewhat ambiguous. As Morse observed, 'one may enter a house by way of the garden and make his salutations on the verandah, or he may pass into the house by an ill-defined boundary near the kitchen, – a sort of back-door on the front side'.[103] Indeed, Morse was fascinated by the differences in perception of notions of entry and procession between houses in the West and those in Japan:

> Some may be inclined to doubt the statement that in the ordinary houses the entrance is more or less vaguely defined. As a curious proof of this, however, I have in my possession Japanese architects' plans of two houses, consisting of a number of rooms, and representing dwellings far above the ordinary type and though I have consulted a number of Japanese friends in regard to these plans, none of them have been able to tell me where the main entrance is, or ought to be![104]

This innate flexibility and lack of formality characteristic of the Japanese dwelling caught Annie Brassey's attention. Her description of a tea-house, although by her own admission somewhat generic, nevertheless provides a good picture of Japanese domestic living and the confusing, if not farcical, manner in which it was performed:

> The apartment we were shown into was so exact a type of a room in any Japanese house, that I may as well describe it once for all. The woodwork of the roof and the framework of the screens were all made of a handsome dark polished wood, not unlike walnut. The exterior walls under the verandah, as well as the partitions between the other rooms, were simply wooden lattice-work screens, covered with white paper, and sliding in grooves; so that you could walk in or out at any part of the wall you chose, and it was, in like manner, impossible to say whence the next comer would make his appearance. Doors and windows are, by this arrangement, rendered unnecessary, and do not exist. You open a little bit of your wall if you want to look out, and a bigger bit if you want to step out.[105]

How different, then, was Isabella Bird's reaction 18 months later when she visited the Revd Philip Fyson (later Bishop of Hokkaido) and his wife at the Westernised Church Mission House in Niigata. It was, she wrote, 'an unshaded building without a verandah' and, so it might be thought, without *shōji* and *fusuma* screens or *tatami* mats either. Indeed, she goes on to say, somewhat ungenerously, 'The home is plain, simple, and inconveniently small; but doors and walls are great luxuries, and you cannot imagine how pleasing the ways of a refined European household are after the eternal babblement and indecorum of the Japanese.'[106]

Minka: The *Tatami*

In their observation of the exposed nature of the Japanese house, both Oliphant and Westfield had drawn attention to the *tatami* mats which both controlled the design of the house and the manner in which the inhabitants used them. Once Oliphant arrived in Yedo (Tokyo), he found that his accommodation in the Tōzen-ji, a Buddhist temple at Takanawa in which Alcock had established the British legation, was furnished throughout with *tatami* which he was quick to recognise as the basic module of Japanese domestic architecture:

> These mats were all exactly the same size, so that there is never a difficulty about getting them to fit the apartment. Each mat was six feet three inches long, three feet two inches wide, and four inches thick; they were made of rice

or wheat straw plaited together. A mat has thus come to be regarded as a standard measure in Japan; and in as much as the rooms are capable of expansion or retraction at pleasure by sliding the screens, and the mats are conveniently small and moveable, the internal fitting of a house is not a very elaborate process.[107]

But for an English gentleman, the conventions of Western dress did not altogether suit the demands of a Japanese lifestyle.

> All our rooms were matted in the usual way with wadded mats, so scrupulously clean that we began by walking about in our own or Japanese socks, for fear of dirtying them; but it was so exceedingly troublesome to be perpetually putting on and kicking off our shoes, that we ultimately sacrificed cleanliness to convenience.[108]

Hawks also commented on the *tatami*, noting both their uniformity and their universality, as well as their applicability to all living conditions:

> These are very neatly woven and bound with cloth, and are all of a uniform size prescribed by law, being three feet by six, and placed in rows upon the floor so neatly as to have the appearance of one piece. Upon these mats the people sit to take their meals, to sell their wares, to smoke their pipes, to converse with their friends, and lie down at night without undressing themselves to go to sleep, adding, however, a quilted mat for cover, and the equivocal comfort of a hard box for a pillow.[109]

It was either the Westerners' inability to adapt to *tatami*-living or the Japanese's desire to Westernise their houses which eventually led to the mats being covered with rugs and carpets. In 1889, Rudyard Kipling stayed at Jutei's Hotel, an accommodation built for the English in Osaka. The building was, as Kipling noted, 'altogether Japanese; wood and tile and sliding screen from top to bottom' and would therefore have been arranged dimensionally according to the *tatami* module. 'But on the floor over the white mats,' he wrote, 'lay a Brussels carpet that made the indignant toes tingle.'[110]

Minka: Scale, Proportion and Symmetry

'In treating of Japanese architecture,' Dresser wrote, 'I should have liked to consider the very important question of PROPORTION. Everything in relation to a Japanese building is determined by rule; but the explanation of these rules would require more space than can be afforded in a work like the present.'[111] The one determining rule which the Western visitors quickly recognised was that of the *tatami*. This controlled the dimensions of the plan and the lengths of the timbers which were employed in the construction of the house, but it did not, as Dresser observed, control the elevation. Since all the rooms in any one house appeared to be of the same height, there was, to Dresser's eye, no obvious relationship, as there might be in Western architecture, between the height of room and the area of the room itself.[112] It would vary, depending upon the area of the room. The constant element was the height of the *shōji* and *fusuma* and the positioning of the *kamoi* at or below a Westerner's head-height. 'Doorways,' Henry Faulds wrote in 1885, 'or rather the grooved lintels in which the screen-doors slide, are very low, and the Japanese, who are always bowing for some reason or another, seem to enjoy having an unusual number of them to pass through in extensive houses.'[113] These beams, Alcock noted, 'are seldom higher than six feet from the ground – as tall Saxons and Celts have found to their cost many times'.[114] Morse draws a similar picture of the Westerner 'stalking about in his stockinged feet, bumping his head at intervals against the *kamoi*'.[115] Although the *kamoi* was low, the ceiling would be higher and the space between the two, the *ranma*, decorated with a carved or fretwork panel – 'another field for the expertise of that decorative faculty,' Morse wrote, 'which comes so naturally to

the Japanese'.[116] Alcock, never one to be impressed by Japanese architecture, dismissed it as 'elaborate, but rather coarse carving'.[117]

Whether or not proportion played a role in the elevations and cross-sections of Japanese buildings, in the way that it did in the plan, is not actually of consequence here. What is significant is that architects and artists visiting from the West looked for it and expected to see it. In so doing they were applying Western values, based upon the Classical Orders, to Japanese architecture. While visiting the temples at Nikkō in 1886, La Farge threw out this challenge:

I should wish that soon someone might undertake to make out in full the harmony of proportions which has presided over these buildings. It is evident that a delicate and probably minute system of relations, under the appearance of fantasy, produces here the sense of unity that alone makes one secure a permanent enjoyment. My information on the subject is fragmentary; I know that the elegant columns are in a set relation to the openings of the temple; that the shape of these same columns is in another relation to their exquisite details; that the rafters play an important part, determining the first departure. I have seen the carpenter's drawings, with manners of setting out work and measurements, and I feel that there is only a study to carry out.[118]

La Farge's curiosity, however, was not that of the antiquarian but one searching for a deeper meaning or order which, perhaps, was more congruent with Buddhist beliefs than the temple architecture which it produced. 'What we need to-day,' he wrote, 'is belief and confidence in similar methods, without which there is nothing for ourselves but a haphazard success; no connection with the eternal and inevitable past, and none with a future, which may change our materials, but will never change our human need for harmony and order.'[119]

In his paper on 'Domestic Architecture in Japan', Josiah Conder demonstrated, after

almost a decade of living in the country, a better understanding than La Farge of the role of proportion and scale in Japanese architecture. Using a tea-room or *chashitsu* as his example, he encouraged his audience not to think in Western terms but to see it as the Japanese would:

In height, as in area, and in the proportioning of all details and parts, the same idea of extreme minuteness and simplicity is carried out. Space, grandeur, and solidity are generally admitted to contributing to impressiveness in architecture. If it be possible to imagine in architecture an exactly opposite impression produced by the greatest refinement of tinyness, delicacy, and fragility, you have the sentiment inspired, and intended to be inspired, by these liliputian *Cha-shitsu.*[120]

Conder's example was indeed very small: a four-and-a-half mat room, with a *tokonoma*, where, as he said, 'the construction throughout [was] in keeping with the tinyness of the arrangements [and where] at the same time the most exquisite care and neatness is displayed'.[121] The minute proportions of the Japanese house were immediately apparent to Algernon Bertram Mitford (later the first Baron Redesdale) when he arrived in Yokohama, as the second secretary to the British Legation, in 1866. He described his residence as 'the daintiest little cottage in the world ... not much bigger than a doll's house, and quite as flimsy ... It was all on so miniature a scale.' He later recalled 'that it seemed as if one must have shrunken and shrivelled up in order to fit oneself to it'.[122]

Symmetry in architecture is not necessarily a product of proportion but often its companion. In Japanese architecture it was reserved for the temple, as a symbol of divine perfection, although, as the Jesuit priest João Rodrigues had observed of castles in his *História da Igreja do Japão* (1620–33), 'the decoration of the roofs and the symmetry of these buildings are wonderful to behold in every detail'.[123] It was, however, the conscious avoidance of such perfection, evidenced by what he called bi-lateral symmetry, which Morse noticed in the

domestic architecture.[124] Using an illustration of an interior where the *tokonoma* and the *chigai-dana* evenly divide the wall, Morse notes how the asymmetry is explicit 'in the two recesses which are unlike in every detail,– their floors as well as the lower borders of their hanging partitions being at different levels. And in the details of the *chigai-dana* symmetrical arrangement is almost invariably avoided … In fact everywhere, in mats, ceiling, and other details, a two-sided symmetry is carefully avoided.'[125] Morse contrasted the lack of symmetry in the Japanese house with the adherence to symmetry of American architecture. 'How different has been the treatment of similar features in the finish of American rooms!', he wrote. 'Everywhere in our apartments, halls, school-houses, inside and out, a monotonous bi-lateral symmetry is elaborated to the minutest particular, even to bracket and notch in pairs …'[126] It is likely that La Farge and Morse, both Americans and from a country where the Beaux Arts classical tradition in architecture was then in the ascendance, were respectively confounded and delighted by what they saw in Japanese architecture.

Minka and the *Kura*

'If we survey one of the larger Japanese towns from a higher standpoint,' wrote Johannes Rein in *Japan: Travels and Researches*, 'it has the aspect of an indistinct sea of houses, in which, as the height of the buildings varies but slightly, we can discern very little except the broad greyish-black roofs without chimneys, interspersed with the white-pointed gables of the fireproof go-downs (*kura* or *dozō*).'[127] The very fragility of *minka* made them easy victims of fire. Within a couple of months of arriving, Mitford's house was destroyed in the great Yokohama fire of November 1866, in which about half the foreigners' buildings were lost. 'The crazy little wood and paper houses were consumed,' *The Illustrated London News* reported the following February, 'like cotton passed through a candle. The fire literally devoured them and not a trace

remained to show what had been a bustling town a few moments before, save a heap of broken tiles and here and there a charred mast.'[128] For Mitford, it was both a wonderful and an appalling sight, but for the Japanese, as he noted after the 1868 fire at Fushimi, near Kyoto, it was something to which they were accustomed:

> … much of the town had been destroyed by fire, but in this land, where the houses are built of wood and paper and whole districts are burnt down by the peaceful upsetting of a brasero on a windy day, the charred remains of a great conflagration excite little astonishment.[129]

The only real security against fire was provided by the *kura* – Rein's fireproof go-downs – where merchants would keep their goods and the better-off householders their possessions [3.09]. These had been noticed earlier by the Revd George Smith whose *Ten Weeks in Japan* had been published in 1861: 'Some white-looking erections of more than ordinary size and finish, stand out occasionally from the general level of roofs and tiles … These square buildings are to be met with in every street, and are the only preservative against the oft-recurring devastations of fire.'[130] It was the sanctuary of the *kura* which allowed the Japanese house, always prone to burning, to appear so free of clutter or bric-à-brac. The *kura* was in almost every way the opposite of the house: it was solid and robust, usually of two storeys and set on a stone base with thick walls of clay or mud, a heavy door and tightly-fitting shutters for its one or two small windows. Both the doors and shutters, which were hung in pairs, were infilled with mud or clay and rebated to fit snugly into the stepped frame of the opening in the manner which, as Smith said, 'might have suggested the original of our own Chubb patent fire-safes'.[131] The building's framework was made using notched posts and bamboo and coarse-fibre rope to provide a strong structure and a secure key for the successive layers of mud and clay which were built up to a thickness of 450 to 600 millimetres or more, before being finished off with a layer of

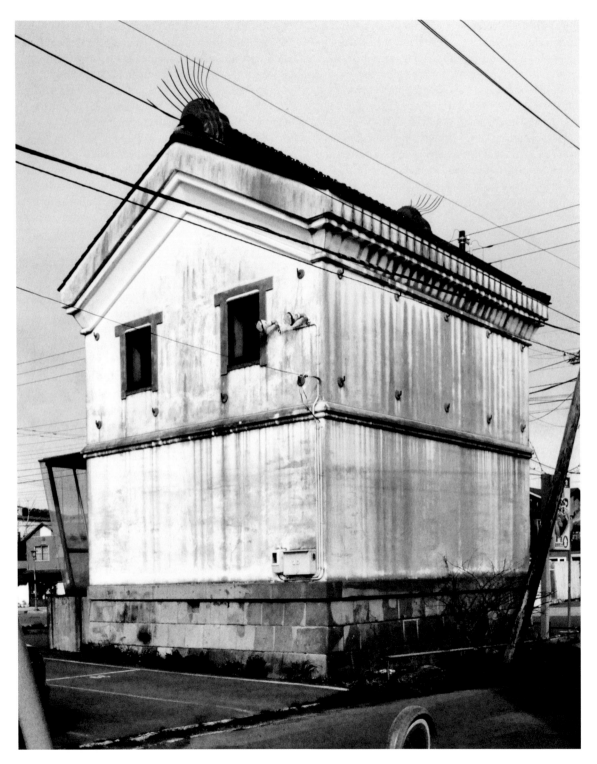

3.09 A *kura* in Hakodate.

3.10 'Arrangement of square tiles on side of house', from Edward Morse, *Japanese Homes and their Surroundings*, 1886.

plaster. So dense was this that it might take two years or more to complete the building, allowing enough time for the layers of mud to dry. This method of construction was also used for the buildings in the Dutch settlement at Dejima where the requirement was for a more robust, Western-style architecture.

'A newly-finished *kura*,' Morse wrote, 'presents a remarkably solid and imposing appearance',[132] but gradually they erode. To prevent this, a heavy cornice extended beyond the wall surface and a drip-mould was run around the building to throw off the water; finally, iron hooks were set in the wall so that a hanging rain-screen could be used if necessary. Usually built near to a house or shop, *kura* were often used as dwelling-places, the hanging rain-screens perhaps becoming permanent and timber-framed screens being added

across the shuttered windows. But since such solid-walled buildings could be damp, they were lined internally with fabric stretched on a timber framework set within the mud walls.

Another method of fireproofing, used in durable buildings such as warehouses, was the hanging of tiles in a diaper pattern on the external wall. Nailed first to a board, these were set a few millimetres apart and the space between pointed with a beading of white plaster which stood proud of the wall surface. This was called *namako* walling and Morse found it to be 'done in a very tasteful and artistic manner, and the effect of the dark-grey tiles crossed by these white bars of plaster is very striking' [3.10].[133] A similar technique of raised pointing was also applied to random-rubble stone walls but there, where there was no regular pattern, the effect was, as Dresser said, 'more strange than beautiful'.[134]

Both Morse and Dresser could have seen such features at the treaty port of Niigata, opened in 1869, where the new buildings combined traditional construction methods with *giyōfū* or Western architectural styling. There the gable end and the cupola of the Customs House was clad in the slate-coloured tiles set on the diagonal, the gaps between closed with a white plaster bead. Equally secure against fire was the nearby Bonded Warehouse, where the thick, rebated, fire-clay doors, of the type used in *kura*, could seal the building from combustion.

The *Azekura* Style

In the same way that *kura* were used for the storage of household possessions, the wealth of the Imperial family was stored in a treasure house or Shōsōin at Nara, the ancient capital. The building, quite unlike either the *kura* or *minka*, was built in the *azekura* style from logs arranged, as Dresser said, 'like those of Russian timber house' [3.11].[135] Built following the death of the Emperor Shōmu in 756, the Shōsōin was over 1,100 years old when Dresser saw it. 'We boast of our oak,' he observed ruefully, 'but what is oak when compared with

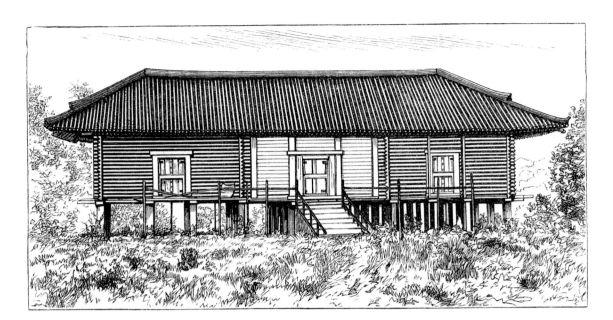

3.11 Shōsōin, Nara, from Christopher Dresser, *Japan: Its Architecture, Art, and Art Manufactures*, 1882.

wood that has actually resisted the storm and the blast for over twelve centuries and is still as sound as it ever was.'[136]

The Shōsōin was a large structure, measuring over 33 by 9 metres and raised 2.5 metres off the ground on circular wooden *piloti*. Unlike the *piloti* in the shrines at Ise, which were planted into the ground, these rested on flat stones so as to avoid damage during earthquakes. The logs which formed the walls were triangular in section and laid so that the inner face was smooth while the outer face zig-zagged. The roof was tiled and the curved eaves overhung the walls in the manner of a temple roof, which helped the preservation of the timber. 'Where a log was exposed,' Dresser had noticed, 'it was three or four inches less in diameter than where hidden, yet the wood was not decayed.'[137] The interior, which Dresser saw, was divided into three compartments, the hefty roof beams being supported on sturdy columns with squared capitals which were notched to receive the beams. The roof structure was typical of Japanese pitched roofs, comprising three layers of beams, supported on struts, and two levels of rafters, the outer one being lifted slightly to lessen the slope of the roof and make the eaves curve. The layered construction of the building and the curved form of its roof was Buddhist, and it was in the Buddhist context of the Tōdai-ji that the Shōsōin was built.

The *azekura* style was also used in Buddhist temples, such as Dresser had noticed at the Sanshinko at Nikkō: 'The lower portion is formed of triangular logs arranged horizontally, and resembling in its construction the old building at Nara in which the Mikado's treasures are preserved. Above the portion thus formed and below the great overhanging roof we have an amount of work in the highest degree beautiful.'[138] What separated these buildings from the Shinto shrines, such as at Ise, was the complexity of the timberwork exemplified by the elaborate bracketing which they displayed. Dresser thought this 'the most marvellous architectural work that I have ever seen, and days might well be spent in considering it',[139] while La Farge, who visited Nikkō in 1886, was equally

impressed. 'Complicated, tremendous corbelling, brackets grooved and dovetailed, fill the cornices as with a network ...'[140] But this elaboration was far from rhetorical. La Farge had understood this immediately: '... all these play an important practical part, and keep the whole construction elastic, as their many small divisions spread the shock.'[141] For Dresser, the realisation came more slowly and, using the entrance gate of the temple of Daibutsu or Great Buddha at Kyoto as an example, he wrote:

> I now understand the reason for that lavish use of timber which I had so rashly pronounced to be useless; and I see that there is a method in Japanese construction which is worthy of high appreciation.[142]

The Temple and the Shrine

The Buddhist temple and the Shinto shrine are to the Japanese what the parish church is to a Westerner. But whereas in the West, nineteenth-century parishioners would have been monotheistic, the Japanese would practise both religions. Dresser summarised the two religions thus: 'Buddhism in Japan consists of a number of sects (about a hundred and fifty), some of which are wholly spiritual, while others are utterly idolatrous';[143] and 'Shinto consists of fire worship, hero worship, and phallic worship, – three of the early worships of mankind.'[144] The two religions are as distinct as their architecture is different: the first, imported from China and Korea in the sixth century, is recognised by its richly carved, colourful buildings, while the other, indigenous to Japan, is characterised by its simplicity and fine workmanship.

The combination of the two beliefs, the first which promoted a love of nature and the second which encouraged the most careful and meticulous workmanship, accounted, as Dresser put it, 'for many of those qualities which characterise Japanese works, be they temples, objects of utility,

or ornaments'.[145] It was, as a result, a cultural environment quite different from that with which he was familiar. 'What buildings can we show in England,' asked Dresser when considering the 1,100-year-old Tōdai-ji at Nara [3.12], 'which have existed since the eighth century and are yet almost as perfect as when first built? ... Besides this the Japanese have, by the medium of wood, produced a characteristic and beautiful architecture.'[146] In fact, the beauty of the temples at Nikkō proved almost too much for Dresser, for he complained, 'I am getting weary of beauty and can understand what Shakespeare meant when he said, "Sweet music makes me sad ..."'[147]

When the first generation of visitors had come to Japan in the late-Edo period, almost 25 years earlier, their response to Japanese architecture had been quite negative, the temple being perhaps its only redeeming feature. Francis Hawks, in his account of Commodore Perry's visits of 1853 and 1854, wrote that 'With the exception of a temple or a gateway here and there, which, in comparison with the surrounding low houses, appeared somewhat imposing, there were no buildings seen which impressed the Americans with a high idea of Japanese architecture.'[148] Alcock, who contended that the Japanese had no architecture, nevertheless conceded that temples 'furnish the only specimens of Japanese architecture',[149] but maintained that 'what architecture there is, however, has no originality, and is in fact only a slight modification of the Chinese style of building, with wooden frames. Their temples, gateways, and larger houses are eminently Chinese, only in better style, and infinitely *better kept*.'[150] However, as if making the best of a bad lot, Kinahan Cornwallis, whose book, *Two Journeys to Japan*, was published between those of Hawks and Alcock, thought the Buddhist temple at Hakodadi (Hakodate), which Hawks had illustrated, to be 'certainly the most beautiful specimen of Japanese architecture I had yet seen'.[151] But being largely limited to the treaty ports, as he and other early travellers were, he had little opportunity for critical comparison.

Like Dresser, Isabella Bird also appears to have tired of the temples when she followed her

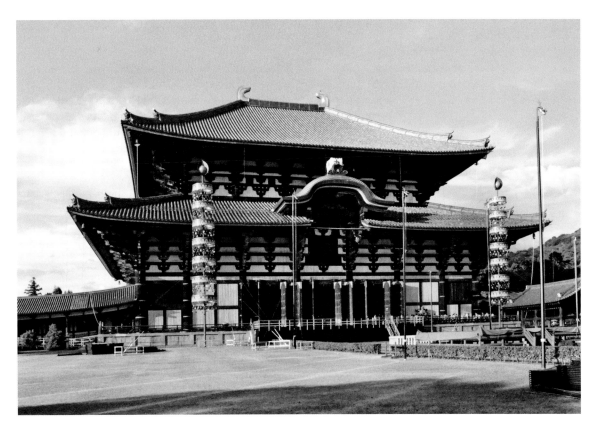

3.12 Tōdai-ji, Nara, 752.

3.13 Taka-no-miya, Gekū, Ise-jingu, Ise, *c.* 500.

Unbeaten Tracks in 1878, but probably due more to their omnipresence than their beauty. 'Once for all I will describe a Buddhist temple,' she wrote of the Sensō-ji at Asakusa, adding that 'in design, roof, and general aspect, Japanese Buddhist temples are all alike'.[152] The construction process was, in fact, very similar to that of the house but on a much larger and more substantial scale. The main difference was that whereas the house was open and flexible in its planning, the temple was closed and inflexible.

The foundations consist of square stones on which the uprights rest. These are of elm, and are united at intervals by longitudinal pieces. The great size and enormous weight of the roofs arise from the trusses being formed of one heavy frame being built upon another in diminishing squares till the top is reached, the main beams being formed of very large timbers put on in their natural state. They are either very heavily and ornamentally tiled, or covered with sheet copper ornamented with gold, or thatched to a depth of from one to three feet, with fine shingles or bark. The casing of the walls on the outside is usually thick elm planking either lacquered or unpainted, and that of the inside is of thin, finely-planed and bevelled planking of the beautiful wood of the Retinospora obtusa. The lining of the roof is in flat panels, and where it is supported by pillars they are invariably circular, and formed of the straight, finely-grained stem of the Retinospora obtusa. The projecting ends of the roof-beams under the eaves are either elaborately carved, lacquered in dull red, or covered with copper, as are the joints of the beams. Very few nails are used, the timbers being very beautifully joined by mortices and dovetails, other methods of junction being unknown.[153]

When Rudyard Kipling visited the Chion-in temple complex in Kyoto, a decade later, his description of the Shūedō, the one-thousand *tatami* assembly hall built in 1635, further elaborated on the construction of these buildings:

One roof covered it all, and saving for the tiles there was no stone in the structure; nothing but wood three hundred years old, as hard as iron. The pillars that upheld the roof were three feet, four feet, and five feet in diameter, and guiltless of any paint. They showed the natural grain of the wood till they were lost in the rich brown darkness far overhead. The crossbeams were of grained wood of great richness; cedar wood and camphor-wood and the hearts of gigantic pine had been put under requisition for the great work.[154]

The richness and scale of the Buddhist temples was only matched by the exactitude of the much smaller Shinto shrines. At Ise, where two sanctuaries, Gekū and Naikū, comprise the large Shinto site of Jingū, the architectural style, *yuiitsu shinmei zukuri* (the only godly style), represents the purest and simplest type of Shinto architecture. There the shrines are rebuilt every 20 years on an empty plot, *kodenchi*, adjacent to the existing building, which is itself then dismantled and its land prepared for rebuilding in another 20 years. It is a process of reincarnation which requires, as Dresser observed, that '... every plank and every post now to be found in their construction [is] of precisely the same shape, and of the same size, as those of the original structure which was erected nineteen centuries since'.[155] Thus the main sanctuary, the Goshōden,[156] although appearing fresh and new, actually dates, as Dresser put it, from 'the time of Rome's ancient greatness'.[157] The shrines, which adopt the form of a traditional rice storehouse, are built out of Japanese cypress (*hinoki*), unvarnished and unpainted, and thatched using miscanthus grass (*kaya*). The circular ridge-beam, which protrudes, is supported at either end by an inward-leaning post (*munamochibashira*) and capped by a number of billets (*katsuogi*) laid across it. At the ends the final pair of rafters are extended upwards as forked finials (*chigi*) [3.13]. In explaining the *katsuogi*, Dresser applies an argument similar to that used by Laugier to demonstrate the emergence of the Classical temple from the primitive hut:[158] '... the circular pieces of wood,' he wrote, 'which rest in a horizontal series on the cresting of each

roof, can be demonstrated to owe their origin to circular bundles of thatch, which were strapped over longitudinally placed reeds to form with them the cresting of the roof.'[159] Dresser further relates the roof construction to the form of Chinese architecture derived from tents or junks, where a sheet was thrown over a pole supported at its ends by crossed sticks, here represented by the *chigi*. Although he concedes that at Ise the ridge-pole does not consequently sag, a characteristic of Chinese buildings, the 'temples at Ise show the crossed supports in a marked manner'.[160]

Architecture and Engineering

Contrary to Alcock's assertion that Japanese have no architecture, Dresser not only argued that they did, but also sought to distinguish the difference between architecture and engineering:

> The Japanese have never been great engineers, but they have undoubtedly, been great architects. Architecture involves a knowledge of structure, but engineering does not necessarily involve any knowledge of the beautiful, as we so often discover to our dismay in England. A man may be able to construct an edifice so that it will stand securely, but he may be altogether unable to erect a beautiful building. No one could look upon either the great temples of Shiba or of Nikko without feeling that the architect of these glorious buildings understood perfectly the principles both of construction and of beauty.[161]

But in the Japanese house it was largely pragmatism which defined its form. As La Farge commented:

> If architecture represents the needs of living of a people, the differences that we see here will have the same reasonableness that other devices show elsewhere. The extreme heat, the sudden torrents of rain, will explain the far projecting and curved roofs, the galleries and verandas, the arrangements for opening or closing the sides of buildings by sliding screens, which allow an adjustment to the heat or the damp.[162]

The comprehension which Dresser, Morse and La Farge displayed in their books of the 1880s and 1890s was far greater than that shown by Alcock, Hawks and even Cornwallis 30 years earlier. In Europe and America, the recent enthusiasm for Japonisme had often resulted in what Morse called 'a mixture of incongruities that would have driven a Japanese decorator stark mad'.[163] It was therefore his intention that with his book 'much will be made clear that before was vague'.[164] But these more recent studies had another purpose. In Japan, Western architecture, either the work of the European *gaikokujin* or the *giyōfū* buildings of their Japanese imitators, was becoming desirable and the traditional Japanese way of building, as these Western commentators realised, was under threat. So, as well as informing the West about the principles of Japanese architecture, Dresser and Morse, in particular, provided an account of Japanese architecture which, 50 years later, offered a new generation of Japanologists an understanding of a fast-disappearing culture.

PART 2

MEIJI

4 THE JAPANESE PAVILIONS

Although Japanese products, especially craft-ware, had been exhibited widely and to large audiences in the exhibitions of the 1860s and 1870s, there was, even by the early 1880s – 30 years after Commodore Perry's arrival in Japan – little opportunity for the untravelled public to see and experience any form of Japanese building. Fashionable middle-class houses displayed lacquer-ware, cloisonné enamels and wood-block prints purchased from dealers such as Arthur Lasenby Liberty, whose warehouse for Japanese products had opened in London's Regent Street in 1875, or snapped up in the sales following the dissembling of the various international exhibitions. Art-architects such as William Burges, Edward William Godwin and even Philip Webb[1] designed furniture pieces or whole interiors with japanned-black woodwork and their friends, such as Dante Gabriel Rossetti[2] and James McNeill Whistler,[3] incorporated Japanese objects and imagery into their paintings. The attraction, in all these cases, was the exotic and this bore little relationship to how Japan was now developing and how it might have wished itself to be seen by the Western world. Where there was a hint of industrial or economic progress in the works put on display, it was regarded with disapproval or dismay by those who saw it. As the special correspondent for *The Times* wrote after attending the 1873 International Exhibition in Vienna, 'With the Japanese it is scarcely too much to say that all is original, beautiful, or quaint, for most

of the exceptions which prove the rule are instances in the very latest years, when they have taken to imitating Europe.'[4]

The fact that the correspondent found that there was 'little that is decidedly novel'[5] suggests, not only that by this date Japanese craft-ware was almost commonplace, but also that what the Japanese were providing for display reflected less their cultural or industrial aspirations than an attempt to satiate the West's ongoing curiosity. The dichotomy is perhaps no better shown than in their architecture, for while in Japan they were building new and Western-style buildings in brick and stone, it was wooden tea-houses, temples and bridges which the West wanted to see.

The presence of Japan as an increasingly significant contributor to the international exhibitions that occurred between 1851 and 1893 and beyond, shows how seriously the Japanese government took them. In 1866, Fukuzawa Yukichi, who had been a member of the delegation which had visited the 1862 International Exhibition in London, published the first part of his 10-volume study of 'Things Western', *Seiyō Jijō*. Here he advocated the concept of the international exhibition, explaining that 'every couple of years in the metropolises of the West they hold a gathering of products. They announce it throughout the world, and each country makes a collection of its special products, useful machines, antiques, and curiosities,

and exhibits them to the people of all nations.'[6] It was soon realised that through such exhibitions Japan could not only achieve international status, but also gain access to the industry and armaments which it badly needed, as well as reaching new export markets which, in turn, would stimulate the domestic economy. Yet it was a paradox that, while Japan tried to modernise, it was the romantic notion of the traditional, hand-crafted work which, at these exhibitions, attracted the West. In the *Official Catalogue of the Japanese Section* of the 1876 Centennial Exhibition in Philadelphia, it was stated that 'The Japanese artisan is still very much like those of mediaeval Europe ...'[7] Whereas this might be what the visitors to the Japanese exhibits wanted to know, it was not altogether how things were, for the increasingly great demand which the exhibitions made for Japanese wares could not have been met without some sort of 'industrialisation', albeit non-mechanical, of the manufacturing process.[8]

The Paris Exhibition, 1867

The first European exhibition which the Japanese attended in an official capacity, thus indicating the *bakufu*'s recognition of the international exhibitions as an important form of statecraft, was the 1867 Exposition Universelle in Paris. This recognition is reflected in what *The Times* correspondent wrote regarding the appearance, some years later, of China at the 1873 Vienna Exhibition. The correspondent regarded this 'as a good omen for the future, and as indicating a disposition to enlist herself on a footing of equality in the ranks of the international comity ... It is by the humanising effects of commerce, and by the friendly intermixture of international courtesies, rather than by gunboats and missionaries, that this result is to be obtained.'[9] At Paris in 1867, not one but three Japanese exhibits were presented, suggesting the confusion and political instability of the time.[10] From Honshu, and ostensibly representing Japan as a whole, came the *bakufu* or Tokugawa *Shogun* contingent; and from Kyushu came independent

parties from both the Satsuma *daimyo* and the Hizen *daimyo*, each with their own secret political agenda.[11] There was much confusion, in Paris, as to who represented what, and when Eugene Rimmel, as Assistant Commissioner to the Exhibition, wrote in his *Recollections of the Paris Exposition of 1867* that 'The Tycoon and the Governments of Satsuma and of Fizen [*sic*] have cooperated in forming a very curious exhibition',[12] curious it might have been but cooperative it was not. While the *bakufu* claimed to represent Japan, the Satsuma initially promoted themselves, to the *bakufu*'s great annoyance, as the Embassy of the King of Ryukyu, thus suggesting that Satsuma was an independent state. It was a prescient move for by the time that the *bakufu* party, led by the *Shogun*'s 14-year-old half-brother, Tokugawa Akitake, had returned to Japan in December 1868, the *Shogun* had been overthrown and the Meiji Emperor installed.

The Exposition Universelle was held on the south bank of the Seine on the Champ de Mars, opposite the Pont d'Iena, and ran from 1 May until 30 September.[13] It was accommodated in a vast oval-shaped building comprising a series of concentric, cast-iron and glass galleries set around a central garden. In the grounds beyond stood almost 100 pavilions, amongst which were the first two Japanese buildings to be built in the West – the *bakufu* pavilion, which was, in fact, designed by the French architect Louis Étienne Alfred Chapon, and the Satsuma pavilion, whose origin is uncertain [4.01 and 4.02]. No matter what visitors to the exhibition might have expected, they cannot have helped but being struck by the simplicity and apparently rustic, if not *paysanne*, nature of these buildings. But such recognition would have simply reflected a European point of reference and resulted in a misreading of this (supposedly) foreign architecture. The art critic and collector Philippe Burty, writing in the *Gazette des Beaux-Arts* soon after the exhibition closed, tried to explain these buildings:

I do not think that Japanese homes, except the ancient temples, differ greatly from what has been built here so beautifully in pine and poplar wood. Those of the great nobles are

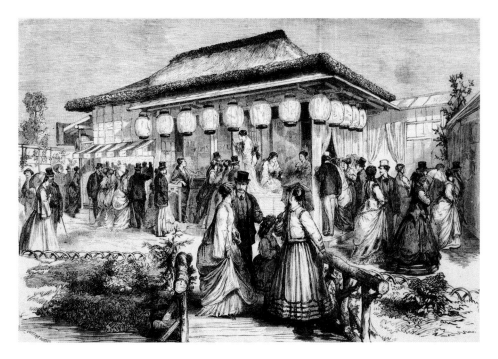

4.01 The Japanese or *bakufu* pavilion at the 1867 Exposition Universelle in Paris, designed by Louis Étienne Alfred Chapon, from *Le Monde illustré*, 31 August 1867.

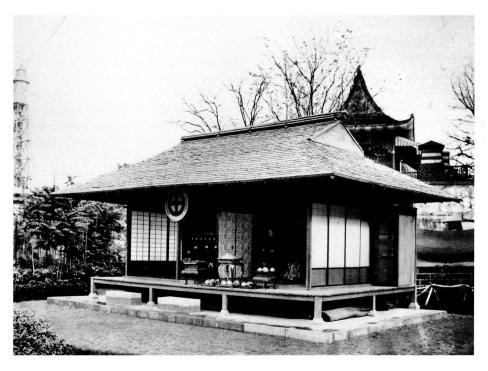

4.02 The Satsuma pavilion at the 1867 Exposition Universelle in Paris.

no different in size to the homes of the poor people. In the Orient, even the palaces are the same, agglomerations of houses separated by courtyards and gardens, rather than large buildings. In this feudal country, the inside of the house is composed only of large, divided rooms, according to the position of the folding screens or the light partitions which slide in grooves.[14]

Burty, however, had never been to Japan so his explanation was, as it were, second-hand.

Although the *bakufu* pavilion was referred to in François Ducuing's serial description of the buildings and exhibits, *L'Exposition Universelle de 1867*, as *une ferme japonaise*,[15] its function if not appearance was that of a tea-house. Surrounded by a wooden fence and bedecked with paper lanterns, the heavily thatched building was raised off the ground and divided into two rooms. In the second room was 'le café' and here, where tea was served by *geisha*, was another world. As *L'Exposition Universelle de 1867* commented, 'On entre, et voilà la France à trois mille lieues, on est en plain Japon.'[16]

Separated from the *bakufu* pavilion by the Chinese enclosure, the Satsuma pavilion was identified by the characteristic Satsuma crest, the *maru-juu* (cross in a circle), hanging at the entrance.[17] It was, once again, an open-fronted structure with *shōji* and *fusuma* beneath a heavy tiled roof. Dwarfed, perhaps, by the elaborate two-storey Chinese pavilion, neither Japanese pavilion caused much architectural interest. A correspondent for the *Pall Mall Gazette* described them as 'a couple of pretty-looking toy structures in the park – the first a sort of summer-house, not unlike a big sandal-wood cabinet, erected by the Daimio Satsuma, one of the few hundred foreign princes who have come to Paris for a holiday; the other a genuine Japanese tea pavilion, situated within a little enclosure which you have to pay five sous to enter'.[18] 'The tea-house is built of bamboo and some choice white wood …' the correspondent continues, before being diverted by the tiny cups of tea sweetened with sugar-plums and the Japanese elegants in Parisian *haute couture* whom he found there.

The Vienna Exhibition, 1873

The race to modernise in Japan was dependent, in many ways, upon the country being seen as a modern place. In the *Official Catalogue of the Japanese Section* of the 1876 Centennial Exhibition in Philadelphia, it was to be admitted that 'The Japanese artisan is still very much like those of mediaeval Europe …'[19] So, if the West's perception of Japan as a romantic throw-back to the middle ages persisted, then it would be more difficult for Japan to be taken seriously as a modern power and the trade and investment for which they were looking might not be as easily forthcoming. The Japanese ambassadors who has visited the International Exhibition in London in 1862 had been largely unimpressed with what had been assembled under their country's name, regarding the displays more as one might a museum than an international sales drive. But following the enthusiasm which this, and more particularly the Paris exhibition, had generated for Japanese products, it was realised that investment in foreign exhibitions was one way of bringing in the foreign currency necessary to develop the industry and purchase the armaments which the country so badly needed. Consequently, the *Hakurankai jimukyoku* or Exhibition Bureau was established in the Home Ministry in 1872, and Japan soon embarked upon a series of international exhibitions, starting in Vienna in the following year.

The International Exhibition in Vienna in 1873 was the first exhibition in which the Meiji government participated and in this they invested 508,000 Yen.[20] By the time it opened on 1 May, the Boshin war was over and the Meiji government could be more outward-looking. Furthermore, the benefit of these exhibitions was now being accepted: already, in 1871, there had been an exhibition in Kyoto of Japanese and Chinese products which had consciously sought to follow the example of the exhibitions in the West.[21] When the Iwakura Embassy visited the Vienna exhibition that June,[22] Kume Kunitake could confidently say:

The exhibits of our own Japan at the exhibition won particular acclaim from visitors. One reason

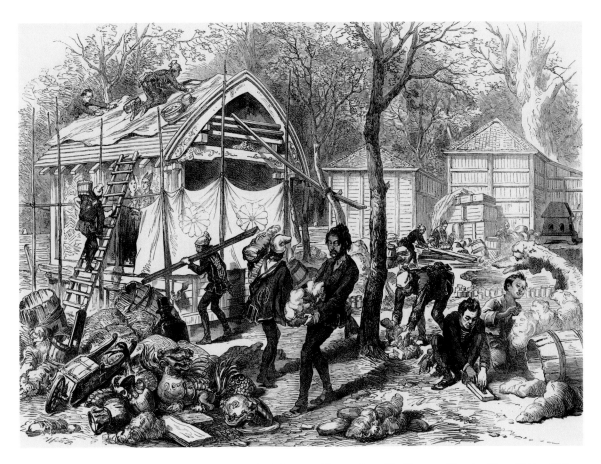

4.03 The Japanese Temple at the 1873 International Exhibition in Vienna, from *The Illustrated London News*, 10 May 1873.

was that the Japanese exhibits were different from European ones in design and taste, so that to European eyes they had the charm of exoticism. A second reason was that there were few notable exhibits from countries neighbouring Japan. A third reason was the growing admiration for Japan among Europeans in recent years ...[23]

In early May *The Illustrated London News* had shown a picture of Japanese workmen in Vienna busy building what was described as a Japanese village [4.03].[24] Yet the village from which, as *The Times* said, a paper fish-flag flew 'all this stormy May',[25] was, in fact, a relatively modest collection of buildings. It comprised, according to Kume,

a reproduction of a Shinto shrine, a Japanese garden, complete with pond, a stone bridge and stone lanterns, and, at the front of the Japanese garden, what he referred to as 'a long building of Japanese cedar wood, with a roof in the style of the ancient capital'.[26] Kume illustrated the Japanese village in his account of the Iwakura Embassy but, set in the shadow of the massive Moorish palace of the Egyptian exhibit, it appears all rather underwhelming.

Nevertheless, the cedar building, which was used as a shop to sell Japanese souvenirs, caused considerable interest. 'Even the Austrian Emperor,' Kume wrote, 'lauded the skilled craftsmanship of the Japanese carpenters. This was the first time Japanese

cedar wood had been seen in Europe and all praised it for its fragrance. Many people asked for cedar wood shavings to take home with them … Those who entered this shop but left without buying something felt as if they had missed the opportunity to acquire a valuable rarity. Crowds jostled to get in.'[27]

The site, which was trapezoidal and surrounded by a paling fence, was entered through a *torii* at one end, leading to a central avenue flanked by two long buildings, both, presumably, of Japanese cedar wood. These were shops or kiosks[28] and were separated from the central avenue by small, rectangular gardens. At the far end of the avenue, and a little distance beyond the end of the long buildings, the visitor entered the Japanese garden where the stone bridge rose over the pond and led to the Shinto shrine. A small Buddhist temple was set to one side.

The Shinto shrine was built in the *Shinmei* style as found at Ise, a *hirairi* (or side-entered) building raised off the ground with *katsuogi* or roof billets along the ridge and, at the gable ends, *chigi* or forked finials extending the barge-boards into the air. The Buddhist temple, shown under construction by *The Illustrated London News*, was a *tsumairi* (or end-entered) building with a gently curved roof surmounted by an ornate finial. Its Buddhist allegiance was signified by the ornate 'rainbow beam' stretching across the front as a tie beam with columns and brackets at each end.[29] Above this, the roof curved to form a pointed arch which was finished off with ornamental bargeboards. In *The Illustrated London News* drawing, the roof is still under construction but the convex curve suggests that it is to be thatched: were it to be tiled, then its profile would more likely be straight or convex. An awning, decorated with the Imperial chrysanthemum, is shown shielding the building, being still incomplete, and carved dragons, vases and other decorations lie in the foreground.

Meanwhile in London Christopher Dresser had, in 1873, set up the Alexandra Palace Company[30] and, following the closing of the Vienna exhibition, had arranged for the Japanese village to be transported to England. Here it was erected to

an almost identical layout in the grounds of the Alexandra Palace, the north London behemoth built on Muswell Hill for the public's enjoyment. The Alexandra Palace had opened on 24 May 1873 but was burnt out 16 days later. The building was rebuilt and opened a second time on 1 May 1875 and it is likely that the inclusion of the Japanese village in the Palace's grounds was seen as a way of reinvigorating the public attraction. In a contemporaneous lithograph, the Shinto shrine, shown on the left, is easily recognisable although the eaves line, when compared to Kume's illustration, can be seen to have been altered; in the centre is the Buddhist temple, previously shown by *The Illustrated London News* under construction in Vienna [4.04]. Now that the awnings are removed, it can be seen to be an ornamented raised structure, somewhat in the manner of the Buddhist temples at Nikkō. To the right is the bazaar, the long cedar building of Kume's description. In his history of *Old and New London* (1878), Edward Walford identifies these buildings as a temple and a residence, although the latter is more likely to be the Shinto shrine. 'In the bazaar,' Walford says, 'articles of Japanese work were offered for sale.'[31] Dresser had established a Japanese company, *Kiritsu Kōshō Gaisha*, to supply souvenirs and this was presumably their outlet. Thus, the first authentic Japanese buildings appeared in Britain but, not without irony, their fate was that of many such buildings in Japan: the Japanese village burnt down in 1897.

Following his visit to Japan in 1876–77, Dresser became an even keener promoter of things Japanese. Soon after his return he arranged displays of Japanese interiors built from wall and ceiling panels sent over from Japan. The first was assembled in 1877 by the fashionable London cabinet-makers Jackson and Graham,[32] and the second, in 1878, by Edwin William Streeter,[33] a leading New Bond Street jeweller.[34] These were, on Dresser's part, as much commercial as cultural ventures. Dresser designed furniture for Jackson and Graham, who had showrooms on Oxford Street, and was probably instrumental in helping Streeter establish connections with Japan. As *The Times* noted:

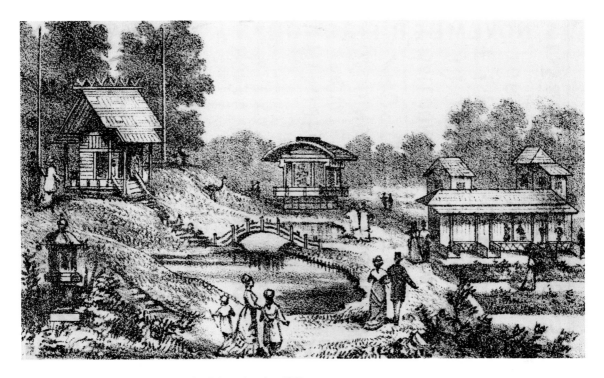

4.04 The Japanese village at Alexandra Palace, London, 1875.

Mr Streeter, with the same enterprise that induced him to send a party of explorers to the diamond fields of South Africa, has engaged a regular staff of artisans in Japan, many of whom had been sword makers thrown out of employment in consequence of the law prohibiting the making of swords in private workshops since the occurrence of the great rebellion.[35]

Streeter's New Bond Street interior was referred to by *The Times* as a 'Japanese nobleman's room' and the newspaper reported that it was made for Dresser, 'according to the highest style and fashion of Japanese aristocracy' under the direction of the Governor of Kyoto's Master of Ceremonies.[36] The room was small, about 13 feet square and 8 feet high (approximately 4 metre square and 2.5 metre high) and was compared in size to a 'mere boudoir' in a Western home. *The Times* remarked on the 'peculiar neatness and finish in the joinery'

and the 'through cut tracery of flowers, birds, or geometrical ornament' which decorated the walls and ceilings.[37] But it was of the assembly process that the correspondent spoke most eagerly:

> What is so remarkable in the construction of this, as of all other rooms and houses in Japan, is that not a single nail, screw, or bolt is used, the whole being fitted together by accurately cut mortice joints, enclosing panels which slide with perfect ease and fit closely, forming doors and windows where required.[38]

The enthusiasm shown here over the construction of the Japanese house indicates the novelty of the process whereas the general appearance of the Japanese interior, barely commented upon in the article, must by then have been so familiar from its representation and interpretation in art that it was no longer newsworthy. The article opined that 'there

cannot be a question as to the superiority of the work over all European carpentry' but questioned, presciently, 'whether such strong originality and character will not give way to the desire to follow European models, and to show themselves as direct competitors in the markets of the world'.[39] But by 1878, that process was already in train.

Following the success of the Vienna exhibition and the good reports of the Iwakura Embassy, the discriminating Meiji government accepted the invitation, proffered through Sir Harry Parkes, the British Minister in Tokyo, to participate in the Intercolonial Exhibition in Melbourne, Australia, in 1875. Although Japan was obviously not a European colony, the new Exhibition Bureau saw it as a good opportunity to test the waters in anticipation of the forthcoming Centennial Exhibition in Philadelphia the following year. The intent was more commercial than cultural but nevertheless was well received by the Australians: 'That the young colony of Victoria should be recognised by the ruler of one of the oldest empires of the world is a fact upon which we cannot congratulate ourselves too much.'[40]

The Philadelphia Exhibition, 1876

The Centennial International Exhibition which opened in Philadelphia on 10 May 1876 inevitably drew comparisons with the earlier exhibitions at Paris and Vienna, such as this from *The Boston Daily Advertiser*:

> The general arrangement of the exhibition is more convenient than that of Vienna and less so than at Paris ... If the exhibition lacks anything it is not wanting in national character – that is, American character. But it is decidedly wanting in foreign elements. Not inside the Main hall ... but in the various establishments outside, showing the architecture, the style of living, the customs of the different people who have taken enough interest in the exhibition to send a representation. The Japanese house, the

Swedish schoolhouse and the Turkish café, all as yet incomplete, are the only distinctly foreign buildings that have yet met my notice.[41]

In addition to Japan, only 12 countries built pavilions in the exhibition grounds and, as at Vienna, Japan built two.[42] The decision by Japan to participate in the exhibition had been taken in 1874 and extensive preparations had been made in Tokyo, under an Imperial Commission, to meet the demands.[43] Goods to the estimated value of $200,000 were dispatched to Philadelphia, the government covering the cost of transport as well as providing a further $300,000 for general expenses.[44]

Although some commentators, such as *The Daily Rocky Mountain News*, expressed a stereotypical view of the foreigners' efforts – 'China and Japan contend with each other in striving to present the best specimen of bamboo architecture ...'[45] – others were more informed in their observation. Although they headlined their report 'Oriental Toy Men', *The Milwaukee Daily Sentinel* could not help but be impressed by the Japanese contribution:

> The Japs had come so far to the Exhibition, says the Philadelphia Times, that they determined to get their oar in pretty deep when they reached it. So they set up their roof-heavy dwelling at the foot of St George's Hill, covered more than a rood of the floor of the Main Building with bronzes, and started a bazaar on the edge of Lansdowne valley.[46]

The first Japanese building to be opened, the 'roof-heavy dwelling', was the Commission Building, also referred to as the Japanese dwelling. 'The building is now nearly completed,' reported *Frank Leslie's Illustrated Newspaper* on 1 April, 'and causes astonishment at its beauty and elegance of finish. It is regarded as the finest piece of carpenter-woodwork ever seen in this country. The wood of which it is built is most beautifully grained, and as smooth as satin. Every portion of the building is most carefully fitted together, and the carving is truly wonderful. Some of our more progressive mechanics are inclined to ridicule the leisurely

manner in which the Japanese workmen labored, but they find that if the work was done slowly, it was done remarkably well.'[47]

Frank Leslie's illustration shows a two-storey, timber-frame building set under a hipped roof. The ground floor is enclosed by lattice screens while the upper floor has sliding shutters or *amado* (rain doors) which could be drawn back into *to-bukuro* (shutter boxes). The building was U-shaped on plan and entered through a timber portico with an ornamented, pitched roof. In Leslie's illustration the *amado* are withdrawn almost completely to open up a whole section of the upper floor, as would be common in Japanese houses. Another illustration, this one from James D. McCabe's *The Illustrated History of the Centennial Exhibition* (1876), shows the *amado* withdrawn in regular sections as if to replicate window openings. This has the effect of normalising the elevation into one of a solid wall punctured by windows which, for most observers, is what they would have expected [4.05]. After all, as the *Centennial Portfolio* noted, this building had, 'during its erection, created more curiosity and attracted infinitely more visitors than any other building on the grounds'.[48] Yet this building would have appeared equally alien to many Japanese observers, for it is without doubt a demonstration of *giyōfū* architecture. Traditional Japanese buildings, as Engelbert Kaemfer had observed 150 years earlier, were single-storey structures. 'Even the palaces of the *Dairi*,' he wrote, 'or Ecclesiastical hereditary Emperor, those of the Secular Monarch, and of all the princes and lords of the Empire, are not above one story high ... The reason of their building their houses so very low, is the frequency of earthquakes this country is subject to, and which prove much more fatal to lofty and massy buildings of stone, than to low and small houses of wood.'[49] Two-storey buildings, not unlike this, did exist at Dejima, but they had been erected under the Dutch influence. In extending it to two storeys, the craftsmen who had made this building were imitating Western architecture. However, the positioning of the portico off-centre suggests that the formality implied by the exterior was not carried through to the inside: such was the nature of *giyōfū* architecture.

The construction of the Commission Building never ceased to amaze. *The Georgia Weekly Telegraph and Georgia Journal and Messenger* had reported that 'everything – even the timbers and the nails – was brought from Japan and Japanese workmen were brought over for the express purpose of unpacking and placing the goods'.[50] *The American Architect and Building News*, which began publication in that centennial year, gave a more accurate account, writing that 'In the bamboo building not a nail will be used; all the material is there, dovetailed, bevelled, and mortised, ready to be fastened together with wooden pins.'[51] In February, it reprinted the *Philadelphia Times*'s description of the pile-driving operation:

> The most curious part of the day's work was the driving of a number of piles, each six feet long and ten inches in diameter, upon which is to rest, like a corn-crib, a rectangular structure eighty-four by forty-four feet, and in general appearance like the pictures of Japanese houses that children see in their primers. The way in which the Japs managed the pile-driving brought many a burst of laughter from the bystanders. They had a portable tripod about twenty feet high, with two fixed pulleys under the apex, from which was suspended by a grass rope a cylindrical iron hammer weighing three hundred pounds. Six Japs on each side of the machine seize a grass rope which passes over one of the pulleys; the foreman stands at one side, holds up his forefinger, closes one eye, and then, apparently not satisfied with this, picks up a short stick, holds it in a vertical position between his two fingers, sights the pile with it, and at last winks with both eyes as a signal to the workman that the ceremony of Japanese plumb-bobbing is concluded; whereupon the hammer moves up and down very rapidly, driving the pile an inch into the earth at every descent, until it is time for the foreman to do a little more plumb-bobbing.[52]

Seven weeks later it could report that 'The Japanese are giving the finishing touches to a most

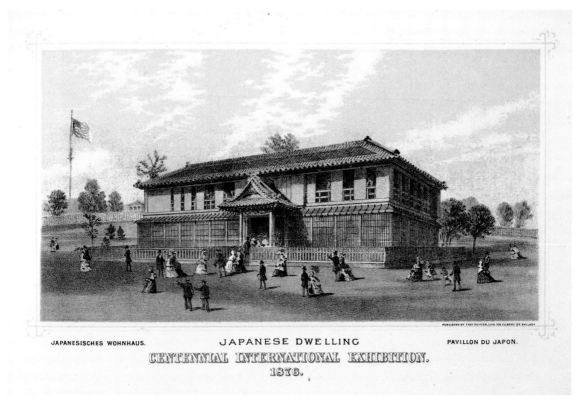

JAPANESISCHES WOHNHAUS. JAPANESE DWELLING PAVILLON DU JAPON.

CENTENNIAL INTERNATIONAL EXHIBITION.
1876.

4.05 The 'Japanese Dwelling' at the 1876 Centennial Exhibition in Philadelphia,
from James D. McCabe, *The Illustrated History of the Centennial Exhibition*, 1876.

extraordinary structure. It is a two-story house, built mainly of cedar, and without a nail or pane of glass in it ... The roof is as innocent of nails as the lower part of the building.'[53] The whole building process, as well as the builders themselves, had been of great puzzlement. There seemed to be nothing about it that was familiar or conventional. 'The Japs draw their planes towards them, instead of pushing them from them,'[54] *The American Architect and Building News* observed, 'and use an ink line instead of a chalk line.' Nor would the officials in charge of the building explain what they were doing: 'Wait till comes time; you then see',[55] being the standard answer. What transpired was what *The Centennial Portfolio* thought 'the best-built structure on Centennial grounds ... as nicely put together as a piece of cabinet work'.[56]

Visitors to the exhibition would have gleaned little about the architecture of the country from the *Official Catalogue of the Japanese Section*. The 90 pages of descriptive notes which ran from Mining and Metallurgy to Silkworm Breeding quite side-stepped Architecture, discussing, under Civil Engineering and Architecture, only hydraulic drainage and ancient aqueducts.[57] Class 102, dealing with Building Stones, commented that 'Although building stones are by no means scarce, yet they have been seldom used for houses, but mostly for foundations ...'[58] As if to contradict Kaempfer's earlier explanation, it asserted that 'the frequency of earthquakes was not the reason for making wooden constructions, but that it was in consequence of the wood being cheap and abundant, and besides more easy to work

JAPANESISCHER BAZAAR. BAZAAR JAPONÉS. JAPONAIS BAZAAR.

JAPANESE BAZAAR.

4.06 The 'Japanese Bazaar' at the 1876 Centennial Exhibition in Philadelphia,
from James D. McCabe, *The Illustrated History of the Centennial Exhibition*, 1876.

and to transport, that preference was given to this building material'. Citing Thomas Waters's Bricktown in Tokyo's Ginza district, then almost complete, the *Catalogue* concluded: 'There is now in Tokio a whole quarter of the town where the houses are built of brick, and stone warehouses can be seen at all the open ports in great number.'[59] Water's Bricktown was to be largely destroyed in the 1923 Great Kantō Earthquake.

Compared with the Commission Building, the Japanese bazaar, located on the edge of Lansdowne valley, was a more traditional affair [4.06]. It opened on 22 June, and, even a month later, *The Milwaukee Daily Sentinel* wrote that its wooden walls and earthen tiles still 'closely resemble the dwelling in construction'.[60] The Chicago newspaper, *The Inter Ocean*, was as non-plussed about the bazaar:

The Japanese Bazaar. a low, odd-looking structure, composed of carved wood and a roof of thick, corrugated earthen tiles, was opened yesterday and was thronged all day. The side where the salesmen stand is open, so, if you want to purchase any antique bronzes, any wood and ivory carved trinkets, or any specimens of the ceramic art, you have no doors to open or close; you step up, make your purchase, and your change, and – room for forty others. Around the building you get an idea, in miniature, of Japanese landscape gardening, and if you have an eye for the beautiful, you will not hurry away.[61]

The novelty and misrepresentation of Japan can be judged as much through the misreading of its national flag[62] as through its exhibits and its

architecture. Like *The Milwaukee Daily Sentinel*, which wrote of the 'Bazaar of the Red Moon',[63] *The Georgia Weekly Telegraph and Georgia Journal and Messenger* observed that 'one on finding himself in the Japanese department is somehow infected with the atmosphere of his surroundings, and has no difficulty in imagining himself to be verily in the beautiful Land of the Moon; for the Japanese section is in every sense of the word thoroughly Japanese.'[64]

The Paris Exhibition, 1878

The third Exposition Universelle to be held in Paris[65] opened on 1 May 1878 and ran through to 10 November. It was located on the site of the 1867 Exposition, the Champ de Mars, but this time

was much more extensive, bridging out across the Seine to where the Trocadéro now stands. With a government investment of 213,000 Yen, Japan provided two buildings, a pavilion in the rue des Nations on the Champ de Mars site, and a farmhouse across the river in the Trocadéro gardens. The rue des Nations was, as its name suggests, a series of pavilions each in a national style, the cumulative effect of which must have been slightly indigestible. The Japanese pavilion, located between those of Victor Emmanuel's Italy and Qing dynasty China, showed up what the art critic Charles Blanc, quoted in *L'Art*, thought 'was insignificant about the first and bizarre about the second' [4.07].[66] For the French architect and theorist, Paul Sédille, writing in the *Gazette des Beaux-Arts*, the Japanese pavilion was one of the successes of the rue des Nations. 'How much,' he wrote, 'we are sensible to the naïve

4.07 The 'Entrance to the Japanese Section (Street of Nations)', at the 1878 Exposition Universelle in Paris, from *The Illustrated Paris Universal Exhibition*, 20 July 1878.

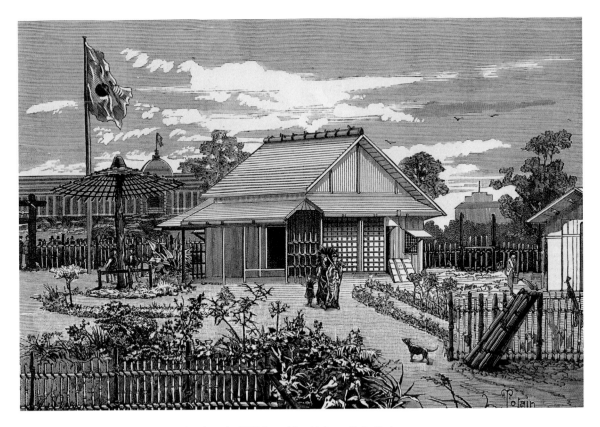

4.08 The 'Japanese Garden – Trocadéro', at the 1878 Exposition Universelle in Paris, from *The Illustrated Paris Universal Exhibition*, 21 May 1878.

and wholesome art of the Japanese!'[67] Framed in heavy timbers, the pavilion offered a symmetrical, windowless elevation to the street. It was entered on axis beneath a slightly curved, pitch-roofed canopy which projected forwards towards two advancing timber screen walls which flanked the entrance. The exposed ends of these heavy timbers were capped with covers of green bronze, and green bronze shoes protected them from the ground. The plastered panels to either side of the canopy were painted with maps of Tokyo and of Japan, and the frieze, beneath an overhanging eaves-line, was decorated with the Imperial chrysanthemum. Once again, all the parts had been brought from Japan and assembled on site. Blanc praised the construction of the Japanese doorway, enthusing on how 'the carpentry-work is presented in its nakedness, thick, solid and dense;

one feels its strength and its smoothness, one considers its veins'.[68] He referred to the Japanese as 'des hommes de goût'[69] and observed how much the pavilion was remarked upon. 'Never,' he wrote, 'has this truth – that architecture is essentially a relative art – been more evident, or more clearly expressed.'[70]

On the other side of the Seine, in front of the curving arms of the Salles des Fêtes and set in a small garden, was the Japanese farmhouse [4.08]. Located just off the main axis which crossed the river at the Pont d'Iena, and next to the Swedish, Tunisian and Moroccan pavilions, it was a more modest affair than its counterpart on the Champ de Mars – a pitched-roof, lightweight structure supported on thin, timber columns, with a lean-to roof across the gable end. Sédille was immediately taken by the whole scene:

The Japanese small-holding, with its gate, its fences, its tiny flower-beds, its slender plants, its bamboo house, and all the unexpectedness of an exquisite art, discreet, refined, original and always different, is one of the wonders of the Exhibition.[71]

In contrast to the apparent fragility of the farmhouse, the gate to which Sédille refers was a robust affair of carved woodwork decorated with flowers and a cockerel and hen pair. It was here, as he observed, that the visitor would be offered 'vases, bronzes, fabrics or those thousand whimsical, useless nothings or children's toys, by which the Japanese can do such wonders for the mind and taste ...'[72] Although referred to in contemporaneous literature as a farm, it is as likely that this building might be seen, by the Japanese, as a merchant's house. Its lowly status, as well as the products on offer, would suggest it. If so, then this is significant. For, as has been noted, the merchant class were traditionally regarded as quite inferior to the *samurai* class but now, a decade after the ousting of the *Shogun* and with a government which sought to promote trade, attitudes were changing. As at Philadelphia, commerce was beginning to precede culture. Nevertheless, this building was traditional and was what anyone looking to buy some Japanese lacquered woodwork, decorated pottery or cloisonné ware might have expected.

The International Health Exhibition, London, 1884

Following the success of the 1878 Paris Exposition Universelle, Japan's enthusiasm for international exhibitions grew. In 1879 private funding allowed the country to participate in the international exhibitions in Sydney and, the following year, in Melbourne, the ulterior motive, no doubt, being to establish trade links with Australia.[73] Two fishery exhibitions, one in Berlin in 1880 and another in London in 1883, drew government funding, as did a horticultural exhibition in St Petersburg, a

forestry exhibition in Edinburgh, and an industrial exhibition in New Orleans, all in 1884.[74] Thus, it was probably due to a feeling of over-commitment that the Japanese government's decision to participate in the 1884 International Health Exhibition in London was made only in February of that year.[75] Nevertheless, they invested 24,000 Yen in the exhibition, which opened at the Horticultural Society's gardens in South Kensington, London, on 8 May. The exhibition, which dealt with themes such as food, smoke-abatement, heating and ventilation, as well as sanitary and unsanitary houses, was hugely popular. As part of what was intended to be a comparative and cautionary exercise, visitors were treated to a historic recreation of the Bishopsgate area of medieval London, the combination of recreated environments and the provision of refreshments then, as now, drawing in the crowds.[76] Again it was *The Times* which reported, towards the end of August, that 'a prettily fitted-up Japanese tea-house may be found in the small open garden by the fountain outside the water companies' octagonal anexe, and in a few days a Japanese restaurant will be opened in the upper galleries of the eastern arcade. Two Japanese cooks have accompanied the Commissioners, and here the visitor will be able to make the acquaintance of some of the dishes which find a place on the *menus* of these Parisians of the East.'[77] When the restaurant, where 'the visitor who wishes to experiment with the viands and cookery of the East may learn how he would fare in the eating-houses of Tokio [*sic*]',[78] eventually opened on the roof of Francis Fowke's great arcade which edged the Horticultural Society's gardens, *The Times* provided no description of it other than it was 'light and airy'.[79] Yet that is possibly enough to confirm its Japanese appearance.

As a result of Japan's late decision to participate, the Japanese exhibits were distributed rather haphazardly throughout the exhibition. In common with previous international exhibitions, a number of the exhibits promoted the familiar and desirable qualities of traditional Japanese culture. 'Court dresses of ancient and modern times, [and] other national costumes which have so far survived in the struggle against European fashion'

were noted with reassurance by *The Times*, as was 'a panel or tray decorated with wonderfully inlaid ivory figures [which] proves that the traditions and spirits of ancient art in Japan have not yet been lost'.[80] But often the exhibits were more didactic in their intent. 'The exhibits of the Education Department,' *The Times* reported, 'are interesting in many respects, and especially as showing the surprising readiness with which the Japanese have adopted Western ideas of education and methods of instruction. It is only 12 or 13 years since a department of education was created, and now with a population, which by the census of 1882 was just over 37,000,000, there are nearly 20,000 primary schools in the country supported by local rates, and children of school age (from six to 14 years) are, it is said, almost invariably sent to school.'[81] As an educational programme this surely rivalled, if not eclipsed, that set up in England following the almost coincidental 1870 Education Act.[82]

As well as 'models of dwellings ... shops, farmhouses, tenement houses, and a public bathhouse, with its great tubs, in which eight or ten men take a warm bath together at a time', *The Times* continued, 'specimens of building materials are shown, including slate-coloured tiles, hard as ironstone, apparently, of a kind made in Japan for 2,000 years or more; thin fir wood shingles for covering the roof below the coating of clay on which the tiles are set; cedar bark shingles for covering the framework of a building which is to be made proof against conflagrations by enclosing it in casing walls of fire-clay ...'[83] Anyone who had read Christopher Dresser's recent book, *Japan: Its Architecture, Art, and Art Manufactures*, would have known of the risk of fire in Japanese buildings. Four days after arriving in the country Dresser's own hotel in Yokohama caught fire and he put it out, he says, almost single-handedly. 'Not one visitor in the hotel,' he recalled, 'whether English, American, German, or French, offered any help, while a great gaping lubber, whom I afterwards found to be the proprietor of the hotel, stood calmly looking on ... I was informed,' he added, 'that our landlord considered it no part of my duty to put out fires on his premises, and that he was well insured.'[84]

To many visitors to South Kensington, some of the exhibits must have appeared curious: 'The Japanese War Department have sent a field ambulance and its fittings, among which the ever-useful bamboo figures in several ways', *The Times* reported, and there were 'the appliances of a Japanese lady's toilet table – powder puffs, black dye for the teeth (now used only by some ladies of the old style), scissors made on the pattern of wool shears, locks of false hair, and razors, employed, it is explained, to shave off the short hairs of the back of the neck'.[85] Others indicated a different way of living: 'A little curved metal-box may excite curiosity,' *The Times* reported. 'It is a hand-warmer, which when filled with heated ashes of oyster or other shells will keep the fingers warm in the pocket for many hours.'[86] And there was also a *hibachi*, 'a large ornamental iron bowl ... filled with hot ashes upon which a small charcoal fire burns for the guest to warm his hands at'.[87] Such comforts were necessary, for the Japanese house offered little protection against the cold winters. The Japanese 'out-of-door life',[88] upon which Dresser had commented in his book, might have been seen to reflect the ulterior aspirations of the exhibition. In a paper on 'the International Health Exhibition of 1884: Its Influences and Possible Sequels' presented to the Royal Society of Arts that November, Ernest Hart, the Chairman of the National Health Society,[89] opined:

It is often said by the public scorner (a person from whose judgements and criticisms we have commonly much to learn), when walking through the crowded course of the exhibition devoted to food, and all that concerns the construction and decoration of a dwelling, 'This is a Health Exhibition – where is the Health?' and the popular answer was, 'Outside in the gardens.' That answer also I accept. I think you will agree with me that the practical demonstration which the Exhibition afforded of the eagerness of the English people to resort to healthful means of outdoor amusement was in itself a valuable result, and an important experience.[90]

The Japanese Native Village, London, 1885

A little over half a mile (about one kilometre) to the east of the Horticultural Gardens stood another well-known Victorian exhibition building, Humphreys's Hall. Located on the south side of Knightsbridge, opposite Albert Gate, Humphreys's Hall was the business of James Charlton Humphreys, a manufacturer of iron buildings, who hosted the Food Exhibition in 1882 and the Medical and Pharmaceutical and the Bread Reform Exhibitions in 1884.[91] In 1885 Humphreys's Hall became the home of the Japanese Native Village.

The village was the idea of Tannaker Bellingham Nevell Buhicrosan, a Japan merchant from Lewisham, with business premises in Finsbury, London.[92] In December 1883 Buhicrosan, together with some associates, had set up The Japanese Native Village Exhibition and Trading Company and although he took an annual salary of £1,000, Buhicrosan declared that he would donate the profits of the exhibition, which opened a year later, to his wife Otakesan, a Christian Japanese from Kyushu, who wished to set up a mission to improve the social position of women in Japan.[93]

The exhibition, which was opened by Sir Rutherford Alcock on 10 January 1885, offered a greater range and number of Japanese buildings than had ever been seen in the West. The buildings, which included an ornamented Buddhist temple and tea-houses, were built using authentic Japanese materials and building processes by Japanese workmen whom Buhicrosan had brought over from Japan. *The Times* reported the exhibition enthusiastically:

> On entering the hall the visitor finds himself in a broad street, as it were, of shops and houses, from which rows of smaller shops, forming narrow lanes, are laid out to the right. These are not mere painted fronts but well-built apartments of varied appearance, each with its own characteristic ornamentation and parti-coloured bamboo, on solid panels, with shingled or thatched roof, and with sliding trellis-shutters and translucent paper screens to serve as a substitute for glass in cold weather. For the rows placed against the sides of the hall, effective landscapes, in which the world-known Fusi-yama appears now and again, have been painted by native artists …[94]

The attraction, in terms of the exhibition, was as much in the craftsmen who occupied these houses, working at their trades, as in the buildings themselves.

> Groups of artisans … were to be seen yesterday in front of the shops, or in some cases squatting on the thickly-stuffed and scrupulously clean mats, 6ft. by 3½ ft. in dimensions, of which the number pack on the floor space denotes the size of the house …[95]

The Builder, however, took a rather superior position and could find no value in either the architecture or the artisans:

> The Japanese village which has been conveniently arranged under cover in the vicinity of Albert Gate will probably be an object of attention, and a sort of agreeable lounge for the curious, until the more important attractions of the season are in full swing. For those who would go to such an exhibition for the study of Japanese art or domestic architecture there is not really much to attract. They can see … a carpenter planing by drawing his plane to him instead of pushing it from him (the Japanese do everything the reverse way to other people) … and he can see for himself the lath and paper kind of dolls' house construction which is used in ordinary Japanese habitations, and how the houses stand on so many legs like a stool.[96]

Buhicrosan, as *The Times* had commented, did not allow any of the great range of craft objects made in the village by the artisans – lacquered woodwork, decorated pottery and cloisonné work as well as paper lanterns, fans and umbrellas – to be sold

until near to the closing of the exhibition, lest this 'make the affair a bazaar'.[97] However, *The Builder* opined that 'of course, the best class of Japanese art-workmen do not come over in this kind of *entourage*; and a good deal of modern work may be seen which seems to represent the Soho bazaar element of Japanese work.'[98]

The Building News, the other leading British architectural journal of the time, was far more positive in its response, reporting that 'the Japanese Native Village at Knightsbridge, opened last Saturday by Sir Rutherford Alcock, for many years Consul-General in Japan, is well worth a visit by everybody interested in art.'[99] Their description, which made an effort to convey an understanding of the construction processes involved, is worth quoting at length:

These rows of shops and houses are no mere imitations constructed by English workmen, and coloured or made to appear what they are not; but erections put up by native Japanese workmen, and representing every variety of construction and design. Different modes of treatment and decoration are here displayed; we see bamboo houses, the bamboo being split in halves and fixed on solid panels or boarded sides, with a roof of shingles or a thatching of rushes, and with fronts of sliding trellis frames filled or covered with a thin transparent and tough paper, which serves the purpose of glass; in other instances, the sides of the houses are constructed of framework papered on the outside, or thin boarded, and thin bamboo strips are nailed over it in vertical lines, with oblique branch-like filling-in, or disposed in diagonal lines, and filled in with cross-pieces alternately arranged. The houses stand each apart, the framework consisting of corner and intermediate posts, the floor raised above the ground, and covered with thick rush mats or 'tattams' ... The most noticeable feature in all these houses are the sliding frame fronts, which are filled with thin paper, and are of a variety of design ... The sliding frames ... run in grooves top and bottom inside the fixed frames. Often the whole front is made of

4.09 'Temple, &c, at the Japanese Village', London, 1885, from *The Building News*, 23 January 1885.

sliding frames, which can be shifted at pleasure. A very fine kind of trellis-work is also seen, made of thin strips nearly close together, or framed with much neatness and care, all in the same light soft-grained wood. The roofs, of the span kind, are of moderate pitch, with projecting eaves; the rafters are placed about 2ft. to 3ft. apart, and are painted green or some bright colour, upon which thin boarding is laid, either covered with shingle or thatched with rush. At the inner end of the street is a gentleman's house of two stories, having a small pent over the lower story, and with a balcony above ... Access to the upper floor is obtained by a ladder inside; the balcony is merely an ornamental feature, and is not intended, from its slight construction, to be used.[100]

The following week, *The Building News* carried a sketch of the temple and what they called a gentleman's house at the 'Japanneries' [4.09],[101] and a week later, a letter of approval from Christopher Dresser:

As I have been in Japan and there have studied the architecture, manufactures, and modes of

work of the country, allow me to say that in most respects the village at Knightsbridge represents faithfully Japanese buildings and modes of life ... The manner in which the industries are carried on in the little open shops, where the goods would be sold, is thoroughly characteristic of the country. All who can should certainly visit this village, for much can be learned from the clever workmen that are there to be found.[102]

Indeed, many people did visit the exhibition – about 250,000 in the first four months.[103] This was no doubt helped by the opening at the Savoy Theatre on 14 March that same year of Gilbert and Sullivan's new light-opera, *The Mikado*, for which Buhicrosan's Japanese visitors had coached the cast in authentic deportment and the correct use of the fan.[104] The exhibition's popularity was commented upon by *The Illustrated London News* which wrote, somewhat imaginatively, that 'the experiment in transporting a complete village with its shops, tea-house, theatre, and place of worship, as well as their inhabitants, from warm, sunny Japan to murky London during the coldest and dullest months of the year, has been a very bold, but an entirely successful one.'[105] It is this notion of Japan as some sort of tropical, Polynesian paradise which suggests how little was still understood of that country. *The Times* suggested that the erection of the village within an exhibition hall was as much for the benefit of the curious Londoner (which it was) as for 'the health and comfort of the interesting strangers, who, in their loose, flowing national costumes, form not the least picturesque element in the scene from the Far East now presented ...'[106] There was, clearly, little understanding that the winter climate in Japan was frequently no better and, particularly in Hokkaido, a good deal worse than in London. The layered use, in the Japanese house, of the *shōji* and *fusuma* to separate the *engawa* or the *hisashi* from the *omoya* had the same effect as wearing the *kimono*: both served to trap the air and thus insulated the building or the body. And, within the house, local heat was supplied by the *hibachi* or the *subitsu*.

Thus, in London, it was to a climate not unfamiliar, but to a culture very alien, that the Japanese came. The majority of the 100 or more craftsmen and entertainers (including women and children) had been recruited in Tokyo and Yokohama the previous year. Once in London they were housed initially in lodgings in the Brompton Road, West Kensington, before moving into dormitories specially constructed in Humphreys's Hall. But the accommodation there was cramped so many began living in the Japanese village which they had built themselves.[107] This, perhaps, was a mistake, for the village and Humphreys's Hall was burned out on 2 May 1885. By nine o'clock that Saturday morning, 'The Japanese Village,' *The Times* reported, 'as had been clear to all experienced eyes from the start, was doomed. The light woodwork and fabric of which the various structures were composed presented inflammable material and food of the least resisting nature to the flames ...'[108] One Japanese, a 22-year-old woodcarver from Yokohama identified by *The Times* as Ename Shekanosuke (whose name was also given as Enymi Shellanssuki[109]) was killed when a wall collapsed.[110] Thus the Japanese village went the way of so many buildings in Japan.

However, despite a reported loss of £10,000,[111] Buhicrosan was undaunted. He took the troupe, as he had always intended to do, to Germany and on 18 June 1885 opened a new village in the Exhibition Park in Berlin. This time it was divided into four sections, each representing a different city – Tokyo-ku, Yokohama-ku, Nagasaki-ku and Saikyō-ku, this last being Kyoto.[112] The exhibition closed after 60 days and transferred to Munich where it reopened at the end of September.[113] Meanwhile Humphreys's Hall was being rebuilt and a new Japanese village erected. When this opened on 2 December, *The Times* could report that 'The space covered by the new village is twice as large as that which was occupied by its predecessor, and the whole of the buildings are of a more solid and permanent character than before.'[114] The new village now consisted of seven streets of shops and houses, as well as temples, tea-houses and an ornamental garden with 'a Japanese rustic bridge'.[115] 'The

houses,' opined *The Times*, 'are accurate models of the various types of Japanese architecture, and are very picturesque buildings, their light bamboo work and quaint Eastern style of decoration affording a pleasant contrast to the heavier and more solid character of European dwelling-houses.'[116]

The Japanese village, which *The Times* predicted would be even more successful than its predecessor, was, in fact, part of a growing fashion. Although the village at Humphreys's Hall closed on 25 June 1887[117] and The Japanese Native Village Exhibition and Trading Company was wound up in August 1888,[118] Buhicrosan opened a new version in Brussels in June 1888 and yet another at the Alexandra Palace in 1889.[119] But Buhicrosan was not alone in seeing the commercial value of the Japanese market, and during the summer months of 1888 there was a Japanese village at New Brighton, on the Wirral peninsula in Cheshire, and another one in Edinburgh in September 1890.[120] Meanwhile, across the Atlantic in America, Japanese villages were erected in New York in 1885 and in Chicago in 1886. Whereas they certainly served to promote the craze for Japanisme, the representation of Japanese architecture had little didactic effect. This was probably due to two things. First, the impression which the exhibition gave that Japan was a tropical country and that the Japanese lived in very small houses;[121] and second, that the experience of the architecture one step removed from the original was not adequately convincing. Whereas art-architects such as Burges, Godwin and even Webb could respond to imported Japanese craftwork and wood-block prints in their furnishings and interior schemes, the need to experience Japanese architecture first-hand precluded most architects – and Godwin here is an exception – from adopting its forms.

Paris Exhibition, 1889

The fourth Exposition Universelle was held in Paris in the centenary year of the storming of the Bastille, 1889. Famous for the erection of the Eiffel Tower, this exhibition, which opened on 5 May, was

considerably larger still than its predecessors and the Japanese government responded accordingly with an investment of 130,000 Yen, although it is likely that this figure was bolstered by private funding. As in 1878, the Japanese government erected two buildings, one in the urban context of the rue de Caire, and the other, once more, across the Seine in the Trocadéro gardens. But there was a third Japanese building, located in what was called *L'histoire de l'habitations humaine*.

The first Japanese building, traditional in design and urban in context, formed part of an exhibition street of similarly exotic elevations [4.10]. Beneath the now familiar overhanging eaves and heavy timber corbels, the lower part of the façade demonstrated the fireproof *namako* wall construction whose hard, slate-coloured tiles had been on display five years earlier at the International Health Exhibition in London. What this showed, now probably for the first time

(*right*) 4.10 'La façade du Japon donnant sur la rue du Caire', at the 1889 Exposition Universelle in Paris from *L'Exposition de Paris de 1889*, 16 October 1889.

4.11 'The Japanese and Chinese Pavilions', designed by Charles Garnier, as part of the 'L'histoire de l'habitations humaine' at the 1889 Exposition Universelle in Paris, from *The Paris Universal Exhibition Album*, 1889.

in built form in the West, was that there was a robust yet powerfully decorative form of Japanese wall construction quite different to the flimsy bamboo and paper walling which had become so characteristic of Japanese exhibition architecture. The other Japanese exhibition building, located across the Seine, brought the architecture and the landscape together. Set in the context of its Japanese garden, this rustic structure provided, as Jean-Thadée Dybowski, later the French Inspector General of Colonial Agriculture, could remark, 'the highest degree of illusion of a journey to distant lands'. It was as if the building no longer held any great novelty, but the context, now more extensive than what had been attempted at Philadelphia 13 years before, allowed the Japanese architecture to be seen in a new light:

> This garden gives us the full appearance of a Japanese landscape. It connects seamlessly to a pretty house, full of vases filled with flowers and various plants. For the Japanese, the garden is the outdoor living room as the living room is the indoor garden. So when inclement weather forces them to abandon the outdoor life, they still find, in the house, the illusion of the beautiful landscape which surrounds them.[122]

The Japanese building which probably received the greatest attention, however, was not provided or designed by the Japanese at all. The collective exhibit, *L'histoire de l'habitations humaine*, was the idea of Charles Garnier, the architect of Paris's great Beaux Arts Théâtre National de l'Opéra, completed in 1875, and now a somewhat reactionary elder statesman of the profession. The exhibition, positioned in a park along the banks of the Seine and almost beneath the legs of the new and, for Garnier, reprehensible Eiffel Tower, was conceived as 44 dwellings, each claiming archaeological and historical accuracy. Garnier intended it as both a tectonic repost to the cast-iron Eiffel Tower and, as he said, 'a moving panorama, where all habitations parade before us'.[123] Grouped with the African, Eskimo, Indian, Aztec and other cultures which 'did not exert any influence on the general advance

of humanity',[124] the Japanese house was Garnier's conception of Japanese architecture – for he designed it himself. Set next to the Chinese house, it was surprisingly unconvincing [4.11]. Built in timber and of two storeys, it was raised off the ground and surrounded by balconies at both levels; the detailing of the woodwork was stylised and more suggestive of Japanisme than Japan; the balcony railings were not what would be found on an *engawa*; the roof took on a curious shape with the bargeboards stretching out from the corners like oars; and the sliding wall panels, proportioned like domestic doors and with windows which might even have been glazed, bore little resemblance to the *shōji* screen. By 1889, Japanese buildings had been exhibited in international exhibitions for over 25 years, and twice in Paris itself. Yet Garnier's conception of what constituted the Japanese house, whether it be for the *samurai* or for the farmer, was surprisingly wide of the mark. Louis Gonse, one of the first Western scholars in Japanese art and Vice-President of the Historic Monuments Commission, was offended by what he saw. Writing in the *Gazette des Beaux-Arts*, of which he was editor, he said, 'For the Japanese house … we deliver M. Garnier, without remorse, to all the severities of the archaeologists', adding, parenthetically, as if apologising for Garnier's mistakes, 'The public appreciate picturesque things.'[125] The building, along with the rest of the History of Habitation exhibition, was demolished in the weeks following the closing of the Exposition Universelle on 31 October 1889.

The Chicago Exhibition, 1893

The position of Japanese buildings in the fairground atmosphere of international exhibitions or under the cavernous roof of exhibition halls was always going to deny them their proper relationship with the landscape. There the notion of *shakkei* or 'borrowed landscape' did not so much help but probably worked to the detriment of the architecture. What was beginning to be evidenced, and what Dybowski had witnessed at

Paris in 1889, was brought into its own in Chicago four years later. Japan was the first country to respond to the invitation to exhibit at the 1893 World's Columbian Exposition and consequently got the pick of the sites.[126] The position it reserved for its main pavilion, the Hōō-den, was at the north end of the 'Wooded Island', located in the centre of the Jackson Park site and surrounded by a lagoon which linked through to Lake Michigan. Although the Japanese pavilion had the island almost all to itself, the scale and sheer hubris of the white, Renaissance exhibition halls which lined the water's edge provided a heavy and distracting backdrop. Directly across the lagoon from the Japanese site was the domed United States Government Building, designed by the Washington DC architect Willoughby James Edbrooke. This, according to the architect Louis Sullivan,[127] 'was of an incredible vulgarity'.[128] Next to it stood the vast Manufactures and Liberal Arts Building, the work of the New York architect George Browne Post, which Sullivan dismissed as 'the most vitriolic of them all – the most impudently thievish'.[129] But, as he conceded, 'The landscape work, in its genial distribution of lagoons, wooded islands, lawns, shrubbery and plantings, did much to soften an otherwise mechanical display ...'[130]

What the Meiji government provided for the 1893 Exposition certainly softened an otherwise mechanical display. It was not only the most ambitious such project thus far, but the one which most clearly represented a significant piece of historic Japanese architecture dating from the Heian period (*c.* 800 to 1200) – the Hōō-dō (Phoenix Hall) in Uji, to the south of Kyoto.[131] Built in 1053 as the Amidado or Amida Buddha hall and located within the Byōdō-in temple complex, it probably took its popular name from the pair of phoenixes which adorn the ridgeline of the *chūdo* or central hall – this mythical bird was believed to be the protector of Buddha – although the shape of the building also suggested a bird with outstretched wings. The Hōō-den at Chicago, designed for the Imperial Japanese Commission to the exhibition by Kuru Masamichi, repeated both the tripartite symmetrical plan of the Hōō-dō at Uji and its

lakeside setting. The location of the Phoenix Hall in Chicago, the 'City of Phoenixes', was an irony not lost on the Japanese Commission.[132]

Smaller than the Hōō-dō at Uji and modified internally to serve as an exhibition building, the Hōō-den was shipped to Chicago and assembled, by Japanese workmen, on site [4.12]. Work started on 19 October 1892 and in December the Chicago-suburban *Oak Park Reporter*, which was Frank Lloyd Wright's local newspaper, revealed that 'Just at present there are at work on the Japanese building in the world's-fair grounds, Chicago, one hundred mechanics and laborers from the land of Nippon ... The men,' it continued, 'were found busily engaged at their respective tasks as if the work of completing the buildings in time for the opening, May 1, depended on individual's effort.'[133] *Harper's Weekly* similarly drew attention to the building activity, although the eventual outcome of these efforts was still unclear:

> When the snow was over a foot deep this winter, and visitors to the works were very scarce in account of the cold, there was still always something of a crowd about the wire rope that was put up to keep visitors away from the Japanese carpenters and joiners who were erecting the houses in the island village ...[134]

But it was the building process which seemed to amaze the *Oak Park Reporter* the most:

> They were at work on a temporary house that looked like a joke. The timbers were solid enough but there wasn't a nail in the whole affair. The cross-pieces were fastened with pieces of jute rope. The carpenters used no ladders of any sort, but climbed from ground to top and back again with the agility of professional trapezists. The men who worked aloft had bunches of rope about their waists, with which they fastened the timbers passed up to them ... They already have the foundations of the three Japanese temples ready for the upright columns and were busy assorting the finished material that was shipped from Japan to go into the superstructure.[135]

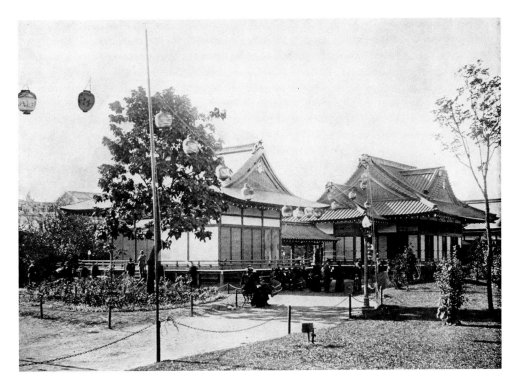

4.12 'The Ho-o-den, or Phoenix Bird Building erected by Japan' at the 1893 World's Columbian Exposition, Chicago, from James W. Buel, *The Magic City* ..., 1894.

The topsy-turvy approach was something which *The Daily Inter Ocean* also observed:

> The Japanese, although advanced in many matters to a degree that will astonish most persons, strangely enough make progress backwards, as it were. In almost everything they do, they act in a manner directly opposite to Americans. In carpentry they tie their timber together instead of nailing it, build the roofs of houses first and the foundations last, and draw their saws in the main stroke toward them.[136]

The Hōō-den, which was decorated by members of the Tokyo Art Academy, was completed in good time and the dedication ceremony was held on 31 March, the 39th anniversary of the signing, by Commodore Perry, of the first United States Treaty with the Japanese. In relinquishing charge of the building and presenting the key to the President of the Commission, Kuru Masamichi explained the didactic nature of the building:

> The three buildings here reproduced represent the styles of architecture which were in vogue from the tenth century to the eighteenth. Although each of these three epochs have architectural styles distinctive of its own, and reproduced here with absolute accuracy, they are planned under a general architectural design. The whole plan is taken from the Hoodo, which is now existing in Uji, Japan.[137]

Daniel Burnham, the architect and Director of Works for the exhibition, responded, congratulating Kuru on the completion of the building, saying how much of an attractive feature the Hōō-den would be at the fair.

Whether or not Burnham recognised the subtlety of the Hōō-den's composition, he would have appreciated its historicist intent, for this was the theme, stated or not, of the whole exhibition. The great Renaissance palaces, criticised by Sullivan for being 'thievish', stole their ideas from the past. The national pavilions were little better, the British one being a half-timbered, mock-Tudor concoction while the French one was a Beaux-Arts wedding cake in the form of a triumphal arch. Thus the Hōō-den, which combined Heian, Muromachi and Tokugawa architecture, fitted in well.[138] Kuru clearly saw the Hōō-den as not one but three buildings, each representative of a different style or epoch, but virtually none of the 27 million visitors who came to the exhibition would have appreciated this. Although Western architects might have recognised in its tripartite arrangement the central-bay and side-pavilion *parti* of Palladian architecture, such symmetry and formality of arrangement would not have resonated with the Japanese. The short, covered colonnades which linked the three buildings, although found at the Hōō-dō at Uji, were here no more than a convenience and the building was intended to be read as three different elements, each one a different lesson in Japanese historic architecture. This, and the manner in which the *shōji* of the external walls could be withdrawn to expose the interior which, on a whim, could be reconfigured by the moving of the *fusuma*, must have had the effect, for many visitors, of de-substantiating the building. Although Frank Lloyd Wright famously denied any first-hand knowledge of the building[139] – and, indeed, there is no immediate effect of it apparent in his work[140] – Charles and Henry Greene saw it when they stopped over in Chicago on their way to California, there to set up in architectural practice in Pasadena, and 'were both deeply moved'.[141] And for the young Chicago-born architecture student Marion Lucy Mahony, then studying at MIT,[142] it was this sense of openness at the Hōō-den, the 'immense quantities of light and air',[143] which struck her most.

The Hōō-den was not the only Japanese building at the World's Columbian Exposition.

There was a tea-house located on the far side of the lagoon, beyond the Fisheries Building, in a group of refreshment buildings which included the Café de Marine, the Swedish Restaurant and the Polish Café. In contrast to the Hōō-den, this building did not allude to historical styles, but was a contemporary building of *sukiya* appearance.[144] Located, once again, on the water's edge, it was a simple, framed structure with boarded walls and a half-hipped, tiled roof. Open on three sides beneath a lower roof which sheltered the *engawa*, the building appears to have been, internally, a double-height space. This, working in combination with the open walls and the nearby water, would have ensured that the building remained cool during the hot Chicago summer. On the Midway Plaisance, the exhibition site's main thoroughfare, there was the Japanese bazaar, a simple if not simplified two-storey timber structure with the shop below and a gallery, perhaps for performances, set above. In contrast to the richness of the Hōō-den, this was a very plain building, the frame and panelled walls left unadorned and the only decoration being to the *ranma* or frieze above the *nageshi*, from which lanterns hung, and to the gable ends of the half-hipped roof [4.13].

The Hōō-den's lasting legacy was not to be in the correct interpretation of historical Japanese architecture but rather, as has been widely recorded, in the influence it is thought to have had on the work of Frank Lloyd Wright and the developing Prairie School. This is because what it offered was not easily understood in Western terms. The 'immense quantities of light and air' of which Marion Mahony spoke did not suggest an architecture in terms of styles or Orders or even craftsmanship, but a perceptibly different response. The architectural historian Grant Carpenter Manson, who elicited that observation from Mahony, saw this too:

Beneath an ample roof – a powerful expression of shelter – and above the platform on which the temple stood, was an area of human activity, an open, ephemeral region of isolated posts and sliding screens that changed its appearance

4.13 The 'Japanese Bazaar, Midway Plaisance' at the 1893 World's Columbian Exposition, Chicago, from F. Dundas Todd, *Snap Shots by an Artist ...*, 1893.

according to the activity of the hour, and that, in Occidental parlance, was not architecture at all.[145]

Isolated on its wooded island, the Hōō-den could not have been more different to the national pavilions which populated Jackson Park or the vast, white Renaissance palaces which surrounded the lagoon. Although the Hōō-den's architecture was, like those other buildings, historicist, it was an architecture still almost completely unknown in the West. Manson's observation recalls Rutherford Alcock's assertion that Japan had no architecture,[146] and it was precisely this non-architecture, this architecture of space – of light and air – which was increasingly adopted in the West. Meanwhile in Japan, the Meiji government and wealthy individuals pushed on with their wholesale appropriation of European historical styles.

The Later Exhibitions

Michael Henry de Young, the owner of the *San Francisco Chronicle*, had been a California Commissioner to the 1889 Paris Exposition and, four years later, vice-president of the National Commission for the World's Columbian Exposition in Chicago. Inspired by these events, de Young campaigned to bring a world's fair to San Francisco where, in Golden Gate Park on New Year's Day 1894, and with him as Director-General, the California Midwinter International Exposition was dedicated. It opened to the public four weeks later. Amongst the 150 buildings erected in the park was a Japanese tea-garden[147] with a *taiko-bashi* (barrel bridge), commissioned by the Japanese government and built by Nakatani Shinshichi in Japan, before being disassembled and shipped to California. There were also replicas of the *shoro-no-mon* (bell gate) at

the Shōgyōji Temple at Jigozen, Hatsukaichi and the *torii* at the Itskushima shrine at Miyajima, as well as a thatched tea-house where 'geisha' served tea and around which *nishikigoi* (or koi fish) swam in the serpentine ponds [4.14]. This compact but elaborate tea-garden was the concession of the Australian Japanophile George Turner Marsh[148] who, having lived in Yokohama as a young man, wanted to show Japan in context. Designed and cared for by a Japanese immigrant, Hagiwara Makoto,[149] it was, however, less of a promotional affair than an experiential one and today would be recognised as a theme park.[150]

If the World's Columbian Exposition of 1893 was the last occasion at which the Japanese exhibit was an expression of statecraft, the California Midwinter International Exposition in San Francisco was the first one where the Japanese exhibit was purely for entertainment. Despite the funding of the *taiko-bashi* by the Japanese government, there were no overt political overtures and the tea-garden, with its collection of Japanese garden 'furniture', represented what soon became a trope of international exhibitions.

A fifth Exposition Universelle was held in Paris in 1900, coinciding with the second Olympiad.[151] Once again, the Exposition was located on the Champs de Mars and across the river at the Trocadéro where the historicist two-storey Japanese pavilion, based upon the Kinkaku-ji or Golden Pavilion at Kyoto, was located. On the Champs de Mars site, close to the Eiffel Tower, was the Panorama-theâtre du Tour du Monde. This curious structure comprised an authentic Japanese entrance gateway flanked by a Siamese *prang* and a Japanese pagoda, giving access to the large, oval-shaped panoramic theatre which came complete with onion domes and minarets. If it were not for the absurdity of the composition, the authenticity of the pagoda was betrayed by the words BRASSERIE VETZEL displayed in large letters on its upper balconies. Like Garnier's Japanese house at the 1889 Exposition, this was the work of a French architect, Alexandre Marcel, who re-erected the

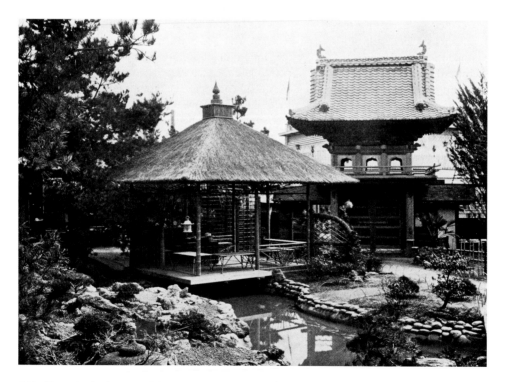

4.14 'Scene in the Japanese Village' at the 1894 Midwinter Fair in San Francisco, from James W. Buel, *The Magic City ...*, 1894.

pagoda in 1901–1904 at Laeken, near Brussels, for King Leopold II. Constructed in the proper manner, with morticed joints and pegs which allowed for its easy removal, the pagoda was then decorated with carved and gilded panels commissioned by Marcel from Yokohama craftsmen. The entrance gateway, which had been originally built in Tokyo by the Japanese architect Komatsu Mitsushige, was also brought to Laeken where it was reconnected, by a series of stepped chambers, to the pagoda. 'It is an incomparable marvel,' wrote *Le Patriote*, 'that unites luxury and the most modern comforts with the splendour of the Orient.'[152]

The 1904 exhibition in St Louis, the Louisiana Purchase Exposition, coincided with the Russo-Japanese War, yet the Japanese were represented. Hoshi Hajime's introduction to the *Handbook of Japan and Japanese Exhibits at World's Fair, St. Louis, 1904*, describing the country's development in the 50 years since Commodore Perry's arrival, is confident, even if a little disingenuous, in its smoothing-over of history:

> The startling and rapid development of Japanese trade is due to the readiness and celerity with which the frank and courageous people of the Empire abandoned their old customs and turned their faces toward a new civilization. There was no hesitation, no halting, no looking backward. The entire nation awoke with a start to the realization that it was moving in the wrong direction, and turned about and dropped easily in the march of modern progress. Foreign ideas

were adopted, foreign methods were imitated and frequently improved upon, and the closest commercial relations were sought with the United States and the countries of Europe.[153]

The Japanese exhibit, which was three times as large as that at Chicago, was centred on a Japanese garden of 150,000 square feet (about 1.4 hectares) in which the Japanese Pavilion, office building, tea-house, observation cottage and Formosa Mansion (reflecting Japan's recent colonial expansion) were located. Other exhibits were displayed in the various themed exhibition pavilions. As was the custom, these buildings were erected by Japanese craftsmen with materials brought from Japan and represented a range of historic styles or, as at Paris four years earlier, specific monuments.[154] But, like at San Francisco, and unlike earlier exhibitions, all the constituent parts of the Japanese garden had now come to be expected.

In the 50 years between 1862 and 1912, the last in the long run of Japanese exhibition showpieces was the mighty Japan-British Exhibition held in 1910 at the eponymous White City in London. This was the largest international exhibition to which the Japanese had ever contributed and, as before, the intention was to introduce Japan to the Western world. But the inclusion, as an exhibit, of Hokkaido Ainu and Formosan (or Taiwanese) natives, together with their native dwellings, was felt by many to be a step too far. Elsewhere, the now familiar assembly of gateways, bridges, tea-houses and pagoda gave the public what they expected to see.

5 THE ART-ARCHITECTS

The Art-architect

'I must not be misunderstood,' Christopher Dresser wrote in *Japan: Its Architecture, Art, and Art Manufactures* in 1882, 'I do not wish to destroy our national art, and substitute for it the Japanese style. I merely wish that we should avail ourselves of those methods which are in advance of our own; not minding where they originated.' The frenzy over the Japanese style is often attributed to the discovery, by the French painter Felix Bracquemond, of wood-block prints or *manga* by Katsushika Hokusai (known simply as Hokusai) which were being used to wrap pieces of blue-and-white porcelain sent from Japan. The date for this is usually given as 1856, although other dates have been suggested.[1] Japanese wood-block prints were not unknown but through Bracquemond's promotion, the interest in both *manga* and the imagery shown quickly developed into an enthusiasm for what the French art critic and collector Philippe Burty was later to call 'Japonisme'.[2] This he defined as 'the study of the art and genius of Japan.'[3] Dresser, who had been to Japan, appears here cautious, advising those interested in the Japanese style to be discerning in what they use: Burty, as noted in the previous chapter, had not been to Japan. Nor had the art-architects who, in England more than elsewhere, took it on board so readily. By the mid-1860s,

stylised decorative devices, particularly Japanese *mon* – roundels or 'pies', as they were called – were appearing frequently in buildings. A decade later the wilful use of asymmetry showed a move from the incorporation of stylised elements to a broader acceptance of the Japanese aesthetic. Happening when it did, Japonisme, through an emphasis on aesthetics rather than dogma, allowed the work of Gothic Revival architecture to evolve into what became known as the Queen Anne Revival. As developed, it had little to do with the architecture of Japan but was more an adaption of Japanese architectural and decorative traditions to a Western lifestyle.

The notion of the art-architect grew out of the Gothic Revival and found its home in the Arts and Crafts Movement. These were men, for they were all men, for whom an artist and an architect were one and the same thing.[4] Their leader, if such a group could have a leader, or rather the man who best expressed their intention, was William Burges – Billy Burges, 'a man of consistent cheerfulness, a buoyant and happy creature'.[5] This was the opinion of his friend, Henry Stacy Marks RA, a painter of slightly whimsical scenes usually involving birds or animals, who also recognised Burges as 'a learned archaeologist who had an extraordinary talent as a designer of gold-smith's work'.[6] Burges, he recalled,

could design decanters, cups and castles with equal ability. And it was he who, when working for Matthew Digby Wyatt, had designed the Medieval Court at the 1862 Exhibition and who first argued the connection between Japan and medieval art and design. His design for the Sabrina Fountain in Gloucester (1856) had caught the attention of a Bristol architect, Edward William Godwin, who was soon to become his friend and supporter.[7] Although a medievalist and initially a follower of Ruskin,[8] Godwin apparently learnt, at an early stage, about Japanese wood-block prints from the sea captains he knew in Bristol.[9] If this story, as told by his inamorata, the actress Ellen Terry, is true, then it would suggest that he was familiar with *manga* before moving to London and seeing the Exhibition of 1862.

From a different background, that of country-house architecture, came William Eden Nesfield and Richard Norman Shaw who had become friends while working in London in the infinitely more prosaic practice of William Burn before meeting up again in the office of Nesfield's uncle, Anthony Salvin. Dante Gabriel Rossetti and his artistic circle shared their mutual interest in Japanese art and design, and in particular blue-and-white china. Indeed, in about 1863 a rivalry began to develop between Rossetti and his neighbour and friend, James McNeill Whistler, over who could collect the greatest number and most rare examples of blue-and-white china. Like all enthusiasms, theirs found its channels in the social milieu of the time, but one institution, the Arts Club, is here worth noting. Founded in 1863 with 250 members, the Arts Club was, from its beginning, a home from home to Burges, Godwin and Whistler, as well as to the illustrator George du Maurier and the painters Val Prinsep and Frederic Leighton, later President of the Royal Academy of Arts, as well as literati such as Charles Dickens, Thomas Hughes and Edmund Yates.[10] The architects Arthur Blomfield, Matthew Digby Wyatt, Horace Jones, Charles Nightingale Beazley and Robert William Edis, who in 1876 succeeded Leighton as colonel of the Artists' Corps, were also founding members. Both Beazley

and Edis were to introduce Japanese motifs into their work. Over the years they were joined at the club by other architects who are part of this story: Owen Jones (1864), George Edmund Street (1865), George Aitchison (1866), John James Stevenson (1870), Richard Phené Spiers (1870), Charles Locke Eastlake (1873) and Thomas Roger Smith (1885). Unlike the Royal Academy, whose membership was smaller, or the Royal Institute of British Architects, whose membership was more exclusive, the Arts Club brought together artists and architects in a social context where new ideas, driven by neither ecclesiological (or other dogmatic) thinking nor professional demands, but by aesthetics, could gestate.

The Art-architects and Medievalism

Twenty years earlier, at the International Exhibition in London of 1862, the art world got its first real taste of Japan and William Burges, the pre-eminent of the art-architects – a term he himself used in 1864[11] – wrote lengthy reviews of both the exhibition and the Japanese Court for *The Gentleman's Magazine*.[12] Burges remembered how at the 1851 exhibition held in the Crystal Palace, medievalism, as shown in the work of Augustus Welby Pugin, had been 'a curiosity penned up in one little court'.[13] Now it was the *lingua franca* of the leading architects with the result that, to Burges's mind, it had lost its cachet and was becoming commonplace, although, as he said, 'a glance at the foreign exhibitors at once tells us that mediæval art has by no means taken that deep root among them that it has with us'.[14] But all was not lost. 'If, however, the visitor wishes to see the real Middle Ages,' he continued, 'he must visit the Japanese Court, for at the present day the arts of the Middle Ages have deserted Europe, and are only to be found in the East … Truly the Japanese Court is the real mediæval court of the Exhibition.'[15] Here the visitor could inspect the copper-work and bronzes, the ivories and, in particular, the use of lacquer, of which he

wrote: '... it is upon them that we see the greatest ability of the Japanese in design, and above all in the distribution of ornament.'[16] Although Burges admired the numerous cabinets, he did not comment upon the cabinet models of Japanese tea-houses or the stereoscopic view of a tea-house, for it was the craft skills which he drew him. 'There hitherto unknown barbarians,' he wrote, 'appear not only to know all that the Middle Ages knew, but in some respects are beyond them and us as well.'[17]

In his book, *Japan: Its Architecture, Art, and Art Manufactures*, Dresser later recalled how Owen Jones, the celebrated author of *The Grammar of Ornament* (1856), had asserted that the Japanese had no ornament as such, and that their decoration consisted wholly of stylised natural forms.[18] 'Few countries,' Dresser contended, 'have more characteristic or carefully considered ornament than Japan.'[19] To make his point, he illustrated diaper patterns where squares and circles interplayed and geometries repeated.[20] 'In power,' he continued, 'it equals the best of our own mediæval work; while in tenderness of expression, beauty of composition and careful thought, it is even superior.'[21] It was such decoration, both stylised and geometrical, which Burges introduced at Skilbeck's drysalter's warehouse on Upper Thames Street, London, in 1864–66.[22] On the cast-iron lintel above the entrance he placed roundels representing the *kiku* or chrysanthemum, the Japanese Imperial emblem. In the deep-set window openings of the brick façade he fixed pierced-lattice grilles, much as Dresser was to see made in Osaka a dozen years later, and subsequently illustrate.[23] A similar pattern was repeated, beneath the cast-iron beam, in the upper part of the shop-front window, while below the dado, wrought iron grasses or reeds stretch up as if reaching towards the light. Skilbeck's, however, being a warehouse, rather than a church or public building, allowed Burges freedom for greater than usual experimentation. The result was well received. Charles Eastlake, in his *History of the Gothic Revival* (1872), observed how the plain bricks and mortar used here tested Burges's ability

'to the full, and with a result which is hopeful for our city lanes and alleys'.[24] Godwin, writing in *The Building News*, thought it 'strikingly clever';[25] *The Ecclesiologist*, usually the guardian of church design, called it 'a great success' and noticed, apparently without a blush, that on the underside of the corbel which supported the great crane was 'a bust of a fair oriental maid'.[26] Although the fair maid does not look particularly Japanese, the inclusion here of Japanese references was not inappropriate since some of the drysalter's materials, such as indigo which was used for dyeing cotton *kimono* in the Edo period, came from the Ryukyu Islands.

Burges was a collector, not just of Japanese prints and objects, but of all 'medieval' art. His elephant ink-stand of 1862–63, for which he designed a castellated howda, incorporated a Chinese bronze elephant and, on its lid, a miniature Japanese ivory toggle or netsuke depicting a pair of manzai-shi or itinerant comics.[27] The result was purely eclectic for, as Godwin said, 'the things he is dealing with are Chinese and Japanese, but the whole is thirteenth-century – Burgesesque'.[28] In his study, *High Victorian Japonisme* (1991), Toshio Watanabe notes that the elephant ink-stand, which was started in the year of the International Exhibition, 'must be one of the earliest examples of Japonisme' and 'one where Japanese art has contributed successfully in the creation of an original work of design in the West'.[29] But significantly, the result was considered not Japanese but medieval: for it was the perception of Japan as a medieval society which was the attraction. Even before 1862, Burges had been moving, in his designs for painted furniture such as the Yatman Cabinet (1858) or the sideboard showing 'The Battle Between the Wines and the Spirits' (1859), towards a decorative system which combined painted figures with geometrical patterns such as Dresser was to record 20 years later. The similarity between the decoration of the sideboard and a lacquer-work cabinet shown in John Burley Waring's illustrated account of the International Exhibition, *Masterpieces of Industrial Art and Sculpture at the International Exhibition*

1862, is noticeable.[30] Here, Waring comments: 'The good taste and ingenuity of the Japanese in lacquer-work was evinced to a remarkable degree', and 'Our own manufacturers would do well to study such works, and improve their present system of decoration, which is fundamentally bad.'[31] Whether or not Burges was actively adopting Japanese decorative devices in his work before 1862 cannot be said, but from that point on he was ready to seize them.

Burges's painted furniture, whether cabinets, washstands or escritoires, were substantial, often architectural pieces, but rarely did he incorporate Japanese architectural, as opposed to decorative, effects into them.[32] One exception is the escritoire which he designed in 1865–67. What is noticeable about it is that in an otherwise symmetrical front the level above the writing desk is divided equally into a locked cabinet, on the left, and a recessed bookcase, itself subdivided by a single column, on the right. The same sense of forced (as opposed to picturesque) asymmetry can be seen in Skilbeck's warehouse, designed at the same time. At Skilbeck's, where the elevation is divided into two equal bays beneath a common gable, that on the left is pierced only by small windows while that on the right is left largely open for the packing bays to receive the goods from the street below. It is the same arrangement of asymmetrical solid and void as in the escritoire and as such reflects the paired *chigai-dana* and *tokonoma* alcoves of the traditional Japanese house.

The Art-architects and the *Mon*

It was the 1862 International Exhibition which drew the West's attention to the Japanese *mon*. Yet this was not because of their heraldic or historic significance but because of their circular form. 'Circular compositions have great favour with the Japanese,' Christopher Dresser wrote in 1863. 'We observed an earthen-ware bowl in the late exhibition decorated entirely with circular arrangements. A friend copied about fifteen of

these groups, and these were not all.'[33] In an article in *The Journal of the Society of Arts*, published the same year, illustrator John Leighton also commented upon them, saying, 'small round crests are very popular in Japan, doubtless from the resemblance they bear to the crests of the Daimios'.[34] As a decorative device, *mon* would have been found ornamenting Japanese imports from porcelain and lacquer-ware to costumes and armour. 'Circular compositions are more common with the Japanese,' Dresser continued, 'than groups of any other form. This seems to be accounted for by most crests being circular.'[35] Noting that about half the Japanese wallpapers which he had seen had circular patterns on them, he illustrated *mon* showing large birds with outstretched wings – a pelican, perhaps, or a peacock – and also leaf patterns arranged within a circle.[36] The bird was later to be taken up by Godwin in the Peacock wallpaper which he designed in 1873, but the leaf pattern had already made an appearance [Plate 9]. This was at St Stephen's University Church, Dublin, which had been designed at the invitation of John Henry Newman, Rector of the Catholic University of Ireland, by John Hungerford Pollen. Pollen, who had been ordained an Anglican priest in 1845 but had converted to Roman Catholicism in 1852, had been appointed Professor of Fine Arts at the Catholic University in 1855, a position he held until 1857.[37] The 1853 Dublin Great Industrial Exhibition had shown some Japanese items, first seen amongst the Chinese exhibits at the 1851 Great Exhibition. Whether these were influential cannot be said, but the apse of Pollen's rich interior included a series of large roundels set on a gridded-lattice ground of ceramic and faux ceramic work. These roundels, comprising a symmetrical leaf pattern with geometric highlights in green and pink, are neither Celtic, Italian Romanesque nor Byzantine, and would indicate another provenance.[38] Furthermore, the shadows of what might have been smaller roundels, positioned diagonally between the larger ones, suggest a more complex pattern which was either revised at an early stage or removed at a later date.

The decoration of the church coincides with the publication of Owen Jones's *Grammar of Ornament* (1856) which did include roundels and flat, gridded patterns amongst the examples of Chinese decoration,[39] but Jones, dismissive of Japanese ornament, was, like the curators of the 1851 Great Exhibition, unwilling to differentiate between Japanese and Chinese designs.

One who did differentiate Japanese from Chinese, from an early stage, was Burges. The wood-block print by Shigenobu Ichiyusai (or Hiroshige II), a pupil of Utagawa Hiroshige, which he pasted into his scrapbook in about 1855, showed 54 separate *mon* [Plate 8]. Amongst them is the *kiku* or chrysanthemum *mon* of the Mikado and those of the Satsuma and Satake *daimyo*. Writing in *Japan: Its Architecture, Art, and Art Manufactures*, Dresser described *mon* as being 'similar to our armorial bearings'. His illustration there showed a range of devices all formed from the leaf of the Maidenhair tree, the *ginkgo biloba*, which is the symbol of *Urasenke*, one of the main schools of the tea ceremony. Not all *mon* were circular like those adopted by the Mikado or the Satsuma *daimyo*, other shapes such as the fan for the Satake *daimyo* being employed. *Mon* would be shown as a sign of princely patronage on Japanese porcelain which was then avidly collected by the art set, such as Rossetti who, together with Ford Madox Brown, was one of the most innovative picture-frame designers of the period. Like Burges, he seems to have had his interest in Japan piqued by the 1862 Exhibition and soon after began designing picture frames incorporating *mon*.[40] Shaw was soon to use them too.

At this time Shaw was working as the principal assistant for the leading Gothic Revival architect, George Edmund Street, and his own work, such as the organ he designed in 1858, was very much in that vein. So when in 1861 he decided to design and build, with the help of the carver James Forsyth, a bookcase, it is not surprising that it should be in the 'reform' tradition of sturdy Gothic furniture then being designed by Burges, William Morris and Philip Webb. What is surprising, perhaps, is the incorporation of a dozen circular devices,

along the top of the cabinet doors, suggestive of Japanese *mon*.[41] Designed in the manner of Burges's earliest architectural furniture, and pre-dating the escritoire by four or five years, Shaw's design was as much a building as a bookcase. The incorporation of Japanese *mon* into what was a piece of Gothic Revival design was not inappropriate; the perception of Japan as a medieval society has already been noted and similar circular forms could be found in English and Continental medieval work, such as in the Cosmati pavement in the sanctuary of Westminster Abbey or at the Palazzo Badoer, which Ruskin had illustrated in the first volume of *The Stones of Venice* (1851). At just this moment Shaw, working in Street's office, would have been watching, if not actually supervising, the building of St James the Less, Pimlico, where 'medallions of dark marble', as at the Ca' d'Oro in Venice, were being incorporated into the belfry window.[42] For throughout Street's work of this period, as in the pulpits at St John, Howsham, Yorkshire (1860) and All Saints, Denstone, Staffordshire (1862), roundels were appearing.

Shaw remained in Street's office until 1862 and then, in early 1863, set up practice with his friend Nesfield, to whom he referred as 'the stout party in the other room'. Although not partners (that happened briefly in 1866–69), they shared space and ideas, each helping the other with their work. Their assistant, John McKean Brydon, remembered the stout party with affection:

His room in Argyle Street was a sight in those days, containing as it did a valuable collection of blue and white Nankin china and Persian plates, Japanese curios, brass sconces and other metal work, nick-nacks of various descriptions, and a well stocked library, in a case designed by himself. It was the studio of an artist rather than the business room of a professional man ... at that time the Japanese craze had not broken out into an epidemic, and, as yet, 'Liberty' as such, existed not, but Nesfield knew all about the movement; he could estimate Japanese Art at its true value, and its place in the grammar of ornament, not hesitating to introduce the

characteristic discs and key pattern into his work when occasion served. One loves to think of him amid the congenial surroundings of his room in Argyle Street, working away at the Art in which he delighted.[43]

It was an eclectic environment almost to rival Burges's: Nesfield's friend, the young Pre-Raphaelite painter Simeon Solomon, called it 'a very jolly collection of Persian, Indian, Greek and Japanese things …'.[44] Shaw's room was less varied, his interest in the 1860s being the collecting of blue-and-white Nankin china – perhaps the items which Brydon remembered. But his interest in Japan was no less. As a student at the Royal Academy of Arts, Shaw had won the Silver Medal in 1852, the Gold Medal in 1853, and the Royal Academy Travelling Scholarship in 1854. It was a hat-trick hard to follow, but 10 years later Richard Phené Spiers pulled it off, winning the Silver and Gold Medals in 1863, the Travelling Scholarship in 1864 and then, something Shaw had not done, the RIBA Soane Medallion in 1865. In the same year Spiers set out on an 18-month tour of Europe and the Middle East. It was then, Spiers recalled, that Shaw, no doubt interested in the young man who had usurped his laurel crown, spoke to him: 'I remember when I was about to set forth on my long travels abroad that he advised me to go to Japan, for in this new country I should see art of the very highest possible type. He further offered me commissions for several thousand pounds should I go.'[45] In the event, Spiers travelled no further east than the Levant.

Within little more than a year of taking the rooms in Argyle Street, Shaw and Nesfield were busy with country house commissions, the one at Willesley, Kent (1864–65), and the other at Cloverley Hall, Shropshire (1864–70). Whereas the former was in the tile-hung Old English style of the Home Counties, and the latter was resolutely robust and Gothic, both found space for the *mon*. For the pargetting of the coving beneath the first-floor tile-hanging at Willesley, Shaw designed a series of *mon*, each within a square frame but off-centred, so as to appear to be overlapping. And from the

centre of each a green bottle-base protruded. Within the house, circular designs were incised into the plaster ceilings and were complemented by the oriental plates displayed along the inglenook mantelpiece in the hall. These plasterwork designs were actually drawn on the soft plaster by Shaw himself and then executed by the builder and his assistants.[46] Meanwhile at Cloverley Hall, Nesfield introduced into the principal rooms plaster ceilings 'elaborately decorated', according to Eastlake, 'in low relief'.[47] In the double-height Great Hall, the oak panels were, according to *The Building News*, 'carved with work of a quaint and intricate pattern, somewhat of a Japanese character',[48] an opinion already expressed by Eastlake, in much the same words, nine years earlier.[49] Nesfield designed *kiku* (chrysanthemum) *mon*[50] overlapping with sunflowers for the music gallery in the Great Hall, and large, intersecting rose-shaped patterns in beaten lead for the external balcony.[51] Many years later Brydon recalled how, at Cloverley Hall, 'the *motif* of the decoration is of a distinctly Japanese character, so cleverly adapted that there is no sense whatever of any impropriety. The touch of the master's hand,' he added, 'brings all into a delightful harmony.'[52]

The overlayering of roundels is a frequent occurrence in Japanese art, so its use here (and at Willesley) is not surprising. Similarly, the positioning of roundels in a rhythm incongruent to the ground is not unusual and this Nesfield proposed for the wall painting of the Great Hall where the *kiku mon* appeared to almost float like soap-bubbles across the key-fret pattern. In his article in *The Journal of the Society of Arts*, Leighton had drawn attention to this technique: 'Pattern upon pattern, and form upon form, are by no means uncommon in eastern art, but the way circular patches are placed upon frets and grounds is, I think, peculiar to China and Japan.'[53]

As Shaw had done at Willesley, Nesfield here used *mon* set within square frames, yet appearing to be overlapping, to decorate the bedroom balcony, while individual *mon* punctuated the parapet above. With his mind on the decoration of the Great Hall, Eastlake wrote:

It is to be observed that the scheme of this pattern, like that of others in the house, is eminently suggestive of a Japanese origin. The introduction of this *motif* in a modern specimen of the Revival may seem anomalous, but it has long been held by the most liberal of the Mediævalists that there are elements in decorative design common to good art of all ages, and certainly in this instance the oriental graft is most fruitful in effect.[54]

The adoption of *mon* represented a distinct step forward in both men's work. Prior to moving to Argyle Street, Nesfield had been making extensive designs for the enlarging and remodelling of Combe Abbey, near Binley, Warwickshire (1862–65) where roundels were used. Similarly Shaw, through the facility of Street's office, was also working with them. But in both cases the roundels were medieval, not Japanese, in design. Once tried, the *mon* continued to appear in their work throughout the 1860s; by Shaw at Leys Wood, Sussex (1868–69) and by Nesfield in the lodge at Kinmel Park, Denbighshire (1868). Although its use in furniture persisted throughout the 1870s, as an element of architectural design it was then to be replaced by the ubiquitous sunflower.

In September 1874, *The Building News* published an elevation of a new house recently completed on Bayswater Hill, London.[55] In the title panel, a *mon* separated the address of the house from the name of its architect, John James Stevenson, while in the foreground, two fine horses, harnessed to another *mon*, appear to be drawing it away. This house was to prove to be one of the most influential designs of the decade.

The Art-architects and Asymmetry

It was probably Brydon who introduced Stevenson to Shaw and Nesfield. Brydon had been an assistant to Stevenson and his partner, Campbell Douglas, before moving down to London in 1867. Stevenson left Glasgow the following year and in 1870 established himself in London as well. In 1871 he went into partnership with Edward Robert Robson, the newly appointed architect to the School Board for London and an old friend from the years which they had spent together in George Gilbert Scott's office in the late 1850s. In the same year, he began to build the Red House on Bayswater Hill.

There was very little about the Red House, apart from a blue-and-white Nankin vase positioned in a niche behind the first-floor balcony, to suggest a direct Japanese influence. Indeed, the vase itself was actually Chinese but nevertheless oriental, and the sunflowers which repeated along the cast-iron railings to the balcony might have been read as *mon*. The basic arrangement of the elevation, a tall bay window on one side and an attached porch on the other, was something even speculative builders were now doing in the great west London estates.[56] But two things were different. Firstly, the removal of the white stucco and the exposing of yellow London stock bricks with red brick dressings; and secondly, the use of eighteenth-century detailing in the dormers, the window openings, the porch and the pedimented niche which held the Nankin vase. Such a raw façade in a street of otherwise stuccoed elevations would catch the eye. And so would the tall, thin proportions of the windows and their small panes of glass, for large sheets of plate glass were now in common use.

Once noticed, this house might be examined, and the careful eye would detect the same forced asymmetry evident a few years earlier in Gothic guise at Skilbeck's warehouse. The strength of the street elevation, contained between the adjacent houses, was in the apparent bi-axial symmetry generated by the two dormer windows which rose above the building's cornice. But then, within this framework, one half of the elevation stepped forward as a polygonal bay while the other half, remaining flat, was punctuated by an assortment of irregularly placed windows (and a pedimented niche) which rarely aligned with the dormer above and never with the porch and its incongruous bull's-eye window below. Such asymmetry, deriving from the English Picturesque tradition, was not unusual in the more artistic houses of the time.

Philip Webb had tried it in a more (although not exclusively) Gothic manner at nearby 1 Palace Green, Kensington (1867–70) and Shaw was about to do the same in the Queen Anne style on the other side of Hyde Park at Lower Lodge, Kensington Gore (1872–75). But whereas both these buildings were free-standing, Stevenson's Red House presented a terraced elevation to Bayswater Hill and thus, like Burges' Skilbeck's warehouse, an ostensibly two-dimensional design.

While the Red House was being designed and built, Shaw was working on New Zealand Chambers in Leadenhall Street, London (1871–73). With its heavily glazed and pargeted façade based upon a seventeenth-century precedent at Ipswich,[57] it might at first glance offer little encouragement to the inquirer after Japanese influence. Similarly, the ground floor oriel windows, each one divided by white wooden glazing bars into 81 small panes of glass, recall eighteenth-century shop-fronts but, when seen with the plaster roundels which decorate the lintels above, might equally well be Japanese *shōji* to the roundels' *mon*. The elevation, arranged firmly in three bays with a central entrance, appears symmetrical until the manner in which the pedimented doorway is pushed to one side is noticed. The culprit here is another roundel, this time a bull's-eye window similar to that above the entrance to the Red House and divided once more into small panes of glass. This asymmetry was all the more jarring because it was so unexpected. Godwin visited the building soon after completion and in *Building News*[58] commented upon the changes apparent between the published drawing and the finished building: the three gables which emphasised the tri-axial symmetry of the building (as Stevenson had done with two gables at the Red House) had been substituted by smaller, boxy dormers which now peeked apologetically from above the great coved cornice.

What had been begun at the Red House and New Zealand Chambers soon came together under Shaw's hand in the house which he built for himself at 6 Ellerdale Road, Hampstead (1873–76). Once again the building is brick and bi-axial, with the left-hand gable commanding a polygonal window bay and the right, the *serliana* of the Ipswich oriels which recall New Zealand Chambers. The size of the windows shows that the left-hand bay contains just two floors while the other contains three, an asymmetry of plan now evidenced in the elevation. Between the two sets of windows are an assortment of apparently randomly placed windows of different sizes and designs. Only the long one is recognisable as a staircase window. The others illuminate smaller rooms or provide additional light to the main reception rooms, the dining room to the left and the drawing room to the right. And to one side is a roundel, a bull's-eye window, lighting the stairs up to Shaw's 'den', where he would work, positioned above the dining room inglenook. Shaw's collection of blue-and-white Nankin porcelain hung on the leather-lined wall above the inglenook where roundels, now transformed into sunflower heads, decorated the half-timbering. A photograph in Herman Muthesius's *Die Englishe Baukunst in der Gegewart* (1900) shows additional plates displayed above the fireplace in the drawing room and a Japanese fan shielding the grate. Here roundels, now looking more like *mon* than metopes,[59] decorate the Ionic fireplace in an act of eclectic audacity.

The Art-architects and Japanese Woodwork

In July 1867 Richard Norman Shaw married Agnes Wood, almost 16 years his junior, at Hampstead Parish Church. As a wedding gift, Nesfield designed and had Forsyth make a six-panel Japanese-style folding screen, a *byōbu* in almost every way [5.01]. Decorated with 'pies' and cherry blossom, and finished with black lacquer, it was a prescient and timely gift. The Exposition Universelle had opened in Paris on 1 May and it is very likely that Nesfield, familiar as he was with Continental travel, soon made the short trip there. The Shaws, it is thought, went there that October.[60] Here one might look again at the Satsuma pavilion [see 4.01a and 4.01b]

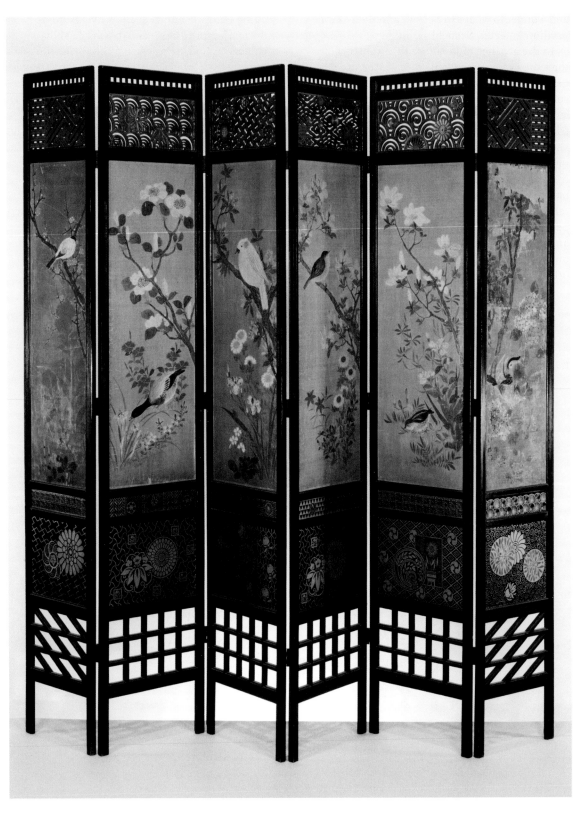

5.01 Folding screen, designed by William Eden Nesfield, for Agnes and Richard Norman Shaw, 1867.

and wonder to what extent that, and the *bakufu* pavilion, infected Nesfield's thinking.

In the absence of Japanese furniture, other than the *byōbu*, precedents for new furniture design had to be sought in architectural elements such as the *shōji* and *fusuma* which were used to subdivide and enclose the house; the *ranma* or frieze above the *shōji*; the *chigai-dana* (staggered shelves), the *tenbukuro* and *jibukuro* (high- and low-level storage cabinets), which were located in the *tokowaki* next to the *tokonoma*; and in balcony railings on the upper floor of houses or in taller buildings such as pagodas. The similarities between Godwin's sideboard of 1867[61] [5.02] and two of the *tokowaki* illustrated by Morse, one containing *tenbukuro* and *jibukuro* and the other *chigai-dana* with a stepped central portion

and set beneath a long, shallow *tenbukuro*, is informative:[62] the high- and low-level cabinets reappear in Godwin's design as do the stepped shelves with a long, shallow drawer above. The construction is all framework, panels and surface-mounted metal hinges or *omote chōtsugai*. It is a piece of Japanese furniture which no Japanese would then have immediately recognised: Godwin called it 'Anglo-Japanese'.[63]

There are many instances of furnishings, fittings and fixtures which took the irregular or diagonal gridded patterns of the *shōji*, *fusuma*, *ranma* and balcony railings as a source: Shaw used it in the nursery balcony on his own house on Ellerdale Road; Godwin used it in the studio dado and on the stair balustrade at Frank Miles's house in Tite Street, Chelsea (1878) and in the backs of

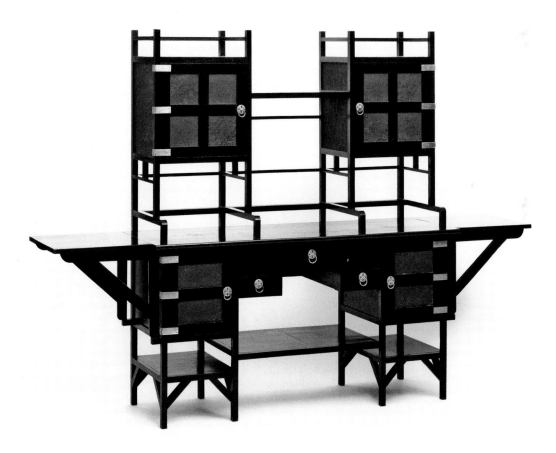

5.02 Sideboard, designed by Edward William Godwin, 1877–80.

chairs, such as the 'Jacobean' armchair made at about the same time by Collier and Plunket of Warwick. Algernon Bertram Mitford, the former second secretary at the British Legation in Tokyo, returned from Japan in 1870, the same year as Charles Nightingale Beazley began designing houses on the Westgate Estate at Westgate-on-Sea, Kent, for the west London developers William Corbett and Alexander McClymont. Although living in London, where he was now Secretary to H.M. Office of Works, Mitford commissioned Beazley to build the house called Exbury at 63 Sea Road, Westgate-on-Sea and in this design either the architect or the client, or both, displayed some of their enthusiasm for the Orient: the square gridded glazing bars have now gone from the windows but the spindly, paired and bracketed uprights supporting the balcony and the lean-to roof beneath the diaper-tiled gable remain, so fragile, so Japanese.[64]

Although at Mitford's Exbury the glazing bar's geometry once covered both the upper and lower sashes of the windows, it was often the way, as in other houses by Beazley along Sea Road, now mostly demolished, that only the top sash was subdivided by glazing bars, the bottom one being left open. This was a feature employed by Robert William Edis, a friend of Shaw,[65] when he modified the façade of the then recently completed 3 Upper Berkeley Street, London (now demolished), giving it a Queen Anne Revival touch and a lightness which the terrace's architect, the older Thomas Henry Wyatt, had failed to do when it was built in 1873.[66] Here, in the main rooms, he inserted 12 panes into the upper sash but just a single pane into the lower one. The appearance, if inconsistent, is arguably Japanese for in the Japanese house, the *arikabe*, the deep plaster frieze set above an external opening, corresponds to the seated position on the floor while providing shelter from the glare of the sky. In the same way these sash windows, when viewed from the inside, suggest an open but low-level view through the bottom sash and, due to the grid of *shōji*-like glazing bars above, a partly obscured view through the upper sash. Should the lower sash be fully run up and

the window left wide open, then the cold air might howl in through the opening as it does, during winter, in traditional Japanese houses.

The Art-architects and Ornamental Japonisme

With the move away from medievalism in English architecture in the 1860s and the adoption of, first, the Old English and then the Queen Anne Revival styles, the opportunity for the development of Japonisme in exterior architecture was reduced. Asymmetry, which the Japanese used to great effect, also had its place in the English Picturesque and thus found its way easily into the Old English and then the Queen Anne Revival styles. Unless English architecture could be divested of its historicist routes, as Godwin tried to do with his stripped-down elevations for James McNeill Whistler and Frank Miles in Tite Street, Chelsea, it was never going to respond fully to the new ideas coming from the East. In an article entitled 'Architectura vulgata', published in *The Architect* of 1875, Godwin argued for the adoption of an ordinary architecture, 'entirely', as he said, 'or almost entirely free from ornament, and void of those details that are so often taken as the beginning and the end of architecture'.[67] Yet Japonisme, as it became popular, was used by many architects as little more than ornament. The decorated plaster surface which Thomas Edward Collcutt applied to 109 Fleet Street in 1875 and published in *The Building News*[68] successfully reduced Japonisme to little more than a parody of itself: Edis's '*arikabe*' glazing pattern, described here as 'pen woodwork', is reintroduced, but so too, stamped into the plaster, are roundels of such variety and size (as well as sunflowers and other botanical decoration) that the whole effect is rather overwhelming [5.03]. Whereas the subtlety of Shaw or Stevenson's elevations had been in the use of asymmetry, the symmetrical formality of this elevation draws too much attention to the decorative system which hardly needs any

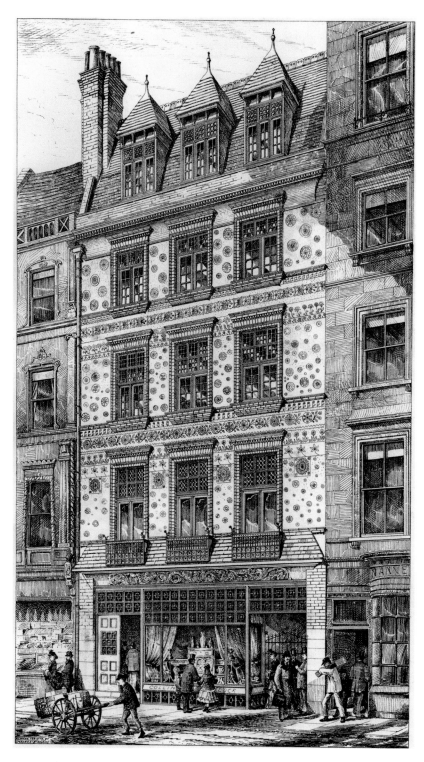

5.03 'Alterations to Old Front no. 109 Fleet-Street' designed by
Thomas Edward Collcutt, from *The Building News*, 1 October 1875.

emphasising. It is almost as if Collcutt has applied Japanese-styled wallpaper across the façade.

In 1870, Alexander 'Aleco' Ionides took over the ownership of 1 Holland Park, London,[69] from his father, the Greek Consul General and wealthy financier, Constantine Alexander Ionides, and set about remodelling it. From his time abroad he knew the 'Paris Gang',[70] which included James McNeill Whistler, Thomas Armstrong and George du Maurier; it would have been du Maurier who in turn introduced him to his great friend, the Norwich architect Thomas Jeckyll. Although Ionides was later to commission work from Philip Webb and William Morris, it was Jeckyll whom he first chose to add a billiard room, a morning room and a servants' hall to his house. Jeckyll was perhaps an unlikely choice; Pevsner describes him as 'an interesting, erratic architect' and is quite dismissive of his Norfolk churches.[71] Yet, in the 1860s, Jeckyll had begun to make a reputation for himself with cast- and wrought-iron designs which the Norwich iron-founders Barnard, Bishop and Barnards commissioned from him. His park gates, which were exhibited at the 1862 Exhibition, were widely praised and subsequently bought by the City of Norwich as a wedding gift for the Prince of Wales and installed at Sandringham in 1863. In May 1862, du Maurier wrote to Armstrong[72] that 'Tom Jeckell's [sic] "Norwich Gates" for a park are one of the finest things in the International, and he is making lots of money.'[73]

Jeckyll was, together with Burges, Nesfield and Shaw, amongst the first of the art-architects to adopt the Japanese decorative arts. Although based in Norwich he had, from the mid-1850s, spent an increasing amount of time in London, acquiring an 'agent'[74] there in 1857, and opening an office there five years later. The Norwich connection, however, was important for it was through his work with Barnard, Bishop and Barnards that he developed his Japanese style. His architecture was conventional enough, moving from Gothic to Old English and Queen Anne Revival, although the cricket pavilion which he designed for St John's College, Cambridge, has, in its heavy roof and verandah, something Japanese about it. The Norwich Gates contained

no hints of Japonisme but his Four Seasons Gates, which Barnard, Bishop and Barnards exhibited at the 1867 Exposition Universelle in Paris, did. Along the bottom of each gate was a square-grid lattice behind which were repoussée panels showing the four seasons – buds and blossoms for spring and summer, and berries and bare branches for autumn and winter. Small birds sat feeding on the boughs or, in summer, flew behind the lattice chasing insects. If this suggested a *shōji* with a Japanese garden beyond, the *verso* displayed sunflower or chrysanthemum *mon* set in the centre of each of the 58 square panels. The idea, however, probably came less from Japan than from *Trellis*, the first wallpaper William Morris designed. *Trellis* had been issued in 1864, the lattice and the tendril plant forms being drawn by Morris and the birds and insects added by Philip Webb. Both men were part of Aleco Ionides's artistic circle. The Four Seasons Gates were exhibited again at the Vienna Exhibition of 1873, where they were awarded a medal, and after which they were also known as the Vienna Gates.

Whether the lattice decoration on the Four Seasons Gates is evidence of Japonisme is, therefore, debatable. Apart from the *mon* on the *verso*, there was, here and over the next three years, little indication of a Japanese influence in Jeckyll's work. However, in 1870, coincident with the commission for 1 Holland Park, he introduced terracotta panels of definite Japanese extraction at the now demolished Rectory in Lilley, Hertfordshire (1870–71) and at other contemporaneous buildings.[75] Being moulded, bas-relief panels, these were similar in conception to the gates' repoussée panels.

It was Barnard, Bishop and Barnards who, in 1871, made the Holland Memorial Screen on Bedford Walk, Holland Park, to Jeckyll's design. Whereas the railings were conventional enough, the repoussée copper panels which provided a splash-back to the twin fountains were suggestive of a *byōbu*, decorated with an underwater scene of fish and rushes set, like the cherry blossom on the terracotta panels at Lilley, against a background of waves. From their foundry came, over the next few years and in increasing numbers, Japanese-style gates, fenders and ashes pans, and, in particular,

stove fronts. The first slow-combustion cast-iron stove to display Japanese decoration was designed by Jeckyll in 1873 and showed chrysanthemum *mon* set against a diagonal pattern of interlocking T-shapes – 'Japanese key-diapers'. Later variations followed, larger and sometimes in brass, but always with *mon* or roundels containing plants or birds, set against a diapered or reeded background. The designer and critic, and founder member of the Art Workers' Guild, Lewis Foreman Day described the stoves as being 'enriched with variously decorated circles (all of them very ingenious and many of them charming) set in Japanese key-diapers', before adding: 'the brutal mutilation of the circles by the boundary lines which cut them short relentlessly, is more Japanese than artistic.'[76] These stoves sold in their thousands and it was with the prospect of selling them to the American market that Barnard, Bishop and Barnards commissioned Jeckyll to design a cast-iron pavilion. This structure, which is discussed below, was the summation of Jeckyll's application of Japonisme to cast-work. The dog irons and the garden and railway station furniture which followed were really just spin-offs.

The Art-architect and the Japanese Interior

The addition which Jeckyll built at 1 Holland Park for Aleco Ionides might, with its bay window and tall chimney, have appeared, at first glance, to be as Italianate as the rest of the house [5.04]. Yet on closer inspection the white stucco walls can be seen to be incised with wave patterns and the soffit to the cornice decorated with overlapping *mon*. Such devices were now, in 1870–72, appearing in Jeckyll's decorative work and would soon be the staple of his stove-front designs. But what is really significant is the arrangement of the timber lattice-grid which covers the exterior, recalling at once the lower panels of the Four Seasons Gates, but also heralding the treatment of the interior. The spacing of the lattice is irregular and is generated by the arrangement of the mullions and transoms in the bay windows to the billiard room on the ground floor and the morning room above it. These, with their leaded lights, would be quite at home, in both style and design, in an Old English mansion such as Shaw was building

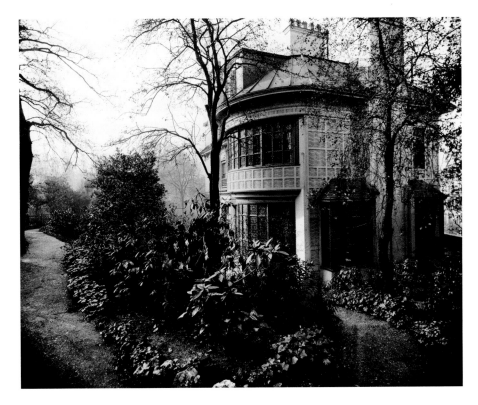

5.04 The exterior of 1 Holland Park, London, designed by Thomas Jeckyll, 1870–72.

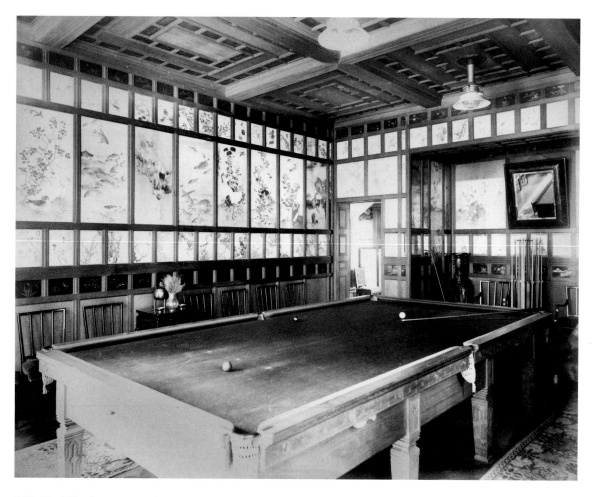

5.05 The billiard room at 1 Holland Park, London, designed by Thomas Jeckyll, 1870–72.

at the time. Thus there is a fusion or transition effected here between the late-medieval and the new Japonisme. And it is not restricted to the exterior, for the proportions of the windows similarly define the internal panelling and thus extend the rhythm of the external lattice-work around the rooms. The walls might be solid, but the suggestion, most explicit in the rectangular bay windows which flank the chimney, is of a light-weight, timber-framed and panelled structure. The conceit was taken further by the incorporation of Japanese paintings and prints within the latticed walls of the billiard room, evoking, perhaps, views over a distant Japanese

landscape [5.05]. Jeckyll also used Japanese red-lacquered trays to infill the lattice and decorate the heavy-beamed ceiling, as well as providing a background to the *étagère* above the mantlepiece in both the dining room and the morning room, against which Nankin porcelain was displayed. It was as complete a Japanese architectural expression as had been achieved at that time.

The interiors which Jeckyll designed in 1875–76 for the Liverpool ship-owner, Frederick Leyland, at 49 Princes Gate, London, were, in the main, less Japanese but the over-painting which James McNeill Whistler worked on the dining room to create the

famous Peacock Room has imbued Jeckyll's design with a reputation for the exotic which really belies its original intent.

49 Princes Gate was, like 1 Holland Park, an Italianate, speculatively built house of the mid-1850s, but larger and with a better address. Leyland bought the house in 1874 and almost immediately began to create a 'Palace of Art'. Although it is thought that Leyland employed Jeckyll on the advice of Murray Marks,[77] a leading London china dealer from whom he had bought a large collection of blue-and-white porcelain, he might well have met him through Whistler who frequently invited himself to stay for lengthy periods at Leyland's Liverpool home, the sixteenth-century Speke Hall. Whistler's rear-view portrait of Leyland's wife Frances, *Symphony in Flesh Colour and Pink*, was painted in 1871–74. Although Jeckyll's commission included work to the stairs and entrance hall, as well as a study for Leyland, it was the dining room which was the most demanding. Here, Leyland wanted to display both his porcelain collection and Whistler's large portrait, *Princesse du pays de la porcelaine* (1864–65), as well as hanging the walls with sheets of old (but hardly antique) Dutch leather, painted with twisted ribbons of roses and summer flowers, which Marks, himself Dutch, had sourced for him.[78] Such leather, brought in by the Dutch, had been available in Japan since the seventeenth century and, by 1872, the Japanese had perfected a way of manufacturing 'leather paper'. So Jeckyll's use of the original Dutch leather here could actually be seen as an expression of Japonisme, for the Japanese imitation was already on sale at Liberty.[79]

The arrangement of the dining room was, in a way, not unlike the billiard room at 1 Holland Park: the walls below the dado were panelled while above, the thin uprights and horizontals of the walnut *étagère* divided the walls into a lattice of irregular rectangles like *chigai-dana*, each designed to accommodate a specific piece of porcelain. No longer did this lattice screen a distant view but instead provided a sort of cabinet of curiosities which wrapped itself around the room. The only painting was the *Princesse*, hung in a recess above the fireplace in a frame designed by Whistler and decorated with *mon*. At 1 Holland Park, the mullioned and transomed windows and the beamed ceiling recalled late-medieval architecture; here at 49 Princes Gate, the flat, wooden-rib ceiling (albeit with pendant gas lights) was identical to that of the Great Watching Chamber (1535–36) at Hampton Court Palace.[80]

The relationship between Whistler and Jeckyll should here be touched upon. As the dining room neared completion in April 1876, Jeckyll expressed to Leyland some uncertainty as to what colour to paint the doors and shutters. Leyland therefore asked Whistler, who was then busy redecorating the entrance hall, and whose *Princesse* was soon to hang in the dining room. At his invitation Whistler began to transform the dining room, first painting the walnut shelving and then the Dutch leather. Golden overlapping roundels soon spread across the walls and wainscoting, and covered the ceiling, while peacocks lined the inner faces of the shutters. When Leyland refused to pay him what he asked, Whistler added to the wall facing the fireplace and the *Princesse* two strutting peacocks, one representing himself and the other Leyland, and called the room the 'Peacock Room or Harmony in Blue and Gold'.[81] If Jeckyll, who had become ill with manic depression and was no longer involved with the job, was in a fit state to object to this transformation of his design, he appears not to have done so. In September 1876, even before the room was completed, Whistler wrote to both *The Builder* and *The Academy* anxious to point out that the 'proportions and graceful lines' of the dining room were Jeckyll's alone;[82] and once the room was finished he wrote, in February 1877, to Jeckyll's brother, Henry, expressing his distress at the architect's illness and assuring Henry, in the most obsequious way, that there was no greater admirer of Tom Jeckyll than himself.[83]

The Art-architect and the Artist

In an article called, belligerently, 'Red Rag' and published in *The World* in May 1878, James Abbott McNeill Whistler wrote:

Art should be independent of all clap-trap – should stand alone, and appeal to the artistic sense of eye or ear, without confounding this with emotions entirely foreign to it, as devotion, pity, patriotism, and the like. All these have no kind of concern with it; and this is why I insist on calling my works 'arrangements' and 'harmonies'.[84]

He then referred specifically to the famous portrait of his mother which, when first exhibited at the Royal Academy in London in 1873, was called an *Arrangement in Grey and Black.* Painted in 1871, this composition was followed in 1873 by another *Arrangement in Grey and Black (No.2)*, this one a portrait of the Scottish historian and essayist, Thomas Carlyle. The two compositions are very similar although the canvases are of different proportions. What comes through clearly in both 'arrangements', as Whistler called them, is the use of the Golden Section and a sense of forced asymmetry. The fact that the subjects of both portraits are, apparently, anonymous is also of significance for it draws attention away from the sitters towards the compositions.

In 1877 Whistler commissioned his friend Edward William Godwin to build him a house, including a teaching *atelier*, on land leased from the Metropolitan Board of Works in Tite Street, Chelsea. Whistler's friend and Chelsea neighbour, Algernon Mitford,[85] might have regretted that he allowed Whistler to give his name as a referee for the lease, for the negotiations which followed proved to be long and troublesome.[86] Despite its name, the White House (which was adopted only when the building was well underway[87]), it was not the colour but its composition which would have made it really stand out against the ornamented yellow stock-brick and red-brick trim of the adjacent properties. This, together with the fact that Whistler had actually started building long before any building permission was sought from the Metropolitan Board of Works, was more than the Works and General Purposes Committee could accommodate and it was almost inevitable that the project was going to have a rough ride.

The street elevation of the design eventually submitted to the Metropolitan Board of Works,

showed a heavy, green-slated gambrel roof pressing down upon a wall barely two storeys in height, punctuated by irregularly sized and almost randomly placed windows and doors [Plate 10]. The wall and the parapet above were, for the greater part, of red brick but large, irregular panels of white stucco separated the upper windows and threw into confusion the notion of the brickwork acting as a plinth or base. Although George John Vulliamy, the Superintending Architect with the Metropolitan Board of Works was, on consideration, prepared to accept the design, his Works and General Purposes Committee was not and two further designs had to be submitted.[88] Even so, Vulliamy thought the design to be 'like a dead house' and refused to issue a lease unless further changes were made.[89] The 'comprehensive modification to the elevation'[90] for which he was asking involved the raising of the parapet along the left-hand half of the elevation to hide the gambrel roof which was thought too heavy – or maybe too rustic. The doorway displayed a certain amount of moulded decoration but this was presumably thought inadequate and panels of cut and rubbed brick, in the Queen Anne Revival fashion, were added to link the upper and lower windows and to relieve the newly raised parapet. Perhaps the most significant change, however, was to reduce to a flat plane the subtly articulated elevation where the doorway and surmounting tower had originally been set back from the façade. What had been, to paraphrase Whistler, an arrangement or a harmony of asymmetrical solids and voids, became compromised by clap-trap. The similarity of the composition, when compared to Whistler's *Arrangement in Grey and Black (No.2)*, cannot be missed nor, for the aficionado of Japanese prints, would have been the relationship between the heavy gambrel roof (which contained the *atelier*) and the compressed street elevation: this was the Japanese roof such as Robert Fortune had written about in 1863. Unfortunately, Whistler's bankruptcy in 1879[91] forced him to sell the White House and the new owner, the art critic Harry Quilter, made substantial alterations to the building, much to Whistler and Godwin's displeasure. The resulting mess was demolished in 1968.

The 'arrangement' of the first elevation would suggest, directly or indirectly, Whistler's hand. Indeed, it is hard to imagine that he could have stepped back from the project, so keen was he to get the building built. The Whistler Correspondence held at the University of Glasgow shows his continual involvement, although much of his concern was with the financing of the works which was dependent upon Vulliamy approving the design. Volatile and artistically emotional, Whistler felt that he had fought most of the battles himself and was at one point inclined to let the whole thing go to hell.[92] Vulliamy, it appears, was equally frustrated, finding the works not progressing in accordance with his given approval. He complained that Whistler had behaved in a most unbusinesslike way and had acted in direct violation of the agreement which he had signed with the Board.[93] It would be wrong, therefore, to separate Whistler the artist from Whistler the designer of architectural form. As well as drawing upon the flattened perspective of the Japanese wood-block print, his two *Arrangement in Grey and Black* paintings are thoroughly architectural in composition. His *Nocturne: Blue and Gold – Old Battersea Bridge* (1872), which is based upon the view of Mount Fuji from under the Fukagawa Mannen Bridge, a wood-block print by Hokusai, shows his interest in both Japanese prints and architectural form.

In 1878, Godwin ran into further trouble with the Metropolitan Board of Works with the house which he designed in Tite Street for George Francis 'Frank' Miles: 'Why, this is worse than Whistler's,' exclaimed Vulliamy.[94] Frank Miles was a pastel portraitist who had 'discovered' Lillie Langtry and was an enthusiast for flowers, introducing a number of Japanese varieties into England. Smaller than the White House, his house was intended to be no less radical, the asymmetrical elevation balancing the tall studio windows with the heavy but diminutive entrance porch which, with its Doric frieze, contained the only conventional architectural expression [Plate 11]. Elsewhere sgraffito decorated the otherwise plain façade which at the level of the studio was cut across dramatically by a broad balcony, supported on deep, tapering corbels. As in the initial design for the White House, it was through the modulation of the façade rather than an unconventional palette of materials that the architectural effect was sought. Godwin intended to use the yellow stock and red bricks common to London architecture, together with green slates and terracotta ornamentation. But this design was not carried through and what was eventually completed in 1880 retained only traces of the original composition, an ornate Dutch gable appearing above the studio windows and a moulded brick surround to the doorway. 'I introduced a number of reminiscences of a visit to Holland,' Godwin later recalled, 'and the thing was pronounced charming.' This, he added, was 'very sad. I am bold enough to say I am a better judge than the Board of Works as to what is right in architecture.'[95]

If Godwin's response to the influence of Japanese design on Miles's house remained only in the asymmetry of the street elevation, it was clearly expressed within. The woodwork of the stairs assumed the irregular grid of Japanese timber railings and the newel posts were capped (as on the external balcony) with brass *giboshi* (finials) imitative of the way in which the exposed beam-ends in Japanese temples are protected. Godwin had used cast-iron grates, designed by Jeckyll, at the White House and these he reintroduced here. He also incorporated the idea of the *arikabe* into the tall studio windows, subdividing the upper half of each window into 48 small panes while glazing the lower half with two uninterrupted sheets of plate glass. If notions of Japan were not apparent in the exterior, they were certainly invoked from the inside. Here Miles painted Lillie Langtry[96] and here he lived with Oscar Wilde.

The Art-architect and America

Godwin was to design interiors for both Lillie Langtry[97] and Oscar Wilde,[98] but before both became, each in their turn, the toast of American society,[99] Japonisme had crossed the Atlantic.

Although the New York designers of decorative arts, Charles Tiffany and, more particularly, his son Louis Comfort Tiffany, had for some years been adopting, in their work, Japanese features derived from sources such as Hokusai's *manga*, it was the occasion of the 1876 Centennial Exposition in Philadelphia which really brought an awareness of Japanese design to the American public. As Morse later observed, 'The Japanese exhibit at the Centennial exposition in Philadelphia came to us as a new revelation ... It was then that the Japanese craze took firm hold of us.'[100] Encouraged by the visit that year of Christopher Dresser, en route to Japan, and the publication the following year of William Watt's illustrated catalogue of *Art Furniture from designs by E.W. Godwin FSA and others: with hints and suggestions on domestic furniture and decoration*, Japonisme soon secured its place in the American home.

Japan was the only oriental country to participate in the 1876 Centenary Exposition at Philadelphia and its contribution has already been discussed. But theirs was not the only Japanese pavilion; there also came one from England, made of cast iron, and designed by Thomas Jeckyll. This was the showpiece in which Bernard, Bishop and Barnards intended to display their combustion stoves. The idea of an oriental cast-iron pavilion was not altogether new. At the Cremorne Gardens,

5.06 Decorative detail designed by Thomas Jeckyll for an ornamental pavilion in cast- and wrought-iron, made by Barnard, Bishop and Barnards of Norwich, 1876.

a pleasure ground by the River Thames in Chelsea, there had been built in 1845 a three-storey cast-iron pagoda, 'the inclosing ironwork ... enriched by Defries and Son, with devices in emerald and garnet cut-glass drops, and semi-circles of lustres and gas jets, which have a most brilliant effect'.[101] Known as the 'Chinese Platform', it was able to accommodate a band at the middle level and 2,000 to 3,000 dancers below. These pleasure grounds were frequented and painted by Whistler[102] and it is probably safe to assume that Jeckyll, a bachelor, was not an infrequent visitor as well.

Had Jeckyll, as his friend du Maurier did,[103] visited the 1867 Exposition Universelle in Paris in 1867, where his Four Seasons Gates were on show, he might also have seen the elaborate Chinese Pavilion. If not, he could have known it from François Ducuing's *L'Exposition universelle de 1867*, or other contemporaneous publications. The combination of the two-storey structure and the gambrel roof with its concave or hollow-curve eaves offers a striking precedent for his Philadelphia pavilion designed nine years later. As a two-storey structure, Jeckyll's pavilion could never have been built out of timber as would have been a real Japanese (or Chinese) pavilion. The heavy brackets and rich decoration which Jeckyll achieved in cast iron [5.06] certainly suggest Japanese timber structures, such as the gateway to the Todai-ji at Nara, but the legs, had they been in timber, were too spindly for the substantial superstructure; in Paris, a central core had supported the upper storey of the Chinese pavilion. As at Cremorne Gardens, where the dancing area is surrounded by a low railing, Jeckyll introduced, around his pavilion, a cast-iron railing decorated with sunflowers. This was unfamiliar but, again, not without precedent. In 1869, an illustrated essay by Aimé Humbert[104] called 'Le Japon' was published in London as part of Alfred Grandidier's *Le Tour du monde: nouveau journal des voyages*.[105] This contained a curious drawing of the 'Danse des prêtres de Founabas' showing a number of priests dancing around a lightweight temple enclosing a Buddha. This drawing, together with many others of Japan, was included in the 1874 English-language edition of what had now become a substantial book

5.07 An ornamental pavilion in cast- and wrought-iron, designed by Thomas Jeckyll and made by
Barnard, Bishop and Barnards of Norwich, in 1876. The pavilion was first exhibited at the 1876 Centennial
Exposition in Philadelphia and then at the 1878 Exposition Universelle in Paris. It was finally re-erected,
as seen here, in Chapelfield Gardens, Norwich, but was demolished in 1949.

by Humbert, *Japan and the Japanese*.[106] Although the
structure is different, it is, like Jeckyll's pavilion,
fragile, and the railings separating the dancing
priests from the Buddha could almost represent
sunflowers.

In manufacturing the pavilion, Barnard, Bishop
and Barnards used cast-iron for the structure
and wrought-iron for the ancilliary parts, such as
the railings at the upper level, which Lewis Day
described as 'a kind of Japanese open fret-pattern
formed wholly of straight lines',[107] and for the
sunflowers railing below. Day described the latter
as 'one of the boldest and at the same time the
most successful examples of modern wrought-
iron work'.[108] Indeed, the sunflower design was
afterwards adapted by Jeckyll for andirons and
marketed by Barnard, Bishop and Barnards. In
distinguishing the cast- from the wrought-iron,
Day pointed out that in the West cast-iron was
a modern material, medieval ironwork being
hammered (or wrought), and that Jeckyll had
'recognised, what others seem to have ignored,
that the Japanese metal workers were artists too,
and, artists who knew more about casting than

any others. His designs for cast iron,' he asserted,
'is distinctly founded upon the Japanese.'[109] Day's
analysis and criticism was considered. The editorial
comment which accompanied the article in *The
British Architect and Northern Engineer* was a more
blunt assessment of the pavilion:

> Whilst we can only speak in the highest terms of
> the thought and skill displayed in the charming
> detail of Messrs. Barnard's Pavilion, we cannot
> but think it is like a throwing away of good
> work on a combination which is anything but
> charming, and pretty nearly useless.[110]

Following the closure of the Centennial Exposition,
the pavilion was transported back to Europe and
erected at the 1878 Paris Exposition. It eventually
found a home in Chapelfield Gardens in Norwich
[5.07], from whence it had come, and remained
there until, following wartime bomb-damage, it
was demolished, in 1949 – something which the
Norwich-born architectural critic Reyner Banham
described in a lecture of 1953 at Norwich City
College as 'absolutely scandalous'.[111]

Christopher Dresser's appearance at the Centennial Exposition, where designs of his were on show, had an almost ambassadorial effect for the promotion of Japonisme in America, although he was still on his way to Japan. 'One of the most perfect specimens of art intellect shipped to the United States for exhibition at Philadelphia,' wrote the *New York Times*, 'was, without doubt, Dr Christopher Dresser, Ph.D., F.L.S., F.E.B.S.'[112] Dresser was a Glaswegian Scot by birth, although this was apparently not immediately perceived. 'The Doctor, as he is generally termed, is a full-grown Cockney – black of beard, bright of eye, and who would talk a man into a state which American ingenuity illustrated some time ago by a skeleton in a deal box; but his chat is charming ...'[113] His charms were presumably in evidence at the three lectures which he gave at the Pennsylvania Museum and School of Industrial Art, and must have had their effect on the Tiffanys. 'Dr Dresser,' the *New York Times* reported, 'seeing that art in America is still subservient to trade, accepted an order to the amount of several thousand pounds from Tiffany & Co. to supply them with Japanese rarities, which, while on exhibition at the store, have a far greater interest than those exhibited in a museum.'[114] In the event, he purchased 8,000 pieces of ceramics, enamel, lacquer, metalwork and textiles for them which they subsequently sold at prices varying from 10 cents for a pocket mirror,

to $1,000 for an enamel screen. The availability caused a popular sensation as the *New York Times* could not fail to notice. 'The bronze department of the well-known house of business, generally so quiet in its grandeur at this time of the year, is in an uproar – a Japanese uproar – at the present time. The whole of the side on Fifteenth-street is invaded by the Japs ...'[115]

As *The Atlantic Monthly* said, the clean lines and simple elegance of these Japanese objects made everything else look 'commonplace and vulgar'.[116] The same simplicity was carried through to the interior of the Japanese Commission Building, which the *Centennial Portfolio* described as having 'costly carpets of odd design' and 'curtains of vegetable fibre, which keep out the sun, but admit the air'.[117] Although there is no mention of *tatami* – perhaps they were covered by the costly carpets – the overall impression, to the American audience, must nevertheless have been somewhat bleak. Therefore the publication the following year of *Art Furniture from designs by E.W. Godwin FSA and others: with hints and suggestions on domestic furniture and decoration* by the furniture maker William Watts was timely for it showed how Japonisme could suit Western living. A Japanese-styled cabinet designed by Godwin had been exhibited at the Exposition[118] and now this slim volume of Anglo-Japanese designs also provided an indication of the sort of rooms in which such

5.08 Frontispiece to *Art Furniture* (1877), by Edward William Godwin.

furniture should be used. The frontispiece to *Art Furniture* showed a panelled interior with ornamental fretwork in the *ranma* (frieze), decorative *giboshi* (finials) on the newel posts, *mon* on the furnishings, blue-and-white china plates on the wall and a Japanese lantern hanging from the ceiling [5.08]. The fluidity of space, noticed in Shaw's houses of the time, is also hinted at and the lady of the house, like Godwin's own love-children by Ellen Terry, is wearing a *kimono*.

The newly established *American Architect and Building News* had, in its first year, 1876, contained both a series of articles on the Japanese building at the Centennial Exposition[119] and, more importantly, an article on Japanese houses.[120] As well as describing the fragility of the structure and their susceptibility to fire, the article drew attention to the weight and solidity of the roof and referred readers to the British journal, *The Building News*, where, in 1875, Godwin had written two articles on Japanese wood construction.[121] 'The roofs of Japanese buildings,' Godwin noted, 'are, or at any rate have been, the chief delight of Japanese architects ... The eaves, the hips, the gables, the ridges, are most of them designed with wonderful fancy, and wrought with marvellous complication.'[122] Godwin then sought to explain the nature of the Japanese roof in terms of the ground plan, noting that the almost universal use of the verandah had led to the concave or hollow curve of the Japanese roof. Where this was successfully affected, Godwin found it graceful; where not, he claimed that 'by bold emphasis, a piquant picturesqueness results, and the quaint side of the Japanese character is revealed.'[123] The dominance of the roof, where eaves, hips, gables, ridges and particularly verandahs were all part of the vocabulary, made this new awareness of Japanese architecture very timely. It resonated well with Alexander Jackson Downing's eulogy, of 1850, for the board-and-batten or 'Bracketed Farm-house in the American Style': '... our climate and the cheapness of wood as a building material, will, for a long time, yet, lead us to adopt this as the most pleasing manner of building rural edifices of an economical manner.'[124] And it dove-tailed

nicely with what was then emerging, through the architecture of Henry Hobson Richardson, McKim, Mead and White, and Bruce Price, as the Shingle Style.

The other significant point which *The American Architect and Building News* alighted upon was the impermanence of the Japanese house interior. 'At any moment,' it said, 'any partitions can be taken down, and two or more rooms, or the whole house, be thrown into one large apartment, broken only by the posts which marked the corners of the rooms.'[125] The flexibility which this implied might have been unknown to the American reader but would have had a special resonance in a building industry where the majority of domestic buildings, unlike those in England, were timber-framed. Yet the corollary still was beyond the imaginings of Western architecture:

> ... screens, windows, and shutters, in fact, are considered as furniture, not as fixtures. Houses are usually sold or let without them; and, when a tenant quits or a proprietor sells a house, he takes them all away, and leaves to his successor only a solid roof and floors, held together by a strip or two of plastered wall and a few slender posts, through and through which all the winds of heaven may dance.[126]

It was to be 75 years before the American house could properly reduce itself to this condition.

Even before the Centennial Exposition, Japonisme had been finding its way into American architecture. Henry Hobson Richardson, who had been in Paris from 1859 to 1865, studying at the École des Beaux Arts (where Richard Phéne Spiers was a fellow pupil) and in the *atelier* of Louis-Jules André before going, in 1862, to work for Théodore Labrouste, cannot have been immune to its influence, although the architects for whom he worked were traditional and conservative. He would have been in Paris in 1862, when the Japanese ambassadors, staying at the Hôtel de Louvre on the Place du Palais Royal, were received with great pomp by the Emperor Napoleon III at the Tuileries. He might also have travelled to London for the 1862 Exhibition and seen the work displayed there of

which the ambassadors were so critical. Richardson was certainly interested in Japanese design, but from what date it cannot be said. The inventory of his library and other personal possessions, prepared following his death, lists George Audsley's *The Ornamental Arts of Japan* (1882–84) as well as Edward Morse's *Japanese Homes and Their Surroundings* (1885) amongst his 233 books on architecture and art; although these two titles come late in his career, he did own a copy of William Burges's *Architectural Drawings*[127] (1870), and here Burges the medievalist was at his most demonstrative. Richardson's library, as shown in Mariana Griswold van Rensselaer's monograph,[128] published in 1888, two years after the architect's death, had roundels or *mon* set within square tiles above the fireplace and larger *mon*, at least one representing a chrysanthemum, decorating the wallpaper above the book shelves. Although no Japanese wood-block prints can here be seen, the inventory also lists 'vases, jars, lamps, casts, bronzes, bowls, clocks, plaques, bric-a-brac'. Yet, having said that, there is little evidence of Japonisme in Richardson's work following the departure of his young and talented chief assistant, Stanford White, in 1879. When White indicated his intention to leave, Richardson wrote to him, 'I can never hope to fill your place to me or in the office ...'[129] It might not be far wrong to suggest, therefore, that White was to Richardson what Godwin was to Burges – the aesthete to the medievalist – and White's life was certainly as colourful as Godwin's and his death, tragically, more so.

White never studied architecture in a formal sense, joining Richardson's office at the age of 18 to work alongside Charles Follen McKim. There he demonstrated a facility which must have been the envy of his peers and the delight of his employer. This gave Richardson the confidence to allow White increasing responsibility, particularly when they were designing houses.[130] Living and working in New York, White became close friends with the sculptor Augustus Saint-Gaudens, recently returned from studying at the École des Beaux Arts, and it was probably from him, and maybe his father, who wrote widely on music, art, literature and the stage,[131] or even through his father's

friend, John La Farge, that White learned of the new fashion for Japonisme. White's collaboration with Saint-Gaudens, an architect and a sculptor designing together, was unique in the American arts and while Saint-Gaudens was in Paris for the 1878 Exposition, for which he helped choose American paintings, White represented him in New York. Their collaborative project, the Admiral David Farragut Memorial in Madison Square, New York (1876–81),[132] was conceived at this time and finalised during White's visit to Paris in 1878–79; it clearly reflected, in the bas-relief female figures and the curve of the seat along the pedestal wall, the sensuousness then developing in European design. It is hard to imagine, therefore, that the incipient Japonisme evidenced in Richardson's office at this time, such as the chair designed for the New York State Capitol at Albany (*c.* 1876) and decorated with *mon*, or the sketch for a hall, unidentified and undated, where *fusuma* and *ranma* sit incongruously within a manorial setting – both of which appear as vignettes in van Rensselaer's book – were not from the hand of Stanford White.

The building which should be considered here is the house which Richardson built in 1874–76 at Newport, Rhode Island for William Watts and his wife, Annie Sherman [5.09]. The Watts Sherman House has been written about at length due to its significance as the progenitor of the Stick and Shingle Style.[133] Much of the discussion has been about whether it was the work of Richardson or of White who was to return to the house, soon after it was completed, to redesign the library, drawing room and hall, and to make a fairly substantial addition to the east elevation. However the house is considered, it is clear that the younger man's input must have influenced the Japonisme of the original design, for the new works, rather than complementing it (which, of course they do), can be seen to justify it.

The earliest published illustrations of the Watts Sherman House, which appeared in the *New York Sketch Book* in May 1875 and are thought to be drawn by White, show no obvious leanings towards Japonisme – apart from the heaviness of the roof.[134] By contrast with other recent houses

5.09 The Watts-Sherman House at Newport, Rhode Island, designed by Henry Hobson Richardson, 1875.

in Newport, such as Richard Morris Hunt's Griswold House (1861–63) and Peabody and Stearns' Matthews House (1871–72),[135] the Watts Sherman roof is low-slung and almost all-encompassing. Yet is difficult at this early stage, a year before the Centennial Exposition in Philadelphia, to attribute such a feature to Japonisme. It is more likely, as is often suggested, that the New England vernacular 'saltbox' encouraged this response: a photograph of the Bishop Berkeley House in Middletown, Rhode Island (1728) had been published in the *New York Sketch Book* the previous year.[136] The accepted opinion is that the principal influence on the Watts Sherman House was actually British. The view of the house from the north-west,[137] which appeared in the *New York Sketch Book* in May 1875, offers a very similar building to those Royal Academy drawings by Norman Shaw, such as that of Hopedene at Holmbury St Mary, Surrey (1873),[138] published in *The Building News*, in the early 1870s. These houses were in Shaw's Old English style of steeply pitched roofs and tall chimneys, half-timbering and tile hanging. An interior perspective of the hall and stairway at the Watts Sherman House is equally Old English, even if the ceiling beams appear more like scantlings than hearts of oak. An unpublished drawing of the Watts Sherman House, now from the south-east,[139] which borrows in part from Shaw's Preen Manor (1870–71),[140] as well as his Hopedene (1873–74),[141] provides the first indication of the influence of Japonisme in the Watts Sherman design. This might (or might not) be in the finial above the north-east gable, which appears similar to the Japanese-styled finials at Shaw's Glen Andred (1866–68),[142] as yet unpublished, but it is certainly in the *mon* which decorate the bargeboards of the south gable. Although perhaps a little indistinct in this drawing, the pattern is intentional and shows what was built. This is also what makes this drawing significant. For when the house was completed a year after the view from the north-west was published in the *New York Sketch Book*, the corresponding north gable, previously shown with exposed tiling, was now fully fitted with bargeboards decorated with *mon*. And there are other changes to the west elevation, all showing the

influence of Japonisme, which were not apparent in the published drawing. This suggests that the south-east perspective drawing was prepared later than its counterpart and after the decision to introduce the Japanese features had been made, which would explain why it was not published in the *New York Sketch Book* in May 1875.

The completion of the Watts Sherman House was almost coincident with the opening of the Centennial Exposition in Philadelphia.[143] To what extent the interest in the Japanese pavilion and its exhibits affected its design cannot be said, but the west or entrance elevation of the house displayed a number of recognisable Japanese features. Firstly, there were, flanking the second-floor windows in the great gable, two large *mon* squeezed in between the tiles and the window frame. These complemented the smaller *mon* in the decorative panel set at the top of the gable, a feature which had appeared in the published north-west perspective drawing; although the published drawing for Shaw's Grims Dyke (1870–72) showed a similar pattern in the pargetting, it did not include *mon*, nor was it effected in the finished building. The window arrangement at first floor level had also been altered (suggesting an adjustment to the plan of the hall and stair) and the Old English half-timbering had been changed to something similar to the Japanese pattern of woodwork which Shaw had used in the nursery balcony at 6 Ellerdale Road.[144] Elsewhere, Edis-style '*arikabe*' sash windows (that is, without heavy transoms) had been substituted almost throughout and where the leaded lights had previously been diamond-shaped, they were now square. All these modifications distanced the design from its Old English roots, as had the addition, relatively late in the design process, of the great west gable itself. It has been argued that this was certainly Richardson's hand[145] but the subsequent titivation with Japanese detail is most likely to be by White, for it provided the precedent for his later reworking of the building.[146]

There are further aspects to the treatment of the building which suggest an awareness of Japanese architecture but could equally well be seen as a response to American vernacular forms.[147] These

include the manner in which the wood was left untreated, in its natural state; the way in which the wooden singles on the gables were cut and laid to represent thatching;[148] and the emphasis in the horizontal apparent in the layering of the west gable. Richardson's eye was, however, still directed towards Europe, as his subsequent sketches and building designs show.[149] Meanwhile, two unexecuted designs for houses, the first for Rush Cheney (1876) and the second for James Cheney (1878), continue to show White's hand. Indeed, the perspective drawing for the James Cheney House in South Manchester, Connecticut,[150] which is clearly indebted to Shaw's drawing for Leyswood (1878–79),[151] bears Stanford White's signature. The houses are Old English and half-timbered in the manner of Shaw but both houses employed what Hitchcock calls 'glass beads set in stucco',[152] which could well be the bottle-bases as seen at Shaw's Willesley. The Rush Cheney House has bargeboards to match those on the north and south gables at the Watts Sherman House, while the James Cheney House not only has a large *mon* beside the entrance but also half-*mon* alternating left and right along the adjacent bargeboard.[153] This was the last piece of known work White did before leaving Richardson's office.

In July 1878, White and his friend and former colleague from Richardson's office, Charles McKim, sailed to Europe on the French steamer *Perière*. In Paris, where McKim had studied at the École des Beaux Arts in 1868–70, they joined Saint-Gaudens, who had rented a studio, and saw the 1878 Exposition.[154] A three-way partnership with William Rutherford Mead was formed after their return to America and thus, in 1879, McKim, Mead and White was born. That White would have begun work again on the Watts Sherman House in the same year is not surprising: he did this on Richardson's recommendation because, according to the second Mrs Watts, Richardson did not regard the interiors of the house as being complete.[155] White's new work involved the rebuilding of the south-east corner of the house and the rearrangement of the drawing room, library and hall, where he introduced *mon* into the stair newels (if not already there[156]) and blue-and-white Dutch tiles into the fireplace.

The library which White created in the former drawing room was panelled in the Colonial manner but within its gridded framework, Japanese-style fretwork decorated the low-level cupboard doors and was picked up in the plaster ceiling. What would have been the frieze was transformed into a gridded *ranma* punctuated with *mon*, and more Japanese-style patterning decorated the chimney breast. The shelves, unlike those at Jeckyll's recently completed Peacock Room, owed nothing to Japanese design but, like Whistler's painting scheme, it was richly coloured – dark green with the patterns picked out in gold. Did White know of the Peacock Room? Maybe not then but he certainly did later. In September 1895 he wrote to Whistler that he had gone with John Singer Sargent to see the Peacock Room and how delighted he was with it, adding, 'Before it was covered by your own splendid work, it seems to me that the room must have been one of the most damnably ugly and hideous rooms ever concocted.'[157] Even so, he had hoped to secure the room, should it come up for sale, for the new Boston Public Library,[158] since Leyland's house, he thought, was now in the hands of Philistines.

Architects who had not seen the Japanese Commission Building at the Centennial Exposition in Philadelphia could have read about it in *The American Architect and Building News* which described the use of the *shōji* and *ranma* in detail:

From the level of the top of the screen to the ceiling is a fixed frame or upper partition [the *ranma*]; and a slot in the bottom of this receives the upper ends of the screens [the *shōji*], which, being slipped into the slot, can be lifted enough to clear the rail at the foot, and allow the lower edges to slip into the groove ... The frames or partition-tops over the screens are plastered in the poorer houses; but in the better are filled with wood carved, often very richly, in open work.[159]

Having explained how the *shōji* could be inserted and removed, *The American Architect and Building News* also described how, with the removal of the *shōji*, 'the whole house [could] be thrown into one

large apartment, broken only by the posts which marked the corners of the rooms'.[160] This was a development which had not been seen in England and one which quickly characterised the American response to Japonisme.

The warm summer climate of Newport, Rhode Island lent itself well to this open, timber-framed architecture which contained space while, at the same time, allowed air to flow through. Here the spatial fluidity which *The American Architect and Building News* described began to emerge. The Newport Casino, built by McKim, Mead and White in 1879–81, made great use of *ranma* and perforated screens suggestive of *shōji*, allowing oblique views to be obtained from one part of the building to another or even right through the building itself. At the house which they built for the railway financier, Horatio Victor Newcomb, in Elberon, New Jersey (1880–81), only the *ranma*, curiously bowed on the underside, separated the central hall from its flanking bays and the drawing room positioned beyond the great central fireplace. Here the continuity of the floor, patterned as if to suggest the ribboned edges of *tatami*, and the continuous *nageshi* (the head-height beam), albeit curved where it passed across the window bays, served to visually combine the spaces.

By the mid-1880s, the more obvious insignia of Japonisme, such as the *mon*, had been dispensed with in favour of the more profound statements. Roof slopes became longer and gable ends bolder. Arthur Rich, Arthur Little and John Calvin Stevens all brought their shingle roofs down low while William Ralph Emerson also perforated his façades, thus emphasising the thinness of the building's wooden envelope.[161] Clarence Luce's Joseph House at Newport (1882–83) pulled the parlour and boudoir back so far beneath the great two-storey end-gable that that end of the house almost reverted to the Japanese trope of a house comprising a floating roof and a raised ground plane.[162] At the McCormick House at Richfield Springs, New York (1880–81), McKim, Mead and White allowed the roof to cascade down in a series of sheltered layers which emphasised both the horizontality of the form and the weight of the roof. It was a gesture

which they exceeded for boldness only at the Low House at Bristol, Rhode Island (1886–87) where the architecture is reduced to one great, triangular gable. Despite its appearance as a proto-Classical pediment with a surrounding cornice, this design is as much the Japanese house. The heavy roof floats above a façade which is both open and, in the undulation of the polygonal window bays, flexible. It is as if these close-paned windows were *shōji* and their folded forms, a *byōbu*. Inside, the great hall fireplace broke free from the walls, like an altar, shrine or *tokonoma*, completing the move which the hall fireplace at the Newcomb House had begun. There, the hall fireplace had conjoined that of the drawing room; here it conjoined that of the dining room. Thus, once again, space could flow uninterrupted from the hall to the principal rooms, although their relationship with each other remained axial.

The fluidity of space and transparency of form marks the final stage of this progression. In each of a pair of houses built in Tuxedo Park, New York – one for Winthrop Astor Chanler and the other for William Kent, and both of 1885–86 – Bruce Price adopted a great, two-storey, triangular gable but beneath it, on the raised ground floor, swept away any pretence of containment. At the Chanler House, polygonal bay windows, arranged in pairs around the principal living rooms and folded back beneath the upper floors of the gable, are *shōji* to the surrounding *engawa* [5.10]. And at the Kent House, where the parlour is flanked on three sides by the *engawa* as it recedes beneath its gable, diagonal views cut through the interior and, for the first time, achieve a fluidity of space that McKim, Mead and White, then building the Low House, could not achieve. There, the use of axis and the classical enfilade resulted in containment.

'Exploding the box' is what Frank Lloyd Wright called this process and, within three years of Price's houses at Tuxedo Park, Wright had embraced all the same moves in his own house at Oak Park, Illinois (1889). The great roof, once again a triangular gable, floats above the recessed ground floor where the polygonal bay windows fold back like *shōji* within the *engawa*. From the entrance hall at the bottom of

5.10 The Winthrop Astor Chanler house, Tuxedo Park, New York, designed by Bruce Price, 1886,
from *Architecture*, 15 May 1900 (here incorrectly called 'Chandler').

the stairs the view cuts diagonally across the living room to the dining room, unimpeded by doorways and passing freely through broad openings from which imaginary *fusuma* appear to have been withdrawn. High panelled wainscoting and picture-rails as low as an *arikabe* divide the interior into broad horizontal bands in anticipation of the Japanese interiors which Wright had never seen but were soon to be created for the World's Columbian Exposition of 1893. Japonisme in architecture had now come of age and the Winds of Heaven were soon to dance.

6 THE MANNERS OF THE WEST

In 1875, *The Builder* had reported that 'The Japanese ... seem possessed by a perfect mania for introducing the civilisation, the inventions, and the manners of the West.'[1] The following year, Richard Henry Brunton,[2] a Scottish engineer who, in 1868–76, acted as a lighthouse builder in Japan, confirmed this impression in a paper read to the Asiatic Society of Japan:

> In the minds of the modern Japanese there seems to be the same desire for the adoption of a dwelling constructed after a European mode, as for the adoption of European clothes. They argue, with a show of reason, that the one is as necessary as the other. Europeanized dwellings are therefore now common.[3]

With the arrival of Westerners, following the establishment of trading rights through the Ansei Treaties[4] (the 'unequal treaties') of 1858, came Western architecture. The only existing example of Western architecture in Japan was to be found at Dejima but soon Western-style buildings appeared in the foreign-settlement concessions at the treaty ports. These buildings were either an extension of the colonial architecture of China, Hong Kong and India, built by or for Western 'adventurers', or a Japanese simulation of what was thought to be Western architecture. This *giyōfū* or pseudo-Western-style architecture combined Western design with traditional Japanese building practices.

During *bakumatsu*, the last years of the Tokugawa dynasty and throughout the ensuing Meiji era (1867–1912), *o-yatoi gaikokujin* (hired foreigners) brought in to help modernise the country did much to change the understanding of Western architecture through both example and education. The result was that by the 1880s, the Japanese could largely dispense with the *o-yatoi gaikokujin* and develop their own version of Western architecture. With the advancement of Modernism in the West, following the First World War, so came Modernism to Japan, until, in the later Taishō (1912–26) and early Shōwa (1926–89) periods, a nationalist reaction set in and the *teikan-yōshiki* or Imperial Crown style emerged.

Bakumatsu Architecture

The Ansei Treaties allowed Nagasaki, together with Kanagawa[5] and Hakodate, to open to British traders on 1 July 1859.[6] In early 1860 the Nagasaki Foreign Settlement was established on the Ōura waterfront to the south of the Dutch settlement of Dejima.[7] Here the businesses were to be located, and on the hillside behind, overlooking Nagasaki, were to be the residences and schools. Despite the atomic bombing of 1945, there still stands on the high ground of Minamiyamate (south hillside) a collection of some of the oldest Western buildings

in Japan.[8] Built by a local master-carpenter, Koyama Hidenoshin, the Glover (1863), Alt (1865) and Ringer (1867) Houses show the early expression of Western, and in this case colonial, architecture but remain, nevertheless, Japanese houses built by Japanese craftsmen.[9]

Following the opening of the port, Koyama had built the majority of the Western buildings in Nagasaki and had developed an understanding of what he thought Western architecture would look like. His architecture was polymorphic, drawing on what he might have seen in books, prints or even photographs, and conditioned by the input of his Western clients who could tell him about unfamiliar components such as doors, windows and chimneys, if nothing else. As well as houses and hotels, he built churches, even though the practising of Christianity was still prohibited for the Japanese.[10] In 1862 he built the Episcopal Church, a white clapboard building in the American manner, with a spire and belfry at the front. Two years later, between the building of the Glover House and the Alt House, he built the Catholic Church for the Société des Missions Etrangères de Paris (1864) [6.01]. Located on a site on Minamiyamate overlooking Nishizaka, where 26 Christians had been crucified in 1597,[11] it was a composite expression of French architectural themes, combining, perhaps, the west front of François Mansart's Church of the Val de Grâce in Paris (1645–67) with the conical towers of the eleventh-century Notre Dame la Grande at Poitiers. The inspiration for and the realisation of the church was due to the Société's priests, Fathers Louis-Theodore Furet, whose design it was, and Fathers Bernard-Thadée Petitjean and Joseph-Marie Laucaigne, who supervised it.[12] The four-storey timber-frame and plaster seminary building next to the church was built to the designs of another priest, Father Marc Marie de Rotz, a missionary from Vaux-sur-Aure in Normandy, in 1875.

Both Thomas Glover[13] and William Alt had arrived in Nagasaki in the autumn of 1859; Frederick Ringer, recruited by Glover, came in 1865. All three had been working in China and the houses which they built in Nagasaki differed little from what they would have known in Shanghai and other Western settlements. Yet it seems unlikely that such young men, intent upon making a fortune, would have been particularly concerned

6.01 The Ōura Catholic Church, Nagasaki, built by Koyama Hidenoshin in 1864, from *Les Missions Catholiques*, 7 June 1872.

about the architectural qualities of the houses they built. The style of these houses was, in fact, very dated, reflecting the colonial architecture which had been exported in the early years of the century and based upon images provided in copy books such as Joseph Michael Gandy's *The Rural Architect* (1805) and *Designs for Cottages, Cottage Farms and Other Rural Buildings* (1805).[14] Both publications included small, single-storey buildings with

6.02 The Thomas Glover House at Nagasaki, built by Koyama Hidenoshin in 1863.

shallow roofs, verandahs with simple colonnades and overhanging eaves, and latticed windows. A close match can be found in John Buonarotti Papworth's *Rural Residences* (1818) where 'a Cottage Orné designed for an exposed and elevated situation' approximates to both the appearance and the siting of the Glover House.[15]

Each of these three houses, as it was built, showed an increasing sophistication, not just in the building process, but also in the planning and the use of architectural detail. From the L-shaped plan of the Glover House, with its separate servants' wing, to the linear plan of the Alt House and then the symmetrical plan of the Ringer House, these buildings demonstrated an increasing use of Western architectural principles. A plan of 1863 for the Alt House survives, drawn by C. Ansell.[16] English room names and imperial dimensions are given but are overdrawn with

Japanese *shaku* and *sun* measurements. It is likely, therefore, that the symmetrical Ringer House was also built to a provided plan.

The Glover House was called Ipponmatsu, after the single pine tree around which its L-shaped plan turned [6.02]. The tree has now gone and the house much extended, but the building which Hidenoshin devised was expressive of what he understood Western architecture to be. Using simple wooden columns and lattice-work screens, this building adopted the palette of materials later employed in the Catholic Church. The posts which support the verandah roof are unadorned and, although each has a simple Tuscan capital and astragal, they sit, in the Japanese fashion, on blocks of stone. The arches between are formed from timber latticework with a single wooden 'keystone'. Beneath the verandah roof, as old photographs show, there were originally *voussoirs*

6.03 The William Alt House at Nagasaki, built by Koyama Hidenoshin in 1865.

described around the arches above the French windows, either painted or blocked out in a different coloured render, and the glazing of the fanlights (if glazed at all) was then not subdivided. This, and the treatment of the fireplaces inside, was about the extent of the Western architecture in the building.

The assimilation of Western building practices can be seen to have been rapid across the three houses. The Glover House was of traditional Japanese construction: a post-and-beam timber frame and walls of bamboo laths infilled with layered clay, mud and seaweed, and finished off with lime plaster. The Alt and Ringer Houses were of stone construction, using local Amakusa sandstone;[17] the kitchen and servants' quarters at the rear of both houses were of brick. At the Alt House the verandah columns were also of stone, but a now better proportioned Tuscan order was

used, complete with bases and plinths, but with no attempt at entasis [6.03], while at the Ringer House square columns with Tuscan capitals and bases were adopted [6.04]. Whereas this arrangement might be seen to be Western, their shape could equally well be Chinese, for square columns were used at the Fukken Kaikan (Fujian Assembly Hall)[18] in Tōjin Yashiki, the Chinese Quarter of Nagasaki. This cultural mix is also apparent at the rear of the house where the servants, possibly Chinese, would work. Here the columns are once more timber with Tuscan capitals and astragals, like those at the Glover House, but sit on carved stone 'cushion' bases similar to those at the Fukken Kaikan.

The arrangement of the three houses is very much conditioned by a response to climate. Their plans, although cellular in the Western manner, are all open to the cooling breeze from the bay below. Each is surrounded by a deep verandah onto which

6.04 The Frederick Ringer House at Nagasaki, built by Koyama Hidenoshin in 1867.

a proliferation of French windows, sometimes five to a room, open. Louvred outer doors and a lattice-work ceiling to the verandah allow for continual air movement through both the house and the roof space above. At the Glover House, where all the rooms inter-connect, the principal rooms have external walls and thus ventilation from opposing sides, but in the Alt and Ringer Houses, where there is a central corridor, cross-ventilation is achieved through the internal doors with top-hung opening vents set above. Both the planning and articulation of these houses suggest a tropical or sub-tropical colonial provenance while the inclusion of imported, cast-iron fire grates, with either timber or granite surrounds, demonstrates a response to local conditions, which are cold in winter and where there was an abundance of coal.[19]

The bricks used in the kitchen and servants' wing at the Alt House were fired at the Nagasaki

Iron Works or Seitetsu-sho, the first Western-style building built in modern Japan. This had been put up and fitted out at the invitation of the *bakufu* by Dutch engineers under the supervision of a Dutch naval officer, Hendrick Hardes. Work on the building had begun in 1857, significantly two years before the port of Nagasaki was opened up to the West, and was completed by the time of Hardes's departure in 1861. The Seitetsu-sho was designed in the manner of Palladio's Villa Barbaro at Maser (*c.* 1560) – a long arcaded elevation with a broad pediment over the arcaded central pavilion (a nod here towards the earlier Villa Saraceno at Agugliaro) and smaller pediments over the end pavilions. Positioned within the tympanum of each pediment was a *mon* showing the Imperial chrysanthemum. Technically, the building was as unfamiliar as its appearance. Steel trusses supported the roof and the walls were of brick;[20]

6.05 The Ijinkan at Kagoshima, probably designed by Alexander Norton Shillingford, 1867.

longer and thinner than standard bricks and known as Hardes bricks, they became the basis for the red Nagasaki *konnyaku renga*²¹ bricks. Located on the waterfront at Akunoura and directly across the broad river estuary from Dejima, the Seitetsu-sho offered a bold advertisement for both Western technology and its architecture.

Thomas Glover, who had set up Glover Trading Co. (*Gurabā-Shōkai*) in 1861 and established good connections with the Satsuma and other rebellious local *daimyo*, by supplying them with ships, guns and gunpowder, was to be instrumental in the development of Western architecture in Japan. It was probably he who arranged for a young Irish engineer, Thomas James Waters,²² to come out to Japan in April 1865 to build sugar refineries on Anami-Oshima, then considered the northernmost of the Ryukyu Islands, which were controlled by the Satsuma *han*. Waters, the son of a town doctor,

had grown up in the cultured and intellectual environment of Birr, in County Offaly, and had learned about mechanical engineering while working, first, for his uncle, Henry Robinson, in London and then for John Elder of the Glasgow marine engineers, Randolph Elder and Co. Yet it was his other uncle, Albert Robinson, who set up a dock company in Yokohama in 1864 and it would have been through him that Glover heard about young Waters. There was, however, another side to Waters's visit to Japan: he also came as a missionary and a distributor of Bibles for the Plymouth Brethren. But following Dr Bernard Bettleheim's unhappy experience in the Loo-Choos (see Chapter 3), Waters found the locals unreceptive and took his proselytising no further.

By midsummer 1867, Waters was back in Kagoshima, where he had first landed, working as head engineer for the Satsuma *daimyo*. There he

took up residence in a newly completed building, typical of treaty port houses, where the engineers engaged in the new Kagoshima Cotton Mill (Boseki-jo) were living. This was the Ijinkan, also known as the Gishikan, the foreign engineers' house [6.05]. That July he wrote to his sister Lucy describing the drawing office with a service hatch:

> I am in our new house at last & a very pleasant change it is ... The room I am in is about 20 ft square, wall paper white with blue spots, one door & four windows down to the ground which is covered with bamboo matting, the furniture consists of two drawing desks, for it is supposed to be a drawing office.[23]

Although this description, apart from the furniture, could have been of the residence at Dejima, the exterior was much more Westernised. The symmetry of the elevation, and the verandah which ran across it, passing under the polygonal central bay, was colonial, as were the details – ornamented brackets forming the spandrels of the verandah arches and triglyphs in the cornice above. However, the exposed framing on the upper floor suggested Japanese craftsmanship, as did the windows which, like *shōji*, slid horizontally across the façade. Whereas the house could quite feasibly have been designed and built by a master-carpenter from Nagasaki, just one day's journey away by steamer, it is more probable, considering its relationship to the Boseki-jo, that it was built as part of that operation. In this case, it is likely to be the work of Alexander Norton Shillingford. Shillingford had arrived in Japan in January 1864 and, after a brief partnership in Yokohama with Samuel Rowell as civil and mechanical engineers, he advertised himself, in January 1865, as 'A.N. Shillingford, Civil Engineer & Architect'.[24] Shillingford was soon, however, in Kagoshima and involved in the construction of the Boseki-jo for the Satsuma *han*.[25] It was probably here that he met Waters, for Waters refers to him in letters to his sister Lucy, and if so, Shillingford appears to have been influential upon Waters's developing skills as an architect.

The Boseki-jo was the first stone-built mill in Japan and was fitted out by Henry Ainlie, a *o-yatoi*

gaikokujin advising on cotton spinning, with three weft mules and six throstle frames made by Platt Brothers and Co. of Oldham, Lancashire, to a supplied plan.[26] It was a long, low building with round-headed windows and an advancing, pedimented central bay beneath a Japanese tiled roof. Both the central doorway and the flanking windows had pronounced springers and key stones, while the pediment above, defined by overhanging eaves and a cyma-reversa cornice, was punctuated by a roundel or oculus. It was an arrangement which differed little from the Seitetsu-sho at Nagasaki and suggested a simple Classicism which presaged Waters's later work.

Although the Ansei Treaties had designated the town of Kanagawa as the treaty port on the eastern side of Honshu, the *shogunate* felt it was located too close to the Tōkaidō, which linked Edo to Kyoto and Osaka. Consequently the port and the Western concession, known as the *kannai* (meaning inside the barrier), were established at the neighbouring fishing village of Yokohama, near where Commodore Perry had first arrived in 1854. It was here, closer to Edo, rather than in distant Nagasaki or Hakodate, where the greater number of adventurer architects and engineers established themselves. The first was probably Jonathan Goble, an American Baptist missionary, who arrived in 1860 and built the first Kaigan (United) Church in Yokohama. He also assisted another American, Richard Bridgens,[27] by supervising the building of the temporary British Legation following the Yokohama fire of 1866. Bridgens, who had been working both as a lithographer and as a clerk in the San Francisco offices of the US Engineers in 1863 and 1864,[28] probably came out to Japan at the suggestion of his sister-in-law, Anna Schoyer.[29] She was the wife of Raphael Schoyer, an American from Baltimore who had arrived in Yokohama in 1861. There he became the first chairman of the *kannai*'s board of directors and published one of the earliest English-language newspapers in Japan, the wood-block, single-sheet *Japan Express*, while his wife taught oil painting to the Japanese. The opportunities which the Schoyers and the *kannai* itself offered must have attracted Bridgens, both as a lithographer and an

engineer/architect manqué. Indeed, it could have been the death in 1865 of Raphael Schoyer which precipitated Bridgens's move or even the friendship and subsequent marriage, in 1868, of Anna Schoyer to Robert Bruce van Valkenburgh, the US Minister Plenipotentiary to Japan from 1866 to 1869. Bridgens was clearly well-connected and soon set up (with Alfred Lucy) as an architect and civil engineer in Yokohama. The temporary British Legation, like his design for the Tsukiji Hotel in Tokyo (1868), used, in combination with Western architectural features, *namako* walling and Japanese roof tiles, clearly demonstrating that, at this early date, traditional construction methods co-existed with, if they did not actually lead, the new Western architectural fashions. This influence was probably due to the involvement of his pupil, the carpenter Hayashi Tadahiro, who had begun his training under Patrick Dall and was to be one of the most significant *giyōfū* builders. Following the temporary British Legation, Bridgens might also have been responsible, in 1868, for the 'exceptional and exquisite British Mission building', as the Japanese caption described the new British Legation in Yokohama. However, the involvement of Captain William Crossman of the Royal Engineers, who was in charge of diplomatic and consular buildings in China and Japan, cannot be discounted. Constructed, as far as can be told, from brick with stone quoins (although a timber-frame and stucco construction was possible), this building anticipated the railway termini at Yokohama and Shinbashi, built by Bridgens for the new Yokohama to Tokyo railway line in 1872 [6.06]. As examples of Western architecture, they were stylistically much better informed and technologically more convincing, although the Japanese tiled roof and protruding parapet, which appears to push through the tiles, sat uneasily on the Italianate elevations: nevertheless, the skills of both the designer and his builders, now three years on, had improved considerably.

Similar opportunities for patronage existed amongst the French community in Yokohama, where F.L. Clipet opened an office in 1865 and styled himself 'architect'. With the encouragement of Léon Roches,[30] the French Consul General from 1864 to 1868, he

6.06 The Shinbashi railway station (reconstructed), Tokyo, designed by Richard Bridgens, 1871.

soon drew up the first accurate plan of Yokohama and the following year built the French Legation, a colonial-style stone building with colonnade and verandah. He is also credited with adding, in about 1867, the tetrastyle Ionic portico to the otherwise Gothic Tehshu-do Church, built in Yokohama by the French missionary, Father Prudence Seraphin-Barthelemy Girard, in 1862. This was the first instance of the Classical Orders being used in Japan.[31] Girard's original building, in the style of a *kura* with thick, plastered walls, actually had ogee windows.

The influx into Yokohama of foreigners intent upon profiting from the building industry was considerable, for, as Clipet's plan shows, the *kannai* grew rapidly. Yet the distinction between architect, engineer, surveyor or, indeed, joiner and carpenter was one rarely made and anybody who could erect a building appeared to be in business, although those businesses were often short-lived. Initially it was

the shipping which drew craftsmen to Yokohama. Soon after the port opened in 1859, H.J. Frey and C. Cook established Frey and Cook, Shipwrights, Boat Builders and Mast Makers, as well as House Builders, General Carpenters and Blacksmiths. They were joined in 1861 by Allan Cameron who, with Cook, established Cameron and Cook, Shipwrights and Boat Builders, in 1865. Patrick Dall (*d.* 1866) arrived in 1863 and set up in the *kannai* as an architect and surveyor; it was he who initially taught Hayashi Tadahiro. Dall promoted the building of lighthouses but, following his suicide, the initiative was taken up, through the *Tōmyōdai Yakusho* (Office for Lighthouses), by Richard Henry Brunton and his assistant, Archibald Woodward Blundell, together with the civil engineer Colin Alexander McVean, and the surveyor Samuel Parry, all of whom arrived in 1868. Amongst the military engineers were Frederick Brine, a British army officer, who came in 1863 and built the protestant Christ Church which opened that October, and Iwan Kaiser, a Swiss army officer

who had arrived the same year and opened an office as a civil engineer and civil engineering consultant in 1864. A number of ex-patriots also came from Shanghai: Frederick Knevitt, who had been working there as an architect and surveyor since 1863, opened an office in the *kannai* in 1866. The previous year Philippe Dowson, who had been working in Shanghai for the civil engineers and architects, Whitfield and Kingsmill, had arrived in Yokohama and set up with Alexander Norton Shillingford as civil engineers, architects, surveyors and land agents; but the venture lasted only 14 months before Shillingford left for Kanagawa. Meanwhile, in April 1866, George Whitfield had come over from Shanghai and opened an office under his own name, so Dowson joined him as Whitfield and Dowson, again as civil engineers, architects, surveyors and land agents, a firm which lasted until 1876.

At Yokosuka, just to the south of Yokohama, the French naval officer and engineer François Léonce Verny built shipyards and a foundry for

6.07 Silk-reeling mill at Tomioka, designed by Edmond Auguste Bastien, 1872.

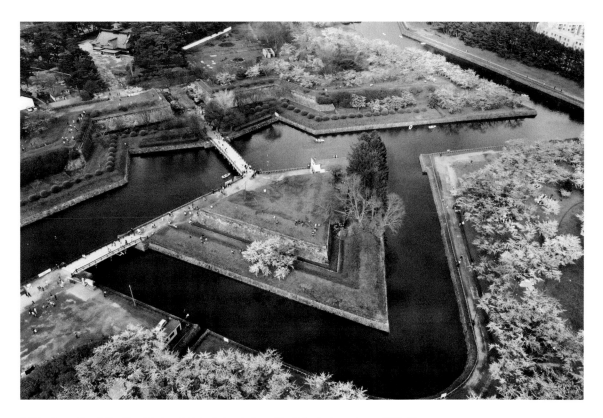

6.08 A ravelin at the Goryōkaku at Hakodate, designed by Takeda Ayasaburo, 1857–66.

the *bakufu*. Started in 1864, these works were so extensive that their completion in 1871 was only to benefit the new Meiji regime. Verny, who was distantly related to Roches, had trained at the École Polytechnique in Paris and the Institute for Applied Maritime Science at Cherbourg, and had been in China building gunboats for the Chinese Navy when Roches persuaded him to come to Japan. Verny's appointment survived the transition from the *bakufu* to Meiji administrations, despite the French government's support for the *shogunate*,[32] and he eventually left Japan in 1876. The building technology which Verny introduced at Yokosuka, which included innovations such as the king-post truss and brick curtain walling, were, for the Japanese builders, a step too far and more traditional methods, such as post-and-beam roof framing, continued to be used.[33] Despite its

Western appearance, Waters's Sempukan, which is introduced below, had post-and-beam roof framing. One of the earliest buildings built by a Japanese master-carpenter which adopted the Western king-post truss was, as has previously been noted, the Prefectural Government Office Building in Niigata, and that was not completed until 1881.

A direct spin-off of the French involvement at Yokosuka was the building, by Edmond Auguste Bastien, who had worked at Yokosuka, of the silk mill at Tomioka (1871–72) [6.07]. Built to plans supplied by Paul Brunat, a French engineer and raw silk inspector employed by the Ministry of Finance, the mill buildings were set around three sides of a quadrangle. The silk-reeling mill and the two cocoon warehouses, respectively 177 and 130 metres in length, represented, together with the ancillary buildings, a major industrial innovation.[34] In each

range, a heavy timber frame supported hefty timber king-post timber trusses. Brick curtain walls, which were laid in a fine Flemish bond, infilled the frames: the bricks had been made by local roof-tile makers and the mortar developed from traditional *shikkui* plaster. Being coincident with the now famous iron-frame and brick Menier Chocolate Factory at Noisiel-sur-Marne, built by Jules Saunier in 1872, these buildings cannot be regarded as representative of the latest French structural thinking, but nothing like it had been seen in Japan until that time.

Hakodate, the third of the 1859 treaty ports, was on the northern island of Hokkaido and it was here that the *bakufu* built the Goryōkaku (1857–66) [6.08] and the nearby Benten Daiba (1868–69) forts as part of the government's attempt both to control rebellious *daimyo* and to reinforce its coastline against foreign attack. Designed not by a military *o-yatoi gaikokujin* but by the *rangaku* scholar Takeda Ayasaburo,[35] Goryōkaku adopted the Vauban-inspired, star-shaped plan and ravelin such as the Takenouchi Embassy saw during their visit to the Musée des Plans-relief in Paris in 1862. Although comparable to the fort at Bourtagne, near Groningen in the Netherlands, of which Takeda might have known from Dutch publications, its similarity to some of those at the

Musée suggest that the Takenouchi Embassy might well have ratified, if they did not actually influence, the design. The steep ramparts and surrounding moat, however, proved inadequate to repel the Imperial army at the Battle of Hakodate in 1869 and here the defeat of the *bakufu* forces, despite their use of French military advisors, marked the end of both the Boshin War and the Tokugawa *shogunate*.

On the south coast of Honshu, Kobe, or Hyōgo, as it was then called, opened as a trade port on 1 January 1863.[36] Here the *bakufu* also began to build a series of defensive stone towers based, without doubt, upon the Martello towers erected along the English coast at the start of the nineteenth century. The towers were to be positioned within star-shaped ramparts with gun emplacements at the angles. Built in heavy stonework with thick, sloping walls, the two-storey towers, such as at the Wadamisaki Battery on Cape Wada, were about 15 metres in diameter at the base and measured 11.5 metres to the top of the shallow conical roof [6.09]. Set about with gun ports at the upper floor level, they appeared impenetrable but, as it happened, were soon over-run by the Imperial forces in 1868.[37]

In that same year the Western *kannai* was granted and, despite political unrest and the occupation of the town by foreign troops, the first Western builders, representing a wide range of the cognate trades and professions, moved into Kobe. W. Carsell started work in Kobe as an architect and surveyor, carpenter and joiner in February 1868. In April, the Dutchman W.C. Bonger opened Bonger Brothers, Architects and Surveyors, and in the same month H.J. Frey moved to Kobe from Yokohama. In June, a British civil engineer, John William Hart, previously engaged in constructing docks at Shanghai, arrived and, that August, set up as a civil and mechanical engineer, architect and surveyor. In July an Australian, John Smedley, came from Hong Kong to establish the Japanese branch of the civil engineering firm, Storey, Son and Smedley. The following year he and Hart joined forces as Hart and Smedley, Architects, a venture which lasted for two years. By the time C. Parker put up his plate as Engineer, Architect, Blacksmith, Boilermaker, Brass and Iron Founder, Armourer and Co. in January 1869,

6.09 The Wadamisaki Battery, a 'Martello' tower at Cape Wada, Kobe, built by the *bakufu* government in 1864.

6.10 The Coining Factory at the Imperial Mint, Osaka, designed by Thomas James Waters, 1868–71.

Early Meiji Architecture

It was Thomas Glover who, in October 1868, recommended Thomas Waters for the job of building the Imperial Mint in Osaka. Initially, because of his knowledge of Western architecture, he was to assist in the work but since progress was so slow, Waters was appointed Chief Engineer in March 1869. For ease of transport, the Mint was located on the bank of the Yodo. From this prominent position it advertised not just Western architecture but also the intention of the newly established Meiji government both to Westernise the country and, by the issuing of a common currency, the Yen,[38] to unify it. In conceiving the central building, the Coining Factory, was Waters thinking, perhaps, of the Dublin riverfront and James Gandon's Customs House (1781–91) and Four Courts (1795–1816) – the former having a hexastyle portico and the latter an arcade of round-headed

the reinstated Meiji Emperor was 12 months into his reign and Japan was never to look the same again.

windows? Yet the building lacked refinement, the portico appearing broad and somewhat squat and the columns tapering rather than affecting entasis. The planning, however, was functional and was derived from that of the short-lived Hong Kong Mint,[39] probably on the recommendation of its mint-master Thomas William Kinder, who was soon to take up the same role in Osaka. Behind the front elevation, a long, linear corridor was separated by security lobbies from the melting, rolling, coining, weighing and other rooms where gold and silver were handled. In the centre, and on the axis which linked the portico with the tall chimney at the rear, were the engine and boiler rooms. It was, in so many ways, an engineer's building [6.10]. Although of a similar composition to the river-front elevation of the Seitetsu-sho in Nagasaki, the details of the Coining Factory, and specifically the round-headed windows, were more like those of the Boseki-jo at Kagoshima. Shillingford, who might be thought to have been involved with the design of the Mint, appears to have gone back to England following the completion of the Boseki-jo,[40] so his input there is unlikely. But he did not stay away long: by October 1870 he had returned to Japan to set up and manage

6.11 The Sempukan at the Imperial Mint, Osaka, designed by Thomas James Waters, 1868–71.
The portico of the relocated Coining Factory is visible behind.

the Vulcan Ironworks in Kobe, and, in 1872, rejoined Waters to help rebuild the Ginza district of Tokyo.

The Coining Factory was flanked by the Sempukan, the official residence of the Commissioner, and by residences for foreign employees. Their design was based upon the Ijinkan at Kagoshima where Waters stayed a few months earlier, but the Sempukan, being built of brick with granite columns, was somewhat more up-market [6.11]. The columns were of the same Tuscan order as the Mint and the broad intercolumnation, with paired end-columns (in the Palladian manner[41]), recalled the portico at the Jardine Matheson Headquarters Building in Shanghai (1851), a building which many of the ex-patriots now in Japan, including Waters, would have known.[42] Yet the formality suggested by the breadth and symmetry of the front elevation was not reciprocated internally. A central hallway, finished with encaustic tiles from Hargreaves and Craven of Jackfield, Shropshire, ran back from the portico, subdividing the plan. To one side were the dog-leg stairs, with turned balusters; to the other was a double reception room with centrally positioned columns. Although visiting Westerners might have thought the Italianate exterior (which originally had a parapet) a little dated, the use of stencilled oriental patterns drawn from Owen Jones's *Grammar of Ornament* (1856) and the inclusion, in the fireplaces, of Minton and Co.'s Japonisme-style tiles, show the decoration to be contemporary.[43] As an official residence where the Meiji Emperor stayed three times, the Sempukan was not intended for continuous occupation but was used for important occasions. It certainly had pretensions to grandeur but, as was to be so often the case with such buildings in Meiji Japan, the façade promised more than the interior provided.

The building of the Coining Factory and the Sempukan confronted Waters with some constructional problems. These Western-style buildings needed Western materials and they were simply not available in Japan. The foundations for the

boiler room at the Mint, as well as its chimneys and the walls of the Sempukan, were to be of brick, so brick kilns were built at Sakai and Hiroshima. In January 1869, Waters's sister Lucy heard from their sister Amy, in England, that 'He [Waters] has to begin at his old work showing them how to make bricks before they can fairly commence!'[44] Waters also had to instruct the Japanese in bricklaying, lest progress on the building slowed down: even so, it was completed a year late. The sinking of the ship from England carrying 48 cast-iron columns for the Coining Factory would not have helped progress; replacement columns had to be salvaged from the Mint in Hong Kong which was then being demolished.[45] From there too came used minting machinery after the new machinery, safely delivered from England and stored in Osaka, was lost in a fire. The length of the replacement columns determined the eventual height of the Coining Factory, which might account for its rather squat appearance. Glass, too, was unavailable in Japan, and had to be imported. But it was heavy and fragile so it is not surprising that, soon afterwards, Waters was involved with the building of Japan's first glassworks, beside the Tōkaidō at Shinagawa (1873–74), an enterprise promoted by his Uncle Albert and the Kōgyōsha company.[46]

In 1868, with the installation of the Meiji government, the ancient *shogun* capital of Edo changed its name to Tokyo (the eastern capital) and the Meiji Emperor took up residence here. The Mint, located in Osaka before the decision had been taken to move the government to Tokyo, was consequently rather left behind. Nevertheless, it was opened in 1871 by the Chancellor of the Realm, Sanjō Sanetomi, in a ceremony recorded by John Reddie Black, the proprietor and editor of the *Japan Gazette* and *The Far East*:

> The Japanese Government, in order to meet the gradual increase of the national requirements, and desiring to further the development of Foreign commerce, undertook, the year before last, the construction of a Mint, with the purpose of putting forth a new and pure coinage, in conformity with the system of coinage existing in other countries. The work has now been completed, owing to the zealous co-operation of the Oriental Banking Corporation, and Messrs. Kinder and Waters.[47]

The success of the Mint, in the eyes of the Imperial government, led to Waters's commission, in 1874, to build the Paper Money Factory in Tokyo, but before that came the new Takebashi Barracks at Kitanomaru-kōen on the edge of the Imperial Palace grounds in Tokyo (1870–74). [6.12] Intended for the artillery battalion of the Imperial Guard, and designed in long ranges around a quadrangular parade ground, the barracks, like the Mint before it,

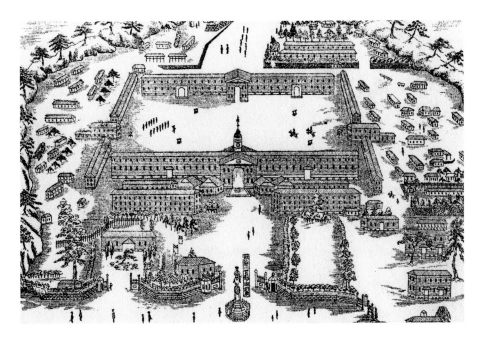

6.12 Takebashi Barracks, adjacent to the Imperial Palace in Tokyo, designed by Thomas James Waters, 1870–74.

149

offered Japan both a new building type and a new architecture. Waters's choice of a quadrangle layout might have been influenced by his knowledge of the Crinkill Barracks at Birr (1807–12), built by Bernard Mullins, or of the Custume Barracks at Athlone (*c.* 1808–20), just 40 miles away. Although not as large as the Crinkill Barracks, the main range of Takebashi Barracks extended for 16 bays on either side of the pedimented central bay where the Imperial *mon* in the tympanum declared the barracks' allegiance. Here, as at Crinkill, the arched and pedimented entrance was surmounted by a cupola and clock in an arrangement which can be traced back to Horse Guards Parade in London where the first barracks for a standing army was built in 1663–64.

On 3 April 1872 (or 26 February on the Japanese lunar calendar),[48] the central Tokyo districts of Ginza, Kyōbashi and Tsukiji, comprising 3,000 buildings housing 50,000 people, burnt down.[49] Within days the government's Council of State, the *Dajōkan*, issued a plan for the area's rebuilding in fire-resistant materials and Ōkuma Shigenobu, the Minister of Finance, together with Inoue Kaoru, the Director of the Mint and Vice-Minister of Finance (who, as Inoue Monta, was one of the Chōshū Five who in 1863 had travelled illegally to England to be educated), took charge of the rebuilding. Ōkuma knew Waters from the Mint project and Inoue knew Glover and might well have known Waters through another of the Chōshū Five, Nomura Yakichi (also known as Inoue Masaru), who had assisted Waters in the building of the Mint.[50] Since brick was the chosen material, it was almost inevitable that Waters, the builder of brick kilns, would be involved.

It is likely that Waters was speedily given a 12-month contract, for by 18 April, two weeks after the fire, he was already preparing estimates for terraces of brick houses per tsubo (3.3 square metres or 35.6 square feet), dividing them into four classes in a manner which reflected the classes or rates applied to houses in England at that time for taxation purposes. The three-storey First Class houses would cost $75 per tsubo; the two-storey Second Class houses, $50 per tsubo; single-storey Third Class houses, $35 per tsubo; and Fourth Class houses, 'built as cheap as possible', would

cost $25 per tsubo.[51] Working under the title of 'Surveyor General, Yedo', he prepared working drawings showing brickwork details[52] and wrote precise specifications: 'Mortar, for brickwork is of the greatest importance. It is made of one part by measure of fresh stone lime & three parts of sharp river sand … Sea sand cannot be used for making mortar.'[53] In May, Waters was joined in the Ginza rebuilding by both Shillingford and his brother, John Albert 'Bertie' Waters, who had arrived in Japan in 1868. Bertie had been working as a road engineer and this was the responsibility he took on at Ginza, where wide, straight roads were to be laid out to replace the chaos of the old town. Shillingford, it would seem, took over from Waters who, after twelve months on the Ginza job, returned to England in April 1873. Although Bertie and Shillingford worked on the Ginza job for another year, until their contracts ended in April 1874, Waters did not return to it. As *o-yatoi gaikokujin*, when their contracts ended their work was seen to be done and the rebuilding of Ginza became the responsibility of the Japanese whom they had trained. Nevertheless, Waters was back in Japan the following February to build the Paper Money Factory, but his was only a 12-month contract and by February of 1875 he was once again unemployed. In August that year, he left Japan for San Francisco, en route for England.[54]

The rebuilding of Ginza was intended not just to clear the city-centre slums but also to create an Imperial capital in the Western image in an attempt to win the respect of the Western powers and facilitate the renegotiation of the 'unequal Treaties'. The streets were widened, which reduced the risk of flame-spread and collateral damage during earthquakes, and vehicular and pedestrian traffic were separated. The widest streets were planted as avenues and broad footpaths flanked the brick-paved roads. Colonnaded elevations were introduced in the two broadest streets, Harumi-dōri and Chūō-dōri, providing sheltered walkways beyond the footpaths. These were of Tuscan columns, surmounted by a balustrade far more elegant than that at the Sempukan, with the upper floor set back and divided rhythmically by pilasters beneath a strong cornice and a blocking course [Plate 12]. The result was very

much what Kume Kunitake and the Iwakura Embassy had seen in England in 1872: 'The horse-drawn traffic passes back and forth on the street below while people on foot go to and fro along the galleried arcades above.'[55]

Although the uniformity of Ginza's showpiece elevations and corner buildings was not repeated as the blocks filled out (some owners rebuilt their properties in timber and without permission[56]), the overall impression was one of harmony, uniformity and a grand scale. London's Regent Street is often quoted as the model for Ginza's colonnades but since the Doric colonnades of John Nash's quadrant, which were regarded as an obstacle to daylight and a place of vice, were demolished in 1848, it could only be from prints and books, such as James Elmes's *Metropolitan Improvements* (1827),[57] that these buildings were known. Park Crescent (1812–22), at the other end of Nash's great urban progression, does, however, offer a precedent which Waters, Shillingford, the Chōshū Five or even the Takenouchi or Iwakura Embassies might well have known.

All the new buildings in Ginza had to be built of brick or stone; this gave rise to the name *Ginza renga gai* (Ginza Bricktown). As with the Imperial Mint, the infrastructure and skilled labour required to provide such quantities of bricks were just not available. Consequently, a private brickworks, using the Hoffmann brick kiln,[58] a relatively new invention, was set up at Kosuge, a small town north-east of Tokyo, where bricks were manufactured under Waters's direction. This subsequently became the site of Japan's first prison-factory and, following the Satsuma rebellion of 1877, rebel prisoners, together with convicts from Tokyo, fired bricks with which to build their own prison. Commissioned in 1879 and completed in 1884, Kosuge was the first brick-built prison in Japan.[59] Meanwhile independent tile craftsmen and kiln owners were set to work to produce bricks for Ginza and large numbers of craftsmen and labourers were engaged to realise the project.[60] The bricklayers used Flemish bond, building their stuccoed walls on granite plinths; only the glazed roof tiles suggested traditional workmanship. However, the brickwork, combined with inadequate ventilation, ultimately proved to

be the scheme's undoing, for in the hot and humid climate of Tokyo the new buildings were prone to damp and mildew. This, and the conditions of sale,[61] resulted in a slow take-up of the properties and it was not until the mid-1880s, following the introduction of street lighting and horse-drawn trams, that Ginza eventually became established. Ironically, the bricks, if not wholly suited to Japan's climate, proved to be a valuable export commodity. In April 1876, as *The Building News* reported,

> a cargo of bricks of Japanese manufacture was placed as an experiment on the London market, the result being that the cargo was instantly bought up, and large orders for future supplies were instantly given by several leading contractors and West-end builders ... It is stated that this venture was at the instigation of one of the young Japanese sent over by the Mikado to be educated in this country at the expense of his Government.[62]

The plan for rebuilding Ginza was implemented without regard for local interest and without compensation for the displaced residents; eventually local opposition and the failure to meet construction costs led to the scheme's demise.[63] Only one third of the projected 993 buildings were completed and the development was stopped in 1877. Following the Great Kantō Earthquake of 1923, Ginza was rebuilt, and only the breadth of Harumi-dōri and Chūō-dōri, and some remnants and reconstructions in the Edo-Tokyo Museum, remind the visitor of Waters's achievement. Although his role in establishing Western architecture in Japan cannot be underestimated, it was not he but another Briton, freshly arrived in the country, who was to assume the sobriquet 'the father of Japanese architecture'. This was Josiah Conder and he had landed at Yokohama on 28 January 1877.

Giyōfū Architecture

Although it had been intended to open Niigata as a treaty port on the first day of January 1860, the shallow water of the Sinano river delayed the

6.13 The Customs House, Niigata, 1869.

use of the port by Western ships until November 1868. The Customs House, which was completed in 1869, represented the enlightened attitude towards both the West and its architecture. Here, where Classical cornices met *namako* walling, import duties were charged by the Japanese and sale prices set by the Westerners.

The Niigata Customs House [6.13] is the oldest extant example of the foreign or Western way of building known as *giyōfū* architecture. Built by local carpenters with a timber frame and *namako* walling in the manner of a fireproof *kura*, it merged local building practices with a crude understanding of Western architecture. The rectangular plan with a cross-passage set beneath a central cupola suggests a functional ordering unfamiliar in the agglomerative planning of larger, traditional Japanese buildings. The straight lines of the heavy, tiled roof are Western, although the tiles and ridgeline decoration are not. At the gable ends, the cyma-recta curve of the stepped cornice almost defines a pediment above the *namako* walling while the side walls, framed in the traditional manner, are treated to glazed windows which, like *shōji*, slide horizontally. At one end, above a Western doorway, there is a cusped window in the Zen Buddhist style, as if acknowledging the China trade routes which ran west from Niigata.

Although the cupola, set on a spreading *namako* base, takes on the pagoda form of an Edo fire-watching tower, it nevertheless represents a feature familiar from many Western port and harbour buildings, such as Henry Bell's Custom House at King's Lynn, Norfolk (1683) or the Lazaretto maritime quarantine hospital erected by the Pennsylvania Board of Health at Philadelphia (1799). To Western sailors arriving at Niigata, the cupola might have appeared curious but not unfamiliar; to the Japanese the cupola was to become a token of Westernism which was repeated in *giyōfū* architecture *ad infinitum*.

The cupola was the central and dominant feature of the Kaichi Gakkō at Matsumoto [6.14], one of the oldest primary schools in Japan. Known as the *taiko-ro* (drum tower), these cupola held drums which, like clock bells, told the time and were a common feature in *gakkō*. Founded in 1873 and built in 1876 by the local carpenter, Tateishi Seijyū, the building used to sit perpendicular to the Matsumoto river but in 1964 was relocated on high ground not far from Matsumoto Castle. The design is unusual in that, in contrast to the colonially influenced buildings such as Waters's Sempukan, it had, with the exception of the two-storey open portico, no colonnade or verandah, but instead presented an elevation of regularly spaced shuttered windows across a flat façade. Although built with a timber frame, the building was clad in stucco, with rusticated quoins and an ashlar base.

6.14 Kaichi Gakkō (primary school) at Matsumoto, built by Tateishi Seijyū in 1876.

This manner of replicating a masonry structure in a wooden building gave the building a solid, urban appearance which the clap-boarded, colonnaded colonial buildings never achieved.

Although a few Japanese carpenters managed to travel abroad, such as Ichikawa Daijirō, the builder of the Nakagomi *gakkō* (1875), who apparently studied architectural engineering in the United States from 1869 to 1873, most had to learn their Western architecture locally.[64] Tateishi studied Western-style buildings in Yokohama, Yamanashi and Tokyo and incorporated their features into his design. His sketchbooks show the hipped roof of the second Mitsui-gumi building (Mitsui Bank) in Tokyo, built by Shimizu Kisuke at Suraga-cho in 1874, but it is likely to have been the cupola-roof of the first Mitsu-gumi building, which Shimizu built at Kaiunbashi in 1872, which was more influential. The long elevation, the shuttered windows and the quoin stones probably came from another building which Tateishi also drew, the Kaisei Gakkō (Liberal Arts College)[65] built in 1873 by Hayashi Tadahiro, Dall and Bridgens's former pupil, now employed by the Ministry of Public Works. The precedent for this type of urban architecture, however, goes back further, to the Dutch influence originally introduced to Japan through Dejima, for images of Dutch scenes would still have been in circulation. The dull northern climate of the Netherlands encouraged the use of large windows, albeit shuttered, and the poor ground conditions demanded piled foundations comparable to those of timber-framed structures. The result was, as at the Town Hall at Enkhuizen, built by Steven Vennecool in 1686–88, a tightly skinned, windowed architecture contained by quoin stones and an overhanging cornice, with the hipped roof capped by an octangular cupola.

Although set a little off-centre, the two-storey open portico of the Kaichi Gakkō leads, as would be expected, to a cross-axial corridor which, in turn, is bisected by a long axial corridor but this is as far as the formal architecture, as suggested by the elevation, goes. The stairs, a feature largely unknown in traditional Japanese architecture, are located either as a dog-leg at one end of the axial corridor or, as winders, squeezed in between the corridor and a classroom to one side of the cross-axis. Upstairs, the axial corridor merges with one side of a classroom or hall, a colonnade of six traditional, tapering wooden posts continuing its line, while at both levels a spur corridor, containing another dog-leg staircase, once led to a long rear extension, a later addition but now removed. Although the balusters on the stairs and between the posts of the colonnade are Western and based upon studies which Tateishi had made in his sketchbook, much of the detailed decorative treatment is, in fact, oriental. The panelled internal doors are decorated with carved dragons or waves while, externally, the portico adopts the cusped gable and richly worked decoration of the Edo period. But here, in the portico, the side-posts of the *torii* have become fluted Doric columns, albeit without entasis, and support a stepped cornice with a bold cyma recta curve. Set across the gable is a banner held by two Renaissance *putti*, declaring the school's name in the manner of the masthead of Japan's first daily newspaper, the *Nichinichi Shinbun*.[66]

It is worth, for a moment, comparing the Kaichi Gakkō with the Japanese pavilion erected the same year at the Centennial Exposition in Philadelphia [4.05]. Bearing in mind that the pavilion was designed and assembled in Japan before being shipped to Philadelphia, the similarities between the two buildings are noticeable. Both have a perceptibly Western appearance, being of two storeys with hipped roofs and an elaborate portico, albeit set a little off axis to the right. The purpose of the Philadelphia pavilion, at this early stage of Japan's transformation, was to show how modern Japan had become: in later years the exhibition pavilions, as has been noted, became historicist and were more like tourist attractions. In the same way, the Kaichi Gakkō could be seen to suggest that the new Japan, expressed in the building by Western architecture and modern, Japanese journalism, was the product of education – so much so that it was exhibited at the World's Industrial and Cotton Centennial Exposition in New Orleans in 1884.[67]

The skill of the Japanese craftsmen and their powers of observation soon enabled them to

6.15 The Police Office at Honjō, built by Kakyta Tomizo in 1883.

mimic the language of Western architecture, although it was almost exclusively the Classical language which they chose to imitate. As a way of building, Classical architecture has always lent itself to reiteration because of its use of the Orders, which are based upon rules, as opposed to Gothic architecture, which might be said to be based upon constructional principles. To facilitate the use of Western architecture, construction handbooks, such as *Shinsen Taishō Hinagata Taizen* (a collection of prototypes of newly selected grand designs), were produced. In the Western tradition of carpenters' manuals and architects' copy books, these handbooks showed both completed designs and constructional

details. The result was a great proliferation of *giyōfū* architecture but, at the same time, a compounding of the errors which such guides contained.

The Police Office at Honjō was built by the carpenter Kakuta Tomizo, using *Shinsen Taishō Hinagata Taizen*, in 1883 [6.15]. Timber-framed and stucco, with expressed quoins and glazed, sash windows, it was a simple Palladian pavilion with a tetrastyle portico raised above a single entrance arch. The plan is straightforward and initially reflects the symmetry of the elevation but, as is so often the case with *giyōfū* architecture, fails to accommodate the stairs satisfactorily. Here the stairs are turned across the central axis and, as a

straight flight, rise steeply to winders at the top. Elsewhere the building is curious and idiosyncratic, the pedimental window-heads being no more than wooden water drips and the florid Corinthian capitals, with one layer of leaves too many, being very much home-grown. The columns (and the bases) are quite unconventional, having the fluting stopping, beneath an astragal, three-quarters of the way up the shaft, and appear disproportionate to the heavy capitals. The glass panes in the sash windows emphasise the horizontal while those in the front door and flanking windows are square; only the fan-light above the balcony door approximates to the proportions found in Western glazing. The stepped cornice has neither a cyma nor a cavetto moulding, but a deeply cut scotia reminiscent of the bracket shown in *Shinsen Taishō Hinagata Taizen*.

In their adoption of the Classical Orders, *giyōfū* carpenters and builders would usually use either a simple version of the Tuscan Order, being the most pragmatic form of building, or, if elaboration was needed, a variation on the Corinthian Order, suggesting vegetation, as done at Honjō. The Ionic Order, having perhaps little resonance with

the Japanese context, seems to have been rarely attempted. The earliest examples employed plain timber posts as columns, the Glover House (1863) using wooden blocks, formed like an up-turned bowl, as capitals, and the Ringer House (1867) using Chinese stonework as bases. Over 20 years later, at the Higashi Yamanashi District Office in Kusakabe (1885),[68] where the building is formal and symmetrical in the Palladian manner, the columns, capitals and bases are still quite unconventional: stone bowls for bases, wooden shafts with fillets for columns and stepped, octagonal blocks for capitals. Unconventional as these might appear, it must be remembered, however, that the standardising and categorising of the Orders by Western architectural writers from Serlio to Chambers[69] was as exclusive as it was inclusive and there remain many examples, both Classical and Renaissance, which departed from the accepted norms. Therefore the variety of interpretations of the Orders found in *giyōfū* architecture during the first 20 years of the Meiji era should be seen as a testament to the imagination and ingenuity of the Japanese craftsmen who so readily adopted the Western way of building.

6.16 The Mei Prefectural Normal School, built in Tsu by Shimizu Gihachi and now rebuilt at Meiji-mura, 1888.

6.17 The Hōhei-kan Hotel at Sapporo, built by Adachi Yoshiyuki in 1880.

The carpenter Shimizu Gihachi built both the Mie Prefectural Offices (1879) and the Mie Prefectural Normal School (1888) in Tsu.[70] In the first, he adopted a fairly conventional interpretation of the Doric Order while in the second, now perhaps more confident, he extended it to imaginatively accommodate the decorated spandrels of the arcading, while adding curious bell-like capitals [6.16]. Meanwhile in Sapporo, Adachi Yoshiyuki built the Hōhei-kan (1880), a large hotel for foreigners with a semi-circular *porte-cochère* supported on paired Corinthian columns [6.17]. In Tsuruoka, another carpenter, Takahashi Kanekichi, built the Nishitagawa District Office (1881) [6.18] and, facing it, the Police Office (1884), the former employing robust, cylindrical columns and capitals and the latter, square Tuscan columns. However time-honoured Japanese building techniques are expressed in both buildings as if they were Western architectural features: for example, the positioning of the dentils at 45 degrees on the corners of the cornice. Whereas both buildings are Italianate and use identical, incised corner pilasters, the

earlier one suggests American colonial architecture whereas the later one, with its traditional features, evokes oriental architecture. The difference between the two was the direct result of the departure, in 1882, of the Tsuruoka prefectural governor, Mishima Michitsune, who had knowingly used the power of Western architecture, as expressed in the District Office building, to establish authority and suppress the rebellious populace.

All these buildings, constructed within a 10-year period, convincingly imitate Western architecture, even if the Orders are unconventional, the decoration occasionally oriental, and the building technique traditional. Yet on examination, their Westernisation is only surface deep, for, as noted before, the plans, and particularly the staircases, do not respond to the elevations. One of the clearest examples of this is the Hōhei-kan at Sapporo, which was built in the Western style for Western engineers working in Hokkaido. While acknowledging that the internal arrangement might have been altered when the building was relocated to its present position in Nakajima-kōen Park in 1958 or, indeed, at some

(*right*) 6.18 The Nishitagawa District Office at Tsuruoka, built by Takahashi Kanekichi in 1881.

other time, it is nevertheless worth pointing out that the symmetry of the façade is not reflected in the layout of the rooms, nor do the stairs in the main entrance hall pick up on the central cross-axis, as might be expected. In fact, both the main and secondary stairs are placed in diagonally opposite corners of the large entrance hall and each are approached by winders. If this was the original arrangement, then the Western engineers must have been nonplussed by this lack of both formality and hierarchy, but the Meiji Emperor's four-day visit to celebrate the building's opening, assured, for the Japanese, its success.

In contrast, one of the earliest and most convincing complexes of buildings in the Western manner still standing is the Omiya campus of the Ryūkoku Daigaku (Ryūkoku University) in Kyoto [6.19]. Ryūkoku had been, since 1639 (the year in which the Portuguese were expelled), a Nishi Hongan-ji Buddhist school but, in 1876, in common with the with Meiji policy of Shinbutsubunri,[71] had become a secularised university. The new buildings, completed in 1879, were arranged around a courtyard and comprised the Honkan (Main Hall) at one end, set on axis with the main gateway, and two long dormitory buildings, the Hokkō and Nankō (North and South Halls), one down either side. What makes this complex stand out is the cohesion of the concept: the twin lodges which flank the

entrance gateway; the repetitious arcading along the Hokkō and Nankō which contain the courtyard space; the archway cut through the Hokkō and the corresponding portico in the Nankō to mark the cross-axis; the advancing central pedimented bay of the Honkan terminating the long axis; the quoins, cornice, pilasters and plinth which grid and regulate the façade; and finally the imperial stair within the Honkan, rising, as would be expected, exactly on axis. Yet despite the consistency of the design, even down to the symmetrical positioning of the Jacobean-styled panelled doors along the main hallway, the presence of traditional building techniques, such as the expression of the pediment as a gabled roof with overhanging eaves rather than as a true triangle, gives the game away. Equally curious are the small Gothic details which have found their way into the design: the cast-iron screens set across the windows and the 'stiff-leaf' carving on both the keystone of the entrance arch and the tabs or brackets beneath the window sills.

In 1879, the same year as the Ōmiya campus was opened at Ryūkoku Daigaku, the first cohort of Western-trained Japanese architects graduated from the Imperial College of Engineering. Very soon home-spun *giyōfū* architecture began to fade away and for almost 50 years, until the introduction of *teikan yōshiki* or the Imperial Crown Style, the architecture of the academy held sway.

6.19 The Honkan (Central Hall) and Hokkō (North Hall) at Ryūkoku University, Kyoto, built in 1879.

7 THE WESTERN ARCHITECTS

Josiah Conder

Josiah Conder was the unlikely choice of the Ministry of Public Works to be the first Professor of Architecture at the Kōbu Daigakkō Zōka-gakka (Imperial College of Engineering, Department of Architecture) and Architect to the Public Works Department of the Imperial Japanese Government. When he arrived at Yokohama in January 1877 he was just 24 years old: he was to live in Japan for the rest of his life. Although he had no buildings to his name, his credentials were good. Unlike the majority of architects in Britain who trained through the pupilage system, Conder had studied architecture part-time through evening classes (there being no full-time courses in architecture) at University College, London. The curriculum there was divided into three parts: Architecture as a Fine Art, Architecture as a Science and the Practice of Architecture; the *College Calendar* noted that 'During the Session, some of the buildings in London, such as the British Museum, St Paul's Cathedral, or Westminster Abbey, and also one of the chief builder's workshops, are visited by the classes.'[1] It was a system which suited the nature of architectural education but one that, as a *Report of the Senate* noted in 1903, 'has very little relation to the general scheme of work in the College and it is arranged on the assumption that the students who attend the classes are giving their chief attention to work outside the College'.[2] The Professor of Architecture there was Thomas Hayter Lewis, but the real influence on Conder was Thomas Roger Smith, then a lecturer and, from 1881, Professor. Smith was, in fact, Conder's father's first cousin, and the young Conder worked as a pupil in his London office from February 1869 to January 1873. Here he would have learned about the East, for Smith was newly returned from India, where he had gone in 1864 to design the Post Office and European General (St George's) Hospital in Bombay (Mumbai). Smith is a significant player in Conder's story, for both his educational and architectural philosophy is reflected in Conder's work in Japan, and his ongoing interest in the East, demonstrated in his editorship of *The Architect*,[3] resulted in him becoming well-known among Japanese architects. In his obituary, the Japanese journal *Kenchiku Zasshi* noted:

> Among our architects who have travelled to England there are very many who have visited Roger Smith and benefitted from his help in furthering their study. Therefore we should say that his direct contribution to our country is great.[4]

In 1874, Conder went to work, as an assistant, for Smith's friend, William Burges. In this aesthetic

environment he 'grimly stuck to what he had to do, soon proving himself a man who could be relied on to carry through whatever he had deliberately undertaken; and his enviable capability for getting work done to time was only in keeping with his characteristic thoroughness.'⁵ Then, in 1876, he won the RIBA Soane Medallion, something of a habit amongst Burges's young men,⁶ with a punchy design for a country house in a Burgesian Early French Gothic style,⁷ and six months later left for Japan. It was this unusual combination of academic and practical training, and his prize-winning display of ability, which made him suitable for what the Ministry of Public Works had in mind. The newly established Kōbu Daigakkō Zōka-gakka or Engineering College had, since 1872, been run by a young Scottish engineer Henry Dyer and there, the engineering curriculum combined academic and practical training. In hoping to emulate this for architecture, it is likely that the Japanese had gone directly to University College⁸ for advice and there found that Smith's philosophy towards Indian architecture embraced the same European (and not necessarily British or English) virtues which the Meiji government wished for Japan. In a paper on 'Architectural Art in India', delivered to the Royal Society of Arts in March 1873, Smith had said that 'it appears only reasonable that as our administration exhibits justice, order, law, energy, and honour – and that in no hesitating or feeble way – so our buildings ought to hold up a high standard of European art.'⁹ Here, then, would be their man and Smith, in all probability, recommended Conder for the position: it would have been both an act of faith in the young man's ability and a demonstration of familial support.

Conder's most significant contribution to the introduction of Western architecture to Japan was not as an architect, although the Rokumeikan or Deer Cry Pavilion (1883) in Tokyo was symbolic of the adoption of Western attitudes and lifestyle, but as an educator. In March 1878, in what might well have been his inaugural address at the Kōbu Daigakkō Zōka-gakka, he stated a position largely drawn from Smith's pedagogy.¹⁰ Sensitive to his employment as an *o-yatoi gaikokujin* and his responsibility as the

educator of the first generation of modern Japanese architects, Conder was immediately considerate of traditional Japanese architecture and landscape design on which he published often:¹¹

> You have your monuments ... to the appreciation of which I am for ever urging you; and would urge you again that you secure careful drawings of them, and learn all lessons to be gained from each, before it is gone.¹²

And at the same time, he is dismissive of recent Western architecture in Japan:

> I must warn you against taking example, too much, from the buildings of the European settlements in your Country. Remember that they are only dwellings in a foreign country, and that consequently they have the character of cheap, temporary structures, unsuitable for those who are building their own Nation, home, and future.¹³

Reflecting again Smith, and no doubt Burges too, Conder laid great emphasis upon the artistic education of the architect. He warned his audience away from cheap, imported copy-books (particularly from America) and examples of what he called 'false Architecture'. Such buildings, now being built by speculators in Europe, were, he said, 'a misfortune for the Arts, but not to be compared to the misfortune and ruin which would follow from taking such works as a type for National buildings of Japan'.¹⁴ He believed that an architect must be a man of culture and he encouraged his students, through the study of historic buildings from all countries, to cultivate 'an imaginative mind'.¹⁵ And so he had them read William Burges's *Art Applied to Industry* (1865) and Albert Rosengarten's *History of the Styles of Architecture* (1876), this edition edited by Smith.¹⁶ Then he tested them on Western architecture, asking them to compare the Grecian and Roman Doric Orders, to explain the principal characteristics of the Byzantine style or to give a brief description of the architecture of ancient Egypt.¹⁷ Some of his questions came from the Royal Institute of British

Architects' proficiency examination, of which he had had experience himself. 'By this means,' he wrote, 'not only the comparative position of the students with regard to their fellows in this College is ascertained, but those who pass satisfactorily may be considered competent according to the standard of the highest examining authority in Architecture.'[18]

Although the Final Examination in History and Design balanced the Classical with the Gothic and the civil with the ecclesiastical, it also offered one self-coined question of immediate relevance: 'what important points does European planning differ from Japanese, and European principles of design in buildings from Japanese?'[19] Such a question could have been the basis of the final-year thesis entitled *The Future Domestic Architecture in Japan*[20] submitted by Conder's student Sone Tatsuzō in 1879. Here Sone, as Toshio Watanabe has observed, 'discusses Japanese architecture within the context of world architecture and within a historical framework, both very new approaches'.[21] Italian architecture, Sone thought, would be a good model for future Japanese architecture.

The two years that Conder had spent in Burges's office were a time of continuing work on large schemes, specifically Cardiff Castle (1866–1928), Castle Coch (1872–91) and St Finbar's Cathedral, Cork (1863–1904). In 1874 Conder joined the office to help with the revised design for Trinity College at Hertford, Connecticut (1873–82) and it is here, and more particularly in his entry for the Soane Medallion, that he had the opportunity to develop his skills as a designer. Thus when, in 1884, *The Builder* published Conder's 1877 designs for Tokyo University [7.01],[22] its similarities not only to the quadrangular Trinity College, but also to Chastel de Bionville's Imperial College of Engineering in Tokyo (see Chapter 8) was apparent. This was one of two designs which Conder produced.[23] What the other was is lost to history.

Although *The Builder* said that 'all the details have, where possible, without incongruity, been infused with a Japanese spirit ...'[24] the design was resolutely Gothic, axial and symmetrical, and as published defies any Japanese categorisation. Yet the inclusion of two square, domical towers with

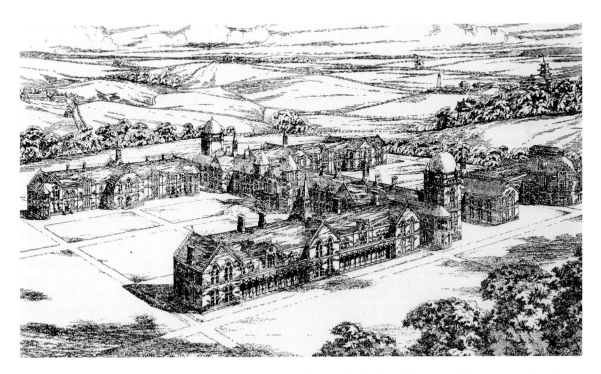

7.01 A design for the University of Tokyo by Josiah Conder, 1877, from *The Builder*, 13 December 1884, and reproduced in Josiah Conder, *Collection of the Posthumous Works ...*, 1931.

onion-domed turrets at the corners introduces an oriental feeling which recalls Burges's unbuilt School of Art in Bombay (1868).[25] This scheme, which *The Ecclesiologist* described as a 'quasi-Orientalizing Gothic', evoked its Indian context through its domical central tower and corner turrets. Its use of thirteenth-century Gothic, Burges told the RIBA, would 'present those broad masses and strong shadows which go so far to make up the charm of Eastern architecture'.[26] Smith, whom Burges had consulted on this proposal, advocated for India 'an adaptation of those European styles which have grown up in sunshiny regions',[27] as well as 'a leaning towards the peculiarities of the best Oriental styles'.[28] This implied 'an absence of such vertical breaks as buttresses, and a prevalence of horizontal cornices, and level projections', as demonstrated in both Burges's Art School and the Post Office and Hospital which Smith designed for Bombay.[29] This was to be the language of Tokyo University, but in the end, only one of the two long ranges flanking the quadrangle was built to Conder's design.[30]

For his first significant building in Japan, the Hokkaido Colonization Agency (1878–81) in Tokyo,[31] Conder took Smith's advice and employed one of the 'European styles which have grown up in sun-shiny regions', Venetian Gothic. Had this been in England, where Godwin's White House was then under construction, it would hardly have received a second glance: Venetian or Ruskinian Gothic had had its hey-day around 1860 and by now was about a decade out of date. Yet to the Japanese, the building must have appeared startling. It was built of red brick with stone dressings, king-post trussed roofs with iron bolts and fireplaces with chimneys; only the roof tiles were recognisably Japanese. Where Conder did innovate was in the concrete foundations which were floated on a lattice-work timber raft, thus saving the building in the 1923 Great Kantō Earthquake. Unfortunately, unlike Frank Lloyd Wright's Imperial Hotel, which also survived the earthquake due to its raft foundation, Conder's building was destroyed in the fires that followed.

Smith's other piece of advice, that there should be 'a leaning towards the peculiarities of

the best Oriental styles', presented Conder with some difficulties for he could detect, in Japanese architecture, 'no decorative or ornamental forms, or forms of outline or contour, which lent themselves constructionally to a ligneous or wooden style'.[32] In the absence, therefore, of a suitable national precedent, his solution was to adopt, in his next two major buildings, an Islamic (Anglo-Mughal) or what he called a pseudo-Saracenic style which, he believed, 'would impart an eastern character to the building'.[33] The best clear expression of this was the Museum (1881) in Ueno Park, designed initially as an exhibition pavilion[34] but opened as a museum the following year. The Meiji government intended the building to be seen, by Westerners, as an outward expression of the new Japan.

Although Islamic architecture had first appeared in Britain over half a century earlier at John Nash's Royal Pavilion (1815–21) at Brighton, the style was maintained well into the second half of the nineteenth-century due to the British Empire's continual building in India.[35] At the end of the 1870s, both Burges and his friend, George Aitchison, were creating Arab Halls for their respective peers, the Marquess of Bute at Cardiff Castle (*c.* 1878–81) and Lord Leighton at Leighton House, London (1877–79).[36] In the 1880s, Thomas Brassey (later the 1st Earl Brassey), whose wife Annie's record of their voyage to Japan on board the schooner *Sunbeam* is mentioned in Chapter 3, had a Durbar Hall erected in his home at 24 Park Lane, London. Conder's promotion in Japan, therefore, of his pseudo-Saracenic architecture, can be seen as being a stylistically fashionable attempt to provide a cosmopolitan, Westernised, if not actually imperial architecture, as Smith would have wanted.

The Museum at Ueno was a long, two-storey structure containing thirty rooms [7.02]. Although there is the suggestion that the plan might have pre-dated Conder's arrival in Japan,[37] its similarity to that of Sir John Soane's Dulwich College Picture Gallery (1811–13), a building in south London which Conder, who was born in nearby Brixton, would almost certainly have known, would indicate otherwise. Another point of reference, for its scale and use of red brick, if not its architectural style,

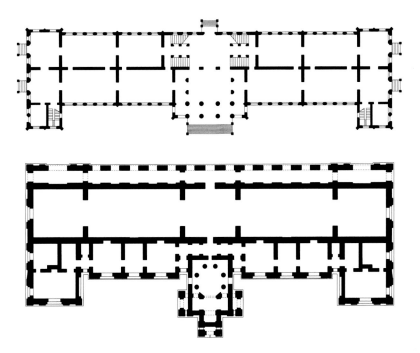

7.02 Comparative plans: The Museum in Ueno Park, Tokyo, designed by Josiah Conder, 1881 (*top*); and the Dulwich College Picture Gallery, London, designed by Sir John Soane, 1811–13 (*bottom*).

would have been the South Kensington Museum (1867–69) where Conder had attended drawing classes.[38] Designed by Francis Fowke in an Italianate manner as a display of both art and national culture, it offered a model for the Japanese Museum which would have suited the intentions of the Meiji government. The use of brick gave the impression of both physical and national stability while the employment of pseudo-Saracenic features, such as the onion-domed *chhatris* which flanked the polychromatic Islamic arches of the entrance bay and the ornamental sun-screens which shielded the upper windows, imparted a decorative treatment appropriate to its masonry construction as well as being suggestive of its Eastern provenance [Plate 14]. For the young architect's first major building in his new country, it was a well-intentioned but misguided stylistic diversion which, even at the end of his career, left him still wondering how well understood was 'my motive in introducing a pseudo-Saracenic style of architecture in Japan'.[39]

Conder's uncertainty might have been because Inoue Kaoru, then Minister of Foreign Affairs, dissuaded him from using the pseudo-Saracenic style at the Rokumeikan (1883), Inoue's wish being for something more Western [Plate 13]. Built with Inoue's patronage near Hibiya Park and the Imperial Palace as an official residence for foreigners, the Rokumeikan was where wealthy and aristocratic Japanese might go to mingle with visitors and affect Western manners. The result was a 'sun-shiny' European building comprising open Italianate loggias across the façade, a French, square-based dome above the pedimented entrance, and an arcaded *porte cochère*. The appearance of the Rokumeikan was closely tied to Inoue's belief that Japan needed to Westernise in order to treat with the West on equal terms. But paradoxically, it was its very assimilation of Western architectural effects which failed it in the eyes of many foreigners who expected, in Japan, to see something more oriental. The French author of *Madame Chrysanthème*

(1887), Pierre Loti, who in 1885 attended the great ball hosted by Inoue in honour of the Emperor's birthday, disliked its painted-brick newness and compared it to a casino in a French spa town.[40] Had Conder been allowed to design a pseudo-Saracenic building, rather than applying a few very curious touches to the upper loggia columns and perhaps elsewhere, Loti might have been less dismissive and Conder's original intentions vindicated. As it was, the building's fortunes declined following Inoue's resignation in 1887 (as a result of his failure to achieve an acceptable reform of the Unequal Treaties) and it was sold.

In 1884, soon after the completion of the Rokumeikan, Conder's contract as Professor of Architecture at the Imperial College of Engineering came to an end and he simultaneously resigned as architect to the Ministry of Public Works, although he went on to work for the *Dajōkan*[41] the next day. The pendulum of patronage now swung towards Germany and it was to Berlin that in 1887 Conder, on his one return trip to Europe, escorted two of his former students, Tsumaki Yorinaka and Kawai Kōzō. There they were to join the firm of Ende and Böckmann.[42] On arriving in England, Conder found that a new architecture, the Queen Anne Revival, was the fashion and that the champions of the Gothic Revival, Burges, Street and Scott, and even Godwin, had all died. Norman Shaw's polychromatic Alliance Assurance Office (1882–83), with its Classical details and Dutch gable, was freshly built on London's St James's Street and his equally colourful but more assuredly Baroque New Scotland Yard (1887–91) was on site down by the Thames. Board Schools, to the designs of Edward Robert Robson and, initially, John James Stevenson, in red brick with more Dutch gables, were springing up all across London. Perhaps realising that the architectural world had changed, Conder did not stay, but returned to Japan and the assured patronage of the Iwasaki family and the new money of the Mitsubishi *Zaibatsu* (or conglomorate), to whom he became an advisor in 1887.

The first *yōfū-jūtaku*, a house in the Western style, which Conder designed in Japan was for the second Naval Minister Kawamura Sumiyoshi,

to whom he was probably introduced by Thomas Glover.[43] Built at Mamiana-chō in 1882, it made no effort to look pseudo-Saracenic but instead took on the appearance of a (very) large mid-Victorian vicarage with the addition of a Japanese temple-style verandah along the front. The adherence of the house, with the exception of the verandah, to a Western architectural vocabulary is easily explained. The houses built by the powerful Japanese politicians and businessmen were not intended for everyday living; their purpose was as much to receive and entertain Westerners in an environment which would make the visitors feel at home and show their hosts to be educated and sophisticated as it was, as Morse explained, to keep the clumsy Westerners out of their traditional houses:

> In Tokio a number of former Daimios have built houses in foreign styles, though these somehow or other usually lack the peculiar comforts of our homes. Why a Japanese should build a house in a foreign style was somewhat of a puzzle to me, until I saw the character of their homes and the manner in which a foreigner in some cases was likely to behave in entering a Japanese house. If he did not walk into it with his boots on, he was sure to be seen stalking about in his stockinged feet, bumping his head at intervals against the *kamoi*, or burning holes in the mats in his clumsy attempt to pick up coals from the *hibachi*, with which to light his cigar. Not being able to sit on the mats properly, he sprawls about in attitudes confessedly as rude as if a Japanese in our apartments were to perch his legs on the table. If he will not take off his boots, he possibly finds his way to the garden, where he wanders about, indenting the paths with his boot-heels or leaves scars on the verandah, possibly washing his hands in the *chodzu-bachi*, and generally making himself the cause of much discomfort to the inmates.[44]

Elsewhere, in a side wing or in a separate building, there would be traditional Japanese accommodation where the owner's family, free from the Westerners, could live in the manner to which they were

(*right*) 7.03 The second Iwasaki Yanosuke House in Tokyo Takanawa, designed by Josiah Conder, 1908.

accustomed. Therefore, in these mansions, Conder could express the whole range of his Western architectural vocabulary without having to create a hybrid, Westernised architecture for Japan.

If there is a modesty about the Kawamura House, there was none about the first house he built for Iwasaki Yanosuke, the second President of Mitsubishi. Constructed soon after his return from Europe, the mansion at Fukagawa (1889) showed neither evidence of what Conder might have learned from Burges or Smith, nor any noticeable response to what was currently being built in England, although there are similarities to Betteshanger House in Kent, which George Devey had been remodelling for Lord Northbourne since the mid-1850s. At Fukagawa, Conder built, in the Elizabethan style, large, curved brick gables with white stone trim and white stone aedicular windows. The *porte cochère* directed visitors to a grand central hall with columns and an imperial stair: to one side, the reception rooms opened onto an elaborate two-storey verandah and an octagonal corner turret with a domical roof; to the other side, passages led to the dining room and kitchen wing. A separate building housed a billiard room and a conservatory. To understand where all this came from one does not have to look far. Robert Kerr, who was, from 1861 to 1890, Professor of the Arts of Construction at Kings College, London, had in 1864 published *The*

Gentleman's House; or How to Plan English Residences from the Parsonage to the Palace.[45] This book was widely read and had been the reason that John Walter, the chief proprietor and editor of *The Times*, had hired Kerr to build his country house, Bear Wood (1865–74) in Berkshire. Here can be found the gables which Conder used and the octagonal turret as well as many examples of the standard, nine-square Palladian plan upon which such houses, despite their Gothic or Elizabethan appearance, were modelled. This allowed for formal circulation along the main cross-axis and reinforced both social and gender hierarchies by the tripartite grouping or discrete separation of the most important rooms, the drawing room, the dining room and the library. But the Iwasaki mansion was lost in the 1923 Great Kantō Earthquake and few illustrations have survived. Conder's use of Bear Wood as a precedent, however superficially, was intelligent, despite that building's extravagance and failings. Kerr's book, which he must have owned, provided plans and lengthy descriptions.[46] The house, built with fireproof construction and infused with Victorian technology, offered a model of modernity, and Iwasaki, like Walter, was *nouveau riche* and very powerful.

Bear Wood was also a source, in part, for the even grander house which Conder designed for Iwasaki Yanosuke in Tokyo Takanawa [7.03].[47]

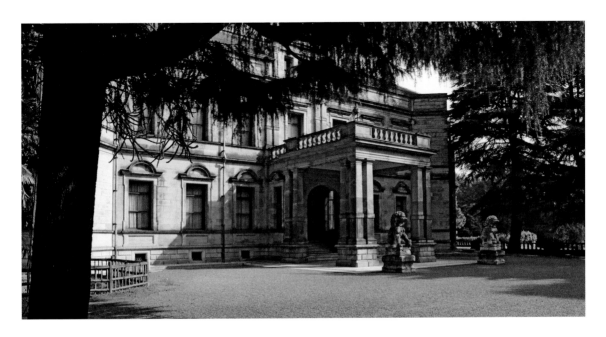

Built in 1903–08, this large, stone building, which is now the Mitsubishi Club, appears, for all its size, like a wing of Osborne House on the Isle of Wight, designed and built for Queen Victoria by Thomas Cubitt and Prince Albert in 1845–51.[48] It is heavy, Italianate, and somewhat ungainly, the stone columns of the obligatory two-storey verandah and the stumpy tower to its side adding no elegance to the garden elevation. It is the *porte cochère*, square with doubled-up columns and capped by a balustrade, which comes straight from Bear Wood. But then, so does the plan of the main house, four-square with canted bay windows and a great, transverse hallway which Kerr calls a *cortile*.[49] Kerr's plan was an unfortunate precedent, for it was unresolved, some rooms having two nominated functions, as if their use was to be always undecided.[50] Some of the same indecisiveness affects Conder's solution. Off the hall are two adjacent lounges linking through to the verandah and the dining room: in later years one became a small dining room and the other a lounge for 'precious guests'. If understood in terms of English house planning, the hierarchical arrangements of the rooms does not work. Both the ballroom and the library are on the first floor, the former above the dining room and the latter above the billiard room. Thus the rooms which make up the male domain, the study, the billiard room and the library, are stretched to three distant corners of the plan, while guest rooms and family bedrooms, including the master-suite, share the same broad, first-floor landing with the ballroom and the library. How the Iwasaki family intended to use this building is hard to say. Japanese social habits were not the same as those to which Westerners, and particularly the English, were used, even if they tried to assume them. In the house, circulation routes did not strictly separate family or guests from servants; and the Turkish baths, removed from the main house, were attached to the servants' wing and formed part of what might otherwise be the kitchen court. If this breaking down of social barriers was acceptable in Japan, it certainly would not have been countenanced in the West.

Contemporary sources suggest that Conder's relationship with Iwasaki was not always easy.[51] It was noted that Conder, 'wishing to satisfy the old Baron's desires of manifold character, made out the plans over and over again'.[52] In 1902 Iwasaki took Conder's final design with him on a seven-month tour of Europe and north America, 'in order to have it critically examined by prominent architects in Britain and France'. It is likely that, while in London, he commissioned the additional design for a Turkish bath-house to be built contiguous with the main house. In the event, this was reworked by Conder.

The fitting-out of the building's interior was, with the exception of the pseudo-Islamic billiard room, as Western as the exterior. The transverse hall had a heavily beamed ceiling with a centrally positioned light well penetrating the first-floor landing with Jacobean balusters and elaborately carved newel posts. Heavily panelled walls and a deep frieze, like an *arikabe*, surrounded the hall from which a triple arch with Ionic columns led to the stairs. The beamed and panelled dining room was equally manorial, the servery, a memory of the medieval screen-passage, being as well defined by two tall columns as it was, by a buffet, at Bear Wood. By contrast, the ballroom with its rococo fireplace and elaborately plastered ceiling was in the style of Louis XIV (although the panelled walls were decorated with Japanese scenes) while the principal reception space, the large guest room, was plastered and panelled in the English eighteenth-century manner, as was the principal bedroom suite above. Although later usage saw part of that suite, as well as one of the plainer guest rooms, adapted as *tatami* rooms, the provision of a large Japanese-style house, a *wafū-jūtaku*, elsewhere in the grounds made such arrangements unnecessary.[53] After the Rokumeikan, Conder, as shall be seen, had never quite let go of the pseudo-Saracenic style. It appears here in the dado, frieze and ceiling of the billiard room and more emphatically, and appropriately, in the Turkish bath-house. Built in brick, with battlements and polychromatic Islamic arches, its costume well suited its function. The

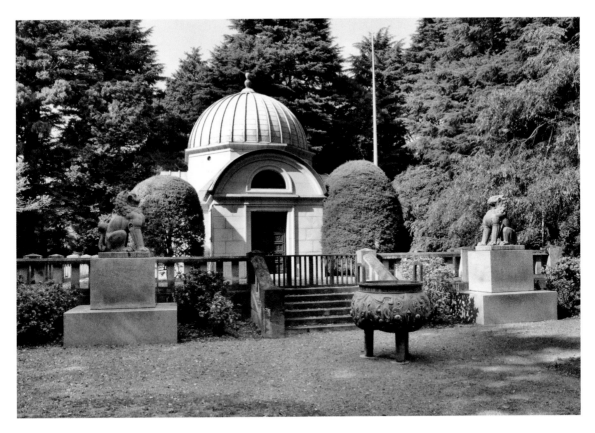

7.04 The Iwasaki Mausoleum in Tokyo Setagaya-ku, designed by Josiah Conder, 1910.

design, in fact, had been originated by G. Harold Elphick, the architect of the highly praised Turkish Baths off Old Broad Street, London (1895).[54] Elphick's drawings, showing a building rather more elaborate than Conder eventually built, are dated July 1903. Comprising a dressing room, frigidarium, trepidarium and a calidarium with a marble seat, it was the first such building in Japan. However, attached to the east side of the servants' wing of the Italianate mansion, and fully visible from the gardens, it was both incongruous and misplaced. It was demolished in the late 1930s.

Iwasaki Yanosuke barely lived to see the completion of his mansion, dying in March 1908. A good patron to Conder, he had commissioned not just the houses at Fukagawa and Takanawa, but also, in 1892, another smaller house at Surugadai

(but built to a different, half-timber design in 1895[55]). Conder was also to build his mausoleum, commissioned by his son Koyata, the fourth and last President of Mitsubishi, in Tokyo Setagaya-ku in 1910 [7.04].

Iwasaki Hisaya was the son of Iwasaki Yataro, the first President of Mitsubishi and, soon after returning from five years studying at the Wharton School of Business at the University of Pennsylvania, became the third President when his uncle retired in 1894. One of his first actions was to commission the Mitsubishi Ichigokan (building number one) which became the home of the Mitsubishi *Zaibatsu* [7.05].[56] Built in Marunouchi, close to the Imperial Palace, on wasteland which had been bought by his uncle, Iwasaki Yanosuke, this development, as suggested

by its soubriquet, kick-started the Tokyo business district. The mansion which Conder built soon after for Iwasaki Hisaya in Tokyo Yushima (1896) [7.06] was, like the earlier design for his uncle's house at Surugadai, constructed of timber and similarly noticeably American in appearance. This was due not just to the two-storey ante-bellum verandah across the rear,[57] but also the rich assembly of American Queen Anne detailing which could have placed the house comfortably in San Francisco. The plan of the house, however, remained resolutely English.

Organised around a broad central hallway, the Iwasaki Hisaya mansion adopted the conventional arrangement of interconnected reception rooms – dining room, drawing room and ladies' guest room – with the library, the male domain, separate and to one side. The billiard room was located in a Swiss chalet-style building to the side. Whereas the hallway, stairs and principal rooms were treated to the familiar country-house Jacobean detailing of turned balusters, panelled ceilings and pedimented architraves, the ladies' guest room was conceived as a rich pseudo-Saracenic boudoir. The marble fireplace has Mughal arches and ornamental fretwork while the ceiling panels and door architraves were given Mughal patterns. It was altogether an eclectic concoction, made all the more surprising, to Western visitors, by the immediate juxtaposition of the much larger Japanese residence.

This combination of Western and Japanese dwelling spaces, known as *wayō-kongō jūtaku*, was not untypical in Japanese architecture. What remains of the Japanese residence at the Iwasaki Hisaya mansion is but a fraction of the original

accommodation built by Ōkawa Kijurō which had extended over 49,000 square metres and comprised 14 rooms. Such a compromise was not unusual – there was a large Japanese house in the gardens of Iwasaki Yanosuke's Takanawa mansion – and Conder, who had married Kume Maenami in 1880, included Japanese accommodation, primarily for her use, in the house he built for himself in Mikawadai-chō, Tokyo, in 1904.[58]

The idea of separating the Japanese accommodation from the Western extended into the landscape. This was due as much to the client's desire to Westernise as to the incongruity of placing a Western house within a Japanese landscape, however picturesque. Conder, who was a great admirer of the Japanese garden and published *Landscape Gardening in Japan* in 1893, explained that:

> A garden in Japan is a representation of the scenery of the country, though it is essentially a Japanese representation. Favourite rural spots and famous views serve as models for its composition and arrangement ... Formal and geometrical arrangements of trees, shrubs, and parterres, as common in European gardens, are indeed rarely admitted, but certain rectilineal objects, such as oblong slabs of hewn stone, straight flower-beds, and short screen fences, are introduced near to the building.[59]

In his last house, built in 1917 for Furukawa Toranosuke of the Furukawa *Zaibatsu* [7.07], the gardens around the hill-top mansion comprise parterres and formal and geometrical arrangements of trees and shrubs; only at the bottom of the valley can be found the Japanese garden, designed by the Kyoto master, Ogawa Jihei.[60] The house, constructed of rough-hewn stone with over-hanging eaves held by wooden brackets, has all the appearance of a Scottish shooting lodge of the mid-nineteenth century. Its interior moves from the heavily beamed Jacobean entrance hall and stairs with its leaded lights and heraldic crests to the almost Adamesque drawing room with its delicate plaster ceiling and fireplace.

The house offers no concession to Japanese living nor, indeed, to the hot and humid summer climate, apart from the proliferation of windows which would, in Scotland, have made such a building very chilly. Although fireplaces and a conservatory make it suitable for the Japanese winter, its effective disengagement from the garden, reached only through a modest, three-arch loggia, show it nevertheless to be a fully Westernised conception. Now, 50 years into the Meiji era, there was no longer any attempt to assimilate Japanese or oriental references into either the architecture or its landscape. The Western take-over was complete.

Ende and Böckmann

The trouble with architectural compromises can be well understood through the problem of the Diet (Parliament) building designed by the Berlin architects Hermann Ende and Wilhelm Böckmann. In 1886 Böckmann had been invited by a government commission, under the leadership of Inoue Kaoru, to draw up plans for a national capital located in Kasumigaseki, close to the Imperial Palace. A hill-top site was selected for the Diet (Parliament) building and from this Parliament Avenue would reach down towards the Imperial Palace at Sakuradamon and then turn east, between Army Place and Exhibition Place, where

Kōkyo-gaien and Hibiya-kōen now are, before diverging as Mikado Avenue and Empress Avenue, with a great *rond-point* set between. On the far side would be a railway station, where Ginza 1-chōme now stands, and government buildings would infill the spaces. The need for such a civic centre was not just a reflection of the Meiji government's, or more particularly Inoue's Westernising programme, but also a concerted effort on Inoue's part to achieve the withdrawal of the Unequal Treaties. For as long as there was no evidence of a new and functioning legal system, the Treaties, which granted judicial extraterritoriality to all Westerners, would remain.[61] Therefore the inclusion of a Ministry of Justice and a Supreme Court within this civic centre was as much a necessity as the provision of a Diet.

Böckmann arrived in Japan in 1886 and stayed for two months before returning to Berlin, with a number of Japanese assistants, to work up a scheme with his colleague Edgar Giesenberg. The design for the Diet which emerged was a large, symmetrical, Baroque affair with a dome over a central court and, beneath Mansard roofs in the flanking wings, the two houses of parliament. It was clearly based on the firm's second-placed entry for the Berlin Reichstag competitions of 1872 and 1882 [7.08].[62] At 170m long and of masonry construction, it was to be a full-blooded exercise in European democracy. But, aware of the growing resistance to both Inoue's pro-Western policies (which led to his eventual resignation that year)

and the awarding of such an important building to a foreign architect, the firm decided to submit a second scheme.[63] Consequently Ende travelled to Japan in May 1887 and during a two-month stay visited both Nikkō and Nara. The result was a Euro-Japanese hybrid in which the massing and disposition of spaces were allowed to remain while the Baroque features of the first proposal were replaced with a pseudo-oriental confection of *kara-hafu* (cusped gable), *chidori-hafu* (dormer gable), battered walls and a pagoda-like tower.[64] It was perhaps just as well that neither this, nor Ende's other efforts in the Euro-Japanese manner – the Daishin'in (the Great Court of Cessation or Supreme Court), the Shihōshō Chōsha (Ministry of Justice) and the Naval Ministry – were built. In an address to the World's Congress of Architects in Chicago in 1893, Conder was highly critical of this approach:

> To design a civil building in masonry having all the characteristics of the classical styles of Europe, and to crown it with fantastic lanterns, roofs and turrets of timber in imitation of portions [of] Japanese religious constructions, is not adapting the national style to modern purposes – it is to create a bizarre and hybrid *ensemble* as revolting to Japanese taste and common sense as it is wanting in the permanent and fire-resisting qualities which are first conditions of the programme proposed.[65]

This invective might have been the result of jealousy, Conder feeling that Ende and Böckmann had usurped his privileged position. Conder did eventually build the Naval Ministry (1894) in a rather ponderous, Second Empire style, while young Hermann Muthesius, later the confidant of Charles Rennie Mackintosh and the author of *Das Englische Haus* (1904–05), who arrived in Japan in 1887,[66] initially took charge of the other two buildings for Ende and Böckmann, the Daishin'in and the Shihōshō Chōsha. He was replaced as senior clerk of works by Richard Seel[67] and what eventually emerged, respectively in 1896 and 1895, was in both cases authoritatively European, the

7.09 The rebuilt Ministry of Justice in Tokyo Kasumigaseki, designed by Hermann Ende and Wilhelm Böckmann with Edgar Giesenberg, 1895.

former a Bavarian Baroque and the latter more resolutely north German or even Dutch [7.09].

The difficulties which Ende and Böckmann experienced in Japan were characterised by an account published in *The Builder* in 1893 and headed, 'The Imperial Law Courts, Tokio':

> Messrs. Ende & Boeckmann, the architects selected, have had no very easy task, having been driven this way and that way in turns, according as the patriotic or progressive party in Japan were predominant, towards a Japanese, a semi-Japanese, or a European type of building.

The Builder showed two designs, one being 'an attempt to combine a certain amount of Japanese character with some of the features of European Renaissance', and then commented:

> This design had been approved and actually commenced when a European fit took the Japanese again and the work was countermanded in favour of a more distinctly European design.[68]

Despite this experience, Ende and Böckmann were not deterred. In 1893 Böckmann became Associate Director of Berlin Zoo and, four years later, its President. This involvement allowed the

(*left*) 7.08 The first design for the Diet building by Hermann Ende and Wilhelm Böckmann, from *The Builder*, 13 October 1894.

firm a number of commissions at the zoo where they built animal houses whose style referenced the parts of the world from where the animals originated. However, the Elephant Gate is perhaps more Chinese than Japanese, although elephants are native to neither country: in Buddhist thinking they represent power and peace. The gate lodge, particularly in the middle storey with its *kara-hafu*, could certainly be seen as Japanese even, if the roof, despite the *chidori-hafu*, might have come from Siam. The exercises in Euro-Japanese styling, provided by the Japanese governmental buildings, had not gone to waste.

Meanwhile Seel, following the termination of his employment in 1893, moved to Yokohama, where he found himself in competition with Pierre Paul Sarda, a French engineer and architect of the Gaiety Theatre (1889) and the Shiloh Church (1892), and even Conder himself, who set up there in 1897. Seel's work, as evidenced in the Stone Clark Memorial Hall which he built in 1894 at the Dōshisha English School in Kyoto, a centre of 'missionary architecture', remained particularly Germanic [7.10]. In 1904, he handed over the office to another German architect, George de Lalande – who expanded the practice considerably – and returned to Germany.

Missionary Architects

The connection between Christian missionary work and the building of buildings is closer than might be thought. Missionaries needed buildings in which to do their work, as the experience of Dr Bernard Jean Bettelheim, who appropriated a Buddhist temple, and Thomas James Waters, who forsook Bibles for bricks, shows. These missionary architects did not, of course, limit themselves to the building of churches. Their flock needed housing, schools, hospitals and all the other trappings of a Christian and ultimately Western lifestyle. Thus, the adoption of Christianity meant also the adoption of Western architecture, for with one came the other. Christianity had

been actively repressed since 1639, but the Meiji Restoration provided the opportunity for Christian missionaries to go back to Japan, and for the very few Japanese who had left the country for a Western, and thus Christian, education to return without fear for their lives. Like the Chōshū Five, Niijima Shimeta had escaped *sakoku* and in 1864 had travelled to the United States where, under his adopted Western name of Joseph Hardy Neesima, had become the first Japanese to graduate from both Amherst College and the Andover Theological Seminary. On his return to Japan, Neesima, together with the Christian convert Yamamoto Kakuma and the American missionary Jerome Dean Davis, and with the backing of the American Board of Commissioners for Foreign Missions, had founded the Dōshisha English School in Kyoto.

The house which Neesima built for himself at the Dōshisha campus, with the advice of Dr Wallace Taylor, a missionary physician and a member of the American Board who was working in Kyoto, was probably the most successful of the cluster of educational buildings which were erected there over the next 15 or so years. Built with an understanding of both Western lifestyles and Japanese building practices, and, unlike the others, designed to respond to Kyoto's seismic conditions and extremes of climate, it offered a sensible solution to the practical questions. What it did not do, however, was to convey through its architecture any sense of Western and thus Christian ideology, yet its message of Christianity was implicit in its arrangement and inferred through Neesima's calling. Although constructed in the traditional Japanese way, as the exposed roof structure of the kitchen shows, it was a two-storey, colonial-style house, with verandahs on both levels, broadly overhanging eaves, sliding lights above both the doors (both external and internal) and the windows, and with the ground floor raised higher than was usual for Japanese houses. Thus, it took care, in terms of Western living, of the climate. Internally, there were no *tatami* rooms but floorboards throughout; the windows, like most of the doors, were hinged and there was not one, but two stairs. These features, and the Western

(*left*) 7.10 The Stone-Clark Memorial Hall, Dōshisha English School, Kyoto, designed by Richard Seel, 1894.

furniture which the architecture demanded, provided for a Western lifestyle. When Neesima came to add a wing for his parents, it was a wholly Japanese, and thus implicitly non-Christian, affair.

The missionary architect who had the greatest effect on Dōshisha was Daniel Crosby Greene who, while a student at the Chicago Theological Seminary in 1866, had met Jerome Davis before transferring, the next year, to study at Andover Theological Seminary which Neesima himself was to attend. Greene received his licence to preach in 1868 and in 1869 applied to the American Board of Commissioners for Foreign Missions to be a missionary. Originally destined for China, a last-minute change of plan sent him as the Board's first missionary to Japan, where, with his newly married wife, Mary Jane Forbes, he arrived at Yokohama in November 1869. The Board's decision must have been a risky one, for the Boshin War was barely over and Christianity still largely unaccepted, yet a foothold was achieved and Davis followed Greene to Japan in 1871. Within five years Greene had established, with 11 members, the Board's first church in Kobe and by 1882 the Board had 19 churches with over 1,000 members.

In Kobe, Greene, with the help of Japanese carpenters, built his own house.[69] He had no experience of architecture, having first trained as a teacher and then as a theologian after serving briefly with the Rhode Island Cavalry in the Civil War. Yet his family's background was one of practical application: one uncle was apprenticed to a mason and bricklayer, while another learned the carpenter's trade, and he himself had a lifelong interest in things mechanical.[70] In the winter of 1881–82, Greene was transferred to Dōshisha to teach a vernacular course in theology for students who could not read English and soon found himself acting as a supervising architect, not only because he had greater experience than his colleagues with Japanese workmen, but also because of his expressed interest in design and construction.

During the summer of 1883 Greene was, as he recalled, 'busy getting ready the drawings for our new school building',[71] the first permanent building on the campus. This was the Shōeikan or Recitation Hall, and only the second brick building to be built in Kyoto. By the time it was completed in 1884, Greene was preparing the estimates for the next two buildings, the chapel, which was dedicated in 1886, and the Shojakukan or library, which opened the following year. Greene was modest about his work, which, as he said, 'makes no special pretensions to architectural merit', although he thought that he could 'put up buildings so that whether as regards solidity or general appearance you will not regret having entrusted them to my care'.[72] Working with the carpenter Otaki Kikutarō, Greene adopted a curious amalgam of Japanese and Western building techniques. Whereas the exterior of the Shōeikan was of load-bearing brickwork with granite piers, arches, quoins and window heads, the interior was framed in the traditional Japanese way with the posts resting on foundation stones. Its appearance is American collegiate, the dominant entrance tower recalling, rather crudely, the brick entrance tower added in 1875 to Bartlet Chapel, the central building at the Andover Theological Seminary. The chapel, a small Gothic building, lacks any real architectural pretension, despite its heavily corbelled brick cornice. The narthex, constrained beneath a multi-pitched roof, is awkward and the chimneys, emerging from the square buttresses on either side, appear like an afterthought. The Shojakukan, also in brick, is bolder and more confident, with a cruciform plan and polychromatic panels and banding. It is likely that it was based upon Louis Sullivan's Hammond Library at the Chicago Theological College which was built in 1882–83: both buildings are libraries, both are brick and both are polychromatic. The foundation stone for the Shojakukan was laid in 1884, so it is wholly possible that Greene had seen photographs, or even drawings, of Sullivan's building before he started on his designs. There is a lack of depth to the elevations of each building, the tripartite window arrangement being only slightly recessed. The panels beneath the arches are decorated by Sullivan with carving and by Greene with polychromatic brickwork, which he then

extends to the aprons below the windows. Greene also introduces stone and brick banding to his *piano nobile* level in the same manner and location as Sullivan does, and fails, like Sullivan, to connect the banding with either the sills or the imposts of the window arches. This idiosyncratic treatment is too close to Sullivan's building to preclude, for an amateur, any other source.

In 1889, two years after Greene completed the Shojakukan, the British architect Alexander Nelson Hansell built the Rikagakukan, or science building, at Dōshisha: it was named Harris Hall after its benefactor Jonathan Newton Harris, the deacon of the Second Congregational Church of New London, Connecticut, who had made his fortune through patent medicine. The son of an Anglican vicar, Hansell had been articled to William Scott Champion, a pupil of George Edmund Street, and had set up in practice in London in 1882, before moving out to Japan in about 1885. His earliest significant work there was the Bishop Poole's Memorial School for Girls in Osaka (1885–90), which was built for the Christian Missionary Society. In 1890 he added a boys' boarding school and a house for the Principal, again paid for by the Society. Harris Hall was built of brick with stone trim in the educational Tudor-style of the day and was a more articulate building than Greene's earlier works. The long elevation was broken by a gabled central entrance bay, inscribed '18 SCIENCE 89', and terminated with broader gabled wings at either end, while inside, the Jacobethan dog-legged stairs was set across the plan and pushed to the back beneath a dome which has since gone.

Hansell maintained a practice in Kobe, where, in 1890, he was doing extensive work for the Kobe Club and, as his FRIBA nomination papers said, 'several other works in Godowns etc. for the principal firms of that place'.[73] The Western-style houses which he built for the foreign community in Kobe would often provide additional Japanese-style accommodation for the servants. This would be a separate building to the rear, connected by a bridge at the upper level so that the servants could attend to the bedrooms without having to pass through the main body of the house or use the stairs. Such

7.11 A house with servant quarters of the 1890s, originally built in the foreign settlement in Kobe and now rebuilt at Meiji-mura.

an example, built in Kobe in the 1890s, can be seen at Meiji-mura [7.11]. Here the servants' building, to the rear, is finished in clapboard and decked out with *shōji* to the balcony and *tatami* within, while the stucco-finished Westerners' residence had a two-storey, wrap-around verandah in front of hinged window shutters.

James McDonald Gardiner, who arrived in Japan in October 1880, later became the mission architect for the *Nippon Sei Kō Kai*, the Anglican Episcopal Church of Japan. What brought him there was his appointment by the Mission of American Churches as Headmaster of the recently defunct and homeless

7.12 Holy Trinity Church (now St Agnes), Kyoto, designed by James McDonald Gardiner, 1898.

Rikkyō Gakkō (St Paul's School)[74] in the Tsukiji district of Tokyo, the approved residential area for foreigners. Here, he soon set about building a new brick and tile schoolhouse (the last had been lost in a fire in 1876) in a respectable mid-nineteenth-century commercial Gothic, the gabled elevations of the Boys' School and Girls' School suitably separated by the central tower with its pyramidal spire. It opened in 1882 and over the next decade Gardiner completed a number of teaching and dormitory buildings for Rikkyō Gakkō, as well as Holy Trinity Cathedral in Tsukiji (1889).

Resigning from the management of the school in 1891, Gardiner had returned to the United States to complete his degree at Harvard before coming back to Japan in 1894 to teach once more at Rikkyō Gakkō, which had now obtained college status. During this time, he built Holy Trinity Church (now St Agnes), Kyoto (1898), a neat brick Gothic building with a north-east tower (now devoid of its crenellations and high roof) and gabled transepts and porch [7.12]. Whereas the exterior is unremarkable, the interior is

curious. It has an almost Japanese fragility which its robust exterior belies: the nave roof is supported by six scissor trusses while above the aisle arcade there is a thin, timber clerestory which opens, through Gothicised Serliana, not to the exterior, but into the aisle itself.

In 1901 Gardiner returned another time to the United States and one could speculate that now he turned his attention to architecture, for he had previously worked in architects' offices in New York and, in 1903, came back to Japan to open an architect's office himself in Tokyo, yet remaining with the Anglican Missionary Church of Japan. His largest extant church, St John's (1907), has moved from its original site in Kyoto to Meiji-mura where, on its exposed hilltop position, it lacks any sense of its original context. With its lower storey in buttressed brick, and the upper parts framed in timber, so as to lessen the effect of earthquakes, it is a double-fronted essay in American Gothic [07.13]. Above the rather thin porch or narthex, the Gothic west window is flanked by twin octagonal

(right) 7.13 St John's Church, Kyoto, designed by James McDonald Gardiner and now rebuilt at Meiji-mura, 1907.

towers set upon two advancing gabled wings. This large, symmetrical church is, in its way, no less idiosyncratic than Holy Trinity, the building offering at times a rather awkward fusion of Gothic arches and Classical pilasters, and veering, in its internal treatment, between the domestic and the institutional. Yet the combination of the dark timber of the columns and trusses which frame the interior and the exposed bamboo lining of the ceiling above must have appeared familiar to both the Japanese craftsmen who built it and the Japanese congregation who worshipped there.

Gardiner's ultimate success as an architect can be judged by his late flowering of houses, such as the American Queen Anne-style house that he built in 1910 for the former Japanese Consul General in New York, Uchida Sadatsuchi, in the Shibuya district of Tokyo. Relocated to the Bluff in Yokohama in 1997 [7.14], this timber-framed two-storey house is now set on steeply sloping land which allows it to drop down to three storeys at the rear, its dominant corner marked by a picturesque octagonal tower with a pyramidal roof not unlike those on the towers of St John, Kyoto. The house's clapboard appearance seems as appropriate here, whether this be Tokyo or Yokohama, as in Hakodate on Hokkaido, where in 1908 Gardiner built the Iai Girls School Missionary House in a similar vein. But with his richer clients, such as the Murai family for whom he built houses in Kyoto (1909) and Tokyo (1911), and Baron Yoshikawa, for whom he built a large house in Tokyo (1911), Gardiner indulged himself in a range of Art Nouveau, Secessionist and Spanish styles. He died in St Luke's International Hospital, Tokyo, in 1925 and was buried in the Shinko church at Nikkō, a heavy, Gothic building in stone which he had built in 1914.

Coming to Japan later than the American Board, the YMCA also sent its missionaries to the country. One of these was William Merrell Vories, who had actually studied architecture at Colorado College from where he graduated in philosophy in 1904. The following year the YMCA sent him as a teacher of English to the Shiga Prefectural Commercial School in Ōmi Hachiman, a small town near Kyoto on Lake Biwa. It was a lonely outpost and,

in his diary, he wrote, 'I believe God sent me here, so I will never move until He makes me move.'[75] There he set up Bible classes which proved so popular that, in 1907, the school refused to renew his teaching contract. Unrepentant, he remained in Ōmi Hachiman, where he was to establish the Ōmi Mission, and in early 1908 began working as director of construction for the new YMCA building in nearby Kyoto. In 1910, following a brief visit to the United States, he started an architectural practice with Lester Grover Chapin, a graduate of Cornell University. Chapin stayed until the end of 1913, after which Vories employed a number of other American architects including Joshua Holmes Vogel, a graduate of Ohio State University, Helen Hollister, also from Ohio State and whom Vogel married, and Leon Whittaker Slack, another Cornell graduate who, on leaving Vories in 1921, set up the American Architectural and Engineering Company with Antonin Raymond in Tokyo. Vories established branch offices in Karuizawa in 1912 and Tokyo in 1915, but in 1920 rearranged the business as W.M. Vories & Company Architects Ichiryusha (office). The year before Vories had married Makiko, the daughter of Viscount Hitotsuyanagi Suenori, and in 1941, shortly before the outbreak of war, he became a Japanese citizen, changing his name to Hitotsuyanagi Mereru and that of his practice to Hitotsuyanagi Architect's Office. Vories's total immersion in Japanese life led, in 1945, to his unlikely role as a supplicant for the Emperor Hirohito and to General MacArthur's eventual agreement not to prosecute the Emperor as a war criminal.

Although extensive, Vories's architectural output was largely unremarkable and shows him to be very much within the mainline of provincial architectural practice. The double house (1921) in Ōmi Hachiman could have come from Letchworth or any garden suburb inspired by Parker and Unwin, although the sub-Doric pilastered stuccoed porch is rather curious [7.15]. Equally eclectic, and of the same year, is the white stuccoed Ōmi Hachiman Post Office, which draws upon the American Spanish style in its corbelled eaves and Baroque detailing. The Ōmi Mission houses

(left) 7.14 The Uchida Sadatsuchi house, originally built by James McDonald Gardiner in Shibuya, Tokyo, in 1910 and now rebuilt in Yamate, Yokohama.

7.15 A double house in Ōmi Hachiman, designed by William Merrell Vories, 1921.

he built in 1913 for Yoshida Etsuzō, a former student and a partner in the Mission, and for Mr Waterhouse, an instructor from Waseda University who joined the Mission, are similarly American.

Despite his continued residence in Japan, and his close involvement through the Ōmi Mission with the Japanese people, Vories's architectural vocabulary remained consistently American, varying from clapboard cottages, which fitted well with the Japanese vernacular, to demonstrably Western styles. The Kwansei Gakuin (university) at Uegahara (1929) was in the Spanish style found in American small-town campuses, such as the Claremont Colleges near Los Angeles. Approached by an avenue flanked with smaller buildings such as the chapel, the Kwansei Gakuin buildings are arranged axially and cross-axially around a large open space, the main building

at the end of the axis being an elaborate concoction of Spanish or Moorish motifs arranged like a Palladian villa. Surmounted by a square, stepped clock tower terminating in an octagonal cupola and belvedere, possibly modelled on that at the East Denver High School which Vories had himself attended, it offered a different academic provenance to Itō Chūta's red-brick Romanesque Kanematsu Auditorium, built two years earlier at Hitotsubashi University, and was equally derivative, if rather less emphatic.

On the few occasions that Vories allowed himself to depart from the didactic or redemptive which seemed to control his educational and missionary architecture, he could be quite inventive. His large department store in Osaka for Daimaru, built in 1922, is as rich as any, and probably richer than

(*right*) 7.16 Daimaru, the department store in Osaka, designed by William Merrell Vories, 1922.

most contemporaneous department stores in America [7.16]. From the bronze entry doors set into the intricately worked Saracenic elevation, to the cavernous sales floors where Gothic elevators and polished granite stairs take the shopper up to the modern restaurant and the roof garden, the building is a feast of decorative detail. The structure was a reinforced concrete frame and external cladding brickwork and stone, with a chequerboard pattern of white stone and brick setting off the tops of the corner towers. Although the stairs become less elaborate as they rise through the seven storeys, the polished granite balustrade eventually changing to a bronze and glass handrail, the attention to detail is persistent throughout. Drinking fountains are set into the stone lining of the landing walls, and mosaics and back-lit filigree glass panels decorate the stone-faced square and polygonal columns, as well as the ceiling beams which hang low in the space. It is a

fantasy world, but not that of the mysterious East, rather that of the mysterious West.

Equally fantastic was the house which Vories built in Kyoto for Shimomura Shōtarō, the owner of Daimaru. It was called Chūdō-ken – the Tudor House. Shimomura had become President of the Daimaru company in 1907 and had toured Europe and the United States the following year; on a subsequent world tour of 1934–35 he took many photographs which were later exhibited and made up into presentation boxes.[76] These photographs show his interest in, amongst other things, English medieval half-timbered English architecture, for there are photographs of the streets of Warwick and of the King Edward VI Grammar School at Stratford-upon-Avon. Whether this architecture had caught his eye on the earlier trip, or perhaps on another occasion, cannot be said, but the house which Vories built for him was solidly English manorial – a stone base with projecting brick and half-timbered gabled

7.17 The architect's own house in Ōmi Hachiman, designed by William Merrell Vories, 1932.

upper stories. In the preface to a book of his own photographs of Chūdō-ken which he prepared in 1932, the year the house was finished, he explains that when in 1922–23 Liberty's Department Store was rebuilt on Great Marlborough Street, London, using the timbers of two old wooden men-of-war, HMS *Hindustan* and HMS *Impregnable*, he was so inspired by the timber-frame architecture that, as he said, he 'became determined to build my house in the half-timbered architecture of the Tudor style'.[77] The result is certainly impressive and, apparently, authentic. Although the stair hall with its hanging tapestries gives the impression of being in Liberty, the bright Art-Deco east bathroom, with its black/green/yellow tiles and red-painted walls and ceiling, comes as a bit of a surprise. Low down on one corner, the foundation stone gives the date, not as Showa 6, but as AD MCMXXXI.[78]

As fantastic as the Daimaru Department Store and as unexpected as Chūdō-ken, is the Yaomasa (now Tōkasaikan) Restaurant (1926) in Kyoto. Set on the corner of the Shijō-Ōbashi (bridge) beside where the herons nest in the Kamo-gawa (river), this building is a rich mixture of Spanish, Jacobean and Moorish architecture. The terracotta doorway is Spanish Baroque surmounted by a Diocletian window. The terracotta decorative pilasters and balustrades on the river-front are Moorish, as is the rich cornice above. Inside, the ceiling of the dining hall is covered with Jacobean strapwork while around the walls, Serliana with stepped arches and more Moorish decoration open through to adjacent spaces. In the entrance hall, the frieze comprises a run of small Islamic arches set on corbels above decorative panels containing shells and octopi.

Vories was more than just an architect and a missionary. He was also a businessman who established the Ōmi Sales Co. Ltd in 1920 to market Mentholatum, 'An External Application for Cure of All Inflammations', and the invention, in 1889, of Albert Alexander Hyde of Wichita, Kansas. It proved so popular in Japan that in 1934 he started manufacturing it in Ōmi Hachiman. His concern for public health and welfare was also apparent in his architecture: the Ōmi Tuberculosis Sanitorium (1918), which was funded by friends in America, and the Seiyūen Kindergarten, which his wife started in their own house in 1922, and was built as the Ōmi Kyōdaisha Gakuen a decade later. It was paid for by Hyde and named after his wife, Ida Elizabeth Todd Hyde. Yet Vories made no profit from these enterprises. He never owned the house which he built as his marital home in 1932. Surprisingly, perhaps, this building betrayed no Japanese influence (such as Conder's marital home had done), but, with its timber-clad exterior and low-beamed interior, remained firmly Arts and Crafts [7.17].

8 THE JAPANESE ARCHITECTS

The Imperial College of Engineering

Josiah Conder was not the first Westerner brought in to teach Japanese students the art of architecture. In 1876 *The American Architect and Building News* reported that a school of fine arts had been established at 'Yeddo' with professorial chairs, 'one to architecture, one to ornamentation, and one to painting and sculpture combined';[1] these the *St. Louis Globe-Democrat* clarified as being in 'architectural drawing, ornamentation and sculptural painting'.[2] Architectural design, it appears, was not included. The Technical Fine Arts School (Kōbu Bijutsu Gakkō) was to be in the Imperial College of Engineering and the professors were to be Italian. '... of all the nations in the world to whom they could turn for direction in art,' *The American Architect and Building News* complained, 'the Italians would seem to be the most antagonistic. If they need a more highly developed architecture, one would think the Japanese capable of developing it for themselves; one shudders at the incongruity of their introducing Vignola and Palladio.'[3] The Italian architect employed was Giovanni Vincenzo Cappelletti[4] and he remained with the art school until 1879, at which time he was hired by the Building and Repair Division of the Ministry of Public Works.

What Conder found when he arrived at the Engineering College, the Kōbu Daigakkō Zōkagakka as distinct to the Kōbu Bijutsu Gakkō, was a group of Western-style buildings located at the southern end of the old Edo castle grounds, near the Toranomon (Tiger's Gate) and overlooking the moat. The College *Calendar* for 1877 contains a site map showing the buildings arranged as an inward-looking compound measuring about 800 feet north to south and 600 feet east to west (240 × 200 metres).[5] Along the western edge was the main college building, designed by the architect Charles Alfred Chastel de Boinville, its long side wings forming a courtyard facing the centre of the site (although, in the event, one wing was never built). To the south were three separate laboratory buildings, one each for Chemical, Engineering and Metallurgical study, also designed by de Boinville. To the north, overlooking the moat, was the long dormitory building designed by two engineers, Colin McVean and Henry Baston Joyner, and to the east, the technical museum building, which they also designed. Beyond the museum, at the easternmost corner of the site, is shown the gatehouse, to be built by Conder.

Education at the Imperial College of Engineering was not solely an academic affair. It was intended to

be a completely transformative experience during which students would wear Western-style uniforms, sleep in beds, sit on chairs, eat with cutlery and live within and amongst Western buildings of masonry construction with stairs, glazed windows, hinged doors, cast-iron columns, and a clock, in the dormitory clock tower, to enforce punctuality. It was, in many ways, like a military academy or a British public school where the regime was rigorous and the rules of confinement strict. This didactic environment was particularly important for the students of architecture who needed to experience and understand the type of buildings they would be learning to design.

The college had opened in 1873 when, after delays, the dormitory, the first building on the site, was completed. Although described rather unimaginatively by William Gray Dixon, the Professor of English Language and Literature at the college, as 'a Gothic building with a clock tower',[6] it was, in fact, a long, two-storey brick and stone building of some 270 feet (81 metres) with a double-height central hall set beneath a tall cross-gable surmounted by the clock tower. At either end lower cross-gables contained, presumably, communal rooms, while between them the dormitories stretched for six bays on either side of the central hall. It was, if not an exciting building, a competent one and suggests a design input other than that from McVean and Joyner. In this case it was the Glasgow architect Campbell Douglas, another facet of the Glaswegian connection behind much of the early development of the college.

Yamao Yōzō, who in 1870 set up and ran *Kobusho* (the Ministry of Engineering or Public Works), was one of the Chōshū Five who had 'escaped' Japan and come to London in 1863. After two years at University College, he had gone to Glasgow to study at Anderson College and work in the Napier shipyards on the Clyde. It was through this connection and on the advice of the University of Glasgow Professor of Civil Engineering and Mechanics, William Rankine, that Henry Dyer had been appointed as the College of Engineering's first Principal in 1873.[7] Colin McVean, who had first arrived in Yokohama in 1868 with his new bride, Mary Cowan, was also from Glasgow. He had initially taken up a position under Richard Henry Brunton as Assistant Engineer in the Lighthouse Department, but resigned a year later, writing: 'I cannot continue to serve under Mr Brunton your Chief Engineer ... because I consider him incompetent as a chief engineer.'[8] Rather than returning to Britain, McVean secured the job of Chief Surveyor in the Works Department, part of Yamao's *Kobusho* which was also responsible for the education of engineers. It therefore fell to McVean to build the first building for the newly established College of Engineering and it was here that McVean's connection by marriage to the Cowan family really came into play.[9]

Mary Cowan's niece, Elizabeth Menzies, was married to the Glasgow architect Campbell Douglas, and it was to him that McVean had turned for assistance with the new college building. Douglas, who from 1860 to 1866 had been in partnership with John James Stevenson (introduced in Chapter 5), had been joined in 1871 by the architect Charles Alfred Chastel de Boinville so when, in April 1872, McVean wrote to say that the Ministry needed 'a good architectural draughtsman, and, if possible, one of quick and skilful resources',[10] it was de Boinville who got the job.

Charles Alfred Chastel de Boinville had been born in Lisieux, France, of a French father of the same name – a Protestant pastor who came from an old, aristocratic family – and a British mother, Mary Léontine Graham.[11] He had worked in Paris under William H. White, later Secretary of the RIBA and, during the Franco-Prussian War, served as an officer in the Garde Mobile. But following the failure of the Paris Commune in 1871 he moved, thanks to his father's connections with the Cowan family, to Douglas's office in Glasgow.[12] However, de Boinville's time there was short for in December 1872 he arrived in Tokyo where he initially worked under McVean in the Works Department. When, in January 1874, the Japanese government transferred the surveyors to the Home Office, de Boinville was appointed head of the Public Works Building Department. This gave him the opportunity

to build a second building for the College of Engineering which Dixon was to describe, now more imaginatively, as '... a chaste French erection forming two sides of a quadrangle'.[13] In the event, it was left unfinished, the promised third side never being built.[14] The building's centrepiece was a great hall in the manner of a Romanesque cathedral, twin-towered with transverse vaults, its galleried interior supported on cast-iron columns. This, Dixon wrote, was 'a very handsome room capable of accommodating 1,000 to 1,500 persons, while the galleries are lined with bookcases stocked with over 13,000 volumes chiefly in the English and Japanese languages'.[15]

Conder's arrival at the Imperial College of Engineering in 1877 not only infused the architecture curriculum with an academic direction but, with the opening that same year of the new college building, must have signified for his students an almost fresh start. Part of de Boinville's role had been that of an instructor but, it appears, this had not been a success. Sone Tatsuzō later commented that de Boinville 'didn't give any lectures on architecture. Also his English didn't seem quite fluent. This person's teaching of architecture was done in a completely ad hoc manner.'[16] Conder's first cohort of students, who were only a year or two younger than their new professor, had enrolled in 1873; Sone Tatsuzō, Katayama Tōkuma, Tatsuno Kingo and Satachi Shichijirō were now well into their studies and due to graduate in 1879. Conder must have felt like a breath of fresh air: 'All the complaints we had before his arrival,' Sone noted, 'have completely vanished.'[17]

Compared with contemporary (or slightly earlier) Gothic Revival designs seen in England, where asymmetrical towers offset the breadth of the buildings, the diploma designs with which Conder's students graduated were all noticeable for their symmetry and horizontality. Although Katayama's Gothic designs for a School of Art might well have been based, with its central tower, upon Godwin's design for the Northampton Town Hall (1861–64), its lengthy and symmetrically arranged elevation implied a Classical provenance which Godwin's insistently asymmetrical elevation never did. Indeed, perfect symmetry controlled the elevation of Tatsuno's Natural History Museum and Satachi's School of Art, despite the fact that the former had Venetian Gothic windows and the latter paired lancets. The use of symmetry by these Japanese students in their diploma schemes suggests the conscious adoption, perhaps at the instigation of the French-trained de Boinville, of a Western organisational device alien to Japanese architecture while, at the same time, the horizontal emphasis which they gave to the buildings remained within the comfort zone of their traditional architecture. It should be remembered, however, that the use of Gothic detailing on an otherwise Classical building was a conceit familiar from Charles Barry and Augustus Welby Pugin's Houses of Parliament onwards. Of Conder's first cohort of students, only Sone produced a purely Classical diploma scheme – a lunatic asylum with a shallow dome, a central pediment, paired pilasters, and triangular and segmental window heads.[18] It is not surprising, therefore, that the buildings which these young men went on to design were, for the greater part, Classical: it was a way of designing which could be taught and one which represented Western culture.

Tatsuno Kingo

Tatsuno Kingo graduated top of his class and was immediately sent, by the Ministry of Public Works, with 10 other top graduates from the Imperial College of Engineering, to continue his studies in England. There, Roger Smith took him in hand and Tatsuno worked for the Cubitt Construction Company[19] for five months before going to work for William Burges in September 1880. Here he surprised the master by being unable, when asked, to describe the nature of Japanese architecture.[20] This suggests a general lack of awareness, not just on Tatsuno's part, but in terms of Japanese culture, of their own architectural tradition. Thus, the adoption in Japan of an architecture readily

definable and easily enough copied, whatever its source, did not necessarily suggest a rejection of indigenous forms: it was just another facet of Westernisation.

Tatsuno's Bank of Japan headquarters in Tokyo (1896) was, like Waters's Imperial Mint in Osaka, the public expression of a Westernised institution [8.01]. Built of brick, faced with granite and reinforced with iron bands and steel beams, it represented not just the official acceptance of Western architecture but also the professional acceptance of new construction methods.[21] Commissioned in 1888, it was the first Meiji government building to be designed by a Japanese architect and therefore is denoted a coming-of-age of the profession in Japan. Indeed, Tatsuno, Conder's successor in 1884 as Professor of Architecture at Tokyo Imperial University (formerly the Imperial College of Engineering), had opened the first Japanese-run architectural office in Japan in February 1886[22] and was a founder member of Nihon Zōka Gakkai[23] (the Architectural Institute of Japan) the same year. The Bank of Japan building, therefore, cannot be underestimated, for nothing like it had been seen before in Japan.

During his visit to Europe in 1882–83, Tatsuno had travelled in France and Italy, visiting Paris, Orleans and the Loire Valley, where he drew the Château de Blois, and then Florence, where he drew the Palazzo Riccardi and the Palazzo Strozzi, as well as the Certosa di Pavia.[24] With the commission for the Bank of Japan he made a second overseas trip, this time to America, first, and then to Europe,[25] with his two assistants, Okada Tokitarō and Sakurai Kotarō. In America he visited banks in Boston and New York, bearing letters of introduction from the Secretary of the American Institute of Architects (AIA); he had become a Corresponding Member of the Institute and was, as they put it, 'the first individual, outside of the Caucasian race, that has appeared in the list of any grade of the Institute'.[26] With the World's Columbia Exposition, at which Tatsuno and Conder were to represent Japanese architecture, just three years away, the American Renaissance, for which the Exposition is famous, was already

in evidence. Whereas the Bank of Japan, as will be shown, took its arrangement and external appearance from European sources, its banking hall immediately suggests that Tatsuno had been studying Chickering Hall in New York, a music shop, warehouse and concert hall designed by George Browne Post in 1875. The Italianate arcading, with pronounced keystones, springing, at upper level, from pilasters which are linked by ornate friezes, gives the banking hall a sense of scale and self-assurance intended to encourage investors. Post, who had already built a number of confident, Classical banks and was to be the architect of the New York Stock Exchange (1901–03), was stylistically eclectic and wrapped his pragmatic and functional buildings with details drawn from a variety of sources; nevertheless, this was the sort of architecture which the Japanese architects, who had an adherence to no one style or interpretation, could accept.

In Liverpool, where he made European footfall, Tatsuno was hosted by the first Honorary Consul for Japan, James Lord Bowes.[27] Despite his name, Bowes was a commoner but he was a great collector and promoter of Japanese art.[28] Streatlam Towers (1871), his home in Liverpool, was designed by George Ashdown Audsley,[29] himself a Japanophile, and contained a Museum of Japanese Art, its entrance decorated externally with *mon*:[30] Bowes was referred to as the Mikado of Princes Road. As an artery into Europe, Liverpool was important for Japanese trade: the Liverpool-based Ocean Steam Ship Company[31] had sent the first ship directly from Liverpool to Japan in 1870;[32] the Takenouchi Embassy had visited the city in 1862, followed by the Iwakura Embassy in 1872 and, in 1886, by Prince Akihito and Princess Yoriko of Komatsu. The Japanese, Bowes said, were 'the most thoroughly original people in the world', but added: 'Japan will assimilate what is best of European ideas, but it will never allow Europe to absorb their national individuality.'[33] It is possible, therefore, that Tatsuno based the plan arrangement of the Bank of Japan on John Foster's neo-Classical Liverpool Customs House (1828–39) which was designed as an H-plan with a dome

in the centre of the crossing. This is the basic form or *parti* of Tatsuno's Bank of Japan, as is clearly apparent from the entrance or south front, where a single-storey wall links the side wings. On the north side, Tatsuno develops the H-plan by linking the side wings but retains between them, nevertheless, internal courtyards. Although Tatsuno makes little use of the dome, either internally or externally, it sits at the centre of the plan, as it did in Foster's building, and in both cases it is signified by a portico on the main axis.[34]

In London, and probably not for the first time, Tatsuno saw the Bank of England by Sir John Soane. Here the windowless wall, erected following the Gordon Riots (1780) by Sir Robert Taylor, gave him the precedent for the rusticated screen wall, complete with gun embrasures, on the south front of the Bank of Japan. Behind the wall, however, the theme turns French and the principal source is probably the Palais Royal in Paris, built by Jacques Lemercier in 1634–39. Here a perforated screen wall added in 1754 by Pierre Contant d'Ivry closes off the *cour de l'horloge*, which is flanked by two wings terminating in high-level porticoes. Beyond the *corps de logis*, Doric colonnades with a balustrade above, built by Pierre Fontaine in 1814–30, flank the larger *cour d'honneur*. All these features are incorporated in the Bank of Japan where the polygonal rotunda beneath the dome similarly recalls the centrepiece of the *corps de logis* at the Hôtel de Matignon in Paris, built by Jean Courtonne in 1722–24.

If the plan form and the arrangements of the parts is an assimilation of ideas drawn from European precedents, the external elevations are less varied. For the elevations Tatsuno turned to the Banque Nationale de Belgique, Brussels, [8.02], built in 1859–67 by Henri Beyaert and Wynand Janssens. Here, in a long elevation facing the Cathedral des Ss Michel et Gudule, paired columns, in a Composite Order, support heavily ornamented pediments above a strongly rusticated base. In replicating the Belgian bank's elevation along the Nihonbashi river façade, Tatsuno extends it to a third portico, and by an extra storey, but does away with the rich, segmental pedimented

window heads in favour of simple drip moulds and, within the portico, replaces the caryatid windows with tripartite, pedimented openings of Greek revival austerity. The same arrangement is repeated at the ends of the side wings flanking the entrance court.[35] Tatsuno's use of three porticoes on the long façade, which might be derived from Claude Nicolas Ledoux's Hôtel des Fermes (1786),[36] appropriately enough the tax office, is

(*left*) 8.01 The Bank of Japan Head Office in Tokyo Nihonbashi, designed by Tatsuno Kingo, 1896.

(*right*) 8.02 The National Bank in Brussels, designed by Henri Beyaert and Wynand Janssens, 1876.

a more comfortable arrangement than Beyaert and Janssens's use of two terminal porticoes in Brussels.

Tatsuno built branches of the Bank of Japan in both Osaka (1903) [8.03] and Kyoto (1906) [8.04] – the former a stone building reemploying the paired columns of the Tokyo bank's portico, themselves borrowed from Brussels, the latter, a robust piece of late-Victorian red-brick building

with white stone banding and window heads. Whereas the Osaka building is formal and very much in the language of bank buildings as developed in the West, the Kyoto building is surprisingly vibrant and is much more suggestive of a public or commercial building: the one looks back to the Tokyo building, the other anticipates Tatsuno's masterpiece, Tokyo Station (1911–14), which was already on the drawing board.

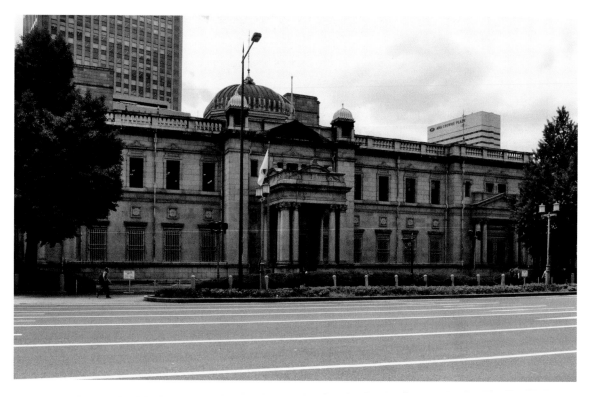

8.03 The Bank of Japan branch office in Osaka, designed by Tatsuno Kingo, 1903.

The polychromatic brickwork of Tokyo Station and the Bank of Japan in Kyoto was another direct European import [8.05]. The ornamental gables and red-and-white banding of Norman Shaw's Alliance Assurance Office (1882–83) would have still been bright and new when Tatsuno arrived in London in 1888; Shaw's New Scotland Yard (1887–91) and Thomas Edward Collcutt's Imperial Institute (1887–93), where Japanese students were soon to study, would have been under construction. These buildings, which drew on Dutch and Flemish Renaissance architecture, combined a domestic, mercantile expression with a metropolitan scale and offered a solution for public and commercial architecture which was not dependent upon Italianate sources. Although Conder's Naval Ministry (1894) and Mitsubishi Ichigokan (1895) picked up on the use of polychromy, they quite failed to reflect the vibrancy of these buildings, showing Conder's lack of awareness of, or facility with, this northern European architecture. It was different, however, for the German architects who had been so recently started to make a mark in Japan. Ende and Böckmann had being employing Japanese students in their Berlin office since 1886 and through this artery northern European Renaissance architecture could be absorbed. Parallels, therefore, can equally well be drawn to Ende and Böckmann's Moravian Square House (1891) in Brno, or to the work of another Berlin firm, that of Joseph Henry Kayser and Carl von Groszheim, whose Palais Reichenheim (1879–81) in Berlin was heavily polychromatic and whose various villas in Berlin, Dusseldorf and Munich[37] were richly gabled, pinnacled and turreted.

(*right*) 8.04 The Bank of Japan branch office in Kyoto, designed by Tatsuno Kingo and Nagano Uheiji, 1906.

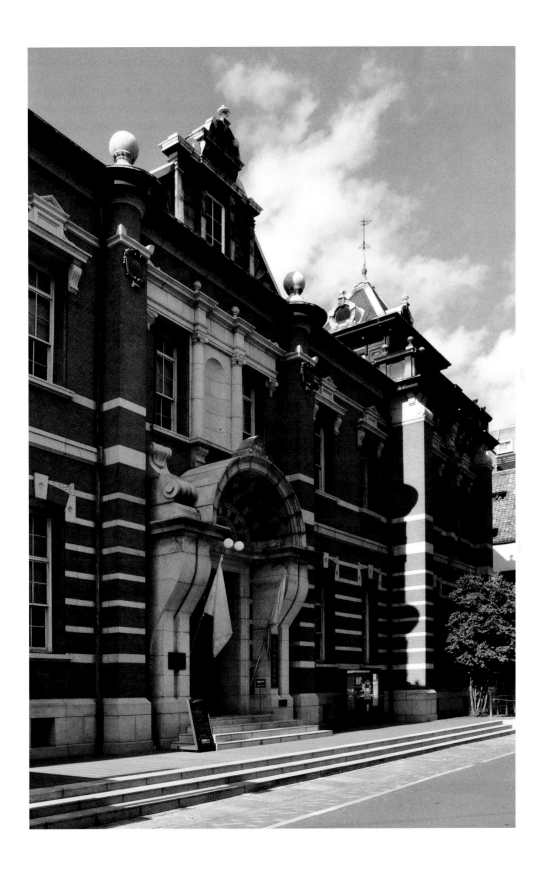

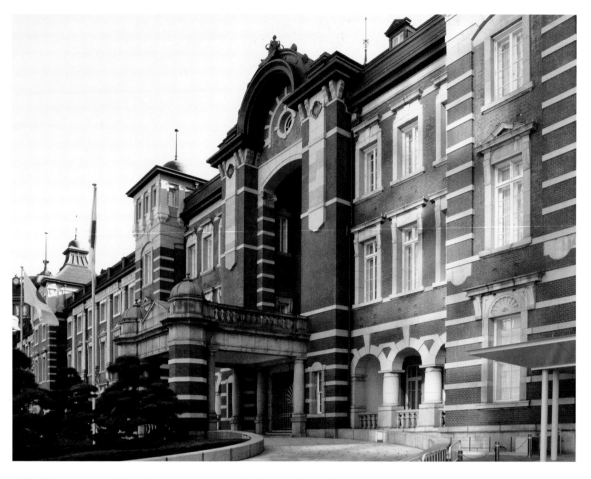

8.05 Tokyo Station in Tokyo Marunouchi, designed by Tatsuno Kingo, 1914.

Nagano Uheiji

Tatsuno had been awarded the commission for Tokyo Station in 1903, the year he completed the Bank of Japan in Osaka, after which he had resigned his position of Professor of Architecture at the Imperial University. In that year he opened the Tatsuno Kasai construction office (with Kasai Manji) and it was here, or possibly in the Tatsuno Kataoka construction office (with Kataoka Yasushi) which he opened in Osaka in 1905, that he was assisted by, amongst others, Nagano Uheiji, who was to succeed him as the principal architect for the Bank of Japan.

Their first joint venture for the Bank of Japan was the Kyoto branch which bears comparison with another bank building in Kyoto, the nearby Daiichi Bank, which Tatsuno completed in the same year, 1906 [8.06].

Although both buildings are polychromatically striped in red and white, the Bank of Japan is much more balanced in composition and consistent in its stylistic reference, suggesting the European Renaissance buildings of the Netherlands and northern Germany, even if its canopied Baroque

(*right*) 8.06 The rebuilt Daiichi Bank in Kyoto, designed by Tatsuno Kingo, 1906.

doorway gives more than a nod to Norman Shaw. The Daiichi Bank, on the other hand, appears clumsy by comparison, probably the result of the later extension by three bays to the left of the now central entrance.[38] Even so, it was, for 1906, dated and a little inelegant, its heavily voussoired windows and the curious cupola on the corners – a feature which also flank the pediment on the Bank of Japan in Osaka – recalling the Islamic or Indian references in Conder's architecture and, in the cupola, his Ueno Park Museum building of 1881. Similar corner cupola, but now suggesting Sir John Soane's tomb in London, appear in the one other Bank of Japan which Tatsuno and Nagano did together, that at Otaru, Hokkaido, completed in 1912.

Both Tatsuno and Nagano embarked on their largest, polychromatic buildings at the same time – Tatsuno, his station building in Tokyo, and Nagano, the Governor-General's Office in the Japanese territory of Taiwan. Winning a two-stage competition in 1906 and 1910, Nagano's design was built between 1912 and 1919. With a frontage of 130 metres and a centrally positioned, 11-storey tower 60 metres high, the design is almost undeniably based upon the Imperial Institute in London. Thomas Edward Collcutt's competition-winning design had been published, together with the runners-up, in *The Building News* in 1887, when the then 20-year-old Nagano was an architecture student at the Imperial University. It seems likely that whereas Nagano looked at Collcutt's design to inform his elevation, his plan, comprising two quadrangles separated by a hall or chapel, was based upon Arthur Blomfield's entry for the same competition. Curiously, the Tokyo authorities requested that the tower be extended from six to 11 storeys, while in London the upper part of Collcutt's tower was similarly modified, the top stage being extended to envelop the dome's tall drum.

Nagano's work for the Bank of Japan continued many years into the Showa era, his last major building being the branch bank in Hiroshima, completed in 1936. Although just 380 metres from the hypocentre and stripped of window frames, shutters and other external fixtures, it survived the atomic blast and, providing refuge for 11 other Hiroshima banks, opened for business two days later.

The Hiroshima branch of the Bank of Japan showed none of the reversion towards *teikan-yōshiki*,

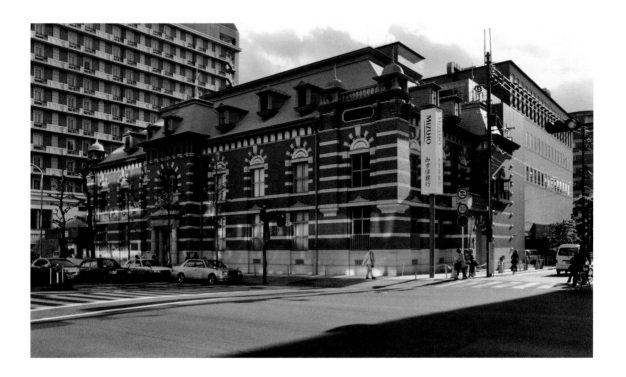

the Imperial Crown Style, which was then affecting much public architecture [8.07]. It was, if anything, a modest reflection of stripped Classicism then to be found in England. The only noticeable concession to Japanese tradition were the four roundels set in the parapet above the central bay: these presumably represented the Imperial chrysanthemum. Inside, the banking hall, like so many others, was a double-height space surrounded by a gallery and top-lit. The heavy, reinforced concrete construction which saved the building nevertheless denies the space any great elegance, the columns, pilasters and roof beams being strongly expressed throughout. But they did give it strength.

There is generally little variety in the bank buildings which Nagano built, whether for the Bank of Japan or for other institutions. Nagano consistently rings the changes from a tetrastyle-in-antis portico, as at Matsue (1918), to a prostyle Corinthian portico, as at Okayama (1922), or an engaged tetrastyle portico, as in the Nanto Bank Head Office at Nara (1926) [8.08]. But behind each varied façade the buildings are largely similar. Only the Bank of Japan branch banks which he built with

Tatsuno divert from this formula. The Soanesque cupola at the Bank of Japan at Otaru (1912) have already been mentioned, but the elevations, strongly rusticated and heavily articulated, are also much more robust than in the other examples. They have the certainty if not the sophistication of the extension which he added to Tatsuno's Bank of Japan in Tokyo in 1932–37 [8.09]. This large addition, with paired giant order Corinthian columns set on a rusticated base, takes its lead and its lines from Tatsuno's earlier work but, by giving greater breadth to the front elevation through the incorporation of three equal bays, achieves a sense of scale, rather than just size, which Tatsuno's original twin-pedimented end elevations lack.

Nagano became very much an establishment figure, the first President of the Japanese Architecture Society. Unlike Itō Chūta, his exact contemporary, he sought to incorporate Western philosophy into Japanese architecture, arguing that, as when Japan integrated Chinese architecture, this did not negate Japanese national identity.[39] What he was promoting, in fact, was something called 'A World-Style in

8.07 The Bank of Japan branch office in Hiroshima, designed by Nagano Uheiji, 1936.

8.08 The Nanto Bank in Nara, designed by Nagano Uheiji, 1926.

8.09　The extension added to the Bank of Japan Head Office in Tokyo Nihonbashi, designed by Nagano Uheiji, 1937.

Architecture', a notion advanced in *The Builder* in 1907 which argued that 'Tradition modified by new construction may open a new chapter in architectural history' – before adding, 'But tradition must be at the base of it!'[40]

Tsumaki Yorinaka

Tsumaki Yorinaka, whom Conder escorted to Berlin in 1887, had studied under him at the Imperial University before leaving to take his degree at Cornell University in America. Although he became a highly successful and influential architect, working first for the Interior Ministry and, from 1901, the Finance Ministry where he was head of the building section, he never quite achieved the success which Tatsuno did as the architect of choice for public and private banks.

In 1904 Tsumaki built the Yokohama Specie Bank in Yokohama, with the assistance of a young local architect, Endō Ōto, who had also studied under Conder and Tatsuno [8.10]. The Yokohama Specie Bank was a powerful international commercial bank,[41] intended for foreign exchange, and the exuberant German Baroque styling which Tsumaki

gave it befitted its role as the bank's headquarters.[42] Large enough to take up a whole city block in the old foreign settlement of Kannai, the steel-frame and brick building, clad with two different granites, opened up to a three-storey banking hall in the centre. Yet for all Tsumaki's Western education and training, the building remains awkward and lopsided. To make the entrance, which is marked by an engaged portico, Tsumaki sliced the eastern corner off the rectangular site and surmounted it with a ribbed dome with bull's-eye windows. The result is that the building does not really have a front or a back since it is approached on the diagonal. This would not have been a problem had Tsumaki run his Corinthian pilasters and pedimented windows uninterrupted around the whole building. However, perhaps for no other reason than hubris, Tsumaki added an engaged portico to the far ends of the two sides (north-east and south-west) flanking the entrance, and then a single engaged portico at one end of the long, 10-bay south-west elevation, leaving that side quite imbalanced. Perhaps this was meant to pick up the diagonal projected by the corner entrance but since there is no corresponding engaged portico on the short north-west elevation, this does not work.

As a demonstration of Japanese architects designing in the Western style, the Yokohama Specie Bank was, for Yokohama, both early and barely to be surpassed for scale and exuberance. Nishimura Yoshitoki's nearby First Bank of Yokohama, built 25 years later before the architect adopted the conventions of *teikan-yōshiki*,[43] was smaller and showed some of the restraint which Tsumaki's Yokohama Specie Bank lacked [8.11]. Responding to a narrow site, this long, thin building terminates in a simple semi-rotunda of four Doric columns set (incorrectly to convention) beneath an Ionic entablature. Inside, in the banking hall, two converging rows of giant Corinthian columns on large plinths support a coffered ceiling.

Few important buildings in the grand manner by Tsumaki remain today. His Tokyo City Hall (1894) was demolished to make way for Tange Kenzō's new City Hall: his Tokyo Court House (1896) and Tokyo Chamber of Commerce (1899)

(*right*) 8.10　The Yokohama Specie Bank in Yokohama, designed by Tsumaki Yorinaka and Endō Ōto, 1904.

8.11 The First Bank of Yokohama in Yokohama, designed by Nishimura Yoshitoki in 1929.

have also gone. His Nihonbashi Bridge (1911), which is still one of the most significant historic landmarks in Tokyo, remains. With the soffit of its arches ornamented, this rusticated stone bridge was designed to be seen from the water as much as from the road, where the mythical *Kirin* guard the tall lamp-posts at its centre, but now, at the time of writing, is almost lost beneath the city's elevated transport infrastructure.[44]

In 1888 Conder's pupil, Shimoda Kikutarō, like Tsumaki before him, had left the Imperial University before graduating and travelled to America, where he arrived in San Francisco. However, unlike Tsumaki, he did not complete his studies there but instead went to work for Arthur Page Brown, who sent him to Chicago to be the Construction Site Deputy Manager for Post's California Pavilion. In Chicago he met Daniel Hudson Burnham for whom he next worked on various Chicago projects including the Great Northern Hotel (1892) and the Marshall Fields wholesale store (1892). It would seem that he intended to make his life in America, for in 1895 he took on American citizenship and the following year, as well as marrying Frank Lloyd Wright's secretary Rose, voted for William McKinley in the presidential election. McKinley, a republican from Ohio, won. By now Shimoda, who adopted the name George, had opened his own practice in Chicago's downtown.[45] He registered as a licensed architect in Illinois in 1897, the year that Illinois, the first state to do so, passed a state law requiring architects to be licensed. Given the number 471, he is likely to have been the first Japanese architect to be licensed in Illinois and therefore the first in the United States. However, the American Spanish War, which started in 1898, affected his business, probably due to the large fall-off of trade with Cuba, and so he returned that year to Yokohama.[46]

What Shimoda had learned from his time with Burnham and from working in Chicago was the value of building with steel. The Japanese preference when building metal-framed buildings was for cast-iron which had far less elasticity than steel and was therefore more likely to shatter as a result of seismic movement. Much of his vexation, which came to a head following the competition in 1918 for the new *Kokkai Gijidō* (Imperial Diet Building), he expressed in a book, published in English in 1928, entitled *Ideal Architecture, Business Building, Barrack: Report on Adaption of My Idea, Partly for the New Diet Building, 1920*. Yet he was successful in persuading Katayama Tōkuma to use a steel frame for the Tōgū Gosho, the Imperial Palace for the Crown Prince, at Akasaka and it was probably through his intervention that the Chicago structural engineer, Edward Clapp Shankland – who had been Burnham's chief engineer from 1893 to 1898 and had worked on the Marshall Fields building – and his brother and partner Ralph Martin Shankland, were asked to design the structural steelwork for the palace.

Shimoda always remained an outsider to the architectural establishment in Japan, regarded, as he put it, as a 'black sheep' and probably resented

for his American ways. It might have been this sense of exclusion which led him, in 1920, to coin the term *teikan-yōshiki* – Imperial Crown style – for the buildings which, despite their modern construction, adopted traditional Japanese motifs and appearance. It is therefore unsurprising that perhaps his best work was not for a Japanese client but for the Hong Kong and Shanghai Bank.

The Hong Kong and Shanghai branch bank which he completed in Nagasaki in 1904 was a palatial structure which, in a minor European capital, might have been mistaken for an opera house [8.12]. Now standing rather forlorn between a petrol-filling station and a bus park, it used to be flanked by Conder's Nagasaki Hotel, a brick building of 1898, with a three-storey arcaded loggia and pediments to the bay. Shimoda's bank, similarly arranged in three layers, must have appeared more robust, its tetrastyle-in-antis Corinthian portico set on a rusticated, arcuated base beneath a roofline crowned with acroteria. Built with a steel frame and clad in granite, it is a formal and impressive edifice but, as so often with Japanese buildings which adopt Western classicism, the plan does not ring true. The axial arrangement which the symmetrical elevation suggests is not extended through to the interior which responds to other demands. The entrance to the ornate ground-floor banking hall is through the central arch but the hall is only five bays wide, the two bays on the right forming a separate room. Within the banking hall, three tall Corinthian columns of polished wood support the coffered ceiling's gridwork of steel beams but are positioned off-centre so as to align with the division walls between the reception rooms on the floor above; yet the wall separating the hall from the adjacent room supports nothing. On the *piano nobile* level, which is reached by a curious staircase with winders set far back in one corner, a broad pilastered corridor divides the building, the two large reception rooms opening to the lower balcony beneath the pediment while the smaller rooms are pushed to the rear (the larger two of which, in the present configuration, are without windows). The reception rooms – which, due to the symmetry of the façade, are inevitably of different sizes – are linked by a broad architraved

8.12 The Hong Kong and Shanghai Bank in Nagasaki, designed by Shimoda Kikutarō, 1904.

opening flanked with Corinthian pilasters and have a polished mahogany fireplace on axis at either end. Unexpectedly, the larger room has a second fireplace set between the glazed doors opening to the balcony, its chimney concealed by the pediment above. Although there is considerable learning in the exterior appearance of the buildings and clarity, if not logic, in its structural design, there is more than a hint of *giyōfū* in the arrangement of the interior and, not least, in the gymnastics demonstrated in the joinery of the stairs.

Sone Tatsuzō

Sone Tatsuzō, whose diploma scheme at the Imperial University, a lunatic asylum, had been the most Classical of his class, went on to benefit

from the same patronage as Conder. Working for the Iwasaki's Mitsubishi *zaibatsu* from 1890 to 1906, he built six further office buildings in Marunouchi adjacent to Conder's Ichigokan. As part of this, he travelled to the United States in 1893 to study cast-iron construction,[47] and possibly as a direct result became, like Tatsuno had before him, a Corresponding Member of the AIA in 1896.[48] The Mitsubishi connection served him well. In 1901 Iwasaki Yanosuke, the firm's President, sent Sone to London, presumably on a study tour, for on his return he built a new Iwasaki mansion, this one on raised ground overlooking the Mitsubishi shipyard in Nagasaki. The Shenshōkaku, completed in 1904, was a two-storey timber structure set on a raised brick basement. With long, shaded verandahs on both floors and ornamental fretwork in the gables, it did not look like anything which Sone might have seen in England, other than, perhaps, a regatta pavilion. The cusped pyramidal roof set over one end and the small Diocletian dormers make it appear more French or Italian than anything. On leaving Mitsubishi, Sone gained the commission for the Keiō University Library [see 8.15], funded by the Iwasaki family as well as the other leading *zaibatsu* for whom Conder had worked, the Mitsui and Furukawa.[49] But the design that emerged was not only his, if his at all, but that of the younger Chūjō Seiichirō with whom he formed a partnership in 1908. That building is discussed below.

Satachi Shichijirō

There remains little evidence today of the built work of Satachi Shichijirō, the third of Conder's first cohort of students. He worked for the Ministry of Communications, designing telegraph/telephone exchanges and post offices, and in this capacity visited America in 1889 to investigate the construction of post offices. Tatsuno introduced him to the AIA and their Secretary once again provided letters of introduction.[50] The small yet robust building for the Japan Standard Point Storehouse or Japanese Water Level Benchmark, designed in 1891, comes from this

time. Built for the land survey department of the army and located in the grounds of the General Staff Office (now demolished) in Tokyo, it was a small Roman Doric temple with an advancing portico at one end and pilasters and a pediment at the other. Satachi eventually went into private practice and in 1906 built the offices for the Nippon Yūsen Kaisha (NYK) Shipping Line in Otaru, an accomplished stone-clad essay in seventeenth-century French architecture which might have come from the Loire. Both buildings are academic essays in the Western tradition which pay credit to Conder's curriculum and his approach to teaching. Neither, however, is on the scale or of the opulence of Katayama Tōkuma's buildings for the Imperial Household.

Katayama Tōkuma

Katayama Tōkuma, the fourth of Conder's students, did not join the construction office of the Imperial Household Ministry until 1887 but, through the patronage of Yamagata Aritomo, a Field Marshall in the Imperial Army and twice Prime Minister of Japan, his way had been well prepared. Soon after graduating, he assisted Conder with the design of a mansion at Kasumigaseki (1881–85) for Prince Taruhito of Arisugawa, whom he accompanied on an official visit to St Petersburg in 1882 as part of an envoy to the court of Alexander III. Within a decade, his Imperial museums at Nara (1894) and Kyoto (1895) showed his masterly grasp of Western Imperial architecture, an achievement which his Hyōkeikan (1901–08) at Ueno and his extraordinary Tōgū Gosho (1899–1909) at Akasaka subsequently confirmed.

The Imperial Museums at Nara and Kyoto were both formal essays in Beaux-Arts classicism and, 15 years after Conder's Museum, indicated a new approach to how Japanese art was to be contained and promoted. The choice, for these Imperial buildings, of Second Empire-style architecture referenced not just Napoleon III but, by the style's copying of the architecture of the Louvre, the reign of Louis XIV, thereby making a visual connection

8.13 The Imperial Museum, Nara, designed by Katayama Tōkuma, 1894.

between the Imperial Meiji and one of Europe's greatest rulers.

The smaller Imperial Museum at Nara is a simple cruciform plan with a grand portico comprising a segmental pediment and paired columns between niches and pilasters placed centrally on the long, western façade [8.13]. This composition was first effected by Salomon de Brosse in the upper stages of the church of Ss Gervais et Protais, Paris, in 1616–21, where a broken segmental pediment was raised above the Ionic level of the main façade on paired Corinthian columns. At Nara, Katayama drops the pediment down, closes its base, and reverts to the Ionic order of the middle level of Ss Gervais et Protais, replicating the round-headed opening and flanking niches of that stage in his entrance portico while adding panels and cartouches.[51] On the east façade, the cross-axis terminates in a triumphal arch with a central, round-headed opening flanked by aedicular windows and panels above, while the long axis connects simple, round-headed porticoes at the north and south ends.

The Kyoto Imperial Museum is arranged, both in plan and elevation, like the south wing of the Place Louis Napoleon at the Louvre, designed by Louis Visconti and Hector-Martin Lefuel in 1850–57. Although reduced in height and length, the elevation offers a central pavilion and two end pavilions, behind which, as at the Louvre, are two courts separated by the central hall. The central pavilion, with its square-based domical roof and pedimented portico with three round-arched openings, borrows its composition from the top stage of the Pavillon Richelieu in the Cour Napoléon at the Louvre in Paris, although the side chimneys are removed, the paired caryatids reinterpreted as pilasters, and the whole affair a little compressed vertically. The side wings, however, make no reference to the Louvre but, as at the Imperial Museum at Nara, are divided by grey pilasters into a series of blank bays before breaking out into the terminal pavilions where aedicular windows puncture both the front and side walls. Internally, the twin courtyards direct the circulation either down the central hall or through smaller galleries arranged around the periphery. In contrast to the Beaux-Arts exterior, the central hall is Roman with peripteral columns

supporting a coved ceiling pierced by cross-vaults framing large acroteria; somewhat at odds with this austere Romanising are the hall's paired doors with ornamental, Baroque pediments. But, paradoxically, it is what one might have found in Counter-Reformation Rome.

These two Imperial Museums show, as did the Bank of Japan, the interpretive nature of both Katayama and Tatsuno's architecture. The smaller essays, such as Satachi's Japan Standard Point Storehouse or even Sone's Keiō University Library, offered a more straightforward rendition of Western sources. But the larger buildings appear to have used their precedents almost as a kit of parts, to revalue, reorganise and reproduce, with little acknowledgement of their original purpose or context. Style-mongering was, in the mid-to-late nineteenth century, common architectural practice and Katayama and Tatsuno's almost Post-Modern approach suggested not so much a lack of understanding of Western architecture but a sense of freedom which comes from working outwith the hegemony of Western architecture.

The architectural development of the Meiji era ended with Katayama's two great buildings for the Imperial Household, the Hyōkeikan [8.14] in Ueno Park and the Tōgū Gosho (which was later called the Detached Palace) in Akasaka. Both were completed in 1909. The first was conceived as a wedding gift from the people of Tokyo to the Crown Prince Yoshihito[52] and Sadako Kujō, the second as the Crown Prince's official residence. In the event, the wedding gift was handed over nine years after the wedding and the palace was never occupied. Nevertheless, the completion, four years after Japan's victory in the Russo-Japanese war, of the huge Tōgū Gosho, which *The Illustrated London News* thought made Buckingham Palace (which it resembled) look dingy,[53] gave visual expression to Japan's new position as a major power, even if the peace terms of the Treaty of Portsmouth were felt by the Japanese to be inadequate.

In 1897 Katayama, together with Adachi Kyūkichi and Takayama Kōjirō, set off, probably via America, on a year-long tour of European palaces. The findings of the tour, adopted initially at the Tōgū Gosho, which Katayama regarded as 'late-eighteenth-century French',[54] and subsequently at the Hyōkeikan, which he designed with Takayama, are apparent in the

eclectic nature of the buildings. In 1899 Katayama made a (second?) visit to America to seek advice on the design and construction of the Tōgū Gosho from Daniel Burnham, who in turn referred them to Bruce Price, and to Edward Strickland, the chief engineer at the World's Columbian Exposition. The Beaux-Arts ideal promoted by the Exposition was now being turned into reality for the American rich. In Newport, Rhode Island, alone, Richard Morris Hunt, the first American to study at the Académie des Beaux Arts and Bruce Price's master, had recently completed Marble House (1892) for William Kissam Vanderbilt and The Breakers (1895) for his brother, Cornelius Vanderbilt II, and Stanford White was building Rosecliffe (1898–1902), in the manner of the Grand Trianon, for Hermann Oelrichs. French companies in both New York and Paris decorated the interiors of such houses and it was the same firms which Katayama engaged to provide the French interiors for the Tōgū Gosho.[55] Thus it can be argued that Katayama was not so much following the American architects, but, in adopting the same eighteenth-century architectural style and using the same suppliers, was working alongside them. As if in recognition of this, he was made an Honorary Member of the AIA in 1896, the first Japanese architect to be elected. The honour might well have come through Daniel Burnham or Bruce Price, both Fellows of the AIA.

The World's Columbian Exposition and the Beaux-Arts architecture which it promoted, however, had its detractors. In his *Autobiography of an Idea* (1924) Louis Sullivan describes the effect of that architectural awakening:

> The crowds were astonished. They beheld what was for them an amazing revelation of the architectural art, of which previously they in comparison had known nothing. To them it was a veritable Apocalypse, a message inspired from on high. Upon it their imagination shaped new ideals ...

Sullivan might here have been writing about the Japanese people.

> A vast multitude, exposed, unprepared they had not time nor occasion to become immune to forms of sophistication not their own, to a higher and more dexterously insidious plausibility.[56]

In his book, *In Japan: Pilgrimages to the Shrines of Art* (1908) Gaston Migeon, the Conservator of the Louvre Museum, described his visit to the still incomplete Tōgū Gosho and questioned its architectural purpose:

> A huge palace is rising on the hills of Akasaka ... Mr Katayama, a learned architect who studied at the Ecole des Beaux Arts, drew the plan and directs the works. The general style is that of Versailles; a homage to France! The greater part of the interior decoration was suggested and even provided by the great Parisian firms of Fourdinois and Hoentschell. It will be very magnificent, yet one cannot but deplore it. Could not the country have dispensed with the intrusion of a style so out of harmony with its own; this country which possesses a palace-architecture as fine as that of the Nijo or the Nishi Honganji of *Kyoto*?[57]

Ultimately it was the Meiji Emperor himself who damned the whole business: *zeitaku da*, he declared – It's an extravagance![58]

Reaction

One architect who was less than enthusiastic about the Westernisation of Japanese architecture was the American, Ralph Adams Cram. The debacle of Ende and Böckmann's 1887 designs for the Diet had encouraged Cram, a decade later, to produce his own design for the building.[59] 'Architecture has fallen into the hands of tenth-rate German bunglers and their native imitators,' he wrote in *Impressions of Japanese Architecture and the Allied Arts* (1906), 'who copy so cleverly that their productions are almost as bad as those of their teachers.'[60] Cram was not alone in his criticisms. As early as 1880 *The Builder*

(*left*) 8.14 The Hyōkeikan in Ueno Park, Tokyo, designed by Katayama Tōkuma, 1908.

had reiterated Mrs (Annie) Brassey's advice that 'travellers who wish to see Japan should do so at once, for the country is changing every day, and in three years more will be so Europeanised that little will be left worth seeing.'[61] In his book Cram writes how, when compared with the West, Japan had for more than a millennium developed a coherent and continuous artistic tradition[62] but concludes that, 'with the close of the nineteenth century, art as a vital thing, a racial attribute, came to its end in Japan.'[63] This he regarded as nothing short of apocalyptic: '... it is a catastrophe,' he wrote, 'compared with which the destruction of the Alexandrian libraries, the coming of the Goths and Vandals, the suppression of the English monasteries, were but unimportant episodes ... In three centuries we [in the West] have sold our birthright for a mess of pottage. Japan bartered hers in less than forty years.'[64]

Cram is not altogether right in this critical assessment of Japanese architecture, for there emerged, in the 1890s, a style or approach known as *shajiyō*, based upon shrine and temple architecture and, significantly, the product of academy-trained architects.[65] Intended for modern building types, *shajiyō* implied the use of traditional architectural forms and construction methods and consequently required the collaboration of a master carpenter. The Nihon Kangyō Bank, Tokyo, built in 1899, the year Katayama started to draw up the Tōgū Gosho, was designed by Tsumaki Yorinaka, soon to be head of the building section at the Finance Ministry, and the young Takeda Goichi. Constructed of timber in the traditional manner, it was both a Japanese carpenter's building and, with its symmetrical, Palladian plan, oriel and sliding-sash windows, and *porte cochère*, a product of the academy or, in this case, the Imperial College of Engineering and Cornell University. The positioning of the building near Hibiya Park and across from Conder's Rokumeikan only served to emphasise its role as a cultural symbol for modern Japan.[66] Yet with its Western arrangement and appurtenances, it could hardly be that. Nevertheless, the self-conscious use, in an architect-designed building,

of such features as the *chidori-hafu* and the *kara-hafu*, as seen in the temples at Nara and the Nijō Castle at Kyoto, gave the building a nationalist quality which served to authenticate the new and emergent Japan.[67] This awareness was even reflected in Conder's own later work, the Unitarian Hall at Shiba, Tokyo (1894), which readily adopted the *kara-hafu* and the latticed gable despite its incorporation of brick chimney stacks and, therefore, fireplaces.

This political and cultural move away from Westernisation had been precipitated, as has been noted, by the resignation of the Minister of Foreign Affairs, Inoue Kaoru, in 1887. It was further confirmed by the decision, the same year, to award the rebuilding in its entirety of the (permanent) Imperial Palace to the master carpenter Kigō Kiyoyoshi, rather than to commission the buildings in the Western style which had been proposed by Conder, Tatsuno and others. Kigō had already built, in timber, a temporary palace at Akasaka, known as the Kari Kyūden (1881), following the destruction of the Imperial Palace by fire in 1873. The subsequent appointment of Kigō, in 1889, to teach traditional building methods at the Imperial University further signalled a change from the Westernised curriculum which Conder had introduced over a decade earlier at the former Imperial College of Engineering.[68] Tatsuno, now head of the Department of Architecture, claimed that he implemented these curricula changes as a result of being ashamed of his ignorance of traditional Japanese architecture when quizzed on the subject by Burges;[69] this is probably only half the story, the other half being that it was an astute move which reflected the emerging *zeitgeist*. This reversion to traditional methods had been anticipated by the closing, in 1883, of the Technical Fine Arts School (Kōbu Bijutsu Gakkō) where the Western techniques were taught, and to be replaced in 1889 by the Tokyo School of Fine Arts (Tōkyō Bijutsu Gakkō). Here time-honoured Japanese methods, characterised by the use of the brush rather than the pencil, dominated and the teaching of oil painting, for example, was dispensed with.[70] This restricting of horizons was,

to Conder, a matter of regret. 'It appears to me,' he had told the Association of Japanese Architects in 1886, 'that the necessity for some complete and non-exclusive method of art education in Japan is very patent, and that such a system should be very quickly inaugurated', adding that he saw 'very little fear of Japan losing national type and character in the art which she will eventually develop, provided that the natural artistic instincts of the people are kept alive'.[71]

A compromise of sorts was reached as a result of the influence upon Japan of John Ruskin, William Morris and the Garden City movement. Although the north-Italian Ruskinian Gothic style had been used by Conder in one of his earliest buildings in Japan, the Hokkaido Colonisation Agency (1881),[72] built near the Eitaibashi bridge in Tokyo, Ruskin's ideas were not introduced to the Japanese until 1888; Morris's poetry came three years later.[73] Although Shiga Shigenami, the Professor of Architecture at the Tokyo College of Technology, published a summary of some of Ruskin's ideas in *Kenchiku Zasshi* in 1911, there was no full translation into Japanese of Ruskin's highly influential books, *The Seven Lamps of Architecture* (1849) and *The Stones of Venice* (1851, 1853), until Takahashi Shōsen and Kagawa Toyohiko took on the task respectively in 1930–31, 70 years after the books first appeared. Yet there was an enthusiasm for the Gothic amongst the 'second generation' of students at the Imperial University, those studying under Tatsuno Kingo, of whom Chūjō Seiichirō and Itō Chūta were the most significant. Chūjō can be considered now but Itō must wait until Chapter 11.

Chūjō, as has been noted, went into partnership with Tatsuno's former class-mate, Sone Tatsuzō, in 1908 and it was probably he who was responsible for the aforementioned Keiō University Library (1907–12) [8.15] in Tokyo. Chūjō had graduated from the Imperial University of Tokyo in 1898 (until 1897 simply the Imperial University), and five years later went to England to study at Cambridge University.[74] The influence, albeit somewhat interpreted, of Cambridge's collegiate red-brick Tudor and Gothic Revival buildings can be seen in the Library at Keiō University, whether that be

the older college gatehouses or the newer work, such as the library Alfred Waterhouse added to Pembroke College (1877–78). At Keiō the library building is asymmetrical yet balanced; the octagonal corner tower with Burgesian gargoyles protruding beneath the machicolated battlements is offset by a broad and somewhat idiosyncratic gable end with a tripartite arrangement of plate tracery lancets, divided by broad brick banding, serving the reading rooms inside. Across the façade the detailing is robust – heavy stone drip-moulds cap the brick buttresses while machicolations support the overhanging cornice. In the apex of the great gables and in bands

8.15 Keiō University Library in Tokyo Mita, designed by Sone Tatsuzō and Chūjō Seiihirō, 1907–12.

beneath the first-floor windows, pale terracotta panels add a textured richness which contrasts well with the smooth red brickwork. The stone porch leads to an entrance hall from which an Imperial stair rises, on axis, beyond a screen of three granite arches with dumpy columns and stiff-leaf capitals which would have quite satisfied William Burges.

In 'The Nature of Gothic', the famous chapter from the second volume of Ruskin's *The Stones of Venice*, which Morris published independently on the Kelmscott Press in 1892, Ruskin defines Gothic in terms of architectural elements and then, more abstractly, in terms of form and spirit – the one belonging to the building and the other to the builder or architect.[75] At the Keiō University Library, the architectural elements are quickly recognised as the pointed arches, the buttresses and the gargoyles. However, it is the form and spirit of the building, what Ruskin called 'the characteristic or moral elements of Gothic', that most resonate in the Japanese context. Whereas Western architectural elements, whether Gothic, as here, or Classical, could be treated loosely, as has already been remarked upon, the form or spirit of the building could be brought through. Thus, at the, 'changefulness', which is apparent in the variety of features making up the façade, suggests a 'love of change'; similarly 'grotesqueness', which might be recognised in the gargoyles around the tower, is evidence of a 'disturbed imagination'. But perhaps most significant in the Japanese context is Ruskin's notion of 'naturalism' which demonstrates the architect's 'love of Nature'. Opportunities for this had been missing from the Western classicism so quickly adopted by Japanese architects in their public architecture, but within the form and spirit of the building, rather than the style, something more inherently Japanese could now be regained.

As Jordan Sand has pointed out, at the end of the nineteenth century domestic architecture was not considered, in Japan, to be 'proper architecture', with the result that it had remained relatively undeveloped for the last 50 years.[76] The Western architecture taught at the Imperial University was that of larger public buildings, for the graduates were destined for public office where monumental or 'high' architecture, rather than domestic architecture, was the goal. Yet it was very much in domestic-scale buildings, not just houses, but shops, tea-rooms and village halls, that progressive ideas of design were being developed in the West. Their expression came in many ways, categorised as Arts and Crafts, Art Nouveau, Jugendstil or Secessionist, but what they had in common was a shared belief in craftwork and nature, whether that be in the use of materials or the depiction of forms. Much of this, of course, had emerged through Japonisme, the visual manifestation of the West's fascination with Japan, and it was these progressive buildings which attracted the attention of the next generation of young Japanese architects. As the architect and historian Itō Chūta remarked some years later, 'While in Japan everyone is talking about the West, in the West everyone is talking about the East. Secession is one point where the two meet.'[77] The circle, as it were, was now closing.

It was a two-year tour of Arts and Crafts, Art Nouveau, Jugendstil and Secessionist architecture that Takeda Goichi embarked upon when he left Yokohama for Europe in March 1901. Arriving in Paris at the end of April, he had met up with Tsukamoto Yasushi, another of Tatsuno's students who had graduated from the Imperial University in 1893.[78] Tsukamoto had been in Paris a little while, visiting the 1900 Exposition Universelle and, on numerous occasions, the eponymous Maison de l'Art Nouveau.[79] This had been established in 1895 by the German art dealer Siegfried Bing who imported *objets d'art* from Japan, as well as exporting French goods to Japan, and from 1888 to 1891 had published the journal *Le Japon Artistique*. But Takeda did not linger in Paris, moving quickly on to London where he enrolled at the Camden School of Arts and Sciences, before travelling north that September to Birmingham, Warwick, Chester, Glasgow, Durham and Lincoln. In Glasgow he saw the School of Art, where he drew the 'Japanese' staircase, as well as visiting the 1901 Glasgow International Exhibition. There he found and drew

the exhibition stand designed by Charles Rennie Mackintosh for the cabinet-maker Francis Smith.[80] While at the Camden School of Arts and Sciences Takeda submitted an entry to the National Competition of Works of the School of Arts and won second prize for a series of coloured Art Nouveau internal elevations in a fusion of Charles Voysey and Victor Horta.[81] By August 1902 he was back in Paris where he lived for five months, visiting Belgium in August/September 1902; and, after two months in Italy, where he went to Genoa, Florence, Rome and Venice, he went to Austro-Hungary in April and May 1903. In Vienna, where he spent a week, he saw the Secession Building (1897) by Josef Maria Olbrich and the Stadtbahn Station at Akademiestrasse (1899) by Otto Wagner and Olbrich.[82] When Takeda eventually returned to Japan in July 1903 he brought with him the idea of some sort of 'Japanese Secession'. Although it was not until 1912 that these ideas appeared in *Kenchiku to shakai* as 'A New Opportunity for Architecture in the World',[83] he soon had the opportunity to express them in built form.

The house Takeda built in 1907 in Kyoto for the President of the Shirokiya Department Store, Fukushima Yukinobu, was designed in what has been termed *Sesesshon shiki* (Secession style)[84] and finished externally in a red/purple render. The colour notwithstanding, the straight lines of the interior panelling and furniture showed the influence of both Mackintosh and Josef Hoffman, as well as the English Arts and Crafts architects such as Charles Voysey, while in the circular form of the inglenook perhaps that of Hector Guimard or even Horta. Even so, the house was not without its more traditional Japanese elements: there was one *tatami* room, with *nageshi* moulding and decorated *ranma*, and externally, half-timbered gables which, although European in extraction, would not have appeared challenging to the Japanese. However the provenance of the Fukushima House might be described, it was a *mélange* of progressive Western architectural fashions. More recognisably Arts and Crafts was the weekend house which Takeda built three years later in Nishinomiya for Shibakawa Mataemon, an Osaka businessman [8.16].

Relocated now to Meiji-mura, the house stands on a promontory much as it had done before, but having been rebuilt and enlarged following the Great Kantō Earthquake, it is now finished with white render whereas previously it had been clad in cedar shingles. Nevertheless, its variety of form and expression of natural materials, as well as its demonstration of craftwork, as seen in the impressed decoration of the internal and external plaster walls, place it firmly in the vanguard of architectural change. Like the Fukushima House, it represented something quite different to what was being taught at the Tokyo Imperial University. When the Department of Architecture opened in the College of Engineering at Kyoto Imperial University in 1920, Takeda was appointed the first Professor of Architecture.

Further evidence of change followed in 1917 with the publication of Ōsawa Sannosuke's paper *Gāden Shichī ni tsuite* (On Garden Cities).[85] Ōsawa was the head of the Department of Architecture

8.16 The Shibakawa Mataemon House, built in Nishinomiya by Takeda Goichi and now rebuilt at Meiji-mura, 1910.

at the Tokyo School of Art[86] and, when travelling in Europe between 1906 and 1909, had visited Hampstead Garden Suburb. What appealed to him was not so much the social reform promoted by Ebenezer Howard in *Garden Cities of To-morrow* (1902),[87] but the Garden Cities' well-appointed houses and the lush gardens in which they were built.[88] It was now almost as if the architectural cultures of Japan and the West were drawing close enough together to become indistinguishable. For one, it was the result of modernisation; for the other, the discovery of the new. During a few brief years when their paths crossed, there was a sense of architectural union until, in the late 1920s, the nationalist influence of *teikan-yōshiki* drew Japanese architecture once again back into itself.

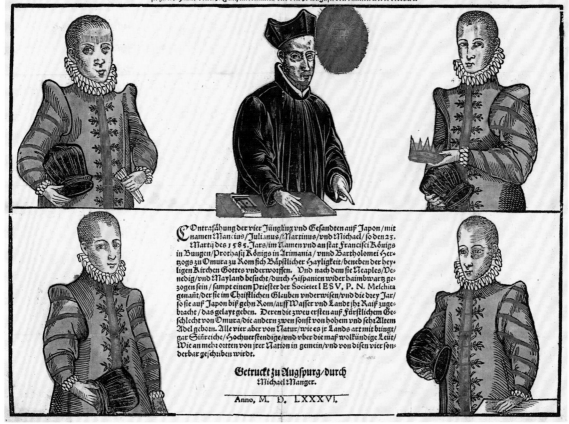

Plate 1 The Tenshō Embassy to Europe, 1584–86: Nakaura Julião, Father Diogo de Mesquita, Itō Mancio, Hara Martino, Chijiwa Miguel.

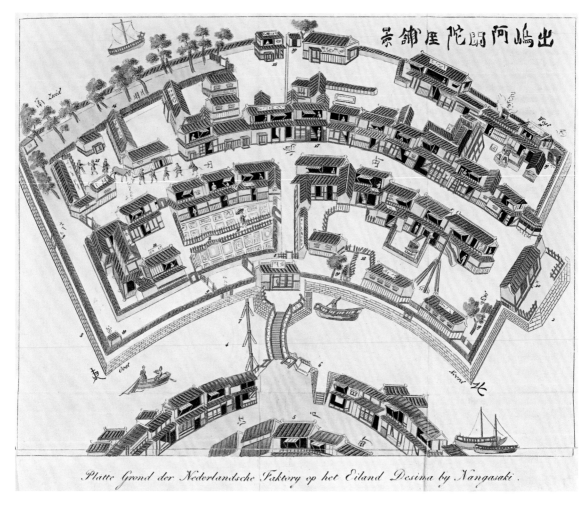

Plate 2 The Dutch settlement of Dejima in Nagasaki harbour, from Isaac Titsingh, *Bijzonderheden over Japan ...* (*Illustrations of Japan ...*), 1825.

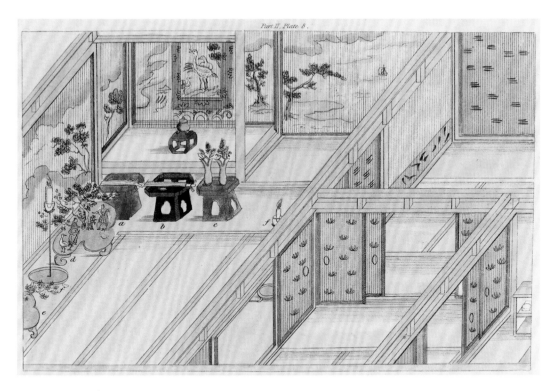

Plate 3 'Apartment in which the Bride's parents entertain the Bridegroom', from Isaac Titsingh, *Illustrations of Japan* ..., 1822.

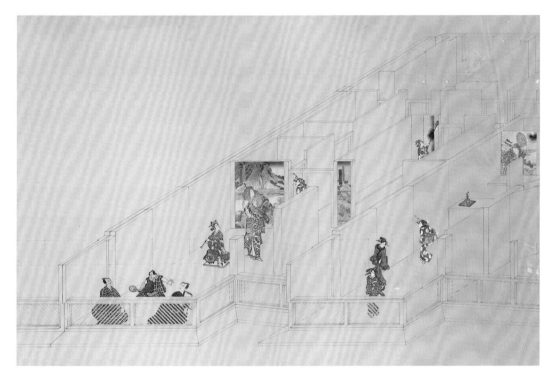

Plate 4 The competition entry for Riverside Apartments in Pimlico, London, from Alison and Peter Smithson with Ronald Simpson, 1977.

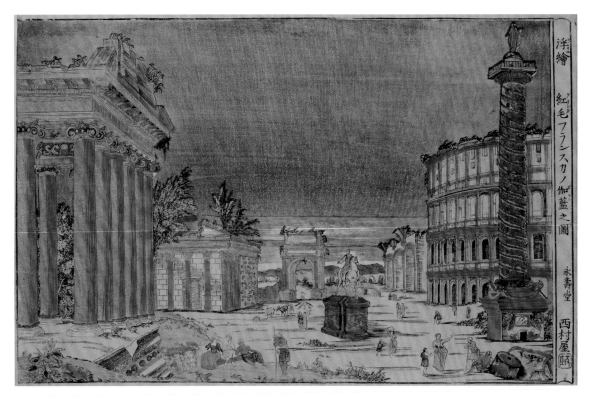

Plate 5　Utagawa Toyoharu, *A Dutch View of a Franciscan Monastery*, showing the Forum at Rome, *c.* 1770s.

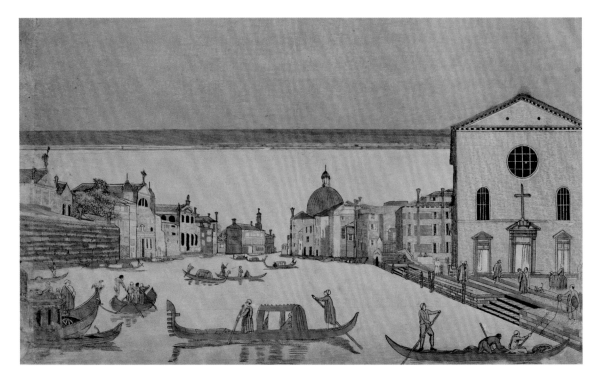

Plate 6　Utagawa Toyoharu, *The Bell Which Rings for Ten-thousand Leagues in the Dutch Port of Frankai*, showing the Grand Canal in Venice, *c.* 1770s.

Plate 7 Kōkan Shiba, a mirror-image copy of George Bickham's *A View to the Grotto of the Serpentine River in the Alder Grove in the Gardens of Earl Temple at Stow, in Buckinghamshire*, 1787.

Plate 8 A wood-block print by Ichiyusai Shigenobu print, owned by William Burges, *c.* 1855.

To be printed in the
pale or ground tint on
the darkest or line tint
the second that for the
hooking of the feathers

E.513-1968

Plate 9 Peacock wallpaper designed by Edward William Godwin, *c.* 1872.

Within the image: Tite St or FRONT ELEVATION of House for J. A. McN Whistler esq. Chelsea

Plate 10 The first design for James McNeill Whistler's White House, 35 Tite Street, London, designed by Edward William Godwin, 1877.

Plate 11 The first design for Frank Miles's house, 44 Tite Street, London,
designed by Edward William Godwin, 1878.

Plate 12 A wood-block print by Utagawa Hiroshige III of Ginza Street and Nipposha, Tokyo Ginza, designed by Thomas James Waters, 1872–77, from the series Famous Places of Tokyo, *c.* 1875.

Plate 13 A wood-block print by Inoue Yasuji of the Rokumeikan or Deer-Cry Pavilion in Tokyo Uchisaiwaichō, designed by Josiah Conder, 1883.

Plate 14 A wood-block print by Chikanobŭ Yōshū of the Museum in Ueno Park, Tokyo, designed by Josiah Conder for the Second National Industrial Exposition in 1881.

Plate 15 A wood-block print of Sukiyabashi (Sukiya Bridge) from the series *Scenes of Last Tokyo* by Hiratsuka Un'ichi, 1945, showing the Tokyo Asahi Newspaper Offices, designed by Ishimoto Kikuji, 1929.

Plate 16 An aerial perspective view of the First Church of Christ, Scientist, in Berkeley, California, designed by Bernard Maybeck, undated, *c.*1910.

·SECTION TO NORTH·

Plate 17 The cross-section through the First Church of Christ, Scientist, in Berkeley, California, designed by Bernard Maybeck, undated, *c.*1910.

Plate 18 The competition entry for the Glasgow School of Art, designed by Charles Rennie Mackintosh and signed 'John Honeyman & Keppie Architects', 1897.

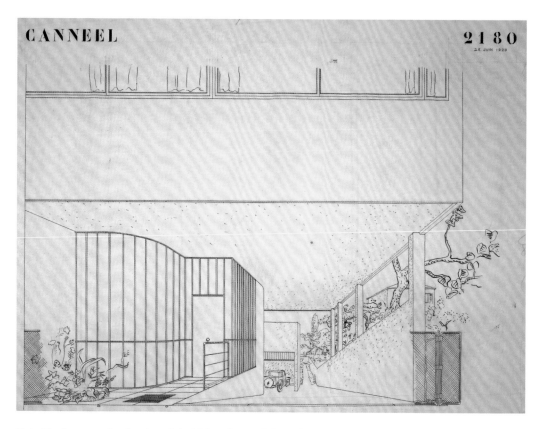

Plate 19 A perspective drawing of the Maison Canneel, Brussels, designed by Le Corbusier and drawn by Maekawa Kunio, 1929.

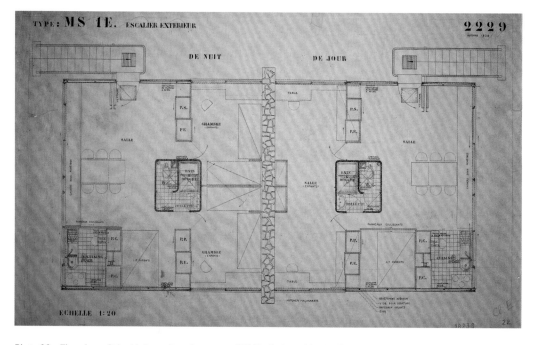

Plate 20 The plan of the Maisons Loucheur type MS 1E, designed by Le Corbusier and drawn by Maekawa Kunio, 1929.

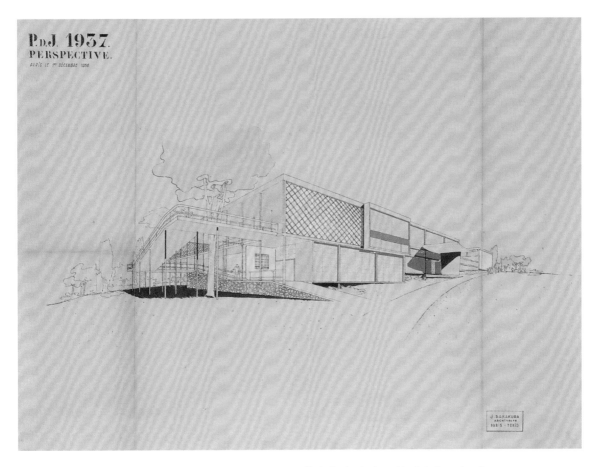

Plate 21 The Japanese pavilion at the 1937 Exposition Universelle in Paris, designed by Sakakura Junzō.

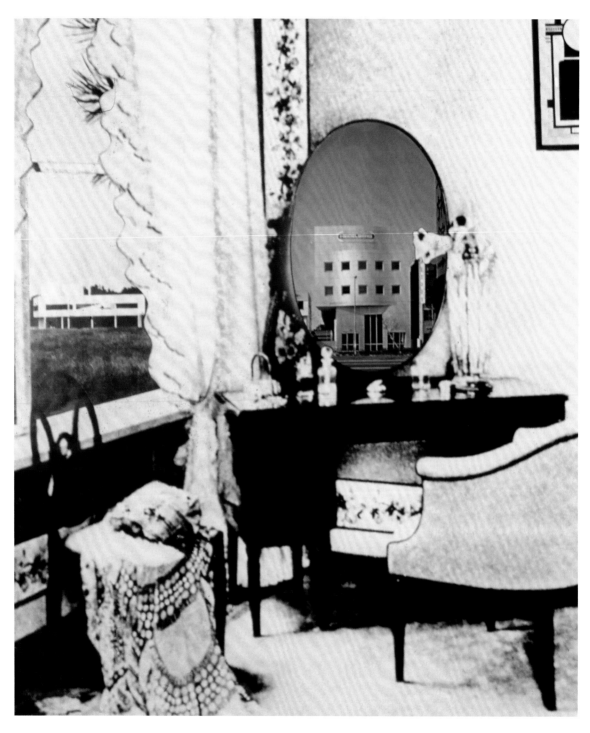

Plate 22 The PMT Building in Aichi, Nagoya, with the Villa Savoye, a photomontage by Itō Toyoo from the 1978 'New Wave of Japanese Architecture' exhibition at the Institute for Architecture and Urban Studies, New York.

TAISHŌ

9 THE WINDS OF HEAVEN

Frank Lloyd Wright

In 1876, *The American Architect and Building News* described the Japanese house as 'a solid roof and floors, held together by a strip or two of plastered wall and a few slender posts, through and through which all the winds of heaven may dance'.[1] It was an accurate enough description and one which could have been increasingly applied to progressive American architecture as the nineteenth century moved into the twentieth. Frank Lloyd Wright, however, always denied the direct influence of Japan upon his architecture. Rather, he would say that he found in Japan 'a great confirmation of the feeling I had and work I had myself done before I got there'.[2] Nevertheless, he was ready to acknowledge, in the introduction to *Ausgeführte Bauten und Entwürfe von Frank Lloyd Wright* (1910), that 'their debt to Japanese ideals, these renderings themselves sufficiently acknowledge'.[3] In his *Autobiography* (1943), Wright accepts the influence of the Japanese print:

> During my later years at the Oak Park workshop, Japanese prints had intrigued me and taught me much. The elimination of the insignificant, a process of simplification in art in which I was myself already engaged, beginning with my twenty-third year, found much collateral evidence in the print. And ever since I discovered the print Japan had appealed to me as the most romantic, artistic, nature-inspired country on earth. Later I found that Japanese art and architecture really did have organic character ... I had realised this during my first visit in pursuit of the Japanese print in 1906.

This visit was, in fact, in 1905, not 1906.[4] Wright was often hazy about dates. He claimed to be born in 1869 but it is now clear that he was born in 1867: his passport for that first visit to Japan confirms this.[5] With a June birthday, the 'process of simplification' of which he writes here can therefore be dated to 1891–92: this would have not been his 23rd, but his 25th year, and corresponds exactly with the design of the Harlan House which is discussed below. If, however, he was referring to his age, Wright would have been 25 (or 23 by his count) when the World's Columbian Exposition opened in Chicago.[6] His involvement with the design of the Transportation Building for Adler and Sullivan would have taken him to the site frequently. There he would have seen the Hōō-den, and the other Japanese buildings, where the 'process of simplification' was fully evident.

Wright's first overseas visit was not to Europe, as might be expected, but to Japan where he arrived on 7 March 1905. There he donned Japanese dress and ventured, on his own, into the hinterland, collecting prints and porcelain.[7] He was, in fact, travelling with his wife Catherine Tobin and Cecelia and Ward

Winfield Willits, for whom Wright had built a house in Highland Park, Illinois, in 1901. Regarded as the first house in the true Prairie style, it picked up on the plan of his own, earlier house (1889) (described in Chapter 5), teasing it and extending it into a cruciform and setting it beneath broad, overhanging eaves. Although he had then never been to Japan, the Japanese qualities of the Willits House are immediately recognisable and were so to the English Arts and Crafts architect, Charles Robert Ashbee. In his introduction to *Frank Lloyd Wright: Ausgeführte Bauten*, published in Berlin by Wasmuth in 1911,[8] he observed that 'The Japanese influence is very clear. He is obviously trying to adapt Japanese forms to the United States, even though the artist denies it and the influence must be unconscious.'[9] The artist did deny it. He wrote to Ashbee in September that year:

> Do not say that I deny that my love for Japanese art has influenced me – I admit that it has but claim to have digested it. Do not accuse me of trying to 'adopt Japanese forms' however, *that is a false accusation and against my religion*. Say it more *truthfully* even if it does mean saying it more gently.[10]

Wright had asked Ashbee to write the introduction when he visited him at Chipping Campden, Gloucestershire, in September 1909. Wright was in a state of anxiety: he had left his wife Catherine and travelled to Europe with Martha 'Mamah' Borthwick Cheney, the wife of one of his clients, Edward Cheney, for whom he had built a house in Oak Park in 1903. Wright did not know how his friend Ashbee would take this news and hesitated in calling upon him; as it turned out, they talked 'about architecture and Japan and mechanization'.[11] Although Ashbee had never been to Japan, he had seen its direct influence on American architecture during a visit earlier that year and was already convinced of the Japanese influence upon Wright's work.

In 1900, Robert Clossen Spencer, a close companion of Wright and, in 1896–98, a fellow tenant of studio space in Steinway Hall, Chicago (1896), wrote a lengthy profile of his friend in the Boston journal, *The Architectural Review*. Here, at this early date, he attributed Wright's skill, 'if not to nature at first hand, then to those marvellous interpreters of nature, the Orientals and the Japanese'.[12] He drew attention to Wright's use of colour, calling him 'a lover of rich, warm, quiet colors', and described the gold enamel and glass mosaic facing panel designed for the Joseph W. Husser House in Chicago (1899), where 'combinations of gold infusion with color on porcelain have been made to delineate vine trunks and a weeping profusion of wisteria sprays and pendant blossoms upon a ground dull gold below and bright gold above a suggested horizon'.[13] It was clearly an instance of Japonisme, both in the pictorial effect and in the method of application.

Wright's awareness of Japanese architecture pre-dated not only his first trip to Japan but also the 1893 World's Columbian Exposition in Chicago. He might, as a precocious nine-year-old, have accompanied his mother to the 1876 Centennial Exposition in Philadelphia and seen the first two Japanese buildings erected in America, but it is more likely that the real outcome of this visit was his mother's discovery of the Froebel Blocks which, as he claimed, so influenced his education.[14] His appreciation and subsequent interpretation of Japanese architecture more probably began in 1887 when he was working for the Chicago architect Joseph Lyman Silsbee whose first cousin and friend was the Japanophile, Ernest Francisco Fenollosa.[15] Fenollosa had first travelled to Japan in 1878 at the invitation of Edward Morse to teach political economy and philosophy at the Imperial University in Tokyo but soon became an expert in and campaigner for the preservation of traditional Japanese painting. In 1886, shortly before Wright joined Silsbee's office, Fenollosa, as a member of the Imperial Japanese Fine Arts Commission, travelled to the United States on a tour of Western art museums. It can only be surmised that Fenollosa, on visiting or passing through Chicago, introduced his cousin to the world of Japanese art and that Silsbee, in turn, drew it to Wright's attention.[16]

If Wright found in Silsbee a picturesque expression in the shingled gables and tall chimneys of the East Coast Shingle Style,[17] in his next employer, Louis Sullivan, he found a sensitivity

to nature which reflected his own country-boy upbringing. Both responses complement well his nascent interest in Japanese art and fed easily into the mix. This he enhanced by reading Owen Jones's *Grammar or Ornament* and Viollet-le-Duc's *Habitations of Man in All Ages*; he had already read Viollet-le-Duc's *Dictionnaire raisonné de l-architecture française* which he thought to be 'the only really sensible book on architecture in the world'.[18] In *Frank Lloyd Wright to 1910: The First Golden Age* (1958) Grant Carpenter Manson draws attention to 'the angular, stylized rendering of shrubbery' around Wright's signed drawing of the J.L. Cochrane House (1887) executed while in Silsbee's office; he also shows Wright's first authenticated design, that for the 'Unitarian Chapel for Sioux City, Iowa', published in the *Inland Architect & News Record* in June 1887.[19] The graphics of the first are as Japanese as the open plan and sliding screens of the other.

Although the Hōō-den at Chicago is usually seen as the genesis of Wright's use of Japanese references in his architecture, the incipient forms can be recognised as early as the Cochrane House of 1887. In itself there is, apart from the drawing of the shrubbery, nothing noticeably Japanese about the design. However, the plan arrangement, with the centrally placed stairs and the pronounced bay on the cross-axis, is exactly the same *parti* later used at the Harlan House (1892), built as a moonlighting job while he was still working for Sullivan. Here it is a more mature plan and tidier, the fireplace now taking the place of the stairs which have been moved to the other end of the cross-axis where they balanced the stairs. The Winslow House of the following year, his first commission after leaving Sullivan's office, was just a further refinement of the same *parti*.[20] Now the access no longer came in from the side but from the front, the depth of the site allowing a linear approach along the main axis to a reception hall which replaced the stairs. Designed in the same year as the Hōō-den was built, the plan of the Winslow House is not so much a response to that Japanese building, but a reflection of its arrangement. From this came the subsequent development of the cruciform plan, as at the Willits House, and T-plan, as at the Cheney House, which so characterised the Prairie style.

It was the 'bootleg' Harlan House which, in 1893, precipitated his break with Sullivan.[21] Compared with the robust solidity of the Charnley House (1891), which was designed by Wright for Sullivan, the Harlan House appears fragile and almost lightweight. Its sources are, without doubt, Japanese: the shallow, hipped roof with generous overhanging eaves; the broad series of French doors opening, beneath the balcony, from the living room to the terrace; and the openness of the plan, allowing diagonal views from the dining room fireplace to the terrace, are all generic. But it is the specificity which is interesting. Pre-dating the Hōō-den, its inspiration can only come from Japanese prints: 'nothing from "Japan" has helped, at all,' he later wrote, as if in confirmation, 'except the marvel of Japanese colour-prints.'[22] The wood-block print of Shimizu Kisuke's first Mitsui-gumi building (1872) in Tokyo (see Chapter 6), drawn by Utagawa Kuniteru II, shows a building with a similarly shallow, hipped roof with a single dormer inserted on each side and a balcony along the front, its posts separated by *ranma*-style decoration. At the Harlan House, the dormers and balcony reappear and, although the panels below the handrail recall the Sullivanesque design of the balcony at the Charnley House, the open fretwork above is fresh and innovative. Kuniteru's wood-block print shows *giyōfū* architecture in Japan: Wright's Harlan House completes the circle and brings it home.

The long, low elevation, surmounted by a large, overhanging roof, that Wright first developed for the Winslow House [9.01] and which reflected so well the *minka* found in Japan, became a standard part of his vocabulary. Combined with the cruciform and T-plans, these buildings reached out sheltering arms across the prairies, encompassing the land which, as terraces and gardens, became, in turn, part of the house. The punctured walls of the earlier houses gave way to ribbon windows which emphasised the horizontal and sank into the darkness beneath the overhanging eaves. The closed box broke apart and separated into planes emphasised by stuccoed panelling or Roman bricks with raked horizontal joints and flush perpends, and the raised ground-floor rooms and adjacent terraces dissolved into one

9.01
The William F.
Winslow House
in River Forest,
Illinois, designed
by Frank Lloyd
Wright, 1893.

great, fluid, contiguous space revolving around the fireplace, Wright's own *takonoma*. 'Thus,' he wrote, 'came the end to the cluttered house.'[23]

The scandal which erupted following Wright and Mamah Borthwick's elopement to Europe effectively ended his career in Oak Park: he built only two further houses there, those for Oscar Balch (1911) and Harry S. Adams (1913). A few clients remained true but the Medway Gardens, Chicago (1913), was his only major commission. The murder, in August 1915, of Mamah Borthwick and her two children, together with four others, and the burning of Taliesin, their home at Spring Green, Wisconsin, devastated him.[24] It was only in 1916 that, as he said, 'came relief, a change of scene as – promptly – was called to build the Imperial Hotel in Tokio, Japan'.[25]

Wright had first been recommended for the job as early as 1911 and negotiations, necessitating a trip to Japan in 1913, had extended through to 1916.[26] Over the next six years he sailed to Japan five times. His sojourns there were lengthy, ranging from four to 10 months and totalling almost three years. Building

work was excruciatingly slow and Wright was always under pressure from the oil heiress Aline Barnsdall to progress the work on her project, the Hollyhock House in Los Angeles, where Rudolph Schindler was holding the fort for him. In Japan Endō Arata, who had travelled to Taliesin in 1917 to help originate the designs for the hotel, was his right arm and completed the building after he eventually left. There too was the Czechoslovak architect Antonin Raymond who was to stay on and make his career in Japan. After many postponements, the north wing and the partly completed central section of the hotel opened on 2 July 1922 and three weeks later Wright left Yokohama for the United States, never to return. It was over a year before the south wing was completed, and the opening celebrations for the whole hotel were arranged for 1 September 1923. That was the day the Great Kantō Earthquake struck. It was on 13 September that Wright, now in Los Angeles, received the famous telegram from Tokyo:

HOTEL STANDS UNDAMAGED AS MONUMENT OF YOUR GENIUS

9.02
The Imperial
Hotel, Tokyo
Uchisaiwaichō,
designed by
Frank Lloyd
Wright and now
partly rebuilt at
Meiji-mura, 1923.

HUNDREDS OF HOMELESS PROVIDED BY
PERFECTLY MAINTAINED SERVICE

CONGRATULATIONS OKURA

Baron Ōkura Kihachirō had been President of the
hotel's Board of Directors, but did he send the
telegram? As Brendan Gill points out, the telegram
was sent to Wright in Los Angeles, not from Tokyo
but from Spring Green, Wisconsin, and no telegram
originating from Tokyo has ever been found at
Taliesin.[27] Although communications between
Tokyo and the rest of the world were cut off, news
of the earthquake was not long in coming. On 4
September *The New York Times* carried the headline,
'100,000 DEAD IN JAPANESE EARTHQUAKE; TOKIO,
YOKOHAMA AND NAGOYA IN RUINS; MILLIONS
DESTITUTE; FIRES STILL RAGING'.[28] Lower down
the page another column announced that 200,000
buildings were razed in Tokyo. Although Wright,
working in Los Angeles, would have heard about
the earthquake, he would have had no idea how the
Imperial Hotel had fared. It had survived a smaller

earthquake – nevertheless the most severe for 30
years – unscathed on 26 April 1922, so he must have
been hopeful.[29] The fact that Ōkura's telegram took
almost two weeks to arrive is not surprising: after
such disasters, there is often a short lull during
which initial reports can be sent before the few
remaining telegraphic lines are so overworked that
it becomes almost impossible for most people to
communicate with the outside world.[30] Perhaps
that accounts for the 13 days it took the telegram
to arrive, even if it was forwarded from Spring
Green. It is wholly possible that in the excitement
of forwarding the telegram the original was lost,
perhaps left at the Spring Green telegraph office. In
any case, another followed soon after from Hayashi
Aisaku, who had been the hotel's previous manager
at the start of the project, saying: 'Imperial stands
square and straight. Congratulations.'[31] Despite
Wright's assertions to the contrary, the hotel did
suffer some damage. Antonin Raymond later wrote
that 'the floor of the dining room had buckled both
lengthwise and crosswise and the high rear portion
sunk enough to necessitate a later change in the

9.03 The plan of the Imperial Hotel in Tokyo Uchisaiwaichō, designed by Frank Lloyd Wright, 1923.

9.04 The plan of the Hōō-den or Phoenix Bird Building built at the 1893 World's Columbian Exposition, Chicago.

rear entrances from an ascent to a descent.'[32] The sinking was to continue for years until the hotel was considered 'unsafe' and finally closed in 1967. It was demolished the following year; however, the entrance and lobby, but not the dining room, were re-erected at Meiji-mura [9.02].

The original location of the Imperial Hotel facing the Imperial Palace across Hibiya Park, now the home of the Taisho Emperor, almost obliged it to assimilate with its context. The H-plan form adopted for the hotel would, however, have been read, by Westerners, as Beaux-Arts [9.03]. For this to come from Wright might seem unlikely but it is, in fact, not surprising. In 1894 Daniel Burnham, then President of the American Institute of Architects, had offered to send Wright to the École des Beaux-Arts for four years, followed by a Fellowship at the new American Academy in Rome, with the promise of employment, presumably as his principal designer, on his return. Although Wright politely declined the offer – 'It is too late now, I'm afraid. I am spoiled already. I've been too close to Mr Sullivan. He has spoiled the Beaux-Arts for me, or spoiled me for the Beaux-Arts – I guess I mean.'[33] – there was ample suggestion in his work, from the Charnley House to the Blossom House (1892) to the Winslow House, that he could have been turned. Even the Japanese, now familiar with the Bank of Japan and the Detached Palace at Asakusa, would have recognised the hotel's classical *parti* but they would also have seen, in the way in which the central core is twice linked by colonnaded walkways to the side wing, similarities to the Hōō-den in Chicago [9.04] and thus the Hōō-dō at Uji from which it was derived. Wright acknowledged the hotel's Japanese qualities but, as always, saw them through the filter which was himself. 'While making their building "modern" in the best sense, I meant to leave it a sympathetic consort to Japanese buildings.'[34] But he also saw himself as something of a missionary, adding, 'I desired to help Japan make the transition from wood to masonry, and from her knees to her feet, without too great a loss of her accomplishments in culture.'[35] Wright's various accounts of the Imperial Hotel tell the same story,[36] centred on its structure, but the variety of

wording sometimes changes the emphasis. In his *Autobiography* (1943), he writes, 'No foreigner yet invited to Japan had taken off his hat to Japanese traditions.' He then adds, 'It was my instinct not to insult them. The West has much to learn from the East ...'[37] In an earlier published description of 1937, he makes the same point but to 'traditions' adds 'conditions',[38] thus justifying what he did at the Imperial Hotel, for there was nothing traditional about it. In acknowledging the ground *conditions*, which were liquid mud three metres below the surface, and the ever-present threat of earthquakes, Wright supported the building on hundreds of short concrete piles – 'a kind of pincushion'[39] – which barely extended beyond the top-soil which he described as cheese. Rather than spanning the upper floors between the outer walls, they were cantilevered from paired columns, 'as a waiter carries his tray on his upraised arm and fingers – *balancing* the load'.[40] It was an appropriate metaphor for a hotel. Because he thought that Japanese buildings were top-heavy, the walls, which were of brick, double-skinned and infilled with concrete, were broad at the base and tapered towards the top so as to lower the centre of gravity. A concrete ceiling slab served to make the structure rigid and supported a lightweight roof clad in copper rather than the usual Japanese roof of heavy clay tiles. Arranged in sections which did not exceed 60 feet (18 metres), the building became 'a jointed monolith' designed to ride out the earthquakes.

What was finally declared open on 1 September 1923 was, as Wright said, 'something not Japanese, certainly, but sympathetic, embodying modern scientific building ideas by old means not strange to Japan. No single form was really Japanese but the whole was informed by unity.'[41] In his *Autobiography* he wrote, 'the straight line and flat plane were respectfully modified in point of style to a building bowing to the traditions of the people to whom the building would belong.'[42] Thus, while the hotel's battered walls reflected the massive stones of the Imperial Palace's moat visible across Hibiya Park, the folded roof planes of the lounge suggested the stepped *oriage* ceilings of the *Shoin* style, and the corbelled supports, which reach out from the hefty columns to support the ceiling slab and were carved in *oya* lava-rock from Ōya, near Nikkō, recalled the corbelled woodwork of the great Buddhist temples there [9.05].

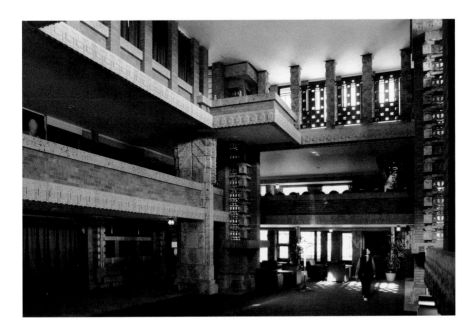

9.05 The main lobby of the Imperial Hotel, in Tokyo Uchisaiwaichō, designed by Frank Lloyd Wright and now rebuilt at Meiji-mura, 1923.

The Imperial Hotel was not Wright's only building in Japan.[43] The first was the Prairie-style house in Komazawa, Tokyo, built for Hayashi Aisaku from sketches prepared by Wright in 1917. Then in January 1920 he designed a large, two-storey annexe for the old Imperial Hotel where he himself had 'a modest little nook' with a penthouse studio-bedroom and a grand piano. Like the project for the Lexington Terrace apartments, Chicago (1909), it was a square courtyard building with spine corridors but now an arm connected it to the existing hotel.[44] Timber-framed and plastered, it was destroyed in fires following the 1923 earthquake.

It was Hayashi who, in 1917, had introduced Endō Arata to Wright, and, in turn, it was Endō who introduced Wright to the journalists, social reformers and educators Hani Motoko and her husband, Hani Yoshikazu, who had founded a girls' school, the Jiyū Gakuen (School of the Free Spirit) in Tokyo Toshima-ku. In January 1921 they asked Wright to design the Myōnichi-kan (House of Tomorrow) for the Jiyū Gakuen and in three months the first room (located at the north-west corner) was completed and the children moved in. Wright sent a congratulatory message:

This little school building was designed for the 'Jiyu' Gakuen – in the same spirit implied by the name of the school – a free spirit. The children seem to belong to the building in quite the same way as the flowers belong to the tree, and the building belongs to them as the tree belongs to its flowers.[45]

Wright was impressed by the Hanis' educational philosophy which encouraged self-reliance, time discipline and household management, even having the girls prepare their own meals:[46] perhaps this influenced his thinking when establishing the Taliesin Fellowship in 1932, for he described the building of this school as 'one of the rare experiences of my life'.[47]

The Myōnichi-kan once again adopts the U-shaped plan, part Beaux-Arts and part Hōō-dō, and appears ambivalent [9.06]. However, despite its symmetrical arrangement, there is an openness about the design: there are four entrances to the site, reducing the sense of symmetrical axiality, and in the central building, the individual rooms are surrounded by circulation space, suggestive of *engawa*, beneath an overhanging, Prairie-style roof. The sense of informality is emphasised by the spatial fluidity of the split-level arrangement of the main block; here the dining room and gallery, set to the rear, overlook the centrally positioned hall with

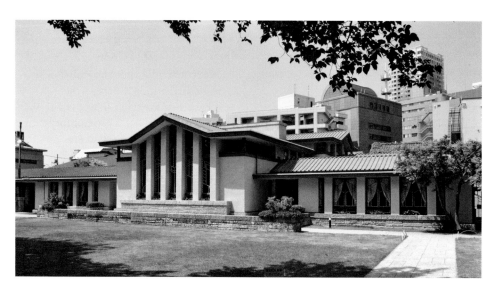

9.06 The Myōnichi-kan (House of Tomorrow) Jiyū Gakuen (girls' school) in Tokyo Toshima-ku, designed by Frank Lloyd Wright, 1921.

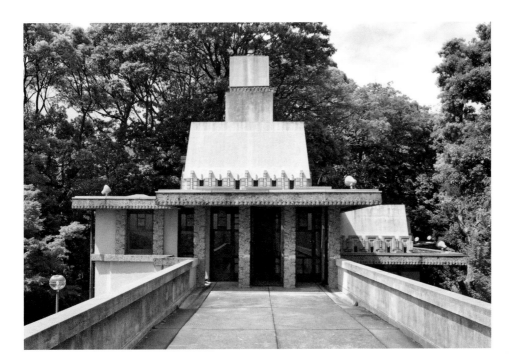

9.07 The Yamamura Tazaemon House in Ashiya, designed by Frank Lloyd Wright with Endō Arata, 1924.

its great stained-glass window opening onto the lawn. The colonnaded side wings, however, are more formal and, turning in at the end, serve to contain the site. The timber-frame construction allows for varied fenestration – vertical, horizontal and even diamond-shaped (in both the walls and the roof) – and for varieties of form internally within the ceiling construction. The resulting play of solidity against transparency emphasises the frame construction which, with the use of ōya lava-stone for bases and plinths, columns and light stands, gives the building a regional sensibility. Endō worked with Wright on this building and, following Wright's departure from Japan, completed the east classroom wing in 1925.

When Wright left Japan, the drawings for a new house in Ashiya, commissioned by Yamamura Tazaemon, a sake brewer from Nishinomiya, were complete and the fee had been paid, but work had not started on site. The Yamamura family therefore asked Endō and Minami Makoto, a structural engineer who was also working on the Imperial

Hotel, to take over the job and the building was completed in 1924. Wright's design of 1918 had not followed the Prairie-style of the Myōnichi-kan and the Hayashi House, nor the layered horizontality of the Imperial Hotel, but rather the new forms currently being explored in the Hollyhock House in Hollywood. Although considerably wetter, the site differed little, both in terrain and climate, from the Hollywood Hills where, following the Hollyhock House, Wright built a series of houses which appeared to grow out of the steep sides of the hills.[48] At Ashiya, the site extended like a promontory from a high plateau, the land falling away steeply on three sides. Wright positioned the house on this ridge, stepping it up and back through four levels [9.07]. It is consequently the cross-section which makes this house most interesting, for there is no place where the house is more than two floors deep. At the lowest level was the entrance and *porte cochère*, and above that, the salon. On the third level, arranged in a linear procession, were three interlinking

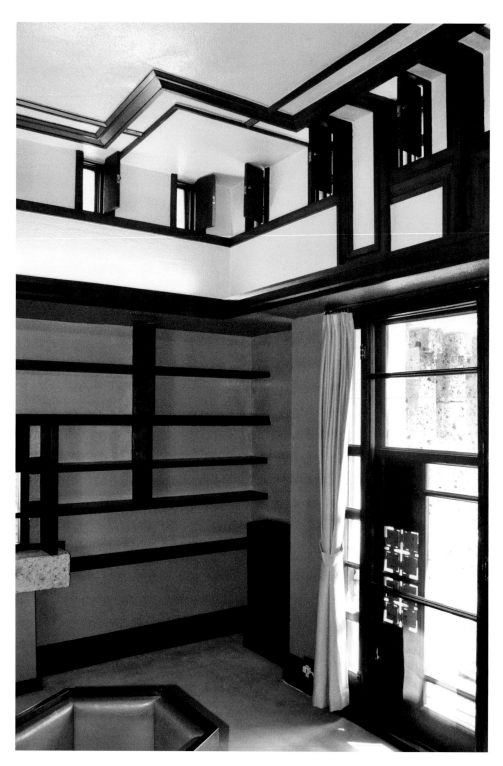

9.08 The salon at the Yamamura Tazaemon House in Ashiya, designed by
Frank Lloyd Wright with Endō Arata, 1924.

Japanese-style rooms and beyond, three Western-style bedrooms. The final level was given over to roof terraces and a penthouse structure containing the dining room and a small kitchen. The incorporation of *tatami* rooms for both family and servants was reputedly made at the client's request:[49] the *shaku* system of measurement which they use is, however, at odds with the Imperial foot employed elsewhere in the house and suggests the work of Endō and Minami. Yet Wright had designed both types of room at the Prairie-style house he built in 1918 for Fukuhara Arinobu in the wooded hills at Hakone; constructed of timber-frame and stucco, with ōya rock, it collapsed in the 1923 earthquake.

The Yamamura House is built of concrete and ōya lava-stone. The choice by Wright of this vermiculated stone coincided with his use of it at the Imperial Hotel and the ōya stone for this building was delivered to the site before he left Japan. The blue-grey stone is used both externally and internally and contrasts well with the dark woodwork and pale walls. Surprisingly, the ōya stone is used for the entrance lobby floor and for the stairs up to the second floor and thus obviates the need to remove shoes on entering. The *tatami*-floored Japanese reception rooms are secluded behind their *shōji* and are therefore all the more

distinct. These rooms are conceived in the late-Edō *Shoin* style, complete with *tokonoma*, *arikabe* and ornamental copper *ranma*. Japanese features, such as the *chigai-dana*, are incorporated in the salon where the inward-stepping cornice opens as a series of small windows which, in the same way as the *ramma*, provide cross-ventilation for the room [9.08]. As at both the Myōnichi-kan and the Imperial Hotel, Wright folds the ceiling planes of the corridors and the penthouse dining room as if it were *oriage* ceilings, thus suggesting the heaviness of the Japanese roof. Dark strips of hardwood, like the edging of a *tatami* mat, define and frame doorways, walls and ceiling panels throughout the building, introducing a fragility which contrasts with the implied solidity of the folded ceiling planes.[50] Stylised plant forms, also in hardwood, line the walls and ceiling of the dining room while externally, other botanical shapes, now in ōya stone, crowd the canopy and make clear reference, in both their form and their position against the mass of the roof, to the eponymous Hollyhock House.

This Hollyhock House [9.09], in its form and texture, is as Japanese as Wright's work ever became, yet, at the same time, it is at one with the houses he was soon building in the Hollywood Hills. Aline Barnsdall did not purchase the site for

9.09 The Aline Barnsdall or 'Hollyhock' House in Los Angeles, California, designed by Frank Lloyd Wright, 1921.

9.10 The master bedroom at the Aline Barnsdall or 'Hollyhock' House in Los Angeles, California, designed by Frank Lloyd Wright, 1921.

the Hollyhock House on Olive Hill in Hollywood until 1919,[51] although Wright had already produced designs for a theatre/residence complex, such as Barnsdall envisaged, on a non-specific site.[52] Work on the foundations for the first buildings began that autumn[53] but the design of the house was not finalized until 1920[54] and by that time the design for the Yamamura House, initiated in 1918, would have been well progressed, if not complete. 'Mr Wright believes that a California house should be half house and half garden', Barnsdall told the *Los Angeles Examiner*, saying also that Wright would create a new style for the area.[55] Wright, on his part, said that it would be 'native to the region of California as the house in the Middle West had been native to the Middle West'.[56] This was to be Wright's first house in California and, being conceived while he was working in Japan, could hardly escape that

culture's influence. It is hard when looking at the plan, therefore, not to recognise the similarities to the Imperial Hotel and the Myōnichi-kan, and thus to the Hōō-den and the Hōō-dō. Although the entrance is placed to one side, the building is set up around an axis intending to connect it to the theatre at the bottom of the hill to the east. As at the hotel, two side wings, turned in at the end (and supporting a bridge above), flank a central garden court which is closed off at the west end by the main body of the building. Here, beyond the glazed loggia – where at the hotel the auditorium and two private dining rooms were positioned – is the living room set between the music room and the library.

On the south side of the building the bedrooms overlooked a patio which was flanked by a conservatory to the west and, to the east, a nursery for Barnsdall's daughter whom she nicknamed

Sugar Top.[57] Here, where the land fell away, the nursery reached out a finger much as the Yamamura House did along its ridge in Ashiya. The similarities between the nursery and its roof-top terrace, and the penthouse dining room and terrace at Ashiya cannot be ignored: nor that of the west elevation of the living room, with its massive roof and hollyhock frieze. Within that larger roof, Wright again folds the ceiling plane and steps in the cornice, outlining the forms with thin strips of hardwood. Elsewhere, built-in furniture recalls the *tokonoma* and the *chigai-dana* [9.10]. Although built of timber-frame, hollow tile and stucco construction, the simple sculptural massing of the Hollyhock House gives every indication that it was conceived, like the Yamamura House, as a poured concrete structure.[58] Why it was not built as such is a matter for speculation but it could be argued that, whereas in Japan the traditional skill of the carpenters was quite adequate for the task of making the shuttering, that of the timber-frame house builders in California was not.

Rudolph Schindler

Rudolph Schindler had joined Wright's office in Chicago in 1917 and in 1920 moved out to California to look after the Hollyhock House project. Part of this was the Director's House and another house called Oleanders, now known as Residences A and B, which were built on the side of Olive Hill. Flat-roofed and planar in form, like Wright's 'Fireproof House for $5,000' (1906), neither house showed much evidence of Schindler's input and were completed by July 1921.[59] In the same year Schindler started a very different building and perhaps the most innovative and most Japanese of all the early Modern buildings in the West – the Schindler/Chace House on Kings Road, West Hollywood. Built as a collaboration between Schindler, his wife Pauline, and the engineer Clyde Chace and his wife Marian, the house was a demonstration of both innovative construction and alternative lifestyle. The two couples shared the Z-shaped plan, each taking one wing and the adjacent outdoor space, with

the kitchen and guest room sharing the common ground between.

Schindler had first come to the United States from his native Vienna in 1914, bringing with him a central European's appreciation of a warm climate. Consequently, the house was designed to accommodate both indoor and outdoor living: each patio had a fireplace as if it were a living room and the 'bedrooms' were board-and-canvas shelters on the roof. Glass and canvas screens – they should be called *shōji* – withdrew to open up the interior spaces to the patios while within the house other partitions, or *fusuma*, could be slid back and forth to reconfigure the space [9.11]. The resultant building was flexible, informal and on plan, immediately reminiscent of traditional Japanese houses – only that the dimensions did not accommodate the *tatami* mat, the floors remaining resolutely concrete.

Pueblo Ribera Court (1925) in La Jolla, California, which commenced a year after the Schindler/Chace House, developed the concept of indoor/outdoor living further. In 1923, Schindler wrote: 'I propose to treat the whole in true California style – the middle of the house being the garden, the rooms opening wide to it, the floors of concrete, close to the ground. The roof is to be used as a porch, either for living or sleeping.'[60] The complex comprised 12 interlocking apartments; whereas at the Schindler/Chace House, tilt-up concrete slabs had formed the solid walls, here slip-form concrete walls separated the units and tall hedges enclosed the patios. In a curious way, Edward Morse's observations on the Japanese house, written 35 years earlier, could have been about Pueblo Ribera Court:

> The house stands on a new street, and the lot on one side is vacant; nevertheless, the house is surrounded on all sides by a high board-fence, – since, with the open character of a Japanese house, privacy, if desired, can be secured only by high fences or thick hedges … There is no display of an architectural front; indeed, there is no display anywhere. The largest and best rooms are in the back of the house … Here all the rooms open directly on the garden.[61]

9.11 The Schindler/Chace House in Los Angeles, California, designed by Rudolph Schindler, 1922.

The concrete walls were left exposed and the floors, doors, window frames, internal partitions and the roof terraces were all made of untreated redwood, further recalling Morse's observations: 'The absence of all paint, varnish, oil, of filling, which too often defaces our rooms at home, is at once remarked … the wood is left in just the condition in which it leaves the cabinet-maker's plane, with a simple surface, smooth but not polished …'[62]

In summarising his intentions in an article in the *Los Angeles Times* published the year after Pueblo Ribera Court was finished, Schindler presents his vision of the house of the future:

> Our homes will descend close to the ground and the garden will become an integral part of the house. The distinction between the indoors and out-of-doors will disappear. The walls will be few, thin and removable. All rooms will become

part of an organic unit instead of being small, separate boxes with peepholes.[63]

Yet other concerns, such as the Viennese *raumplan* concept of space, diverted him and his houses were never again to be so raw, so direct and so Japanese.

Endō Arata

While in California, Schindler followed his own trajectory with buildings like the Lovell House (1926) at Newport Beach and the Wolfe House (1929) on Santa Catalina Island, Wright's Japanese disciple, Endō Arata, appears to have assumed the mantle of the master. The Kōshien Hotel (1930) in Nichinomiya offers a remarkable interpretation of Wright's architecture, 'a blended refinement of

two continents', as the hotel's brochure said, '... a gem of architectural beauty' [9.12].[64] Arranged as a double cross[65] on plan, the hotel adopts the spine corridor of the Imperial Hotel in Tokyo, but not, it would appear, its cantilevered structural system: the concrete beams span from one external wall to the spine corridor and then across to the other external wall, while in the ballroom, where the space is interrupted by two large columns, deep beams span in both directions. Nevertheless, the hotel's brochure advertised it as being both fire- and earthquake-proof.

The hotel was promoted by Endō's friend, Hayashi Aisaku, the former manager of the Imperial Hotel, and there is much in its design which Endō drew from what he had learnt from Wright and the Imperial Hotel. The composition of the elevation, long and low, and broken by two thin vertical towers with a stack of roof planes above the crossings to

either side, comes from Midway Gardens (1914). There too, as elsewhere, can be found similar terracotta panels but the Roman bricks with the raked horizontal joints and flush perpends come from an earlier source, the Robie House (1906), perhaps, or the Oak Park houses. From the Imperial Hotel can be traced the corbelled stonework along the garden front, the rich decoration of the ballroom's frieze and the folded ceiling in the dining room. With 70 rooms (both Western and, on the top floor, Japanese) and accommodating 150 guests, the hotel was dubbed the Kōshien Hotel of the West in deference to the Imperial Hotel of the East.

In July 1930, Wright sent Endō a congratulatory letter in which he also complements Hayashi on his efforts:

A Little-Imperial has been born in Japan ... Hayashi San at last comes into his own. I am

9.12 The Kōshien Kaikan (hotel) in Nishinomiya, designed by Endō Arata, 1930.

glad. We must all admire his pluck and wish him financial and every other kind of success. You have courage and great promise, Endo San. The amount of hard work you have put into the building no one can realize so well as I can ... nor appreciate more, the charming ideas of which there are so many, nor realize so fully where your precedent led you astray.

Your building ends on the side of *exaggeration*. The Imperial was headed that way – in some respects.

But perhaps a little put out at not having had the job himself, Wright assumes the role of the master:

I could wish you had put the plans under your arm and come over for a conference. I think I could have saved you so much by a few suggestions ...

You and I might, together, do some fine things yet. If I were working with you again I could show you the tendencies to emphasize and those to avoid ... in future. I've grown some myself. You are able to do great things, all you need is 'pruning' and a little 'more sand and soil.'

I think my hand is the hand to do the pruning ... I who fed the branches too luxuriantly, perhaps. At any rate – my affection and loyalty all go over to you in best hope for the future.[66]

Greene and Greene

The California Midwinter International Exposition had been held in San Francisco's Golden Gate Park between 28 February and 9 July 1894.

In the late summer of 1893, Charles Sumner Greene and his younger brother, Henry Mather Greene, two boys from St Louis, Missouri, who were now working in Boston, made the long trip across country to Pasadena, California, where their parents had recently settled. In Boston they had studied for a Certificate in Partial Course in Architecture at the Massachusetts Institute of Technology and gone on to work in offices run by architects who themselves had worked for Henry Hobson Richardson and his successor firm, Shepley, Rutan and Coolidge, as well as for McKim, Mead and White. With such opportunities it seems that they were reluctant to leave Boston, but they eventually acceded to their parents' request to join them.[67] It was a fortuitous move.

The train journey west took them to Chicago where, amongst the crowds visiting the World's Columbian Exposition, they saw the Hōō-den. Being unlike anything they had known in Boston, it intrigued them and the following year they travelled from Pasadena up to San Francisco to see the Japanese Tea Garden at the California Midwinter International Exposition. In their early years of practice their architecture showed no evidence of any Japanese influence until, in 1903, they built the house known as El Hogar (the hearth), for Arturo Bandini. Here, their architecture changed from Tudor or Colonial styles to something more immediate and suited to the dry chaparral-country of Pasadena. This single-storey house was set around three sides of a large courtyard with a pergola gateway across the fourth side. River stones from the Arroyo were used for the chimneys but the walls were all timber. Manufactured flat on site, and hoisted into position, each wall section was finished both externally and internally with vertical redwood boarding, the joints covered by a batten which suggested, if not replicated, the Japanese *enkō* joint. Similarly, the manner in which the posts of the verandah were set on boulders from the Arroyo could be seen as Japanese, but it could also be seen as traditional adobe construction.

This move, on Greene and Greene's part, to a much more informal and craft-based architecture was probably brought about in 1901 by two influential periodicals, *The Craftsman* and *The Ladies' Home Journal*. The first, established by Gustav Stickley, set out to promote the teachings and philosophy of William Morris and thereby Stickley's own furniture, which the Greenes readily

specified the next year for the James Cuthbertson House in Pasadena. The other, published by the campaigning Edward Bok of the Curtis Publishing Company in Philadelphia, sought, in a different way, to raise the standard of American house design. Eight articles on 'The Bradley House' by the illustrator Will H. Bradley[68] appeared between November 1901 and August 1902[69] and these were cut out and kept by the Greenes.[70] *The Ladies' Home Journal* also commissioned and sold complete sets of working drawings for new houses at $5 each. One of these was Frank Lloyd Wright's 'A Home in a Prairie Town'.[71] There were few requirements of these designs other than the servants' bedrooms be increased in floor area and supplied with cross-ventilation, and that the term 'living room' should be used instead of 'parlour'.[72] Greene and Greene, it seems, heeded this advice: their earliest houses from 1894 all had 'parlours', but after 1899 they never used the appellation, except occasionally to describe a room additional to the living room.[73]

By 1904, their 'style', if it was that, was developing with their confidence. The U-shaped plan of the Bandini House was revived for the Charles Hollister House in Hollywood and once again the wooden posts of the verandah were set on stone pads; the board-and-batten 'enkō' construction was repeated at the Edgar Camp House in Sierra Madre; and when asked by Lucretia Garfield, the widow of the murdered United States President, why the roof timbers on the house they were building for her in Pasadena should project so, Charles replied that this was 'because they cast such beautiful shadows on the sides of the house in this bright atmosphere'.[74] It seems likely then that Charles's visit that year to the Louisiana Purchase Exposition in St Louis served only to confirm his intentions. Set amid the wedding-cake Classicism of that exposition, the Japanese pavilions, bridges and gardens stood out for their delicacy and difference. Adelaide Tichenor, a formidable Long Beach resident and already a client, who certainly knew what she wanted, had instigated his visit. 'We arrived here only yesterday,' she wrote, 'but the more I see of it, the more I feel that I do not want to go on with my home until you see this ... I think

you will never regret it if you arrange your affairs to come at once ... you will be able to get so many ideas of *woods* and other things for finishing what you now have on.'[75] Charles Greene responded to her summons but the resulting delays to her house, probably due to changes to the design, caused Mrs Tichenor to write again in September 1905:

> Can you leave your Pasadena customers long enough that I may hope to have my house during my lifetime? Do you wish me to make a will telling who is to have the house if it is finished?[76]

When eventually finished, the Tichenor House, set on a high bluff overlooking the Pacific Ocean and arranged once again as a U-shaped plan, clearly displayed its oriental leanings in its green roof tiles and elaborate joinery while, in the garden, set on axis with the terrace, living room and entrance, was a *taiko-bashi*. However, as the New York architect Aymar Embury II observed in 1909, the Tichenor House represented 'the utmost limits to which Japanese architecture could be stretched, and still meet American requirements'.[77]

If the *taiko-bashi* at the Tichenor house was the first certifiably Japanese element in a Greene and Greene house, others quickly followed. The Cuthbertson House, which had been built in 1902 in a fairly safe Tudor style, was remodelled in 1906 and carved relief panels, suggestive of Hokusai's *Thirty-Six Views of Mount Fuji* and other Japanese wood-block prints, were added above the dining-room fireplace and to the frieze in the entrance hall. At the same time the rather incoherent plan of the Katherine Duncan House (1900) was reworked and a second storey added for Theodore Irwin [9.13]. The result, arranged around the small central court, began to take on, albeit on two levels, the informal, almost ad hoc, qualities of larger Japanese houses of the late-Edo and Meiji periods, each room linking through to the next in a staggered series of progressions. So apparent were the references that, in an article called 'The Train of Japanese Influence in Our Modern American Architecture', published in *The Craftsman* in 1907, Henrietta Keith could write:

The chimneys are strongly suggestive of Japanese influence, as are also the treatment of the windows and the open rafter work. Great simplicity characterizes the construction, which is all exposed and made to form the decorative features. The timbers are mortised together with oak pins, and nails are used scarcely at all in the construction. While groups of mullioned windows are largely employed, Japanese suggestion is again felt in the narrow slits of windows which open on the side terrace, with but one long, narrow light, dividing the centre by a single wood muntin.[78]

Part of the attraction, at least for Henrietta Keith, was the picturesque appearance which perhaps accounts for the 'Japanese' chimneys, there being, of course, no precedent in Japanese building for such a feature. 'The highly picturesque character of the natural surroundings,' she wrote, 'the houses being situated on high ground overlooking the wild gorge of the Arroyo Seco – is admirably suited to a certain irregularity and picturesqueness of architectural treatment, and the introduction of Japanese suggestion accentuates the charm.'[79] There was, however, no suggestion of archaeological correctness: that was not the purpose. 'Without employing the queer quirks and angles of Japanese roof lines, their graceful curves, so difficult to achieve, are sufficiently marked to render impossible an effect ordinary or commonplace. While there is a decidedly Japanese feeling, nothing has been carried to extremes, and the slightly foreign accent has been so modified by principles of good domestic design as to give a wholly normal and satisfying result.'[80]

In February 1901, the *Ladies' Home Journal* had published Wright's design for 'A Home in a Prairie Town'[81] which, like the Prairie-style houses Wright was then building back east, adopted the T-plan of the Hōō-den at Chicago.[82] Despite the difference in its craftsmanship, the extent to which this design (and possibly even the Hickox House in Kankakee, Illinois) influenced the house that Greene and Greene built for David Berry Gamble in Pasadena in 1908 cannot be ignored [9.14].[83] The focus of the plan is the living-room fireplace which, as in Wright's Prairie Town house, is placed at the junction of the T, on axis with

the main living-room window, but now recessed into an inglenook.[84] To one side, the entrance hall and stairs separate the living room from the dining room, kitchen and guest bedroom. This is the same *parti*, separating family from servants, as Wright uses at the Prairie Town house and one not uncommon in nineteenth-century house design. In neither building is the plan-form of the living room apparent in the exterior massing but rather is subsumed by layers of overhanging roof and additionally, at the Gamble House, by balconies and external sleeping decks. The result was picturesque but uninformative.

After visiting Wright in Illinois in 1909, Charles Robert Ashbee had travelled on to California where, in Pasadena, he paid a call on Charles and Henry Greene and, in Charles's new car, drove around looking at his buildings. 'Like Lloyd Wright,' Ashbee wrote in his journal, 'the spell of Japan is upon him, like Lloyd Wright he feels the beauty and makes magic out of the horizontal line, but there is in his work more tenderness, more subtlety, more self-effacement … It is more refined and has more repose. Perhaps it is California that speaks rather than Illinois …'[85]

The tenderness, subtlety and self-effacement which Ashbee observed is apparent in the materials and craftsmanship of Greene and Greene's houses. This led many, like Embury, to comment on their Japanese appearance: 'They are very consciously adaptations from Japanese sources,' he wrote, 'and so eloquent of Japan that one is tempted to believe that Greene and Greene must have studied the architecture on its native soil.'[86] Although the Greenes' interest with Japan is not to be doubted – Charles was a member of the Japan Society in London[87] – their buildings are interpretive and the forms generic, belonging to the American nineteenth-century Stick Style tradition. The broad overhanging eaves are taken to be Japanese but, to the Japanese, could well have appeared European. As noted in Chapter 2, Kume Kunitake's record of the Iwakura Embassy's progression through the Swiss Alps in 1873 records buildings similar to the Gamble House. At Sarnen he wrote: '… the houses are attractive, but most are built of wood. They are built in an unusual style and closely resemble Japanese houses in structure. They are two-storeyed, with the upper storey projecting somewhat, and have eaves and

(*left*) 9.13 The Theodore M. Irwin House in Pasadena, California, designed by Charles Sumner Greene and Henry Mather Greene, 1906.

beams.'[88] Although the principle of using wooden pegs by the Greenes is omnipresent, the joinery assembly which is so evident in the houses makes only occasional reference to Japanese building techniques, such as in the scarf joint (the *shamisen-tsugi*), which Morse compared to the work of American carpenters,[89] or the vertical board and batten joint (the *enkō-tsugi*). The Greenes would sometimes wrap the exposed ends of their beam with copper sheeting to protect them from rain, in the Japanese manner, but their much-fêted use of iron straps and wedges to secure the beams together was unknown in traditional Japanese architecture.

Bernard Maybeck

Unlike the Greene brothers, whose professional training was brief, Bernard Maybeck studied in the *atelier* of Louis-Jules André at the École des Beaux-Arts in Paris from 1882 to 1886. And unlike the Greenes, there was a theoretical rather than a craft base to his architecture. Maybeck's knowledge of French, from his time in Paris, and of German, his parents both being German emigrants, opened up for him the writings of Eugène-Emmanuel Viollet-le-Duc and Gottfried Semper. Viollet-le-Duc's ideas of structural determinism found easy expression in the timber-frame architecture of California, but it was Semper's notion of the primitive hut which had the more immediate resonance with Japanese architecture.

Viollet-le-Duc's *Entretiens sur l'architecture* (1858–72) had been translated as *Discourses on Architecture* by the American architect Henry van Brunt in 1874 so Maybeck might well have read it before going to study in Paris. Antithetical to academic architecture, the book promoted Viollet-le-Duc's notion that structure should be honestly and rationally expressed, something which, in Paris, Henri Labrouste had done in his celebrated Bibliothèque St Geneviève (1843–50) and which his *atelier* pupil André was currently doing in his Museum of Natural History (1872–85). Thus Maybeck found himself suddenly deep within this tradition while, on the other hand, being taught the academic Beaux-Arts line. Maybeck would also

have known Viollet-le-Duc's *Histoire de l'habitation humaine, depuis les temps préhistoriques jusqu'à nos jours* (1875), translated by the English architect Benjamin Bucknall as *The Habitations of Man in All Ages* (1876).[90] Although Japanese architecture was not included in this book, the illustrations of Chinese architecture showed large roof forms with elaborate eaves in the Zen manner and expressive, bamboo-frame construction.

On returning from Paris, Maybeck worked in New York for his friend from André's *atelier* and the Académie des Beaux-Arts, Thomas Hastings of Carrère and Hastings, before moving to Kansas City and then, in 1890, on to California. Here he eventually found work with Arthur Page Brown and was involved with the design for the California State Pavilion at the World's Columbian Exposition, travelling to Chicago to supervise its erection, where Shimoda Kikutarō was Construction Site Deputy Manager. Positioned at the north end of the site, the rather Hispanic California pavilion was only a few minutes' walk from the Hōō-den which suggested a very different form of architecture.

Soon after arriving in California, Maybeck started to translate Semper's *Der Stil in den technischen und tektonischen Künsten; oder, Praktische Aesthetic: Ein Handbuch für Techniker, Kuunstler und Kunstfreunde* (1860–63)[91] for the *Architectural News*, a short-lived monthly journal produced in San Francisco by his friend and colleague from Brown's office, Willis Polk.[92] In this book Semper developed an idea which he had first published as *Die vier Elemente der Baukunst* (1850), that the house comprised four basic elements each directly related to craftwork: the hearth with ceramics, the mounding of the earth with masonry, the roof with carpentry and the walling with textiles. In *Der Stil*, these four elements were described as 'The Primitive Hut' and illustrated with drawings of a model of a Caribbean hut which he had seen displayed at the Crystal Palace in Hyde Park in 1851. 'It shows all the elements of antique architecture,' Semper wrote, 'in their pure and most original form: the *hearth* as the centre-point, raised earth as a *terrace* surrounded by posts, the column-supported *roof*, and the mat enclosure as the *spatial termination* or *wall*.'[93] If the hearth was replaced by

(*left*) 9.14 The David B. Gamble House in Pasadena, California, designed by Charles Sumner Greene and Henry Mather Greene, 1908.

9.15 A five-room Wilson bungalow designed by Ernest Allan Batchelder, from *The Bungalow Magazine*, 2 April 1910.

the *tokonoma*, the focal point of the Japanese house, then this description could apply equally well to the traditional Japanese house. In the same chapter on 'Tectonics', Semper illustrates a Bavarian-Tirolean house where 'the roof purlins and rafters project twice as much as the floor beams and are supported by tie beams and braces (angle bands) thrust beneath them ... Similar timber construction,' he adds, 'can be found in Switzerland ...'[94] – just as Kume Kunitake was to observe a decade later.[95] Semper also described how the windows were protected on the outside by sliding shutters which could move either horizontally or vertically.[96] If not exactly *shōji* or *yarido*, they were, at least, not hinged panels.

Maybeck established his own practice in San Francisco in 1894 and perhaps the most primitive hut which he built in the early years was the Grove Clubhouse at Russian River, for the Bohemian Club of San Francisco (1903). Set high within the redwoods, the un-barked rafters of its broadly pitched roof were supported, beneath the eaves, on struts which projected like splayed fingers from long, structural posts made from tree trunks, while on the ridge, billets (*katsuogi*) protruded as at the shrines at Ise. Equally Japanese, and possibly primitive, was some of the detailing on the second J.B. Tufts House, built in San Rafael in 1908. Here, fragile strips of timber roof the verandah at the rear of the house and a chain drains the rainwater from the overhanging roof.

Maybeck's reading of the ideas of Semper and Viollet-le-Duc best came together in the reception hall which he built in 1909 for Phoebe Apperson Hearst[97] to assist the promotion of her international competition for the architectural plan of the University of California at Berkeley.[98] Conceived both as a primitive hut with posts, mats, terrace and hearth clearly expressed, and as a demonstration of structural determinism, it was first erected on a site next to Hearst's own house in Berkeley. Over 16 metres to the ridge, its laminated timber arches provided a framework for a curtain wall clad, both externally and internally, with layers of redwood shingles 900 millimetres deep. The main volume was raised 3.6 metres above the ground floor, resting on a framework of hefty cross-beams supported on diagonal struts. Gobelin tapestries hung between the arches to provide a focal point, and a large canopy of Genoese rose velvet hung above the middle of the hall. Although arranged typologically like a medieval cathedral, its layered cladding, slatted windows, overhanging eaves and stepped roof profile gave it a recognisably Japanese appearance. Its narrative, if not its ultimate use, was equally Japanese, for in 1901, Hearst Hall was dismantled, relocated and reassembled as a women students' gymnasium, before being destroyed by fire in 1922.

Inference as opposed to exactitude best describes Maybeck's responses to Japanese architecture. His scrapbooks[99] contain nine pages of hand-tinted photographs of celebrated Japanese sites such as Nikkō, Mount Fuji and the Katori Shrine, but it is in his best known building, The

9.16 The First Church of Christ, Scientist,
in Berkeley, California, designed by Bernard
Maybeck, 1912.

First Church of Christ, Scientist, in Berkeley, where he is at his most Japanese.

The First Church of Christ, Scientist, was commissioned in September 1909, but work did not start on site until August of the following year. Meanwhile, in April 1910, a Los Angeles monthly called *The Bungalow Magazine* published a drawing by Ernest Allan Batchelder[100] of a five-room Wilson bungalow[101] set on a corner site in some suburban context [9.15].[102] Comprising a single-storey building with a cruciform-plan beneath broad, timbered eaves and linked by an overgrown pergola, through which the pedestrian entrance passed to a roofed corner garage, its Japanese references were clear.[103] The buildings and the landscape worked together as an integrated whole and there was even a Japanese stone lantern positioned in rock-pool within the turning circle of the driveway. 'As to harmony of design,' the article said, 'there is no irrelevancy in the introduction of Japanese details in connection with the later types of Wilson bungalows which bear some of the same appreciation of the decorative value of unconcealed construction that gives such a restful effect to the architecture of Japan.'[104] Few of Maybeck's drawings are dated so it is uncertain when he drew in pastels the aerial sketch which showed his design ideas for the new First Church of Christ, Scientist[105] [Plate 16], yet the similarities of both representation and content between this sketch and the aerial view of the Wilson bungalow published in *The Bungalow Magazine* are striking. Not only is the

viewpoint the same, but the cruciform roof plan, the overgrown pergola, the pedestrian entrance and the linked corner building are all replicated, together with the filigree structure of the arbour, now a traceried window in the Sunday School building, and the stone lantern and circular rock-pool, now a single tree. That Batchelder's drawing was the source for Maybeck's pastel sketch cannot be doubted, especially when the context of the new church is taken into account.[106]

In 1909, five women from the First Church of Christ, Scientist, had come to Maybeck's office and asked him to build a church. It was, they said, to look like a church and to be built of materials which were honest and not imitations.[107] Furthermore, like Batchelder's five-room bungalow, it was to be on a corner site and in an established residential area of Berkeley, so the scale and massing needed to be domestic. The resulting building was, as Maybeck promised them, 'the same on the inside as the outside, and without sham or hypocrisy'.[108] What they got was a cast-concrete and redwood-framed building clad in Transite asbestos-cement panels, roofed in sheet metal (tin) and illuminated by industrial sash windows manufactured by Fenestra who, initially, did not want to supply them, thinking such windows inappropriate [9.16]. Despite its use of industrial materials, the building's inspiration is clearly oriental, its overlapping roofs rising in a shallow pyramid, not unlike the house of the 'Fat Fau' illustrated by Viollet-le-Duc in his *L'Histoire de habitation humaine*.[109] Beneath the eaves, the grey

asbestos-cement panels, fixed at the corners with small diamonds of red asbestos-cement, read clearly as thin sheets while the slender proportioning of the glazing in the industrial sash windows appear as *shōji*,[110] a reference which was reinforced in the sliding doors which could open up the building to accommodate the crowds. The rectangular, fluted concrete columns of the pergola, cast with Romanesque capitols, support hefty redwood beams and cross-beams which, especially in the entrance portico, immediately recall Japanese temple architecture. Internally, four great concrete columns carry deep trusses which, set on the diagonal, reach across the central space, their timber corbel brackets projecting like those in the roofs of Buddhist temples. Completed in 1912, the building was, in its way, both Semper's primitive hut and Viollet-le-Duc's *l'habitation humaine*, an industrial temple for Mary Baker Eddy's Christian Scientists.[111] But Maybeck was not alone in his appreciation of these two theorists.

The plan of the First Church of Christ, Scientist, invites comparisons with that of another concrete church, the slightly earlier Unity Temple, built by Frank Lloyd Wright in Oak Park, Illinois (1906).[112] Completed just three or four years before Maybeck began developing his design for the First Church of Christ, Scientist, it is wholly possible that he would have been familiar with it. The plan of Unity Temple was published in March 1908 in the special edition of *Architectural Record*, titled 'In the Cause of Architecture', an illustrated summary of Wright's own work;[113] it was published again the following month by *The Architectural Review* (from Boston) in Thomas Tallmadge's article which coined the phrase 'The Chicago School';[114] and it also was included in the 1910 Wasmuth edition of *Ausgeführte Bauten und Entwürfe* which, although published in German, would have presented Maybeck with no problems.

At first glance, the similarities between the First Church of Christ, Scientist, and Unity Temple might appear to revolve around the cruciform plans of the two churches where four concrete columns define the central worship space within each. But there is more to it than that. Both buildings are part of an H-shaped complex, the loggia and Sunday School of the one, and the meeting hall of the other being linked to the main building by an entrance lobby or narthex. It cannot be doubted that Wright based Unity Temple's plan on the H-shaped *gongen*-style plan of the Taiyūin-byō at Nikkō,[115] which he had seen a few months earlier in 1905;[116] that Maybeck, in turn, based his plan on Wright's Unity Temple seems highly probable. Within each church both, first Wright and then Maybeck, retained an ambulatory around the four central columns as at the Taiyūin-byō. Although the distinction between the three elements comprising the H-shaped plan at the Christian Scientists' building is not as clear as it is at the Unitarians' building, it nevertheless exists. But unlike in Wright's arrangement, where the entrance is from the side, directly into the linking narthex, Maybeck, in a pure Beaux-Arts gesture, ran his entrance straight along the central axis, between the loggia and the Sunday School, in a manner which also reflects the linear processional route at the Taiyūin-byō at Nikkō.

Wright's involvements with Japan have been well recorded, both by himself and by later scholars. Maybeck's flirtations with Japan, if flirtations they were, have been far less so. It is known, as already stated, that Maybeck worked with Shimoda Kikutarō when in Arthur Page Brown's office and there is ample evidence in his scrapbooks of his interest in the Orient as a whole. There also are many Japanese touches in his work, such as the wooden brackets beneath the eaves of the Senger House (1907) in Berkeley or the raised grain of the fire-blackened timbers of the nearby Wallen Maybeck House (1933), which he achieved with a wire brush after Wallen's mother had accidentally set fire to it.[117] Even at the Packard showrooms (1928) in Los Angeles, the vast columns, hefty roof beams and exaggerated brackets which support them speak of Japanese temples. But Maybeck was too eclectic to be pinned down. He was also never to meet Wright. In an interview given in 1980, Maybeck's daughter-in-law, Jacomena, recalls how, in 1949, Wright was visiting Berkeley and expressed a desire to meet Maybeck. Both were now old men, well into their 80s, but even so Maybeck hesitated. Eventually he went to the house where Wright was but, seeing him addressing a crowd of guests, decided that it was not for him, and left.[118] They were very different men.

10 THE SHAKEN REED

Until the last decade of the nineteenth century, Japan's influence upon the West was largely a long-distance affair. Either Japanese artefacts or exhibits were sent to the West as a display of the country's craft work and even of its architecture, or brought back as souvenirs or collectibles by travellers, diplomats or the *o-yatoi gaikokujin* who had been invited out to Japan to work there. Few were those who went to Japan, such as Christopher Dresser had done, to search out what the country might offer Western culture, and fewer still were architects. Although Josiah Conder did go there in 1877, he barely returned, and Frank Lloyd Wright did not go there until 1905. The story now turns to those Western architects who recognised in Japan something more than the decorative appeal of Japonisme and who, by visiting the country, gained an understanding of what they saw. For some, this allowed new lines of development but for others, it was taken as a justification of a path already chosen.

Glasgow

It was to Glasgow in 1866 that, after two years of studying at University College London, Yamao Yōzō, one of the Chōshū Five, came to work at the Robert Napier and Sons shipyards at Govan and to take classes at Anderson College. Later, as Vice-Minister of Public Works in the Meiji government, Yamao was instrumental in setting up the Imperial College of Engineering and it was his contemporary at Anderson College, Henry Dyer, who, in 1873, travelled to Tokyo to be the college's first Principal and Professor of Engineering.[1] When the appointment was made, Dyer was still studying at the University of Glasgow for his 'certificate in proficiency in engineering' under William Rankine and Sir William Thomson, later Lord Kelvin, and a special dispensation had to be given to allow him to graduate early.[2] Joining him from Glasgow, where they had also worked with Kelvin, came, later in 1873, the physicist William Ayrton and, in 1875, the engineer and mathematician John Perry.[3] When, after 1879, graduates from the Imperial College of Engineering became eligible to study abroad, a great number of them went to Glasgow,[4] so magnetic was Kelvin's reputation and great his influence.[5] But it was not just as a seat of learning that Glasgow impressed the new Meiji government. The steam locomotive factories at Springburn and Palmadie and the ship-building industries along the Clyde provided both the hardware and the inspiration which the newly emergent country needed. From the mid-1880s, trams were built there for the Japanese National Railways; in 1873 the steamship *Meiji-maru* (the *Meiji*), intended for inspecting Japanese lighthouses,[6] was built at Napier's yard at Govan,[7] and in 1890, the warship *Chiyoda* was built by J. & G. Thompson at Clydebank.[8] In 1889 Albert Richard Brown, who had been the first captain of

the *Meiji-maru*[9] and later worked as Marine Advisor for Yamao Yōzō, was appointed Honorary Japanese Consul in Glasgow:[10] for until 1914, there were, with the exception of London, more Japanese living in Glasgow than any other city in Britain.[11]

Glasgow also had its cultural connections to Japan. Robert Henry Smith, a University of Edinburgh graduate and the first Professor of Civil and Mechanical Engineering at the newly established (in 1877) Imperial University, wanted to show his students the range of products manufactured in a modern industrial city so he arranged for Glasgow to send Tokyo, among other specimens, examples of pottery, sewing cotton, Scotch wools, linen thread, tapestry weaving, sugar refining and Lucifer matches, as well as pig iron, fire-clay bricks, varnishes and white lead, asbestos, gas tar and potash.[12] In return, the Japanese government made a gift of art-wares and craftwork to the City of Glasgow and, in December 1878, 31 packing cases arrived, containing 1,150 items, their passage from Japan facilitated by Christopher Dresser. In contrast to the potash and Lucifer matches, these comprised examples of wood and lacquer work, musical instruments, ceramics, metal-ware, textiles and costumes, and paperwork. In the absence of a city museum, part of the collection was placed in the Corporation (or McLellan) Galleries in Sauchiehall Street, which at that time housed the Glasgow School of Art, and the rest in the City Industrial Museum in Kelvingrove Park.[13] In 1882, the *Glasgow City Museum Annual Report* noted that students from the art school 'used the collection for the purpose of continuous study'.[14]

It was also at the Corporation Galleries that there opened, in December 1881, the Oriental Art Loan Exhibition, showing pieces – mainly pottery and porcelain, lacquer work, Japanese bronzes and metalwork, enamels, objects in wood and stone, ivories, textiles, wall pictures and screens – gathered from private collections as well as from the South Kensington Museum and Messrs Liberty & Co. of London.[15] On the organising committee was one of the Governors of the Glasgow School of Art, the Glasgow architect William Leiper who, in 1872, had built Cairndhu, at Helensburgh, with its rich

Anglo-Japanese interiors, for the flour merchant John Ure who was now Lord Provost of Glasgow.[16] In March 1882, Dresser himself returned to the city of his birth to lecture on 'Japanese Art Workmanship', and he used examples from the exhibition as illustrations.[17] By the time the exhibition closed at the end of April, some 30,000 people had seen it. The willingness of the Corporation to invest in Japonisme was further demonstrated in 1891 when the first painting they purchased was James McNeill Whistler's portrait of Thomas Carlyle, *Arrangement in Grey and Black (No.2)*. Bailie Robert Crawford,[18] the Chairman of the Glasgow Corporation's Art Galleries Committee, opened the exhibition and wrote to Whistler the next day: 'I am happy to tell you that the universal Expression was one of great delight and Satisfaction and I was congratulated on all hands on the felicity of our first municipal adventure in the purchase of pictures.'[19]

The Glasgow Boys

Coincident with this, a group of young painters, tired of the conventional, narrative art of the Royal Scottish Academy, began to show the influence of Japanese art in their work. Self-styled as the Glasgow Boys – as much as anything to distance themselves from the Academicians of Edinburgh – their bright, decorative paintings drew upon, among other sources, the Japanese print and Whistler, while their periodical, *The Scottish Art Review*, contained articles on *kakemono* and *tsuba*.[20] With the financial support of the Glasgow gallery owner and art dealer Alexander Reid, whose portrait Vincent Van Gogh had twice painted in 1887, and the Glasgow ship-owner and art collector William Burrell, two of their number, Edward Atkinson Hornel and George Henry, sailed from Liverpool to Japan via Suez, in February 1893, arriving at Nagasaki four weeks later. They were not the first painters from Glasgow to do this, for Alfred East, who had also studied at the School of Art, had travelled to Japan with Arthur Lasenby Liberty and Charles Holme in 1889.[21]

Hornel's lecture, delivered subsequent to their return in July 1894 , at the Corporation Art Galleries, Glasgow, and Henry's interview with the *Kirkcudbrightshire Advertiser* provide, together with a few letters, the only record of their sojourn in Japan. However, Hornel expressed their intentions quite clearly:

> The question might naturally be asked an artist who had visited Japan, 'What went ye out for to see?' and the appropriate answer might be given, 'A reed shaken by the wind'; for to those acquainted even slightly with Japanese art the words express the spirit and *motif* of its dainty achievements.[22]

Once arrived in Tokyo, Hornel and Henry, although armed with *Murray's Guide to Japan*,[23] found that they were unable to travel far, the small towns around Tokyo, such as Chiba, Kanagawa and Kamakura, being the extent of their wanderings.[24] Unsurprisingly, they soon tired of living, as was required of Westerners, within the *kannai* where 'every second man you encounter is a missionary, and your rest is chronically broken by the uncongenial clang of the church bells, whose notes are unmelodious and distressing as the music (so called) of Japan',[25] and found accommodation, illegally and briefly, among the Japanese.[26] 'The real Japan,' Hornel later observed, 'has never been put before us, and in no particular does this remark so forcibly apply, as in the case of the home-life of the people ... In Scotland we pride ourselves on our homeliness. In Japan we see ourselves equalled in this respect, and if a deeper insight could be got into the lives of the people, we might find ourselves surpassed.'[27]

Japanese home-life, as exemplified in the treatment of interior space, was, Hornel believed, inherently artistic.[28] The tea-house, in particular, attracted him, for both its architecture and its beverage, as well as its beautiful women whom he painted. 'A good tea house,' he said, 'is one of the most charming of places, where good nature and hospitality abound.'[29] But it was the Japanese veneration of nature which struck him the most

and this, he thought, 'gives us an insight into their true character ...'[30] This, of course, had long been recorded as wood-block prints but now *Yokohama shashin*, the popular photographs prepared for foreign visitors, provided another and more accurate record of Japanese life. Hornel and Henry had soon become members of the Japan Photographic Society[31] and when they returned brought with them a substantial collection of photographs.[32] However, they did not use the *Yokohama shashin* to provide an accurate record of Japan but rather, in combination with their own observations, as a source for figures and settings. Henry's painting *Salutations* (1894),[33] showing three Japanese women kneeling low on *tatami* with a view of Mount Fuji through an opening in the *shōji*, is as artificial a construct as the hand-coloured *Yokohama shashin* upon which it was based, for that, in turn, was a studio photograph and the distant view of Mount Fuji, a painted back-drop.

Unfortunately for Henry, most of his canvases were damaged in the journey back from Japan so *Salutations*, if it was not actually painted in Glasgow, is likely to have been either finished or made good there. Hornel, however, was more fortunate and was able to hold an exhibition of paintings at Reid's Gallery on St Vincent Street in February 1895. It was a great success, only seven pictures failing to sell.[34] One of Hornel's paintings, *A Geisha*, was hung later that year at the Glasgow Institute of Fine Arts Exhibition, for which posters had been designed by Charles Rennie Mackintosh, Herbert MacNair and Frances and Margaret Macdonald.[35]

Charles Rennie Mackintosh

As a young lad of 13, Charles Rennie Mackintosh might have seen the Oriental Art Loan Exhibition at the Corporation Galleries and he certainly would have seen the Japanese art-wares and craftwork kept at the Galleries once he enrolled there as a student at the School of Art in 1883, the year that Frank Dillon, who had visited Japan in 1876, exhibited *The Festival of the Cherry Blossom, Osaka, Japan* at the Glasgow Institute.[36] The next year Mackintosh

began his architectural apprenticeship with John Hutchison and in 1889, his pupilage complete, joined the firm of John Honeyman and John Keppie. Still living at his father's house, he decorated his basement room with Japanese prints,[37] but it was not until he moved to 120 Mains Street that the full influence of Japan becomes apparent in his work.

The change which came over Mackintosh's work, and is most apparent between the two phases of the Glasgow School of Art, the first of 1897–99 and the second of 1907–09, occurred in the late 1890s. Other than ideas nascent in his six lectures,[38] only one of which he gave after 1893, there is no record, beyond his output of his design thinking. Most likely the change can be attributed to two particular people who came into his life at that time. One would be Margaret Macdonald, she for whom, and of whom, he had done a watercolour drawing called *Part Seen, Part Imagined*; the other was Hermann Muthesius.

In *Part Seen, Part Imagined*, drawn in April 1896, the Japanese influence is immediately apparent in the styling and colouring of the hair, and in the *kimono*. The same figure is repeated in the stencilled decoration designed for Catherine Cranston's Buchanan Street Tea Rooms on which he started working that year. Japonisme was clearly in his

mind when, in September 1896, he drew up his ultimately successful designs for the Glasgow School of Art competition which were submitted under his firm's name of Honeyman and Keppie [Plate 18]. The monogram which he used to identify his entry showed a *mon* of his own devising – three wishbones set against a curved line set within a circle.[39] There are further Japanese references in the design for the south elevation,[40] perhaps drawn from illustrations in Edward Morse's *Japanese Homes and Their Surroundings*: the alternating high and low eaves line, and the small, pitched-roofed conservatory for the Flower Painting Room, located high up on one wall, recall Morse's illustrations of a street in Kanda-ku or of kura in Tokyo [10.01].[41]

When built, however, the south elevation was less stark than originally proposed but the conservatory remained. Inside, the overlapping post and beams of the main stairs suggest an interest in the demountable nature of Japanese joinery which is apparent in other designs by Mackintosh of this time, such as the pegged trusses above the stairs at the Martyrs' Public School (1895–97) and the porch to the caretaker's house at the Ruchill Street Free Church Halls (1898–99).[42] Yet he had never, and did never, visit Japan: these references in both his architecture

10.01 'Kura in Tokio', from Edward Morse, *Japanese Homes and Their Surroundings*, 1886.

and his graphics appear second-hand, not the imagination of one who had visited the country.

It was through his friendship with the German architect and author, Hermann Muthesius, that he was to gain a more first-hand experience of Japan. Muthesius (as noted in Chapter 7) had spent two and a half years working in Tokyo for Ende and Böckmann. While there he had designed a new church in the Gothic style [10.02], and an Evangelical Mission School for the German protestant community [10.03], as well as a house for Prince Sanjō Sanetomi, the Lord Keeper of the Privy Seal of Japan and Chancellor of the Realm. The church, completed to a modified design following his departure in 1890, collapsed in the 1923 Great Kantō Earthquake, but the Mission School, being timber-framed, survived. However, the house for the Prince was redesigned by Tsumaki Yorinaka, much to Muthesius's distress.[43]

(*left*) 10.02 A design for the German Protestant (Evangelist) church in Tokyo by Hermann Muthesius, 1889.

(*below*) 10.03 A design for a 'School with Library and Lecture Hall for the German Evangelical Mission in Tokio', by Hermann Muthesius, 1889.

Muthesius first met Mackintosh and the others of The Glasgow Four – Hector McNair, and Margaret and Frances Macdonald – as well as Talwin Morris, in the spring of 1898 on his first trip to Glasgow while in pursuit of material for an article on the emergent Glasgow school, published anonymously in *Dekorative Kunst* that November.[44] His and his wife Anna's subsequent friendship with The Four grew and is recorded in a lengthy correspondence, some of which survives in the Deutsche Werkbund Archiv in Berlin. All this while Mackintosh's relationship with Margaret Macdonald, a fellow student at the School of Art, was developing and, in July 1900, while working with her on the frieze panels for Catherine Cranston's Ingram Street Tea Rooms, Mackintosh wrote to Muthesius, telling him of their forthcoming marriage. The wedding was on 22 August and, as a gift, Hermann and Anna Muthesius sent two *Surimono* prints, one by Utagawa Shigenobu and the other by Utagawa Kunisada.[45] Toshie (as he was known) and Margaret placed them on the mantelpiece in their newly decorated flat at 120 Mains Street, Glasgow, and wrote a letter of thanks: 'We now have the prints framed and we count them among the most valued and beautiful things we possess. In our white drawing room they are the most perfect note of colour.'[46]

The white drawing room was part of a suite of rooms which Toshie and Margaret had decorated in 1899–1900 in anticipation of their forthcoming wedding. Quite unlike anything seen in Glasgow at the time, it was, significantly, set within the smoke-blackened stone walls of a tenement block and appeared to exist in spite of, rather than because of, its host building. In 1904 Muthesius illustrated the apartment in *Das englische Haus*, noting enthusiastically 'that the Glaswegians have borrowed the ideas that Whistler introduced into painting for the decoration of their rooms'.[47]

The high-ceilinged drawing room was cut by a low frieze-rail running, like a *ranma*, along its walls and across the tall windows. Four suspended ceiling lights, set in the corners of the room, dropped to the level of this *ranma* from which the muslin window drapes also hung. The walls below the *ranma* were finished in light grey canvas panels framed by vertical wooden strips. Above, the walls and ceiling were white, as was all the woodwork. A similar treatment was afforded the much smaller and darker dining room, although now, beneath the white ceiling and generous frieze, the panelled walls were covered in plain, brown wrapping-paper and the *ranma* and wooden verticals stained brown. In both rooms, arrangements of dried twigs recalled the metaphor in Hornel's 1895 lecture on Japan. This event is significant: given at the Corporation Art Galleries on 9 February, Mackintosh would almost certainly have heard if not read it, for it was delivered, in Hornel's absence, by Mackintosh's employer, John Keppie.[48]

John Paton, the Curator of the Art Gallery, had actually written to Hornel saying: 'John Keppie will take the platform after the announcement that Mr Hornel has been suddenly and unexpectedly called away to Windsor Castle or some equally suitable excuse.'[49] Keppie was a close friend of Hornel and in 1909 the firm, by then Honeyman, Keppie and Mackintosh, was to add a picture gallery at the rear of Broughton House, his home in Kirkcudbright. The lecture he read was illustrated with lantern slides provided by William Kinnimond Burton who, in 1890, had built Tokyo's first high-rise building, the Ryōunkaku in Asakusa.[50] The following quotation reads very much as if it were to be accompanied by a lantern slide:

> Nature to them is symbolism itself, and associated with traditions handed down from remote periods ... This symbolism and its traditions finds its highest expression perhaps, in the arrangement of flowers in their homes. It is not the haphazard jumbling together of leaves and blossoms so characteristic of this country, which, in effect, is vulgar and commonplace: but an Art expression requiring many years of careful study. A few flowers, one or two twigs quaintly put together in a beautiful vase, and these tiny parts of nature express a thought, a story, or tradition. But what an effect![51]

In his paper on *The Theory of Japanese Flower Arrangements*, read before the Asiatic Society of Japan in 1889, Josiah Conder had commented that:

the art has been principally practised by men of culture whose occupations have spared them leisure for aesthetic pursuits ... As a close examination of the principles of Japanese floral design will shew, there is a bold and masculine vigour displayed in the best compositions which comes far more within the compass of the stronger than of the weaker sex.[52]

His book, *Landscape Gardening in Japan*, together with the *Supplement to Landscape Gardening in Japan*, followed in 1893. It is hard to think that Hornel was not familiar with these texts.

The reduced aesthetic which Hornel describes was something which Toshie and Margaret understood and which Muthesius described in *Das englische Haus*:

The special character of the Mackintosh group rests as much in form, especially in their ideas about the relationship between surface and decoration, as in colour. In both connections the keynote is a spacious, grandiose, almost mystical repose, broken only here and there by the application of a small decorative area, which has the effect of precious stone. Repose is achieved by the use of broad, unarticulated forms and a neutral background colour, such as grey, white or a dark brownish-grey. The strictly architectonic character stems from strongly emphasised rhythmic sequences, such as vertical elements or series of any similar elements.[53]

The quality of mystical repose is often attributed to Margaret. It is this about which Blanche-Ernest Kalas,[54] a painter and the wife of the Rheims architect Ernest Kalas, wrote in 1905 following a visit to the Mackintosh's flat where she found 'two visionary souls, in ecstatic communion from the heights of loving mateship ...'[55] Kalas, the architect, was fulsome in his praise but it was second-hand, drawn from an eulogy which he remembered having read and which referred to Mackintosh as 'the original inventor of the "masculine skeleton"':

The straight line, and above all the perpendicular, is exploited to such a degree that it almost becomes supernatural. When a curve appears it is introduced furtively as if it hardly dared be seen. All appearance of effeminacy is expunged by an adherence to vertical lines. These severe almost skeleton-like lines and a flair for repetition add strength to the whole idea. Behold then the skeleton of this art, its masculine side.[56]

These are, in fact, the words of Muthesius, for Kalas then goes on to identify the feminine side 'as effeminately sweet as the other is sternly masculine',[57] a notion which Muthesius had already expounded in *Dekorative Kunst*.[58] Blanche-Ernest equally sees in the feminine side the contribution of Margaret, who, 'still with work to do, slips away to her brush, her panels of painted plaster, and her winding trails of plastic ivory', [59] and Margaret alone is pictured.

Outside the confines of their domestic idyll, Margaret and Toshie worked together on a number of projects: her twin panels of *The May Queen*, and his *The Wassail*, prepared for the Ingram Street Tea Rooms, were shown, in 1900, at the eighth Secession Exhibition in Vienna, together with two hanging panels of appliqué-work, both by Margaret. These the critic W. Fred described as 'slender figures with Japanese masks'.[60] Margaret's involvement here in the Scottish room, which Fred thought was in 'a curious Japanese style' which 'reaches the very limits of possibility', should be recognised. Not least, perhaps, because a year later, in anticipation of an article which Muthesius was preparing on the Glaswegians for *Dekorative Kunst*, she wrote to him saying, 'Will you please be so kind as to always make my name Margaret Macdonald MacKintosh', before adding, with underlined emphasis: 'We both think that the article should be entitled "The Work of Charles R. MacKintosh + Margaret Macdonald MacKintosh."'[61] The article duly appeared in September 1902 as 'Die Glasgower Kunstbewegung: Charles Rennie Mackintosh und Margaret Macdonald-Mackintosh'.[62]

Fred's recognition of Japanese masks might be little more than wishful thinking, for so abstract

was their depiction in that appliqué-work. However, the use of *Noh* theatre masks was much more recognisable in the pair of gesso panels entitled *The Opera of the Seas* and *The Opera of the Winds* which Margaret prepared in 1903. These were created for the piano in the Music Room which the Viennese industrialist Fritz Wärndorfer had commissioned from the couple the previous year, having been impressed by their work at the Secession Exhibition. White, mask-like faces appeared again in her 1911 painting, *The Mysterious Garden* and were further emphasised in her recreation of *The Opera of the Seas* in 1915. Thus it seems likely that if Margaret was not the progenitor of any Japanese direction in the work she did with Toshie, she was certainly the respondent.

The Glasgow School of Art

Whereas the first phase of the Glasgow School of Art could be said to represent Japonisme, the second, completed in 1909, was recognisably different. In Studio 58, the Composition Room, located on the top floor of the new west wing, Mackintosh evoked Japanese *torii* with a directness not found in the earlier part of the building. Here, high in the gable end above the Library, two pairs of tall, tapering uprights, one at each end of the

10.04 The roof structure of Studio 58 at the Glasgow School of Art, designed by Charles Rennie Mackintosh, 1909.

room, supported the purlins and threw long arms out to the rafters on either side [10.04]. Braced both laterally and against the gable walls by a series of paired beams, they recall both *torii*, such as frequently illustrated by Dresser in *Japan: Its Architecture, Art, and Art Manufactures*,[63] and the horizontal and vertical framing adopted by the Japanese in the absence of triangulated trusses. In contrast to the coursed stonework and rough bricks which enclose the studio, the timbers are squared-off and machined smooth, and the junctions not pegged but bolted, a process which allows for ease of disassembly.

Outside Studio 58 Mackintosh built the loggia of heavy brick vaults, and beyond this, as if in contrast, the lightweight, timber and glass pavilion known as the 'Hen Run' was cantilevered from the south wall of the Director's studio to provide a connection to the earlier part of the building. In contrasting the solidity of the Japanese storeroom or *kura* with the fragility of the Japanese house, Morse had written: 'While the *kura* generally stands isolated from the dwelling-house, it is often connected with the house by a light structure of wood, roofed over, and easily demolished in case of fire.'[64] It is this juxtaposition of the permanent and the temporary, of the robust and the delicate, which Mackintosh suggests here. Ironically, the Hen Run was burnt out in the fire which swept through the western end of the building on 24 May 2014.

The walls of both the Hen Run and of the corridors and studios in the School of Art were lined with rough vertical boarding intended for the pinning of drawings. In the Old Board Room the joints between the vertical boards are covered by a batten in the manner of the Japanese *enkō* joint. The same treatment was used by Mackintosh, but with a finer finish, at the Queen's Cross Church (1897–99), in the dining room at Windyhill, Kilmacolm (1900–01) and then in the Ingram Street Tea Room (1901–03).

Mackintosh's interest in the texture of surface materials, first exploited in the Mains Street apartment, was evident in the east and west staircase which comprised part of the second phase of the School of Art. Here, the masonry surface was finished with a hard, smooth cement render into

which square grids of glazed tiles were set. Again, Mackintosh might have been looking at Dresser's book, for here are shown many examples of gridded and diaper patterns[65] as well as an illustration of Japanese plasterers at work, which emphasises the layered and textural treatment of the wall surface. These tile arrangements pick up, in turn, the gridded pattern of the wrought iron-work at the stair-heads which, to a visitor, would have already been signalled in the extensive gridded glazing to the studios on the entrance front of the building. The reference to *shōji* is immediately apparent and, when combined with board and batten construction, as in the window bays of the Old Board Room which penetrate the east staircase, provides a Japanese paradigm which only the curve of the bays denies.

Whereas it could be argued that Mackintosh's use of Japanese idioms in the second phase of the Art School and in his contemporaneous buildings is drawn from the publications of Dresser and Morse, their broad application and sense of coherence would indicate a deeper understanding of Japanese architecture and building methods than those line illustrations would supply. Hermann Muthesius knew such things and, as fellow architects, the two men would indulge themselves in architectural explorations. On one occasion in 1903, when Toshie and Margaret were planning to visit Hermann and Anna in their rented house, The Priory, at Hammersmith, Mackintosh wrote: 'Nothing could give me more pleasure than to make the tour you suggest to Surrey to see some houses by Lutyens. If you are too busy to go you can easily direct me.'[66] Muthesius's proposed visit would have been in preparation for his book, *Das englische Haus*, and might well have taken in Munstead Wood (1897) and Orchards (1897), both of which were still quite new.[67] On the same trip, Mackintosh could well have seen a house of 1893 by Arthur Heygate Mackmurdo: 25 Cadogan Gardens, just off London's Sloane Square. This was the home of the painter Mortimer Menpes, a Japanophile and an acolyte of Whistler, and as will be shown, it would soon influence the design of the Library at the School of Art.

The best way to understand the Library is as a stone shell into which a carefully worked lining

had been inserted. This, in effect, was the approach Toshie and Margaret had taken at 120 Mains Street, and more particularly what he had done in the drawing room at Hill House, Helensburgh (1902–04). In a similar way, the Tea Rooms designed for Catherine Cranston can also be seen as installations, one space created within another. As such, it bears relationship with the Scottish Baronial castles of which Mackintosh had spoken in his lecture of 1891,[68] the roofless carcasses of many of which, with their broken stone stairs and empty put-log holes, would have been familiar to Mackintosh. Yet it is as a recreation of the Japanese storehouse or *kura* that the Library is best read. Being fireproof and built of solid construction, the walls of the *kura* were often, in the humid Japanese climate, cold and damp. Therefore, as Morse explains in *Japanese Homes and Their Surroundings*,

> for the fitting up of such a room, to adapt it for a living-place, a light framework of bamboo is constructed, which stands away from the walls a distance of two or three feet; upon this cloth is stretched like a curtain. The frame-work forms a ceiling as well, so that the rough walls and beams of the floor above are concealed by this device [10.05].[69]

This was how the Library, set within the solid walls of the School of Art, was conceived: a framed room, lined with a curtain of books, beneath a suspended, gridded ceiling [10.06]. Set within its three-storey stone enclosure, the two-storey Library is lit by great light shafts which seemingly disappear up into the ceiling. In fact, the upper parts of the windows light the storage space above the Library whose floor, the Library ceiling, is suspended from steel beams by twisted, wrought-iron braces. Although this is a technique used in ship-building, common enough along the Clyde, it is also a Japanese construction technique illustrated by Morse.[70]

This approach, the insertion of one space within another, was also that taken by Mortimer Menpes in the completion of his house in Cadogan Gardens. Rather than have Mackmurdo fit out the house, Menpes took it upon himself to do it. 'It was with a

10.05 'Framework for draping room in kura', from Edward Morse, *Japanese Homes and Their Surroundings*, 1887.

view to decorating my newly built London house,' he wrote in *Japan: A Record in Colour*, 'that I paid a second visit to Japan, being convinced that it was possible to handle the labour there at a cheaper rate and with finer results than in Europe. My experience proved that I was right.'[71] Working with the help of a shopkeeper he nicknamed Inchie, from his habit of measuring things as one-inchie, two-inchie, etc., Menpes created an exquisite series of rooms. As he explained:

> Each room should be some individual and beautiful flower – such as the peony, the camellia, the Cherry-blossom, the chrysanthemum, – and, just as a flower begins simply at the base, expanding as it reaches the top into a full-blown bloom, so my rooms should begin with simple one-coloured walls and carpets, becoming richer and richer as they mounted up, ending as they reached the ceiling in a perfect blaze of detail.[72]

Menpes soon discovered that the Japanese artists and craftsmen each had their favourite species of flower:

Having found three or four men who had a special fancy for the peony, I allowed them to occupy themselves entirely in the peony room. I gave them the exact measurement of the ceiling, squaring it out into a certain number of panels, with complete measurements of the doors, the frieze, and every portion of the room, allowing them to give bent to their own artistic instincts as to colour and design. These drawings were then handed over to the woodcarvers, to be pasted on to wood panels and carved. In a very short time every workman in Inchie's store, and every artist too, became enthusiastically interested in this work that they were undertaking. In fact, it was no work to them at all, but one long artistic joy. So much rubbishy bric-a-brac has to be made for the European market that when a Japanese is allowed to go his own way and create self-imagined beautiful things, it is an untold personal pleasure to him.[73]

Once the finished craftwork was crated up and shipped to England, Menpes's difficulties were only just beginning. When the British workmen saw the tools with which the Japanese had done the work – 'saws as thin as tissue paper with their teeth set the wrong way; tiny chisels that almost broke as they handled them; hammers the size of a lady's hat-pin'[74] – they were contemptuous, but once the work was unveiled, they were amazed. Even with five or six good workmen whom Menpes had to train to handle the material, it took two years to fit out the interior. 'It was all straightforward clean design,' he later wrote, 'and there was no artistic effort needed for it; but the obstacle was that they always struggled to make the woodwork a little thicker than necessary. Their inclinations were always to strengthen things, and it took a great deal of perseverance and patience to uproot their fixed ideas.'[75]

The Studio, which had first promoted the work of the Glasgow designers and in particular of The Four in 1897,[76] published Menpes's house in 1899 and, had Mackintosh read the account, it would have resonated with him.[77] The article, entitled 'An Experiment in the Application of Japanese

(*right*) 10.06 The Library at the Glasgow School of Art, designed by Charles Rennie Mackintosh, 1909.

Ornament to the Decoration of an English House', opened thus:

> It has come to pass, therefore, from the ignorance of lecturers and writers, as well as from that of the general public, that a fallacious idea of Japanese decoration has become general, and that in almost every attempt to introduce it into Western buildings its principles have been absolutely ignored, and the greatest of aesthetic crimes committed in its name.[78]

Beneath this rebuke was a photograph of Mackmurdo's tall, brick house on the corner of Cadogan Gardens and Symons Street [10.07]. On both elevations tall, small-paned windows linked the first and second floors, cutting thin vertical strips through the brickwork. Whereas the four windows facing Cadogan Gardens were flat, the three looking on to Symons Street were canted, stepping out as bay windows beneath a deep, overhanging cornice. It was a curious design for it gave greater emphasis to the lesser elevation, the canopied front door being on Cadogan Gardens. Whatever Mackintosh thought of the Symons Street elevation, had he seen it on site or in *The Studio*, can only be guessed, but the similarity between that elevation and the west elevation of the Library at the School of Art is so striking, both in arrangement and proportion, that the use of Mackmurdo's building as a precedent must be accepted [10.08].

It is not Mackmurdo alone to whom Mackintosh appears to have turned for precedents at the Glasgow School of Art. The articulation and fenestration of the south elevation of the new west wing shows distinct similarities to the new City Library in Bristol, a building similarly set on a slope, designed by Charles Holden in 1906. It is also from here that comes the small triangular stone gable which peeks above the west elevation of the School of Art. So why should Mackintosh alight upon these English precedents? They were clean and they were modern, and perhaps they appealed to his rather reductivist taste. Yet they both might have appeared strangely familiar, for there is something of the

10.07 The Mortimer Menpes house at 25 Cadogan Gardens, London, designed by Arthur Heygate Mackmurdo, 1893.

Scottish tower house in the broken silhouette of Holden's Bristol library, while the oriel windows on Menpes's house might have recalled Castle Huntly, Aberdeenshire, where, as he said in his Scottish Baronial lecture of 1891, 'we find a very uncommon feature in the three oriel windows.'[79] If the Scottish influence never left him, the milieu of late-nineteenth-century Glasgow in which he developed as an architect allowed the Japanese influence to grow. But Mackintosh was cautious, at least early on, of taking on board too much foreign influence. In an untitled paper written soon after his Italian tour of 1891,[80] he wrote:

> In fact I think we should be a little less cosmopolitan & rather more national in our

10.08 The Library windows at the Glasgow School of Art, designed by Charles Rennie Mackintosh, 1909.

Archi. as we are with language, new words & phrases will be incorporated gradually, but the wholesale introduction of japanese senta [*sic*] for example would be denounced & rightly by the purist.[81]

Mackintosh never fully introduced Japanese sentences (or sentiments) into his work but, with time and the influence of Hermann Muthesius, he allowed its presence to grow. As Eckart Muthesius, Hermann and Anna's son and Mackintosh's godson, and himself an architect, later remarked, 'what a pillar of moral support Muthesius was to him.'[82] The Japanese quality of the School of Art, and especially the Library, has often been commented upon. The British architect Sir Denys

Lasdun said that it reminded him of 'the brooding mystery of a Japanese temple',[83] while the Japanese architect and fellow Royal Gold Medal winner, Isozaki Arata, has observed that 'A Japanese person looking at the work of Charles Rennie Mackintosh is immediately struck by how "Japanese" his designs are. The simplicity,' he adds, 'needs no explanation. It is amazing how he has grasped the essence of Japanese aesthetics.'[84] Andy MacMillan, for many years the charismatic Head of the Mackintosh School of Architecture at the Glasgow School of Art, recognised common ground between Mackintosh and Frank Lloyd Wright:

> Japanese architecture revealed to him – as to Wright – that beyond the Picturesque and the Arts and Crafts there could be a true non-historical style based only on space and a direct use of materials ... It is interesting that only Mackintosh and Wright grasped the essence of space in the Japanese print, the use of interlocking ground and figure, rather than the line, which both increasingly rejected in their development.[85]

The interest in and sympathy for Mackintosh's work in Japan should not be surprising. Alan Crawford, while commenting in his 2002 biography of Mackintosh that the Library 'is certainly the greatest of Mackintosh's timber fantasies, and his fullest tribute to Japan',[86] also draws the English reader's attention to Morita Shingo's *manga*, 'C.R. Mackintosh, The Young Architect Ahead of His Time' in the series 'Geniuses without Glory'.[87] Here the success of the Glasgow School of Art and the tragedy of Mackintosh's subsequent alcoholism and the frustration of his later years are told in stark monochrome images alongside the lives of Benoît Rouquayrol, the inventor of the first underwater breathing regulator, and Takagi Tokuko, Japan's first film actress. In 1979 the Charles Rennie Mackintosh Society in Japan was founded in Tokyo with, as Tajima Kyoko said, 'a commitment among our members to the further encouragement of cultural relations between Glasgow and Japan'.[88] By 2003 the organisation had spread to Osaka, Kyushu, Kanazawa and Nagoya.

11 THE PRINCIPLE OF EVOLUTION

Itō Chūta

On 29 March 1902, the Japanese architect Itō Chūta departed Shinbashi, Tokyo, on a world tour. A week later he was on a boat between Hiroshima and Tianjin, China, which was then, following the Boxer Rebellion of 1900–1901, under the control of the Eight Nation Provisional Government comprising, amongst others, Japanese representatives. Tianjin was Itō's first footfall of what was to be an extensive journey which took him down through China to Burma and on to India and Ceylon, and then back to Bombay from where he sailed on 9 March 1904. Passing Aden, Itō continued up the Red Sea, through the Suez Canal and, barely pausing to disembark, crossed the eastern Mediterranean and sailed along the Dalmatian coast to Trieste. From there he travelled across land to Munich and Berlin and by the end of April was in Vienna. There could be many reasons for heading first towards Germany and Austro-Hungary: one might be the emergent strength of Germany in the later years of the nineteenth century, a model which certainly reflected Japan's own aspirations, and the interest which Japanese architecture had recently taken in German firms such as Ende and Böckmann.

As a Grand Tour, Itō's itinerary was noticeably different to what a Western architect, coming from Britain or America, might have taken, for his world view of architecture was not occidental. The two years spent in reaching Europe had not made him impatient for Florence, Rome or Paris: they were not to be visited for yet another year and the remainder of 1904 was spent exploring first Egypt, and then the Levant, before eventually crossing from Greece to Italy in February 1905. Italy, France and England, together with a second visit to Berlin, occupied him until the middle of May when he sailed from Liverpool to New York. Anxious, perhaps, to get home, or simply uninterested in any more Western architecture, he crossed north America in two weeks and took a ship from Vancouver to Yokohama, where he arrived on 22 June 1905. He had been away for three years and three months, barely one year of which had been spent looking at the architecture of the West.

What this world tour confirmed for Itō was his belief that although Japanese architecture might have distant Western roots, it was essentially an Asian architecture and if it was to move from the 'dark age' of its current transitional period brought about by the Meiji Restoration, it had to do so by evolution and not by eclecticism, nor by the adoption of Western styles of architecture.

Itō had studied architecture at the Tokyo Imperial University in 1889–92. There Josiah Conder was still teaching a course on the Styles of Architecture,[1] and

Ito's world view of architecture would have been gained from him and through Western publications. Albert Rosengarten's *History of the Styles of Architecture* (1876) has already been mentioned in this context, but the two great English-language surveys of the time which ostensibly took a world view were by James Fergusson and Banister Fletcher. Fergusson's *History of Architecture in All Countries From the Earliest Times to the Present Day* of 1865–67 was followed by *The History of Indian and Eastern Architecture* in 1876; Fletcher's *A History of Architecture for the Student, Craftsman and Amateur: Being a Comparative View of Historical Styles from the Earliest Period* came out in 1896 (with revised and enlarged editions in 1897 and 1901), after Itō had completed his studies but before he left for his world tour in 1902. The two years he then spent in China, India and Ceylon demonstrated, if not confirmed, to his mind, the shortcomings of these books. He was to regard Fergusson's view of Eastern architecture as extremely illusionistic, not only lacking in an understanding of Chinese architecture but dismissive of it, in the same way 'as a blind person would not be afraid of snakes';[2] and Fletcher, Itō thought, expressed an equally occidental view, grouping together Eastern architectures – Islamic, Indian and Chinese – as non-historical architecture and treating Chinese architecture in the same way as the dead Inca and Aztec architecture of Peru and Mexico.

In 1892, Itō's graduation project had been the design of a Gothic cathedral accompanied by a written dissertation entitled *Kenchiku Tetsugaku* (Architectural Philosophy) in which he argued for an architecture based upon Japanese and Gothic forms.[3] Once he eventually got to Paris in April 1905, 13 years later, it was not the Louvre or the new Opera which he sought out but Notre Dame and the late-fifteenth-century Musée de Cluny. At the end of 1904 he had spent almost three weeks in Cairo before arriving in Istanbul in mid-December. In Cairo he had seen the ninth-century mosque of Ahmad Ibn Tūlūn and in Istanbul, where he was to stay six weeks, what impressed him was the mosque of Hagia Sophia (Aya Sofiya) which he later published in *Kagaku chishiki* (Scientific Knowledge).[4] He

admired the thinness of the dome structure and the way that, as he put it, 'the outline of the building is parallel to the inside space'.[5] He saw it not as a typical Western dome, such as St Peter's in Rome, where a structural space separates the internal dome from the external, but as a fusion of ancient Western and Eastern architectural traditions; for it was neither purely one nor the other and thus it perhaps provided a lesson for Japanese architecture – an architecture drawn from ancient and, as he would argue, common roots.

The appointment, in 1889, of the master-carpenter Kigō Kiyoyoshi to teach traditional building methods at Tokyo Imperial University must have shown Itō another way forward for Japanese architecture. In 1893 *Kenchiku zasshi* published the first of Itō's studies of the eighth-century Hōryū-ji Buddhist temple at Ikaruga.[6] Following its critical success, he was commissioned, with Kigō, to rebuild the Daigoku (the Great Audience Hall) within the Chōdō-in, the official compound of the Emperor's Palace in the ancient capital of Heian-kyō (Kyoto) [11.01]. Intended both for the 1895 Fourth National Industrial Exhibition and to celebrate the 11th centenary of the city, the reconstruction of the building, at five-eighths of its proper size, was based upon old records and *emakimono* (picture scrolls).[7] Yet, despite all the knowledge behind its reconstruction, there are king-post trusses in the rebuilt Daigoku, which suggests the preference for pragmatism over precedent.

11.01 The Daigoku within the Chōdō-in at Kyoto, rebuilt by Itō Chūta and Kigō Kiyoyoshi, 1895.

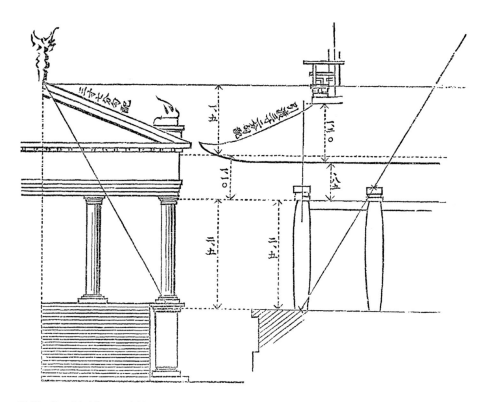

11.02 Gottfried Semper's Vitruvian Tuscan temple from *Der Stil ...* (1860) and the Chūmōn (middle gate) at Hōryū-ji compared, from Itō Chūta, 'The Architecture of the Temple of Hōryū-ji', *Kenchiku zasshi*, November 1893.

The Hōryū-ji, the subject of a number of published essays entitled 'Hōryū-ji Kenchiku-ron',[8] was the oldest extant timber building in Japan and Itō regarded it as the progenitor of Japanese architecture. But the source of Japanese architecture, he believed, was to be found in the area of the Peshawar Valley and the confluence of the Kabul and Indus rivers where Gandhāra Graeco-Buddhist architecture flourished from the time of Alexander the Great's invasion (*c.* 325 BC) to the Islamic conquests 1,000 years later. In this much he was following Fergusson's history. By comparing the columns and the proportions of the elevation of the Chūmon (middle gate) at Hōryū-ji with Gottfried Semper's depiction of a Vitruvian Tuscan temple in *Der Stil in den technischen und tektonischen Künsten oder praktische Ästhetik* (1860), Itō provided evidence of a trans-Asiatic connection

between Western and Japanese architecture and a common source for both traditions [11.02].[9] Due to Japan's remoteness, the enforced separation of *sakoku*, the continued use of timber, the extremes of climate and the seismic and topographical conditions which the country presented, Japanese architecture had evolved, in an almost Darwinian way, from a common understanding of structural proportions to an expression that was distinct and unique.

Following his return to Japan in 1905, Itō took up the debate surrounding the building of a permanent Diet building which, subsequent to the debacle of Ende and Böckmann's scheme, had rumbled on through the building of two temporary structures, the first of which had burned down in 1891, just two months after opening. In 1908, in a paper jointly authored with Tatsuno Kingo

and Tsukamoto Yasushi, another of Tatsuno's students, and published in *Kenchiku zasshi*, Itō argued for an architectural competition to find the best design for the permanent building, rather than sending an exploratory delegation to Europe and America, as was being proposed by the Ministry of Finance. Behind this was a confidence, as evidenced by Katayama Tōkuma's Tōgū Gosho, the Imperial Palace for the Crown Prince then nearing completion at Akasaka, that Japanese architects could now tackle anything, and the belief that the Japanese Diet should be a Japanese building. 'Neglecting such important matters and going abroad to find a solution,' they wrote, 'is not understandable.'[10] In 1910, a Diet planning committee was appointed with Itō as a member, and the discussion ranged from style to materials and construction. Itō objected to the proposal that, were a competition to be run, the Italian Renaissance style should be stipulated and, as he later recalled, he 'managed to modify the guideline to say, "the style should be a suitable one to reflect the spirit of the national ideal"'.[11] The following year, he took up this argument once more in *Kenchiku zasshi*, writing that 'even if we make a copy of a European Palace ... this would be meaningless if it does not reflect the spiritual taste of the Japanese contemporary mind.'[12] The architect of this building, he concluded, should be chosen by the nation. When the competition for which he had so much wished was eventually run in 1918, he wrote in *Kenchiku zasshi*:

> I am very disappointed at the fact that most of the entries are in the Italian Renaissance style ... Other countries' parliaments may be in that style, but they were designed fifty to one hundred years ago when the Renaissance revival was the newest architectural style ... It is pointless to imitate this style now in Japan.[13]

One entry for the competition which was not altogether in the Italian Renaissance style came from Shimoda Kikutarō. This was a combination of a vast, Beaux-Arts façade where the central decastyle portico was approached by a sweeping ramp, and,

above the parapet, a variegated roofline of Japanese temple forms. Dubbed *teikan-heigō* or Imperial Crown Eclecticism, it was not destined to succeed, but anticipated the emergence of the *teikan-yōshiki* style a decade later.

In 1909, while the discussions surrounding the new Diet building were gathering steam, Itō published his essay on 'The Prospect of Japanese Architecture Seen From the Principles of Evolution',[14] in which he described the current state of Japanese architecture as being in a Dark Age. Believing that 'Japan should not worship West as the absolute ideal',[15] he rejected Europeanisation as being culturally suicidal and rejected Euro-Japanese eclecticism as an impossible grafting. 'Aubergine vines,' he said, 'do not bear marrows. It is natural to develop aubergine as aubergine.'[16] And so, in arguing for architectural evolution, he continued the botanical metaphor: 'It is like fostering one species with special care and fertiliser, and gradually developing it over time into a different species.'[17] In the same way that Greek architecture evolved from timber into stone,[18] so Japanese architecture, which was still almost all in timber, could evolve into an appropriate stone architecture. But, conscious of the slow process of evolution, he added, 'I have no intention to eliminate European architecture ... this argument is not a topical matter, and is not concerned about how to design buildings in the immediate days to come.'[19]

The basis of Itō's argument for evolution was contained in the world view which he had developed following his tour of 1902–1905. This he expressed as a Venn diagram which showed how the three systems of world architecture, Eastern, Western and Ancient, were inter-related through evolution [11.03].[20] Although each system contained many sub-systems, there were few overlaps between them. Of the Ancient system, only Persian, Assyrian and Cardian (or Thracian) architecture overlapped with the Eastern system, and then only with that of the Indian sub-system. In the Western system, which abutted but did not overlap the Ancient system, only Byzantium sat fully within the Eastern system, and did so within the Islamic

EASTERN SYSTEM

Japan

Korea

CHINESE SYSTEM China

Vietnam

ISLAMIC SYSTEM

Seljuks Turkey

Tibet

North Africa Persia

INDIAN SYSTEM

Nepal

Burma

Spain Turkistan

Siam

Cashmere

Cambodia

Arabia

Egypt

Java

India

Syria

Byzantium

WESTERN SYSTEM

Persia

ANCIENT SYSTEM

Romanesque

Assyria

Cardia

Greek

Asyrif

Gothic

Roman

Akinief

Egypt

Agni

Renaissance

Jew

Hittites

America

Art Nouveau

11.03 Systems of world architecture, from Itō Chūta, 'The Prospect of Japanese Architecture ...', *Kenchiku zasshi*, January 1909.

sub-system. At the furthest point from the Western system was Japan, perched perilously on the edge of the Eastern system and overlapping only with the Chinese sub-system.

As an architect designing buildings, Itō almost always remained within the Eastern system, even if only by the application of decorative details as a rebuff to Western architectural hegemony.[21] Although his Shinshū Shinto Life Insurance building, built in Kyoto in 1912, was very much a contemporary Western composition, being built of brick and stone with a domical corner tower,

pedimented window bays, arched carriage entrance and horizontal banding linking the upper-floor windows, the decoration and details were all Indian, as if it were a contemporary expression of Gandhāra architecture. In many ways it was no more Japanese than Conder's Museum in Ueno (1881) or his Rokumeikan (1883), both of which had heeded Thomas Roger Smith's advice regarding the appropriateness of Indian architecture for hot climates. Equally inspired by Asian architecture were the Shōgyō-den (1931), a repository for religious artefacts at Ichikawa, and the Tsukiji

11.04 The Tsukiji Hongan-ji temple in Tokyo Chūō-ku, designed by Itō Chūta, 1934.

Hongan-ji temple (1934) in Tokyo Chūō-ku: but whereas the Shōgyō-den was simply a Thai *stupa*, but now in reinforced concrete, the Tsukiji Hongan-ji temple, despite its raised *chaitya* hall roof and the *stupa* at either end, was a balanced Palladian elevation dressed in early Buddhist columns and Mughal arches upon a rusticated base [11.04]. When Itō did stray into the Western architectural language, as in the Umeda Hankyū railway station concourse in Osaka (1929), it was in an almost Secessionist manner which his students were travelling to Europe to investigate.

The one building which stretched Itō's Venn diagram to the extreme was the Kanematsu Auditorium at Hitotsubashi University, then the Tokyo University of Commerce,[22] in Kunitatchi, Tokyo [11.05]. The university's old buildings in

the former Kanda-ku district of Tokyo had been destroyed in the 1923 earthquake so, when the campus was relocated to Kunitatchi, the new auditorium, built in 1927, was constructed of reinforced concrete and clad with stone and clay tiles. Nevertheless, it was an historicist essay in Romanesque revival with quadripartite rib vaulting behind the entrance arcade, corbels beneath the eaves and round-headed windows in the central loggia and to the side. Within, where the cross-vaults along the side aisles are lit by Diocletian windows, a great barrel-vaulted hall reaches the length of the building, its transverse ribs decorated with terracotta (or similar) panels which also frame each bay. At the end, a massive Romanesque arch reaches across the stage. If a visitor from Europe were to happen upon the building unexpectedly,

11.05 The Kanematsu Auditorium, Hitotsubashi University, Tokyo, designed by Itō Chūta, 1937.

an examination of the monsters who inhabit the stiff-leaf foliage of the carved capitals would almost make them believe that this was the real thing. There were two reasons for this choice of style: the first was that, in Itō's diagram, Romanesque, like Greek, overlapped both the Greek (Western) and the Byzantine (Eastern) systems, thus putting it close to Gandhāra; and the other was that the Romanesque was the new collegiate style currently being advanced in the United States. In Los Angeles, the University of Southern California's Bovard Hall, designed in the Romanesque style by John and Donald Parkinson, had been completed in 1921 and was soon to be followed there, and at the University of California Los Angeles campus, by other buildings in that style.

The destruction caused by the Great Kantō Earthquake of 1923 brought Itō, now respected as an architectural historian and theorist, a flurry of commissions. In 1934 he rebuilt the Shogunal Taiseiden at the Yushima Shrine in Tokyo in reinforced concrete, having four years earlier employed a similar Buddhist style, in steel-frame and reinforced concrete, for the Memorial Temple to Great Disasters in Yokoamichō Park, Tokyo. But the most evolutionary of his buildings was the Tokyo Reconstruction Memorial Hall [11.06], also in Yokoamichō Park. Built in 1931 in the *teikan-yōshiki* or Imperial Crown Style, it presented a fusion of Western ideas with Eastern features. What could be understood, in terms of Western architecture, as a hexastyle portico is made up of rusticated

11.06 The Reconstruction Memorial Hall in Tokyo Sumida-ku, designed by Itō Chūta, 1931.

semi-hexagonal pilasters, the four central ones topped with stone dragons. Above this, stepped square-cut stone corbel-brackets support the Japanese glazed tile roof. Inside, the white, stone-clad columns of the reinforced concrete frame support deep beams on black stone strapworked capitals. Such stylistic references, although disguised, can be identified. But what is much clearer, so much so that it is probably not noticed today, is the manner in which the rectangular brick porch breaks out through the front of the building and how, down the side, the recessed window panels create a 12-bay colonnade in the buff-coloured brick wall. This is neither traditional Western nor Japanese architecture, but Modern architecture in its nascent form. As an architectural historian and teacher of architecture, Itō would have been aware of buildings such as Walter Gropius and Adolf Meyer's Model Factory for the 1914 Werkbund Exhibition in Cologne or even their Sommerfeld House in Berlin (1922). These were the sort of buildings that were attracting Itō's students to Europe and they seem to have had an influence on the Tokyo Reconstruction Memorial Hall as well.

Teikan-yōshiki

In his essay on 'The Future of Japanese Architecture' Itō recognised that, compared with the ancient timber structures which evolved into the stone

temples of Classical Greece, Japanese timber buildings were now sophisticated affairs so, in evolving that style into something of the twentieth century the change might appear regressive. But, he argued, this was a necessary process, 'just like a beautiful caterpillar becomes a cocoon before flourishing into a butterfly'.[23] This, in many ways, was *teikan-yōshiki*.

In 1926, the young architect Obi Karo had won the competition for the new Kanagawa Prefectural Government offices in Yokohama.[24] Intended to replace the building destroyed in the Great Kantō Earthquake, this large, symmetrical building, with two internal courtyards, a *porte cochère* beneath a pilastered central bay and a tall central tower above, was formal in the Western sense but undeniably oriental, if not actually Japanese, in appearance. Completed in 1928, this was the first major public building to adopt the *teikan-yōshiki* and, located close to the Yokohama waterfront where the ocean liners would dock and disembark their Western passengers, it demonstrated a noticeably new direction in Japanese architecture.[25]

A sense of nationalism was both explicit and implicit in the Gunjin Kaikan or Soldier's Public Hall in Tokyo, a barrack and training complex for

Imperial Army reserve soldiers [11.07]. Built as the result of an architectural competition in 1930 which asked for a building 'imbued with national essence',[26] the design by Kawamoto Ryōichi and Ono Takeo, on which Itō Chūta advised, featured, at the uppermost level, two stone-fronted, gabled rooftop pavilions with heavily bracketed eaves supporting a green, glazed-tile roof reminiscent of Buddhist temples as at Nikkō. Otherwise, the building was not dissimilar to the Kanagawa Prefectural Government offices and, like that building, presented a formal, Western elevation to the street: a stone plinth, pilastered central bay and attic storey above. As in that earlier building, its modern framed structure was easily identifiable through the regular placing of the windows within the stone and rusticated clay-tile elevations. Completed in 1936, the Soldiers' Public Hall was to be the headquarters for the martial law imposed following the February Incident in 1936, when junior army officers staged an unsuccessful coup d'état which, nevertheless, led to the military increasing its control over the civilian government. By this time Japan had occupied Manchuria, established the state of Manchukuo and withdrawn from the League of Nations.

11.07 The Gunjin Kaikan (Soldier's Public Hall) in Tokyo Kudan, designed by Kawamoto Ryōichi and Ono Takeo, 1934.

11.08 The Imperial Household Museum in Ueno Park, Tokyo, designed by Watanabe Hitoshi (Jin), 1938.

In civil architecture, *teikan-yōshiki* gained its greatest success in the new Imperial Household Museum in Ueno, Tokyo, won in competition by Watanabe Hitoshi (or Jin) in 1931 [11.08]. Conder's Museum in Ueno had been seriously damaged in the 1923 earthquake so, to commemorate the enthronement in 1928 of the Shōwa Emperor, a new building was proposed to house Eastern works of art. The conditions stipulated that the design had to be 'in an Eastern style that is based upon Japanese taste, so that it will preserve harmony with the contents of the museum'.[27] Completed in 1938, Watanabe's building was, in almost every way except for its appearance, a Western building.[28] It was axially arranged with a symmetrical plan and a *porte cochère*, and was constructed with a steel-frame and reinforced concrete structure. The two long, parallel pitched roofs, which from the end elevations gave the impression of a traditional castle, overhung

the attic storey, while the open roof of the *porte cochère* was an elaborate concrete simulation of timber construction. Inside, the marbled walls and Imperial stairs make for a palatial entrance lit from above by a glazed, coffered ceiling. The same type of ceiling lights the secondary stairs which, with their streamline details, appear particularly Modern. Only in the upper galleries, where the now exposed concrete structure supports the pitched roofs, is there any recollection of the building's external narrative.

Teikan-yōshiki came in for fierce criticism from Makino Masami, writing in *Kokusai kenchiku* in 1931. In an article rhetorically entitled 'Nationalistic Architecture or Architecture of National Disgrace?',[29] Makino argued that the architects who designed the so-called nationalist architecture imparted Japanese-ness only through the details of the building, such as the roofs, eaves and gables, and he ridiculed the application of traditional

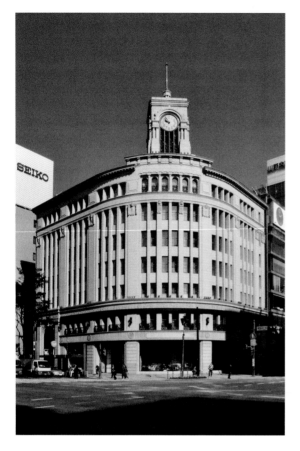

11.09 The K. Hattori and Co. Building (now Wakō Department Store) in Tokyo Ginza, designed by Watanabe Hitoshi (Jin), 1932.

being erected in Japan as being far more Japanese than what was currently being promoted through the *teikan-yōshiki* style.

The thinness of the *teikan-yōshiki* style can be understood by comparing Watanabe Jin's K. Hattori and Co. Building, now Wakō Department Store [11.09], in Ginza, Tokyo, with the Imperial Museum. The Hattori Building, which was completed in 1932, just as work on the museum was beginning, anticipated the museum's structure, and much of its Modern treatment internally. Only the external appearance differs, for the Hattori Building is now Italianate, of sorts, with a cupola, an arcaded loggia and a modillioned cornice: once again the architectural style is only skin deep. Watanabe was not bound by style or, it would seem, conviction. Two buildings which he also completed in 1938 could not have been more different. One, the Daiichi Life Insurance Building, designed with Matsumoto Yōsaku [11.10], stands across from the Imperial Palace in Hibiya and is stripped almost naked of its Classical costume in the manner of contemporaneous Italian Rationalism;[30] the other, the white-rendered Hara House in Gotenyama, Tokyo, has turned the corner into Modernism.

Japanese temple roofs to Western-style high-rise buildings. Makino, who had worked briefly for Le Corbusier in Paris, pointed out how Western architects analysed and understood, from only a few examples, the essence of Japanese architecture. He went on to say how they sometimes regarded their own International Style architecture as being far more Japanese than the *teikan-yōshiki* style, given that traditional Japanese architecture was both a true expression of structure and, due to its lack of ornamentation, purist; surface decoration, he added, was no more than a deception. Consequently, it would be more appropriate to recognise the new International Style buildings

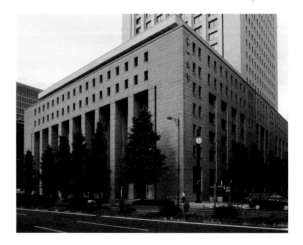

11.10 The Daiichi Life Insurance Building in Tokyo Hibiya, designed by Watanabe Hitoshi (Jin) and Matsumoto Yōsaku, 1938.

Bunriha

In February 1920, six young graduates of the Tokyo Imperial University founded *Bunriha Kenchikukai* – the Secessionist Architecture Association or Group. Enthused by Itō Chūta's teaching, they chose the word *Bunriha*, which means 'secession', to reflect the eponymous movement in turn-of-the-century Vienna. Their intention was to break away from the Western historicist architecture which was then still the standard fare of the Japanese architectural profession, and to replace it with a modern, Japanese (but not nationalist) architecture which responded to their concept of 'tradition'.[31] This they called *shinkenchiku*: new architecture. The group, more a loose collective than a cohesive organisation, was formed around Horiguchi Sutemi, Yamada Mamoru and Ishimoto Kikuji, who were joined by Yada Shigeru, Morita Keiichi and Takizawa Mayumi.

With an exhibition of their work held that year at the Shirokiya Department Store at Nihonbashi, Tokyo, they declared their intent:

We arise!

We breakaway from the realm of past architecture that we might create a new architectural realm where all of the architecture that we produce is given genuine significance.

We arise!

In order to awaken all that is sleeping in the realm of past architecture

In order to rescue all that is in the process of drowning

In a state of joy, we dedicate everything that we have to the attainment of this ideal and we will wait expectantly for it until we collapse and die

In unison, we declare this to the world![32]

As a manifesto, it had all the enthusiasm of Filippo Marinetti's *Futurist Manifesto* of 1909, but their work was not Futurist. What really caught their attention,

initially, were the Secessionist designs of Joseph Maria Olbrich and Josef Hoffman, the German Expressionism of Peter Behrens, Hans Poelzig, Erich Mendelsohn and Bruno Taut, and, after visiting Europe themselves, the work of the Amsterdam School and the Bauhaus.

Indicative of the extreme position the members of the group were taking was Ishimoto's graduation project for a family ossuary, a smooth, symmetrical, plastic design devoid of almost any detail. Also included in the exhibition was Yada's graduation project for a community hall for an artists' colony which not only appeared to be based on the stripped Classicism of Hoffman's Palais Stoclet in Brussels (1911) but, in its title, made reference to the artists' colony at Darmstadt where, in 1908, Olbrich had built the Mathildenhöhe Wedding Tower. This tower then became the model for Horiguchi's short-lived Memorial Tower erected at the 1922 Peace Exhibition in Ueno Park. By the time Horiguchi first saw the Mathildenhöhe Wedding Tower in 1923, his Memorial Tower had been demolished. What this demonstrates is the effectiveness of the architectural press as a conveyor of architectural ideas.

Bunriha's second exhibition, held in 1921, included a project for a mountain hut by Takizawa which, like Ishimoto's family ossuary, could well have been influenced by the Einstein Tower at Potsdam, built by Erich Mendelsohn in 1919–21.[33] Also shown was a design for an office building which Yamada, now working for the Ministry of Communications, built as the Central Telegraph Office in Tokyo in 1925. Comprising two parallel, barrel-vaulted wings separated by a rectangular block where the windows were set deep between tall piers and beneath an overhanging cornice, this large reinforced concrete structure was given vibrant expression by a series of parabolic cross-vaults, reminiscent of those at the Grosse Schauspielhaus, a theatre recreated from an old market building in Berlin by Hans Poelzig in 1919. It also recalls, in its vaulted roof construction, as well as its

choice of material, the unsuccessful entry for the 1902 Liverpool Anglican Cathedral competition submitted by the Arts and Crafts team of Henry Wilson, William Richard Lethaby and others. It is unlikely, however, that Yamada would have known of this design, and would only have known the Grosse Schauspielhaus from published illustrations in German architectural journals such as *Frülicht* or in Moriguchi Tari's *Collection of Expressionist Architecture*, published in Tokyo in 1923.[34] He was not to visit Europe until 1928 and when he did eventually see the building, which was painted red, he found that its 'colours and materiality in real life were a great disappointment'.[35]

Horiguchi had visited Europe a few years earlier, in 1923.[36] Although he intended to study architecture in Germany, the unsettled state of the country following the Great War and the effect of the Great Kantō Earthquake brought him home after six months. However, in his desire to see the new European architecture, he travelled in France, Belgium, Germany and Austria, but it was the Netherlands which interested him most. Although he would have known of Modernist Dutch architecture through Theo van Doesburg's journal *De Stijl*, he found in the Expressionist work of the Amsterdam school an unexpected resonance with the rustic qualities of the Japanese *sukiya* style, as evidenced at Katsura. This observation, which suggested to him the Modernist qualities of Katsura, were the same as those made by Bruno Taut, but with much greater effect, a decade later. Horiguchi's book, *Gendai Oranda kenchiku* (Contemporary Dutch Architecture), published in 1924, was a paean to his European trip. With a cover design copied from the German journal *Wendingen*'s special issue on Mendelsohn, published in January 1921, and its contents comprising images 'borrowed' from other sources, it was very much an acknowledgement of the old connections between the Netherlands and Japan and the conscious and unconscious parallels in architecture and design.

Completed in 1924, and therefore too recent to be included in *Gendai Oranda kenchiku*, the Schröder House in Utrecht, designed by Gerrit Rietveld,

demonstrates clearly what Horiguchi recognised as familiar in the emergent *De Stijl* architecture. The Dutch, it should be remembered, could claim, more than any other Western country, a long-time knowledge of traditional Japanese architecture: *ukiyo-e* had been available for hundreds of years and, since 1818, the model of the Dutch settlement at Dejima had been in the collection of the Royal Cabinet of Antiquities in The Hague. At the Schröder House the lapped joints of traditional Japanese frame construction are recalled in the way the coloured steel columns extend past the thin concrete balcony and roof slabs which they support, and the shifted grey-and-white planes of the external walls read like *shōji* or *amado*, sometimes open, sometimes closed, suggesting the layered lightweight walling of the Japanese house. Inside, the ground floor is cellular, divided by solid walls, but the upper floor is flexible, a planar arrangement subdivided by the moveable walls which slide back to create a series of interlocking spaces.

For Horiguchi, the European tour was an opportunity to see the new, but, like any young man in a totally alien culture, it was also an opportunity to find reassurance in the familiar. The architecture of the Amsterdam school of design, as distinct to that of *De Stijl*, was organic, often using rough and rustic materials, gentle forms and vernacular references. In 1915 the Dutch industrialist Arnold Heystee had asked Frederick Staal to plan a colony of 17 houses at Park Meerwijk in Bergen. Together with his friends, including Margaret Kropholler, whom he later married, and Piet Kramer, who went on to build the de Degeraad housing (1920–23) in south Amsterdam, he built a series of single, double and triple houses with irregular, rough brick walls, small-paned windows in heavy wooden frames, and copiously thatched roofs.[37] Like the studio house near Achtmaal which Kropholler built in 1919 for the Dutch romantic writer Adriaan Roland Holst, they were both modern and traditional, Expressionist and vernacular. These were a revelation to Horiguchi. He saw how the bricks, as in Japan, were uneven and not properly fired, and was very much surprised by the use of thatch. 'I never thought I would go to Europe and see an assemblage of thatched roofs,'

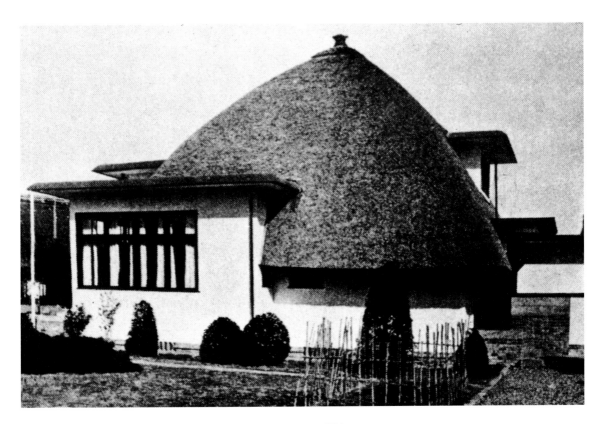

11.11 The Villa Shien-sō at Warabi, designed by Horiguchi Sutemi, 1926.

he said. 'However, the effect was to open my heart to *sukiya* design.'[38] Compared with traditional thatched Japanese houses, these buildings showed just how sculptural and Expressionist thatch could be.

Sukiya was the style of the Katsura and of Japanese tea-houses: if the thatched roofs and rough brickwork of these Dutch Expressionist buildings showed Horiguchi what was possible within the Modernist canon, his almost Damascene experience at the Parthenon in Athens confirmed this. Standing there on the Acropolis in 1923 – the same year as Le Corbusier presented the Parthenon as an argument for Modernism in *Vers une architecture* – he realised that the fallen Doric columns which lay in front of him were the architecture of Greece and not of his country. As Itō had demonstrated through his study of the Hōryū-ji and argued in his world view of architecture, Classical Greece was the genesis for the

architecture of both the West and the East, but as it developed in the East, and in Japan, it had taken on its own forms and meaning. 'From that standpoint,' Horiguchi said, 'I newly became aware of the classics that came to my mind: Japan's tradition of the *sukiya* style – Katsura Villa, Myōki-an Teahouse ... and so on.'[39] This realisation soon manifested itself in a small rural retreat of 1927, built for Makita Seinoskue at Warabi and known as Shien-sō – purple haze [11.11]. With its sculptural thatched roof and white external walls edged in black, its framed interior panelling and circular windows, it was a fusion of Eastern and Western sympathies, of the *sōan* (thatched cottage) tea-house and the *Shōi-ken* tea-house at Katsura, and of Margaret Kropholler's Dutch Expressionism from Meerwijk and Josef Hoffmann's Viennese Secessionism from the Palais Stoclet in Brussels. In contrast to *teikan-yōshiki*, this

was traditional without being nationalistic, while at the same time it was unashamedly modern.

German, rather than Dutch, Expressionism was to feature strongly in Ishimoto Kikuji's architecture. Ishimoto had gone to Germany in 1921–22 to work for Walter Gropius but, following his return, it was the influence of Hans Poelzig, rather than Gropius, which was initially apparent. His book *Kenchiku-fu* (Symphonic Architecture),[40] published in 1924 soon after his return, included Poelzig's proposal for the Salzburg Festspielhaus (1922) and this might have further influenced Yamada in his design for the Central Telegraph Office in Tokyo. His 1927 design for the Tokyo Asahi Newspaper Offices in Tokyo [Plate 15], a large and complex concrete-framed structure, contained more than a reference to Poelzig's Milch Chemical Factory of 1911 at Lubon, near Poznan. The semi-circular windows are a clear acknowledgement of that precedent, but it is the manner in which, on the rear elevation, the heavily corniced roofs step down from a corner tower which really shows the influence. Both buildings are irregular in outline, the functional requirements of

the manufacturing process, as much as the shape of the site, controlling their massing.

It is again the influence of Poelzig which comes through in the presentation drawing for the Shirokiya Department Store in Tokyo Nihonbashi, which Okamura Bunzō (later known as Yamaguchi Bunzō), a latecomer to the *Bunriha* group and then working for Ishimoto, drew up in 1927 [11.12]. Like Tokyo's (and Asia's) largest building, the similarly round-cornered Marunouchi or Marubiru Building, designed by Sakurai Kotarō and built for the Mitsubishi Corporation by the Fuller Construction Company[41] in 1922, the Shirokiya building has a triple-arched entrance but here the references stopped. For whereas the Marunouchi is, like Louis Sullivan's Carson Pirie Scott Department Store in Chicago (1899), vertically arranged in the Classical manner with a rusticated base, a variable number of intermediate floors, and an attic storey beneath an overhanging cornice, the Shirokiya building is horizontally layered, the lines of the floor-plates sweeping unencumbered around the corner in the manner of Poelzig's Junkernstrasse office building[42] built in Breslau in 1913.

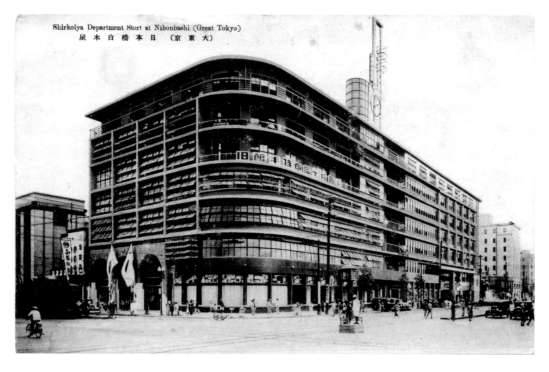

11.12 The Shirokiya Department Store in Tokyo Nihonbashi, designed by Ishimoto Kikuji and Okamura Bunzō, 1931.

When completed in 1931, the Shirokiya building did not extend to its full length as projected, yet what was built was even more Expressionist than Okamura's perspective drawing had suggested. Once again the influence could be Poelzig,[43] for the richness of the faïence-like finish applied to the interior as well as to the entrance arches recalls the Grosse Schauspielhaus or even the glazed brick exterior of his Haus des Rundfunks in Berlin (1930). Yet curiously there are, as at Horiguchi's Shien-sō, grids of rounded windows which take the mind straight back to Katsura. This return to traditional Japanese sources recalls Okamura's enthusiasm, expressed in the 1924 *Bunriha* exhibition catalogue, for the rejection of 'the conventions and rigid customs' of Western architecture: 'Let us restore the world to its original state of long ago; reform from that point forward and dance out into the heaven of creation.'[44] Okamura's concurrent involvement with the *Sōu-sha* group, founded in 1923, who initially demanded the promotion of Rationalist design, was ultimately directed, through an increasingly Marxist dialectic, at social as much as at architectural change. Thus the group found inspiration in the *Siedlungen* designed by Gropius, Ernst May and Bruno Taut and designed their own Modernist housing for Japanese textile workers.

The Bauhaus

The Japanese interest in German architecture, which had started when Ende and Böckmann had come to Tokyo 40 years earlier, was manifest in the small number of architects who went to work or study in Germany following the Great War. Ishimoto, as noted, had worked for Walter Gropius in 1921–22 and Yamaguchi followed him there in 1930–32. Yamada Mamoru visited Germany as part of his world tour of 1928–29 and even attended the 1929 CIAM meeting in Frankfurt. Ostensibly there to research post and telegraph offices, Yamada studied German in Berlin for three months and met Mendelsohn as well as Gropius, Hugo Härring

and Hans Scharoun. The first Japanese to visit the Bauhaus, when it was at Weimar, was Nakata Teinosuke[45] in 1923. He started publishing articles such as 'State Bauhaus' and 'Bauhaus Postscripts'[46] the following year, and in 1927, Okada Takao published a lengthy double article on Gropius and the Bauhaus in *Shinkenchiku*.[47] Horiguchi had already written briefly about the Weimar Bauhaus in *Kenchiku gahō*,[48] showing an axonometric drawing and a photograph of Gropius's office; the same illustrations were used again in *Buahausu Waimāru hen*, a small booklet of 20 plates and three pages of text published in the series *Kenchiku jidai* (Era of Architecture) in 1929.[49] The latter also included Georg Muche's Haus am Horn, built for the 1923 Bauhaus exhibition in Weimar, but by the time that booklet appeared, the school had moved to Dessau.[50]

It was at Dessau that Mitzutani Takehiko took Joseph Albers's preliminary course in 1927; he was the first Japanese to enrol at the Bauhaus and was student no.150.[51] In 1930 Yamawaki Iwao enrolled as student no.469, with his wife Michiko as no.470.[52] Although, as an architect, Yamawaki had gone there to specialise in construction and development, he was drawn to the study of photography under Walter Peterhans. Meanwhile Michiko studied textiles. Yamawaki arrived in Dessau in the same week in August 1930 as the Director of the Bauhaus, Hannes Meyer, was sacked. His reports and letters recall the time well:

> Directed by a railroad employee, I crossed the bridge. Following along the railroad tracks for about two blocks, past the roofs of scattered buildings of red brick, there entered into my vision the white building of the Bauhaus with which I was very familiar through photographs. Under the noon sun, the brass railing of the dormitory was glistening yellow. The window was open and a red mattress was being dried. In the empty lot to the left of the building I could see two white poles, high-jump poles, perhaps, standing as if waiting for someone. At the entrance was an abandoned bicycle.[53]

In his report of 6 September 1930 he records how, on Gropius's recommendation, the decision was made to appoint Mies van der Rohe as the next Director. The school, he later wrote, was 'in quite a turmoil',[54] but by that December he could write that things had normalised and Mies had settled in:

> With the *Weihnachtsfest* of four or five days ago, the entire atmosphere seems to have mellowed. That night not only the male and female students, but the director and even the daughter of the doorkeeper, participated in the merrymaking, dancing until nearly dawn in outrageous, skimpy clothing. And Mies van der Rohe danced around with them from dusk until the departure of the last person.[55]

In his final report of 4 September 1932, he wrote:

> Today, after a stay of over two years, I have encountered the opportunity to write about the end of the Bauhaus ... The Bauhaus that was driven from Weimar in 1925 because of the National Socialist Party, was now, after seven years, driven again from Dessau by the National Socialist Party. The Dessau Bauhaus has been completely trampled upon. But I think that the Bauhaus-like force that has been disseminated throughout the world will, in some form or other, rear its head once again in the world of plastic arts.[56]

Yamawaki recorded the event in a photo-collage, just as he had described it in his report. Published in *Kokusai kenchiku* in December 1932 as 'Der Schlag gegen das Bauhaus' (The Attack on the Bauhaus), it shows a Nazi Party official in jack-boots trampling across the building [11.13].

There was, in Japan, a curious and equally short-lived parallel to the Bauhaus. In 1931,

11.13 'Der Schlag gegen das Bauhaus' [The Attack on the Bauhaus] by Yamawaki Iwao, from *Kokusai Kenchiku*, December 1932.

Kawakita Renshichirō, an architect and friend of Yamawaki, founded the School of New Architecture and Industrial Arts in Ginza.[57] The intention was to introduce Bauhaus design theories to Japan – indeed, Yamawaki and his wife Michiko did some teaching – but, like the Bauhaus, it was neither understood nor approved of at the time. Refused a permit by the Ministry of Education, and amid rising nationalist sentiment, the school was forced to close down in 1936.[58]

SHŌWA

12 THE ARTIST-SAMURAI

International Architecture

In the first Bauhaus book, called *Internationale Architektur*, based upon the 1923 Bauhaus exhibition and published in 1925, Walter Gropius wrote:

> In Modern architecture, the objectification of the personal and the national is clearly recognizable. Impelled by world-wide trade and technology, a unification of modern architectural characteristics is progressing in all civilized lands, across the natural borders to which peoples and individuals remain bound.

> Architecture is always national, always individual, too; but of the three concentric circles – individuality, nationality, humanity – the last category includes both of the others. Therefore the title: 'INTERNATIONAL ARCHITECTURE'.[1]

Coincident with this, the eponymous international architectural journal *Kokusai kenchiku* was launched in Japan in 1925, publishing the work of foreign architects alongside that of Japanese,[2] and in July 1927, in Kyoto, the International Architecture Association of Japan (Nihon Intānashonaru Kenchiku-kai) was founded. This was the effort of six architects from the Kyoto/Osaka region, including Ishimoto Kikuji, Motono Seigo and Ueno Isaburō.[3] In their manifesto, they declared that they would 'think of

human survival when we try to solve basic problems arising in the future course of our architecture [and] design a style appropriate to the new life that emerges with the progress of mankind'.[4] In April 1930, those European architects whose work had been of the greatest influence in Japan – Peter Behrens, Josef Hoffman, Erich Mendelsohn, Gerrit Rietveld, Bruno Taut and Walter Gropius, as well as André Lurçat, Richard Neutra, Jacobus Johannes Pieter (J.J.P) Oud and Jan Wills – were invited to join. Although Neutra, who had worked with Mendelsohn in Berlin in 1921–23, had now moved to America and was living in Los Angeles, the others of this influential group were still active in Europe.

Richard Neutra

In May 1930, soon after completing the Lovell Health House in Los Angeles, Austrian-born Richard Neutra left California for Europe: he was to attend the third CIAM meeting in Brussels. But rather than travel eastward, he took the cheaper route, saving $150, and went west, stopping off for two weeks in Japan.[5] While working for Frank Lloyd Wright at Taliesin in Wisconsin, between November 1924 and January 1925, Neutra had become friendly with Tsuchiura

Kameki and his wife Nobuko, whose drawing boards were respectively next to and behind his in the Taliesin drawing office.[6] In anticipation of Neutra's arrival in Japan, the Tsuchiuras had arranged for him to give a lecture in Tokyo, sponsored by Kokusai Kenchiku Kyōkai, the publishers of *Kosukai kenchiku*. The lecture was mentioned in the 'News' column of *Kenchiku zasshi*'s June issue,[7] and the following month *Kokusai kenchiku* published an essay by Neutra together with articles on Neutra and his work in America by Kishida Hideto and Tsuchiura Kameki.[8]

The lecture, entitled 'Modern Architecture as an Idea and in Practice',[9] was delivered at the Kokumin-shinbunsha Hall in Tokyo on 11 June 1930, with Tsuchiura acting as an interpreter. 'I was a bit dumbfounded,' he later wrote, 'seeing so many listeners crowded in a huge hall when I spoke of a new architecture we might share in the future.'[10] In an expression of self-deprecating modesty which contrasted with the considerable publicity which his visit to Japan had generated, Neutra stated that the design of this new architecture should be a collective as opposed to an individual effort and should be anonymous, like the design of a ship or aeroplane. 'We do demand a cooperative, devoted scholar,' he said, 'rather than a famous architect.'[11] The cooperative anonymity brought to architecture by standardisation and industrialisation was something which he recognised in the use of the modular *tatami* mats in traditional Japanese architecture. Observing the ubiquity of the *tatami* during his visit to Japan, he later wrote, 'the rich and the poor, the urban wealthy and the peasant, all had the same standard dimensions, from *tatami* floor mats, sliding door panels, to *tansu*, as simple and normalized as they were superbly neat. I had been striving for all that, and I was no longer alone.'[12]

One of those who heard the lecture was Maekawa Kunio, freshly returned from Le Corbusier's office in Paris. The next day he wrote to Neutra:

The only thing that I've learned in Europe is that so long as the architects of today will be adhering to their rather romantic title which is 'architect' and which accompanies often so ridiculously

heroic childish glory, the modern architecture in its most correct sense never will be obtained ...

Maekawa then declared eternal friendship and collaboration, adding, 'I was so happy last night to have found one more comrade who are you.'[13] Maekawa's hopes for collaboration had already been the *modus operandi* between Tsuchiura and both Neutra and Rudolph Schindler. The Tsuchiuras had got to know Rudolph and Pauline Schindler while working for Wright in California in 1923, and had been frequent visitors to their house on Kings Road, Hollywood, which Tsuchiura Kameki regarded as 'primitive and revealing the basis of architecture'.[14] Neutra's long-time friendship with the Schindlers presumably only helped bond that connection for they all spent Christmas together at Kings Road in 1925, soon before the Tsuchiuras returned to Japan.[15] When still at Taliesin East in December 1924, Tsuchiura Kameki had written to Schindler to request photographs and drawings of the Pueblo Rivera Court in La Jolla[16] and a few months after his return to Japan, Neutra had written to him asking, '... do you want to send me some of your work for European publications?'[17] There was, indeed, a sense of comradeship between these young Modernists, not least because of their equally distant location on the Pacific rim, both eastward and westward, from the heart of Modernism which was then still firmly located in Europe. 'Progressively-minded architects like us,' Neutra added to his letter to Tsuchiura Kameki, 'are still so few that we should combine our forces in working international propaganda.'[18]

Throughout his tour of Japan, Neutra was accompanied by his Modernist hosts and what he saw, as he wrote to his wife Dione, was 'a confusion of contemporary buildings, many pseudo-modern and of adventurous ideas ... It seems every where the place teems with new experiments.'[19] In Tokyo, where Ishimoto Kikuji showed him the Asahi Newspaper Offices and the Shirokiya Department Store, he was accompanied by Yamada Mamoru, Koyama Masakazu (the editor of *Kokusai kenchiku*), and Tsuchiura Kameki; in Kamakura, where Ishimoto showed him his Asahi Clubhouse, then barely completed, he was accompanied by Tsuchiura

Nobuko and Yoshida Tetsurō; and in Kyoto, where he was accompanied once again by Ishimoto, he met Ueno Isaburō[20] and his Viennese wife, the wallpaper and textile designer Felice Rix, as well as Motono Seigo whose prototypical concrete block house of 1924 he visited.

In Osaka, where on 17 June he gave a second lecture, this one on 'New Architecture, International Architecture',[21] Neutra visited the huge Municipal Market building, recently erected by the city architect, Senobe and the engineer, Sadao Karaki. It was, Neutra thought, 'a magnificent steel and reinforced concrete raw structure'.[22] He illustrated it in a short article he wrote on 'Current Construction in Japan' for *Die Form* in January 1931. The article dealt more with industry and politics than architecture, noting that 'There is political and personal sympathy for Germany [and] some cooling against England since the strange construction of the battleship base of Singapore.'[23] The 'Singapore strategy' to which Neutra refers was to be central to British Imperial defence policy in the Far East in the 1920s and 1930s but, as the events of 1942 were to show, proved to be quite inadequate. Unexplained in the text, but clearly illustrated by photographs, was an electrical testing office by Yamada Mamoru and an electrical laboratory by Yoshida Tetsurō, both for the Ministry of Transportation.[24] There were also, in addition, elevations for a meteorological station on Kyushu by Horiguchi Sutemi, built in 1931,[25] and plans and elevations by Ishimoto Kikuji for the Haneda Airport office in Tokyo, completed in 1932.

The growing interest in Germany, to which Neutra alluded, was soon reflected in a large exhibition of 'New German Architecture and Crafts' held at the Matsuzakaya Department Store at Ueno, Tokyo, from 14 to 29 May 1932. The council membership for the exhibition included representatives of the Ministry of Foreign Affairs, the Ministry of Education and the German Embassy, as well as the President of the Imperial Art Academy, which attests to the political as well as cultural importance of this event. The record of the show, compiled by the Architectural Institute of Japan and the Japan-German Cultural Association, was published as three volumes which contained dozens of illustrations of both contemporary German buildings as well as modern furniture and photographs of the exhibition itself.[26] Although some of the display, particularly that part showing building materials and equipment, was a rather chaotic arrangement of models, photographs and artefacts, the furniture, which included Mies van der Rohe's MR Chair (1926) and Marcel Breuer's Lounge Chair (1928), was usually shown on stands or in neat domestic-interior displays. The architecture, however, was presented as large black and white photographs run horizontally in two rows across the white display screens, but separated from the visitor, rather incongruously, by a small wooden fence. Such an innovative approach to photographic display had been taken by Mies van der Rohe and Lilly Reich in their exhibition *Die Wohnung Unserer Zeit* (The Dwelling in Our Time) held by the Deutsche Werkbund in Berlin in May to July 1931 and copied by Henry-Russell Hitchcock and Philip Johnson for their *Modern Architecture* exhibition at the Museum of Modern Art in New York in February and March 1932.[27] Thus the 'New German Architecture and Crafts' exhibition which opened at the Matsuzakaya Department Store only a few weeks after the MOMA show closed was about as fresh, in terms of architectural display, as anyone could have hoped. The architecture itself, however, was fairly catholic in its selection, such as the work of Paul Bonatz which ranged from the powerful stripped Romanesque of his Stuttgart Railway Station (1913–27) to his much more Futurist reinforced-concrete dam and bridge on the Neckar river at Grondelsheim (1932–35). Lectures were also on the programme: Takeda Goichi, Kishida Hideto and Kurata Chikatada, a later member of the *Bunriha* group who had worked for Gropius, all spoke on German architecture, while Yamada Mamoru spoke on German 'Siedlung', and Kume Gonkurō, who had studied at the Technical University Stuttgart from 1925 to 1928, spoke on building materials in Germany. Kume's 1929 doctoral dissertation, not coincidentally, was on Bonatz, for whom he had also worked.[28]

Neutra's second and third articles on Japan, published in *Die Form* in March and September 1931, dealt respectively with Japanese dwellings and new

Japanese architecture. In the first, entitled 'Japanese Dwellings, Developments, Difficulties', he recorded, in plan, the four-storey Momonoki-Ura municipal workers' housing in Osaka where the tightly planned apartments, arranged around a U-shaped courtyard, each measured 22.5 × 12.6 *shaku* (6.75 × 3.78 metres), with a washhouse shared by eight dwellings on the roof. In comparing these to the traditional, albeit contemporaneous Japanese house, where everything, from the *tatami* mats to the *tansu*, was modular and everything fitted, he appears to regret the mediocre uniformity of the modern workers' housing which he noted was 'very populated, quickly deteriorating'.[29] As he pointed out, since the school boards prohibited the wearing of Japanese hairstyles and clothes, and made the children sit on seats so that their lower leg did not warp, the *tatami* mats and the *tansu* had disappeared along with the *geta* and the *tabi*. Consequently, 'the Japanese house', he wrote, 'loses its functional scale, its functional features, its functional authority. It almost completely disappears without trace with the approach of new design tools and materials and accessories such as concrete, steel, glass windows, double-sided swing doors, wall and floor coverings, and kitchen and bathroom décor'.[30] Although the caption, written in German, French and English, says simply 'Small dwellings in Tokyo', Neutra illustrates with three photographs the Harajuku or Aoyama Apartments on Omotesandō in Shibuya, Tokyo, built by the Dōjunkai Housing Corporation in 1926. These concrete-framed apartments, with their canopied balconies and metal windows, were slightly larger than the Momonoki-Ura apartments in Osaka, measuring 8 × 5 metres (26.6 × 15 *shaku*) internally. Established in 1924, following the Great Kantō Earthquake, the Zaidan-hōjin Dōjunkai built 13 such concrete apartment complexes in Tokyo under the supervision of the Home Ministry (Naimu-shō). A very small section of the Omotesandō housing has been preserved.

Although Neutra's tour of Japan took in Nikkō, Hakone, Kyoto (where he 'thought the Kiyomizu temple to be the most beautiful'[31]), Nara and Kamakura, places best known for their shrines and temples, his third and final article in *Die Form*, 'Neue Architektur in Japan', concentrated on the modern. Here he wrote enthusiastically about the 'wonderful plans for useful and well-laid-out streets, traffic designs, proper zoning laws, and small house districts',[32] but also recognised the primitive state of the Japanese building industry and the difficulties it had with producing Modern architecture to a lasting standard. Stucco, he observed, would be unreliable in a climate considerably wetter than that of the Netherlands, yet the Japanese building industry had not developed the alternatives, terracotta or metal cladding, to an adequate standard. However, he was complimentary about the use of ceramic tiles by Horiguchi in his house for Grafen Kittsukawa [*sic*] (Kikkawa Motoaki, known also as Kitsukawa or Yoshikawa) near Tokyo, which he illustrated.[33] The other illustrations, which show over a dozen different buildings through both photographs and plans, are quite independent of the text and range from the Asahi Clubhouse in Kamakura (1929) and the Mori office building in Osaka (*c.* 1929), both by Ishimoto, to the Star Bar in Kyoto by Isaborō (1930) and two houses, one each by Tsuchiura Kameki and Nobuku. Nobuku's house was actually a competition-winning design for a small house and, like her husband's built design, shows no lasting influence from Frank Lloyd Wright but rather demonstrates an allegiance to European Modernism, its spaces being small and cellular, its form cubic and its appearance stuccoed or, more likely, ceramic-tiled.

What Neutra saw in Japan appeared to satisfy a deep sense of need or perhaps rightness. Like Wright before him, and Bruno Taut and Walter Gropius after him, he found what he was looking for. But, unlike them, it was for him not so much a confirmation of his own intentions, or a justification of his own work, but a reflection of what he had always thought to be the truth. Writing of Japan in his meditative autobiography *Life and Shape* 30 years later, he commented: 'All was so unbelievably different from my own background, and yet so close to my feelings of treating space and nature or giving emphasis often only by surrounding restraint.'[34] And then he added, almost with a sense of relief: 'Detailing and finishing were as simple and normalized as they were superbly neat. I have been striving for all that, and I was no longer alone.'[35]

Wells Coates, Serge Chermayeff and the Artist-Samurai

A little over a month after *Die Form* carried Neutra's third article, 'Neue Architektur in Japan', an article entitled 'Inspiration from Japan' appeared in the London-based *Architects' Journal* and declared:

> Sound design has existed in Japan for centuries. It is an architecture which could not possibly be imitated in the European climate; it is an *inspiration*, not a *precedent*. Its principles, however (which are similar to our own), are easily apprehended.[36]

Its author, Wells Coates, would have known, for he was born in Tokyo to Canadian Methodist missionary parents and was 17 when, in 1913, he left the country for the first and last time. He was not brought up, as he later wrote, 'with a "British" bias – or even a "white" one',[37] and Japan was to be a constant source of reference in his work and a continual influence on his domestic lifestyle. His upbringing there had been immersed in the culture and the peoples to which his parents, as missionaries and teachers, had dedicated their lives. His education was unconventional, as he later told the BBC:

> No schools for English-speaking children existed in Japan at that time ... Manual (eye-and-hand) training formed a large part of my early education. I was put at an early age under the tutorship of a Japanese Painting Master, who taught me to draw with a brush, and of a Japanese Architect-Builder, who taught me the principles of his art, and the way to use a craftsman's tools ...[38]

He was later tutored by George Edward Luckman[a] Gauntlett, a Welshman and a Canadian church missionary who, as well as inventing the first Japanese shorthand, was a founding member, in 1906, of the Japanese Esperanto Society. Coates was probably also home-educated by his mother, Agnes

Wintemute Coates, who was later a teacher at the Jiyū Gakuen in Toshima-ku, Tokyo. Although Frank Lloyd Wright was not to build the school's Myōnichi-kan until a decade after Coates had left Japan, it is likely that his mother, who had reputedly trained as an architect under Louis Sullivan in Chicago,[39] wrote to him about it. However, his interest in architecture must have started at an early age: his 1909 diary, entitled 'Sights and Experiences of Japan', records, with annotated sketch plans, the family visit to Katayama Tōkuma's newly completed Tōgū Gosho where, 'in the grand parlor, one of the most beautiful of all the rooms ... there were sixteen pillars of salmon pink marble and streaked with light green'.[40] Yet, when he was about to leave Japan for the West, his mother told him:

> If you still think you want to be an architect, I give you this advice – don't stay at an architecture school longer than you can bear it – study engineering.[41]

It was advice well taken for in Canada, at McGill University College, Vancouver, he studied structural and mechanical engineering before moving to the University of London to take a PhD, in 1924, on 'The Gas Temperature of the Diesel Cycle'. His significant work as a designer of interiors, and subsequently whole buildings, is, with the exception of the AIROH aluminium bungalow (1945–48) and the Telekinema and Television Pavilion for the 1951 Festival of Britain, almost totally confined to the 1930s and England. Thus it was coincident with Neutra's and then Bruno Taut's 'discovery' of Japan, but the lessons of that country had been long learned and were deeply embedded in his psyche.

After Coates's death from a heart attack while swimming off Vancouver beach in 1958, Walter Gropius wrote to his daughter Laura:

> I wish you could have been with us when he visited us after we had just returned from Japan. It was as if a door to a secret room had suddenly been opened and he became more and more entranced after our remarks about Japanese culture had started a whole reaction in himself.

His deep tenderness for his early Oriental experiences made him really glow ...[42]

In using Japanese architecture as an *inspiration*, rather than a precedent, Coates demonstrated a wholly new approach to making architecture. Unlike the Japonisme of the late-nineteenth century, where the Japanese influence was largely decorative, or the more recent work of Frank Lloyd Wright, Rudolph Schindler or the Greene brothers, where it was apparent in both the spatial and structural arrangements of the buildings, in Coates's work it was found in the way the buildings were used. For none of his buildings, at first glance, could be thought of as Japanese, yet a Japanese person visiting one might feel immediately at home in the environment which Coates created.

The clue to Coates's success was in the incorporation, within the Western building tradition of concrete, masonry and steel construction, of the principal elements of the Japanese house: the *shōji* and *fusuma*, the *takonoma* and *engawa*, the *tatami* and *tansu*. In writing in *The Architectural Review* about his own studio flat at 18 Yeoman's Row, London, he said, 'I do not like big sofas and easy chairs, so I make a hearth scene, à la japonais, penned off by a shaped fitting which is a bookcase on one side and a back-rest for the cushions on the other.'[43] This space, which he completed in 1936 and then lived in for the next 20 years, incorporated *tatami* and *tansu*: Patrick Gwynne, who worked for Wells and was his principal assistant on this job, observed, 'Everyone except Wells, who could happily squat eastern style, [was] very uncomfortable on the padded seating area but not daring to say so' [12.01].[44] The flat, which measured just 37 × 19 feet (11.1 × 5.7 metres), with a 12 feet (3.6 metres) high ceiling, was, in the manner of Japanese houses, a kinetic space. Sliding doors were employed, like *fusuma*, to separate the kitchen and cocktail bar from the hallway, and the 'dressing cupboard' from the bathroom; the typing desk could be rolled back into the long sideboard or *ji-bukuro*, while the ladder to the guest sleeping balcony could be retracted to allow the serving trolley to roll out into the dining area from its housing beneath the kitchen

12.01
The top-floor studio flat at 18 Yeoman's Row, Knightsbridge, London, designed for himself by Wells Coates, 1936.

counter. The mezzanine, which incorporated the bathroom and entrance hall below and the sleeping balcony above, was an example of what Coates promoted in *The Architectural Review* as 'Planning in Section': 'Your programme,' he wrote, 'demands that the largest possible space of full ceiling height is available for "living" in. You do not want a "separate" bedroom (although the design allows for it, if this is to be a condition.) Your furniture and equipment is to be an integral part of the design, planned to enclose every cubic inch of space, and disposed to use and convenience, at every point.'[45] Yet it was also absolutely in the tradition of the Japanese *minka*, where, within the single-storey building, a ladder would give access to the storage space on a mezzanine within the pitched roof.

Wells Coates's ability to plan a tight space, as at 18 Yeoman's Row, was no better demonstrated than in the single-person flats intended for modern professionals which he designed for Isokon at Lawn Road, Hampstead, in 1934. Isokon Ltd had been formed in 1931 by Jack Pritchard and his wife Molly,[46] with Coates as its consultant architect.[47] The name Isokon, a conflation of *isometric* and *unit construction*, is immediately suggestive of Coates's influence. *Isometric*, the form of graphic projection where all lines are to scale, is often favoured by engineers[48] as a method of accurately depicting three-dimensional form but, in the absence of perspective, it was also the manner in which buildings were shown on painted *byōbu* as early as the sixteenth century; similarly, *unit construction* might be regarded as equally Japanese where the *tatami* mat is the basic modular unit for all traditional Japanese houses. As he told students at the University of British Columbia in 1957, the Japanese architect-builder to whom he was entrusted also taught him 'the skills of shaping materials into elements of structure, and the arts of regulation of dimensions pleasing to the eye and to the mind'.[49]

The Minimum Flat (as it became known) at Lawn Road measured just 17 feet 8 inches (5.3 metres) by 15 feet 4 inches (4.6 metres), yet accommodated a bed-sitting room, kitchen, bathroom and dressing room, with the other spaces, as in the Japanese house, retained in a 'wet-zone' to one side. A sliding

door separated the dressing room and bathroom while a curtain enclosed the entrance space and shielded the kitchen door.[50] Although meals could be ordered to be sent up on a tray from the kitchen on the ground floor, the curtained separation of the kitchen and front door from the rest of the space suggested the presence of a servant, perhaps to clear away the dinner, something which his 1931 article, 'Inspiration from Japan', implied was equally common in Japan. An easy chair and a dining table set was all the moveable furniture necessary: everything else, including the bed which doubled up as a couch, was built in. As Coates explained in *The Architectural Review* in 1932:

> The dwelling scene of tomorrow will contain as part of its structure nearly all that today is carried about for the purpose of 'furnishing' one house after another. Very soon it will be considered quite as fantastic to move accompanied by wardrobes, tables and beds, as it would seem today to remove the bath, or the heating system, including all the pipes.
>
> Thus 'furniture' in the dictionary sense will take its place in the logic of construction, becoming an integral part of architecture. For the rest, clothing, bedding, crockery, utensils, books, pictures and sculpture will have the select value of a personal environment; will be, in fact, the only furniture (personal belongings) in use.[51]

This was, of course, an idea familiar from Japan, as he went on to explain:

> As an example of this principle actually carried out over a number of centuries, it is possible to describe, as the present writer has done, the structure and interior organization of the household in a typical Japanese dwelling-scene, without a single reference to furniture, and to end the note with the words: 'By the way, there is no furniture properly speaking. Trays for food are usually provided with short legs, so that the tray forms the individual table for the squatting diner. Beds are simply mattresses and coverlets, pulled out of structural cupboard-spaces. The structure

and internal organization of the scene permits any room to be a bedroom ...' and so on.[52]

The economy of planning in Japanese houses is only equalled by their flexibility. *Amado* and *shōji* could be successively withdrawn to open the house up to the landscape in the same way as *fusuma* could be slid away to open up one room to the next. These were principles which Coates frequently used: in the four larger double flats in the Isokon building, a sliding wall separated the living room from the bedroom. In his early conversions, such as that which he did in 1932 at 1 Kensington Palace Gardens, London, for George Russell Strauss and Patricia O'Flynn, whom Strauss was about to marry, Coates placed translucent *shōji* across the bay window of the dining room of the Victorian mansion. The following year, at 34 Gordon Square, London, he employed painted plywood sliding screens as well as transparent *shōji* to separate the reception rooms for the thespians Elsa Lanchester and her gay husband, the actor Charles Laughton. Here, where Coates designed fitted furniture for both the reception rooms and the bedrooms, Laughton would skilfully arrange *ikebana*, but if asked, say that his wife had done it.[53]

In his Sunspan House designs (1934–36) and at Shipwrights at Leigh-on-Sea (1937), where the living room was positioned on the corner, Coates used sliding walls to open it up to the rooms on either side. In the Seaside Weekend Cottage version of the Sunspan house, this had the effect of achieving a 180 degree vista from bedroom to bedroom, while at Shipwrights, also close to the sea, the living/dining room, landing and bedroom at the upper level were brought together as a single space behind a ribbon window which stretched across the building's façade. Although the glazing here comprised sliding panels, those at the Hampden Nursery School (1936), a conversion of a Victorian house in Holland Park, London, and at the newly built Embassy Court, Brighton (1937) – were sliding-and-folding windows which could be completely withdrawn to expose the rooms to the outside and the fresh air. In the penthouse at 10 Palace Gate, Kensington, London (1939) [12.02], Coates used sliding-and-folding doors to connect the flat to the extensive roof garden. At Embassy Court, a mansion block with eight repetitive floors of flats overlooking the sea and a concrete entrance canopy which could almost be a *torii*, a shallow, cantilevered walkway, just 2 feet 9 inches (825 millimetres) wide, ran around the outside at each level linking the sun/living rooms as they stepped forward to the building's edge.[54] To the English family on a seaside holiday, these would appear to be no more than rather shallow balconies, a feature familiar enough from the nearby terraces of Brighton and Hove: but to Coates they were *engawa*, that narrow external walkway both separating and joining the indoor and outdoor space.

During the early 1930s, Coates was an activist for Modern architecture. In 1933 he established and named the MARS (Modern Architecture Research) Group, of which he was chairman, and later that year he was one of the British delegates to the fourth CIAM conference which, on the *SS Patris II* between Marseilles and Athens,[55] drew up the Athens Charter.[56] Here, where the theme was 'The Functional City', Coates first came into direct contact with the leading European Modernists – Le Corbusier, Sigfried Giedion, Cornelis van Eesteren, Alvar Aalto, José Luis Sert, Lazlo Máhóly-Nagy and so on.[57] However, his activism had begun in July 1930 when, with the Cambridge academic Mansfield Forbes, the Head of the Architectural Association Howard Robertson, his new client at Lawn Road, Jack Pritchard, and the Director of Waring and Gillow's Modern Art Studio – who was also one of the best tango dancers in the world – Serge Chermayeff, he had formed the 20th Century Group. The Constitution stated that the aims of the group were 'to define the principles to which contemporary design should conform' and 'to co-ordinate the efforts of modern British designers, with a view to the achievement of architectural unity'.[58] This they would accomplish through exhibitions, writings, lectures and discussions. At a large lunchtime meeting at the Savoy Hotel, London, on 26 February 1931, Coates read his 'Notes for the Sketch Plan of a New Aesthetic'. In this call-to-arms, he cast himself

as the critical outsider, 'a child of an ancient and non-European culture … born and brought up according to the inflexible customs of the ancient civilisation of Japan'. This character, whom he called the Artist-Samurai, 'has been told that a man whose eyes have been trained in the East will only rarely want to open them in the West'. Equipped, therefore, with 'a kind of aesthetic X-ray' and a world view of architecture comparable to Itō Chūta's, the Artist-Samurai is able to discern the source of the Western architectural tradition:

Gradually there becomes perceptible a basic pattern. Its grandeur calls forth his admiration. This and this only of European traditions is the one comparable to his own. He describes it as at once rich and severe. It is the tradition of Greece.

Then the Artist-Samurai speaks:

'How barbaric is your habit of overloading! How seldom does an object stand in the place which correlation appoints to it! How obtrusive your pictures are! And how rarely is a European aware that a room exists for the man, and not vice versa, that he, and not the curtain or the picture is to be given the best possible setting! …'[59]

Few in that dining room at the Savoy would have realised how far from play-acting this really was, and that Coates himself, as he stated in his 'Autobiographical Description' penned for the BBC that year, was in fact 'The man whose eyes have been trained in the East …'[60]

Serge Chermayeff would have understood. Born in Grozny, in the Caucasus, but educated in England, he was, like Coates, untrained in architecture, although both were to become Fellows of the RIBA.[61] The two had met through Jack Pritchard and each could bring to design an eye unencumbered by academic conditioning. Chermayeff's work for Waring and Gillow was modern but Art Deco, although in his own house, 52 Abbey Road, London, which he leased in June 1929, there was, in the sliding doors and horizontal panelling, a distinct nod towards the East.

At the Exhibition of British Art in Relation to the Home, held at Dorland Hall in London's Lower Regent Street in June 1933, these two founding members of the 20th Century Group made good the Constitution's intention 'To promote exhibitions of contemporary design in relation to architecture and interior equipment.'[62] Here, where one reviewer thought 'The modern note has had for the first time the opportunity of explaining itself to the reasonably intelligent',[63] Coates assembled his Minimum Flat, as intended for Lawn Road, and Chermayeff,[64] his Week End House, albeit without its kitchen and entrance hall. The Minimum Flat was applauded for being 'a brilliant feat of intelligent compression … a miracle of "Multum in parvo" compactness without constriction … [where] a highly satisfactory aesthetic is the result'.[65] However, by traditional Japanese standards it was probably generous, the living space equating to an 11 *tatami* room. Although more spacious, but in its way equally Japanese in conception, was Chermayeff's Week End House where all the dimensions, including the fitted PLAN furniture units, were 'designed for a uniform, economical method of construction'.[66] The relationship between the two exhibits was not missed by *The Architectural Review* which observed:

… one supposes that the modern young man, having moved from a Coates single flat with his charming wife into a double flat in the Isokon block, has now graduated (and collected the modest means necessary) for the possession of the Chermayeff retreat, and clearly a new race will obviously be evolved in this stimulating environment.[67]

Any visitor who sensed the Japanese spirit in the 'intelligent compression' or the fitted furniture of the Minimum Flat might also have recognised it in the horizontal panels of the full-height sliding windows of the Week End House which, like *shōji*, separated the living-dining room from the outdoor terrace. It was an idea which Chermayeff took much further in the house which he built for himself at Halland, in Sussex, in 1937–38.

The genesis of Bentley Wood at Halland was slow and not without its problems.[68] Although the site was purchased in 1935 and the drawings submitted for planning permission in November 1936, permission was refused, leading to an appeal and a public enquiry the following January. Even though Chermayeff was successful with his appeal, new drawings for a far more modest building were submitted in September 1937 and permission was granted. Construction started soon after and the house was occupied by the following summer. Although reduced in scope, the basic design remained: a two-storey, timber-framed, flat-roofed house of six open bays to the south and a single-storey side wing, comprising service rooms and garage, extending to the rear. Sliding glass doors, 11 by 9 feet, divided into two sheets of ¼-inch plate glass, opened the whole of the ground floor to the terrace, while above, a loggia – or *engawa* – linked all the bedrooms and overlooked the extensive garden. Inside, a cupboard-spine separated the inter-linked living spaces from the kitchen and hallway, the sliding walnut panels on the living-room side suggesting *fusuma*.

The use of the timber frame at Bentley Wood was not surprising. A special issue of *The Architectural Review* in February 1936 promoted timber construction and showed, amongst mostly Scandinavian and British examples, Antonin Raymond's own summer-house at Karuizawa which had appeared just a few months earlier in Le Corbusier's *Oeuvre Complète de 1929–1934*. But more proselytising was Robert Ferneaux Jordan's article in the *RIBA Journal* of January 1936 titled 'Modern Building in Timber'. Here he used Katsura, which he illustrated only in plan, to promote both timber construction and Modernism.

> Its plan is astonishingly modern in many respects and shows a freedom and flexibility which would only be possible in a very light form of construction ... it shows that the idea of arranging a series of apartments, each well proportioned and well lit for its purpose, in convenient relationship to each other, was an idea which was fully developed in the Far East many centuries ago.[69]

Apart from the influence of his friend Wells Coates, there was, during the building's long gestation, much, like Jordan's article, which might have encouraged Chermayeff to take on the role of the Artist-Samurai. He had left Waring and Gillow in 1931 to set up in independent practice but in the autumn of 1933 had gone into partnership with the German émigré Eric[h] Mendelsohn. Although that partnership lasted only to December 1936, it was, as Chermayeff said, 'invaluable to me. I learnt architectural organisation and design of some complexity including both schematic presentation and meticulous detailing.'[70] In 1935, while he was still in partnership with Mendelsohn, the Berlin publisher Ernst Wasmuth issued Yoshida Tetsurō's *Das Japanische Wohnhaus*;[71] then, the following year *The Studio* published, in London, Harada Jirō's *The Lesson of Japanese Architecture*.[72] Both these publications (like Robert Ferneaux Jordan's article in the *RIBA Journal*) came hot on the heels of Bruno Taut's 'discovery' of Katsura (which is discussed below) and no doubt were intended to build upon this new interest. Although Harada's book showed just one illustration of Katsura, Yoshida's featured 32. For *The Studio* to publish *The Lesson of Japanese Architecture* was not surprising: in the late nineteenth century the magazine had done much to promote Japonisme and its current editor, C[harles] Geoffrey Holme, was the son of the magazine's founding editor and Japanophile, Charles Holme. In his introduction, Holme *fils* wrote:

> The lesson of Japanese architecture for the Western world may be summarized briefly as standardization, variety in unity, conformity to a mode of living, connection with nature, simplicity and, of course, usefulness of purpose ...

but ended with a caution:

> Japanese architecture is devised not for the sake of architecture, but for the sake of living.[73]

More surprising was that Wasmuth would choose, in 1935, to publish Yoshida's *Das Japanische Wohnhaus*. Germany's Nazi government might have regarded its contents as being too suggestive of Modernism, yet its illustrations and drawings of an indigenous,

traditional architecture also had a certain resonance with *Volksarchitektur*. Hugo Häring and Ludwig Hilsberseimer, whom Yoshida had met in Germany in 1931–32, had encouraged the book and it was widely read.[74] Indeed, the plan of Katsura which Jordan used in the *RIBA Journal* came from here.[75] As well as showing traditional architecture, Yoshida included many illustrations of his own house designs and argued that there was much in traditional Japanese house design which could complement a modern, Western lifestyle. Whether or not Chermayeff knew this book, or the other, cannot be said, nor if he had seen Bruno Taut's lengthy article on 'Architecture Nouvelle au Japon' in the April 1935 issue of *L'Architecture d'aujourd'hui*;[76] but Chermayeff was a linguist,[77] his partner was from Germany and his fellow founding member of the 20th Century Group, Howard Robertson, had a keen interest in Japanese architecture. Both he and Chermayeff had reviewed Sakakura Junzō's Japanese pavilion at the 1937 Paris Exposition, the former in *The Architects' Journal*, calling it 'a design particularly happy in the combination of materials – steel, wood trellis, and paving units',[78] and the latter in *The Architectural Review*, similarly referring to 'the effectiveness of controlled repetition of motifs: structural steel, trellis screens and paving units'.[79] In a lecture given to the West Yorkshire Society of Architects in 1929, Robertson had opined:

> The Orient, particularly Japan, has been a source of inspiration to the modernist. Flat tones, plain surfaces, colour combinations of red and black, yellow and green, the use of lacquers, are typical of Japanese art, and very popular to-day. And rhythm, which is fundamental in the decoration of the Orient, is a basic factor in present-day design.[80]

Bentley Wood had flat tones, plain surfaces, sober colours[81] – and rhythm. This was largely imparted by the advancing timber frame made from jarrah which was painted cream in contrast to the cedar-clad side walls. Based on a module of 2 feet 9 inches, each 11 foot bay was divided and subdivided with perfect regularity from the sliding glass doors to the trellis above the loggia.

Bentley Wood also had an important relationship to the garden, an extensive sweep of Sussex landscape designed with Christopher Tunnard. Tunnard was, like Coates, Canadian, and a member of the MARS Group.[82] In 1960 he was to participate in the Tokyo Design Conference but in the mid-1930s he was already expressing his enthusiasm for, and understanding of, Japan. His book, *Gardens in the Modern Landscape*, was serialised in *The Architectural Review* in 1937 and published in 1938. Here he writes that, although 'we have seen enough of the trappings of Japanese art to sicken us of it for ever ... the original landscape art of that country has never been clearly understood by European garden makers and only rarely by painters such as Whistler, who found economy of line and colour in the Japanese print.'[83] This he blames on a disengagement characteristic of Western attitudes:

> For centuries European art has turned its back on the fundamental conception of Nature in art, and Western man has imagined himself and Nature as being in antithesis. In reality, his much vaunted individualism is an illusion, and the truth which the Orient now reveals to him is that his identity is not separate from Nature and his fellow beings, but is at one with her and them ... This conception of Nature and natural forms finds one of its expressions in Japan (and is beginning to in Europe) in the unity of the habitation within its environment.[84]

To connect the house with its landscape, he writes of *shōji*, where 'the whole side of the room may be thrown open to let in cool summer winds' and of how 'house walls are echoed by screens placed near them, stone repeats stone on the simple terrace, plants encroach on the walls of the house and wreath themselves among its timbers' [12.03].[85] This could be Bentley Wood, where a yellow brick screen wall reached out towards a reclining Henry Moore figure, where the paved terrace comes within the silently sliding glass windows to meet the hardwood floor, and where given time, wisteria or clematis might bind themselves along the loggia's trellis.

12.02 The penthouse flat at 10 Palace Gate, Kensington, London, designed by Wells Coates and drawn by Gordon Cullen, from *The Architectural Review*, April 1939.

12.03 The living room at Bentley Wood, Halland, designed by Serge Chermayeff for himself, from *The Architectural Review*, January 1939.

But time was not what Chermayeff had. Cost over-runs on Bentley Wood, which the eminent Liverpool Professor Charles Reilly had described as 'a regular Rolls Royce of a house',[86] and the collapse of promised work due to the prospect of war, forced Chermayeff into bankruptcy in 1939. In January 1940 he departed with his family, reluctantly, for Canada. Wells Coates stayed on but, as international relations with Japan worsened, the uncertainties of the later 1930s ultimately worked against him. What in 1931 he had promoted as Japanese, by 1937 he was referring to as '*à la japonais*'.[87] With the commencement of hostilities in Europe he closed his office and turned his hand to the war effort.

Bruno Taut

As Serge Chermayeff was finishing his drawings for the first version of Bentley Wood in the autumn of 1936, on the other side of the world the German architect Bruno Taut was preparing to leave Japan. It might, in the context of this story, be regarded as a case of 'job done', for Taut's brief stay in Japan seems to have coincided with a surge of interest, in the architectural press, in Japanese architecture. To what extent he was the catalyst for this can only be speculated, but his own publications would certainly have drawn the attention of a German, French and ultimately English readership to both the new and the traditional architecture of Japan.

Taut's journey to Japan, over three years earlier, was that of a political refugee. He was not, as might be thought, Jewish, but a Communist who until recently had been in Moscow with his mistress Erica Wittich. In that winter of 1933 it had been his plan to travel from Berlin to Vladivostok and then, via Japan, where he could enjoy the April cherry blossom, to America. While in Moscow he had been seeking an invitation to visit Japan and had received, by letter, a 'yes in principal' from Ueno Isaburō in Kyoto; he had also been soliciting an invitation to America from the American Institute of Architects.[88] Returning to Berlin on 16 February, he began to prepare for the trip, but on 27 February the Reichstag was burned and the Communists were blamed. The next day the Chancellor, Adolf Hitler, made President Hindenburg issue the 'Decree of the Reich President for the Protection of the People and State' intended to prevent Communist acts of violence, and arrests began.[89] On 1 March, the day Wittich returned from Moscow, Taut was tipped off by Kurt von Hammerstein-Equord,[90] then Commander-in-Chief of the Reichswehr and an ardent anti-Nazi, that he was on a 'black list' and should leave Berlin. That evening he and Wittich travelled to south Germany, where the 'black list' was less well known, and on 10 March, with the assistance of Sigfried Giedion, arrived in Stein am Rhein, Switzerland.[91] Taut was never to return to Germany.

On 14 March, Taut, armed with an invitation from the International Architecture Association of Japan, went to the Japanese consulate in Bern to obtain his visa: within a week his journey was planned. To pass through Germany was impossible, so from Switzerland he went to France and on 27 March sailed from Marseilles to Naples, Athens, Istanbul and finally Odessa, from whence he journeyed by rail to Moscow and eventually Vladivostok.[92] On 29 April Taut boarded the *SS Amakusa-maru* and sailed for Japan, arriving on 3 May at Tsuruga, a port town on the Sea of Japan and the connection for the Europe-Asia International train which terminated at Shinbashi station in Tokyo. Taut, however, did not travel on to Tokyo but only to Kyoto, about 75 miles (120 kilometres) away, where he stayed at Chūdō-ken – the Tudor house built in Kyoto for Shimomura Shōtarō by William Merrell Vories the previous year. The next morning it was his 53rd birthday and a visit to Katsura was planned.

The cherry blossom had gone by the time Taut arrived in Japan and, since the onward journey to America could not be arranged, what might have been a few weeks in the country extended to almost three and a half years. He eventually left Japan, not for America but for Turkey, on 15 October 1936. This was six weeks before the signing of the German-Japanese Anti-Comintern Pact,[93] an agreement directed against the Communist International (Comintern) and the threat of Communist subversive activities. It is therefore unlikely that, in this growing state of

nationalism and anti-Communism, Taut's visa to remain in Japan would ever have been renewed.

The birthday visit to Katsura was organised by Ueno Isaburō, chairman of the International Architecture Association of Japan. Being German-speaking, Ueno and his Austrian wife Felice Rix were the obvious people to escort him in Kyoto. However, Ueno had to seek advice on what to show Taut, and Horiguchi Sutemi, Itō Chūta's former student and *Bunriha* member, recommended Katsura. Then, as now, advance permission had to be given to secure entry to Katsura so either Ueno or Shimomura Shōtarō, who also came on the visit, must have obtained this.[94] What he saw there, however, was a revelation. 'Today is probably the most exquisite I have even had,' he wrote in his diary. 'Katsura is truly a miracle without parallel in the world of culture. Here, "eternal beauty" is revealed more remarkably than in the Parthenon, the gothic cathedrals or Ise Shrine.'[95]

Taut is generally credited with 'discovering' Katsura. Whereas it is true that he was the first Western architect of modern time to see it, its secrets had been revealed in a series of loose-leaf folios of drawings and photographs edited by Kawakami Kunimoto and published in Tokyo under the direction of the Imperial Household Ministry between 1928 and 1932.[96] Available only by subscription for research and educational purposes, these detailed folios served to emphasise the importance of Katsura as a cultural monument. Horiguchi must have known of them, possibly through Itō: Ueno clearly did not. Yet it was the hope of Ueno and the International Architecture Association that, by showing Katsura to this famous Western architect, he would acknowledge it as both traditional and Modern and thus confirm the theoretical connection between traditional Japanese architecture and Western Modernism. However, Taut's response, which was overwhelmingly enthusiastic, was not quite what the Association had hoped. Although, as he later wrote of that visit, '"How completely modern this looks!" was the thought in all our minds',[97] he showed little interest in the building's perceived Modernist character: the most he was prepared to do was to declare it functionalist. In *Houses and People of Japan* he wrote:

After some talk we came to the conclusion that it was an architecture of function or one might also call it an architecture of motive. The entire arrangement, from whichever side one might care to look at it, followed always elastically in all its divisions the purpose which each one of the parts as well as the whole had to accomplish ...

I have stated on former occasions that the most important basis for the further development of modern architecture lies in function ... In Katsura I found in an ancient building the absolute proof of my theory, which I regarded as a valid basis for modern architecture.[98]

Indeed, the aligning of Katsura with Western Modernism was an association which Taut did ultimately not wish to make for, in as much as it held a memory of a fast-receding past, it should not be contaminated. 'I had a conversation,' he later recorded, 'with some advanced architecture students of aesthetics in the Imperial University of Tokyo, who ... knew nothing of the existence of Katsura – and the penetration of modern business into all the pores of Japanese culture menaces these last remains with a final death.'[99]

What Taut did recognise and appreciate in Japanese architecture was not its proto-Modernism but its traditional qualities. As was noted in the Foreword to his lecture on *Fundamentals of Japanese Architecture*, published by Kokusai Bunka Shinkōkai (The Society for International Cultural Relations) in 1936, 'The Japanese have been so engrossed in studying, appraising and adopting aspects of Western civilization that they have given very little thought to making their own civilization and culture known abroad.'[100] Taut's lecture to the Kokusai Bunka Shinkōkai, given on 30 October 1935, was both a response to the current Western interest in Japanese scholarship and a reflection of the growing nationalism in the country. His paper promoted diagrammatically a lineage which he called 'MOD. QUALITÄT', connecting the Shintō shrine at Ise and the traditional *minka* of Shirakawa to Katsura; in contrast that which connected the Buddhist temple to the temples at Nikkō was described as 'MOD.

KITSCH *(ikamono-inchiki)*' [12.04]. 'The positive line,' he explained, 'which begins in the Ise Shrines, was not diverted in consequence of Buddhist influence; but the principal of rational construction as represented in Shirakawa was later destroyed. Buddhism – particularly Zen – contributed in the Tea Ceremony a spiritual aesthetics which for the second time (that is, after Ise) brought Japanese architecture to a zenith in the Palace and garden of Katsura.' Then he adds: 'The negative line, in which the degeneration of construction into decoration was intensified by the rulers' orders for ornamentation, comes from the Buddhist temple.'[101] In making this distinction between what he regarded as 'modern quality' and 'modern kitsch', Taut was drawing a fine line. Nikkō, the burial site of Tokugawa Ieyasu, was still associated with the *shōgunate* whose politics were increasingly revered by the nationalists; therefore the true Japanese-ness of the Shinto tradition derived from Ise had to be emphasised.

However, Katsura (and Ise and Shirakawa), as Taut was soon to find out, was hardly representative of modern Japan. From Kyoto he must have travelled by land and sea to Yokohama from where he was driven to Takasaki, about 60 miles (96 kilometres) north-west of Tokyo where a house had been arranged for him. What he saw on the road between Yokohama and Tokyo 'affected our eyes and nerves like a cold shower of disillusionment'.[102] He later recorded the journey in *Houses and People of Japan*:

> ... we could hardly take in the crabbed pretentiousness, the ludicrous would-be modernity of the tin façades that confronted us, could not fathom the loud hideousness of this confusion of architectural styles. What had become of the refined vision of the Japanese, whose scenery was so admirably fitted to sensitize the optic nerve? ...

> The general impression was one of intolerable garishness. In the course of our travels we had only too often come up against civilization in decay. But this utter aimlessness, this total lack of direction even in bad taste, did more than shatter our illusions about Japan; it lacerated our

finer feelings. After all, Berlin, Paris and London, even in their drearier aspects, are never devoid of character and integrity.[103]

By the time they reached Ginza, as he recalled, 'The spectacle which had already offended, now positively assaulted the eye. Being sensitively organized, I yielded to a mood of acute depression. Not a word escaped my lips but I was seriously regretting that I had ever ventured on the journey to Japan.'[104]

His experience did not get any better when he found that the small rural house which, at his own request, he had been given to live in was cold, uncomfortable, flea-ridden, rat-infested and unhygienic. Located at Shōrin-zan, near Takasaki, and called, rather hopefully, 'Purification of Heart',[105] it was far removed from the 'idealised conception of cleanliness, clarity, simplicity, cheerfulness and faithfulness to the materials of nature'[106] which, he later told his audience at the Peers' Club, attracted Western architects to Japan. This, he said, 'gave them a liking for things in Japan quite at variance with the preferences of the general public in the West and this divergence has continued to the present time.'[107] What the public liked, he explained, was what was different about Japan – the exotic, as characterised by the temples at Nikkō where the 'barbaric overloaded baroque'[108] provided a welcome theme of conversation. It was a distinction which Maekawa Kunio's professor at Tokyo Imperial University, Kishida Hideto, was making at just this time:

> Only it must be noted that from the point of architectural esthetics, the buildings at Nikko do not represent the pure 'spirit of Japan', as their decoration is exaggerated in its detail, and their architecture is marked by certain defects ... One can certainly recognize in the buildings of the Kyoto Palace the so-called 'Japanese taste', and I wish to emphasize here that this Japanese taste which is expressed in this palace building is not to be seen either in the buildings of Buddhist temples or in the Nikko-Bye.[109]

Taut had not come to Japan with the expectation of building but to give some lectures and possibly advise

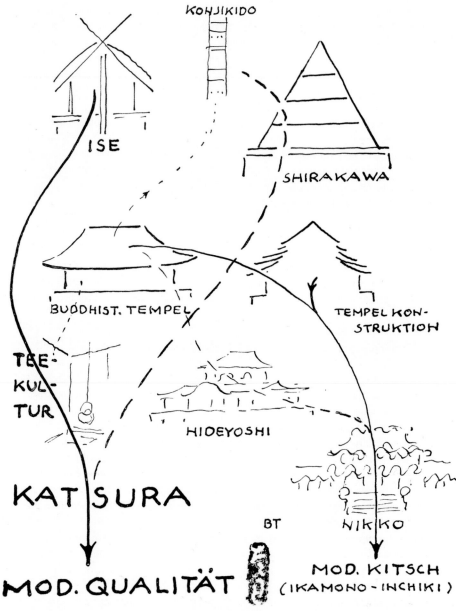

1. Die positive Linie beginnt bei den Ise-Schreinen. Sie verlief nicht gerade, infolge des buddhistischen Einflusses und nachdem das rationalkonstruktive Element (Shirakawa) zerstört war. Der Buddhismus, speziell die Zen-Philosophie, gab ihr in der Teekultur eine geistige Ästhetik, die im Bau und Garten von Katsura nach Ise zum zweiten Male den Höhepunkt japanischer Architektur schuf.

Die negative Linie kommt von buddhistischen Tempel, bei dem die Konstruktion zur Dekoration entartete, verstärkt durch die Repräsentationswünsche der Machthaber.

12.04 'Mod. Qualität' and 'Mod. Kitsch', from Bruno Taut, *Fundamentals of Japanese Architecture*, 1936.

on housing development. However, he was soon asked to summarise his opinions of Japan and by July 1933 had completed *Nippon – mit europäischen Augen gesehen* (Japan – Seen Through European Eyes) which was published in Japan the next year. Other books followed. In May 1934, he published a concertina-style sketchbook called *Katsura Album*, a collection of 26 annotated drawings from 1933 and a second visit of May 1934; by February 1935 he had completed *Japans Kunst, mit europäischen Augen gesehen* (Japanese Art – Seen Through European Eyes), published there in 1936; and in the same year *Grundlinien der Architektur Japans* (Fundamentals of Japanese Architecture), his Kazoku Kaikan (Peers' Club) lecture given on 30 October 1935 at Josiah Conder's Rokumeikan, was published in Tokyo.[110] He also contributed to *L'Architecture d'aujourd'hui*, publishing on 'Architecture Nouvelle au Japon' in April 1935.[111]

In this long article, while illustrating modern work by Antonin Raymond, Horiguchi Sutemi and others, he identified Ueno Isaburō and Yoshida Tetsurō as 'the best representatives of the modern Japanese idea'.[112] This was not because they were the best imitators of Western Modernism but rather because they understood the relationship between modern architecture and tradition. 'The more the architect realizes that a continuous tradition leads from ancient architecture to that of our day,' he wrote 'the more his position is safe, without the risk of imitation.'[113] The importance of tradition was a theme to which he frequently returned, particularly in his final book on Japan, *Das japanische Haus und sein Leben* (Houses and People of Japan). Published in Tokyo, first in English (1937) and then in Japanese (1938), and 'Dedicated to my Japanese friends', it was, unlike the other books and articles which were written primarily for a Western readership, a message from a Western architect to Japan on the importance of tradition. As he observes in the final pages, 'We had seen many beautiful things. But as our thoughts went back to the energetic modern development of this land, we had the feeling that this beauty was threatened by a terrible disaster.'[114]

Houses and People of Japan attempted to tell the Japanese reader that their traditional architecture was unique. By drawing a Japanese version of Leonardo da Vinci's Vitruvian Man, he sought to demonstrate how Japanese architecture had developed to suit that physique, and thus to adopt a Western architecture was to adopt an architecture out of scale and out of harmony not just with their own traditional architecture, but with the Japanese themselves. As he wrote:

> All details of the house showed the greatest harmony with the human measures, this being the key to its aesthetic effect … the figure of a Japanese man or woman in their way of walking, or of opening the sliding-doors, the handle of which is placed only 2ft 5½ ins from the floor and even lower, as the Japanese woman kneels when opening the door and kneels again on the other side when shutting it, makes a delightful picture in harmony with the walls and the entire room. Sitting on the mats gives the right view for judging the room. From this position it seems high and wide …[115]

In *Houses and People of Japan* Taut recounts a conversation which he had with Mr Suzuki, an architect, at the Hyōtei Restaurant in Kyoto. 'I have had a good look at quite a lot of new Japanese houses,' he tells his friend. 'In them the typical Japanese characteristics are nowhere to be found.'[116] It was not the *tatami* or the *shōji* to which he was referring but, as he put it, 'the admirable way in which the Japanese house has adapted itself to the special climate of Japan and is in harmony with local customs and daily occupations'.[117] The modern Japanese house had apparently dispensed with all that was sensible about Japanese architecture such as the verandah, raised above the garden to give a better view, and the broad gable, sheltering both the verandah and the wide open 'windows' from the sun and the rain. 'Terraces and balconies,' he declared, 'are Western imitations.'[118]

Working with the architect Kume Gonkurō, Taut had the opportunity in 1936 to test his theories at the Okura House, a family villa in Azabu, Tokyo.[119] Although it was then already under construction, Taut had the builder introduce *noki* and *engawa* which had the effect of providing both a shaded and

12.05 Cross-section through the Western-style reception room at the Villa Hyūga in Atami, designed by Bruno Taut, 1936.

sheltered outdoor space around the building as well as, on the ground and first floor, a light-shelf which would bounce light, through shallow, clerestory windows, up onto the ceiling above.[120] Five years later, in 1941, Nikolaus Pevsner, who much admired Taut as a Modernist architect,[121] wrote an article in *The Architectural Review* entitled 'Bruno Taut's Japanese Modern'. Here he noted that Taut thought that 'the "Europeanizing" Japanese architects whose ideal is the suburban villa of any Western town, were going completely off the rails [and] made a great effort to bring them back to reason and tradition by lining up the traditional technique with the modern movement.'[122] The result, at the Okura House, however awkward, was, he thought, 'not unsuccessful in creating the appearance, at any rate, of a modern building with definite Japanese character'.[123] But that, possibly, was not Taut's intention: maybe he wanted the house to 'work' like a traditional Japanese house, not to simply 'look' like one.

Despite starting a number of projects while in Japan, Taut had almost no opportunities to work

there as an architect: in his diary entry of 23 January 1934 he noted how depressed this made him.[124] There had been a chance, a few weeks before, to realise his Alpine *Die Stadtkrone* (City Crown) project of 1919 on Mount Ikoma, between Osaka and Nara.[125] Commissioned by the Daiki Railway Company, it was to be a *siedlung* comprising housing set in parkland on the mountain's slopes and a hotel at the summit. But this came to nothing, as did plans for a small house in Maeoka the following year.[126]

However, in April 1935 he was asked by the businessman Hyūga Rihei to add a series of day rooms to his new house at Atami, designed by Watanabe Jin and completed only the year before.[127] This two-storey (with basement) stuccoed timber-framed house was rather nondescript externally but the interior was fitted out neatly in the traditional Japanese manner (including a *tatami* room and a sunken-bath room) and offered views out across Sagami-wan (Sagami Bay) to Hatsushima Island about 10 kilometres distant. To give these rooms accessible outside space, a large concrete terrace

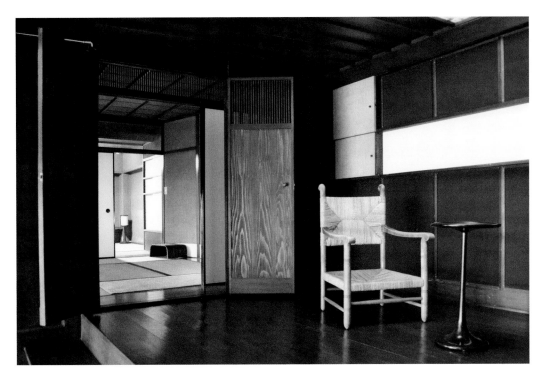

12.06 The moon-watching platform in the Western-style reception room, with the Japanese rooms beyond, at the Villa Hyūga in Atami, designed by Bruno Taut, 1936.

had been constructed on the seaward side where the land fell away steeply, and this was grassed over. It was within the vaults below this terrace that Taut, with Yoshida Tetsurō (who did the working drawings), installed a series of recreational and ceremonial rooms which made repeated reference to the *shoin* at Katsura [12.05]. Taut had not come to Japan three years before unknowing: in his 1923 book *Die neue Wohnung* (*The New Dwelling*) he had illustrated two interiors from the sixteenth-century Shinboin temple in Kyoto, commenting, 'In such a (modest) space [a] human comes completely himself.'[128] What he saw at Katsura on his second day in Japan had confirmed his impressions rather than coming as a surprise, and clearly was to influence his thinking at the Villa Hyūga.

The four rooms which Taut added to the villa followed the concrete structure of the raised lawn above to produce an informally arranged series of linked spaces which quoted, rather than copied, the *shoin* at Katsura. Accessed from the basement level of the house, the rooms were set out, like the four parts of the *shoin*, in a linear manner from east to west.[129] These comprised a games or ball-room, a central, Western-style reception room, a 12-mat Japanese reception room and a small, 5½-mat sleeping room set in behind a screened sunroom. The rear of both reception rooms was raised up by five broad steps which, while providing tiered seating, allowed views out across the bay [12.06].

The treatment of the rooms was all completely different: the Japanese rooms had *tatami* and *shōji* and the Western-style reception room floorboards and folding glass doors. The games room was a fusion of the two cultures. The arrangement of the panelled walls, divided at the level of the *kamoi*, together with the twin *fusuma* which open onto the central reception room, suggested the *yari-no-ma* (the Spear Room) at

the *ko-shoin*; the ceiling, boarded with *kiri* (paulownia), recalled rather than replicated the timber ceilings of the *ko-shoin* where *kiri* leaves decorated the printed papers of the walls; and the floor, albeit finished with Japanese oak, was set out in a gridded pattern which suggested *tatami*. The eastern end of the room was faced with *kokomo* bamboo, like the screening which enclosed the external space beneath the *shoin*'s raised floor, and a *kokomo* handrail, tied with dark brown cocoa fibre, guarded the lower steps of the entrance stairs where they turned into the space. The central reception room, lined with red silk from Takasaki, was much more Western in appearance if not in finish: the floor was boarded and the folding glass doors and the connecting doors at the rear were hinged. Although *fusuma* separated this Western room from the Japanese room beyond, Taut emphasised the difference by raising the floor of the Japanese room one step higher, in the same way as, at the *shoin*, the *chu-shoin* is distinguished from the earlier *ko-shoin* by a single step. In the Japanese room, characterised by *shōji* and *tatami*, and the small sleeping room beyond the sunroom, the *osalama* above the *fusuma* is crafted of thin, vertical strips of wood like that between the *ichi-no-ma* and the *ni-no-ma* (first and second rooms) of the *ko-shoin*. Here too, in what could be described as the *tokowaki*, is a fold-down writing desk incorporated within the *chigai-dana*. But perhaps the most distinguishing feature is the raised platform at the rear, not because of what it is but because of what it represents. At the *ko-shoin* the moon-watching platform which extends from beyond the *Ni-no-ma* is one of the most contemplative spaces at Katsura. At the Villa Hyūga, when the *shōji* are withdrawn, the raised platform will give an uninterrupted view out across the sea towards Hatsushima Island and, as at Katsura, the moonlight might be seen reflecting off the water.

Bruno Taut left Japan in October 1936 just weeks after the Villa Hyūga was finished. In *Houses and People of Japan* he wrote, with obvious regret, of his final train journey: 'Never had we seen Mount Fuji so distinctly before ... All but a very few of the people in our compartment stood watching the mountain, gazing at it as long as it could be seen.'[130] The time he spent in Japan had been an unexpected and not altogether satisfactory interlude in Taut's life. But what he had achieved was, in a sense, to save modern Japanese architecture from itself – or would have, had not *teikan-yōshiki* and the war interceded. He had recognised the value of tradition in Japanese architecture and rather than use it as a means to promote Modernism, as Walter Gropius was to do, he anticipated Tange Kenzō and found in the fusion of tradition and modernity a way forward. This is what Nikolaus Pevsner, in his article on 'Bruno Taut's Japanese Modern', recognised at the Villa Hyūga:

> Great care was necessary not to outrage traditional Japanese architectural etiquette. Despite the strictness of their formulas, the ancient Japanese Masters valued originality and despised imitativeness. Nothing is more foreign to their spirit than an attempt at Ye Olde, and in the distribution of the matting, the arrangement of the coverings and mouldings, the architect finds plenty of freedom in spite of all that Japanese standard measurements can do.[131]

To indicate approval, the magazine *Kokusai kenchiku* (International Architecture) published the Villa Hyūga that December, soon after it was completed, in a nine-page spread of photographs, drawings and captions with a commentary by Yoshida Tetsurō.[132]

Taut's exile continued in Turkey where he secured, with the help of his friend and fellow German architect Martin Wagner, the position of Professor of Architecture at the State Academy of Fine Arts in Istanbul. Once again, in the two brief years before he died, he was able to build, but the climate and culture was not as he had known in Japan. The house which he designed for himself overlooking the Bosphorus in Ortaköy had a pagoda-like tiled roof but also the expression of an eighteenth-century folly. Far more convincing, perhaps because of its reticence, was the faculty building he built for the Academy for Language, History and Geography in Ankara. Here, supported on one corner by a single, unadorned column, the broad cusped roof of the entrance canopy is instantly recognisable as Japanese, yet not that of Katsura, but rather of Nikkō and, rather surprisingly, the then current *teikan-yōshiki*.

13 THE PRESENCE OF LE CORBUSIER

Antonin Raymond and Le Corbusier

In an undated manuscript, published in Japanese in *Shinkenchiku*[1] in 1953, Antonin Raymond wrote:

> A true designer tries every moment of his existence to rid himself of his own personality, to conceive and create things in an impersonal way. He believes that personal opinion is wrong and is nothing but a bundle of idiosyncracies. He designs according to definite and age long principles.[2]

Quite whom he might have had in mind, and why he chose to publish that just then, can only be imagined. He was certainly, at that moment, neither being ignored nor was he without work. The previous year he had become a Fellow of the American Institute of Architects and received an award from the Architectural Institute of Japan for his Reader's Digest Building in Tokyo and now, in 1953, he had over 20 ongoing jobs in the office and, that year, almost as many new ones.[3] His protégés were making their way successfully in the world: Maekawa Kunio's Kanagawa Prefectural Library and Auditorium was well advanced in Yokohama, while in New York, in the garden of the Museum of Modern Art, Yoshimura Junzō was building his Japanese house. 'I follow these architects' works with great interest,' he later wrote, 'because an important part of their early creative

life was spent in direct contact with me and in close association.'[4] Indeed, he and his wife Noémi were about to visit Yoshimura in New York.

In the same year, 1953, Maekawa and Yoshimura, together with Sakakura Junzō, were to start work together on the International House in Tokyo. As the combined expression of three architects, it might be seen as a fusion of different ideas or approaches. In this case it would be that of the two Western architects who were most influential on the development of Modernism in post-war Japan: Antonin Raymond and Le Corbusier. For Maekawa and Yoshimura, as has been said, had worked for Raymond while Maekawa and Sakakura had both worked for Le Corbusier. In view of Raymond's relationship with Le Corbusier, as shown below, and his apparently paternal attitude towards his former employees, it is quite possible that his comments published that year in *Shinkenchiku* were aimed at Le Corbusier himself.

Antonin Raymond, born in Bohemia in 1888, was only seven months younger than Le Corbusier although Le Corbusier initially thought himself by far the senior. 'He was surprised when I told him my age,' Raymond wrote to Noémi in 1935. 'He thought I looked much younger.'[5] Always elegantly slim, Raymond was then already 45, but due to a recent

contretemps, Le Corbusier must have imagined him to be a bit of a young upstart.[6]

The problem, if there was a problem, came with the rustic summer-house which Raymond built for himself in the countryside at Karuizawa in 1933 [13.01]. In 1931 Le Corbusier had published the Chilean Errázuris House project in *L'Architecture vivante*[7] and, whereas that house remained unbuilt, Raymond took the arrangement of the long, dog-leg ramp beneath a butterfly roof for his own house at Karuizawa. This was published in *Architectural Record*[8] in May 1934, just when Le Corbusier was assembling the 1929–34 volume of his *Oeuvre complète* for the Zurich publisher

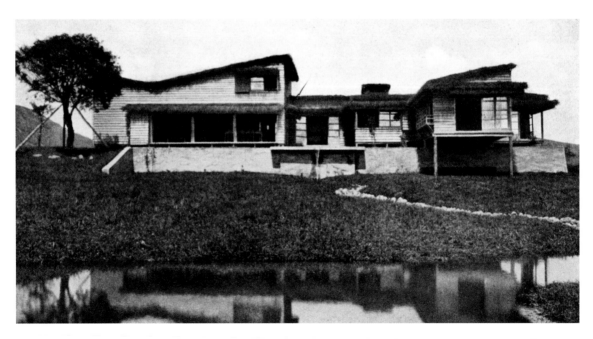

13.01 'Coupe d'une maison' (*above*) and 'Vue d'une maison construite au Japon, par M. Raymond, architecte, en 1933' (*below*), from Le Corbusier and Pierre Jeanneret, *Oeuvre complète de 1929–1934*, 1946.

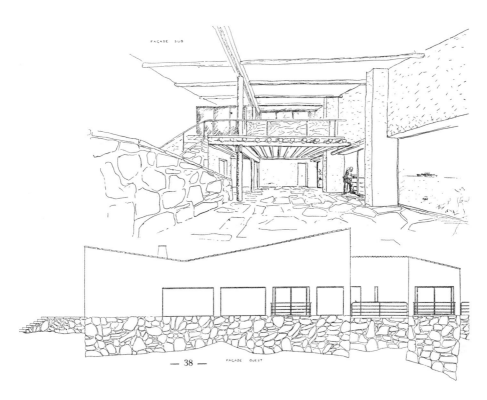

13.02 Elevation and perspective sketch of the Errázuris House project by Le Corbusier, 1930, from Le Corbusier and Pierre Jeanneret, 'Errazuriz Maison en Amerique du Sud', *L'Architecture vivante*, Spring/Summer 1931.

Willy Boesiger, and, as one caption indicated, the appropriation was shameless: 'Ramp to upper level was inspired by a plan of Le Corbusier for a house in South America.'[9] Rather than being annoyed, which he might well have been, Le Corbusier illustrated Raymond's house in his book under the probably ironic title 'Pas la peine de se gêner!'[10] Four photographs of Raymond's house, together with a long cross-section, are interspersed with Le Corbusier's own drawings for the Errázuris House [13.02]. Le Corbusier even draws attention to the similarities of the long sections, noting wryly, 'The least we can say, is that great minds think alike.'[11] The rustic nature of the interior of the Errázuris house is clearly reflected in Raymond's house where the chestnut posts similarly support the butterfly roof, although the rubble-stone ramp is now interpreted in *in-situ* concrete and what

might have been plastered walls are now lined with cedar boards. Even so, the similarities are striking. Le Corbusier's perspective view of the interior, looking towards the mezzanine gallery, is replicated almost timber for timber in Raymond's interior, as photographed and reproduced in *Architectural Record*: indeed, Le Corbusier's drawing shows 12 circular wooden beams supporting the mezzanine; Raymond's version used 11. In the account of the affair in his *Autobiography*, Raymond was a little off-hand, writing, 'Although I gave him full credit for it, he made an unnecessary fuss about it in one of his books.'[12] Yet Le Corbusier was apparently very accommodating and declared that he bore Raymond no grudge. In a letter to Raymond of May 1935, written in French, he says, 'There is between us no ill feeling, be sure of that, but, as you say yourself – there was a little mistake on your side;

that is, you omitted writing me a word at the time you published your house in Tokyo, which is really very good.'[13] Then he added: 'I shall say more – that you have made such a successful interpretation of my idea that page 52 of Boesinger's [sic] book is probably the best of the entire work.'[14] Although Raymond presents the incident as of being of little consequence, the translation of Le Corbusier's letter is so favourable to his position (e.g. 'a successful' as opposed to 'a pretty' interpretation of Le Corbusier's idea) that the nuances and implied condescension of the original wording are covered over.

Although the house included two eight-mat *tatami* bedrooms,[15] Raymond was, of course, not Japanese, so the design, as he conceived it, reflected as much his innate Western lifestyle and upbringing as it conjured up, with its rough materials, rattan *sudare* and thatched roof of larch twigs, albeit set on tin sheeting, notions of the traditional Japanese farmhouse or *minka*. As Ichiura Ken observed in *Shinkenchiku* at the time, 'Here we see a harmony between Japanese and Western living and methods unimaginable to a Japanese person.'[16] In the pursuit of the Western influence upon Japanese architecture the rustic Karuizawa summer-house represents, in many ways, a false trail. It was certainly a model which Raymond repeated, notably in his contemporaneous St Paul's Catholic Church at Karuizawa (1935), as well as in a number of post-war churches and houses, but it was not until Yoshimura Junzō, who had worked for Raymond in 1931–34, built his own summer-house at Karuizawa in 1963[17] that what Ichiura saw as the harmony between Japanese and Western living and methods was realised, in the rustic context, by a Japanese architect in Japan.

A few months after this exchange of letters, Raymond travelled to the United States in search of work. At a luncheon at the Architectural League in New York in early November, he was seated next to Le Corbusier who was then on a lecture tour. That afternoon he wrote to Noémi:

I had a short talk with Le Corbusier. He was very cordial – His speech was excellent. You feel that he is very deliberate and his capacity for speaking is perfect.

I think he is more of a speaker or journalist or writer or painter than an architect, but one is just taken for a flight as soon as one meets him.

He chanced on him again that evening at the Savoy-Plaza Hotel on Fifth Avenue:

I spent a most delightful hour with Le Corbusier – We both opened up – We were sitting at the bar of my hôtel ('the' hôtel in N.Y.), Corbusier unshaven, I just got him out of a terrible hotel, full of gangsters, God knows why he stays there …

Corbusier, short of money and short of work, said that he wanted to work with Raymond, an offer about which Raymond was unsure – 'Is that for the good or not?' Nevertheless, they spent the next few days together, visiting Brooklyn Bridge, talking about New York's tall buildings and ideas based on the Ville Radieuse. Raymond sketched them in a letter to Noémi[18] and wrote:

I learn a lot from him but I realize more and more how way up in the sky he really is – He is there all alone too – He is not an architect or builder – he is a brilliant and inspiring brain …[19]

Five days later he wrote again:

I like Corbusier's soaring spirit, but – isn't he like a European edition of FLW? He is jealous and nothing is but Corbusier – When I was talking to the secretary of the Museum of Modern Art Corbusier was there – he stayed on, wanted to know what I have to say – then left, but I saw him near the door, still eavesdropping – I thought that was silly …[20]

By early December, Raymond was back in Tokyo with Noémi, in the house they had built on Reinanzaka hill in 1924–26. Constructed out of cedar board-marked monolithic concrete, in response to the devastation of the 1923 Great Kantō Earthquake which had destroyed their home in Shinagawa, this building brought together not just Western technology and Japanese craftsmanship, but Western architectural

forms with Japanese architectural space – especially in its open relationship with the courtyard garden. As the French Ambassador Paul Claudel remarked, Raymond here 'tried to preserve that which is essential and delightful in the Japanese house – less a box than a vesture, an apparatus for living and breathing ...'[21]

Writing of the Reinanzaka house in his *Autobiography*, Raymond records his debt to Le Corbusier:

> In Japan, I believe that I was the first architect influenced by Le Corbusier and that resulted in my residence in Tokyo in 1924, in which Japanese influence was combined with that of Le Corbusier.[22]

What he must have been looking at was the paired Lipchitz-Miestchaninoff villas, built on the outskirts of Paris at Boulogne-sur-Seine in 1923–24. Yet these were not published until 1926 when *L'Architecture vivante* carried them.[23]

Designed for two sculptors,[24] these houses had high-ceilinged ground-floor studios – the 'grand atelier' and the 'petit atelier' – and bedrooms above. Positioned on the edge of the site, they were inward-looking towards a courtyard garden, at the far corner of which was a single garage where a high-level bridge came to an abrupt halt. This was because the third studio-house intended for the site beyond the garage was never built to Le Corbusier's plans. Rounded stair towers, elevated walkways, roof terraces with metal railings and overhanging canopies gave the buildings a sculptural outline and there is certainly something of the fragmented incompleteness of these buildings to be seen in the composition of Raymond's Reinanzaka house. Internally, at the Reinanzaka house, there is little, apart from the spiral stair which rises from the living room, to suggest Le Corbusier.[25] But even this avoids replication, for there is no gallery in the space as Le Corbusier might have used, nor industrial-scaled glazing to light the room: the windows, comprising fairly conventional French doors with a fixed light surround, rise to a height of only 8 feet 6 inches (2 metres 550 millimetres).[26] Although from the massing of the building to the disposition of the rooms and the location of the garage, Raymond was clearly drawing upon the Lipchitz-Miestchaninoff villas, he was not copying: where Le Corbusier broke the courtyard wall with five-barred railings, Raymond now punctuated it with a circular Japanese window.

Published as drawings and a model in *L'Architecture vivante* in 1925, the Reinanzaka house was described as a 'curious testimony of the universality of the [Modern] spirit in architecture' and Raymond was hailed as being on the leading edge of the avant-garde.[27] Yet it is, in its way, a curious building. Where much of it can be traced to the influence of the Lipchitz-Miestchaninoff villas, there is also something in its free form to suggest the Expressionist work of the Amsterdam school of Frederick Staal and Piet Kramer, and the emerging de Stijl architecture of Theo van Doesburg and Gerrit Rietveld. Raymond would have known of this through contacts in Europe, and particularly Jean Badovici, the editor of *L'Architecture vivante* and a keen promoter of both de Stijl and concrete construction, who kept him well supplied with architectural publications, and in all probability through Horiguchi Sutemi's book, *Gendai Oranda kenchiku* (Contemporary Dutch Architecture), published in 1924.

Designs for the Reinanzaka house had begun in February 1924, but the house was not to be completed and occupied until June 1926. During that time, from August to November 1925, Raymond had been travelling in the United States and Europe where, in Prague on 29 September, he was officially appointed Czech consulate in Tokyo. On his return through Paris he met August Perret and Pierre Jeanneret (but, it seems, not Le Corbusier) and visited the Exposition internationale des arts décoratifs et industriels modernes. There he might have seen Le Corbusier's Pavillon de l'esprit nouveau (which was located outside the exhibition grounds) unless, due to the scandal it provoked, it was closed to the public at the time; but it is more likely that at the Exposition he sought out Perret's Théâtre for the lessons it could teach him about

13.03 The Chapel at the Women's Christian College (now University) in Tokyo Suginami-ku, designed by Antonin Raymond, 1938.

building in concrete. In Paris he also met Bedřich Feuerstein, a Czech architect who soon came to join him in Tokyo. He had worked in Perret's office from 1923 to 1925 and, as Raymond was to write to Noémi soon after his arrival, 'Feuerstein does me a lot of good. Perret speaks through him, when he criticizes my work ... I have the feeling, that Perret came to help me and push me a little further, and on the right road.'[28] Although Feuerstein left in 1929, Perret's influence remained, with the strongest reference still to come: the Tokyo Women's Christian College chapel [13.03], built between 1934 and 1938.[29] When writing about this building in his *Autobiography*, he said:

The design by Auguste Perret of the Cathedral in Raincy, France, had made such a deep impression on me that I decided to take it as the beginning of my design, which thus followed, in the main, what Perret achieved. The design, therefore, is not original.[30]

In his *Autobiography* Raymond states that Le Corbusier's influence upon him culminated with the Tokyo Golf Club, built in 1930.[31] But this is really a matter of interpretation, for in 1930 Maekawa Kunio joined the office, fresh from two years with Le Corbusier in Paris. Whereas Raymond might have wished to move on, Maekawa's presence, as he wrote, 'kept up

the influence of Le Corbusier in my office'.[32] This is quite apparent from the Akaboshi Kisuke House (1931–32) in Tokyo, where Le Corbusier's *parti* of the Maison Citrohan (1922), realised in the Stuttgart Weissenhof single house (1927), is combined with the elevation of the Maison Cook (1926) at Boulogne-sur-Seine; the pavilion on the top floor, which at the Weissenhof comprised two small bedrooms and which the Cooks used as a library, now became the *tatami* room. The influence of Le Corbusier must have been further revived following the Raymonds' visit to France in November 1932. Here they met him in his *atelier*, which Noémi described as 'the most impossible sort of a corridor in an abandoned convent. Very amusing …',[33] and, in the company of Jean Badovici, visited the recently completed Pavillon Suisse and the Armée du Salut and Immeuble Molitor, both still under construction. Once back in Japan, Raymond's first job of the new year, 1933, was the Kawasaki Morinosuke House (1933–34), followed by his own Le Corbusian summer-house at Karuizawa and soon after by the Akaboshi Tetsuma House (1933–35).[34] Less compact than the Akaboshi Kisuke House, both these Tokyo buildings respond to their more generous garden sites and recall, in their articulated massing and cranked plans, Le Corbusier's two annex buildings in the Villa Church's gardens at Ville-d'Avray (1928–29). Had the Raymonds seen this as well? Perhaps, for both these houses, like the Akaboshi Kisuke house, were designed in every detail by Raymond and Noémi.[35]

The Japanese and Le Corbusier

The first Japanese architect to discover Le Corbusier and to make his work known in Japan was Yakushiji Kazue. At the Salon d'automne in Paris in 1922 he had seen the drawings for the Ville contemporaine de 3 millions d'habitants and, greatly interested, managed to meet Le Corbusier of whom he had never heard before. On his return to Japan in 1923 he published in *Kenchiku sekai* an account of their meeting together with drawings of the Immeuble-villas and the Maison Citrohan.[36] Here he called Le Corbusier 'Kobusse-Sunié', an interpretation of the pseudonym Le Corbusier-Saugnier, and published the drawings, not under Le Corbusier's name, but that of the Compaigne d'habitation franco-américaine. Nakamura Junpei, then a student at the École des Beaux-Arts, also visited the exhibition and similarly, after his return to Japan, wrote about the Ville contemporaine in *Kenchiku Shinchō*[37] in 1924.[38]

Thus, Le Corbusier, or Ru Korubyujie, as he was called, began to attract the attention of the Japanese. In 1925, the art critic Moriguchi Tari and Tsutsui Shinsaku of the Ministry of Finance managed to visit Le Corbusier's Pavillon de l'esprit nouveau at the Exposition internationale des arts décoratifs (even though the building was closed at the time) as well as the Maison La Roche/Jeanneret; in 1926 Imai Kenji, a lecturer at Waseda University who had read *Vers une architecture* in 1924, obtained from Walter Gropius at the Bauhaus an introduction to Le Corbusier, whom he then visited in Paris; in 1927, Fujishima Gaijirō, then a professor at the Technological High School in Seoul, Korea, saw Le Corbusier's buildings in Paris, and also the workers' housing at Pessac and the two houses at the Weissenhof in Stuttgart; and in 1928 Nakao Tamotsu, who had already been working in Paris for Henri Sauvage, asked at Le Corbusier's *atelier* for a job, but he was turned down.[39]

By 1929, Le Corbusier's star had come into the ascendant. In that year (Showa 4 *nen*), but in which month is uncertain, Koyosha of Tokyo published *Ru Korubyujie sakuhinshū* which, in 72 pages of illustrations, showed over 20 of his projects including the as yet unbuilt Villa Savoye.[40] Part of the attraction of this publication, and of Le Corbusier's work as a whole, was that he showed his buildings in axonometric projection which was a method familiar to the Japanese from *Yamato-e* or *fukinuki-yatai*-style paintings dating back to the Heian period (784–1185).[41] Thus, it was easy to understand. Furthermore, it was felt that there were common elements between traditional Japanese architecture and Le Corbusier's houses

and that the Japanese could easily assimilate his plans, which seemed to resemble the *sukiya* style, and his architectural forms, which were like Katsura.[42]

In May and June of 1929, *Kokusai kenchiku* published two special issues on Le Corbusier, the first containing 14 articles and the next a further 11. In the first, Ichiura Ken, then a recent graduate of the Tokyo Imperial University,[43] lamented the lack of discussion afforded Le Corbuser in Japan. He identified Gropius, Mendelsohn and Behrens as his predecessors and urged Japanese architects to read *Vers une architecture* which was still not fully available in Japanese:[44] a translation by Miyazaki Kenzō was eventually published in September that year.[45] Elsewhere in the May issue, Nakamura Junpei wrote admiringly of Le Corbusier's 'colourful' plans,[46] while Kishida Hidetō, a professor at Tokyo Imperial University, included Le Corbusier in a pantheon of architects from Palladio to Otto Wagner and declared that 'among many points to admire in Le Corbusier, I would like to give first and foremost the harmony between his thorough architectural theory and the practice of it.'[47] The June issue contained Maekawa Kunio's translation of Le Corbusier's own autobiographical statement which gave both a personal history and a list of the projects undertaken.[48] Despite all this enthusiasm, there were detractors. In May 1929, *Kenchiku* published a translation of Le Corbusier's 'City and Houses'[49] by Mizuki Kimiji, only to follow it that October with 'Flag of Japan: Rising Sun or Setting Sun?' in which Kido Hisashi asked, 'Although I am not fascist why follow Western trends? Le Corbusier may be revolutionary … but look at the Nishi Honganji temple or at your own residence. Japanese economical artistry is far more advanced than Ruskin. Why Le Corbusier for us now?'[50]

Le Corbusier's *Atelier* (pre-war)

It was Kishida Hideto who opened Maekawa Kunio's eyes to Le Corbusier. While Maekawa was a student at Tokyo Imperial University Kishida had given him books by Le Corbusier, including *L'art decorative d'aujourd'hui* (1925), extracts of which Maekawa was to translate into Japanese in 1930. For his diploma he had written a 'Discourse on Le Corbusier' and so, with an uncle living in Paris, he determined to go there upon graduation.[51] Consequently, in April 1928, Maekawa found himself, thanks to his uncle's intercession and financial guarantee, working unpaid in the *atelier* Le Corbusier et Pierre Jeanneret at 35 rue de Sèvres. There, another Japanese apprentice, Makino Masami, a contributor to the May and June 1929 issues of *Kokusai kenchiku* and soon to be a vocal critic of *teikan-yōshiki*, joined him for a few months. Albert Frey and José Luis Sert (who designed the Spanish pavilion for the 1937 Paris Exposition) were also there, but it was perhaps Charlotte Perriand, Ernest Weissmann and Norman Rice whom he got to know best. While in the *atelier*, Maekawa worked on the vast Centrosoyuz Building in Moscow (1928–36) and the Cité Mondiale, as well as smaller, often unbuilt, projects such as the Maisons Loucheur (1929) and the Maison Canneel (1929), which he signed off in the *atelier*'s *Livre Noir*. This was published in *Oeuvre complète de 1910–1929* as the 'Maison de M. X. à Bruxelles' [Plate 19].[52]

It was more than prescient that on his first day at the *atelier* in April 1928, Le Corbusier and Pierre Jeanneret took Maekawa to see the recently completed Villa Stein at Garches. 'The fresh sensation I felt,' he later recalled, 'when I walked to the back of the house and looked at it from a stand of trees in the garden will always be with me.'[53] Four years later, when he designed his first independent commission in Japan, the Kimura Manufacturing Laboratory [13.06] in Hirosaki (1932–34), the memory of the Villa Stein returned.

It is difficult to determine how much Le Corbusier might have absorbed of Japanese architecture at this time. Beyond what was being published in Western journals, his best opportunity to hear first-hand of Japan was, of course, from Maekawa. In September 1929, Le Corbusier, accompanied by Maekawa, attended the second CIAM conference in Frankfurt and here Maekawa might have introduced him to Yamada

Mamoru. It was at Frankfurt that Le Corbusier and Pierre Jeanneret presented 'An Analysis of the Fundamental Elements of the Problem of the "Minimum House"' and illustrated it with designs for the Maisons Loucheur. In lambasting the inadequacies of the traditional (Western) dwelling, which he described as an envelope of solid materials belonging to a static system, Le Corbusier drew attention to other methods of house construction, citing the Japanese tea-house in particular. Here he called for standardisation as a prerequisite for industrialisation and spoke of the façades as providers of light, the partitions which mark off or define the interior spaces as membranes, and described the structure as a series of floors supported independently of the façades by posts. Although this was his vision of the Minimum House, it was also a description of the Japanese house. In *Oeuvre complète de 1929–1934*, he wrote: '... it is certain that the architectural art of Japan is better prepared than Western methods to exploit successfully the theses of modern architecture. Japan possesses an admirable tradition of the house. It has exceptionally fine and spiritual handiwork. The old tea houses in Japan are adorable works of art.'[54] In 1929, Maekawa had worked on the Maisons Loucheur type MS 1E which Le Corbusier later illustrated, in both day- and night-time conditions, in *Oeuvre complète de 1910–1929* [Plate 20].[55] These framed, modular units, which were to be assembled in pairs as raised, back-to-back dwellings, contained largely open-plan spaces each arranged around a central bathroom core. With sliding screens and fold-down beds allowing their easy conversion to night-time use, they were the Western equivalent of the Japanese house with its modular *tatami* mats, *shōji*, *fusuma* and *futon*. At the time, some Japanese architectural critics did not miss the affinity between Le Corbusier's work and traditional Japanese architecture. In the May 1929 celebratory issue of *Kosukai kenchiku*, Tsutsui Shinsaku observed how similar Le Corbusier's use of *piloti* was to Japanese post-and-beam construction, and Makino Masami, in a comment which was to echo his later criticism of the *teikan-yōshiki* style, said

that he thought that Le Corbusier's work was more Japanese than that of many Japanese architects.[56] It was a prescient thought, as the Petit Cabanon at Cap Martin, built many years later, was to show.

When Maekawa left Paris on 6 April 1930, to start the long overland journey back to Japan, he had been there for 12 days short of two years. What he found when he got back to Japan he did not like. On 1 June 1930 he wrote to Le Corbusier:

> It is already a month and a half since I returned to Tokyo and, at present, I am beginning to understand what happened during my absence and what is going to happen in Japan. What I see, what I hear, all of it disgusts me terribly. Nowadays, if one contemplates seriously all the conditions and the current state that surrounds one, one has only two paths left to choose from: – becoming nihilistic or being very left.[57]

It was not encouraging, but there were opportunities. Three weeks earlier he had been invited to attend a special reception in honour of the visiting American architect Richard Neutra. The other guests[58] included Horiguchi Sutemi, Yamada Mamoru and Yamaguchi Bunzō of the now defunct (since 1928) *Bunriha* group, and his former classmate, Ichiura Ken, the enthusiastic advocate of *Vers une architecture*. Yet despite such connections, it was to be four months before he could find employment and then it was his former professor, Sano Riki, who recommended him to Antonin Raymond.

Maekawa's letter of 1 June had contained a postscript in which he recommended to Le Corbusier a young compatriot, Monsieur Sakakura, asking Le Corbusier to give him whatever advice was needed.[59] Sakakura had come to Paris in the hope of working in Le Corbusier's *atelier* but, not being trained in architecture but in history of architecture, had enrolled at the École spéciale des Travaux Publics to study construction, particularly what the French call *béton armé* (reinforced concrete). A year later, on 16 June 1931, he wrote to Le Corbusier (in French) from his residence on rue Caulaincourt in Montmartre:

After graduating from the Imperial University in Tokio, where I studied architectural history, I came to Paris more than a year ago, with the desire to improve my architectural studies with you, the greatest architect of his time ... Now I burn with a long-cherished desire to work with you as a humble yet fervent disciple.[60]

In the archive at the Fondation Le Corbusier, there is a note in Le Corbusier's hand appended to the letter recording how the emotional Sakakura presented him with a large Japanese album as a gift.[61] This, and the fact that he had continued his architectural studies in Paris, must have impressed Le Corbusier for soon Sakakura was a member of the *atelier*. He was to remain there longer than any other employee, working on, amongst other projects, the Armée du Salut, the Centrosoyuz Building and the Obus plan for Algiers. But he was still not paid.

The Japanese Pavilion

By the time Sakakura Junzō left Le Corbusier's *atelier* in April 1936 to return to Japan, the junior staff would, in the absence of Le Corbusier or Pierre Jeanneret, defer to him. However, his family, who were wealthy *sake* producers in Hashima, could no longer afford to support him. While honouring the commitment to his family, Sakakura probably had every intention of returning to France, the reason being the Exposition Internationale des Arts due to be held in Paris the next year. That February, Le Corbusier had written to Maekawa's uncle Satō Naotake, now the Japanese Ambassador to France, announcing that he had several competent Japanese architects working for him and that he would design the Japanese pavilion in the best contemporary style.[62] Although his opportunism came to nothing, the project nevertheless found its way into his *atelier*.

Rather than have the Japanese pavilion designed by a foreigner, the Japanese Foreign Ministry held a limited competition to find an appropriate design. This was organised by Kishida Hidetō, and

Maekawa Kunio and Ichiura Ken were amongst those invited to compete.[63] Maekawa's Modernist design for a steel and glass building offering panoramic views across Paris was initially selected but this met with objections from the anti-Modernist establishment for not being Japanese enough and a more conservative design by Maeda Kenjirō was chosen in its place. This in turn was criticised in the press by Moriguchi Tari who had visited Le Corbusier's Pavillon de l'esprit nouveau at the Exposition internationale 11 years before.[64] However, the host's requirement that the building should be built of French materials and by French workmen necessitated another change of heart and, rather than returning to Maekawa, who would have been familiar with French construction procedures, the job of building Maeda Kenjirō's scheme was given to Sakakura Junzō. Sakakura promptly returned to Paris and rented space in Le Corbusier's *atelier*.[65] But then, on finding that Maeda's scheme did not fit the topography of the site, he resolved the problem by designing a completely new building.

The site for the Exposition Internationale des Arts et Techniques Appliqués à la Vie Moderne stretched from the Place de la Concorde to the Pont de Grenelle and from the Trocadéro to the École Militaire. There was a sense of modernity about the exhibition which could not be missed. 'Perhaps the most remarkable feature evident even to the most obstinate anti-modernist,' observed the *RIBA Journal*, 'is the fact that without exception the best pavilions are those which show a comfortable assimilation of modern forms and modern materials and a lively understanding of the modern aesthetic.'[66] These it identified as the Danish, Austrian, Finnish, Polish, Swiss, Spanish and Japanese pavilions. 'Another most important and significant merit of the Exposition,' added Talbot Hamlin, writing in *American Architect and Architecture*, 'is its daring use of many materials, and especially of glass. This is what most differentiates it from fairs of the past ... Perhaps its most significant achievement is that here, in 1937, is a host of buildings which differ enormously in plan, conception, and detail,

each one free and in its own way creative, and yet each helps the next and all seem part of one movement, one great design, one culture.'[67] These observations might have been brought about by a sense of disappointment with the home team, for neither the *RIBA Journal* nor *American Architect and Architecture* thought much of their own country's respective contributions. The RIBA's correspondent wrote that the British pavilion[68] had 'one of the best sites in the exhibition and one of the worst exhibits',[69] while Hamlin thought that in the American building,[70] 'indecision and aimless wandering destroy the effect of its exhibits almost entirely.'[71]

It was in this context of international pavilions that, for the first time, a Japanese architect designed and built a Modern building in the West [Plate 21].[72] The Japanese pavilion was located in the corner of the exhibition ground below the Trocadéro and near to rue le Notre. To one side was the Romanian pavilion and to the other, the cinema: the view to the river Seine was blocked behind the hugely long USSR pavilion. The amount of Western press coverage which Sakakura's pavilion received was prodigious. Talbot Hamlin thought that it 'translates the jewel-like elegance of the Orient into candid terms of steel and glass',[73] while another American correspondent, writing in *Architectural Record*, said that it was, 'in spite of its palpable modernity, intimately Japanese'.[74] This turn of phrase might have come from the *RIBA Journal*, which had already described it as 'intimately Japanese and palpably "international".'[75] Meanwhile *The Architect and Building News* thought it 'a real beauty … traditional without being silly'.[76] The pavilion was illustrated in the French journal *L'Architecture d'Aujourd'hui* as well as in the British *Architects' Journal*, the American *Architectural Record*, the Finnish *Arkkitehti*, the Danish *Bygge Kunst* and the German *Das Werk*.[77] Serge Chermayeff wrote the most extensive single critique for the London-based *Architectural Review*.[78]

Sakakura's pavilion sat on a wooded slope, its lightweight steel frame raising it, by stages, off the ground. Circulation was by enclosed ramps which

initially followed the contours of the site before doubling back, through the building, and thus gaining height, before finally leaving the visitor in the covered tea-room high above the ground amidst the foliage of the surrounding trees. From here a long open-air ramp, in the form of a square helix reaching out above the Japanese garden, took the visitor down to the ground, depositing them close to where their journey had begun. Solid panels and broad sheets of glass clad much of the building, but there were also screen walls where the small, horizontal panes of glass suggested *shōji* or, as in the tall end walls of the tea-room and the enclosed circulation ramps, the diagonal lattice of wood and glass recalled *namako* walling. As well as these cultural references, the building had the sense of openness of the traditional Japanese house, yet the architectural language, and the materials, were quite Modern. *L'Architecture d'Aujourd'hui* thought it both 'moderne' and formally foreign, the only concession to tradition which it noticed being the entrance canopy which it regarded as expressive without mimicking the garden gateways and the roofs of Japanese temples. 'Clear plan, clear frame,' it said in summary, 'respect for the beauty of natural materials (stone, steel, glass, wood and fibre-cement).'[79] Writing in *The Architectural Review*, Serge Chermayeff observed how the building was planned 'in relation to existing trees, with ramps and galleries freely disposed so that the trees make their effect actually from within the perimeter of the pavilion.'[80] Chermayeff admired 'the gay colours and lovely texture effects of large wood lattice screens' and 'the transparency, lightness and elegance of the whole and the effectiveness of controlled repetition of motifs: structural steel, trellis screens and paving units'.[81] But his most interesting observation pertained to the nature of the building:

> In the Japanese case the national characteristics prevail, although they suggest a curious Japan-via-Europe-via-Japan origin. Japanese elegance in wood construction is expressed through steel.[82]

There was, apart from the adoption of ramps and the use of rubble stone walls to support them

(for Le Corbusier said 'stairs are the enemy of the public'[83]), little in this design to suggest Le Corbusier's influence. As José Luis Sert wrote almost 40 years later, after Sakakura had died, 'The elements of his architecture that were imported to Japan were assembled by a mind that had enjoyed and understood Europe without losing its attachment to the best in Japanese tradition: to those elements deeply rooted in the anonymous architecture of his country ...'[84] What Sakakura had achieved at Paris was a lightweight, Modern building of a different tradition. As the Exposition closed, the pavilion was awarded the Diplome de Grand Prix (Class 21, Group V).

Charlotte Perriand

Following the success of the Internationale Exposition, Sakakura Junzō remained in the *atelier* at Le Corbusier's express request, eventually returning to Japan at the beginning of 1939. In February 1940 he wrote to his old friend and collaborator, Charlotte Perriand, to say that he had been asked by the Bureau of Commerce at the Imperial Ministry of Commerce and Industry to suggest a French designer who could act as a consultant, and that he had recommended her *sans hesitation*.[85] Yet it was not until May 1940 that Perriand received, from the Japanese Embassy in Paris, the official invitation from the Department of Trade Promotion at the Ministry. Had it been sooner, she might well have refused, but even now, with the war in Europe getting closer to Paris, she was unsure if she should accept. Fernand Léger said she should go; it would be safer. Furthermore, Pierre Jeanneret, with whom she had a long affair, said he would join her in Japan. However, when she eventually told Le Corbusier of her decision to leave, he felt deserted and betrayed, complaining, 'You'll have all the time you need to meditate on the harm you've done me.'[86] That December he wrote: 'So Pierre and Charlotte had decided before the debacle to go to Japan. They would have left me with a fait accompli. So be it!'[87] At the time, it

must have seemed to be a decision well taken: on 12 June, two days after the Germans marched into Paris – the debacle to which Le Corbusier referred – Perriand left for Marseilles where she boarded the *Hakuzan-maru* for Kobe, arriving there on 21 August.[88] It was to be almost six years before she returned to France.

On the ship Perriand read, at Sakakura's recommendation, *The Book of Tea* by Okakura Kakuzō.[89] It was as good an introduction to Japan, and her role there, as she might find anywhere. First published in 1906, it was as much a meditation on the tea ceremony as it was on the relationship between the East and the West. Thinking of her departure from Paris, Perriand might have paused when she read these words:

> We have an old saying in Japan that a woman cannot love a man who is truly vain, for there is no crevice in his heart for love to enter and fill up.[90]

Saka (as Perriand called Sakakura) and she had enjoyed a close friendship in Paris, even going skiing together in the Alps, and Sakakura was keen to bring her to Japan. 'Tu n'as pas envie de visiter le Japon?' he wrote. The role, as he explained, 'est à desiger la fabrication des oeuvres d'arts decoratifs dans les plusieurs institutes appartenant à la ministeres de Commerce' [sic].[91] Once in Japan, Perriand, accompanied by the young designer Yanagi Sōri, travelled extensively in search of craftwork suitable for export to the West. These finds she displayed in an exhibition designed with Sakakura and held at the Takashimaya Department Store in Tokyo from 27 March to 6 April 1941.[92] Although promoted under the somewhat ponderous title, *An Exhibition of Madame Perriand's Works: A Suggestion of Interior Equipment for the House of the Year 2601 – Utilization of the Materials, and Techniques Available under Wartime Circumstances*,[93] its theme, *Sentaku*, *Dentō*, *Sōzō* (Selection, Creation, Tradition), chosen by Perriand herself, was displayed in outsized *kanji* at the entrance. Next to this, forming a backdrop, were two large photographs: one, a picture of the moon-viewing platform taken from

within the Old Shoin at Katsura (which Perriand had visited the previous September), and the other, the vaulted interior of Le Corbusier's 1935 Weekend House at Vaucresson, looking through to the garden beyond. The juxtaposition was telling: the message was not about the proto-Modernity of Katsura but rather, as Taut had recognised, its traditional, hand-made qualities which were intended to be complemented by the rugged interior of the Vaucresson house. It was a relationship which was echoed by the selection of Japanese craftwork, displayed alongside reinterpretations of Perriand's own furniture designs, including her *chaise longue* of 1928–29. Here she used wood and bamboo and employed traditional manufacturing techniques, such as that for making woven straw coats (*mino*), in place of the tubular steel and processed leather of the French prototype. The book of the exhibition, *Sentaku, Dentō, Sōzō*, which was produced later, was dedicated to Le Corbusier and Pierre Jeanneret, 'who continue their brave struggle – determined to create a new world'.[94]

Perriand continued her work for the Department of Trade Promotion but, following Japan's entry into the war in December 1941, found that she was unable to leave the country. However, since France was regarded as a neutral state, she was not detained but placed under police surveillance. The scuttling of the French fleet at Teulon in November 1942 paradoxically served her well. Her Japanese friends thought that it reflected the *samurai* code of honour and they came to share their pride with her. It was not, she thought, a sentiment which would have been widely felt back in France.[95] Yet there were other things, reflecting a calmer, more spiritual lifestyle, which she learned from Japan. These she expressed in her essay 'L'Art d'habiter', published in 1950 in *Techniques et architecture*:

Dwellings should be designed not only to satisfy material specifications; they should also create conditions that foster a harmonious balance and spiritual freedom in people's lives ...

Tranquility for every family member is an even greater necessity in the hectic life of our century.

Ambience can be created through intelligent urban planning and architecture. In the interior, equipment can create an ambience of spatial emptiness.

We have to take our stand ... Better to spend a day in the sun than to spend it dusting our useless objects (with or without a vacuum cleaner) ... Walls with built-in storage are the first priority ... Our houses must always be empty so that we can dream or rest on the floor like Easterners, or in chairs like Westerners, and the children can play.[96]

Eventually, in December 1942, the French Ambassador, Charles Arséne-Henry, secured for Perriand an invitation from the Government of Indochina. Since this was an official request, the Japanese government allowed her to go and, following a reception in her honour at the embassy, she departed by train for Hakata from where she flew to Formosa, Canton and Saigon.[97] There, in the French colony, she remained until February 1946.

One unexpected benefit, at least to the Japanese, of Perriand's visit developed from a collection of drawings and photographs she had brought with her from France. These were of pre-fabricated, demountable cabins which had been designed by Jean Prouvé in late 1939 for the Société Centrale des Alliages Légers at Issore, and on which she and Pierre Jeanneret had worked. The larger version, supported on centrally placed steel A-frames, offered a split-section with double-height living accommodation in the manner of the Maison Citrohan. Sakakura recognised the potential in the design and developed the idea as War Assembly Architecture, using wood instead of steel, with the intention of locating them throughout south-east Asia and Australia as the Japanese 'Greater East Asia Co-prosperity Sphere' developed. But it was not until 1958 that something closer to the original Prouvé/Perriand/Jeanneret prototype emerged in Japan. This was the house which Iizuka Gorozō built for himself in Kamakura, using two steel A-frames for lateral support. Ironically, he was, as he said, 'attracted to the steel because its dimensions

approached those of wood, and because its rounded corners and smooth surface make it a congenial material for a dwelling.'[98]

Sakakura Junzō

Soon after returning to Japan, Sakakura Junzō opened the Sakakura Centre for Architectural Research. The success of the Japanese pavilion at the 1937 Paris Exposition, and his relationship with Le Corbusier, made him popular with young architects. Tange Kenzō and Hamaguchi Ryūichi, for example, would go in the evenings to Sakakura's office to hear him talk about Le Corbusier and to borrow books and magazines brought back from Paris. Tange is even credited on the large Nan Hu housing scheme for Xinjing, the capital of Manchukuo (Manchuria), which Sakakura drew up in 1939. Soon after returning from Paris, Sakakura had visited Manchukuo with Kishida Hideto, who had done so much to promote Western Modernism, and saw in the great *tabula rasa* offered by this territorial expansion the opportunity for a 'living laboratory' of architecture. He even wrote to Charlotte Perriand to ask if Le Corbusier and Pierre Jeanneret would act as consultants.[99] They might not have been needed, for the provenance of Sakakura's scheme was clear – slab blocks in the manner of La Ville Radieuse (on which he had worked in the early 1930s) raised off the ground, not quite on *pilotis*, but on a series of elliptical cross-arches; there are also elliptical arches along the elevation, recalling the famous Karl-Marx-Hof in Vienna (1930). On the lower three floors of the six-storey blocks, Sakakura proposed the spine-corridor and inter-locking cross-section which was to become famous over a decade later at Le Corbusier's Unité d'habitation in Marseilles. This arrangement had already been promoted by Le Corbusier for the Type I and Type II apartments in the Ilot insalubre No.6 project of 1936 which must have been topical in the *atelier* at the time that Sakakura was there working on the Japanese pavilion.[100] It is not surprising, therefore, to see that cross-section repeated in the Nan Hu housing scheme. Although in this version

there were no double-height volumes and the cranked stairs seemed not to make best use of the space, the internal walls were 'free' and fluid in the Corbusian manner.[101]

From the beginning, Sakakura's Japanese projects were similarly infused with borrowings from and references to Le Corbusier: the project for a War Memorial Tower (1939) was based on the pyramidal form of the Mundaneum (1929); the butterfly roof of the Takashimaya Department Store (1948) at Wakayama came from the first Maison Jaoul project (1936); the entrance canopy of the Tokyo Risshō Senior High School (1950) was derived from that at the Villa Stein at Garches (1927); and the *piloti* beneath the entrance canopy at the Takashimaya Department Store (1950) in Osaka Nanba, although tapering, displayed the same figure-of-eight cross-section as those supporting the Pavillon Suisse (1932) in Paris. Heavier than one might expect from Corbusier, and probably for seismic reasons, were the mushroom columns of the Franco-Japanese Institute (1951) in Tokyo, but the thin, wrap-around end-wall and the long, glazed façade with its expressed floor slabs, here faced with blue mosaic tiles, more than nodded at both the Armée de Salut (1933) and the Pavillon Suisse.[102]

Sakakura's big opportunity came in 1951 with the commission, following a limited competition, for the Museum of Modern Art at Kamakura. Built with a steel frame and clad with asbestos-cement panels, this white, rectangular building with its *pilotis*, ribbon windows and central courtyard, immediately recalled not so much the Villa Savoye at Poissy (1929), which it does, but the Ferme Radieuse from the Village Radieuse of 1938. Like the Museum, the Ferme Radieuse was a steel-framed building, raised off the ground and clad with asbestos-cement panels. But at the same time, the Museum's lightweight and constructionally explicit appearance suggested traditional Japanese architecture as much as it did Le Corbusier, a reference enforced by the way in which the steel *pilotis* on the south side rest on rocks emerging from the water of the Heike Pond against which the building was set [13.04].

On the west side, a long entry stair approaches the triple-height entrance bay, reminiscent of

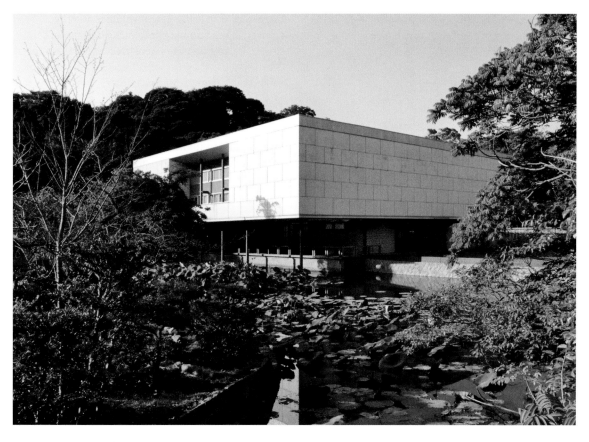

13.04 The Museum of Modern Art at Kamakura, designed by Sakakura Junzō, 1951.

the garden elevation of Le Corbusier's Villa Stein at Garches (1927). Here a tall, incongruous, steel column, painted red, bifurcates the entrance much as the single column does at Le Corbusier's Maison Cook at Boulogne-sur-Seine (1926). From here the visitor is led to the Museum's upper floor overlooking the central courtyard where sculpture is displayed. At this lower, courtyard level, where at the Ferme Radieuse Le Corbusier would have used concrete, Sakakura uses *ōya* lava-rock set as panels between the steel columns. The promenade then takes the visitor in a clockwise procession through the galleries before coming to the south front where an open balcony overlooks the Heike Pond in a manner reminiscent of Katsura. It is a controlled movement, terminating in a raised viewing

platform, as can be found in the Villa Stein or the Villa Savoye, a Le Corbusian effect well learned and here exploited.

But such an effect was surely not unknown to Sakakura. When Charlotte Perriand visited Katsura in September 1940, she observed how there were the same spatial principles as found in Le Corbusier's work.[103] This she probably recognised in the 'architectural promenade', the linking of the spaces, whether physically or visually, as the visitor moves from one to another, not in the formal manner of an *enfilade* arrangement, but quite informally, sometimes straight ahead, sometimes to the right or left, sometimes on the diagonal. She would have noticed too how the rooms were irregular in both shape and size, how the low *kamoi* might make one

stoop when passing into another room which would then seem suddenly taller, or how the *ranma* would allow a view above the *nageshi* through to the high-ceilinged space beyond. Such a sense of variety and surprise would be enhanced by the uniformity in scale and size of the grid-like *shōji* and *tatami* which enclosed the spaces.

The City Hall which Sakakura built in his home town of Hashima in 1959 displays a fusion of Le Corbusian precedents and recognisably Japanese elements [13.05]. Sakakura was now beginning to find his own way. Comprising a regular, four-storey gridded concrete frame with projecting balconies all around, the building is accessed by a ramped drive-through at one end, marked by a tall observation tower and cantilevered stairs, and surmounted by the raised roofs of the Assembly Hall and Civic Hall located on the top floor. This arrangement – the gridded elevation, the

ramp, the stairs, the roof structures – all recall Le Corbusier's Millowners' Association Building in Ahmedabad, India, completed in 1956, while the vertical wall of buff bricks, punctuated by small square windows and physically separating the layers of concrete balconies, is a move straight from the Unité d'habitation at Marseilles (1947–52). But where the City Hall diverts most obviously from Le Corbusier's precedents is in the treatment of the Assembly Hall roof, a sweeping, temple-like form which, in this context, could only be Japanese. More subtly, the skill of the Japanese carpenter is as apparent in the precise patterns of the board-marked concrete, as is the precision of the bricklayer in the buff bricks of the façade or the white tiles which face the roof structures. It is a building which, in its craftsmanship, eschews the much more rough-and-ready construction of, say, Le Corbusier's contemporaneous Maisons

13.05 The City Hall at Hashima, designed by Sakakura Junzō, 1959.

Jaoul (1954–56), where similar materials are brought together.

Throughout the 1950s, Sakakura Junzō maintained a close contact with Le Corbusier, not least due to the building of the National Museum of Western Art. In 1955 he arranged an exhibition of the work of Le Corbusier, Fernand Léger and Charlotte Perriand – *A Proposition of the Synthesis of Arts* – held, as had been Charlotte Perriand's exhibition in 1941, at the Takashimaya Department Store in Tokyo. He next oversaw the manufacture and installation of the 230-square-metre stage curtain designed by Le Corbusier for the cinema in the Tōkyū Bunka Kaikan (or Tōkyū Culture Centre)[104] in 1956, part of his redevelopment of Shibuya, Tokyo. And from the spring of 1957 he was involved with preparing the working drawings and supervising the construction of Le Corbusier's National Museum of Western Art in Ueno Park, Tokyo.

Maekawa Kunio

Maekawa Kunio's experience of working on the Centrosoyuz Building while in Le Corbusier's office, and his previous and no doubt enhanced understanding of the Palace of the League of Nations competition entry (1927), probably predisposed him towards large-scale commissions. Once back in Japan, where he arrived in April 1930, his potential client base did not allow, as Le Corbusier's did, for expensive private houses – unless through the facility of Raymond's office – whereas competitions for such public building offered a way forward.[105] In 1929, while still in Le Corbusier's office, he had teamed up with Ernest Weissmann and Norman Rice to design a public office building for Zagreb in Croatia. This was modelled on the Centrosoyuz building, as was his own competition entry for the Nagoya City Hall submitted the same year. A similar *parti*, overlaid with that of the League of Nations design, was adopted for his unsuccessful but highly contentious entry for the Tokyo Imperial Household Museum competition in 1931, as well as

for his entry for the Dai-ichi Seimei Building (First Mutual Life Insurance Company) competition in 1933 and the Tokyo City Hall competition of 1934. Although unsuccessful in these competitions, his 1931 design for the Meiji Confectionary Company's Ginza building was awarded first prize. The judges were Kishida Hideto, who had first exposed Maekawa to Le Corbusier, and Watanabe Jin, the winner of the Tokyo Imperial Household Museum competition.[106] The design of a thinly framed curtain-wall elevation of ribbon windows and a top-floor balcony and roof garden, set above a double-height, recessed shop floor, falls somewhere between that of Le Corbusier's Maison Planex, Paris (1927) and his Pavillon Suisse. While not quite reflecting either – indeed, the Pavillon Suisse was hardly started when Maekawa left Le Corbusier's office – it clearly reflects ideas which were prevalent in the office at the time.

These ideals are no more noticeable than in Maekawa's first independent commission, the Kimura Manufacturing Laboratory, Hirosaki [13.06], designed in 1932–34 while he was working for Raymond. Here the memory of that first-day visit to the Villa Stein is evident, as are memories of the Maison La Roche/Jeanneret (1923–25) in Paris as well as more generic, Corbusian ideals.

Although noticeably altered, there are still features about the Kimura Manufacturing Laboratory which make it stand out, not just as the confident work of a young man freshly returned from Europe, but also as the first authentically Corbusian 'villa' to be built in Japan. It is the rear elevation of the Villa Stein which is first referenced, where the ribbon windows run across the two upper floors before ending in a large, covered void which cuts deep into the building. This arrangement Maekawa repeated in his building's front elevation although the horizontal run of the ribbon windows is broken, as Le Corbusier did at the Maison La Roche/Jeanneret. The void, which at the Villa Stein offered a double-height space beyond the protruding, first-floor balcony, is here condensed to a double-height space overall. The balcony, which once protruded to form an entrance canopy, has now been removed, as have

13.06 The Kimura Manufacturing Laboratory at Hirosaki, designed by Maekawa Kunio, 1934.

the external stairs at the back of the building which referenced those at the Villa Stein, but inside, a feature of the Maison La Roche/Jeanneret remains, where the rounding of the back wall of the half-landing on the dog-leg stairs is still apparent. To one side of Maekawa's front elevation there is a vehicle drive-through, the upper storey supported on four circular columns or *piloti* – a memory, perhaps, of the drive-through at the Maison Canneel [Plate 19]. A long ribbon window set opposite the columns surveys the space. Just beyond the drive-through, where a single-storey wing extends to the back of the site, a shallow bay window pushes forward as if, again, to monitor the

incoming traffic. Viewed from the outside it is of little consequence, but once inside, where a single circular column supports the roof, its provenance becomes clear. What Maekawa here has in mind is the curved blank wall and the single supporting column of the first-floor picture gallery at the Maison La Roche/Jeanneret. But rather than set one above the other, he has flattened the layers, bringing the curved wall and clerestory window of the La Roche gallery down to ground level.

Although the parapet walls, which once gave the elevation such a clean appearance, have now been replaced with box gutters and overhanging eaves, and a pitched roof is all too visible above the curved

window bay, the simple Corbusian canopy above the rear door remains which, like the four *piloti*, attests to the memory of a more rational aesthetic. Yet it was not this small, first building located in a distant town in the north of Honshu which made his reputation as a Modernist and a follower of Le Corbusier, but the 1931 competition for the Tokyo Imperial Household Museum. However, when asked, as he was, 'Aren't you a disciple of Le Corbusier? Why don't you build houses that look like Le Corbusier's?', Maekawa could have pointed at the Kimura Laboratory, for, as he said, he was proud of such talk.[107]

The hiatus of the war did nothing to dampen Maekawa's enthusiasm for Le Corbusier and his memories of his time in Paris. In January 1947, he wrote what must have been his first letter to Le Corbusier and Pierre Jeanneret after, as he put it, '10 years of suffocating isolation!'[108] Bombing raids had 'calcined' his office and he had lost all his design work, photographs and books. However, his staff of 15 was safe, as was his house from where he was now working. In the letter he asks after his friends from the *atelier*, Sert, Frey, Roth, Nachmann, Rice and the others, and says how much he would like to return to Paris to see Le Corbusier and Pierre Jeanneret and to talk about modern architecture one more time. He tells them of his current work on PREMOS[109] pre-fabricated housing (although he doesn't name them) and his rather dispirited thoughts on industrialised housing:

> In my opinion, the industrialization of architecture is possible only when the general social production approaches its peak, while at home, we are obliged to start at the moment when it is at its bottom!

> Truly, between us, we see a huge amount of work waiting, but we have no more materials! To win materials it takes exports and there are only men and women to export; and I would like to export myself.[110]

The letter ends with a P.S.: 'I was married 10 days after the "ATOMIC BOMB".'

At the Nihon Sōgo Bank in Yaesu, Tokyo, completed five years later in 1952, Le Corbusier was still on Maekawa's mind: this time he was thinking of the Pavillon Suisse. It has been suggested that the bank was, in fact, derived from Maekawa's pre-war competition entry for the Meiji Confectionery Company's Ginza building (1931),[111] but it is more the case that both buildings drew strongly and separately on Le Corbusier, the front elevation of the Maison Cook (1926) being the precedent for the competition design. The compositional elements of the bank's north elevation which once faced Eitai-dōri were the same as the south front of the Pavillon Suisse: raised ground floor, curtain wall, screen wall with openings. The *piloti* which ran down the spine of the Pavillon Suisse were here redefined as 10 giant concrete columns surrounding the double-height banking hall; above this, the central stage of the building was a five-storey aluminium curtain wall while the top two floors, which contained a dining hall and auditorium, were enclosed behind a double-height screen wall of pre-cast concrete panels interrupted by balconies and glazed openings. Earlier designs had shown this whole screen wall perforated by a grid of small square windows, just like the north elevation of the Pavilion Suisse.[112] But Maekawa drew variously on Le Corbusier's *oeuvre*: the L-section balconies on the north and west elevations derived, like that in the Meiji Confectionery Company competition entry, from the Villa Stein (1927).[113] Although the Nihon Sōgo Bank was significant both for its technological innovations[114] and as one of Japan's first modern, post-war office buildings, it has, during the writing of this book, been demolished.

Pre-war buildings by Le Corbusier could not forever provide the precedents which his disciples sought, for his architecture was developing fast, and new and even outrageous buildings were appearing, not just in France but in India as well. Although overseas travel was restricted, Japanese architects could still keep abreast of developments through national and international publications. Corbusier's own steady stream of publications received a ready audience. Sakakura Junzō translated into Japanese *Manière de Penser L'urbanisme* (1956) and also *L'Unité*

d'habitation de Marseille (1955), and Yoshizaka Tamamasa translated *Le Modulor* in 1952, the first foreign language edition of the book.[115]

Maekawa's early post-war buildings paralleled, if not reflected, the move in Le Corbusier's work, as observed by Raymond, from the pre-war post-and-beam approach to the far more plastic. Yet he was not alone in this and it is difficult to attribute the change to any one influence. His third-placed competition entry for the Hiroshima Peace Memorial Catholic Cathedral[116] of 1948 had featured zig-zag walls beneath a rolling eaves-line, a structural response which characterised the auditoria at both the Fukushima Education Hall, designed by MID (the Maekawa Institute of Design[117]) in 1955 and completed in 1956, and the Setagawa Municipal Offices and Community Centre in Tokyo, built under Maekawa's own name in 1957–59 – although here the eaves were straight. The zig-zag walls provided depth in the vertical plane, and thus strength, obviating the need for a heavy grid of columns and beams, something which each building, in their ancillary spaces, still employed. Even so, in both instances a transverse connecting beam extended across the folded plates for lateral support. In the relatively small world of Japanese architecture in the 1950s, where Tange Kenzō had worked for Maekawa and Maekawa had worked for Raymond, it is not unexpected that such innovative ideas were quickly shared. The zig-zag walls which Maekawa, perhaps first, had proposed for the Catholic Cathedral in Hiroshima were adopted by Raymond in his Catholic church of St Anselm, Tokyo, of 1952–56 and by Tange in the Imabari City Hall of 1957–59. Coincident with all these was Raymond's Gunma Music Centre at Takasaki of 1955–61, where, as at St Anselm, he used the folded wall to allow vertical strips of natural or artificial light into the building.

Tange Kenzō

Tange Kenzō first met Le Corbusier when, at the invitation of José Luis Sert, he and Maekawa Kunio attended the eighth meeting of CIAM at Hoddesdon, England, where the theme was The Urban Core. Here Tange presented his proposal for the Peace Memorial Park at Hiroshima,[118] the winner of the 1949 Peace Memorial competition.[119] But this was not his first encounter with Le Corbusier. In 1939, two years after graduating from Tokyo Imperial University and while he was working for Maekawa,[120] Tange had published in *Gendai kenchiku* an essay called 'A Eulogy to Michelangelo: A Preliminary Study of Le Corbusier'. As the title might suggest, the discussion of Le Corbusier, which was largely confined to the Conclusion, played second string to a much broader discussion ranging from ancient Greek architecture to Michelangelo:

> The residential architecture of Le Corbusier is surely located at a place of tension within the total design spectrum that has Phidias at one pole and Michelangelo at the other. But does this very assertion not mean that we are stranded at the outset? We are stranded indeed.[121]

At a time when Japan was becoming increasingly isolated politically and, in the official adoption of the *teikan-yōshiki* style, architecturally moribund, Tange saw in Le Corbusier hope for the future.

> Le Corbusier is now living within the same time frame as Michelangelo and he bears the same historical mission.

> Anybody who looks at his recent paintings is likely to sense a dark shadow lurking within them.

> Because of the extreme importance of his mission, he finds himself in a magnificent loneliness. Transforming and metamorphosing all alone, he seems to possess that dark despair that characterizes the creative individual, the person who is truly original.

> But what exactly is this supreme mission?

In a warm atmosphere around an uneven hexagonal table, the architect Sakakura Junzō told us that Le Corbusier was in the process of creating modern classicism.[122]

Encouraged by Sakakura and supported by Maekawa, Tange took on the mantle.

As an advisor to the Wartime Damage Rehabilitation Board, Tange had begun developing his proposals for Hiroshima in 1946, but it was not until 1949, following the passing of the Hiroshima Peace Memorial Reconstruction Act, that the competition gave him the opportunity to realise them. However, if it were not for the interest which the West took in the scheme following the Hoddesdon presentation, and the special treatment and thus funding which the occupying Americans allowed Hiroshima, it might not have happened at all.[123] There were two reasons for this. Firstly, the architectural profession, or at least those that mattered and who had gathered at Hoddesdon, probably recognised in Tange's proposals a response to the Athens Charter, drawn up following the fourth CIAM meeting of 1933 and eventually published in an edited form by Le Corbusier in 1943.[124] The second was a sense of guilt: 60,000 people had died when the atomic bomb was dropped in August 1945 and by that December, the number of related deaths had risen to 140,000.[125] By allowing the development of the Memorial Peace Park, the occupying powers could assuage their guilt without admitting their culpability. Both sentiments are captured in this brief extract from the Athens Charter:

Since cities, and especially historic town centres, are nations unto themselves, there is a sense of moral value that holds a meaning and to which they are indivisibly linked.[126]

The site for the Peace Memorial Park was the newly created Nakajima Park,[127] located at the north end of an island in the Ōta river delta, at the tip of which was the T-shaped Aioi Bridge which served as the target for the bomber crew of the Enola Gay. Adjacent to this, on the east bank of the river, was the Hiroshima Industry Promotion Hall; to the south, a broad avenue running east/west called the One Hundred Metre Street, which closed off the site. Tange's proposal placed the elevated Peace Memorial Museum, with its flanking auditorium and community centre, at the south end of the Peace Park, parallel to the broad avenue now renamed Peace Boulevard. From here he ran a sight-line, defined by a broad watercourse, through a memorial arch to the battered remains of the Industry Promotion Hall, now called the Atomic Dome. Although this was, in its cross-axial planning, a Western conception and, like some of the nineteenth-century proposals for Tokyo, quite alien to the nature of Japanese cities, its positioning, ironically, was not due so much to a Hausmann-like grand gesture on Tange's part but rather to the fact that the Peace Boulevard followed the line of what was a firebreak, 100 metres wide, created in 1944 in anticipation of Allied bombing.[128] However, such broad avenues and axial planning provided a unique response to a unique situation and, with the limited exception of Tokyo and Nagoya, no Japanese city centres were treated to such wholesale Western realignment.

Following Tange's presentation at Hoddesdon, he and Maekawa visited Le Corbusier in Paris, after which they travelled to Marseilles to see the Unité d'habitation, then still under construction. Although this was Tange's first visit to Europe, he would have been very familiar with Le Corbusier's work through publications and his conversations with Maekawa and Sakakura Junzō. But the reality of these buildings must still have made him wonder. The form of the Peace Memorial Museum, raised off the ground on concrete *piloti*, was by 1951 already determined, but to what extent were the details thought through? Precedents, such as Le Corbusier's Pavillon Suisse, or Antonin Raymond's recently completed Reader's Digest Building in Tokyo, might be cited, the one giving the robust strength of the lower level and the other, the delicate screen wall set above. As the Australian architect and critic Robin Boyd said, the Peace Memorial Museum 'looked entirely modern and yet had a curiously evocative Japanese touch' [13.07].[129]

13.07 The Peace Memorial Museum at Hiroshima, designed by Tange Kenzō, 1949–56.

The Peace Memorial Museum's Modernism is easy enough to recognise: the board-marked concrete, the *piloti*, even the suggestion of a ribbon window in the great louvred façade. But these are less important for it would, in a way, have been too easy for Tange to reproduce a Western, Le Corbusian building; it is the 'curiously evocative Japanese touch' which is more interesting. This was not, as it were, a residual effect which he might cast off as his architecture matured but rather the opposite: a rediscovery of traditional values which, in combination with a Futurist agenda, would provide the way forward for post-war Japanese architecture.

The debate over tradition and modernity, which absorbed Japanese architects in the 1950s, is presaged here. To build in the *teikan-yōshiki* style, it was felt, would be to recall the great disaster of the war, whereas to adopt Western Modernism would be to kowtow to the conquerors. With the

Peace Memorial Museum Tange anticipated the solution to the conundrum which he developed through the 1960s. In his civic buildings, such as the Kagawa Prefectural Government Office at Takamatsu (1955–58) and his City Hall at Kurashiki (1958–60), Tange represented the *azekura* or log-cabin style of the eighth-century *Shōsō-in* or treasure house at Nara in board-marked, reinforced concrete; in the Library at Tsuda College, Tokyo (1953–54) and the City Hall at Kurayoshi (1955–56), he reinvented the *sukiya* style of the *shoin* at Katsura in trabeated concrete construction; and in the Sumi Memorial Hall at Ichinomiya (1955–57) and the Library at Rikkyō University, Tokyo (1959–61), he evoked traditional Japanese forms, with an imitation of *namako* walling in the one and a pagoda-like roof in the other. The Modern or Futurist agenda which these buildings presented is most often referenced in the details, be it the wall of the entrance hall at

Kurashiki City Hall or the water spouts at the Sumi Memorial Hall; in both instances one is reminded of Le Corbusier's chapel of Notre Dame du Haut at Ronchamp (1950–55).

Le Corbusier's Later Influence

At the CIAM meeting in Hoddesdon, Le Corbusier showed drawings of his proposals for Chandigarh as well as photographs of the model. Those buildings, which had a great effect on Japanese architecture in the 1950s and early 1960s, indicated a further development in both scale and form for Le Corbusier's architecture and one which corresponded well with urgency for large civic buildings in Japan. Few architects at this time seemed to respond as readily to Le Corbusier's changing palette as did Maekawa Kunio, whose Kyoto City Hall (1960), Tokyo Metropolitan Festival Hall (1957–61) and Kanagawa Youth Centre at Yokohama (1961–62) all copied the oversailing roof of the chapel at Ronchamp or, if read differently, the curved eaves of the Courts of Justice at Chandigarh (1951–56). It was a form which, when adopted by Tange Kenzō in the Golf Clubhouse at Totsuka (1960–61), became, in its representation of a *torii*, instantly recognisable as Japanese.

Maekawa's development of the Gakushūin University campus in Tokyo (1959–60) as an open-cornered quadrangle is immediately suggestive, due not least to the pyramidal auditorium set within the space, of Le Corbusier's monastery of La Tourette (1952–59) where the elevated oratory has a prominent pyramid roof. It is not only this use of a Platonic Form which suggests the precedent, but its location off-centre at the intersection of the two diametric pathways which cross the quadrangle; here, in a similar arrangement, Le Corbusier placed the tall, mono-pitch atrium at La Tourette. Both the layered horizontality of Le Corbusier's cellular buildings which surround the quadrangle and the blank walls of the chapel at La Tourette are reflected at Gakushūin University, the first in the teaching and

(now replaced) administration buildings and the second in the natural science building where, in place of the chapel's belfry, Maekawa employed an inverted conical tower, based on the chimney at the Unité d'habitation at Marseilles, to give access to the roof terrace.

In the referential same way, Maekawa's 10-storey apartment block on Harumi (1956–58), a man-made island in Tokyo Bay, immediately recalls the Unité d'habitation at Marseilles which he had seen with Tange following their visit to Hoddesdon in 1951 [13.08].[130] Although both buildings are of board-marked concrete and are raised off the ground on *piloti*, when the two are compared the initial similarities do not stand up to scrutiny: indeed, the spaces between the *piloti* are, at Harumi, infilled with apartments, a direct contradiction of the concept of a continuous landscape so noticeable

13.08 The Harumi Apartments at Tokyo Harumi, designed by Maekawa Kunio, 1958.

at Marseilles. However, the main difference between the buildings is in the cross-section where the spine corridor and interlocking maisonette apartments of the Unité are replaced, at Harumi, by balcony access walkways and single-level flats. These walkways, positioned on the north side of the building, are on the second, fifth and eight floors, from where stairs go up and down to the apartments on the intermediate floors; those on the first floor, which, like the ground floor, is independent of this balcony arrangement, are accessed in pairs from a series of seven dumpy, circular stair towers (derived, perhaps, from the porter's lodge and *parlois* at La Tourette) and from the fire escape stairs at the ends of the block. The need at Harumi for hefty seismic cross-walls resulted in an elevation divided into nine bays containing, on each level, a double-width balcony which, on the south front, were extensions of the apartments; on the north the balconies provided social spaces along the length of the three access walkways. The larger apartments, where there was no access balcony, consequently benefitted from through ventilation, whereas the smaller ones, restricted by the balcony to an almost square plan, opened only to the south. In describing the development of the plans to *The Japan Architect*'s Western readership, Maekawa's colleague Ōtaka Masato explained that Western-style plans were not well suited to Japanese habits and were understood 'only by a comparatively small class of urban intellectuals in Japan'.[131] Consequently, the apartments, with their Japanese bath-tubs, were traditional in arrangement, using *tatami* mats to define the spaces and sliding *shōji* to separate them. In reviewing the building as 'A Step Towards the Future', Kawazoe Noboru equated the larger apartments to city house plans and the smaller ones to farmhouse plans, arguing that such a distinction, learned from tradition, was something which Tange Kenzō had identified at the time the apartments were first being designed. Writing in *Shinkenchiku* in 1956, Tange had observed:

> Japanese farmhouse, with its simple floor plan in the style of the Chinese character 卅,

and the typical city dwelling, with its hallway running the length of the house, are cases in which the accumulated wisdom of life is given a methodological expression.[132]

Harumi, therefore, provides a good understanding of Maekawa's *modus operandi*. It was not that he copied Le Corbusier but rather that Le Corbusier, whom he had followed since the 1930s, would metaphorically open a door to a new type of architecture, and Maekawa would enter. In his explanation of the Harumi Apartments in *The Japan Architect*, Ōtaka Masato had acknowledged that they could have used a spine corridor and a two-storey maisonette plan 'as in Le Corbusier's high-rise apartment house in Marseille [sic]'.[133] However, they chose not to, the arrangement decided upon providing a more effective use of space.

Yoshizaka Takamasa

Maekawa and Tange had met another Japanese architect, Yoshizaka Takamasa, at the CIAM meeting at Hoddesdon and probably saw him again when they came to Le Corbusier's *atelier* in Paris. A former student of Imai Kenji at Waseda University, Yoshizaka had joined the *atelier* in 1950. He had spent part of his childhood in Geneva, where his father represented Japan at the International Labour Organization,[134] and therefore spoke fluent French. Supported by one of the first bursaries granted by the French government after the war, he remained in the *atelier* until late 1952, working on Chandigarh, the Unités d'habitation at Marseilles and Nantes-Rezé, and the Maisons Jaoul. It was he who translated into Japanese *Le Modulor* (1953), the first foreign language edition of the book. He also translated *Le Modulor II* (1960) and the eight-volume *Oeuvre complète* (1978).

It was at the Unité in Marseilles, apparently, that Yoshizaka met Ura Tarō, then a Japanese mathematics student; later they both lived in the Japanese students' hostel at the Cité Internationale Universitaire in Paris close to the Pavillon Suisse.

13.09 The Ura Tarō house in Nishinomiya, Hyogo prefecture, designed by Yoshizaka Takamasa, 1956.

On returning to Japan Ura commissioned Yoshizaka to build him a house subject to three conditions: it should be of concrete; it should be supported on piloti; and, in the Western manner, the living spaces should be separate from the bedrooms. What emerged in 1956 was a pair of conjoined buildings – one for living and one for sleeping – square on plan, and raised not on rounded *piloti* of the International Style, but L-shaped supports set at 45 degrees midway along each side [13.09]. The external palette of exposed concrete and clay brickwork was repeated internally, where hinged wooden panels opened for ventilation, as at the Maisons Jaoul and, in the absence of any good quality ironmongery, door handles and latches were made of wood and painted. Throughout the interior, muted Corbusian colours prevailed except on the landing above the

entrance hall where coloured glass lit the interior. With the exception of a *tatami* room for Ura's mother, inserted into one corner of the main living space, the living arrangements were purely Western. Although there is no segregation here between the generations of the family, each leaving their handprint forever in the concrete of the stair wall, what is detected is a *parti* similar to that for Mrs Manorama Sarabhai's house in Ahmedabad (1955), where the mother's house is linked to but separated from the son's by a covered car port and verandah, all executed in brick and concrete.

Although Yoshizaka did not repeat the Catalan vaults of the Maisons Jaoul and the Sarabhai House at the Ura House, he soon employed them in the extension he proposed for Mr M's house in Den-en-chōfu, Tokyo, in 1956 while working on the Japanese

13.10 The Villa CouCou in Tokyo Yoyogi, designed by Yoshizaka Takamasa, 1957.

pavilion in Venice. However, his ideas for a Corbusian two-storey, concrete-framed structure with vaulted roofs and brick infill walling proved too much for the client, and a single-storey timber extension was built instead. It also proved rather too much for the critic Watanabe Yasutada. In a lengthy review, in which he stated that 'anyone who is an architect has his own criticism on culture', he observed:

> Mr Yoshizaka's way of thinking is the French way which is the logic where poetry and prose intermingle and are difficult to grasp systematically. Instead of logical progression, the healthy mind of criticism is of greater value, and the idea is to understand one another; therefore, the wording is short and the progress fast. In other words witty spirits are necessary to understand Mr Yoshizaka's criticism of culture.[135]

Equally derivative, as its name would suggest, was the eponymous Villa CouCou – the French word for cuckoo. Designed by Yoshizaka and his students at Waseda University and completed in 1957, this one-room studio house in Yoyogi, Tokyo, was the most plastic of any building designed by one of Le Corbusier's former assistants [13.10]. Trapezoidal on plan, its splayed side walls projected outwards at the west end to shelter the broad living room windows; at the other end, facing the street, the roof, punctuated by upstanding sculptural rooflights, swept up in a graceful curve to accommodate a sleeping balcony above the study and bathroom. The entrance was in a small projection to the side bearing the building's name. Constructed from in-situ concrete – 'to give luxury in life without too much expense'[136] – the highly articulated external walls displayed a range

of expressive window surrounds and a variety of board-marked and impressed concrete patterns. Internally, small square windows are dug deep through the thick concrete walls while the stairs' pre-cast concrete steps, shaped like split logs, were individually cantilevered from the wall. The source for most of these gestures was clearly the chapel at Ronchamp, but the scale was diminutive, yet its sheer exuberance must be admired. Talking of Le Corbusier many years later, Yoshizaka remarked: 'He said that architecture begins at the point where the designer thinks that he has found a way of fitting everything into place.'[137] That is surely the case here.

Only when designing a building which somehow needed to represent Japan did Yoshizaka, in these early years, distance himself from Le Corbusier. The Japanese pavilion for the Venice Biennale, located on a small wooded hill in the Biennale Gardens, was the first building to be built by a Japanese architect in Europe after the war [13.11]. The idea of a Japanese pavilion for the Biennale, which was supported by the government as well

as by artists and critics, had been four years in the making, having become mired down in the debate of tradition versus modernity. The long delay eventually forced a decision and the Commission for the pavilion gave Yoshizaka complete freedom, so long as he finished on time. The occasion was to be in the 1956 Biennale which opened on 1 June. Speaking later to the Italian magazine *Domus*, Yoshizaka recalled the urgency:

> A fifty-hour flight from Tokyo to get to Venice, fifty hours on the ground, then again a fifty-hour flight to return; and the time that I had to complete was this: from Christmas to New Year. I have to say that God was with me ...[138]

The solution, a 15-metre elevated square box, was essentially a simple framed structure where a floating roof and floor were supported, like in a traditional Japanese house, by four columns. But as at the Ura House, the supports were not rounded *piloti* but slab-like wall sections, such as Le Corbusier was now using at La Tourette and in the Sarabhai House. The plan of the building was based on the Buddhist symbol of a swastika set within a square, the four supporting walls defining the arms of the swastika. Each arm supported a screen wall in the gallery which in turn supported a deep-beamed section of concrete roof through which light filtered as past a *brise-soleil*. In the centre of the room, the crossing of the swastika was marked by a square opening in the floor which looked down upon the sculpture court below. The purity of this revolving plan, where each identical quarter was set at 90 degrees to the next, was broken only by the entrance positioned at the southern corner of the pavilion: here a concrete canopy, cantilevered from a stepped buttress, sheltered a floating flight of stairs.

Although, as *Domus* said, the pavilion displayed some aspects of Le Corbusier's teaching, it was nevertheless a very recognisably Japanese building.[139] The tapering floor and roof beams recalled the *torii* and the blank stuccoed brick walls, the *amado*. Even the concrete handrail, now replaced, took on a cross-section as if made of

13.11 The Japanese pavilion for the Venice Biennale in the Arsenale, Venice, designed by Yoshizaka Takamasa, 1956.

wood. As Yoshizaka told the Italians, 'I admire the laws of our ancestors, I love Japan, I live in Japan and I am Japanese; what else does it take for my work to appear Japanese?'[140]

The National Museum of Western Art

Located in Ueno Park, close to Watanabe Jin's Imperial Household Museum of the 1930s, Le Corbusier's National Museum of Western Art, conceived just 20 years later and completed in 1959, could not be more different [13.12]. The Museum was one of his last large public buildings[141] and, as James Richards put it in *The Architectural Review*, 'has less impact than his great works, though one should remember that it is only part of a more ambitious, incomplete project'.[142]

The Museum was built, initially, to house the art collection acquired in Europe between 1916 and 1928 by Matsukata Kōjirō, then president of the Kawasaki Dockyard Company. A considerable part of the collection, which was still in France, had been confiscated by the French government as enemy property in accordance with the 1951 San Francisco Peace Treaty. Negotiations for

its restitution had highlighted the need, from the French point of view, to keep the collection together and therefore the provision of a museum in Tokyo, initially seen as a French Art Museum, to hold and exhibit it. The 1953 Japan–France Bilateral Cultural Treaty provided the incentive for such an initiative and the French government agreed to donate some 400 artworks from the Matsukata collection. In 1954, the Japanese Ministry of Foreign Affairs, in a diplomatic move designed to support the notion of cultural exchange, asked Maekawa Kunio to approach Le Corbusier to see if he would accept the commission if it was offered; he said that he would, and in early 1955 the Ministry of Education announced that Le Corbusier had been chosen as architect. The contract was signed that October.[143]

In November 1955 Le Corbusier, en route to Chandigarh, made his only visit to Japan: he stayed just one week. On his arrival at Haneda airport he told the assembled press:

Since my youth, I have been particularly attracted by the scenery and architecture of Japan. [Now] I am hoping to gain something besides design work. At present the page is completely blank,

for the museum design concept will emerge by first assimilating the ambiance of the site and requests from the Japan side, and then adding my own ideas.[144]

In Tokyo, where he stayed four nights in the Imperial Hotel, he was shown some of the new buildings designed by his former assistants, Maekawa Kunio, Sakakura Junzō and Yoshizaka Takamasa, as well as making five visits to the site in Ueno Park. He also made a brief trip to Kyoto, where he stayed at Murano Tōgo's Miyako Hotel, built in 1939. There Sakakura took him to Katsura, but other than drawing the Manji-tei, he seemed uninterested. 'The Japanese do not know how to build walls',[145] he later told Yoshizaka, who recalled that he was much more impressed by the hefty proportions of the timber structure at the Daibutsu-den at nearby Nara, and the raw condition of the *piloti* at the *Shōsō-in* there.[146]

The page, when it came to be filled, was not, as it turned out, completely blank. The idea behind the design for the Museum building, a square spiral derived from the Golden Rectangle, dated back more than a quarter century to the Musée Mondial of 1929 intended for the Mundaneum, intended for Geneva, of the same year. The idea resurfaced in the Musée d'art contemporain proposals (1931), in the Sanskar Kendra City Museum in Ahmedabad (1957), and in the Museum and Art Gallery at Chandigarh (1964). Indeed, the exteriors of the Ahmedabad and Chandigarh buildings are very similar to the Museum of Western Art. But the Museum, contrary to the expectation of the Japanese, was not to be alone on the site. In addition, there was to be a library, an experimental theatre with banked outdoor seating called the Boîte à Miracles[147] and a temporary exhibition pavilion. None of these were built, although a version of the temporary exhibition pavilion, with its folded plate roof, was to be built as the Heidi Weber Pavilion in Zurich and completed posthumously in 1967. What Le Corbusier had envisioned, probably at the instigation of Sakakura,[148] was a cultural centre, and although this was to be realised with the completion in 1961 of Maekawa Kunio's Tokyo Metropolitan Festival Hall

on the adjacent site, the complex he had planned was never attempted.

In August 1956 the Ministry of Education, which was overseeing the project, had received from Le Corbusier three sheets of drawings: a site plan, a building plan and two cross-sections.[149] These showed not only that the design included a number of buildings not asked for, but that the Museum itself exceeded the required area by about 30 per cent. The scope of the proposal was reined in by the removal of the library and auditorium, and the size of the Museum reduced. In March 1957 Maekawa visited Paris to discuss with Le Corbusier the working drawings which were due at the end of the month. The first batch of blueprints, comprising four sets of plans, two elevations, two cross-sections and a detailed drawing of a rooflight,[150] were sent just in time, the last two drawings, both elevations,[151] arriving at the end of May. That, with the addition of a 'Concept Manual' which arrived, together with the original drawings, in June, was the extent of it.[152] Although various iterations of these drawings were sent from Paris between March and May, they lacked structural or mechanical information and only one contained any actual dimensions. Le Corbusier's three former assistants, who were to oversee the building of the Museum, met in May to allocate roles: Maekawa took charge of the structure and the mechanical facilities while Sakakura and Yoshizaka were to produce the working drawings. It fell therefore to Yoshizaka, the only one familiar with the *Modulor* system, to determine the dimensions for the building and to brief the other architects. Problems with the design and the 'Concept Manual' required Yoshizaka to make two visits to Paris (one when the building was on site) and Sakakura to make one,[153] and following the May meeting, five further conferences were held between the three supervising architects before the building went out to tender in February 1958. In March a groundbreaking ceremony was held and 15 months later, on 13 June 1959, the Museum opened to the public. Considering – or maybe because of – the paucity of information which Le Corbusier had provided, this was a considerable achievement.

(*left*) 13.12 The National Museum of Western Art in Ueno Park, Tokyo, designed by Le Corbusier and built by Maekawa Kunio, Sakakura Junzō and Yoshizaka Takamasa, 1959.

13.13 Bunka Kaikan (Metropolitan Festival Hall) in Ueno Park, Tokyo, designed by Maekawa Kunio, 1961.

The Museum, as Richards observed, 'is disappointingly neat: a square mass raised on pilotis, the only elements with any plastic vigour being a couple of external stairs.'[154] Although Le Corbusier insisted on using the French manufacturers Saint-Gobain to provide the frameless glazing for the entrance, the neatness which Richards recognised was probably due as much to the care and precision of the Japanese building industry as it was to Le Corbusier's absence. However, the interior is more animated and, as Richards said, 'does show Le Corbusier's customary command of space'.[155] The double-height central gallery, then called the Nineteenth Century Hall, is interrupted by one centrally placed concrete column which rises up to support two deep, intersecting beams that cut across a tall, triangular pyramidal rooflight. The rotational effect which this induces draws the visitor to the dog-leg ramps on the left, where a second column marks one corner of the triangle, and from there, eventually, clockwise and upwards around the space. Throughout the building, the separation of the structure and the envelope, a notion going back to the Dom-ino House of 1914, is clearly demonstrated. Externally, four layers of concrete panels, embedded with stone from Katrura-hama in Kōchi prefecture, wrap around the building with barely a break, while internally the advancing columns reduce the clear wall space and confine the display area to a series of equally sized bays. Insisting that the columns were not an obstruction, Le Corbusier recommended the provision of moveable screens.[156]

Even before the Museum building had gone out to tender, Maekawa was commissioned to design the new Tokyo *kaikan* or Metropolitan Festival Hall on the site opposite where Le Corbusier had intended to place the Boîte à Miracles [13.13].[157] The scale and sense of compression of this building almost pushes Le Corbusier's Museum back into its courtyard. Although the east side of the Festival Hall confronts visitors emerging from Ueno Station, the principal, north side separates itself from the public concourse with a moated garden. The effect is to force a full view of the building which now dominates the space. If here, where Chandigarh appears to confront Ahmedabad, the apprentice has not eclipsed the sorcerer, then he has come very close. But whereas the Museum is redeemed by its internal space, Maekawa's Festival Hall, once entered between the giant *piloti* and beneath the great overhanging roof, is, despite the glazing which surrounds the foyer, a little dark and foreboding. The canted walls to the main auditorium, faced with concrete panels embedded with broken marble, remind one of both the façade of the Museum opposite and traditional Japanese stone-built fortifications, in the same way that the canopied entrance they guard recalls the Shinto *torii*. The allusion here is fairly obvious. In the Museum opposite, where the tall board-marked column in the Nineteenth Century Hall and the concrete beams it bears suggest the great timber columns and beams of the Daibutsu-den which Le Corbusier admired at Nara, the reference is more speculative.

James Richards's Summary

In a special issue of *The Architectural Review* published in September 1962, the editor, James Richards, included a 155-page record of his visit to Japan earlier that year. The following year he published it, a little extended, as the book, *An Architectural Journey in Japan*.[158] Much of the original article is in the form of a daily journal, recording whom he met, what he saw and his impressions of it. But there are also short feature-pieces, ample illustrations and brief biographies of the Japanese architects discussed. His preconception of modern Japanese architecture, as might be expected from a British architectural journalist, was of something 'strongly influenced by Le Corbusier, vigorously rectilinear, like timber turned to concrete'.[159] He was not altogether disappointed. In Maekawa Kunio's buildings at the Gakushūin University, 'the influence of Le Corbusier [was] evident but fully assimilated';[160] at Matsue, where Kikutake Kiyonori had recently built the Prefectural

13.14　The Prefectural Museum and Art Gallery at Matsue, designed by Kikutake Kiyonori, 1958.

Museum and Art Gallery (1958), he could see 'the influence of Le Corbusier, but perhaps in this case more particularly the influence of his work in India' [13.14];[161] and in Osaka, where Sakakura Junzō had just finished the Shionogi Research Laboratory (1961), 'the influence of Le Corbusier [was] very evident'.[162] Yet the influence was more in the form-making than in the making of the building. Richards marvelled at Tange Kenzō's extension to the Atami Gardens Hotel at Atami (1962): 'Beautifully finished concrete again, straight from the plywood shuttering though the arrises are so precise the shuttering might have been sheet-metal.'[163] And at Kikutake's Hitotsubashi Secondary School he noted that 'Le Corbusier's use of rough-boarded shuttering to give a tough character to his concrete has not generally been followed in

Japan, where exposed concrete is for the most part smooth and geometrically precise.'[164]

The value of James Richards's extended review was that it came at just that moment in Japanese architecture when the next wave, Metabolism, was beginning. In this sense it was a summary of the first 15 years of post-war Japanese architecture which recognised the importance of Maekawa, Sakakura, Tange, and their followers, who, as he said, 'have a maturity and sophistication unexcelled anywhere'.[165] But it also recognised that this was just the beginning:

... there is no pretence of finality in the achievement they represent; they are rather, in their Japanese context, a first break-through, the vital initial establishment of a modern design

method and a recognizable modern aesthetic that can open the way for any number of subsequent developments ...[166]

Antonin Raymond, whom Richards observed held 'strong opinions about the shortcomings and wrongheadedness of others',[167] had initially seen Le Corbusier's influence as beneficial, 'showing the Japanese architects how to liberate themselves from the uncreative eclecticism prevalent in Japan ... and pointed a way to architects working more in my spirit',[168] However, he came to believe that Le Corbusier's post-war work, such as Ronchamp, Chandigarh and the Unité d'habitation in Marseilles, 'had a surprisingly bad influence on the Japanese architects',[169] This he blamed on the plastic or sculptural qualities of these buildings which represented a departure from the more rational post-and-beam construction of the pre-war years, as he exemplified so perfectly in his Reader's Digest Building. He was, in fact, very damning of this evolution:

When Japanese architects took that hint they exaggerated it to such an extent that I would call some of their efforts today a shaggy super-brutalism of which there is hardly an example in Europe, although there may be some in the United States ...

Of one thing I am sure. Should Le Corbusier ever visit Japan again, he would be rather appalled by what he would see of the super-brutalities.[170]

Le Corbusier 'post mortem'

Le Corbusier died on 27 August 1965 while swimming in the sea of Cap Martin where he lived in a small wooden cabin – Le Petit Cabanon. This he had built in 1952, while Yoshizaka Takamasa, who translated *Le Modulor*, was working in the *atelier*, and its dimensions are based on that system. The ceiling height of 2.26 metres corresponded to the 1.83-metre-tall 'ideal' man standing with his arm held aloft, while the room dimensions of 3.66×3.66 metres were twice the length of the 'ideal' man lying down. The area, therefore, was almost exactly the equivalent of an eight-mat *tatami* room. This small cabin represented for Le Corbusier part of his continual investigation into the minimum dwelling, the furniture being built-in and often serving a dual purpose. Even though it was designed for Western living – and not for sitting on the floor – it was, conceptually and dimensionally, a very Japanese space.

In September 1965 Andō Tadao, unaware of Le Corbusier's death, was walking the streets of Paris searching, with what little information he had, for Le Corbusier's *atelier*.[171] The previous April he had left Yokohama on the steamship *Baikal* (Байкал) bound for Nakhodka and travelled across the Soviet Union on the Trans-Siberian Railway. He was now on a pilgrimage and, in visiting Switzerland, Greece and Italy, was following in the footsteps of the master. As he later told students at Tokyo University's Graduate School of Architecture:

I found a collection of Le Corbusier's sketches at a used bookstore. His images captivated me so greatly that I began tracing their forms tirelessly. Since I was educating myself, Le Corbusier – a man who paved the way for modern architecture without receiving any formal architectural training – was more than merely someone I admired. Le Corbusier travelled extensively while in his twenties, before he began his career as an architect, searching for the roots of Western architecture. Travel was my single most important teacher as well.[172]

Andō's fascination with Le Corbusier's drawings became a fascination with the man himself.

I wondered about his personality and about the design office where he worked; merely reading about him no longer satisfied me.[173]

Thwarted in his desire to meet the man, but armed with a copy of Sigfried Giedion's *Space, Time and Architecture*, he searched out his buildings. The Villa Savoye was in 'complete disrepair'; at the

Unité d'habitation in Marseilles, the image of the concrete – 'this materialization of free, sculptural expression' – became deeply ingrained in him. He visited La Tourette and Ronchamp, a church that left him 'awestruck by the incredible possibilities of architecture'.[174] As he later wrote in his essay, 'The Agony of Sustained Thought: The Difficulty of Persevering':

> It is not just a matter of exterior form. Inside Ronchamp, the visitor is assaulted by phantasmal lights entering through windows of diverse sizes fitted with coloured glass. This chapel, unlike earlier works by Le Corbusier, which were controlled by reason and expressed rationality, seems to have been created directly and intuitively, almost in the manner of a painting. Its brutal physical strength remains undiminished and continues to shock us.[175]

It was this change from rational to intuitive expression which so impressed him. As he told the students in Tokyo:

> I think that Le Corbusier, as the creator of modern architecture, defied the strictures of his own five-point philosophy to create solid, powerful concrete structures free from his own limitations.[176]

Andō returned to Europe for a further six months in 1968, living in Paris during the riots of that summer, and in 1969 made two trips to the United States of America, the first to the West Coast and the second comprising a Greyhound bus journey from Los Angeles to New York, via Chicago and Montreal. On the way he stopped at Plano, Illinois, to see Mies van der Rohe's Farnsworth House (1951). It affected him as much as Ronchamp had done. 'These two works continue to speak to me,' he wrote in 1994, adding, 'the Farnsworth House and Ronchamp provide me with inspiration. I want to retain freedom of thought and to create buildings that continue to be thought provoking to those who experience them. The fact that these two buildings still stand like signposts before me gives

me hope.'[177] The signposts led, respectively, to the Church on the Water and the Church of Light.

In 1968, on his extended stay in Europe, Andō visited Rome. 'I first experienced space in architecture inside the Pantheon',[178] he later wrote. This building, rebuilt by the Emperor Hadrian in the second century, had similarly drawn Le Corbusier. The Pantheon, as Le Corbusier put it in *Vers une architecture* (1923), belongs (as Frederick Etchells translated it in 1927) to architecture.[179] Comprising a semi-spherical dome of 43.2 metres set upon a cylinder of the same diameter, and pieced at the top with an oculus, the building is a perfect arrangement of Platonic forms. Le Corbusier explained the strength of the building in *Vers une architecture*:

> Architecture is the masterly, correct and magnificent play of masses brought together in light. Our eyes are made to see forms in light; light and shade reveal these forms; cubes, cones spheres, cylinders or pyramids are the great primary forms which light reveals to advantage; the image of these is distinct and tangible within us and without ambiguity.[180]

For Andō, it was the effect of light upon the interior space of the Pantheon which held him:

> It is when this structure is illuminated by light from an oculus 9 metres in diameter at the top of the dome, that architectural space becomes truly manifest. A condition such as this of matter and light cannot be experienced in nature. It is only in architecture that one encounters such a vision. It was this power of architecture that moved me.[181]

It is a response which Andō has sought to recreate in his own work: at the Museum of Wood in the Mikata-gun forest in Hyogo Prefecture (1994); at the Benessa House Oval in Naoshima (1995); and at the Meditation Space at UNESCO, Paris (1995).

At the Church on the Water,[182] it is the uninterrupted view *out* through the great window that recalls the Farnsworth House; at the Church

13.15 Comparative plans and a common analytical diagram: the Church of the Light at Ibaraki, designed by Tadao Andō, 1989; and the Church of Notre Dame du Haut at Ronchamp, designed by Le Corbusier, 1955.

of the Light, it is the way in which the light leaks *into* the church which so recalls Ronchamp: indeed, Ronchamp was its inspiration.[183] Built at Ibaraki and completed in 1989, the volume of the church is a Platonic composition of three 5.9-metre cubes cast in smooth, panelled concrete. Its plan is a rectilinear version of Le Corbusier's chapel and is entered, as at Ronchamp, at one end of a long, angled side wall which cuts in beneath the building's roof without, apparently, ever touching it. Beyond the end wall of each building, behind the altar, there is another space, both within and outwith the building's curtilage: at Ronchamp it is used for outdoor masses, at Ibaraki it is a space for planting between the building and the stone-faced retaining wall which supports the site. A simple analysis of both church plans soon demonstrates their similarity [13.15].

At Ronchamp, the light penetrates in a thin line all around the interior volume where the roof never quite engages, and in bright-coloured patches where deep-set windows punch through

the angled wall whose rough concrete finish soon absorbs the leaking colours [13.16]. At Ibaraki, as at Ronchamp, a vertical streak of light marks where the angled wall breaks through at 15 degrees, but its precise concrete surface is here left uninterrupted [13.17]. Instead, the four quarters of the south-facing altar wall are withdrawn to reveal a cross of light which, following the late morning sun, skims down the gridded walls and ceiling and bounces off the polished floorboards of the narrow interior. Despite the occasional criticisms that the building is too naked, it could be described with Andō's own observation of the Pantheon quoted above:

> A condition such as this of matter and light cannot be experienced in nature. It is only in architecture that one encounters such a vision.[184]

In his essay of the same title, 'Materials, Geometry and Nature', Andō writes that, 'Architecture comes

13.16 Interior of the Church of Notre Dame du Haut at Ronchamp, designed by Le Corbusier, 1955.

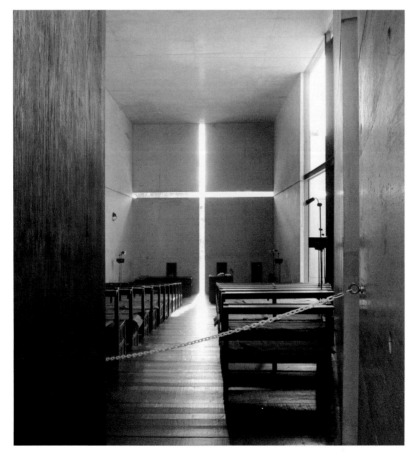

13.17 Interior of the Church of the Light at Ibaraki, designed by Andō Tadao, 1989.

to possess power and becomes radiant only when these three elements come together. Man is then moved by a vision that is possible, as in the Pantheon, only with architecture.'[185] So it is at Ibaraki.

In a culture of assimilation, where foreign architectures have always been quickly absorbed, Le Corbusier's architecture has lent itself well to direct quotation. Many such references are unsurprising but some, such as the Hōan-den or storehouse at the Taiseki-ji Temple at Fujinomiya, built by the Gaisakushu Group in 1955, are more unexpected. Here it is the rooftop gymnasium at the Unité d'habitation at Marseilles which is the source. The curved form, cast in board-marked concrete, replicates but does not quite copy Le Corbusier's original: the raised ventilation ridge down the centre of the roof is not conjoined but separated by an open lattice and the glazed end is treated as a Diocletian window rather than being divided by a single central fin.

Even though *The Japan Architect* could comment in 1961 that 'the passion for Le Corbusier ... is

beginning to subside',[186] a survey carried out by the magazine revealed 'a continued interest in the works of Maekawa and Tange, considered adherents of the Le Corbusier school'.[187] Although Post-Modernism is generally accepted as a reaction to the (late) Modernism of Le Corbusier and his generation, that seems to have been no reason for Japanese architects to reject his influence in the way many Western architects did. Itō Toyoo's house for his sister, the White U, built at Nakano, Tokyo, in 1976, might seem at first glance to be idiosyncratic, but as Itō told Fujimori Terunobu in conversation, 'The day the magazine covering White U came out, I received a phone call from Kikutake who said, "That house is wonderful. It reminds me of Villa Savoye."'[188] So to test the idea, Itō made a model combining the White U with the Villa Savoye [13.18]. It worked.

Far from distancing himself from Le Corbusier, Itō has perhaps gone out of his way to acknowledge his presence. The White U is a case in point. 'When you go to a small curved space by Le Corbusier,' he told Fujimori, 'the curve never seems off, no matter

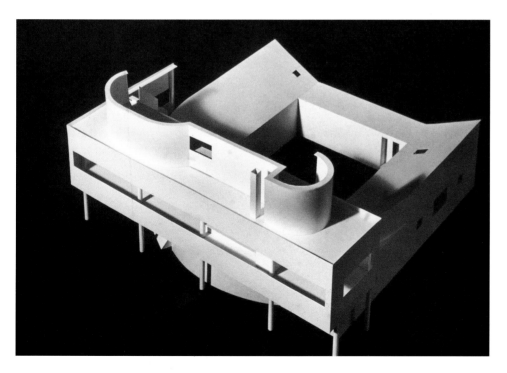

13.18 The White U House combined with the Villa Savoye – a model by Itō Toyoo, *c.* 1976.

what sort is used ... If the Chapel at Ronchamp had been designed by an ordinary architect, it would be awful. Le Corbusier was a true genius in making such designs beautiful.'[189] In one of his nine collaged panels prepared for the 'New Wave of Japanese Architecture' exhibition[190] at the Institute for Architecture and Urban Studies (IAUS) in New York in 1978, Itō showed, as a commentary on his own PMT Building in Nagoya (1978), a distant view of the Villa Savoye [Plate 22]. In one corner of the collage he also included a glimpse of one of Le Corbusier's paintings. Two years later, in 1980, he began his own Dom-ino Project, an investigation of industrial housing. The acknowledgement is clear.

For many architects, such as Itō, who were educated in the hot-houses of Tokyo University, where Tange Kenzō had his studio, and Waseda University, where Yoshizaka Takamasa and Imai Kenji both had theirs,[191] 'The Japanese architecture world, of the 1960s,' as he told Fujimori, 'was engrossing – so much so that one scarcely realized that there were other worlds like that one.' These schools were the Japanese equivalents of the Architectural Association in London, or of Harvard's Graduate School of Design, or of Yale University. 'It was a remarkable period for contemporary Japanese architecture. We would be in the drafting room and not only Tange, but Arata Isozaki and Kurokawa Kishō would walk past us. The corridor outside the Tange Laboratory was lined with wooden models, and I remember seeing them and thinking, "This is what architecture is about."'[192] It is no surprise, then, that the influence of Le Corbusier continued through this lineage, which makes the achievement of Andō Tadao, who received no formal architectural education, all the more remarkable.

14 THE PACIFIC RIM

During the 1950s, the re-emergence of Japanese architecture to both Western consciousness and view began with the building in 1954 of *Shōfū-so*, the Japanese House, at the Museum of Modern Art in New York, and culminated in 1960 with three significant events: one, which attempted to show a way forwards through the past, was the publication by Walter Gropius, Tange Kenzō and the photographer Ishimoto Yasuhiro of *Katsura: Tradition and Creation in Japanese Architecture*; another, which effectively showed a way backwards towards the past which eschewed Modernism, was Elizabeth Gordon's special issue of *House Beautiful* entitled 'Discover Shibui, the Word for the Highest Level of Beauty'; and the third, which for architects had the greatest significance but probably achieved the least, was the publication during the World Design Conference in Tokyo of the manifesto, *Metabolism 1960*.

Since 1949, the Museum of Modern Art in New York, where Philip Johnson was once again Director of Architecture and Design,[1] had been running a biennial 'House in the Garden' series and for 1954 elected to build a Japanese example. It was decided that the exhibition house should be an example of traditional Japanese architecture which would demonstrate affinities, as was the popular conception, with Modernist architecture. So, in 1953 Arthur Drexler, then the Museum's Curator of Architecture and Design, and John D. Rockefeller III, the President of the Japan Society (New York),

visited Japan to research the exhibition. They were accompanied on their visits to Kyoto, Shiga and Nara by Antonin Raymond's former assistant, Yoshimura Junzō, who had been selected by a special Rockefeller Architectural Committee to be the project architect, and by the photographer Ishimoto Yasuhiro,[2] who was to take photographs for the exhibition catalogue.[3] The model which they selected for the exhibition house was the Kōjō-in guest house at the Onjō-ji temple at Ōtsu, a building of 1601 in the *shoin-zukuri* style; for the adjacent tea-house they chose the Masu-doko-no-seki tea-house at the Daitoku-ji temple in Kyoto.

Yoshimura, who had first gone to work for Raymond in Tokyo in 1931 had, from May 1940 to July 1941, joined him at his farm and studio at New Hope, Pennsylvania. Raymond had purchased the old farm buildings in 1939 and, through the introduction of post-and-beam framing, *shōji* and *fusuma*, had opened up the three-storey stone barn to provide living and studio accommodation for himself and his community of apprentices. Thus, Yoshimura's introduction to the West was not European, or even Modernist, like that of the majority of his contemporaries, but American, rural and, in its Japan-ness, not unfamiliar. He might have come there sooner had he not spent the previous year in Kyoto supervising, for Raymond, the construction of a traditional tea-house which was then disassembled and shipped to New York where it was reassembled for the recently established Japan Institute located

on the 36th floor of the Rockefeller Center.[4] Thus Yoshimura's commission from the Museum of Modern Art to build something traditionally Japanese in New York was not his first, nor was it to be his last: the Japan House on East 47th Street, built for the Japan Society in 1971, although modern, contained Japanese gardens and a host of traditional Japanese references.[5]

Yoshimura's version of the Kōjō-in guest house was not a copy, but a free adaptation intended to accommodate the restrictions of the museum site and the large number of visitors expected to visit it. Like his earlier tea-house for the Japan Institute, the *Shōfū-so* was also manufactured and preassembled in Japan, this time in Nagoya by the master carpenter Itō Heizaemon, before being shipped to New York in 700 crates. Among the items included, Drexler later wrote in *The Architecture of Japan*, 'were prefabricated panels of *hinoki* (cypress) bark shingles for the roof, lanterns, fences, furnishings, and kitchen utensils, stones of all sizes and coarse white sand for the gardens'.[6] It was, in its way, as comprehensive an operation as the Japanese contributions to the great nineteenth-century exhibitions had been. The exhibit remained open from June 1954 to October 1955 and almost 250,000 people came to see it.[7] What they saw was intended, as Drexler put it, 'to illustrate some of the characteristics of buildings considered by the Japanese to be masterpieces, and considered by Western architects to be of continuing relevance to our building activities'.[8] These characteristics Drexler identified as 'post and lintel skeleton frame construction; flexibility of plan; close relation of indoor and outdoor areas; and the decorative use of structural elements ...'[9] With the exclusion of the latter, the recitation of this list became a mantra which was to be heard increasingly around the Pacific Rim as the decade progressed.

The American North-West

A glance at a map of the Pacific will reveal a number of latitudinal relationships which not only tie in Japan with the coastal region of the western United States, but also, in the southern hemisphere, with Australia. Wakkanai, at the north end of Hokkaido, is almost on the same latitude north as Portland, Oregon, while further south on Kyushu, Nagasaki is on the same latitude as San Diego, California. San Francisco, Niigata and Melbourne are nearly equidistant from the equator, as are Tokyo and Canberra. Therefore, the height of the sun and the hours of daylight in these corresponding cities will always be the same. Although climatic variations, if not the solar position, might recommend different architectural responses, the availability of timber for construction and the relative seismic instability of the regions suggests common architectural solutions.[10]

The war in the Pacific of 1941–45 had the effect of both familiarising Allied personnel with Japan and its people while at the same time creating for many a dislike of the Japanese and a hostility towards them. However, the American occupation of Japan until 1952 and the importance of Japan as a forward base for the United Nations forces during the Korean War of 1950–53 did much to break down these prejudices and in America this, combined with the release from internment in 1945 of Japanese Americans, the majority of whom lived on the West Coast, served to some extent to reintegrate the divergent cultures. In Australia, however, the Japanese population, which had never been large, had been interned following the outbreak of hostilities in 1941 and, with the peace in 1945, were mostly deported, effectively eradicating Japanese communities and businesses across the country. No immigration from Japan was allowed until 1949 and even a decade later, the Japanese community in the state of Victoria had barely reached 600.[11]

Whereas the International Style had become established before the war in Los Angeles, and to a lesser extent in San Francisco, the contemporary architecture of West Coast America in the later 1940s and early 1950s remained decidedly regional. Writing in *The New Yorker* in 1947, Lewis Mumford referred to 'the Bay Region style [as] a free yet unobtrusive expression of the terrain, the climate, and the way of life on the Coast ... The style,' he continued, 'is actually the product of the meeting of Oriental

and Occidental architectural traditions, and it is far more truly a universal style than the so-called international style of the nineteen-thirties, since it permits regional adaptations and modifications.'[12] When, in April 1953, *Architectural Record* posed the question 'Do we have an indigenous Northwest architecture?'[13] the Seattle architect Paul Albert Thiry thought back to the 1930s and 'the wonderful things Antonin Raymond was doing in Japan'.[14] It had been then, as a young man, that he had understood the need for, as he put it,

> a building that would better fit a way of life, that would fit the land, exploit the vast panoramas of waterways and mountains that make the Northwest, that would enliven the gray days of the winter and share the exterior country in summer; buildings that would be flexible and adaptable to an infinite variety of situations; buildings that would shed the rain, take it away from the walls, yet permit the sun to infiltrate the interior.[15]

Looking out across Puget Sound, Paul Thiry was 'particularly conscious of the faraway land of Japan whose topography is similar to our own – whose people have developed a post and lintel architecture free in its adaptability of form, modular in its application, high in its quality of relationship with nature'.[16] His own office building in Seattle, built in 1946, prefigured the house which Tange Kenzō was soon to build for himself in Tokyo,[17] although it lacked the finesse which Japanese craftsmanship brought the later building. Set on a slope, the balconied front part was raised off the ground, providing car parking underneath, while to the rear *shōji* gave on to a small gravelled entrance court, a moment of quietness set behind a tall wooden fence, much as Edward Morse would have recognised in Japan over half a century earlier [14.01].[18] Thiry's Japanese styling found further expression in the holiday retreat he built for himself in the Kittitas Valley near Ellensburg, Washington, in 1956 [14.02]. Here a pair of pitched-roofed shelters, like two displaced Ise Shrines, were set on simple concrete platforms at the edge of a small, dammed lake. The great protective gabled roof of

14.01 The Thiry architectural office in Seattle, Washington, designed by Paul Thiry, 1946.

14.02 Holiday retreat in near Ellensburg, Washington, designed by Paul Thiry for his family, 1956.

the larger, parental shelter, supported by a central ridge-post, recalled Maekawa Kunio's own house in Tokyo of 1942, itself a reference to the traditional *gasshō* farmhouse, while at the boy's bunkhouse, the rafters, expressed like *chigi* on a Shinto shrine, extended upward beyond the ridge-beam while supporting a translucent, plastic roof.

None of this was coincidental. In 1934, Thiry had gone to Japan to work for six months with Takashi (Tommy) Matsumoto, a friend from the University of Washington architecture department. While there, through another architecture department alumnus, George Nakashima, he had met Antonin Raymond whom he thought was 'a very open sort of person, and quite a braggart. But he had reason to brag,' Thiry later explained, 'because to my opinion he's probably the greatest architect of the whole bunch of them, and even including Corbusier. I admired him, and of course he liked that.'[19] Raymond would take Thiry to see his buildings but, although he wanted the young American to work for him, Thiry eventually chose to move on, first to China and then via India to France. There, in February 1935, he met Le Corbusier. Knowing Raymond so well, Thiry mentioned the Karuizawa summer-house and Raymond's debt to Le Corbusier's Errázuris house project. 'He never talks about his house,' Thiry told Le Corbusier (in French), 'or publishes a thing or anything else that he doesn't give you credit [for]. And I think it's too bad that you're mad at him. "Oh," he said, "Mon Dieu, mon Dieu, c'est moi qui est trompé."'[20] When in 1957 Thiry came to design the suspended dog-leg stairs in one of the women's residential buildings at Washington State College, Pullman, it would have been Raymond's summer-house, not Le Corbusier's Errázuris house, that he had in mind.[21] 'I honestly respected him as an architect,' he confessed, 'probably more than anyone I have encountered, before or since.'[22]

In the autumn of 1928, the year in which Paul Thiry graduated, Lionel Pries joined the teaching staff at Washington University's architecture department.[23] If there was any doubt in students' minds of the importance of Japanese art and architecture, a quick conversation with Pries, or even a visit to his house, would soon have dissuaded them of that. Pries had been brought up in San Francisco where his father worked at S & G Gump, the now famous department store. Following the 1905 earthquake and fire, the store was reborn on a new downtown site near Union Square with a suite of oriental rooms specially built by Japanese and Chinese craftsmen to display the imported Asian art and craftwork upon which Gump's reputation was rebuilt. Emily Post, the fashion writer and daughter of Bruce Price, while visiting the Panama-Pacific International Exposition in 1915, was encouraged to go to the store:

> It was as though we had been transported, not only across the Pacific, but across centuries of time. Through the apartments of an ancient Chinese palace, we walked into a Japanese temple, and again into a room in a modern Japanese house … The windows of all the rooms, whether in the walls or ceiling, are of translucent porcelain in the Chinese, or paper in the Japanese; which produces an indescribable illusion of having left the streets of San Francisco thousands of miles, instead of merely a few feet, behind you … In one of the Japanese rooms there were decorated paper walls held up by light bamboo frames, amber paper *shōji* instead of windows, and the floors covered with *tatami*, the Japanese floor mats, two inches thick. You sit on the floor as in Japan and drink tea, while silks of every variety are brought to you.[24]

It was this world that Lionel Pries, as a child, inhabited and its influence infused his life. He collected oriental art, becoming the Seattle agent for the Oceanic Trading Company: a pair of six-panel *byōbu*, probably by Kanō Sanraku, are now in the Seattle Art Museum.[25]

Despite his absorption of Japanese culture, Pries's architecture was not overtly Japanese, although he was probably the first Seattle architect to incorporate *shōji* into his houses.[26] The broken and irregular plan of the house he built on Lopez Island for Richard and Ruth Lea in 1946 allows it to cling to its shallow, promontory site while the broad eaves supporting the sod roof help it to

blend with its context. It is not a framed building, but rather one built of concrete blocks, yet, with its sliding glass walls and low, cedar-boarded ceiling, is curiously prescient of the domestic architecture which *Shinkenchiku* (*Sinkentiku*) and *The Japan Architect* would be publishing in the 1950s and 1960s – a Japanese response to modern materials and Western living. The second house which Pries built for the Leas, in Seattle in 1958, was much more recognisably Japanese. Here, where a small Japanese garden was set in the entrance court, Pries provided a setting for the Leas' collection of Japanese art. Wooden *ranma*, *byōbu* and *shōji* all served to give the artwork an appropriate setting while the house remained, nevertheless, a modern Western building.[27]

Before the War, the Japanese community in Seattle – or Shiatoru, as they called it – outnumbered all other oriental immigrant communities combined.[28] In Nihonmachi, Seattle's Japan town, the Panama Hotel had, in its basement, a *sento* or public bathhouse, the Hashidate-Yu, and the nearby Astor Hotel, a *kabuki* stage complete with *hanamichi* in its Nippon Kan Hall.[29] For anyone then growing up in the city the Japanese presence could not be ignored and for Paul Hayden Kirk, disabled as a child by polio, it might have provided, in a way, a refuge from the more rumbustious

baseball diamonds or football fields frequented by his peers. Graduating from the Washington University architecture department in 1937, Kirk worked in practice throughout the war years and by the mid-1950s had developed in his architecture a lightweight post-and-beam vocabulary which allowed him to combine flexible living spaces with contained outdoor spaces. Much of his work was medical clinics, of which he built over 50, and on which he wrote a book with Eugene Sternberg.[30] Clinics, almost more than houses, need to be relaxing and reassuring, and this Kirk achieved by the incorporation within the gridded plans of private outdoor space – a walled Zen garden at the group practice clinic in Lake City, Washington (1955), or planted gardens within the pergola-like framework of the McNair Price Clinic at Medford, Oregon (1959) [14.03]. In his houses, although smaller and more compact, the incorporation of courtyard or garden space fused the indoors with the outdoors while *shōji* allowed for both flexible internal spaces and an openness to and thus connection with the landscape: such was the essence of the Imperial Villa at Katsura [see 14.12]. A good example of this is the guest house he built on the Prentice Bloedel Estate on Bainbridge Island in 1964 [14.04]. The expressive, timber-framed interior together with the *shōji*-like window walls support his assertion that

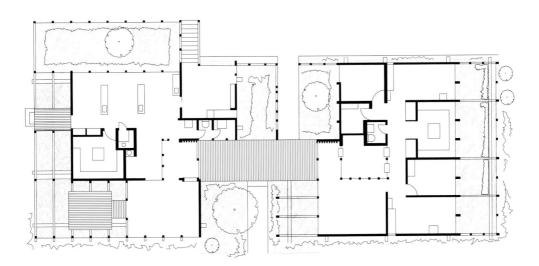

14.03 Plan of the McNair Price Clinic at Medford, Oregon, designed by Paul Hayden Kirk, 1959.

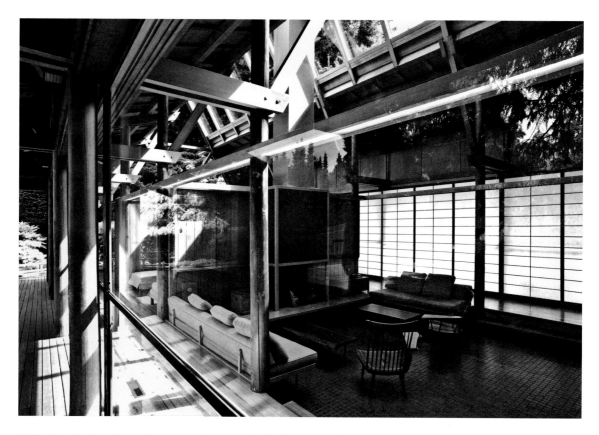

14.04 The Prentice Bloedel Estate guest house on Bainbridge Island, Washington, designed by Paul Hayden Kirk, 1964.

he was attempting 'to combine a Japanese style with Native American and Pacific Northwest ideas'.[31] The presence beside the house of an existing Japanese garden, designed three years earlier by Kubota Fujitarō, would seem to confirm this.

In 1957, the year that Paul Thiry's holiday retreat in the Kittitas Valley was judged by Harwell Hamilton Harris, Charles Eames and the landscape architect Thomas Church to be one of *Sunset Magazine* and the AIA's 'Seven Best Houses in the West',[32] two of the seven awards went to Paul Kirk: one for his low-cost builder's house at Kirkland, Washington (1956), where every room had its own outdoor space or special view, and the other for his house in Seattle, where the central core was a three-storey enclosed garden court and where *shōji* separated the living from the dining areas.

The importance in the Pacific North-west of the architecture department at the University of Washington in Seattle cannot be underestimated. The influence of Lionel Pries, who was known as 'Spike', was considerable. Although he had joined in 1928 and brought with him a great, but nevertheless second-hand, knowledge of Japan, it was 30 years before the department recruited a faculty member who had actually been there. This was Richard Haag who had spent a two-year Fulbright Fellowship in the country. He was joined, three years later by Philip Thiel, whose wife was the Japanese artist Kono Midori, and who had just spent 15 months in Japan. Then in 1962 Victor Steinbrueck, already a member of staff, received an Asian Arts Fellowship which took him to Japan for five months. Although Pries was forced

(*right*) 14.05 The house and architectural office in Seattle, Washington, designed by Gene Zema for himself, 1953.

to resign in 1958, the year Haag arrived, Haag, Thiel and Steinbrueck kept up the department's interest in Japan and passed it on to generations of students.[33] In 1965, Thiel led a two-month study programme in Japan together with Itō Teiji, the author of many books on Japanese architecture and a teacher at Tokyo University.[34] There they visited the tea-houses at Katsura, the castles at Himeji, Matsumoto and Takamatsu, the shrines and temples at Ise, Izumo, Nara and Nikkō, and the *minka* in the Shirakawa-go villages, on which Itō was an expert. On this programme they were joined by one of Pries's former students, Gene Zema, a successful architect who was already, due to Pries's influence, a collector of Japanese antiquities.[35]

This was Zema's first visit to Japan and what he saw there confirmed the correctness of his chosen architectural path, as demonstrated in his own home and office building completed three years earlier at 200 East Boston Street in the Eastlake district of Seattle. Located above the corner of a road junction and framed with deep beams set between paired uprights, this courtyard building, with its board timbers and overhanging eaves, was more prescient of what he found in Japan than he might have imagined. 'I so liked their use of wood,' he said, 'the sense of order, the ruggedness and the honesty, the logic, the consistency of the absolute

module until you get to the great roof structure … I just gravitated toward what the Japanese had done; I could see what they had accomplished, how much they had accomplished, and it touched me' [14.05].[36] It was then that he began selling on for a profit the Japanese antiquities he collected. The building at 200 East Boston Street soon displayed the sign 'The Japanese Antiquities Gallery' and he would frequently cross the Pacific in search of more Japanese pieces: he made 63 visits in all.

Further south in California, where the weather was hotter and there was less rain, the incorporation of courtyard or garden spaces into house plans had been a frequent response in the traditional architecture of the haciendas. From the 1920s both Rudolph Schindler, at Pueblo Ribera Court, La Jolla (1923), and Richard Neutra, at the Lovell Health House, Los Angeles (1929), incorporated outdoor space within their modern buildings. However, it was not until after the war, and the promotion of smaller family homes for post-war living, that a more recognisably Japanese relationship between house and garden developed. This was due, as much as anything, to the expression of the structural frame, in timber or steel, as an architectural device in place of the opaque, white rendered walls of the pre-war International Style buildings. In 1959, the year in which Neutra built a timber-framed house in Bel Air

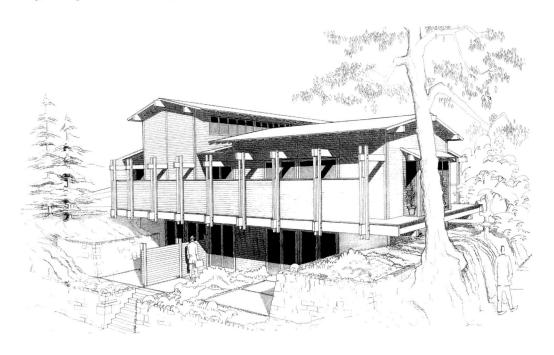

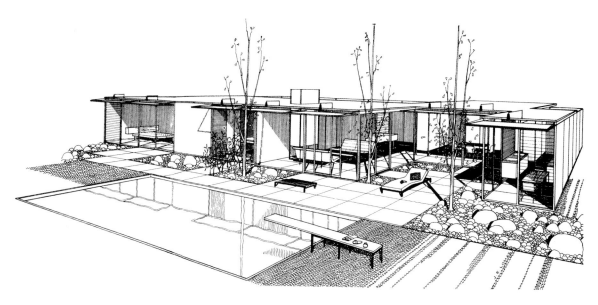

14.06 Case Study House 18 (the Fields House) in Los Angeles, California, designed by
Craig Ellwood Associates, 1958, from *Arts & Architecture*, April 1957.

for the industrialist Harry Singleton where the house
and garden are almost seamlessly interwoven, he
wrote in the foreword to *Japanese Gardens for Today*:

> David H. Engel points in his text to the mystery
> of how traditional Japanese houses fuse with
> their gardens, gardens so spontaneously free
> of the shackles of dry geometricity. The house,
> on the contrary, could well serve American
> prefabricators as prototype solutions of the
> problems of modular construction, as an example
> of the most humanized standardization accepted
> by a hundred million people.[37]

It was a relationship and approach to building which
had been recognised already in the Case Study House
Program promoted by John Entenza's monthly
magazine *Arts & Architecture*. Of the eight modular,
steel-frame Case Study houses built in Los Angeles
between 1949 and 1960 only one, John Entenza's
own house designed by Charles Eames and Eero
Saarinen (1949), failed to incorporate or embrace the
outdoors into its plan or open up to the sky some

internal part of its gridded structure. Case Study
House 18, the Fields House, was Craig Ellwood's
third contribution to the Program and was the most
apparently Japanese of all [14.06]. Located in Beverly
Hills and completed in 1958, it showed a fragility in
the modular steel frame that almost implied bamboo
construction and a blending, through the use of
enclosed courts, overhanging roofs and a universal
4-foot (1200-millimetre) constructional module, of
indoor and outdoor space.

Yet these Mid-century Modern California houses,
unlike their counterparts in Japan, had, for the
most part, flat roofs. This was a response both
to the regional climate and the influence of the
International Style which came, like many of its
architects, from Europe. Although not in California,
Mies van der Rohe's Farnsworth House at Plano,
Illinois (1946–51), with its exposed steel frame and
fully glazed walls, recalled, in many ways, Christopher
Dresser's observation (already quoted) that in Japan
the house was more of 'a floor raised above the
ground with a substantial roof than a series of rooms
properly enclosed by substantial side walls'.[38] In

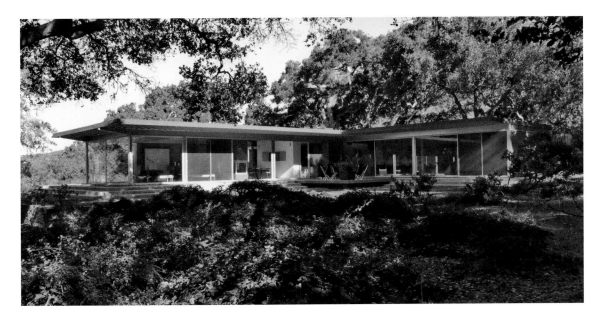

14.07 The Cyrus Johnson House in Carmel Valley, California, designed by Pierre Koenig, 1962.

California, where the threat of earthquakes was, as in Japan, far greater than in Illinois, the use of a welded steel frame made a great deal of sense. Although not actually elevated above the ground, Pierre Koenig's Johnson House in Carmel Valley (1962) evokes, with its raised platform, transparent envelope and clearly expressed steel structure, a very Japanesque piece of architecture [14.07]. It is little surprise that the present owners, who had the house restored and extended by Koenig in 1995, had spent much of their married life living in Japan.

Shinkenchiku and The Japan Architect

The monthly magazine now known as *The Japan Architect* had been published, since August 1925, with a fully Japanese text and the title, written in *kanji*, on the cover. But by 1950 the *Romaji* lettering 'Sinkentiku', meaning 'new architecture', was in regular use on the cover alongside the *kanji*. In 1955 Kawazoe Noboru, soon to be one of the Metabolists, took over as editor (only to leave in 1957) and in June 1956 launched the first English-language edition as *Sinkentiku* with the subtitle, 'The New Architecture of Japan'. The decision to become international was precipitated by perceived changes, both political and architectural, as the January 1957 Editorial explained:

> The last year was called the last of the postwar years and in retrospect, one may say that it was a year in which the Japanese architectural world, which in the 10 postwar years had devoted itself to bringing up the level of architecture to that of Europe and America, finally rid itself of direct foreign influences and direct importation, and the efforts to create a modern Japanese architecture for the sake of the Japanese themselves, had started putting forth buds ...

> The purpose in beginning this international edition was in the hope that it might play even a modest role in helping Japanese architecture develop under correct international evaluation.[39]

In February 1958 the Japanese title *Sinkentiku* was re-Romanised as *Shinkenchiku* 'to facilitate pronunciation by English-speaking readers',[40] and then in January 1959, in the belief that 'an all English magazine should have an all-English title',[41] the name was changed to *The Japan Architect*. But, as the owner and editor Yoshioka Yasugorō explained:

> THE JAPAN ARCHITECT is by no means a translation of SHINKENCHIKU, which means 'new architecture'. My staff and I believe, however, that it conveys the necessary information in concise form, and that you will find it easier to pronounce and remember.[42]

The English language edition was well received, and by June 1959 the magazine was, as Yoshioka said, 'growing faster than ever'.[43] This allowed it to include a number of features not found in the Japanese version, such as a series of articles on 'Technique' which explained the elements and features of the Japanese house, such as 'Tatami Floor Mats' or 'Japanese Roofing'.[44]

In late 1959 Yoshioka opened offices in New York which not only further expanded *The Japan Architect*'s circulation but also provided an opportunity for the readership to feed back to the magazine suggestions as to what they might like included. Yoshioka's confidence in the marketability of the magazine was further strengthened by visits to the United States and Central and South America in 1959 and 1960 where, as he put it, the 'distinct impression was that there is great interest abroad in Japanese architecture.'[45] This was encouraged by a New York publisher who predicted that the magazine might achieve a readership of 5,000 in that city alone and 20,000 in the United States as a whole. Brave figures, perhaps, but by July 1961, on the occasion of the magazine's fifth birthday, Yoshioka could boast that, 'Even now *The Japan Architect* is being sent to the United States, England, Australia, Canada, China, Colombia, Cuba, Denmark, Egypt, France, Germany, Greece, India, Israel, Italy, Mexico, the Netherlands, New Zealand, Norway, the Philippines, Portugal, Spain, Switzerland, Taiwan, Turkey, Venezuela and smaller countries all over

the world.'[46] As testament to *The Japan Architect*'s success, Yoshioka printed a number of letters from both Japanese and international readers:

Suzuki Takao, the Director of the National Diet Library:

> The growth of this magazine, which follows in the long tradition of *Shinkenchiku*, is clear testimony to the ever-increasing world interest in Japan and to the desire of people in other countries to know more about Japanese culture ...[47]

Kondo Shinichi, the Director of the Bureau of Information and Cultural Affairs:

> I am confident that a wider circulation overseas of *The Japan Architect* will vastly contribute to a better understanding of Japanese culture on the part of the peoples of the most of the world and the promotion of mutual friendship and goodwill.[48] [*sic*]

Gio Ponti, the founder and editor of *Domus* in Milan, Italy:

> Like all sensitive people, I am an admirer of Japanese architecture, an art that enjoys great admiration all over the world, and that shows us architects and designers a perfection of taste, harmony, and refinement.[49]

George Nelson, the New York industrial designer:

> During the short period *The Japan Architect* has been in existence it has made an important place for itself among international publications. The excellence of its material, the quality of the editing, and the handsome appearance are most impressive.[50]

Another encomium came from Pietro Belluschi in Portland, Oregon. 'I have studied with care and great interest every issue of your excellent magazine,' he wrote. 'You have been able to show with skill, through beautifully chosen photographs, the evolution of a strong and imaginative Japanese architecture, well

suited to modern conditions. Again we all have much to learn from Japan.'[51] Belluschi had been drawn to Japan, as had so many others from that region, because of its resonance with the Pacific Northwest. As early as 1938, in the house which he built for Jennings Sutor on a hillside site overlooking the Willamette Valley, with views of Mount Adams and Mount Hood, there is an almost indigenous Japanese response to site and context. It was a simple, timber-framed building with a large pitched roof reaching beyond the long window-wall to rest on tall wooden posts. Inside, where the entrance hall has a woven-wood ceiling and grass-paper on the walls, the furniture is built-in. But what made it feel particularly Japanese was the *irimoya* roofline, where the core of the building was expressed above the eaves which extended over the decking or *engawa* surrounding the building. Belluschi had a 1936 copy of Harada Jirō's *The Lessons of Japanese Architecture* in his library, as well as Yoshida Tetsurō's *Das japanische Wohnhaus*, published a year earlier. Harada, who at that time was a visiting professor at the University of Oregon, delivered a series of lectures on Japanese architecture at the Portland Museum of Art in 1935 and 1936.[52] There Belluschi befriended him and they had a number of conversations. This was the Pacific Rim speaking to its own.

Australia

In February 1955, coincident with the Japanese House exhibit at the Museum of Modern Art in New York, Melbourne's first Ideal Homes Show opened at the Melbourne Exhibition Building to large and enthusiastic crowds.[53] Although supported by the Royal Victorian Institute of Architects, its architectural aspirations must have been fairly modest: *The Argus* reported an Australian version of the American rumpus room complete with 'an aboriginal motif' and a bar in the shape of a boomerang.[54] It might have been this which prompted *Architecture and Arts and the Modern Home* to ask, in its March issue, if there is such a thing as an ideal home and, if so, what are its

ingredients. In answer, it provided an annotated visual survey of 'some of the most outstanding and successful "modern" houses that have been built'.[55] Rather than starting with Europe or even America, the essay began with Japan:

> Long before this country was discovered, the carpenter-architects of Kyoto, in Japan, were building homes which, had they possessed modern conveniences, would probably be better 'ideal homes' than is the standard accepted by the average Australian today.[56]

Recognising the climatic similarities between Japan and Australia, the magazine saw the benefit of an architecture which had developed both environmentally and constructionally to deal with hot summers, heavy rains and frequent earthquakes.[57] Alongside photographs of Katsura, the magazine stated:

> They had already achieved many of the refinements of house design that we are still 'discovering' – climate control, indoor-outdoor living, flexible open plans, multiple use of rooms, modular planning, standardised parts and a sensitive expression of materials and structure.[58]

The house that Sydney Ancher built in 1957 for his family at Neutral Bay, New South Wales, was one of the first to bring together all these attributes. Built with a timber post-and-beam frame on a 12-foot (3.6-metre) grid, its glazed front stepped back to provide a covered porch or *engawa* within the building's framework.[59] The same sense of containment was achieved internally where, within the open plan which stretched the length of the house from the dining room to the bedrooms, one quarter of the living room was defined by a free-standing column and a lowered beam or *kamoi* from which a curtain hung in the manner of a *kabeshiro*. Curtains similarly separated the sleeping from the living areas and a *byōbu* screened the dining from the living room. These Japanese readings might be thought fanciful were it not for the use on the ceiling of black-edged Cane-ite acoustic panels which gave a curiously inverted or reflected impression of

tatami.[60] So novel was the effect that Cane-ite used the house to promote its product:

> Cane-ite's soft, textured look is especially attractive in ultra-modern, open-planned homes such as that of prize-winning architect, Mr S. Ancher.[61]

A similar timber-frame construction set on a 12 × 8 foot (3.6 × 2.4 metre) grid was used for the house built for Darian Smith at Turramurra, New South Wales, in 1961.[62] Here, where the accommodation is arranged around an internal courtyard and sliding doors separate the principal living spaces, there is no acknowledgement in the literature of any Japanese influence, although two lines of *kanji* do appear on the published drawings. Although Ancher travelled to Europe in the 1930s, where in London he heard Frank Lloyd Wright lecture, no record of him visiting Japan has emerged.

Neville Gruzman, whose interest in Japan began when he read Horiguchi Sutemi and Kojirō Yūichirō's 1955 book, *Architectural Beauty in Japan*,[63] did go to Japan and he stayed for four and a half months. The Goodman House in Middle Cove, New South Wales, which he built in 1957 soon after his return, draws heavily on the modern *sukiya* styling of Horiguchi's Hasshōkan at Nagoya (1950), even to the extent of the free-standing platform set in advance of the building, although the cable-supported roof clearly owes nothing to Japanese construction techniques. The Probert House, built at St Ives, New South Wales, in 1959, was less dramatic but, in both its plan and its modular construction, more conventionally Japanese. Nominated by the renamed *Architecture and Arts* as one of its 10 best houses of 1959, it was, the magazine said, 'a truly sophisticated house'[64] as well as being, rather paradoxically, 'exotic but Australian'.[65] There was an enclosed, paved garden on the south side and, on the north, a thin projecting terrace, rather like the moon-viewing platform at Katsura, which extended out over the landscape from the living room. Because of the repetitive, modular nature of its glazed elevations, the Probert House was used by *Architecture and Arts*, in October 1962, to illustrate Gruzman's short essay, 'An Approach to Architecture', in which he argued

for modular co-ordination 'so that all individual manufactured elements will fit together from a size point of view'.[66] It was an approach which lent itself to both timber-frame construction, which was then becoming increasingly popular in Australia,[67] and the use of simple, orthogonal gridded plans.

Although *Australian Home Beautiful* had also promoted Japanese architecture as early as 1955,[68] this was an enthusiasm which, in the Australian architectural press, appears to have waned as quickly as it had arisen, and for the next five years the Japan question was largely side-stepped.[69] In a review of Japanese exhibits at the 1959 Melbourne International Trade Fair, *Architecture and Arts* observed that 'Examples of Japanese architecture … reveal an adaptability for Australian conditions',[70] but when the opportunity came to really demonstrate the point with, perhaps, the as yet unpublished Probert House, the magazine's editor, Kenneth McDonald, seemed to hold back. Yet suddenly in January 1960, in what was a clear response to *The Japan Architect*'s growing international outreach, *Architecture and Arts* asked the rhetorical question, 'Japanese Houses for Australia?' At a time when, in Australia, there was still considerable post-war ambivalence towards Japan, the posing of a question rather than the making of a statement allowed *Architecture and Arts* to venture onto contentious ground.[71] Not only did this article declare that 'Japanese design fits today's Australian house like a glove' and that 'There are many other lessons that Australian architects and builders can learn from the Japanese', but it illustrated its argument with four examples of recent Japanese domestic architecture taken directly from the November 1959 issue of *The Japan Architect*.[72] But then, as if to distance itself from too strong an advocacy of Japan, *Architecture and Arts* pointed out some of the non-applicable aspects of Japanese house design, such as the use of *tatami* for sitting and sleeping and the resultant lowering of the eye-level throughout the house, concluding with an apparent *volte face*, that 'if we use the Japanese house as a model we must learn to re-develop it to conform to our special ways of living.'[73] Where, then, was the glove?

On the pages following the Japanese polemic, *Architecture and Arts* printed a short review of 'A

Beach House at Carrum', then a small township close to Melbourne on the eastern edge of Port Philip Bay. The beach house was built in 1960 by Professor Zdenko von Strizic, an émigré German who had trained and practised in pre-war Berlin and until recently was Professor of Architecture at the University of Zagreb in Yugoslavia; (von) Strizic was now a senior lecturer at Melbourne University School of Architecture and soon to be hailed by *Architecture and Arts* as 'A new Australian who showed Australians how to build Australian houses.'[74] Despite the obvious Japanese qualities of the beach house, such as its fragile timber frame and brushwood (rather than bamboo) fence surrounding a gravelled inner court, it was as an Australian house that it was promoted. The wooden deck which served as an *engawa* was described as 'a traditional Australian feature used here in a slightly varied way'[75] and the point was made that 'No new materials, no new structures neither eccentric nor special forms were introduced.'[76] Furthermore, as if almost to deny the possibility of any foreign influence, the review concluded that 'What matters is the fact that an attempt was made to use the traditional Australian features for contemporary functional purposes.'[77] Whatever its origins, *Architecture and Arts* nominated the beach house at Carrum the third best house of 1959–60.[78]

Architecture and Arts second best house of 1959–60,[79] the Grenville Spencer House at Red Hill, Victoria (1959),[80] designed by Mockridge, Stahle and Mitchell,[81] was similarly timber-framed and set around three sides of an open courtyard. But whereas the beach house at Carrum had confronted the gravelled inner court as if it were a Zen garden, the Grenville Spencer House incorporated it into the plan. Set out on an 8-foot (2.4-metre) grid, the courtyard appeared rather like an oversized *tatami* room where the 8 × 4 foot mats were interpreted as either hard or planted landscape. Whereas one side of the courtyard was closed off by the garage, the remaining two sides were glazed with 8-foot sliding glass doors. At one corner, separated only by a sliding screen, was a room called the *lanai*. This Hawaiian term, suggesting a verandah or roofed patio furnished and used as a living room, belies

its true function of a space used for both living and sleeping, what in Japan is called a *zashiki*.[82]

Proposed suburban houses, even in Australia, often suffer from site restrictions. This was the case at the Darian Smith House which, although open to views of 'desirable brick residences', was turned inwards onto its own private court to give minimum exposure to the street.[83] The house which John James built for Bruce Wildman at Wahroonga, New South Wales, in 1960 had the benefit of an open and sloping site which fell away from the road, allowing the building to step back while opening onto a timber deck in a manner which recalled the incremental, stepped plan of the Katsura Imperial Villa. Internally, this allowed diagonal views from the living room to the kitchen which, as at Katsura, could be interrupted at will by *shōji* which could quarter the daytime spaces – dining, kitchen, play and living room – as needed. Whereas the diagonal view might be a Japanese response, it was also one which Frank Lloyd Wright, in 'exploding the box', had effected at the Harlan House in Chicago in 1892.

Wright, as a progenitor of Japanese effects, cannot in this context be ignored. Peter Muller, who won a Fulbright scholarship to study architecture at the University of Pennsylvania in 1950–51, sent Wright a selection of his early work once back in practice in Australia. The response, written from Taliesin West and dated 20 March 1956, was surprisingly accommodating:

> My dear Peter Muller: Your modern schemes are interesting.
>
> I hope to see some of them put into effect. While I have no present intention of reaching Australia, I do contemplate a trip to Japan sometime this year. If ever you come this way we will be happy to have you come to see us. Meantime, good luck.
>
> Sincerely
>
> Frank Lloyd Wright[84]

Amongst that selection of work which Wright saw must have been Muller's first house and office built at Palm Beach, New South Wales (1954). Comprising brick walls, oversailing flat timber roofs and large

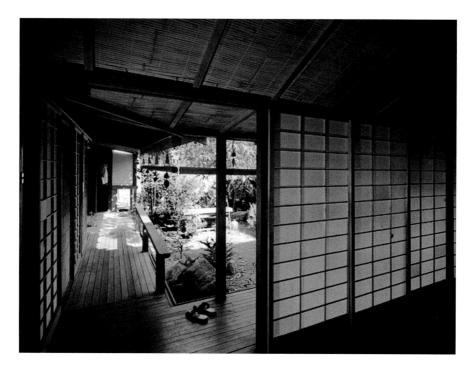

14.08　The Muller architectural office in Paddington, New South Wales, designed by Peter Muller, 1963.

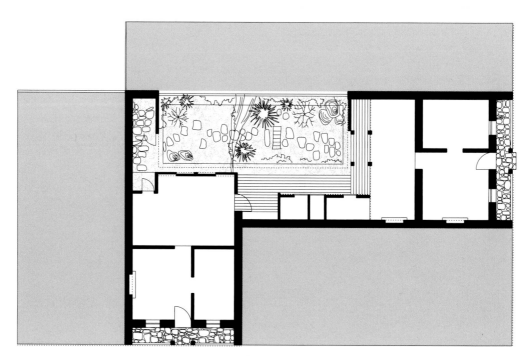

14.09　Plan of the Muller architectural office in Paddington, New South Wales, designed by Peter Muller, 1963.

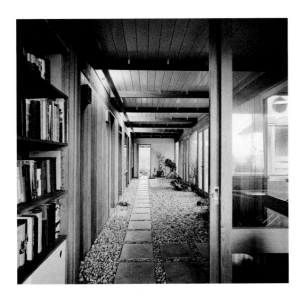

14.10 Portsea Holiday Homes (Imogen Farfor Flats) at Port Philip Bay, Portsea, Victoria, designed by Robin Boyd, 1968.

plate-glass windows, this extraordinary, diffracted house extended its plan through the boulders, gum and ancophera trees of the steeply sloping site. Yet for all its integration of house and garden, it is more Wrightian, in the manner of his Usonian houses, than Japanese.

It was not to be until the spring of 1961 that Muller visited Japan for the first time, a second visit, lasting six weeks, coming two years later. On this occasion he was ordained, perhaps a little to his surprise, a Jōdo Buddhist Chion-in priest and given the name of the venerable *Toku Shin*. 'I don't to this day,' he later wrote, 'have the slightest understanding why all this happened.'[85]

Between 1961 and 1991, Muller visited Japan five times, staying a total of 13 weeks. Although, as he later wrote, 'To admire certain work, such as that of Frank Lloyd Wright, or Japanese traditional architecture does not necessarily mean being influenced by them', it is difficult not to see those influences in his work. The most obvious Japanese expression was in the architectural office which he assembled on a back lot in Paddington, New South Wales, soon after his visit to Tokyo and Kyoto in

1963. Concealed in the crook of an L-shaped site which conjoined tin-roofed, nineteenth-century bungalows on Gipps Street and Margaret Place was an enclosed Japanese garden, flanked by an *engawa* and approached at one end through *shōji* screens [14.08] [14.09]. Bamboo panels lined the sloping ceiling and *sudare*, as well as *fūrin* (wind bells), hung from the eaves. It was, as Emily Post had experienced at Gump's, a step into another world, here maybe a hidden garden in Kyoto's Gion district. With perhaps the exception of the integrated house and garden of the contemporaneous Gordon Barton House, set behind a high wall at Castlecove, New South Wales (1963), Muller was never again in his work to be so Japanese.

Diagonally across Port Philip Bay from Carrum is Portsea where, similar in conception and location, the Portsea Holiday Homes or Imogen Farfor Flats were built in 1966–68 by Robin Boyd, the architectural critic and author of the insightful 1962 book on *Kenzo Tange*, and a partner in the Melbourne firm of Romberg and Boyd. Slotted onto

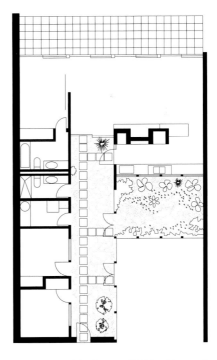

14.11 Plan of one of the Portsea Holiday Homes (Imogen Farfor Flats), at Port Philip Bay, Portsea, Victoria, designed by Robin Boyd, 1968.

a narrow strip of land between the Point Nepean Road and the cliffs overlooking Port Philip Bay at Portsea, Victoria, the four small houses were arranged in two conjoined pairs, each with an internal open court separated from the living space by a covered and glazed gravelled walkway which, with its paving stones and discrete planting, gave the impression of an indoor Zen rock garden [14.10] [14.11]. Timber-framed and with full-height glazing, these houses offered a respite from the sprawl of Australian suburbia of which Boyd was so critical in his 1960 book, *The Australian Ugliness*. Boyd was a powerful critical force within Australian architecture but died young at the age of 52. Nevertheless, these small houses, and his own timber and glass house on Walsh Street, South Yarra, show an understanding of how Japanese architecture, which he described as 'a sort of refined extension of nature: a concentration of nature's own kind of beauty',[86] could answer the rhetorical question posed by *Architecture and Arts*'s 'Japanese Houses for Australia?'

Katsura

In January 1960, the same month as *Architecture and Art* asked this question, Tange Kenzō was in Tokyo writing the foreword to *Katsura: Tradition and Creation in Japanese Architecture* which he co-authored with Walter Gropius and Ishimoto Yasuhiro. What is apparent from reading this book is that while Tange was intent upon displaying the cultural contradictions of the place as implied in the *Tradition and Creation* of the title – the collision of the lyrical, patrician *Yayoi* culture with the plebeian, irrepressible *Jōmon* – Walter Gropius, as a Western architect, saw in Katsura the redemption of Modern architecture.

> I had found, if only in illustrations [wrote Gropius], that the old hand-made Japanese house had already all the essential features required today for a modern pre-fabricated house, namely modular coordination – the standard mat, a unit

of about 3' × 6' – and moveable wall panels. It deeply moved me, therefore, to come face to face with these houses.[87]

The book, which began as a photographic project initiated by Ishimoto Yasuhiro, ended up as an architectural manifesto by Tange, sanctioned by Gropius. It was, on Tange's part, a deft piece of manoeuvring. In 1954, Ishimoto had spent the month of May photographing Katsura and was joined, for at least one afternoon, by Tange. On the basis of these photographs and the ones taken for Arthur Drexler in 1953, Ishimoto was given a book contract by the Tokyo publishers David-sha who agreed, the following year, that Ishimoto should invite Tange to contribute an accompanying essay. By the summer of 1955, with Ishimoto's photographs now delivered, Tange quickly assumed a controlling editorial role, inviting Herbert Bayer to design the book and Gropius, Bayer's former boss at the Bauhaus, to provide an essay.[88] Whether or not Tange used Bayer as a lever to obtain Gropius's support is hard to say, but Gropius wrote to accept the invitation the day after Bayer did: perhaps there had been some collusion.[89] Tange's invitation to Gropius, although it also bore Ishimoto's name, was sent without the latter's knowledge.[90] The proposal was open-ended, suggesting that Gropius might like to express his views 'either on Japanese architecture as a whole or on the Katsura in particular'.[91] The result was a little of each, produced quickly and apparently without consultation.[92]

What Gropius found at Katsura was what his compatriot Bruno Taut had been expected to find, by his young Japanese hosts, 21 years before – 'a "modernity" that transcends time, which may be considered the best trait of Japanese residential architecture'.[93] And this is how he approached his essay:

> The traditional house is so strikingly modern because it contains perfect solutions, already centuries old, for problems which the contemporary Western architect is still wrestling with today: complete flexibility of moveable exterior and interior walls, changeability and

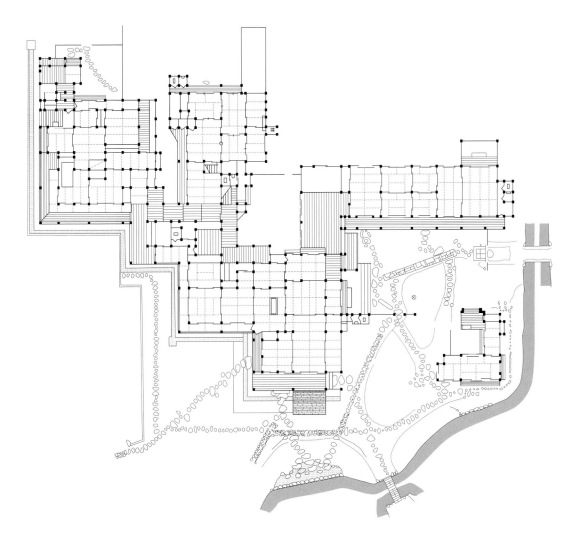

14.12 Plan of the Katsura Imperial Villa, Kyoto, completed in the mid-seventeenth century.

multi-use of spaces, modular coordination of all the building parts, and prefabrication.[94]

And again:

The indoor-outdoor relation between house and garden which has only been so recently 'discovered' in the West was a matter of great concern in Japan centuries ago.[95]

And with a final flourish:

I am convinced that invaluable benefits will accrue to a contemporary student of art and architecture from a visit to Japan. There he will find sublime, mature solutions of the intricate, ever-new problems of space and human scale, the very media for the art of architectural creation.[96]

The English language edition of *Katsura: Tradition and Creation in Japanese Architecture*, which was translated by Charles S. Terry and published by Yale University Press, appeared towards the end of 1960,

some months after the Japanese edition.[97] Despite Yale's publicity statement, which announced that 'No other building in Japan holds such deep meaning for the people of the West', any Western architect coming new to Katsura would have been left struggling to understand the totality of the complex [14.12]. Of the 138 photographs of Katsura included in the book, only two (apart from the aerial shot) showed a complete building: one was the 'General view of the north side of the Shōkintei' and the other, the 'General view of the Shoin group'. The Shōkintei was treated to a full-page bleed whereas the Shoin group was run as a strip across the bottom of an otherwise white page. Above it were these words:

> From texture to pattern, from pattern to space, and from space to time – the flow never ceases, never achieves the condition of a plastic entity.[98]

The purpose of the book, as Tange produced it, was not to explain Katsura but rather to provide the experience. Ishimoto's carefully composed black-and-white photographs, although often close-up shots of rocks, gravel, grass and post-and-beam architectural details, had included complete views of buildings but these Tange excluded from his final selection. Furthermore, he cropped many of Ishimoto's 4 × 5 inch (100 × 125 millimetre) full-plate images, often reducing exterior and interior views alike to Mondrianesque patterns, playing up the grid or emphasising the perspective. The pages of photographs are not numbered but just 'grouped following page 36',[99] making it hard to find any one particular image: the reader is consequently forced to move through the book as they might move through Katsura itself, obtaining a glimpse of a pathway here, or the corner of a building there.[100] This, of course, bore little relationship to Gropius's polemic but nevertheless provided Western architects with numerous monochromatic images of smooth gridded surfaces and richly textured materials, of *shōji* and *fusuma*, and of stepping stones and *tatami*. And it was often these features, more than the sequential layering of space or the diagonal

view, which became almost a commonplace in Western architecture at this time.

Tange's own essay had a different agenda and one to which Western architects, following the introduction of *Sinkentiku*'s English language editions, had only recently been introduced. This was the debate about tradition versus modernity which, early in the decade, had become a central point of discussion amongst Japanese artists and architects. The first English language edition of *Sinkentiku* contained Tange's essay 'Creation in Present-day Architecture and the Japanese Architectural Tradition'[101] which, in its argument, anticipated his essay on *Katsura*, then in his mind if not yet actually written. 'At Katsura,' Tange argued in the book, 'the dialectic of tradition and creation is realized.'[102] By tradition, he meant the lyrical, patrician *Yayoi* culture, as exemplified in the delicate, controlled architectural language of the main building comprising the Old and Middle *Shoin* and New Palace; and by creation, the primitive appearance of the surrounding rock formations and tea-houses which were characteristic of the plebeian, irrepressible *Jōmon* culture. The two cultures, *Yayoi* and *Jōmon*, worked together and against each other to provide what might be called a creative tension. At the *shoin*, Tange believed, 'the naïve vitality and ever renewed potentiality of the *Jōmon* tradition of the common people … prevents it from becoming a mere formal exercise and gives its space a lively movement and a free harmony.'[103] Meanwhile, in the rock formations and tea-houses of the garden, 'the aesthetic canons of the Yayoi tradition act as a sobering force which prevents the dynamic flow, the not-quite-formed forms, the dissonances, from becoming chaotic.'[104]

Where then, in Charles S. Terry's elegant translation of the original Japanese of Tange's text, was there a message for Western architecture? It was not, as in Gropius's essay, in an attempt to resuscitate the flagging fortunes of the Modern Movement but rather in a new and less forgiving architecture which if, in Japan, it had its genesis in Tange's public buildings of the mid-1950s, was already making itself felt in Europe as the New Brutalism.

Elizabeth Gordon and
The Discovery of *Shibui*

The New Brutalism, however, would have
represented everything about Modern architecture
which Elizabeth Gordon, the Editor of *House
Beautiful* from 1941 to 1964, deplored. In 1953 she
had taken up the cause of Edith Farnsworth whom
she described as 'a highly intelligent, disillusioned
woman who spent more than $70,000 building
a 1-room house that is nothing but a glass cage
on stilts'.[105] However, her attack on Mies van der
Rohe's architecture was not just because of its
'unlivability, stripped down emptiness, lack of
storage space and therefore lack of possessions',[106]
but because it symbolised, as the article's title said,
'The Threat to the Next America'.[107] The threat, as
such, was represented not just by the architecture
but also, at this time of McCarthyism, by the
architects who introduced it – often European
immigrants and frequently left-wing if not actually
Communist.[108] Paradoxically, those particular
architectural qualities were very much the ones
which she was to champion seven years later with
her discovery of *Shibui*.

The August 1960 issue of *House Beautiful* came
with the sub-title 'discover shibui, the word for
the highest level in beauty'[109] printed across the
cover photograph of the *shoin* at Katsura. To help
readers grasp the idea, Elizabeth Gordon explained
that '*Shibui* is the deepest beauty word in the
world. It applies to a severe exquisiteness that is
way beyond mere prettiness. It is serviceable to
all peoples to use to measure, quite plainly and
easily, the degree of profound lasting beauty.'[110]
The August issue was not a piece of lightweight
journalism but a well-researched thesis. Her list of
recommended reading included Ruth Benedict's
The Chrysanthemum and the Sword as well as Bruno
Taut's *Houses and People of Japan*.[111] Starting in the
mid-1950s, Gordon had begun to explore Japanese
art, architecture and culture, eventually making
her first visit there in April 1959, only to return that
December and once more in March 1960. She was
there again that August as the '*Shibui* issue' was

causing a sensation back home.[112] Although *House
Beautiful* had a circulation in excess of 750,000, it
quickly sold out and thousands of extra copies were
printed and shipped to Japan at the request of the
Japanese Foreign Office.[113]

What Gordon identified as *Shibui* was both
folk-craft *Jōmon* and aristocratic *Yayoi* – *sukiya*
and *shoin*. '*Shibui*,' she wrote, 'is the essence of
Japanese culture and is considered the ultimate
in taste – for all but the very young. There are two
strains of it: the folk craft school of thought and
the aristocratic school of thought. We Americans
can encompass them both.'[114] The comment about
the very young was probably as much an allusion
to the recent anti-American riots in Tokyo as
it was a sideswipe at Modernism. In June 1960,
students and others had demanded the return
to Japanese control of Okinawa and the repeal of
the US–Japan Security Treaty. 'Very few modern
things,' she assured her readership, 'can be said
to be *shibui*. Modern design is too new to a point
of view to have developed the depths necessary
for *shibusa*. Anyway, the modern movement has
put too high a value on the machine-made look.
Shibusa is humanistic and naturalistic, and the
opposite of mechanistic. For this reason it has
nothing whatever to do with the "less is more"
thinking of Bauhaus and "The International Style."
Shibusa is organic simplicity producing richness.
It is not denial and austerity, for it is developed
to the hilt.'[115] Despite her rhetoric, Gordon did
espouse real concerns that had been expressed
by Westerners as far back as Christopher Dresser:
'*Shibusa*'s lifespan may be nearing its close, as the
grosser forms of Westernization sweep the country.
… We are glad we saw it while it was still a living,
operating way of life.'[116]

In one section headed 'The Most Flexible House
in the World', Gordon is seemingly unaware of
the paradox of her position: 'The main message
that the Japanese house can have for Americans is
the obliging way it can be manipulated … With so
many variables, a house can accommodate itself
to changing social requirements and changing
climate needs.'[117] It was a delicate balance which she
proposed, something which, like Vladimir Ossipoff's

Japanese-inspired houses in Hawaii, were modern without being Modernist. Ossipoff, who, like Wells Coates, had been born and raised in Tokyo, similarly imbued his architecture with Japanese sensibilities: in 1958 *House Beautiful* had named his Liljestrand House near Honolulu on Oahu (1952) as a Pace Setter House.[118] This is what Gordon was promoting. 'We are not recommending that we transplant or copy the Japanese way,' she wrote. 'But if we can understand the attitudes and values that produced such sensitivity and awareness, it can help us find our own American way to the same rewarding ends.'[119]

The August 1960 issue of *House Beautiful* was illustrated with carefully composed colour photographs by Ezra Stoller and Norman Carver, which were arranged by John deKoven Hill,[120] the magazine's architectural editor. These showed the sorts of colours and textures, artwork and artefacts which could grace the American home. The images could not, in their way, have been more different to Ishimoto Yasuhiro's deep-toned black-and-white photographs which, by that August, were already circulating amongst American reviewers in Japanese-language copies of his book on Katsura.[121] However, the *Shibui* theme, once floated, was not allowed to sink. The September issue of *House Beautiful* (which also sold out) showed how the concept of *Shibui* could be expressed through non-Japanese objects and in 1961 the magazine launched a travelling exhibition to promote, through vignettes designed by Hill, the concept of *Shibui*. Sponsored by Japan Air Lines, it moved from Philadelphia to 10 cities, including Dallas and Honolulu, terminating in San Francisco the following April. At each venue, Gordon gave an illustrated, introductory lecture: it probably was, in its way, a bit of a circus.

A year later, in March 1963, the Australian magazine *Architecture and Arts* published a commentary by the Italian writer and critic, Bruno Zevi:

A scrimmage, kind in manners but substantially hard, is going on between American critics and Japanese architects. The Americans are illustrating in enthusiastic terms the culture of Japanese architecture – publishing books

and special issues of magazines on the ancient aesthetics. The Japanese thank them, bow, and, proud because the Americans are so interested in them, declare that they are glad and honoured because their products are so commercially required in the USA. Then, in a very polite and obsequious way, they add: 'But you don't understand a thing.'[122]

After explaining the meaning of *Shibui*, 'this non-translatable adjective [which] summarizes ideals and the most intimate essence of the Japanese culture',[123] Zevi began to take Elizabeth Gordon to task. He criticised her for completely ignoring recent Japanese architecture, for promoting *Shibui* as an antidote to the Modern Movement (thus recalling her earlier diatribes) and, most significantly, for suggesting that 'perhaps, before it disappears in Japan, we can make it our own – as we have assimilated other foreign concepts and "Americanized" them'.[124] 'Such talk', he wrote, 'may please the ladies who read the magazines but it is absolutely offensive to architects – either American or Japanese.'[125]

The *Shubui* which Elizabeth Gordon promoted was not the tradition which the recent debate in Japan pitted against modernity, but the traditional, the backward-looking, which if suitably Americanised and placed alongside the right carpets, paints and papers, might, indeed, make the house beautiful. 'The chief of the anti-traditional movement,' Zevi concluded, 'is Kenzo Tange,' and then, recalling how much Tange owed to Le Corbusier, added, 'it is not by accident that Le Corbusier can perfectly embody and represent anti-"shibui".'[126]

The World Design Conference, Tokyo, 1960

With the many public commissions that followed the success of the Hiroshima Peace Park, his teaching at Tokyo University and his establishment there of the Tange Lab, Tange Kenzō became

the driving force behind the re-establishment of Japanese architecture during the 1950s. Thus, he readied the stage for the World Design Conference before departing, in 1959, to teach the Fall semester at the Massachusetts Institute of Technology in Cambridge, Massachusetts. With Sakakura Junzō chairing the conference's Preparation Committee, arrangements were well under way when Tange returned to Japan in February 1960, bringing with him the floating housing system for Boston Harbour which his studio at MIT had developed. This he was to present at the conference and reissue as his *Plan for Tokyo 1960*.

The first announcement of the World Design Conference had actually been made the previous September, when Tange was attending the 11th (and last) CIAM meeting at Otterlo in the Netherlands. There the conflict which developed between the progressive Team X, comprising, amongst others, Alison and Peter Smithson, Aldo van Eyck, Jaap Bakema, Georges Candilis and Shadrach Woods, and the historicist Italian group, including Ernesto Rogers, Ignazio Gardella and Giancarlo de Carlo, led quickly to the dissolution of CIAM. Curiously Tange, in terms of the recent debate in Japan on tradition versus modernity, was positioned somewhere between what he termed 'the Utopian view of Team X and the escapist fatalism of the Italian group'.[127] In a letter sent to the Chairman Jacob Bakema following the meeting, Tange wrote, 'It is a problem of technology versus humanity, and the task of today's architects and city planners is to build a bridge between these two things, to discover a dynamic balance and an order that will link them.'[128] This would have been achieved physically, as well as metaphorically, in his water-borne *Plan for Tokyo 1960*, had it ever been realised.

Both sides of the final CIAM debate, Alison and Peter Smithson, and Ernesto Rogers, came to Tokyo the following May for what was styled WoDeCo. There were 143 Japanese participants, 37 from North America, 22 from Europe and five from Australia and New Zealand. Amongst the Westerners on the programme were the architects Ralph Erskine, Louis Kahn, Jean Prouvé, Paul Rudolph, Raphael Soriano and the Japanese

American Minoru Yamasaki; the graphic designers Saul Bass and Herbert Bayer; and the landscape architect Christopher Tunnard. It was, for many of them, their first visit to Japan. On 13 May Kahn made a visit to Sky House, which Kikutake Kiyonori had presented the previous day, and with Maki Fumihiko translating, a spontaneous, all-night debate developed. On 15 May, Asada Takashi, who in Tange's absence had helped organise the conference, took the Smithsons and Le Corbusier's collaborator Balkrishna Doshi up in a small aircraft to get a better view of Tokyo. The sight of collective housing blocks did not please Alison Smithson who kept repeating 'cheap looking', while husband Peter remarked, in a manner prescient of Tange's *Plan for Tokyo 1960*, that 'Tokyo should stretch over the sea.' At that time Tokyo, four years before the 1964 Olympics, had a population of 10 million but was still without any major highways or any great sense of urban order. 'The West has many bitter experiences of urban planning,' Alison Smithson commented, 'and the Japanese should learn from them.'[129]

The conference ran for five days, from Wednesday 11 to Monday 16 May, with the Sunday free for sightseeing. The alliterative seminar themes of Personality, Practicality and Possibility, occupied the three mornings while broader panel discussion themes, ranging from Individuality to Universality and from Production to Philosophy took up the afternoons. In many ways, the arguments rehearsed at CIAM in Otterlo the previous year were revived. 'The return to the past is an important tendency nowadays' (Prouvé); 'We have the duty to take our tradition apart, and then to put it together in a new way' (Kamekura Yūsaku); 'Evolution has been a wasteful process' (Bayer); 'The future city must change and renew itself uniquely to adapt continuously to the life of tomorrow' (Kurokawa Kishō). Although at times seemingly pulling in different directions, a common concern for the greater environment emerged: 'Modern architecture ... so far has thrown little light on how to relate one building to another or to the environment' (Rudolph);[130] 'When we build, it is not enough to consider merely the conditions under which

the building is to take place and to merely satisfy the necessary function; it is further necessary to think of the influence which it will have on its surroundings and its mutual interrelations with these surroundings' (Peter Smithson).[131]

It was in this context that Kikutake Kiyonori, Kawazoe Noboru, Ōtaka Masato, Maki Fumihiko and Kurokawa Noriaki (Kishō) launched their manifesto, *Metabolism 1960*, selling it unofficially at the conference for 500 Yen a copy. As a name, 'Metabolism' was a translation of the Japanese word *shinchin-taisha*, meaning 'regeneration' or 'the replacement of the old with the new'. Suggesting only adaptation to change, it was not a perfect word for what their broader idea also implied – growth, propagation and metamorphosis.[132] But it would be understood around the English-speaking world and, with the added benefit of being an 'ism', would have to do. As it emerged, Metabolism, in

its vitality and sophistication, was both *Yayoi* and *Jōmon*: Kikutake Kiyonori's Tōkō-en Hotel, Yonago (1964), Isozaki Arata's Prefectural Library, Ōita (1966) and Kurokawa Kishō's Nakagin Capsule Tower, Tokyo (1972) all displayed the additive incompleteness characteristic of Metabolism. As a movement it lasted a little over 10 years, only to disappear with the Japanese economy in the early 1970s. Many years later, when recalling Team X's hope that a specific spatial vision, characterised by 'the planless plan', could be achieved through 'energies and possibilities', Alison and Peter Smithson were to write rather ruefully, 'The notion of Metabolism was beautiful – of a building fabric, of a town fabric, which could organically adapt to circumstances – which had the possibility of change built into its genes. It was a Japanese notion that should not be betrayed or abandoned by Japanese architects.'[133] But it was.

15 THE WEST AND JAPAN

From Tokyo to Osaka

Chapter 4 of this book examined how, in the nineteenth century, Japan had first learnt about the West through the great international exhibitions and how there the West had, similarly, first seen examples of Japanese architecture. Now, a century later, we must return again to the international exhibition. Expo '70 at Osaka, however, was not so much another showpiece for the exchange of architectural ideas but rather a manifestation of the Japanisation of Western architecture. In the 10 years of the Japanese 'Economic Miracle' which followed the 1960 World Design Conference in Tokyo, the surrender, consciously or unconsciously, of Western architectural thinking to the Japanese mind had been almost complete. The evidence lay all about – both *Yayoi* and *Jōmon* – from the incipient stirrings of high-tech architecture to the board-marked concrete of the New Brutalism. And then, when that was all over, it was from Japan, and it could have only been from Japan, that came the first full flush of Post-Modernism.

The New Brutalism

On the opening page of its January 1955 issue, the London-based journal *Architectural Design* introduced 'The New Brutalism':

The name is new; the method, a re-evaluation of those advanced buildings of the twenties and thirties whose lessons (because of a few plaster racks) have been forgotten. As well as this, there are certain lessons in the formal use of proportion (from Prof. Wittkower) and a respect for the sensuous use of each material (from the Japanese).[1]

In an attempt to provoke a response, the journal asked Alison and Peter Smithson, whom it described as 'the prophets of the movement', to explain what it meant. Their statement, which was reproduced in an edited form, made quite clear modern Western architecture's allegiance to Japan:

Our belief that the New Brutalism is the only possible development *for this moment* from the Modern Movement, stems not only from the knowledge that Le Corbusier is one of its practitioners (starting with the 'béton brut' of the Unité), but because fundamentally both movements have used as their yardstick Japanese architecture – its underlying idea, principles, and spirit.[2]

In relating to Japanese architecture both the Modern Movement, which to their minds was already dying, and the New Brutalism, as first expressed in their

own Secondary Modern School at Hunstanton, Norfolk (1954),[3] the Smithsons were acknowledging the influence (on Western architecture) of not only the *Yayoi* of the *shoin* at Katsura but also the *Jōmon* of the tea-houses which surrounded it. Brutalism, as it is now called, is a difficult word and has taken on many interpretations, often pejorative, in the last 60 years. However, what the Smithsons meant was not to do with form or finish in buildings – 'It has nothing to do with craft,'[4] they said – but the handling of materials. 'What *is* new about the New Brutalism among Movements,' they wrote, 'is that it finds its closest affinities, not in past architectural style, but in peasant dwelling forms.' In this it was undoubtedly *Jōmon*.

The importance of the garden in Japan, not as a separate entity but as an integral part of the home, is enormous. In Japanese architecture the outdoors, or nature, takes on a particular significance. In the West, architecture conceived in the Hellenic tradition was thought of in terms of form, such as order and symmetry: 'But for the Japanese,' the Smithsons explained to the readers of *Architectural Design*, 'their FORM was only part of a general conception of life, a sort of reverence for the natural world and, from that, for the materials of the built world.'[5] *And*, they continued, 'It is this reverence for materials – a realization of the affinity which can be established between building and man – which is at the root of the so-called New Brutalism.'[6] Only in such a highly structured, hermetic society which had been denied foreign intervention for almost 230 years could such an attitude have developed: 'We see architecture', the Smithsons declared, 'as a direct result of a way of life.'[7]

Concrete, or *béton brut*, is often regarded as the *bête noire* of Brutalism. Yet, from the Smithsons' explanation, as well as their architecture, it should be apparent that the New Brutalism was not specific to any one material. However, the use of concrete takes on a very different significance in Japan when compared to the West where, for many years after its introduction, it was regarded as an engineering material.[8] The reality of earthquakes and the consequent conflagrations soon gave it an acceptance in the Japanese architectural community, and its resilience to wartime bombing, not least

at the Industry Promotion Hall in Hiroshima, demonstrated its efficacy. Whereas in the West, major public buildings were traditionally built of stone, or sometimes brick, in Japan they were always constructed of timber. Thus timber, as a worthy and appropriate material, had a significance and acceptability in Japan which in the West it never had. Therefore, the introduction in the early twentieth century of reinforced concrete provided a reliable building material which could simulate the dimensions of timber construction and reproduce, in the board-marking, a convincing timber grain.

It was probably Maekawa Kunio who in Japan, at the Kanagawa Prefectural Library and Auditorium at Yokohama, first used in public architecture the board-marking of concrete for decorative or aesthetic effect [15.01]. Whereas this finish would have been decided upon at some stage during the design or building process, its realisation would not have been apparent until the shuttering was struck or, to a wider audience, until the building was completed: this was in October 1954.[9] As has been noted, Maekawa and Tange Kenzō had travelled together to Marseilles in 1951 to see the Unité d'habitation then under construction:[10] 'The *pilotis* were very impressive,'[11] Tange said, soon after his return. Whereas Tange's contemporaneous Peace Memorial Museum at Hiroshima was also to show board-marking on its *piloti*, it was Maekawa's building at Yokohama which, by a few months, was the first finished. In Le Corbusier's pre-war villas, on which Maekawa had worked, the *piloti* had always been left smooth-faced. In the Library at Yokohama, Maekawa's board-marked columns referenced far less Le Corbusier than the composite timber columns of the Todai-ji at Nara and other Buddhist temples. In the quietude of the Library, where the reading rooms looked out onto trees, it was an association which would have been most appropriate and maybe even understood.

Tange's representation of timber construction in concrete at his civic offices at Kurayoshi (1956), Takamatsu (1958) and Kurashiki (1960) has already been discussed. However, his rhetorical use of concrete as timber draws particular attention to the material: in the Library at Tsuda College, Tokyo

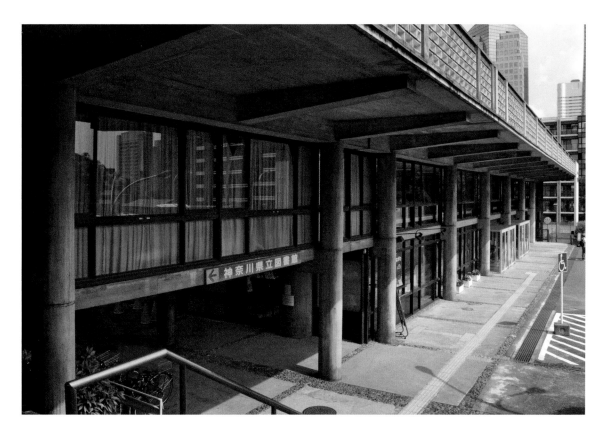

15.01 Kanagawa Prefectural Library and Auditorium in Yokohama, designed by Maekawa Kunio, 1954.

(1954), the concrete frame appears to float above the ground in a manner which belies the weight of the material, while at the Kagawa Prefectural Government Office at Takamatsu, the board-marking of the concrete columns stops just short of the ground in order to demonstrate that what appears to be timber is in fact a cladding.[12] Similarly both Tange and Maekawa constructed concrete balustrades to look like they were made of timber. Those on Tange's stairs at the Rikkyō University Library, Tokyo (1961), show mortice and tenon construction, while at Maekawa's City Hall, Kyoto (1960), the handrail is shaped and smoothed, ready for the human touch.

The use of concrete to express timber construction at the Japanese Cultural Institute in Rome, built by Yoshida Isoya in 1962, must have been a conscious effort not only to produce a piece

of modern, Japanese architecture for the Western public but also to evoke the spirit of traditional Japanese construction [15.02]. Located on high ground next to the British School at Rome and overlooking the Villa Giulia[13] and the Galleria Nazionale d'Arte Moderna e Contemporanea, the building is as much a cultural counterpart to its neighbours as it is a didactic interpretation of the heavy-columned Heian period architecture (c. 800 to 1200), such as the Daigoku-den at the Chōdō-in in Kyoto (or Heian-kyō) which Itō Chūta rebuilt. Viewed from the Japanese pond garden, the three-storey building appears to sit low, the *engawa* fronting the Director's apartment becoming a moon-viewing platform reaching out over the water, its concrete guardrail simulating timber construction. The reinforced concrete frame is expressed externally,

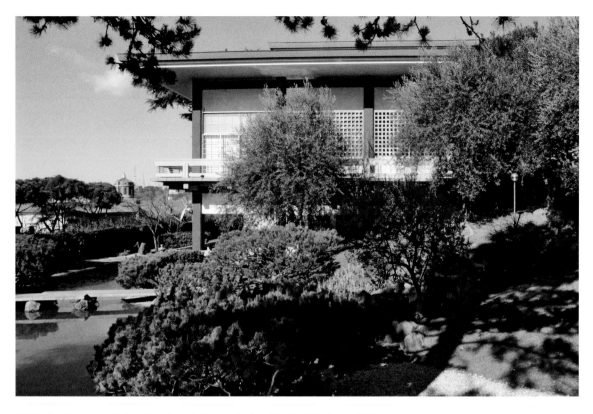

15.02 The Japanese Cultural Institute in Rome, designed by Yoshida Isoya, 1962.

its columns set on-grid but closer than is really necessary, implying again a timber frame where the spans are more limited. Inside, the Japanese illusion is continued, the zig-zag acoustic walls of the auditorium suggesting *byōbu*, while on the upper floor, *shōji*-like screens can be drawn back to reveal the *takonomo*. Although neither the concrete columns, which are faced with small mosaic tiles, nor the guardrail are board-marked, the allusion to timber construction is clear and thus the reverence for materials, of which the Smithsons wrote, explicit.

The Smithsons

Alison and Peter Smithson were largely ahead of the game when it came to employing the lessons of Japanese arcitecture, although it was not until 1960,

on the occasion of the World Design Conference, that they first visited the country. There were, nevertheless, frequent nods towards Japan before then in their built and unbuilt architecture. The expressed steel frame and gridded glazed walls of the Hunstanton School in Norfolk (1954), they said, probably owed as much 'to the existence of Japanese Architecture as to Mies',[14] and their third-placed entry for the 1957 Berlin Hauptstadt competition, submitted in collaboration with Peter Sigmonde-Wonke,[15] betrays more than a suggestion of a pagoda in the cross-sections. The staggered plan of the student accommodation in their unplaced entry for the 1959 competition for Churchill College, Cambridge, recalled the *shoin* at Katsura in the way in which it stepped out corner after corner [15.03]; internally, the low level of the window sills, set only a foot (300 millimetres) above the floor, also would

15.03 Competition entry for Churchill College, Cambridge, from Alison and Peter Smithson, 1959.

have encouraged the use of the floor as a place to sit, as in a Japanese house.[16]

The manifesto *Metabolism 1960* bore the subheading, 'The Proposals for New Urbanism'. One of these, which became known as the 'megastructure',[17] was shown in a number of projects: 'The Tower-Shape Community' and 'The Marine City' by Kikutake Kiyonori; 'Wall City' by Kurokawa (Kishō) Noriaki; and the 'Group Form' shopping town at Shinjuku, Tokyo, by Maki Fumihiko and Ōtaka Masato. Although specific to Group Form, the concept of 'master form' (as opposed to master plan) was common to all these megastructures, as Maki and Ōtaka explained:

A master plan is basically a static concept, whereas the concept of master form we are proposing here is dynamic. Master form is an entity that is elastic

and enduring through any change in a society. Therefore, master form is one of the principles of a more dynamic approach in urban design ...[18]

It was very much this notion of elasticity and change which the Smithsons had proposed seven years earlier in their competition entry for the University of Sheffield:

The technological intention of much of the university seems to point to buildings of the maximum flexibility – so that today's laboratory can be tomorrow's testing room or group of studios ... This flexibility is most easily achieved in a simple, repetitive, continuous structure.[19]

The drawings accompanying this statement showed a megastructure comprising reinforced

15.04 The competition entry for the University of Sheffield by Alison and Peter Smithson, 1953.

concrete fixed construction and light steel flexible construction [15.04]. It was Metabolism before Metabolism had been invented.

The Smithsons' competition entry was unsuccessful and was not immediately published in the architectural press. However, it was illustrated in perspective and block plan in Reyner Banham's article on 'The New Brutalism' in *The Architectural Review* in December 1955:[20] this would have introduced it to Japanese readers. In celebrating the scheme's 'aformalism', Banham notes how 'The "connectivity" of the circulation routes is flourished on the exterior and no attempt is made to give a geometrical form to the total scheme; large blocks of topographically similar spaces stand about the site ...'[21] In this, perhaps,

can be seen the genesis of Maki Fumihiko's 'Group Form' work with Ōtaka Masato and his later Daikanyama Hillside Terrace (1969–92) in Tokyo.

Although Tange had by the late 1950s established a reputation and presence overseas, few of his group had much experience outside Japan. Maki, however, had studied in America, first at Cranbrook Academy in 1952, and then the following year at Harvard under José Luis Sert, before working for SOM in New York and for Sert in Cambridge.[22] In 1958–60 he travelled around Europe and Asia, thanks to a Graham Foundation Fellowship, but it was probably at the World Design Conference in Tokyo that he first met the Smithsons. Two months afterwards, in July, they invited him to attend the Team X meeting in Bagnols-sur-Cèze, France; years

after, he was to recall how Peter Smithson later came to befriend him.[23] However, such influences, at this point, remain speculation: it is more likely that the similarity of this thinking was the result of the confluence of ideas. At the 1959 CIAM meeting at Otterlo, where Tange presented Kikutake's Tower-Shape Community, Peter Smithson addressed the commonality between the Japanese architecture and the ideas of the emergent Team X:

> It just so happens, by accident of history, that the aesthetic of the old Japanese architecture, which has a certain openness in its construction, corresponds to a feeling we have for an open aesthetic with its possibilities of cycles of fixed things, of changed things, and so on.[24]

Then, with special reference to Tange, he continued:

> Now if Tange had not lived in Japan he would have had to invent that language. He has, however, the possibility of using his language, but no one else of us has … We simply do not have Tange's possibilities.[25]

Smithson was here neither implying a critique of Tange, nor promoting a return to a stylistic past. He was simply commenting, perhaps a little ruefully, that the Japanese already had the type of flexible architecture towards which Western architects, and Team X in particular, were striving.

Alison and Peter Smithson's visit to Tokyo in 1960 must have confirmed for them the rightness of their interest in Japan for in early 1961 they published 'The Rebirth of Japanese Architecture' in what was perhaps the most progressive of the British architectural journals, *Architectural Design*. The article, however, did not dwell solely on Japan but incorporated a review of Le Corbusier's recent buildings in India, due to their acknowledged influence on the resurgent architecture of Japan: '… and once in India,' they wrote, 'it was found that the old architecture held the key to many of the things Le Corbusier had done there.'[26] This recalls Itō Chūta's *Systems of World*

Architecture where the Indian System overlaps with the Chinese System, of which Japan was an off-shoot. Thus to say that Japanese Modern architecture was (apart from its own inherent qualities) wholly a Western construct would not be true. Some of the old traders' paths which Itō had identified were still being trodden. More recently Maki Fumihiko, as a Graham Foundation Travelling Fellow, had also visited India where, in Chandigarh, he had shown Le Corbusier the design for his first Japanese building,[27] the Toyoda Memorial Hall at Nagoya University (1960). 'He looked at the drawings in a dimly lit, high-ceilinged atelier,' Maki later recalled. 'It may have been flattery, but he said they were very good. He noticed then that the columns were linked to the wall (a seismic connection), which apparently bothered him. "Take good care of the column." I did not venture to contradict him. I left him feeling that his few words were precious.'[28]

The Smithsons' review of Japanese architecture did not include Maki's new building in Nagoya but concentrated largely on Tange and Maekawa of the older generation.[29] Of the younger Metabolists, only Kikutake was included. His Sky House was singled out as being important for representing in its pure form 'the *art nouveau* flank of Japanese modern architecture'.[30] But, as they said, 'In this house all the decisions from the choice of structure and plan to detailing and even furnishing appear to have been made for formal reasons.'[31] Such moves they regarded as historicist, hoping that they were but 'temporary devices pending the "creation" of more appropriate forms',[32] but nevertheless recognised in them two elements which were to be the theme of their next foray into Japanese architecture: the rectangular plane and a certain sort of curve. 'Shapes and forms other than can be made with these delineators,' they observed, 'are very rare indeed.'[33]

'The Rectangular Plane and a Certain Sort of Curve' was the sub-heading for the first part of Peter Smithson's essay, 'Form Above All', presented at the Architectural Association in London as the Michael Ventris Memorial Award Lecture for 1963. The rectangular plane,

comprising straight lines, is, in the context of traditional Japanese architecture, easy enough to understand; but the 'Certain Sort of Curve' is more difficult. In the earlier essay Smithson had described it as 'a single form of curved line that is nearly a straight line followed by a short curve.'[34] In 'Form Above All' he does not define it but rather shows it as evidenced in Maekawa's Harumi Apartments: 'the classic formula of the rectangle and a certain sort of curve. A building conceived in absolute purity and executed with absolute rigour – a building so very hard to fault yet so very hard to take.'[35] Although Smithson would have known about the Harumi Apartments before he first went to Japan, it is more likely that it was at the World Design Conference that he first came to understand the 'certain sort of curve'. One of the official publications at the conference was *Nature and Thought in Japanese Design*, a tri-lingual guide to Japanese aesthetics. Here Smithson would have read that 'The Japanese curve is a variation of the straight line. Most typical of it is the curve of the bamboo bending under the weight of snow',[36] and that 'the straight line and the curve are not mutually opposed lines; they are twins born from the one and only strength.'[37] In the same way, Smithson saw the two as inseparable:

> The heart of the matter is that Japanese architecture is at its most successful when its *mastering volumes are defined by rectangular planes and a certain sort of curve*, and this is the basis of the major works of today.[38]

Despite their apparent common interest, it is unlikely that Peter Smithson's attention to the curve was due to Itō Chūta's essay of 1894, 'Nihon kenchikujutsu ni okeru kyokusen no seishitsu wo ronsu' ('On the Quality of Curve in Japanese Architecture').[39] Here Itō, ever the mediator, is trying to define Japanese curves in terms of Western mathematical notions.

In addressing 'Object Making and Place Making' in the second part of the Michael Ventris Memorial Award Lecture, Smithson took the Japanese architects to task for adopting uncritically the Western approach to place making which he described as 'the independent villa and the bleak block of flats'.[40] Although the masterplan for Tange's Kurashiki City Hall was, as he said, 'entirely conventional – by that I mean derived from Le Corbusier – Europe at its best – conventional *to us*',[41] it was still a Western approach. Equally Western, but Europe at its worst, was the Harumi development which included Maekawa's Apartments. 'This building,' he wrote, 'stands like a stranded rhinoceros in a sea of five-storey walk-ups for all the world like Amsterdam.'[42] What the Japanese architects had failed to do in the making of place was to create an urban environment based upon their traditional use of sequential, intimately organised, inside and outside space. This is what, in their own work, the Smithsons called the 'Pavilion and Route': the separation of the closely placed elements – pavilion and route, solid and void – which allowed each to grow and develop independently within a cohesive group form. This was particularly noticeable at the Economist Building in St James's, London (1964), where the close proximity of the three buildings positioned on their podium creates a cohesive group, while the canted corners, as the American critic Vincent Scully has observed, is 'a method whereby the pedestrian is led into the platform-plaza and drawn through it'.[43] In the second volume of their two-volume collected works, *The Charged Void*,[44] they wrote of this scheme:

> The very closed plan forms emphasize the separation of the elements, particularly necessary on this very small site. The space between that is consequent is more [sic.] than the sum of the spaces that each of the buildings carries with it.[45]

In trying to achieve what they called a '"half open and half closed" space system',[46] the Smithsons hoped to free up the urban structure and edge towards 'the collectivity of the as yet unbuilt',[47] so that the city, like the old towns in Japan, might grow in such an open yet close-knit way.

Although the early 1960s witnessed the Smithsons' most regular writings on Japanese architecture, their interest in Japan never waned. As has been shown, they were not always complimentary and sometimes openly hostile. In May 1962, Peter Smithson wrote a short critique of Tange's Tokyo Bay Plan, although it was not published until over two years later:

> Let me, however, give you straight away my immediate reaction to the plan: that of fear. That whatever may be explained, it is above all centralized, absolutist, authoritarian.
>
> I am, of course, sure that this was not the intention of the authors – far from it – but somehow it has crept in at all levels – into its basic thinking, into its organization, and residually, into its imagery – for only the natural sensitivity of its designers has taken the hard edge off its ruthlessness.
>
> That off my chest, I can proceed with the formal criticism.[48]

The 'natural sensitivity' was in the straight lines and the certain sort of curve which defined the major forms, but it was the proposal's formal brilliance and graphic presentation which, it seems, saved the scheme. Writing as 'I Chippendale' in 1969, Alison Smithson, in a review of Robin Boyd's *New Directions in Japanese Architecture* (1968), praises Maekawa for his Horatian cool-headedness in the face of American hegemony. She contends that the Japanese had then not yet developed any critical facilities of their own to deal with their modern architecture, citing how 'Kikutake's perfectly traditional house is repeatedly praised to the skies',[49] yet it is the equivalent, in terms of its traditional form, of Bill Howell and Stan Amis's London terraced houses at South Hill Park, Hampstead (1954–66). 'The Japanese,' she says, 'might do well to consider closing their country for another 200 years to digest what they have taken in.'[50] In a review, written a couple of years later, of *Shinohara Kazuo: Jūroku no jūtaku to kenchiku-ron* [Sixteen Houses and

Architectural Theory] (1971), and entitled, pointedly, 'The Emperor's New Clothes', Peter Smithson quotes some of Shinohara Kazuo's finer phrases – '*I want very much to cherish ordinary places where the character of the world reveals itself*' – and asks, 'How can he square his eloquent, anguished prose with what he is actually doing? ... Not an animal or a man or a common Japanese industrial artefact appears in the photographs of these 16 villas.'[51] But what Shinohara was actually doing was continuing his diatribe against Metabolism and the world of the giant Japanese construction firms, with their banal and standardising architectural capacity, against which the individual house was the, and his, last bastion of defence.[52]

Always challenging and never easy, the Smithsons saved their boldest Japanese gesture, conceived with Ronald Simpson, for the Riverside Apartments competition of 1977 [Plate 4]. In a set of drawings which probably did as much to lose them the competition as it might have done to win it, the Smithsons provided a series of axonometric views which showed the jagged, layered scheme as traditional Japanese interiors in the manner of Isaac Titsingh's *Illustrations of Japan* (1822) [see Plate 3]. The annotations on the drawings claimed both Katsura ...

> These drawings are intended to convey the moonviewing, river-struck aspects ... that its aesthetic is essentially one of many 'skins' ... many layers of meaning.

and their own lineage:

> Layers, layering, screening ... the dressing of the seasons ... the decorating by the event ... lattices ... degrees of self-chosen exposure ... some of our oldest themes.[53]

The manner in which the spaces were populated by the *kimono*-clad figures showed a variety of activities within close confines. As in a Japanese house where the *shōji* and *fusuma* afford very little privacy, so these riverside apartments ask for what the Smithsons called 'Interval'. This is:

... to do with rightful spheres of influence, space for each to be its own thing ... ultimately the sense of territory, respect for another's sense of territory, which is not only the ground but also spatial, to do with sense of overlooking, of unbreathed air, blocking of sunlight, and so, shade and shadow ...[54]

This is probably more than a speculative riverside development in central London could ask for.

Expo '70

As in the previous century, it was initially through the medium of the international exhibition that post-war Japanese architecture was shown to the West. Three years after Yoshizaka Takamasa built the Japanese pavilion for the 1955 Venice Biennale [see 13.11], Maekawa Kunio had the opportunity to achieve, in the pavilion and exhibition which he designed for the 1958 Brussels World's Fair [15.05], what he had missed out on at the 1937 Exposition Internationale in Paris. In the Cold War climate of the Brussels World's Fair, where the round American pavilion[55] and the rectangular Russian pavilion[56] competed for attention, Maekawa's Japanese pavilion was located almost out of sight behind the red-and-gold portico columns of what *The Architectural Review* referred to as 'the clumsy and garish pavilion of Iran'.[57] As *The Architects' Journal* observed, 'most people will find the Japanese garden a haven of rest on a tiring day. This is the ideal place to recover one's strength before mounting an assault on the formidable obstacles that lie ahead: the American and the Soviet pavilions.'[58]

The success, to the Western mind, of the Japanese pavilion was as much in its garden, whose pebbles, moss and white sand were allowed to penetrate the building, as in the pavilion itself. Arranged in three parts, the pavilion comprised a rectangular glass and steel exhibition space with a central courtyard set beneath a broad, butterfly roof cantilevered from a pair of I-section steel beams set on four pairs of splayed concrete

'legs'; at either end were two smaller structures of traditional timber construction, one housing a restaurant opening onto the garden and the other, staff accommodation and, rather incongruously, an electrical sub-station. Although the exhibition space was, as *Shinkenchiku* noted, 'built entirely with modern factory-made materials and by modern methods',[59] its modular structure and sense of flowing space gave it a traditional appearance, prompting the magazine to wonder if 'the building is perhaps too quiet to compete with its gaudy surroundings'.[60] But what a Japanese critic might see is not necessarily what a Western critic would. For *L'Architecture d'aujourd'hui*, the pavilion represented the synthesis of tradition – found in the simplicity of the volumes and the modulation of space, the oversailing eaves and the use of wood, bamboo and oiled paper – and the bold technology of the cantilever roof, which both confronted and complemented each other.[61] The critic writing for *Architectural Design*, however, took a more nuanced view, noting that the pavilion's Japanese qualities were neither caricatured nor played down.

> It is a success as an exhibition and as architecture, and is very serious; and it is because it is so expressive of all that the Japanese are, that it works. The Japanese are not a sophisticated European people. They are a people who have retained their taste and qualities, their particular uniqueness, and have taken from the West those things they feel they want, and have, in a way, bent our culture to fit their requirements.[62]

For the Western critic, and in particular a British one, it was as much the experience as it was the architecture of each national pavilion which was important.

> The Japanese restaurant is exactly as one would expect – sophisticated yet primitive, all the utensils exquisite, every object to be touched a thing of delight; the food excellent, beautifully cooked, and cooked while you wait and watch.

15.05 The Japanese pavilion at the 1958 World's Fair, Brussels, designed by Maekawa Kunio.

How instructive to compare this with, say, the German pavilion, where coffee is served in machine aesthetic cups and saucers, where the sugar wrappings are specially designed, each object well chosen. And then with the British pavilion where our eating habits are carelessly displayed to the world – but do not even qualify for aesthetic approval.[63]

As if to recognise the total experience – building, garden and, no doubt, food – the Japanese pavilion was awarded a Gold Medal and judged the ninth best of the 116 separate buildings. As the World's Fair ended, offers came from Canada, Italy and the Netherlands to buy the building, while the United States requested that it be sent over to the Century 21 Exposition to be held in Seattle, Washington, in 1961.[64]

It is surprising, therefore, that back in Japan the pavilion became the centre of a loud debate, reported in *Shinkenchiku*,[65] about how the country should be displayed to the rest of the world. Kita Kazuo, a Liberal-Democratic member of the House of Representatives, criticised the pavilion for being 'a whimsical collection of arty objects', while the designer Kamekura Yūsaka countered that, should it attempt to show the country's industrial output, it would be seen to be 'second rate or worse'. In his own defence, Maekawa said, 'I wanted to show that even in the machine age, the hands of the Japanese are busy weaving the threads of a new tradition.' At this point, as *Shinkenchiku* recounted, Hirabayashi Taiko, a popular novelist, put in a word:

'The nice thing about Japanese architecture', said Miss Hirabayashi for Maekawa and all other architects to hear, 'is the open arrangement of rooms, permitted by shōji and open doors.' There is no sense, she went on, in trying to represent Japan with a row of teabowls on a table on a straw mat on a wooden floor in a room surrounded by walls. 'This is coddling to Western notions about Japan. It presents a very mistaken view of the true life of the Japanese.'

But in 1958, this true life was no more represented by *shōji* and the open plan than it was by a row of teabowls on a table. As Gropius, Tange and Ishimoto, on the one hand, and Elizabeth Gordon, on the other, were about to show, *shōji* and the open plan were as much the Western construct of what was Japanese as were the teabowls on a table. In Japan, where an estimated 4,200,000 housing units were needed after the war[66] and the population was now housed in developments like that at Harumi, true life in Japan was less about *shōji* and the open plan than the Nikon camera (1948), the Sony transistor radio (1951), the electric rice cooker (1954), the Casio calculator (1957) and instant noodles, invented in 1958 by Andō Momofuku.[67] In the same way as the architecture of the pavilion confronted traditional forms with modern technology, so too did the pavilion's craft and industry exhibits which ranged from carpenters' tools to modern cameras.[68] The threads of Maekawa's 'new tradition' were being woven with the new technology which, through the facility of the Japanese Economic Miracle and the vision of the Metabolists, was to become the techno-utopia of Expo '70.

It was, once again, Maekawa Kunio who designed the Japanese pavilion for the 1964 World's Fair in New York. But whereas the Brussels pavilion of 1958 appeared progressive, the one Maekawa designed five years later was very much the work of the old guard. The idea was based on buildings such as the Nijō Castle at Kyoto, where the stone-faced ramparts contrast with the *sukiya* structures within. The main exhibition hall, constructed of concrete and faced externally with lava stone, represented the ramparts: square on plan and set within a water-filled moat, its battered walls led the eye up to a central mast from which the roof was suspended. To one side and surrounding an open court was a lightweight framed structure containing further exhibition space and beyond that, rather ingloriously but with the requisite Japanese garden, was the House of Japan, a three-storey assemblage of restaurants, bars and performance spaces. For an exhibition which styled itself 'A Century of Progress' – exactly a hundred

and ten years after Commodore Perry had signed the American–Japan Treaty of Peace and Amity – its architecture was a backward-looking affair.

Expo '67 at Montreal was a different matter; not that the Japanese pavilion designed by Ashihara Yoshinobu was particularly challenging architecturally, but because there was an architectural progressiveness to the Expo, seen in the United States and West German pavilions and the Habitat 67 housing structure,[69] which had been missing at New York. It was these buildings which at the time Tange Kenzō picked out:

> Both Fuller's American building and the tent structure by Frei Otto for the West German building are particularly ripe with suggestions for the future in terms of architectural techniques and urban design. In addition to these two buildings, Safdie's Habitat 67 is of great importance in two senses. First, I feel a truly positive approach in the idea of using residential architecture to symbolize the exposition. Secondly, although the idea is not particularly new, the fact that Safdie actually put into practice a form containing prefabricated units piled up in such a way as to create an organically unified whole in which each unit has ample individuality is deeply important.[70]

It is not surprising that Safdie's Habitat 67 appealed so much to Tange, for it was, in its indeterminacy, a thoroughly Metabolist concept.

The plan for Expo '70 at Osaka was already well advanced when Expo '67 opened in Montreal. Therefore, what might be learnt from Montreal could only confirm or supplement the decisions already taken, for many of which there was no going back. In 1966, Tange Kenzō and Nishiyama Uzō had been commissioned to develop the masterplan and from an early date the notion of a central axis, 150 metres wide, a kilometre long and named the Symbol Zone, was established. This was to be the centre of a trunk-and-branches plan, the trunk containing the Festival Plaza, the Theme Hall, the Auditorium, the Art Gallery, the Main Building and the Observation Tower, while the branches supported the national

pavilions. It was an approach to urban design which characterised Tange's work from *Tokyo Plan, 1960* to his 1966 redevelopment plan for Skopje, in then Yugoslavia, as he later explained:

> From the beginning of the sixties till the middle of the decade, I thought of cities in terms of structure. In *Tokyo Plan, 1960* and in many other urban projects I thought of urban design as a matter of providing a fairly hard structure; and the network of the Expo trunk facilities may well be a reflection of this approach ...[71]

It was in this approach to urban design that Osaka differed from Montreal. At Montreal, as Take Motoo commented as early as 1967, 'the urban design of the grounds stayed pretty well within the boundaries of technology as we know it now', but at Osaka, 'at least in the Symbol Zone, the proposed plan for Expo 70 is a step ahead in introducing urban design into the grounds.'[72]

By 1967 the Big Roof, a great space-frame that defined the Festival Plaza, was already conceived [15.06]. It was to be 108 metres wide, 261.1 metres long and to stand 37.7 metres high, supported by six legs. Although 10 times bigger than conventional space-frames,[73] its lineage could be traced back to Konrad Wachsmann's aircraft hangers designed in the early 1950s for the US Air Force. In 1955 Wachsmann had held, in Tokyo, what turned out to be a two-month-long seminar on space-frames. Arranged by Tange's right-hand man Asada Takashi and attended by Tange, Kawazoe Noboru and Isozaki Arata, the seminar explored Wachsmann's ideas for giant space-frame construction which at that time were far beyond the capabilities of Japanese industry; but 15 years later they were achievable. Engineered by Kawaguchi Mamoru, the Big Roof not only provided shelter at both the hottest and the wettest time of the year, but a structure which together supported and suspended, in a mid-air exhibition, some of the most futuristic exhibits at the Expo. These were the work of both Japanese architects and designers, including the Metabolists, and a wide range of Western architects. On home ground, or rather high above

15.06 The Big Roof at Expo '70 at Osaka, designed by Tange Kenzō and Kawaguchi Mamoru.

it, were Kamiya Kōji from Tange's studio and the Metabolists Kurakawa Kishō, Awazu Kiyoshi and Maki Fumihiko, all of whom were engaged with capsules; from Canada came Moshe Safdie with a rationalised version of Habitat 67; from Russia, Alexi Gutnov, with a megastructure called Spiral City; and from Europe, Giancarlo de Carlo (Italy), Yona Friedman (France), Hans Hollein (Austria), and Archigram (England). Beneath them, trundling around and controlling events on the stage, were Isozaki's two 20-metre-tall robots, Démé and Déku.

To realise his ambition for the Expo, Tange gathered around him a group of now youngish designers drawn from his studio and the Metabolist group. Their ideas, like Isozaki's robots, gave the Expo not so much a lack of cohesion but a

variety of directions. Straddling the railway link to Osaka which ran alongside the site was Ōtaka Masato's main entrance which at peak times had to accommodate 48,000 visitors a day. Derived from his Group Form thinking, it was a large raised platform separating the pedestrian concourse from the train tracks below. Beyond this, at the south end of the Symbol Zone, stood Kikutake Kiyonori's Expo Tower, a vertical space-frame structure supporting a cluster of polyhedral capsules. Its similarities to Peter Cook's unrealised 1963 design of a tower for Expo '67 are possibly no more than coincidental since it had been Kikutake's intention to produce something more in line with his earlier Tower-Shape Community (1958), but cost prevented this. In the Big Roof, Kawazoe Noboru was given the job

of curating the mid-air exhibition where Isozaki designed the lighting and Kamiya, Kurokawa and Maki suspended their capsules. Kurokawa also designed two separate pavilions, the Takara Beautillion and the Toshiba IHI Pavilion, both of which flaunted, through their flexibility and potential for growth, their Metabolist provenance. And to give the whole site coherence, Ekuan Kenji, who had designed the interior of the Beautillion, was set the task of designing the transportation, street furniture and signage from the monorail to the multi-face clocks.

There was, in their techno-utopian vision, a difference between what Tange's hand-picked team designed and the variety of pavilions designed for the various Japanese companies represented. In summarising the experience for *The Architectural Review*, James Richards, who avowed that 'This should be the last Expo ...',[74] wrote:

> In the industrial and commercial buildings at Osaka competitiveness runs riot: most of them have chosen to compete by means of science-fiction extravaganzas (with the far more reprehensible exception of a computer company which has erected a clumsily imitated, out-of-scale, seventh-century pagoda). The result ... gives the total Expo scene more of the character of a fun-fair than the amount of responsible architecture there, and the degree of serious endeavour, deserves.[75]

The Australian critic Robin Boyd was of a like mind:

> This is the most exhibitionist exposition ever, perhaps because it comes so soon after Montreal and Expo 67's complex image was still so fresh in all designers' minds ... The worst offenders, with a few international exceptions, are the Japanese industrialists.

> The atmosphere of Japan encourages exhibitionism. No country has a greater divergence between the taste of its sophisticated architects and that of the unsophisticated mass led by American-orientated ad-men.[76]

In the Japanese government pavilion, Yoshizaka Takamasa (Ryusei) had built a model of a future city, what Boyd calls a 'megametropolis', comprising vertical service towers and horizontal living or working planes. Although there was by now nothing particularly original in this vision, it would still have been a novelty to most of the visitors. But, as Boyd recalls, 'the Japanese girl attendant, whose job and inclination were not to denigrate the displays, commented on behalf of her pavilion's staff: "We do not think it would be a nice place to live. We call it the City of Sorrow."'[77]

There is nothing now left of Expo '70 except for Okamoto Tarō's giant and somewhat grotesque Tower of the Sun. It was the *Jōmon* to the *Yayoi* of Tange's Big Roof through which it once pushed its head. There were architectural innovations on both sides from which the other, Japan or the West, might learn. If there had been a lesson to be taken from Montreal it was to avoid the visual noise and confusion of Expo '67. As Jacko Moya, designer of the British pavilion at Osaka, commented following his visit to Montreal, 'The first day was splendid, everywhere exciting, amazing structures ... after a couple of days amazement ceased. It was tiring. It was a blooming mess. One longed for something plain, simple and flat.'[78] Although in Tange's masterplan for Expo '70 there was cohesion and order, there was in many of the pavilions the lack of restraint observed by Richards and Boyd. Perhaps the quietest pavilion, if it could be spotted, was the almost subterranean United States pavilion. Designed by Lewis Davis and Samuel Brody, it comprised a low-profile cable-restrained air structure spanning 78.6 × 138.0 metres (262 × 460 feet) set within a grassed berm. Described by Peter Blake, the editor of *Architectural Forum*, as 'quite simply, the most daring structure at Osaka',[79] it offered a vast, uninterrupted open space illuminated by a translucent roof made of a single layer of vinyl glass and would glow at night. 'It really advances building technology as no other building at Expo '70,' Blake said. Equally quiet, perhaps, but more noticeable, was Powell and Moya's British pavilion, conceived, Blake thought, 'in the best tradition of British establishment

architecture ... clean, neat and safe ...'[80] The pavilion comprised four lightweight windowless boxes suspended beneath a 2,618-square-metre (29,089 square foot) diagrid roof, 2 metres (6 feet 8 inches) deep. This, in turn was suspended from four pairs of 33 metres (110 feet) steel masts, painted red. The apparently Japanese appearance of the building, due to the *shōji*-like aluminium-faced external panelling and the red masts which suggested Shinto *torii*, was, with the exception of the superimposed *kanji*, coincidental. What was less so, and only visible from the air, was the giant Union Jack painted on the building's flat roof. Both pavilions were prescient of the high-tech architecture which was to characterise much of the next two decades where the aim was to obtain the maximum amount of space with the minimum amount of materials. As such, this was new to Japan where the older generation, such as Maekawa and Tange, had been building solid structures in poured concrete and the younger generation, the Metabolists, were intent upon an architecture of incremental growth and change.

Closer to what the Metabolists were doing was the Swiss Tree of Life, designed by Willi Walter, Charlotte Schmid and Paul Leber, an overhead structure of tubular aluminium lit by 32,000 incandescent light bulbs. In its indeterminant form it was thoroughly Metabolist but, apart from emitting an awful lot of heat and light, it had no other real purpose. The Dutch pavilion, designed by Jaap Bakaema of Team X and Carel Weeber, also suggested indeterminacy and the potential for growth in any direction and might be compared with Isozaki's Prefectural Library in Ōita, completed four years earlier in 1966. Like the library, the Dutch pavilion was constructed of concrete, albeit 35-millimetre (1½-inch) pre-cast panels as opposed to *in-situ* concrete; and, like the library, it was what its architects called a 'communication machine'.[81] However, unlike the library, its concrete was painted – red and blue in deference to the Dutch flag which flew from the rooftop. Whereas the red seemed to indicate points of entry and vertical or horizontal circulation within the building, the blue showed the relative

depth below sea level had the building been built in the Netherlands.[82]

Expo '70 was hugely popular. There were over 64 million visitors, many people coming two or three times, and the busiest day was in the penultimate week, Saturday 5 September, when there were 835,832 visitors.[83] Yet the number of Western architects who went was comparatively few. One who did go was James Stirling. His copy of *A Guide to Japanese Architecture with an Appendix of Important Traditional Buildings*,[84] published by Shinkenchiku-sha, the publishers of the eponymous journal, contains four small sheets of hand-written notes on Olivetti Auditronic notepaper.[85] These brief notes and directions suggest the difficulties Western architects had in visiting the Expo and the inaccessibility of the language once there. The inclusion, on the verso of one of these sheets, of Isozaki Arata's telephone numbers in Tokyo and Fukuoka (where he was to be from 21 to 28 June) would suggest Isozaki's authorship. One sheet shows a sketch map of the Japanese archipelago with arrows running from the Korean peninsula to Kyushu (was this Stirling's point of entry into the country?) and then across to Honshu and onward to Osaka and Tokyo, presumably, both of which are circled. A larger diagram shows the relationship of the Kobe/Osaka/Kyoto/Nagoya area to Tokyo in the east. Mount Fuji and the ancient sites of Uji, Nara and Ise are also indicated. The diagram on the next sheet, centred on the Expo site, shows rail connections and travelling times from there to Osaka, Kyoto and Nara. The two other sheets contain a list of buildings to see, one for Kyoto, including Katsura and the Ryōan-ji rock garden, and the other for Nara and Uji, where the Todai-ji and Byōdō-in (the Hōō-dō or Phoenix Hall), amongst other sites, are named. Written in both *romaji* and *kanji*, the lists show only traditional buildings, an interest echoed in the subtitle of the guide book and one which gives an interesting insight into Stirling's work of this time.[86] Although the cluster of tall, tightly spaced circular columns in Leon Krier's presentation drawing of the interior of Stirling's British Olivetti Headquarters at Milton Keynes[87]

(1970–74) might suggest one of the Buddhist temples,[88] there were to be no Japanese examples included amongst the nine historical plan-forms which Stirling sketched out in his typological study done a few years later for the pavilions at the Wissenschaftszentrum, Berlin.[89]

As an opportunity for the exchange of architectural ideas between Japan and the West, Expo '70 was almost a one-way street. There is little that Japan could, or would, have picked up from the West and had they done so, the oil crisis of 1973 and the collapse of the Yen would have put an end to that as surely as it did the Metabolists themselves. In allowing such a free hand to a younger generation of architects, Japan turned the tables on the West. The average age of Tange's hand-picked team was then just 41:[90] Tange himself was their senior by only 10 years so if he is included, the average age becomes 43.[91] Although it might be thought inconceivable in the West to entrust such an important task to so many so young, in so doing Japan gave free rein to what was, architecturally, the post-war generation.[92] As the riots of 1968, in both the West and Japan, demonstrated, the establishment was in many ways not ready to hand over to the post-war generation, but with a theme which reflected the counter-culture, 'Progress and Harmony for Humankind', Expo '70 was intended to show a way forward. As *Time* magazine commented that March, 'No country has a stronger franchise on the future than Japan.'[93]

Archigram and the Metabolists

It is often suggested that the Pompidou Centre in Paris (1971–77), designed by Renzo Piano and Richard Rogers, had its origins in the paper architecture of Archigram.[94] That might be so, but it is a Euro-centric view for it could be argued that the Big Roof at Expo '70 and everything it implied in terms of scale, the incorporation of technology and even, to some extent, construction, was picked up at Pompidou. The difficulty lies in trying to disentangle, one from the other,

the Metabolists and Archigram. Although the Metabolists were properly launched in 1960 with the publication of *Metabolism 1960* and Archigram, with the publication of *Archigram* Paper One the following year, both groups contained in their first publication work which had been done in the late 1950s – Kikutake Kiyonori's Marine City and Tower-Shape Community (1958), and Michael Webb's Furniture Manufacturers' Association Offices in High Wycombe (1959). While both groups were informal alliances of young architects (although the average age of Archigram was five years less than that of the Metabolists), it was not until 1969, when Archigram won the competition for a leisure centre in Monte Carlo, that either group coalesced enough to formalise an architectural practice, something which the Metabolists could be said to have done while working under Tange's direction the following year at Expo '70. Subsequent to *Metabolism 1960*, the Metabolists produced no further cohesive documentation to promote their ideas, *Metabolism 1965* remaining unfinished.[95] Instead, they built buildings. On the other hand, Archigram, who built nothing, issued their eponymous architectural telegram on an almost annual basis, the ninth edition appearing in 1970. So it could be said that while Archigram published the Metabolists' ideas, the Metabolists built Archigram's.

The first appearance of the Metabolists in the pages of *Archigram* was in issue 5 published in 1964 [15.07]. Here, above the caption 'The Molehill and the Cluster', was Isozaki Arata's 1963 project Clusters in the Air alongside Yona Friedman's spatial city buildings representing the molehill;[96] further on, on a page titled 'It All Happens Everywhere', were Kurakawa Kishō's Helix City (1961) and a plan of the Nihonbashi area of Tokyo with sweeping expressways and the footprints of megastructures;[97] finally, superimposed on swirling blue lines representing Underwater City, was Kikutake's Marine City (1958) alongside Warren Chalk's Underwater City Project (1964), a complex series of spheres connected by tubes like an atomic cluster model.[98] As if to emphasise the point that megastructures were the theme, Peter Cook's

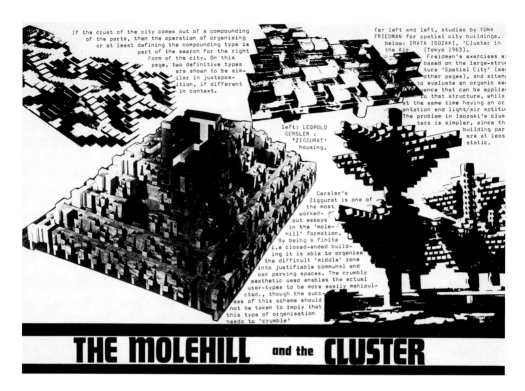

15.07 'The Molehill and the Cluster', from *Archigram* 5, 1964.

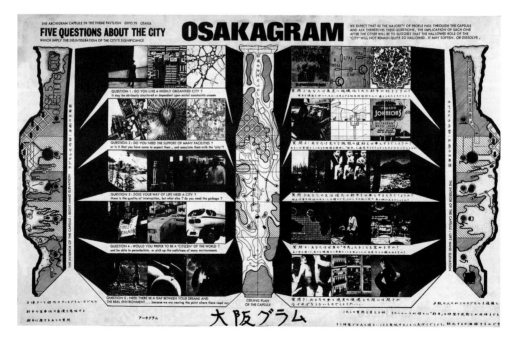

15.08 'Osakagram', from *Archigram* 9, 1970.

Plug-In City, which had first appeared earlier that year in *Amazing Archigram* 4,[99] reappeared bearing the statement, 'within this big structure almost anything can happen'.[100] It was later hailed by the critic and historian Reyner Banham, somewhat inaccurately, as 'the first convincingly complete demonstration of the idea of megastructure':[101] As if to emphasise the notion of megastructures, Kurakawa's page declared, 'ALL THE BUILDINGS ON THIS PAGE dispel the notion that cities need to be a COLLECTION of buildings or parts. The all-happening nature of the WHOLE and the idea of the city as a single building are foreshadowed.'[102]

By issue 5, megastructures were not new to *Archigram*. Indeed, the very first issue in 1961 had shown Steve Osgood's 1960 Teignmouth Seaside Development, described as 'housing and industry as an organism, continuous and whole', and Peter Cook and Gordon Sainsbury's 1961 complex of hotels and offices for Piccadilly Circus, London.[103] Where one was reminded, for the price of six pence, that 'THIS IS ARCHIGRAM – PAPER ONE – A STATEMENT', swirling captions (Archigram captions often swirled) declared, as if in unison with Team X, that 'A new generation of architecture must arise with forms and spaces that seem to reject the precepts of "Modern"', and then, as if echoing the Metabolists, that 'Roads, walls, spaces <u>can</u> exist as one and be enjoyable – This is architecture beyond, beyond bey...'[104] [sic] The rhetoric here fades away.

Peter Smithson's critique of Tange's Tokyo Bay Plan – 'Let me, however, give you straight away my immediate reaction to the plan: that of fear'[105] – although written in 1962, did not appear in *Architectural Design* until October 1964. Of the older generation – Smithson being Peter Cook's senior by 15 years – Alison and Peter Smithson, the *enfants terribles* of CIAM's final congress, were amongst the few architects whom Archigram held in esteem. Peter Smithson's recognition that the Tokyo Bay Plan was centralised, absolutist and authoritarian must have struck home, as did the cries of 'Fascism' at the international student conference which Archigram hosted at the New Metropole Arts Centre at Folkestone, England, on 10 and 11

June 1966. Almost 500 students, many from abroad, attended, as did Ron Herron, Yona Friedman, Hans Hollein, Cedric Price and Reyner Banham, who declared that architecture was dead.[106] Isozaki's Clusters in the Air were on show which, with the presentation by Hollein of his 'classical' designs, must have engendered a sense of that centralised, absolutist authoritarianism which, if still not fresh in the minds of British students, would have been in those from Germany, the Netherlands and France, most of whom would have been born during the war and grown up in the post-war years.

The consequent, or perhaps just coincident, move, in the pages of *Archigram*, from megastructures to micro-structures, or capsules, was not as difficult as it might seem. *Archigram* 5, in showing Isozaki's Clusters in the Air and Cook's Plug-In City, had already displayed multiple-capsule schemes. In 1965 *Archigram* 6 had shown Ron Herron and Warren Chalk's Gasket Homes and the following year *Archigram* 7, published in the same year as the Folkestone conference and entitled 'Beyond Architecture', included David Greene's Living Pod, which had been shown at the conference, as well as Ron Herron and Barry Snowden's Free Time Node and Peter Cook's Plug-In City/Expandable Place-Pads. Located on dead land in London's Paddington Basin and with a penthouse set at 124 metres above ground, this version of Plug-In City was still an inner-city megastructure but the interest now seemed to be in the expendable place-pads or 'family cage capsules'. 'A TYPICAL FAMILY DWELLING', a caption reads, 'with Granny on her travelling chair, personal capsule components as necessary.'[107] Also in *Archigram* 7, under the title 'International Ideas', was a scheme by Arthur Golding, Craig Hodgetts and Doug Michels from the Yale Graduate School. Called MAXX (minimum accommodation, expandable, expendable) Plug-In American Blend, this project consisted of a tubular steel framework into which were plugged living capsules made from vacuum-formed Myalite sprayed with reinforced epoxy resin. Although the three-dimensional grid was regular, at about 8 feet (2.4 metres) in every direction, the capsules, when hung externally,

could extend across two bays either horizontally or vertically, as well as fitting snugly within the cubic volume of a single bay. It was neat and tidy and the open ends of the tubular framework did not offer connection plates and bolt holes such as Kurokawa's Takara Beautillion did four years later, in a remarkably similar scheme, at Expo '70.

Archigram 9, which was published in 1970, coincident with the Expo, divided the world into Archizones: Japan was Archizone 8. Printed green on yellow, their page showed Isozaki's robots and the Festival Plaza beneath the Big Roof at Osaka. However, the page also contained the message, '3000 students have been arrested to prevent "trouble" at Osaka's World's Fair ... More news wanted.'[108] As if to explain this breakdown in law and order, *Archigram* 9 also contained the Osakagram, illustrating the theme of Archigram's capsule (their word) at the Expo [15.08]. Suspended in the south-east corner of the mid-air exhibition and close to Hollein and Friedman's installations, the Archigram capsule was entered down a pink rock-faced tunnel displaying five questions which implied the disintegration of the city's significance. The final question, 'Need there be a gap between your dreams and the real environment?', was as much a question about the Expo as it was one for the 3,000 arrested students.

The axis which developed between England and Japan, and led to Archigram being invited to participate in Expo '70, also ran through Los Angeles and Vienna, where Hollein was working. As early as 1964, Archigram had been picked up by Monica Pidgeon, the editor of *Architectural Design*, and, through the advocacy of Reyner Banham, by Peter Blake at *Architectural Forum*.[109] It was here in *Architectural Forum* where Isozaki finally saw *Archigram* – a full-page monochrome reproduction of the cover of the 'Zoom' issue, *Amazing Archigram* 4, and a smaller reproduction of Peter Cook's Plug-in City from page 17 of the same issue.[110] Later that year *Architectural Design* published the progenitor of many of Archigram's ideas, Cedric Price's Fun Palace, where 'Everything would be flexible and moveable, even the lift towers and escalators',[111] and the following year, a large

article on Archigram itself.[112] 'The year before, 1963,' Isozaki later recalled, 'I took a trip to Europe and visited London ... but I didn't know where Archigram was or what it means.'[113] Although his work was published in *Archigram*, it was not until the aborted 1968 Milan Triennale that Isozaki first met Peter Cook and Dennis Crompton, and there he also met Hans Hollein. But it was probably in Los Angeles that Isozaki came to know the Archigram team best. The North American schools of architecture, as the scheme from the Yale Graduate School showed, became a good conduit through which Archigram's ideas could spread. In 1965 David Greene had gone to teach at Virginia Polytechnic Institute and Michael Webb, to the Rhode Island School of Design soon after. In 1967 Warren Chalk became a visiting lecturer at the University of California, Los Angeles (UCLA), where he was joined by Ron Herron in the winter of 1968–69 and then by Peter Cook. Also teaching at UCLA at this time was Isozaki. As, in the mid- to late 1960s, both Archigram and the Metabolists' ideas moved from the megastructure to the micro-structure, so the question about who originated the capsule arose. Years later, in conversation with Isozaki, Cook commented:

> Some of the things that were done within the Metabolist Group were ahead of us, I'm sure, but the discussion of who shouted first in terms of the capsule is an endless conversation, unless to say, well, actually, Buckminster Fuller was there anyway. I suppose the difference is that, curiously, we were into Pop, whereas one would have expected Japan to have been into Pop first.[114]

Metabolism R.I.P.

The oil crisis brought about in October 1973 by the United States' military support of Israel in the Arab–Israeli War (Yom Kippur War) had its effect on Japan as much as it did on many Western countries when the Organisation of Arab Petroleum Exporting Countries (OAPEC) imposed an embargo

on oil exports and cut oil production. In November, the Saudi and Kuwaiti governments declared Japan a 'non-friendly' country, forcing it to state its support for Palestinian self-determination and that Israel should withdraw to its pre-1967 borders. By the end of the year Japan, which imported over 90 per cent of its oil from the Middle East, was once again considered an Arab-friendly country, but the increase in crude oil prices by almost 400 per cent over five months shocked the economy, caused *kyōran bukku* (crazy prices) and panic buying in the shops, and sent industrial production into decline, as well as setting off severe price inflation. In 1974, for the first time since the Second World War, Japan's economy went into negative growth and Prime Minister Tanaka Kakuei's 'Japanese Archipelago Rebuilding Plan' of 1972, which had called for massive public investment in highway and Shinkansen construction, was abandoned. For the Metabolists, with their parallel vision of megastructures and expressways, this meant the end of the dream.

Post-Modernism

In 1966, six years after Gropius, Tange and Ishimoto published *Katsura*, Robert Venturi took issue with the whole idea that the salvation of Western Modernism might be found in the *shoin* and coined, perhaps for the first time, the ultimate put-down – 'Less is a bore'. Writing in *Complexity and Contradiction in Architecture*, he said:

> I question the relevance of analogies between pavilions and houses, especially analogies between Japanese pavilions and recent domestic architecture. They ignore the real complexity inherent in the domestic program – the spatial and technological possibilities as well as the need for variety in visual experience. Forced simplicity results in oversimplification ... Where simplicity cannot work, simpleness results. Blatant simplification means bland architecture. Less is a bore.[115]

In the same way that Japanese was the first foreign language into which Le Corbusier's *Le Modulor* was translated, so it was with *Complexity and Contradiction in Architecture*. The Japanese language edition, entitled *Kenchiku no tayo-sei to tairitsu-sei*, appeared in 1969, followed by the French in 1971 and the Spanish in 1972. Mixed in with what is otherwise a universally Western pageant of examples, there is one Japanese building illustrated: Katsura. Here Venturi shows a similarly sized bamboo rod and wooden post, the former being in tension and the latter in compression – a contradiction of form versus function which, in the context of 'the current inclination toward traditional Japanese design',[116] he relishes. More significant, but curiously not illustrated, is Maki Fumihiko's Group Form – presumably the shopping town at Shinjuku, Tokyo – which Venturi cites as expressing both *complexity* and *contradiction*.[117] At once equally a bridge and a building, it has 'complex and contradictory hierarchies of scale and movement, structure, and space within a whole'.[118] It is, as he later says, 'the antithesis of the "perfect single building" or the closed pavilion'.[119] It is also a very Japanese way of building.

When Charles Jencks published the first edition of *The Language of Post-Modern Architecture* in 1977, the dominant theme was Japanese architecture in which he saw signage and symbol as the signifier.[120] The cover illustration, repeated on the cover of the April 1977 special issue of *Architectural Design*, was Takeyama Minoru's 1970 Niban-kan (No.2 Building) entertainment centre in Tokyo. It was still there when the second edition of Jencks's book appeared in 1978 but the colourful supergraphics which had so dominated the earlier representation had now changed into a monochromatic, orthogonal response to the building's layered and fragmented architecture. Was this transformation unexpected? Perhaps not in Japan, where the configuration of rooms and, indeed, the external appearance of a building can change with the sliding of a screen. By the third edition, published in 1981, American architecture had assumed supremacy and Charles Moore's

Piazza d'Italia in New Orleans (1979) adorned the front cover while Michael Graves's Portland Public Services Building in Portland, Oregon (1982), headed the Preface. The tone of the language was clearly changing and although a few examples of Japanese buildings remained from the first edition, such as Isozaki's Gunma Prefectural Museum at Takasaki (1974)[121] and Kurokawa's Nakagin Capsule Tower in Tokyo (1972)[122] there were very few new buildings which were too recent to have made the first edition. Whereas this might suggest a change of focus on Jencks's part, it more likely shows the shifting fashion in Western architecture which the free-thinking of Japanese Post-Modern architecture instigated.

Following on from *Complexity and Contradiction in Architecture*, Robert Venturi's next major statement on what was now being recognised as Post-Modern architecture, written with his wife Denise Scott Brown and their colleague Steven Izenour, was *Learning From Las Vegas* (1972). Its revised and retitled second edition, *Learning From Las Vegas: The Forgotten Symbolism of Architectural Form*, was published five years later, in the same year as the first edition of Jencks's *The Language of Post-Modern Architecture*. Las Vegas is about as different to Tokyo as any city can be, yet the use of supergraphics, a term coined by the architectural writer and critic C. Ray Smith in yet another book of 1977, *Supermannerism: New Attitudes in Post-Modern Architecture*,[123] was common to both. In Las Vegas, *space*, *scale* and *speed* (to use Venturi's signifiers) characterised The Strip where, as he said, 'impressions are scaled to the car'[124] and signage took on the dimension of buildings which Venturi termed *decorated sheds*. In Tokyo, at the Niban-kan, signage was the building, yet the building was not what Venturi called a decorated shed but, due to its sculptural presence, a *duck*,[125] 'where the architectural systems of space, structure, and program are submerged and distorted by an overall symbolic form. This kind of building-becoming-sculpture we call the *duck*, in honour of the duck-shaped drive-in ...'[126]

The contrasting and contradictory forms of Takeyama's colouration emphasised rather than submerged the building's form and therefore were not a decorative device. As C. Ray Smith said, 'the Supermannerist's use of bold stripes, geometric forms, and three-dimensional images is, emphatically, a spatial experimentation.'[127]

The interest in supergraphics emerged in Japan and the West at much the same time. Perhaps the earliest instance was in California where Barbara Stauffacher Solomon painted supergraphics internally and large signage externally at Charles Moore's Condominium One at Sea Ranch, California (1965); in 1968 Lance Wyman's supergraphics for the Mexico Olympics gained worldwide attention. Contemporaneous with this was the design for a small concrete auditorium which the French architect Jean-Philippe Lenclos had built in the Grand Palais in Paris for the Salon des Artistes Decorateurs in 1967 and published in *Domus* the following year.[128] He had travelled to Japan on a Japanese government scholarship in 1961 to study architecture in Kyoto, where he met Maekawa Kunio and Tange Kenzō, and had become fascinated by Japanese calligraphy and notions of pictorial space in *ukioy-e* 'where the white', as he said, 'has as much importance as the black'.[129] His interest in colour led to commissions for a wide range of applications including the use of supergraphics on walls at the Robespierre School and the École les Madras, both in Paris and in 1972. Meanwhile Shigeta Ryōichi, who had been living in Paris and Boston, Massachusetts, returned to Tokyo in 1966 where, in 1969, he painted the tall chimneys of the Dainichiseika Chemical Colourants Factory, thus transforming what Venturi would have classified as a duck into a decorated shed.[130]

Cultural differences, as indicated by the importance to the Japanese eye of white in *ukiyo-e*, result in different terms of reference. Consider Kurokawa's Nakagin Capsule Tower, which had been the frontispiece to the first edition of *The Language of Post-Modern Architecture* but by the 1981 edition had been replaced by the Pavilion Soixante-Dix at St Sauveur, Canada (1978),[131] although a full-page illustration was still retained inside. When Jencks visited the building with Kurokawa

he suggested that it was unfortunate that the capsules with their circular windows looked like stacked-up washing machines. Kurokawa retorted, 'They aren't washing machines, they're bird cages. You see in Japan we build concrete-box bird nests with round holes and place them in trees. I've built these bird nests for itinerant businessmen who visit Tokyo, for bachelors who fly in every so often with their birds.'[132] It was, as Jencks suggests, a good response, but it was also indicative of how different were Kurokawa's points of reference. Japan, as has often been demonstrated in this book, has been quick to adopt and absorb other architectures and, free from any cultural baggage that might drag them down, have made their version of Western architecture their own. Kuma Kengo, for example, threw all caution to the wind with his bombastic use of the Ionic order in the M2 Building in Tokyo (1991) [15.09], whereas in New Orleans, Louisiana, Charles Moore was constrained to irony in his tongue-in-cheek representation of Classical architecture at the almost diminutive Piazza d'Italia (1979). Set hard against Setagaya's busy Kanpachi-dori, the primary function of Kuma's building, like those around it, was as a car showroom, this one built for Mazda (Matsuda). In an attempt, apparently, to make the building blend into the suburban chaos of its surroundings, Kuma created what he called 'an architecture of fragmentation'.[133] The building certainly fragments: a broken staircase hangs from the façade while a length of parapet rests perilously at one end. But it is not just this appearance of imminent collapse which imparts a sense of chaos to the building: it is total distortion of the Classical language of architecture achieved through the piling up of over-scaled corbel brackets, voussoirs and Ionic volutes, like any old Brobdignagian spolia.

The publication in 1980 of Jencks's new book, *Post-Modern Classicism: The New Synthesis*,[134] even before the appearance the following year of the third edition of *The Language of Post-Modern Architecture*, should have indicated the drift of his thinking. In Japan, it was a direction in which Isozaki, with his Schinkelesque entry for the

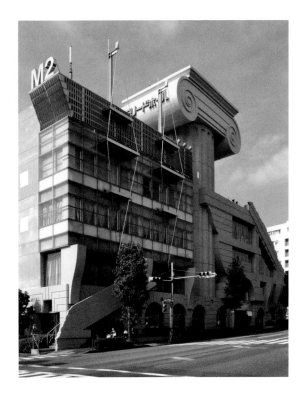

15.09 The M2 Building in Tokyo Setagaya-ku, designed by Kuma Kengo, 1991.

Tegel Harbour Complex competition in Berlin, was already going. By the time the fifth edition of Jencks's book appeared in 1987, he had revised his thesis to the extent that he no longer placed the origins of Post-Modernism in the symbolic meaning he saw in Japanese architecture but now situated it in the antique architecture of Greece and Rome, the final chapter of the book being entitled 'The Synthesis: Postmodern Classicism'. Following Venturi, other Western architects such as Michael Graves, Philip Johnson, Robert A.M. Stern and James Stirling had now long since turned to Classicism for their sources, but none as egregiously as Kuma. Yet, if there was a precedent for this, it would not be in the West but in Japan: this was Isozaki's 'Incubation Process', drawn in 1962 and referred to variously as Ruined Megastructure or Future City [15.10]. Exhibited in

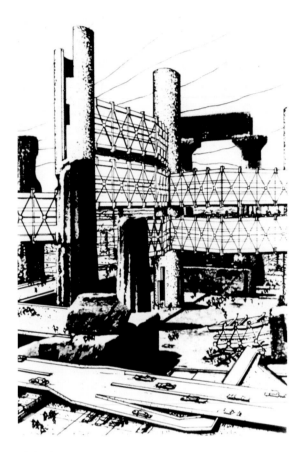

15.10 'Incubation Process', a photomontage by Isozaki Arata from the 1962 'City and Life of the Future' exhibition at the Seibu Department Store, Tokyo.

15.11 The Temple of Poseidon, Paestum, drawn by Isozaki Arata.

the 'City and Life of the Future' exhibition held at the Seibu Department Store in Tokyo in 1962, it shows a new, Metabolist city – the Joint Core System Shinjuku Station (City in the Air) project of 1960 – emerging out of the ruins of fluted Doric columns based on those he had drawn at Paestum [15.11]. The montage was accompanied by a poem:

> Incubated cities are destined to self-destruct
>
> Ruins are the style of the future cities
>
> Our contemporary cities, for this reason, are destined to live only a fleeting moment
>
> Give up their energy and return to inert material
>
> All of our proposals and efforts will be buried
>
> And once again the incubation mechanism is reconstituted
>
> That will be the future.[135]

It was an apocalyptic vision, Post-Modern before its time.

The success, if that is what it was, of Post-Modern architecture in Japan was, Jencks told *Architectural Design* in 1977, for three reasons: 'partly because cultural tradition persists so strongly in Japan, partly because no revolutionary avant garde has established itself and also because the Japanese, characteristically, have a sophisticated understanding of signs.'[136] The familiarity with signage, as the Niban-kan shows, is clear and the plurality of Japanese architecture, at least at that time, shows the absence of any single, Modernist philosophy. It was, perhaps more than these, the cultural tradition of accommodation which allowed Post-Modern architecture to flourish, as Kurokawa explained:

> A hundred years ago when we first began importing European civilization, people wore kimonos; to these they later added shoes. This was not a harmonious combination but it was a very good way even so. The Japanese way is to mix everything, not as a synthesis but as a *situation*. Situation is reality to us because our whole tradition is a tradition of flexibility and change.

There is no real opposition to progress here because we do not decide what is right and what is wrong, or what is good and what is bad – that is a very European kind of thinking. What we do is to separate them but accept both.[137]

Resurgence

The Plaza Accord, signed at that eponymous hotel in New York on 22 September 1985, had an immediate effect, not just on the value of the US dollar in relation to the leading world currencies, but on the architecture of Japan. The collapse of the Yen like, indeed, other currencies, following the OAPEC Oil Crisis of 1973 to 1974 caused it to fall, over the next two years, to a new low of 300 Yen to the US dollar, putting paid, as has been noted, to the technological dreams of the Metabolists. By 1978 the Yen had recovered to 211 Yen to the US dollar, but the second oil shock following the Iranian Revolution of 1979 knocked it down again. The Japanese trade surplus of the early 1980s exacerbated the problem and by 1985 the Yen was trading at 239 Yen to the US dollar. One result, put simply, was that foreign architects were too expensive to hire in Japan. And then came the Plaza Accord. Within two years the yen rose by 51 per cent against the dollar to a peak of 128 Yen in 1988, virtually doubling its relative value.

By the time that the Accord was signed, Nigel Coates was already completing his first Japanese restaurant, the Metropole in Roppongi, Tokyo, but the effect of the Accord was to bring Coates a host of further similar commissions. The interest had begun when Coates's somewhat Bohemian apartment in London's South Kensington, described by the style guru Peter York as 'Pasolini meets Palladio',[138] had been published in the fashion magazine *Harpers & Queen* in 1980. It was soon shown by the Japanese magazine, *Brutus*, and this, in turn, led directly to the commission to design the Metropole.[139] What was wanted, as Coates has explained, was 'the mix of the English gentleman's club and a European café'.[140] An old

garage, which provided the necessary double-height space, was eventually found and fitted with a sub-Corinthian colonnaded screen wall: 'Back in London,' Coates recalls, 'they shrieked, "It's classical!"'[141] Behind the colonnade, a French bistro-style glazed wall opened onto the bar where a staircase, with a sweeping hard-wood hand-rail, rose to a library stocked with specially chosen European novels and poetry. A chandelier hung from the ceiling and an ornate, eighteenth-century mirror was set above the marble fireplace, reflecting the candle-light back into the room; in the restaurant beyond the proscenium-like archway with its gilded clock, a swagged and tasselled canopy was supported by more Classical columns while plaster casts, including Aphrodite of Ostia, surrounded the room.

The Metropole and the subsequent commissions provided for Coates and his partner from 1985, Doug Branson, an outlet for the type of architecture he taught at London's Architectural Association School of Architecture. '… while we're acting as a sort of cultural attic for the new Japan,' he said, 'they're using their time and money to build what in Europe would be dismissed as unreal or unbuildable.'[142] The cultural attic was also a very real attic full of architectural spolia. Caffè Bongo [sic], built or rather fitted-out in Shibuya, Tokyo, in 1986 used cast-iron columns from a demolished Welsh chapel; for The Wall, completed four years later, Coates imported stonework from Italy.

The Wall, located in Nishi-Azabu, midway between Roppongi and Shibuya, was conceived on the conceit that the Romans had once been in Tokyo [15.12]. For here are the remnants of an antique wall where the collage of forms and materials tells a story. Random rubble and diaper-shaped stones, inscribed with the building's name in a seriffed Roman font, make up its lower part beneath a shallow cornice. Above this and partly hidden by remnants of flaking plaster, thin Roman brickwork, striated with rough stone coursing and interrupted by stone relieving arches, betray, through its many building phases, the fabric's apparent age. The fact that it was actually built in the late 1980s by two Tuscan masons, whom Coates

knew, is neither here nor there. Within the wall's thickness, a steep staircase rises unseen under a barrel-vaulted brick roof to emerge through an opening onto the upper flight of a metal stair which rises like the remnants of a fire escape across the five-storey façade. To the front of this, an industrial cast-iron framework reminiscent of an old gasometer and, as if to demonstrate its British origins, embossed with both the architects' and foundry's names, provides an outer screen which brings the building to the street's edge. Sculptural figures entwine themselves around the tops of the uprights where cogwheels draw attention to the seven clocks which punctuate the building's façade. A thin, overhanging cornice supported on cast-iron brackets terminates the brickwork, above which a glazed belvedere suggests yet another building phase. The Italianate theme is continued to the rear where an open spiral stair clings to the side of the adjacent Art Silo, much as the Scala del Bovolo does to the five-storey loggia at the rear of the fifteenth-century Palazzo Contarini del Bovolo in Venice. The Art Silo itself, built two years later, appears wholly modern. Elliptical on plan and rising to eight storeys above six squat quasi-Doric columns, it is clad in diaper terracotta tiling with expressed diagonal ribs reminiscent of *namako* walling. Similarly, Japanese are the *shōji*-like gauze screens on each balcony and the bulging, copper shingles at the base and top of the tower which suggest *minka* roofing. To the rear, as if to forestall any further doubt as to the building's true provenance, the faceted *shōji*-like steel and glass curtain wall, studded with golden bosses, reminds one that this in Japan, not Italy.

Despite its clearly European provenance, the aging patina of The Wall's façade implies *wabi sabi* – the Japanese sense of gentle decay. Like Coates's other designs, this was a creation by a team of artists including Grayson Perry (ceramic work), Tom Dixon (wall clock), Jessica Thomas (bronze sculptures) and the two Tuscan stonemasons.

The success of these buildings is in what Coates recognises as 'the overlaying of the extraordinary and the commonplace', in their 'artistic intervention ... [and their] ... filmic handling of space';[143] whether this be Caffè Bongo [sic], where the wing of an aeroplane, while acting as an entrance canopy, appears embedded in the building's façade, or the Arca di Noè in Sapporo, completed in 1987, where a petrified ship in the form of a Tuscan temple is revealed on top of Mount Ararat. It was an exuberant architecture needed by a society now tired of the white concrete of the Japanese new-wave and the sartorial black of its creators. But it was also, as Thomas Weaver has put it, 'a society nostalgic for a culture not its own'.[144] But here is the irony. For by his choice at The Wall of hand-made bricks and cast-iron imported from England, Coates is reusing the materials which Thomas James Waters first used in Japan over a century before and, by his informed use of historical precedent, is reintroducing into Japan the same architectural language that Josiah Conder had then taught his students, Tatsuno, Katayama, Sone and Satachi, who were, in the 1880s, just beginning to build the new Japan. So, contrary to what Weaver might say, this Western culture was, by adoption, once their own and Coates, with his multi-disciplinary approach to architecture, was, in many ways, just closing the circle.

Ma: the Japanese Sense of Place

In April 1966 *Architectural Design* devoted almost 40 pages to *ma*, what they called the Japanese Sense of Place. In an editorial epilogue to this lengthy discussion, Robin Middleton, the Technical Editor,[145] wrote:

> For *Architectural Design* to devote so much space to an historical survey of Japanese temple precincts can only be justified if it has served to increase understanding of our control of space through the disposition of forms and objects and, in addition, if it has managed to destroy that facile attraction of Japanese architecture that has resulted in so many meaningless imitations in the West during the past decade and had replaced it with a deeper comprehension of the magnificent architecture of Japan.[146]

(*left*) 15.12 The Wall and the Art Silo, Tokyo Azabu, designed by Nigel Coates and Doug Branson, 1990, 1992.

The concept of Architecture (with a capital A) was unknown in Japan until modern times. Indeed, only in 1894 did Itō Chūta first propose the word *kenchiku* as a term for 'architecture' in place of the commonly used term *zōka-gakkai*, which meant 'building-house society'.[147] In Japan there had never been architects, as such, or even designers. There were carpenters who responded to the tastes and wishes of their patrons, as at Katsura, or who rebuilt in the manner of generations of their predecessors, as at Ise. Writing in *Fundamentals of Japanese Architecture* (1936), Bruno Taut looks at Ise, which he regards as absolutely Japanese – 'more so than any other thing in Japan'[148] – as he would look at the Parthenon:

Here one is dealing not with engineering but with architecture, such as is the case with the Parthenon where the last definite form has also been created – there in marble and here in wood and straw.[149]

In a contemporaneous yet quite differing interpretation of Ise, Horiguchi Sutemi described it as 'an architectural ensemble, built within a thousand-year-old forest and surrounded by a sacred hedge and imperial fence'.[150] By then quoting a *waka* by the twelfth-century monk and poet Saigyō – 'I know not what lies within, but I am in tears with gratitude' – Horiguchi shifts attention from the building as object to the *genius loci*. This is what the later architectural historian Ōta Hirotarō recognised when he asked: 'Was it the beauty of architecture – which made Taut value Ise on par with the Parthenon – that impressed Saigyō? Perhaps not quite. The deep forest of Japanese cedar and the sanctuary of raw wood that it surrounds in such serenity – this harmony between the architecture and its environment inspired him.'[151]

In taking the Parthenon, as Le Corbusier had done in *Vers une architecture* (1923), as the gold-standard by which Western architecture could be judged, Taut espoused a deterministic view basic to Western architecture which Isozaki, in his book *Japan-ness in Architecture* (2006), characterises as 'a matrix of planes and lines'.[152] This, of course, was

how Gropius perceived Katsura and how, through his editing of Ishimoto Yasuhiro's photographs, Tange promoted it to a Western and Japanese readership alike. However, traditional Japanese architecture was not like this. In the same way that the size of a room was defined by the number of *tatami* it contained, since the mats were always the same size, so the size of a building, which was modular, was defined by the spans between the columns. Thus it was not so much an architecture, as in the West, based on solids, the planes and lines of wall and column, but one based on voids, the interstices, the spaces in between. This is what is known as *ma*.

In 1964, Isozaki's essay 'Space of Darkness' posited that in traditional Japanese buildings space is conceived only in terms of the intensity of light as it penetrates the all-encompassing gloom – thus 'shadows are not born when light is projected. They are everything left over when light cuts through the darkness.'[153] It is a perception similar to that of 'negative space' as described by Okakura Kakuzō in *The Book of Tea* (1906). Here he is quoting Laotse, the founder of Taoism:

The reality of a room, for instance, was to be found in the vacant space enclosed by the roof and walls, not in the roof and walls themselves. The usefulness of a water pitcher dwelt in the emptiness where water might be put, not in the form of the pitcher or the material of which it was made. Vacuum is all potent because all containing. In vacuum alone motion becomes possible.[154]

In his book *In Praise of Shadows* (1933, 1934), Tanizaki Juni'chirō took the Taoist concept of space further, seeing it in terms of light and dark. 'A Japanese room,' he wrote, 'might be likened to an inkwash painting, the paper-panelled *shōji* being the expanse where the ink is thinnest, and the alcove where it is darkest.'[155] Accordingly, 'the beauty of a Japanese room depends on a variation of shadows, heavy shadows against light shadows.'[156] Although he claimed no specialist knowledge of architecture, Tanizaki distinguished

Western architecture from Japanese architecture in terms of the roof – a cap versus a parasol.[157] Western buildings, he said, are assembled upwards until a cap is placed on it; but in Japan 'we first spread a parasol to throw a shadow on the earth, and in the pale light of the shadow we put together a house.'[158] As a result, the sense of space is quite different. It is neither contained nor even defined by walls, for there might well be none, but by shadows. 'The "mysterious Orient" of which Westerners speak,' Tanizaki writes, 'probably refers to the uncanny silence of these dark places.'[159]

In 1978 Isozaki installed his exhibition *MA: Space-Time in Japan* first at the Festival d'Automne in Paris and then at the Cooper-Hewitt Museum in New York. Since Japan's reconnection with the West a century before, Western concepts of space and time – the Cartesian notion of three dimensions, together with time as the fourth – had confused the meaning of *ma* so much so that it had come to suggest 'in-between space' or, in music or speech, a 'pause' (in time). Instead, he believed that *ma* should best be understood as a 'gap', in the sense of a difference or disparity between things. The purpose of Isozaki's exhibition, which, in an interpretation of Katsura, incorporated a tea-house and large stones set on cushions on a carpeted floor, was therefore to try to explain to a Western audience, who understood space and time – the Cartesian notion of three dimensions, together with time as the fourth – as separate entities, what the Japanese concept of *ma* saw as the same thing. For Western architects, grounded in the Modernist tradition of Sigfried Giedion's *Space, Time and Architecture*, this was an unfamiliar concept. As Isozaki said, 'I wanted, at all events, to grasp *ma* at the moment at which time-and-space had not yet been disentangled and rendered as distinct notions. I hoped to present the ways in which *ma* shows up in different modalities of thought and speech: logical, visual, and performative.'[160]

Was this a step too far? For *ma*, as 'in-between space', is how it is mostly regarded today. In his essay in *Architectural Design* which accompanied that magazine's investigation, 12 years earlier, into the Japanese sense of 'place', Gunter Nitschke wrote:

The twentieth century revolution in Japanese architecture appeared at first altogether destructive of the traditional concept of 'place'-making. The introduction of Western ideas, and in particular the attempts to emulate the Western handling of form and space did mark the end of the intuitive understanding and acceptance of *Ma* – *Ma* was replaced by that concept of space that the Japanese call *ku-kan*, not only in architecture but in sculpture and painting too. But, surveying the modern movement in Japan, it now seems that the early, somewhat superficial attempt to broaden this control of form and then space in adopting the techniques of the West has been enriched and deepened by a new concern for the traditional concepts of *Ma*, so that the total resulting effect is one of a true Renaissance. An altogether new sense of place has emerged from the process of comprehension of form, of space and finally, of *Ma*.[161]

Writing in 1966, Nitschke recognised this 'new consciousness of *Ma*',[162] in the as yet unrealised Metabolist projects which, as he said, 'in their lack of emphasis on either the form or the Western concept of three-dimensional space, they are pointers to the future. They all involve the notion of *place* as something dynamic and liable to change and in them space is created by the distribution of symbols, not mere objects.'[163] With the exception of the Big Roof at Expo '70, itself emblematic of *ma*, the oil crisis of the early 1970s ensured that most of those projects were not to be. However, symbols as part of the language of Post-Modern architecture were to live on.

The 'in-between space' was what Alison and Peter Smithson referred to as *The Charged Void*, the title chosen for their collected works. In explaining this choice, Peter Smithson wrote in the first volume:

In calling our collected works *The Charged Void: Architecture*, we are thinking of architecture's capacity to charge the space around it with an energy which can join up with other energies, influence the nature of things that might come. ... a capacity we can feel and act upon, but cannot necessarily describe or record.[164]

15.13 The Economist Plaza, St James's, London, designed by Alison and Peter Smithson, 1964.

The platform-plaza (to use Scully's term) at the Economist Building in London is in this same way 'charged' [15.13]. As they said in their 1965 essay 'The Pavilion and the Route', 'The very close plan forms emphasize the separation of the elements, particularly necessary on this very small site. The space between, is the collective of the spaces that each of the buildings carries with it.'[165]

This same separation of the elements characterises the Brion family cemetery which the Venetian architect Carlo Scarpa built at San Vito d'Altivole in the Veneto in northern Italy [15.14]. Completed in 1972, this is a garden cemetery where the tombs and the chapel, although all contained behind a canted concrete wall, are a series of events and, as at the Economist Building (to paraphrase the Smithsons), the spaces between the buildings are as much part of the whole as they are part of any one building.

Carlo Scarpa was already 63 and just starting work on the Brion Cemetery when he first visited Japan

in August 1969.[166] Giuseppe Brion, co-founder of the innovative electronics firm Brionvega,[167] died in 1968 and his widow, Onorina, invited Scarpa to design a family tomb in the municipal cemetery of the small town where Giuseppe was born. They already owned a funerary chapel and a plot of land there, and it was initially for this site that Scarpa began his design. But the purchase, the following May, of a large L-shaped plot along the north and east boundary of the cemetery quite changed the scope and scale of the project. It was with this new setting in mind that Scarpa left, three months later, for Japan.

The visit to Japan was occasioned by the inclusion of work by his son Tobia in the Festival of Italian Furniture Design which opened on 30 August at the Tokyo Furniture Salon. Tobia Scarpa (b.1935) had achieved critical success the previous year with the Soriana armchair designed for the Italian manufacturers Cassina and now Cesare Cassina was bringing a group of architects and designers to

Tokyo for the show.[168] Carlo Scarpa was invited to join them.

Scarpa did not go to Japan unprepared. The Japanese architect and furniture designer Takahama Kazuhide, who lived in Bologna and designed for Dino Gavina (for whom Scarpa had built the Bologna furniture showroom in 1960), must have advised him, for the two men were to join up in Japan and travel on to Nara and Ise together and alone. He might also have remembered his conversations with Frank Lloyd Wright, whom he had met on the occasion of Wright's visit to Venice in 1951 and for whom he had designed an exhibition at the 12th Milan Triennale in 1960, or with the Italian-domiciled Japanophile Ezra Pound, many of whose books he had in his collection.[169] He certainly used the books on Japan by Mario Gromo and Fosco Maraini as well as other books in his collection such as Harada Jirō's *The Gardens of Japan* (1930) and Norman Carver's more recent *Form and Space of Japanese Architecture* (1955), with a text in both Japanese and English.[170] In *Taccuino giapponese* (1959) Gromo had written, 'A stay in Kyoto, albeit short, cannot neglect the villa Katsura. It is of the end of the fifteenth century. Some of the most distinguished civil architecture of Japan ...' Here Scarpa had scribbled 'Katsura' and 'Kioto'

in the margin and marked up the text.[171] Maraini was equally enthusiastic about Ise. In the 1959 English language edition of *Ore giapponesi* (1957) he writes, 'What makes the Ise and Izumo shrines so interesting ... is the fact that they represent the purest possible survival of the Japanese architectural tradition as it existed before the Chinese cultural invasion began in the sixth century.'[172] On the frontispiece map in *Ore giapponesi* Scarpa marked up in red pencil his intended route – Tokyo, Kamakura, Nagoya, Kyoto, Osaka, Nara and Ise – and in the event largely succeeded in following it.[173]

In a letter to his wife from Nara, where he stayed at the rather grand Nara Hotel designed by Tatsuno Kingo in 1909, Scarpa wrote:

> My dear, here everything is beautiful, or rather it is much more than we know. The gardens are fantastic. We must come back together next year, for Osaka. You will like living like the Japanese (except for the food), you'll see; we slept on the ground, in our kimono, in a beautiful and old Japanese home (but it was expensive) we could do it at home as well![174]

Scarpa felt an affinity for Japan which this late-in-life visit released in him. He was from Venice, a city

15.14 The Brion Cemetery at San Vito d'Altivole, designed by Carlo Scarpa, 1972.

of water, and the presence of water is fundamental to Japanese design. His design for the Fondazione Querini Stampalia in Venice (1948–53), where lily ponds and watercourses divide up the enclosed garden beyond the building's colonnade, has often been compared to a Japanese garden; water was to play a similarly fundamental role at the Brion Cemetery. The Japanese, in turn, could respond to Scarpa's architecture as if it were their own. When the Japanese journal *Space Design* published his work in their June 1977 issue, they wrote to him saying, 'It is our great pleasure now that we could have the opportunity to introduce you and your splendid works to the Japanese readers in our magazine "SD"'.[175] In an interview with Barbara Radice in October 1978, shortly before his second and last trip to Japan, Scarpa said:

> I am very much influenced by Japan, and not just because I visited it, but because even before I went there, I admired their essentiality and above all their supreme good taste. What we call good taste is present everywhere in Japan.[176]

It is both sad and ironic that he should die there, in Sendai, just a month later following a fall down a flight of concrete steps. He was only 72.[177] His remains were brought back to Italy and buried close to the Brions in the San Vito d'Altivole municipal cemetery.

Throughout his first trip to Japan the Brion Cemetery must have been in his mind. Did the Kinkaku-ji (Golden Pavilion) at Kyoto inspire the Water Pavilion, raised likewise on thin legs above the water's surface? Early sketches in a notebook could suggest it was conceived while in Japan. In the background of the sketch is the more developed form of the Arcosolium, retained from the earlier version of the project, where the sarcophagi of Giuseppe and Onorina Brion were to be placed.[178] As the Water Pavilion developed, so did the sense of Japanese detailing, its thin legs of paired Corten steel broken, offset and reassembled with a brass joint. The contrast between the fragility of the supports and the apparent heaviness of the steel frieze and rough-cut planks which make up the

raised roof are like that of the *minka* with the *shōji* removed. Set on axis with the Water Pavilion, the bridge-like form of the Arcosolium lies low in the ground, its humped back directing the eye towards the heavy roof of the family tomb which leans hard against the outer wall of the compound. Its mass recalls the great *gasshō* (praying hands) roof-form of the *minka*: inside, the textured and patterned concrete of the tomb's heavy structure evokes the *minka*'s beamed and braced framework. It is hard to think that these elements were not conceived without the influence of what Scarpa experienced in Japan. As with both Richard Neutra and Wright before him, Japan confirmed for Scarpa the rightness of his approach to architecture.

What particularly resonates at the Brion Cemetery is the sense of *ma* as both Isozaki and the Smithsons (had they known) might have had it. Within the confines of the boundary wall it both holds these buildings apart and draws them together. Due to their small scale the sense of proximity is initially not that of the Smithsons' Economist Building Plaza but something more open, like at Katsura, where the tea-houses are separated by water but connected by pathways. At the Brion Cemetery, lily ponds isolate the Water Pavilion from the lawns around the Arcosolium, enforcing a sense of difference or disparity, or 'gap', as Isozaki would have it. At the other end of the site water again surrounds the chapel. Here, between the stepped and fractured concrete walls, the spaces are tighter, more restricted, more intense. This is what the Smithsons called the 'charged void'.

There is much about contemporary architecture which is universal, so much so that its provenance is often impossible to identify. Yet, despite its few excursions into the West, the Japanese concept of *ma* remains firmly Japanese. One interpretation of *ma*, however, which has been successfully exported to the West with no apparent modifications is by the Tokyo firm SANAA led by Sejima Kazuyo and Nishizawa Ryūe. The concept is simple: a floating roof over an often undulating floorscape where glazed enclosures, sometimes open to the sky, interrupt the volumetric flow with geometries frequently in contradistinction to the geometry of

15.15 The Twenty-first Century Museum of Contemporary Art at Kanazawa, designed by SANAA, 2004.

the building as a whole. Thus, glazed from floor to ceiling with full-height sheets of glass and laced through with a grid of thin steel columns, each volume plays host to a series of smaller volumes set within. Ignoring the columns' grid, these rather amorphous volumes mould and manipulate the reticulate space in between: pavilion and route, solid and void, this is a very Japanese experience.

In Japan SANAA demonstrated this most clearly at the Twenty-first Century Museum of Contemporary Art at Kanazawa, completed in 2004 [15.15]. In this early manifestation of the idea, the building is circular and the enclosures rectangular; what is more, the enclosures are largely solid so that the spaces between recall the narrow, walled streets of the nearby *Samurai* district of Naga-machi Buke-yashiki. At the Hiroshi Senju Museum at Karuizawa, designed by Nishizawa and completed in 2011, the idea is taken further: the floor undulates around enclosed gardens which pierce the roof and the exterior of the building takes on an amorphous shape. A similarly undulating floor characterises their first major cultural building in the West, the Rolex Learning Centre École Polytechnique Fédérale in Lausanne, Switzerland, opened in 2010. This was followed in 2012 by the Musée national du Louvre's satellite gallery in the former mining town of

Lens in northern France [15.16]. In what is a long, distended building comprising five rectangles, it is only the central entrance hall and one of the end pavilions, the Pavillon de verre, which, as the latter's name would suggest, are fully glazed. The two linking arms, the Grand galerie and the Galerie du temps, as well as the other end pavilion, the Scène, are faced with reflective aluminium sheeting set to the rhythm of the glazing bars. The effect of these reflective panels is to Westernise the building by rendering it impenetrable to the gaze, a condition which is further enforced whenever the internal blinds are lowered behind the glazed walls. Yet, so long as the building is allowed to remain transparent, it remains Japanese. As Christopher Dresser said of the Japanese house in 1882, 'the building consists of uprights, a floor, and a roof.'[179] It is defined not by what is there but, ultimately, by what is not. *Ma*, as Isozaki expressed it, is not the in-between space or the pause in time, but the gap, the sense of difference.

Recognition

In 2010 Sejima Kazuyo and Nishizawa Ryūe (SANAA) were awarded the Pritzker Architecture Prize and four years later it went to Ban Shigeru. In receiving this, they joined an elite group of award winners, a disproportionate number of whom are Japanese. The list of these award winners, however, is small and four names keep reappearing: Andō Tadao, Itō Toyoo, Maki Fumihiko and Tange Kenzō. Andō, Itō and Maki have each won the five major international architectural awards: the AIA Gold Medal, the RIBA Royal Gold Medal, the UIA Gold Medal, the Pritzker Architecture Prize and the Japan Art Association's Praemium Imperiale. The only Western architects to have also done so are the Italian Renzo Piano and the American Ieoh Ming Pei. Tange is close behind with four, the UIA Gold Medal having eluded him. Isozaki Arata has won both the RIBA Royal Gold Medal and the Pritzker Architecture Prize, and Taniguchi Yoshio, the Praemium Imperiale, while the newest

international award, the British Royal Academy of Arts Architecture Prize, instituted in 2018, has gone to Hasegawa Itsuko, the first Japanese woman to win, on her own, any such award.

What discussions go on behind the scenes to determine these rewards remains largely unknown. However, in 1964, following a split vote, Maekawa Kunio was nominated for the RIBA Royal Gold Medal by the Royal Gold Medal Committee, but when the decision was presented to the RIBA Council, it was overturned and the Gold Medal went to the other candidate, the Englishman Edwin Maxwell Fry who, with his wife Jane Drew, had worked with Le Corbusier at Chandigarh.[180] Although nominated again in 1965 and 1966, Maekawa never won the Gold Medal.[181] Why it was denied him cannot be said, but the war might have still been too recent a memory. Yet the following year it was to go to Tange Kenzō: but this was in the wake of the Tokyo Olympics and the Yoyogi stadia would have been fresh in everyone's minds.

Why the amount of awards given to architects from Japan should be so disproportionate, per capita, when compared to architects from the West is really not that surprising. Sixty-five years ago, Hamaguchi Ryūichi, the editor of *Kokusai-Kentiku*, made a very simple observation:

It is impossible to understand the rise of modern architecture in the West without some reference – all along the line – to the architecture of Japan.

It is equally impossible to understand the rise of modern architecture in Japan without reference, especially in recent times, to that of the West.

This story is concerned with architectural give-and-take and that has been going on between Japan and the West for three quarters of a century.[182]

Completing this book in the sesquicentenary of the Meiji Restoration gives the opportunity to consider the international role played by Japanese

(*left*) 15.16 La Musée national du Louvre at Lens, designed by SANAA, 2012.

architecture. The modernisation of Japan following the Meiji Restoration was not so much a leap forward into the dark, nor less into the light of Western culture, but a careful and considered attempt to avoid colonisation by the Western powers. This was achieved by adopting the West's methods and learning, as, over a millennium before, the people of the Japanese archipelago had adopted Tang methods and learning in an attempt to withstand the Tang dynasty. Although in the Meiji era this involved importing Western architecture, Japan never lost sight of its own architectural tradition. The Japanese house, the *minka*, continued to be built while Western-style museums, railway stations and department stores arose all around. Western architecture came without the baggage of tradition that it has in the West and it could be used and misused freely. Thus it is that, with a sense of tradition and a freedom of opportunity, Japanese architecture has in recent decades established itself on the world stage in a way that Western architecture, often hamstrung by its own internal debates, has not quite managed to do. For, to paraphrase Hamaguchi Ryūichi, Modern architecture in the West needs Japan rather more than Japanese architecture needs the West.

NOTES

Introduction and Acknowledgements

1 Ian Fleming, *You Only Live Twice* (London: Pan Books, 1965) p. 18.

Prelude

1 9 July.

2 Michael Cooper, *The Japanese Mission to Europe, 1582–1590: The Journey of Four Samurai Boys Through Portugal, Spain and Italy* (Folkestone: Global Oriental, 2005), p.119.

3 See Nandini Das, 'Encounter as Process: England and Japan in the Late Sixteenth Century', *Renaissance Quarterly*, vol.69, no.4, 2016, pp 1357, 1363–4.

4 See Cooper, *The Japanese Mission*, p.196.

5 *Tradado doa Embaixadores Iapões que Forão de Iapão à Roma no Anno de 1582* was eventually published by Yoshimoto Okamoto and Henri Bernard SJ in J.A. Abranches Pinto (ed.), *Monumenta Niponica* Monograph 6 (Tokyo: Sophia University, 1942).

6 See Guido Gualtieri, *Relationi della Venuta degli Ambasciatori Giaponesi a Roma fino alla partita di Lisbona* (Rome: Francesco Zannetti, 1586).

7 See Cooper, *The Japanese Mission*, p.194.

8 This is Cooper's interpretation. See ibid., p.194.

9 Although the name is Portuguese, Eliot describes Mesquite as being Italian. See John Eliot, *Ortho-epia Gallica: Eliots Fruits for the French: Enterlaced with a double new Invention, which teacheth to speake truely, speedily and volubly the French-tongue*, Book 1 (London: John Wolfe, 1593), Chapter 2, n.p.

10 Constantine Kazariya is usually known as Constantine Douardo.

11 See Cooper, *The Japanese Mission*, pp 184–5.

12 ibid., p.54.

13 ibid., p.66.

14 ibid., pp 67–8.

15 ibid., p.124.

16 See Das, 'Encounter as Process', pp 1347–50.

17 Eliot, *Ortho-epia Gallica*, pp 36–7.

18 Cooper, *The Japanese Mission*, p.100.

19 The screens had been made in 1581 and probably had been painted by an artist of the Kanō school, if not by Kanō Eitoku himself, the artist who had been principally responsible for the decorating of Azuchi Castle. See Cooper, *The Japanese Mission*, p.207.

20 They are published in Vincenzo Cartari, *Imagini delli Dei de gl'antichi* (Venice: Presso il Tomasini, 1647), pp 381–2.

1 The Chained Country

1 Timon Screech says that the Tokugawa *shogunate* or *bakufu* lasted for 15 generations from 1603 to 1867. See Timon Screech, *The Lens Within the Heart: The Western Scientific Gaze and Popular Imagery in Later Edo Japan* (Honolulu: University of Hawai'i Press, 2002), p.9.

2 These two examples are chosen knowingly, for they were two of the earliest Western inventions to be adopted in Meiji Japan – the telegraph in 1869 and the railway in 1872.

3 The Chinese and Dutch enjoyed exclusive trading rights with Japan for 218 years (1641–1859). In 1715, the Japanese limited the number of Dutch ships to just two a year; they would have sailed from their mother port of Batavia, now Jakarta, in Indonesia. By contrast, the Chinese maintained very strong trade relations. In 1688, 194 Chinese junks entered Nagasaki harbour, compared with just three Dutch ships. See Brian Burke-Gaffney, *Nagasaki: The British Experience, 1854–1945* (Folkestone: Global Oriental, 2009), pp 5–6.

4 Other foreign trade was limited to certain Japanese domains: Tushima for the Korean, Satsuma for the Ryūkyū and Matsumae for the Ainu people.

5 See Burke-Gaffney, *Nagasaki*, p.6.

6 The tri-partite arcade bears comparison with the Law Court of the Old Town Hall on Dam Square, Amsterdam. See, for example, the paintings and engravings of the Old Town Hall by Jacob van der Ulft (1657–89), Pieter Saenredam (1657) and others, held at the Amsterdam Historical Museum.

7 Burke-Gaffney adds this footnote: 'Although essentially a peasant revolt instigated by heavy taxation, the rebellion was viewed by nervous officials in Edo as a Christian-inspired insurrection because the area was populated heavily by former Japanese Christians.' See Burke-Gaffney, *Nagasaki*, p.250, n.6.

8 The Dutch had bombarded Hara Castle, the base of the Christian rebels, from the sea.

9 For the Dutch involvement in the Shimabara rebellion and their move to Dejima, see Donald Keene, *The Japanese Discovery of Europe, 1720–1830* (Stanford: Stanford University Press, 1969), p.2.

10 Rupert Faulkner, 'Personal Encounters: Europeans in East Asia', in Anna Jackson and Amin Jaffer (eds), *Encounters: The Meeting of Asia and Europe 1500–1800* (London: V&A Publications, 2004), p.180. See also Grant K. Goodman, *Japan and the Dutch, 1600–1853* (Richmond: Curzon Press, 2000), p.22.

11 Captain A.I. von Krusenstern, *Voyage Round the World in the Years of 1803, 1804, 1805, & 1806* (London: John

Murray, 1813), vol.1, p.252, quoted in Keene, *The Japanese Discovery*, p.9.

12 Isaac Titsingh, *Illustrations of Japan; Consisting of Private Memoirs and Anecdotes of the Reigning Dynasty of the Djogouns, or Sovereigns of Japan*, trans. from the French by Frederic Schoberl (London: R. Ackerman, 1822).

13 C.R. Boxer, *Jan Compagnie in Japan, 1600–1850* (The Hague: Martinus Nijhoff, 1950), p.79.

14 There was accommodation for some 2,000 Chinese. See Burke-Gaffney, *Nagasaki*, p.7.

15 *Rangaku* meaning *Dutch-learning: ran* is short for *Oranda*, a corruption of Orange, referring to the Dutch; *gaku* means *learning*.

16 See Anna Jackson, 'Visual Responses: Depicting Europeans in East Asia', in Jackson and Jaffer, pp 216–17. See also Keene, *The Japanese Discovery*, p.124.

17 Boxer likens them to horse-leeches; see Boxer, *Jan Compagnie*, p.46.

18 ibid., pl.vi, p.56.

19 Colen Campbell, *Andrea Palladio's First Book of Architecture* (London: S. Harding, 1728); Isaac Ware, *The Four Books of Andrea Palladio's Architecture* (London: Isaac Ware, 1738).

20 Alexis-Hubert Jaillot (1632–1712), a French cartographer, collated and re-drew Sanson's maps and published them in Paris in 1689. The 1692 edition was published in Amsterdam.

21 For Titsingh and Masatsuna, see Timon Screech, *Secret Memoirs of the Shoguns: Isaac Titsingh and Japan, 1779–1822* (London and New York: Routledge, 2006), pp 32–3.

22 Kōkan claimed that Titsingh gave him the book but Johan Frederik van Rheede tot de Parkeler (1757–1802), not Titsingh, was *opperhoofd* at the time. See Screech, *Secret Memoirs*, p.29.

23 Quoted in Keene, *The Japanese Discovery*, pp 19–20.

24 Blussé describes this view, drawn from memory, as being Caspar Romberg's room. If Kōkan visited Dejima in 1788, then it would be Johan Frederik van Rheede tot de Parkeler's room: Romberg was the *opperhoofd* preceding and following de Parkeler who was there from 1787 to 1789. See Leonard Blussé, 'Dutch Settlements and Trading Centres', in Jackson and Jaffer, p.137.

25 For peep-boxes, see Timon Screech, 'Europe in Asia: The Impact of Western Art and Technology in Japan', in Jackson and Jaffer, p.321, and also, Screech, *The Lens Within*, pp 119–27.

26 For copper-plate etchings, see Screech, *The Lens Within*, pp 94–106.

27 The plate is by George Bickham, after Jean B.C. Chatelain, and was included in R. Goadby, *A New Display of the Beauties of England* (London, 1776), third edition, vol.1, between pp 278 and 279.

28 Kent built these buildings in the 1730s. They have now been removed.

29 Possibly by Sir John Vanbrugh, *c.* 1723.

30 French attributes The Basketmaker (*De Mandelmaaker*) to Peter Abraham van St Clara (trans. J. Le Long), *Lets Voor Allen* (Amsterdam: 1717, 1736, 1771), but this is surely incorrect: it must be from Luiken. See Calvin French, *Shiba Kōkan: Artist, Illustrator, and Pioneer in the Westernization of Japan* (New York: Weatherhill, 1974), p.98.

31 For Kōsaku, see Screech, *Secret Memoirs*, pp 21–6, and also Screech, *The Lens Within*, p.15. See also Faulkner, 'Personal Encounters', p.186.

32 Quoted in Screech, *The Lens Within*, p.15.

33 ibid., p.15.

34 See ibid., p.15, illus. 2, and also Screech, *Secret Memoirs*, p.29.

35 See Toru, Nomura, 'Magotaro: An Eighteenth Century Japanese Sailor's Record of Insular Southeast Asia', *Sari*, vol.27, 2009, pp 45–66.

36 Hoshū Katsuragawa [trans. Gérard Siary], *Naufrage & tribulations d'un japonais dans la Russie de Catherine II (1782–1792)* (Paris: Editions Chandeigne, 2004), p.152.

37 ibid., p.153.

38 ibid., pp 152–3.

39 ibid., p.155.

40 ibid., p.154.

41 ibid., p.155.

42 ibid., p.154.

43 ibid., pp 156–7.

44 ibid., pp 157–8.

45 See Keene, *The Japanese Discovery*, pp 50–57, and also Timon Screech, review of Mary Elizabeth Berry, *Japan in Print: Information and Nation in the Early Modern Period*, Reviews in History (review no.537), 2005, www.history. ac.uk/reviews/review/537, accessed 5 April 2010.

46 Keene also suggests that, in addition, 'all persons seriously interested in the West would learn Dutch'. See Keene, *The Japanese Discovery*, p.77.

47 *Seiiki Monogatari* was published in a simplified version as a supplement to a Tokyo newspaper in 1888. See Keene, *The Japanese Discovery*, pp 94 and 235, n.8.

48 ibid., p.209.

49 Quoted in ibid., pp 209–10.

50 Quoted in ibid., p.210.

51 See Screech, 'Europe in Asia', p.323.

52 See Keene, *The Japanese Discovery*, p.3.

53 Quoted in Michael Cooper, *They Came to Japan: An Anthology of European Reports on Japan, 1543–1640* (Berkeley and Los Angeles: University of California Press, 1965), pp 93–5.

54 Quoted in ibid., p.132.

55 Quoted in ibid., p.132. In translating the same passage, Boxer writes, 'I assure you most emphatically, that among all the palaces and houses which I have seen in Portugal, India and Japan, I never yet saw anything comparable to this in freshness, elegance, sumptuousness and cleanliness ...' See C.R. Boxer, *The Christian Century in Japan, 1549–1650* (Berkeley and Los Angeles: University of California Press; and London: Cambridge University Press, 1951), p.62.

56 Quoted in Cooper, *They Came to Japan*, p.131.

57 Quoted in ibid., p.132.

58 The Hospital Real de Todos os Santos (All Saints Royal Hospital) in Lisbon was completed in 1504. The symmetry expressed in the balancing of the two wings of accommodation on either side of the chapel would have been in response to the need to provide separate accommodation for the two sexes.

59 Quoted in Cooper, *They Came to Japan*, p.132.

60 Quoted in ibid., p.132.

61 Quoted in ibid., p.132.

62 Quoted in ibid., p.133.

63 Hinago, Motoo, *Japanese Castles*, translated and adapted by William H. Coaldrake (New York: Kodansha International Ltd, 1986), p.11. Originally published as *Shiro*, vol.54 in the series *Nihon no bijutsu* (Tokyo: Shibundo, 1970).

64 Donald F. Lach, *Asia in the Making of Europe, Vol.1, Bk 2* (Chicago: University of Chicago Press, 1970), p.688.

65 Tokugawa Ieyasu became *Shogun* following the Battle of Sekigahara in 1600. Adams became an advisor and interpreter to Ieyasu, for whom he built Western-style ships.

66 William Adams, in a letter 'to my loving wife' dated 22 October 1611, quoted in Cooper, *They Came to Japan*, p.115.

67 Sotelo, who had been based in the Philippines until 1608, would have already known Vivero y Velasco. He was eventually martyred at the stake.

68 In 1608 Adams had exchanged friendly letters with Vivero y Velasco in the Philippines in the hope of setting up trade relations with New Spain. Valesco completed his journey to Mexico on a ship built by Adams.

69 An incomplete version of the text, edited by José Joaquín Pesado, was first published in José Joaquín Pesada (ed.), *La Ilustracion Mexicana* (Mexico City: Ignacio Cumplido, 1855), pp 277–88.

70 Quoted in Cooper, *They Came to Japan*, pp 140–41.

71 Quoted in ibid., p.116.

72 Edward Maunde Thompson (ed.), *The Diary of Richard Cocks, Cape Merchant in the English Factory in Japan, 1615–1622, with Correspondence*, 2 vols (London: Hakluyt Society, 1883).

73 ibid., 7 September 1616, p.172.

74 ibid., 1 September 1616, p.169.

75 Quoted in Cooper, *They Came to Japan*, p.216.

76 On the use of nails, see William H. Coaldrake, *The Way of the Carpenter* (New York: Weatherhill, 1990), p.81.

77 He was also known as John Roberts.

78 Quoted in Cooper, *They Came to Japan*, p.217.

79 Quoted in ibid., p.218.

80 The book, *Gedenkwaerdige Gesantschappen der Oost-Indische Maatschappy in't Vereenigde Nederland aan de Kaisaren van Japan*, was translated into English by John Ogilby (1600–76) and published in London by Thomas Johnson in 1670. The French edition was published in Amsterdam by Jacob de Meursontanus in 1680.

81 See Arnoldus Montanus, *Atlas Japannensis Being the Remarkable Addresses by way of Embassy from the East-India Company of the United Provinces to the Emperor of Japan …*, edited by John Ogilby (London: Thomas Johnson, 1670), p.119. Others are shown with swarthy southern European or Middle Eastern features. See p.298. In 1671 Montanus published *De Nieuwe en Onbekende Weereld: of Beschryving van America …* (*The New and Unknown World: or Description of America …*).

82 Montanus, *Atlas Japannensis*, pp 35–6.

83 For Kaempfer, see Beatrice Bodart-Bailey and Derek Massarella (eds), *The Furthest Goal: Engelbert Kaempfer's Encounter with Tokugawa Japan* (London: Routledge, 2012).

84 Engelbert Kaempfer (trans. and ed. J.G. Scheuchzer), *The History of Japan*, vol.2 (London: printed for the translator, 1727), pp lxxix–lxxx.

85 Kaempfer, *The History of Japan*, p.lxxx.

86 Montanus, *Atlas Japannensis*, p.69.

87 ibid., p.61.

88 ibid., p.69.

89 ibid., p.69.

90 ibid., p.139.

91 ibid., p.139.

92 Kaempfer, *The History of Japan*, p.lxxx.

93 See, for example, Montanus, *Atlas Japannensis*, pp 94, 138, 141 *et seq.*

94 ibid., p.156.

95 ibid., between pp 138 and 139.

96 This might be seen as *shōji* screens but the grid is too small to be those.

97 The Synod of Dort was held by the Dutch Reformed Church to settle the disagreements following the rise of Arminianism.

98 See James Murdoch, *A History of Japan, Vol. III, The Tokugawa Epoch, 1652–1868* (London: Kegan Paul, Trench, Trubner and Co., 1926), p.270. Since he is wearing a crown, it is possible that the figure in the centre represents the *Shogun*, Tokugawa Iemitsu, whom they also met.

99 In 1691 Kaempfer departed from Nagasaki on 14 February and arrived in Jedo or Edo on 13 March. The journey, he records, had taken 29 days. His audience was on 29 March. The return journey lasted from 5 April to 7 May. See Kaempfer, *The History of Japan* (1727), vol.2, pp 449, 520, 518, 529, 539 and 561. For his first such journey, Titsingh departed from Nagasaki on 19 February 1780, arriving in Edo on 25 March. His audience with the *Shogun* was on 5 April. His return journey lasted from 14 April to 27 May. See Boxer, *Jan Compagnie*, p.142.

100 Kaempfer, *The History of Japan*, p.404. On p.449, Kaempfer states that the journey from Nagasaki to Jedo is of about 200 German miles.

101 ibid., p.531.

102 At the *Shogun*'s request, the Dutch were required, as Kaempfer said, 'to walk, to stand still, to compliment each other, to dance, to jump, to play the drunkard, to

speak broken Japanese, to read Dutch, to paint, to sing', etc. ibid., p.535.

103 ibid., p.531.

104 ibid., p.532.

105 ibid., p.531.

106 ibid., p.475.

107 ibid., p.524.

108 ibid., p.530.

109 ibid., p.532.

110 ibid., p.525.

111 ibid., p.411.

112 Montanus, *Atlas Japannensis*, between pp 384–5.

113 Montanus refers to the Emperor and the Emperor's castle at Jedo, which is Edo. Since it was the *Shogun* who resided at Edo, while the Emperor lived at Kyoto or Meaco, and since it was the *Shogun* who wielded absolute power, it is likely that Montanus has mistaken the *shogun* for the Emperor. See ibid., pp 384–6.

114 ibid., p.386.

115 ibid., p.386.

116 Kaempfer, *The History of Japan*, p.531.

117 Quoted in Boxer, *Jan Compagnie*, p.168.

118 Titsingh, *Illustrations of Japan*, part 1, facing p.166 and part 2, between pp 224 and 225.

119 William Farish, 'On Isometrical Perspective', *Transactions of the Cambridge Philosophical Society*, vol.1, 1822, p.12.

120 *El Palacido de los Virreyes*, Museo de América, Madrid. Inventory no.00207.

121 Farish, 'On Isometrical Perspective', p.13.

2 The Japanese Ambassadors

1 There were 42 students in the party which was led by the Plenipotentiary Minister of the Right, Iwakura Tomomi.

2 Norimasa Muragaki, *The First Japanese Embassy to the United States of America: Sent to Washington in 1860 as the first of the series of Embassies specially sent abroad by the Tokugawa shogunate* (Tokyo: The America-Japan Society, 1920), p.19.

3 See *The Times*, 3 May 1862, p.11.

4 The modern names of these countries are given in these cases.

5 There has been some confusion over who engineered their escape, Gower or Glover. Alexander McKay, writing in *Scottish Samurai*, pp 37–8, attributes the escape to Glover; see Alexander McKay, *Scottish Samurai: Thomas Blake Glover, 1838–1911* (Aberdeen: Canongate Press, 1993), pp 37–8. But Andrew Cobbing, *The Japanese Discovery of Victorian Britain: Early Travel Encounters in the Far West* (London: Routledge, 1998), p. 27 and Michael Gardiner, *At the Edge of Empire: The Life of Thomas Blake Glover* (Edinburgh: Birlinn, 2007), pp 58–60, demonstrate unequivocally that it was Gower.

6 Andrew Cobbing, *The Satsuma Students in Britain: Japan's Early Search for the 'Essence of the West'* (London: Routledge, 2000), p.49.

7 Cobbing, *The Japanese Discovery*, p.36, table 1.

8 *New York Times Illustrated News*, 26 May 1816 (*sic*, surely 1860?), reproduced in Muragaki, The *First Japanese Embassy*, p.266. There were nine verses in all.

9 Muragaki, *The First Japanese Embassy*, p.185.

10 The half-shaven heads of several other of Muragaki's countrymen were visible at the different windows of the steamer, and by their words and laughter were evidently passing some very original opinions on what they saw.

11 Muragaki, *The First Japanese Embassy*, pp 184–5.

12 ibid., p.34.

13 ibid., p.47.

14 ibid., p.66.

15 ibid., p.63.

16 ibid., p.65.

17 ibid., p.21.

18 ibid., p.42.

19 ibid., p.67.

20 ibid., pp 28–9.

21 In 1872 the Iwakura Embassy travelled eastward to San Francisco and then crossed the continent overland.

22 Quoted in Cobbing, *The Satsuma Students*, p.50. Cobbing gives the average speed at 24mph.

23 *The Times*, 4 April 1862, p.12.

24 Quoted in Cobbing, *The Japanese Discovery*, p.39.

25 Writing in *The Japanese Discovery*, p.54, Cobbing suggests that they would have paid attention to local institutions such as Murray Barracks, the Anglo-Chinese College and the Mint.

26 *The Times*, 16 April 1862, n.p. (Editorial/leader).

27 *The Times*, 4 April 1862, p.10.

28 *The Times*, 7 April 1862, p.10.

29 *The Times*, 30 April 1862, p.5.

30 Quoted in Cobbing, *The Japanese Discovery*, pp 62–3.

31 Quoted in ibid., p.63.

32 Quoted in ibid., p.68.

33 Quoted in ibid., p.90.

34 Quoted in ibid., p.92.

35 Quoted in ibid., p.92.

36 Quoted in ibid., p.91.

37 Quoted in ibid., p.91.

38 Quoted in ibid., p.63.

39 Quoted in ibid., p.91.

40 Quoted in ibid., p.91.

41 *The Times*, 10 April 1862, p.9.

42 *The Times*, 10 April 1862, p.10 and *The Times*, 11 April 1862, p.5.

43 *The Times*, 16 April 1862, n.p.

44 *The Times*, 16 April 1862, n.p.

45 *The Times*, 30 April 1862, p.5.

46 *The Times*, 3 May 1862, p.11.

47 *The Times*, 10 August 1862, p.10.

48 *The Times*, 22 October 1862, p.10.

49 See Cobbing, *The Japanese Discovery*, pp 102 and 112, and also Cobbing, *The Satsuma Students*, pp 56–7.

50 Quoted in Cobbing, *The Japanese Discovery*, p.77.

51 Quoted in ibid., p.57.

52 Quoted in ibid., p.77.

53 Quoted in Cobbing, *The Satsuma Students*, p.58.

54 *The Times*, 10 April 1862, p.9.

55 *The Times*, 2 May 1862, p.11.

56 *The Times*, 10 April 1862, p.10.

57 *The Times*, 16 April 1862, n.p.

58 Quoted in Cobbing, *The Japanese Discovery*, p.95; *The Times*, 10 April 1862, p.9.

59 *The Times*, 24 April 1862, p.10.

60 William Burges, 'The International Exhibition', *The Gentleman's Magazine and Historical Review*, June 1862, p.664.

61 *The Times*, 2 May 1862, p.11.

62 ibid., p.11.

63 Rutherford Alcock, *International Exhibition, 1862: Catalogue of the Works of Industry and Art, Sent from Japan* (London: William Clowes and Sons, 1862), p.2.

64 See ibid.

65 Quoted in Cobbing, *The Japanese Discovery*, p.95.

66 *The Times*, 8 May 1862, p.11.

67 ibid., p.11.

68 *The Times*, 20 May 1862, p.7.

69 Kume Kunitake, *The Iwakura Embassy 1871–73: A True Account of the Ambassador Extraordinary & Plenipotentiary's Journey of Observation through the United States of America and Europe, Great Britain* (Matsudo, Chiba: The Japan Documents, 2002), vol.2 (trans. Graham Healy), p.104.

70 ibid., p.155.

71 Kume, *The Iwakura Embassy*, vol.1 (trans. Martin Collcutt), p.67.

72 ibid., pp 368–9.

73 Kume, *The Iwakura Embassy*, vol.3, p.249.

74 Kume, *The Iwakura Embassy*, vol.5 (trans. Healey et al.), pp 14–15.

75 This was a Mr Lloyd, also described as engineer-in-chief to the Admiralty.

76 *The Times*, 14 May 1862, p.12.

77 ibid.

78 *The Times*, 26 May 1862, p.9.

79 The North Seaton Colliery was then producing 1,000 tons of coal a day and employing 520 men and boys, of whom 320 were hewers. See *The Times*, 29 May 1862, p.14.

80 *The Times*, 29 May 1862, p.14.

81 The Kogyosha company established the first glassworks at Shinagawa, Tokyo, in 1873. Thomas Walton, an English engineer, was hired as an instructor.

82 Martha Chaiklin, 'A Miracle of Industry: The Struggle to Produce Sheet Glass in Modernizing Japan', in Morris Low (ed.), *Building a Modern Japan: Science, Technology and Medicine in the Meiji Era and Beyond* (Basingstoke: Macmillan, 2005), pp 166–7.

83 Muragaki, *The First Japanese Embassy*, p.45.

84 *The Times*, 6 May 1862, p.14.

85 *The Times*, 20 May 1862, p.7.

86 *The Times*, 14 May 1862, p.12.

87 *The Times*, 29 May 1862, p.14.

88 Kume, *The Iwakura Embassy*, vol.2, p.47.

89 ibid., p.70.

90 ibid., p.414.

91 ibid., p.73.

92 ibid., p.145.

93 ibid., p.168.

94 ibid., p.83.

95 ibid., p.47.

96 Kume, *The Iwakura Embassy*, vol.1, pp 363, 368–9.

97 ibid., p.202.

98 Muragaki, The *First Japanese Embassy*, p.67.

99 Kume, *The Iwakura Embassy*, vol.1, p.210.

100 Kume, *The Iwakura Embassy*, vol.2, p.70.

101 Kume, *The Iwakura Embassy*, vol.3, p.35.

102 ibid., p.30.

103 ibid., p.32.

104 ibid., p.33.

105 ibid., p.295.

106 ibid., p.305.

107 Kume, *The Iwakura Embassy*, vol.1, p.214.

108 Kume, *The Iwakura Embassy*, vol.2, p.403.

109 Although this might be the Higashi Honganji (the Eastern Temple of the Original Vow), founded by the *Shogun* Tokugawa Ieyasu in 1602, it is more likely to be the original foundation, the Nishi Honganji (the Western Temple of the Original Vow), built in 1568–98.

110 Kume, *The Iwakura Embassy*, vol.3, p.55.

111 Kume, *The Iwakura Embassy*, vol.4 (trans. P.F. Kornicki), p.293.

112 ibid., p.295.

113 ibid., pp 270–71.

114 Kume uses the word 'arch', written in *katakana* to mean both arch and vault.

115 Kume, *The Iwakura Embassy*, vol.4, p.271.

116 Kume, *The Iwakura Embassy*, vol.1, p.345.

117 Kume, *The Iwakura Embassy*, vol.4, p.40.

118 ibid., p.119.

119 Quoted in Daniel V. Botsman, *Punishment and Power in the Making of Modern Japan* (Princeton: Princeton University Press, 2005), p.149.

120 Kume, *The Iwakura Embassy*, vol.1, p.353.

121 Kume, *The Iwakura Embassy*, vol.2, p.169.

122 ibid., p.169.

123 Kume, *The Iwakura Embassy*, vol.3, p.135.

124 ibid., pp 341–3.

125 Kume, *The Iwakura Embassy*, vol.2, p.402.

126 Kume, *The Iwakura Embassy*, vol.5, p.98.

127 Moynier was to be a co-founder of the International Committee for Relief to the Wounded, which became the International Committee of the Red Cross.

128 See Botsman, *Punishment and Power*, pp 154–6.

129 Quoted in ibid., p.162.

130 Kume, *The Iwakura Embassy*, vol.3, p.227.

131 ibid., pp 246–7.

132 ibid., p.225.

133 ibid., p.229.

134 ibid., p.247.

135 Kume, *The Iwakura Embassy*, vol.1, pp 382–3.

136 Kume, *The Iwakura Embassy*, vol.2, p.49.

137 Kume, *The Iwakura Embassy*, vol.4, p.386. See also p.117.

138 Kume, *The Iwakura Embassy*, vol.5, p.52.

139 ibid., p.75.

140 ibid., p.71.

141 Kume, *The Iwakura Embassy*, vol.1, p.91.

142 ibid., p.109.

143 Kume, *The Iwakura Embassy*, vol.5, p.109.

144 Kume, *The Iwakura Embassy*, vol.3, p.338.

145 Kume, *The Iwakura Embassy*, vol.1, p.91.

146 Kume, *The Iwakura Embassy*, vol.3, pp 34–5.

147 Kume, *The Iwakura Embassy*, vol.4, p.386.

148 ibid., p.388.

149 ibid., pp 388–9.

150 Kume, *The Iwakura Embassy*, vol.2, pp 40–41.

151 Kume, *The Iwakura Embassy*, vol.3, p.40.

152 Kume, *The Iwakura Embassy*, vol.2, p.245.

153 *The Times*, 20 May 1862, p.7.

154 ibid.

155 ibid.

156 Laurence Oliphant, *Narrative of the Earl of Elgin's Mission to China and Japan in the Years 1857, '58, '59*, 2 vols (Edinburgh and London: William Blackwood and Sons, 1859), vol.2, p.171. At Hojee (*sic*), 'a charming village embosomed in a wood' and located about ten miles from Edo, were gardens favoured 'by pleasure-parties from Yedo of the highest rank'. There, Oliphant writes, 'Their wives play, dance, or sing for their benefit; in fact, so far as I could gather, they behave very much as we do when we are working off the fag-end of the season in picnics to the Star and Garter, or Hampton Court.' See vol.2, pp 167, 168.

157 Oliphant, *Narrative of the Earl of Elgin's Mission*, vol.2, p.166.

158 Kume, *The Iwakura Embassy*, vol.2, p.116.

159 Muragaki, The *First Japanese Embassy*, p.69.

3 The Houses of the People

1 Oliphant, *Narrative of the Earl of Elgin's Mission*, p.1.

2 ibid., p.10.

3 ibid., p.10.

4 ibid., p.51.

5 Charles MacFarlane, *Japan: An Account Geographical and Historical …* (New York: George P. Putnam, 1852), pp ix–x.

6 J. Willett Spalding, *Japan and Around the World: An Account of Three Visits to the Japanese Empire, with Sketches of Madeira, St Helena, Cape of Good Hope, Ceylon, Singapore, China and Loo-Choo* (New York: Redfield, 1855), p.134.

7 These were the 'twenty thousand hairy kuriles on the island of Yeso' referred to by Spalding in *Japan and Around the World*, p.308.

8 Henry Faulds, *Nine Years in Nipon: Sketches of Japanese Life and Manners* (London and Paisley: Alexander Gardner, 1885), p.vii.

9 See ibid., p.33.

10 Albert Berg, *Die preusiusche Expedition nach Ost-Asien: Ansichten aus Japan China und Siam* (Berlin: Königliche Geheime Ober-Hofbuchdruckerei, 1864–1873).

11 Johannes Justus Rein, *Japan: Travels and Researches, Undertaken at the Cost of the Prussian Government* (New York: A.C. Armstrong and Son, 1884), p.465.

12 ibid., p.468.

13 ibid., p.469 and plan facing, p.468.

14 Edward S. Morse, *Japanese Homes and Their Surroundings*, 2nd English edn [1st edn 1885] (London: Sampson Low, Marston, Searle & Rivington, 1888), p.xxviii.

15 He estimated that he travelled 1,715 miles. See Christopher Dresser, *Japan: Its Architecture, Art, and Art Manufactures* (London: Longmans, Green, and Co., 1882), p.213.

16 Karl Gegenbaur was Professor of Anatomy at Jena from 1855 to 1873 and Ernst Haeckel, who had studied under Gegenbaur, became Professor of Comparative Anatomy there in 1862. Both were supporters of Charles Darwin whose *On the Origin of Species* was published in 1859.

17 The University of Tokyo was officially opened in May 1877. In 1886 it became the Imperial University. Morse's invitation to teach here was made by David Murray, an advisor to the Japanese Ministry of Education (*Mombusho*). See Christopher Benfey, *The Great Wave* (New York: Random House, 2003), pp 57–61.

18 The Imperial College of Engineering was founded in 1873. The first principal was the Scotsman, Henry Dyer.

19 Conder had trained under Smith, who was his first cousin once removed: Conder's great-grandparents were Smith's grandparents.

20 Josiah Conder, 'Notes on Japanese Architecture', *Transactions of the RIBA*, 1877–1878, p.179.

21 ibid., p.86.

22 Josiah Conder, 'Domestic Architecture in Japan', *RIBA Transactions*, 1887, vol.3 (new series), pp 103–27.

23 In 1905 Conder built his own house which was half Western and half Japanese, his wife being Japanese.

24 See: https://en.wikipedia.org/wiki/Ryukyu_Islands#History, accessed 6 May 2018.

25 Bettelheim's use of the term Great Loo Choo to describe Okinawa, and by association Lesser Loo Choo, to describe Taiwan, reflects Chinese and not Japanese terminology.

26 Bayard Taylor, *A Visit to India, China and Japan in the Year 1853* (London: Sampson, Low and Son, 1855), p.369.

27 The Bishopric of Victoria in Hong Kong existed from 1849 to 1951 and ministered to Anglicans in Hong Kong and South China. George Smith was the first Bishop and held the position from 1849 to 1865.

28 George Smith, *Lewchew and the Lewchewans: Being a Narrative of a Visit to Lewchew, or Loo Choo, in October, 1850* (London: T. Hatchard, 1853), p.9.

29 Taylor, *A Visit to India*, p.369.

30 ibid., p.320.

31 Smith, *Lewchew and the Lewchewans*, p.12.

32 ibid., p.89.

33 ibid., p.10.

34 Their stroll is described in George Smith, *Ten Weeks in Japan* (London: Longman, Green, Longman and Roberts, 1861), p.343.

35 Smith, *Lewchew and the Lewchewans*, pp 12–13.

36 Spalding, *Japan and Around the World*, after p.112.

37 Taylor, *A Visit to India*, p.384.

38 Spalding, *Japan and Around the World*, pp 156–7.

39 Francis L. Hawks, *Narrative of the Expedition of an American Squadron to the China Seas and Japan Performed in the Years 1852, 1853, and 1854, Under the Command of Commodore M.C. Perry, United States Navy, By Order of the Government of the United States*, vol.1 (Washington: Beverley Tucker, Senate Printer, 1856), p.346.

40 ibid., pp 340, 342.

41 See ibid., p.346, and Spalding, *Japan and Around the World*, p.227.

42 Hawks, *Narrative of the Expedition*, vol.1, p.395.

43 Rutherford Alcock, *The Capital of the Tycoon: A Narrative of Three Years' Residence in Japan* (London: Longman, Green, Longman, Roberts & Green, 1863), vol.2, p.279.

44 ibid., p.279.

45 ibid.

46 ibid., p.280.

47 ibid.

48 Dresser, *Japan*, p.23.

49 Morse, *Japanese Homes*, p.11.

50 Rein, *Japan*, p.419.

51 ibid.

52 Morse, *Japanese Homes*, p.12.

53 ibid.

54 Rein, *Japan*, p.389.

55 Morse, *Japanese Homes*, p.viii.

56 ibid., p.248.

57 ibid., p.13.

58 Mrs Annie Brassey, *A Voyage in the 'Sunbeam', Our Home on the Ocean for Eleven Months* (Chicago: Belford, Clarke & Co., 1881), p.319.

59 Morse, *Japanese Homes*, p.26.

60 ibid.

61 William Dobson and John Harland, *History of the Preston Guild, the Ordinances of Various Guilds of Preston, the Charters of the Borough, the Incorporated Companies, List of Mayors from 1327 &c.* (Preston: W. & J. Dobson, 1862).

62 Faulds, *Nine Years in Nipon*, p.66.

63 ibid., pp 67–8.

64 Hawks, *Narrative of the Expedition*, vol.1, p.404.

65 ibid., p.438.

66 Morse, *Japanese Homes*, p.10.

67 ibid., p.11.

68 ibid., p.26.

69 *Hints on Household Taste* was first published in London in 1868 and then in Boston, Massachusetts, in 1872.

70 The architectural allusion implied by the Eastlake style is largely unknown in Britain but in America has some credence. Vincent Scully argues that 'the epithet "Eastlake" applied to houses of the early [eighteen-] seventies – an epithet coined by the Eclectic Apologists of the early twentieth century – cannot be regarded as a very satisfactory designation'. Morse's early application of the epithet, however, would suggest that Scully was wrong. See Vincent J. Scully Jr., *The Shingle Style and the Stick Style: Architectural Theory and Design from Downing to the Origins of Wright* (New Haven: Yale University Press, 1971), p.lv, n.90.

71 Morse, *Japanese Homes*, p.26.

72 ibid., p.23.

73 Conder, 'Domestic Architecture in Japan', p.104.

74 Dresser, *Japan*, p.235.

75 Hawks, *Narrative of the Expedition*, vol.1, p.439.

76 John La Farge, *An Artist's Letters From Japan* (London: Waterstone; New York: Hippocrene Books, 1986 [1897]), p.76.

77 Morse, *Japanese Homes*, p.106.

78 Hawks, *Narrative of the Expedition*, vol.1, pp 404–5.

79 Robert Fortune, *Yedo and Peking: A Narrative of a Journey to the Capitals of Japan and China* (London: John Murray, 1863), p.50.

80 ibid., p.50.

81 La Farge, *An Artist's Letters*, pp 76–7.

82 Conder, 'Domestic Architecture in Japan', p.105.

83 Tanizaki, Jun'ichirō, *In Praise of Shadows* (London: Vintage Books, 2001), p.29.

84 Dresser, *Japan*, p.255.

85 J.M. Tronson, *Personal Narrative of a Voyage to Japan, Kamtschatka, Siberia, Tartary, and various parts of the coast of China, in HMS 'Barracouta'* (London: Smith, Elder and Co., 1859), quoted in Hugh Cortazzi, *Victorians in Japan: In and Around the Treaty Ports* (London and Atlantic Heights, NJ: The Athlone Press, 1987), p.35.

86 Hawks, *Narrative of the Expedition*, vol.1, p.439.

87 ibid., p.439.

88 Oliphant, *Narrative of the Earl of Elgin's Mission*, pp 18–19.

89 See 'Street in Kanagawa – The Tokaido or Imperial Highway', in Fortune, *Yedo and Peking*, p.32.

90 Thomas Clark Westfield, *The Japanese; Their Manners and Customs* (London: Photographic News Office, 1862), p.13.

91 Brassey, *A Voyage in the 'Sunbeam'*, pp 325–6.

92 Conder, 'Notes on Japanese Architecture', pp 179–92. The paper was read *in absentia* at the RIBA by Thomas Roger Smith on 4 March 1878.

93 ibid., p.180.

94 Conder, 'Domestic Architecture in Japan', p.106.

95 'Discussion of Mr Conder's Paper – Notes on Japanese Architecture', *Transactions of the Royal Institute of British Architects*, 1877–1878, p.210.

96 ibid., p.211.

97 Morse, *Japanese Homes*, pp 54–5.

98 La Farge, *An Artist's Letters*, p.82.

99 ibid., p.83.

100 Morse, *Japanese Homes*, pp 241–2.

101 Captain Bernard Whittingham, *Notes on the Late Expedition Against the Russian Settlements in Eastern Siberia; and of a Visit to Japan and to the Shores of Tartary and of the Sea of Okhostk* (London: Longman, Brown, Green, and Longmans, 1856), p.32.

102 Isabella L. Bird, *Unbeaten Tracks in Japan: An account of travels in the interior including visits to the aborigines of Yezo and the shrine of Nikko*, 4th edn (London: John Murray, 1893), p.18.

103 Morse, *Japanese Homes*, p.235.

104 ibid.

105 Brassey, *A Voyage in the 'Sunbeam'*, pp 318–19.

106 Bird, *Unbeaten Tracks*, pp 111–12.

107 Oliphant, *Narrative of the Earl of Elgin's Mission*, vol.2, p.120.

108 ibid., p.19.

109 Hawks, *Narrative of the Expedition*, vol.1, p.439.

110 Rudyard Kipling, *From Sea to Sea and Other Sketches*, *1*, *Letters of Travel*, 2 vols (London: Macmillan, 1917), p.154.

111 Dresser, *Japan*, p.264.

112 ibid., pp 264–5.

113 Faulds, *Nine Years in Nipon*, p.266.

114 Oliphant, *Narrative of the Earl of Elgin's Mission*, vol.2, p.388.

115 Morse, *Japanese Homes*, p.320.

116 ibid., p.169.

117 Oliphant, *Narrative of the Earl of Elgin's Mission*, vol.2, p.388.

118 La Farge, *An Artist's Letters*, p.78.

119 ibid.

120 Conder, 'Domestic Architecture in Japan', vol.3, p.110.

121 ibid., p.111.

122 From a paper on 'Feudalism in Japan', read at the Author's Club on 6 November 1911. Hugh Cortazzi (ed.), *Mitford's Japan: The Memoirs and Recollections, 1866–1906, of Algernon Bertram Mitford, the first Lord Redesdale* (London and Dover, NH: The Athlone Press, 1985).

123 Cooper, *They Came to Japan*, p.131.

124 This difference is identified by Walter Gropius in Walter Gropius, Kenzo Tange and Yasuhiro Ishimoto, *Katsura: Tradition and Creation in Japanese Architecture* (Tokyo: Zōkeisha Publications, Tokyo; and New Haven: Yale University Press, 1960) and Bayer p.4.

125 Morse, *Japanese Homes*, pp 135–6.

126 ibid., p.136.

127 Rein, *Japan*, p.465.

128 'The Great Fire at Yokohama', *The Illustrated London News*, issue 1412, 9 February 1867, p.128. A very similar description appears in Mitford's paper on 'Feudalism in Japan' of 1911, suggesting that he might have sent the original report of the fire to *The Illustrated London News*. See Cortazzi, *Mitford's Japan*, p.25.

129 From Mitford's paper on 'Feudalism in Japan', read at the Author's Club on 6 November 1911, in Cortazzi, *Mitford's Japan*, p.95.

130 Smith, *Ten Weeks in Japan*, p.91.

131 ibid.

132 Morse, *Japanese Homes*, p.34.

133 ibid., p.33.

134 Dresser, *Japan*, p.250.

135 ibid., p.102.

136 ibid., pp 102–3.

137 ibid., p.102.

138 ibid., p.203.

139 ibid., pp 204–5.

140 La Farge, *An Artist's Letters*, p.77.

141 ibid.

142 Dresser, *Japan*, p.238.

143 ibid., p.233.

144 ibid., p.229.

145 ibid., p.234.

146 ibid., p.115.

147 ibid., p.209.

148 Hawks, *Narrative of the Expedition*, vol.1, p.463.

149 Alcock, *The Capital of the Tycoon*, vol.2, p.280.

150 ibid., p.299.

151 Kinahan Cornwallis, *Two Journeys to Japan, 1856–57*, vol.1 (London: Thomas Cautley Newby, 1859), p.167.

152 Bird, *Unbeaten Tracks*, n.p.

153 ibid.

154 Cortazzi, *Victorians in Japan*, pp 193–4.

155 Dresser, *Japan*, p.250.

156 According to tradition, the Inner Shrine was founded in 4 BC, but historians date it to the third century AD. The Outer Shrine was founded in the late fifth century AD. Around 680 AD, Emperor Tenmu established Ise as the primary Shinto shrine of Imperial Japan and built the first temple on the site. The first rebuilding ceremony took place under his wife, Empress Jitō, in 692.

157 Dresser, *Japan*, p.250.

158 This is encapsulated in the allegorical engraving of the Vitruvian primitive hut shown in the frontispiece to Marc-Antoine Laugier's *Essai sur L'architecture*, 2nd edn (Paris: Duchesne, 1755).

159 Dresser, *Japan*, pp 250–51.

160 ibid., p.251.

161 ibid., p.243.

162 La Farge, *An Artist's Letters*, p.75.

163 Morse, *Japanese Homes*, p.xxvi.

164 ibid., p.xxxii.

4 The Japanese Pavilions

1 For example, the interior of the Armoury, St James's Palace, London, 1866–69.

2 For example, *The Beloved*, 1865–66, Tate Britain, London.

3 For example, *Caprice in Purple and Gold: the golden screen*, 1864, Freer Gallery of Art, Smithsonian Institution, Washington, DC.

4 'Japanese Art at Vienna', *The Times*, 20 May 1873, p.10.

5 ibid.

6 Quoted in P.F. Kornicki, 'Public Display and Changing Values: Early Meiji Exhibitions and Their Precursors', *Monumenta Nipponica*, vol.49, no.2, Summer 1994, p.169. Kornicki gives the initial publication date for *Seiyō Jijō* as 1866; other sources give it as 1867 and 1868.

7 *Official Catalogue of the Japanese Section, and Descriptive Notes on the Industry and Agriculture of Japan* (Philadelphia: The Japanese Commission, 1876), p.51.

8 See Olive Checkland, *Japan and Britain after 1859: Creating Cultural Bridges* (London: RoutledgeCurzon, 2003), pp 45–9.

9 'The Chinese Court at the Vienna Exhibition', *The Times*, 1 November 1873, p.4.

10 See Cobbing, *The Japanese Discovery*, pp 27–8; Ellen P. Conant, 'Refractions of the Rising Sun: Japan's Participation in International Exhibitions 1862–1910', in Tomoko Sato and Toshio Watanabe, *Japan and Britain: An Aesthetic Dialogue 1850–1930* (London: Lund Humphries, 1991), p.82; and also Checkland, *Japan and Britain*, p.44. Checkland, however, does not mention the Hizen presence.

11 The Satsuma wished to develop trade links with Europe and the Hizen wanted to order a warship from the Dutch. See http://blog.gale.cengage.co.uk/index.php/2017/04/13/the-paris-international-exposition-of-1867/, accessed 4 February 2018.

12 Eugene Rimmel, *Recollections of the Paris Exposition of 1867* (Philadelphia: J.P. Lippincott, 1868), p.252.

13 The exhibition is described in both *The Imperial Almanac and Paris Exhibition Guide for 1867* (London: Clayton and Co., 1866) and in David Thomas Ansted (ed.), *Black's Guide to Paris and the International Exhibition of 1867* (Edinburgh: Adam and Charles Black, 1867).

14 Philippe Burty, 'Le Mobilier moderne', *Gazette des Beaux-Arts*, January 1868, pp 26–45.

15 Paul Bellet, 'Les Costumes populaires du Japon', in François Ducuing, *L'Exposition Universelle de 1867* (Paris: Bureaux d'Abonnements, 1867), Sommaire de la 23ième livraison, 22 July 1867, para. vii, p.362.

16 'One enters, and there, a thousand leagues from France, one is in the middle of Japan.' Bellet, 'Les Costumes populaires du Japon', in ibid., p.362.

17 An engraving in *Le Monde Illustré*, 1867, reproduced in Christian Polak, *Soie et lumières: L'âge d'or des échanges franco-japonais (des origines aux années 1950)* (Tokyo: Chambre de Commerce et d'Industrie Française du Japon,

2001), shows the Chinese pavilion with the Japanese flag behind it. There is no evidence of either Japanese pavilion in this illustration.

18 Anon., 'The round of the restaurants at the Paris exhibition. – II', *The Pall Mall Gazette*, 14 August 1867, p.10.

19 *Official Catalogue of the Japanese Section*, p.51.

20 Checkland, *Japan and Britain*, p.17.

21 The catalogue reads: 'In the countries of the West there is an excellent custom of holding what are called *hakurankai* … thus spreading knowledge and encouraging people to innovate and to profit from their inventions. Wishing to follow this good example …' Kornicki, 'Public Display', p.190.

22 The Iwakura Embassy visited the exhibition on 6, 9, 14, 16 and 17 June 1873.

23 Kume, *The Iwakura Embassy*, vol.5, p.32.

24 'Opening of the Vienna Exhibition', *The Illustrated London News*, 10 May 1873, p.433.

25 'The Vienna Exhibition', *The Times*, 3 July 1873, p.5.

26 Kume, *The Iwakura Embassy*, vol.5, p.40.

27 ibid.

28 See Tanaka, Yoshio and Hirayama, Shigenobu (eds), *Oukokuhakurankai sandou kiyou* (Tokyo, 1897) (National Diet Library: YDM42151).

29 A rainbow beam is thus called because it is slightly curved and tapered at the ends. They are unique to the Great Buddha style, being nearly round in section and having a groove in the soffit in the shape of a monk's staff. See Nishi Kazuo and Hozumi Kazuo, *What Is Japanese Architecture?* (Tokyo, New York and London: Kodansha International, 1983), p.25.

30 John M. MacKenzie, *Orientalism: History, Theory and the Arts* (Manchester: Manchester University Press, 1995), p.128.

31 Edward Walford, *Old and New London: A Narrative of Its History, Its People, and Its Places. The Western and Northern Suburbs*, vol.5 (London, Paris and New York: Cassell, Petter & Galpin, 1878), pp 428–37.

32 The firm of Jackson and Graham (1836–85) were leading furniture makers with extensive premises on Tottenham Court Road, London.

33 Streeter was a leading diamond and gem-stone dealer who published *Pearls and Pearling Life* (London: G. Bell and Sons) in 1886.

34 Hugh Cortazzi, *Japan in Late Victorian London: The Japanese Village in Knightsbridge and the Mikado, 1885* (Norwich: Sainsbury Institute for the Study of Japanese Arts and Culture, 2009), p.3. Cortazzi mistakenly calls Streeter 'Edward'.

35 ibid.

36 ibid.

37 ibid.

38 ibid.

39 ibid.

40 'Advance Victoria', *Herald*, Melbourne, 2 September 1875, quoted in Checkland, *Japan and Britain*, p.24.

41 'The Exhibition. A Comparison with the Vienna Weltaustellung', *The Boston Daily Advertiser*, Boston, 22 May 1876, n.p.

42 The 12 countries were Australia, Brazil, Canada, Egypt, Germany, Great Britain, Morocco, Spain, Sweden, Turkey, Austria and France. See 'Our Centennial Show', *Inter Ocean*, Chicago, 10 May 1876, p.2.

43 *Official Catalogue of the Japanese Section*, p.3.

44 *Official Catalogue of the Japanese Section*, p.4. Checkland, *Japan and Britain*, p.17, says that 360,000 Yen was invested in the exhibition.

45 'Sights at the Centennial', *The Daily Rocky Mountain News*, Denver, 3 May 1876, n.p. The full sentence reads as follows: 'China and Japan contend with each other in striving to present the best specimen of bamboo architecture and to paint on their commissioners' offices, of the tea-caddie style, the ugliest old grannies with bald pates, expressionless almond eyes and queues that many a cabbie Jehu sighs for as he looks at his worn-out whip.'

46 'Oriental Toy Men. The Bazaar of the Red Moon at the Great Centennial Exhibition', *The Milwaukee Daily Sentinel*, Milwaukee, 25 July 1876, p.3.

47 'The Japanese Building', *Frank Leslie's Illustrated Newspaper*, New York, 1 April 1876, p.60.

48 Thompson Westcott, *Centennial Portfolio: A Souvenir of the International Exhibition at Philadelphia* (Philadelphia: Thomas Hunter, 1876), p.22, quoted in Clay Lancaster, 'Japanese Buildings in the United States Before 1900: Their Influence Upon American Domestic Architecture', *The Art Bulletin*, vol.35, no.3, September 1953, p.218.

49 Kaempfer, *The History of Japan*, vol.2, pp 411–12.

50 'The Centennial Exhibition', *The Georgia Weekly Telegraph and Georgia Journal and Messenger*, Macon, 13 June 1876, issue 43, col. F.

51 'Japanese Work at the Centennial Grounds', *The American Architect and Building News*, 12 February 1876, p.56.

52 ibid., p.55.

53 'Japanese Architecture', *The American Architect and Building News*, 2 April 1876, p.136.

54 'Japanese Work at the Centennial Grounds', *The American Architect and Building News*, 12 February 1876, p.55.

55 ibid., p.56.

56 Westcott, *Centennial Portfolio*, p.22, quoted in Lancaster, 'Japanese Buildings', p.218.

57 'Class 330. – Civil Engineering, etc.', *Official Catalogue of the Japanese Section, and Descriptive Notes on the Industry and Agriculture of Japan* (Philadelphia: The Japanese Commission, 1876), pp 94–6.

58 'Class 102. – Building Stones, etc.', *Official Catalogue of the Japanese Section*, p.45.

59 ibid.

60 'Oriental Toy Men. The Bazaar of the Red Moon at the Great Centennial Exhibition', *The Milwaukee Daily Sentinel*, Milwaukee, 25 July 1876, p.3.

61 *The Inter Ocean*, Chicago, 23 June 1876, p.2.

62 The *Nisshōki* or 'sun-mark' flag, more often known as the *Hinomaru* or 'sun disk', was the national flag between 1870 and 1885. Its then recent adoption would perhaps account for its unfamiliarity in the West.

63 *The Milwaukee Daily Sentinel*, 25 June 1876, p.3.

64 'The Centennial Exhibition', *The Georgia Weekly Telegraph and Georgia Journal and Messenger*, Macon, 13 June 1876, issue 43, col. F.

65 There were four Expositions Universelles in Paris during the period under consideration: 1855, 1867, 1878 and 1889, the last celebrating the centenary of the French Revolution.

66 Charles Blanc, quoted in Philippe Burty, 'Le Japon ancien et le Japon moderne', in *L'Art*, 4$^{\text{ième}}$ année, vol.4, bk.15, 1878, pp 242–3.

67 Paul Sédille, 'L'Architecture au Champ de Mars et au Trocadéro – 2: L'Architecture étrangère', *Gazette des Beaux-Arts*, July to December 1878, pp 732–52.

68 Burty, 'Le Japon ancien et le Japon moderne', pp 242–3.

69 'Men of taste'.

70 'Jamais cette vérité que l'architecture est un art essentiellement relatif, n'a été plus sensible, plus clairement exprimée.' Burty, 'Le Japon ancien et la Japon moderne', pp 242–3.

71 Sédille, 'L'Architecture au Champ de Mars et au Trocadéro', pp 732–52.

72 ibid.

73 See P.F. Kornicki, 'Japan at the Australian Exhibitions', *Australian Studies*, vol.8, 1994, pp 15–60.

74 For the 19 international exhibitions in which Japan participated between 1873 and 1893, see Checkland, *Japan and Britain*, p.17.

75 'Japan at the Health Exhibition', *The Times*, 28 August 1884, p.2 states: 'Owing to various causes, it was late in February before the Japanese Government decided to be represented at the Exhibition.'

76 See the Supplement to *The Illustrated London News*, 2 August 1884.

77 'Japan at the Health Exhibition', *The Times*, 28 August 1884, p.2.

78 'The Health Exhibition Japanese Restaurant', *The Times*, 17 September 1884, p.4.

79 ibid.

80 'Japan at the Health Exhibition', *The Times*, 28 August 1884, p.2.

81 ibid. The population figure given here, checked against current information based on the *koseki* registration system, overestimates by about one per cent.

82 In 1881, the population of Great Britain and Ireland was just over 35 million and that of England and Wales 12.6 million. The 1870 Education Act, known as Forster's Education Act, provided for the schooling of all children between five and 12 in England and Wales.

83 'Japan at the Health Exhibition', *The Times*, 28 August 1884, p.2.

84 Dresser, *Japan*, p.20.

85 'Japan at the Health Exhibition', *The Times*, 28 August 1884, p.2.

86 ibid.

87 ibid.

88 Dresser, *Japan*, p.23.

89 Hart was also a member of the Executive Council of the International Health Exhibition.

90 Ernest Hart, 'Abstract of a Lecture of the International Health Exhibition of 1884: Its Influences and Possible Sequels', *British Medical Journal*, 6 December 1884, p.1121.

91 See *The Building News*, 12 September 1884, p.424.

92 Buhicrosan was probably born in Nagasaki to a Dutch father and Japanese mother.

93 See John Greenacombe (ed.), *The Survey of London, Vol. 45, Knightsbridge* (London: Athlone Press, 2000), p.85, and 'Sir R. Alcock on Japanese Work', *The Times*, 12 January 1885, p.10.

94 'A Japanese Village in London', *The Times*, 10 January 1885, p.6.

95 ibid.

96 *The Builder*, 17 January 1885, p.96.

97 'A Japanese Village in London', *The Times*, 10 January 1885, p.6.

98 *The Builder*, 17 January 1885, p.96.

99 'A Japanese Village', *The Building News*, 16 January 1885, p.78.

100 ibid., pp 77–8.

101 'Temple etc., at the Japanese Village', *The Building News*, 23 January 1885, p.121.

102 *The Building News*, 30 January 1885, p.189.

103 See Cortazzi, *Japan in Late Victorian London*, p.39.

104 See Greenacombe, *The Survey of London*, p.85. See also Cortazzi, *Japan in Late Victorian London*, pp 60–64.

105 *The Illustrated London News*, 21 February 1885, p.203.

106 'A Japanese Village in London', *The Times*, 10 January 1885, p.6.

107 Cortazzi, *Japan in Late Victorian London*, pp 9–10.

108 'Burning of the Japanese Village', *The Times*, 4 May 1885, p.10. A similar report is given in *The Builder*, 9 May 1885, p.649: 'The shops were composed of light wood and matting, and a variety of trades were carried on therein. The shops and streets were lighted by gas at night, and, considering the time the place has been open, there is very little doubt that the whole of the interior was of a most inflammable character ... The building, which was surrounded by dwellings, was completely gutted in an hour ...'

109 'The Japanese Village', *The Times*, 15 May 1885, p.8.

110 'The Japanese Village', *The Times*, 8 May 1885, p.11.

111 'Burning of the Japanese Village', *The Times*, 4 May 1885, p.10.

112 At the time Kyoto was still known as Saikyo, the 'western capital'.

113 Cortazzi, *Japan in Late Victorian London*, p.43.

114 'The Japanese Village', *The Times*, 2 December 1885, p.6.

115 ibid.

116 ibid.

117 See Greenacombe, *The Survey of London*, p.85.

118 Cortazzi, *Japan in Late Victorian London*, p.47.

119 'The Bank Holiday', *The Times*, 6 August 1889, p.9. See also *The Times*, 22 August 1889, p.1.

120 Cortazzi, *Japan in Late Victorian London*, p.48.

121 This was an opinion expressed in the Japanese newspaper *Jiji Shimpo* in April 1886. See Cortazzi, *Japan in Late Victorian London*, p.47.

122 J-T. Dybowski, *La Nature*, 7 September 1889, n.p.

123 Charles Garnier, *L'Habitation Humaine* (Paris: Hachette, 1892), quoted in Zeynep Çelik, *Displaying the Orient: Architecture of Islam at Nineteenth-century World's Fairs* (Berkeley: University of California Press, 1992), p.71.

124 ibid., p.72.

125 Louis Gonse, 'L'Architecture à l'Exposition universelle', *Gazette des Beaux-Arts*, November 1889, pp 465–86.

126 At the dedication ceremony, the Japanese delegation commented that '... our country was among the first to express her willingness to participate ...' and expressed appreciation for '... the assignment of the most favourable space ...' President Palmer, of the National Commission, noted that 'Japan was the first Nation to make an appropriation for the exposition ...' See 'Triumph for Japan. Formal dedication of artistic Hooden palace', *The Daily Inter Ocean*, Chicago, 1 April 1893, p.5, issue 8, col. D.

127 Sullivan designed the Transportation Building, but it was neither white nor Renaissance in style.

128 Louis Sullivan, *The Autobiography of an Idea* (New York: Dover Publications Inc., 1956), p.322.

129 ibid.

130 ibid.

131 Cherie Wendelken, 'The Tectonics of Japanese Style: Architect and Carpenter in the Late Meiji Period', *Art Journal*, vol.55, no.3, 'Japan 1868–1945: Art, Architecture and National Identity', Autumn 1996, p.37, n.18.

132 See the President of the Commission's speech reported in 'Triumph for Japan. Formal dedication of artistic Hooden palace', *The Daily Inter Ocean*, Chicago, 1 April 1893, p.5, issue 8, col. D. The great Chicago fire had been in 1871.

133 'Workmen of Japan', *Oak Park Reporter*, December 1892, n.p., reproduced in Kevin Nute, *Frank Lloyd Wright and Japan: The Role of Traditional Japanese Art and Architecture in the Work of Frank Lloyd Wright* (Abingdon: Routledge, 2000 [1992]), p.54.

134 Anon, 'The World's Columbian Exposition: The Japanese Village', *Harper's Weekly* 37, no.1891 (18 March 1893), p.259, quoted in Nute, *Frank Lloyd Wright*, p.53.

135 'Workmen of Japan', *Oak Park Reporter*, December 1892, n.p., reproduced in Nute, *Frank Lloyd Wright*, p.54.

136 'Japanese Building at the World's Fair', *The Daily Inter Ocean*, Chicago, 15 January 1893, n.p.

137 'Triumph for Japan. Formal dedication of artistic Hooden palace', *The Daily Inter Ocean*, Chicago, 1 April 1893, p.5, issue 8, col. D.

138 The north wing was in the manner of the Heian period (894–1195), the south wing in that of the Muromachi period (1436–1490), and the central hall in that of the Tokugawa period (1603–1868). For a full description and explanation of the spaces, see Nute, *Frank Lloyd Wright*, pp 56–9, and David B. Stewart, *The Making of Modern Japanese Architecture from the Founders to Shinohara and Isozaki* (Tokyo, New York and London: Kodansha International, 2002), p.71.

139 See Bruce Brooks Pfeiffer (ed.), *Frank Lloyd Wright: Collected Writings*, vol.5 (New York: Rizzoli, 1995), p.70.

140 See Nute, *Frank Lloyd Wright*, pp 65–6. Hitchcock says: 'The Ho Ho Den ... had had, contrary to generally accepted theory, almost no immediate effect on Wright.' See Henry-Russel Hitchcock, *In the Nature of Materials: The Buildings of Frank Lloyd Wright, 1887–1941* (New York: Da Capo Press, 1975), p.26.

141 Randell L. Makinson, *Greene and Greene: Architecture as Fine Art* (Salt Lake City and Santa Barbara: Peregrine Smith Inc., 1977), p.32.

142 Mahony graduated with a bachelor's degree in architecture in 1894, only the second woman to do so. She was a talented perspectivist, who worked for Wright and was to marry Walter Burly Griffin (1876–1937).

143 Marion Mahony Griffin, unpublished interview with Grant Carpenter Manson, quoted in Janice Pregliasco, 'The Life and Work of Marion Mahony Griffin', *Art Institute of Chicago Museum Studies*, vol.21, no.2, 'The Prairie School: Design Vision for the Midwest' (1995), p.173.

144 This attribution is made in Stewart, *The Making of Modern Japanese Architecture*, p.71.

145 Grant Carpenter Manson, *Frank Lloyd Wright to 1910: The First Golden Age* (New York: Reinhold Publishing Corporation, 1958), quoted in Stewart, *The Making of Modern Japanese Architecture*, p.71.

146 'They have no architecture.' See Alcock, *The Capital of the Tycoon*, vol.2, p.279.

147 This still survives as the oldest Japanese tea-garden in the United States.

148 Marsh, who spoke Japanese fluently, established G.T. Marsh and Co.: Japanese Art Repository in San Francisco in 1876, the oldest oriental art store in the United States, with branches eventually in Coronado, Los Angeles, Santa Barbara and Monterey. Born near Melbourne, Australia, his family emigrated to California via Yokohama where, aged 15, he remained alone for four years working for a tea import/export house and auction firm.

149 Hagiwara had immigrated to the United States in 1879.

150 Arthur Chandler and Marvin Nathan, *The Story of the California Midwinter International Exposition, San Francisco, California, 1894* (St Paul, Minnesota: Pogo Press, 1994), p.51.

151 There were no Japanese contestants at the 1900 Olympic Games. The first Olympic Games in which the Japanese participated was that in Stockholm in 1912, to which they sent two athletes.

152 *Le Patriote*, 4 November 1904: a label displayed at La Tour japonaise, Laeken.

153 Hoshi Hajime, *Handbook of Japan and Japanese Exhibits at World's Fair, St. Louis, 1904* (St Louis: Woodward and Tieman Print Company, 1904), p.5.

154 ibid., pp 114–15.

5 The Art-Architects

1 The date of 1856 was first given by Léonce Bénédite in 'Felix Bracquemond, l'animalier', *Art et Décoration*, 17, February 1905, pp 37–47. Watanabe suggests 1859–60. See Toshio Watanabe, *High Victorian Japonisme* (Berne: Peter Lang, 1991), p.85.

2 Burty used the term as the title of a series of articles published in *La Renaissance littéraire et artistique* in 1872–73. For Burty and Japonisme, see Watanabe, *High Victorian Japonisme*, p.13.

3 Philippe Burty, 'Japonism', *The Academy*, 7 August 1875, p.150, quoted in Watanabe, *High Victorian Japonisme*, p.13.

4 See J. Mordaunt Crook, *William Burges and the High Victorian Dream* (London: John Murray, 1981), p.58.

5 For Billy Burges, see Crook, *William Burges*, pp 86ff.

6 Henry Stacy Marks, *Pen and Pencil Sketches, Vol. 1* (London: Chatto and Windus, 1894), p.221.

7 'Friends in Council: No.15. William Burges ARA', *The British Architect*, 29 April 1881, pp 213–14.

8 See Aileen Reed, '"Theoria" in Practice: E.W. Godwin, Ruskin and Art-Architecture', in Rebecca Daniels and Geoff Brandwood (eds), *Ruskin & Architecture* (Reading: Spire Books, 2003), pp 278–317.

9 Information supplied by Aileen Reed.

10 G.A.F. Rogers, *The Arts Club and Its Members* (London: Truslove and Hanson Ltd, 1920).

11 See Stefan Muthesius, *The High Victorian Movement in Architecture 1850–1870* (London and Boston: Routledge and Kegan Paul, 1972), p.157.

12 William Burges, 'The International Exhibition', *The Gentleman's Magazine and Historical Review*, June 1862, pp 663–76; Burges, 'The International Exhibition', July 1862, pp 3–12; Burges, 'The Japanese Court in the International Exhibition', September 1862, pp 243–54.

13 Burges, 'The International Exhibition', June 1862, p.665.

14 Burges, 'The International Exhibition', July 1862, p.9.

15 ibid., pp 10–11.

16 Burges, 'The Japanese Court in the International Exhibition', September 1862, p.251.

17 ibid., p.254.

18 Dresser, *Japan*, p.262.

19 ibid., p.263.

20 See ibid., p.266, fig.102.

21 ibid., p.263.

22 See 'A Warehouse in Upper Thames Street', *The Builder*, 17 November 1866, p.851; 'New Warehouse, 46, Upper-Thames Street', *The Building News*, 23 November 1866, p.783, illus. p.780.

23 See Dresser, *Japan*, p.121, fig.37.

24 Charles L. Eastlake, *A History of the Gothic Revival* (London: John Murray, 1872), p.366.

25 'New Warehouse, 46, Upper-Thames Street', *The Building News*, 23 November 1866, p.783, illus. p.780.

26 'New Warehouse in Thames Street', *The Ecclesiologist*, October 1866, p.310.

27 RIBA drawings collection, William Burges, *Orfévrerie domestique*, 26.

28 *Art Journal*, 1886, p.180, quoted in Crook, *William Burges*, 1981, p.139.

29 Watanabe, *High Victorian Japonisme*, pp 170–77.

30 John Burley Waring, *Masterpieces of Industrial Art and Sculpture at the International Exhibition 1862* (London: Day and Son, 1863), vol.3, pl.288. The cabinet belonged to Sir Rutherford Alcock.

31 Waring, *Masterpieces*, vol.3, pl.288.

32 For illustrations of Burges's furniture and other work, see Crook, *William Burges*.

33 Christopher Dresser, 'Japanese Ornament', *The Builder*, 13 June 1863, p.423.

34 Leighton worked under the pseudonym Luke Limner (a limner being a painter). See John Leighton, 'On Japanese Art', *The Journal of the Society of Arts*, 24 July 1863, p.598.

35 Dresser, 'Japanese Ornament', p.423.

36 ibid., illus. p.424.

37 In December 1854 Newman wrote from Dublin to Pollen: 'I want very much to be able to induce you to come to Dublin – in the capacity of Professor or Lecturer in the Fine Arts in our University ... As to the decoration of a University Church ... we must have a Church, temporary or permanent, and it must be decorated – and I should be very much obliged by your assistance in the decoration.' Quoted by Eileen Kane, 'John Henry Newman's Catholic University Church Revisited', *Artefact* I, Autumn 2007, p.9.

38 There are also roundels on the semi-dome of the apse which are painted in the same (Western) manner, and on a similar ground as those which Pollen painted on the ceiling of the chapel at Merton College, Oxford, in 1850. At Merton, the roundels at the top of the roof showed figures of angels in white robes playing musical instruments and those at the bottom contained heads of saints. The ground shows curling oak branches with leaves and acorns. See 'Ecclesiological Works at Oxford', *The Ecclesiologist*, October 1853, pp 302–3.

39 See 'Chinese No.2' and 'Chinese No.3' in Owen Jones, *The Grammar of Ornament* (London: Day and Sons,

1856), pl.lxi. Roundels were also included in the plates showing 'Nineveh & Persia' and 'The Middle Ages'.

40 Mary Bennett writes: '... in the early 1860s Brown and Rossetti produced their most recognised and innovative frames.' Mary Bennett, *Ford Madox Brown: A Catalogue Raisonné*, 2 vols (London and New Haven: Yale University Press, 2010), vol.2, p.599. In the opinion of Laura MacCulloch, it is not possible to say that Rossetti produced roundel-style frames before 1862. For more on Rossetti, see Laura MacCulloch, *The Influence of Japan on Dante Gabriel Rossetti 1854–1872*, MPhil thesis, University of Birmingham, 2005.

41 See Andrew Saint, *Richard Norman Shaw* (New Haven and London: Yale University Press, 1976), p.22, fig.11.

42 Shaw would have known these from G.E. Street's book, *Brick and Marble in the Middle Age: Notes of a Tour in the North of Italy* (London: John Murray, 1855), where on p.162 he writes: 'There are, throughout this front, many medallions of dark marble, which, let into a field of light marble, are most brilliant in their effect.'

43 J.M. Brydon, 'William Eden Nesfield, 1835–1888', *The Architectural Review*, April 1897, pp 236–8. Quoted in Watanabe, *High Victorian Japonisme*, pp 178–9.

44 Solomon, in a letter to Algernon Swinburne, quoted in Watanabe, *High Victorian Japonisme*, p.179.

45 Marcus B. Huish, 'England's Appreciation of Japanese Art', *Transactions and Proceedings of the Japan Society*, vol.7, 1906, p.137, quoted in Watanabe, *High Victorian Japonisme*, p.184.

46 See Saint, *Richard Norman Shaw*, p.34.

47 Eastlake, *Gothic Revival*, p.341.

48 'Cloverley Hall, Shropshire ...', *The Building News*, 8 June 1881, p.642.

49 In *Gothic Revival*, p.341, Eastlake writes that 'the scheme of this pattern, like that of others in the house, is eminently suggestive of a Japanese origin'. Much of *The Building News* article of 8 June 1881 is drawn almost verbatim from Eastlake.

50 Watanabe suggests that these may be based upon *hōsōge*, derived from the lotus flower and the peony. See Watanabe, *High Victorian Japonisme*, p.180.

51 Nesfield's drawings for Cloverley Hall are held in the Prints and Drawings Study Room, Victoria & Albert Museum, London. Ref.no. D.1401–1907.

52 Brydon, 'William Eden Nesfield, 1835–1888', *The Architectural Review*, April 1897, p.242.

53 Leighton, 'On Japanese Art', p.598, quoted in Watanabe, *High Victorian Japonisme*, p.182.

54 Eastlake, *Gothic Revival*, p.341.

55 *The Building News*, 18 September 1874, p.340, illus. p.351.

56 See 66–68 Cromwell Road, Kensington, 1870–74.

57 The oriels here are based upon the façade at Sparrowe's House at Ipswich, 1656.

58 E.W. Godwin, *The Building News*, 24 October 1873, p.450. The drawings for New Zealand Chambers had been

exhibited at the Royal Academy in 1873 and published in *The Building News* on 5 September 1873, p.252, illus. pp 260–61.

59 Metopes belong to the Doric Order and would be out of place if used here with the Ionic Order.

60 See Saint, *Richard Norman Shaw*, p.53.

61 This example is in the Victoria and Albert Museum, London. Watanabe cites four other versions of this sideboard and gives the dates as between 1867 and 1877. Furthermore, Watanabe dates the V&A sideboard as 1877 or later. See Watanabe, *High Victorian Japonisme*, p.193.

62 See Morse, *Japanese Homes*, p.138, fig.119 and p.145, fig.126.

63 See Watanabe, *High Victorian Japonisme*, pp 189–90.

64 See Mark Girouard, *Sweetness and Light: The 'Queen Anne' Movement 1860–1900* (Oxford: Oxford University Press, 1977), p.189, fig.174.

65 Shaw proposed Edis for membership of the Architectural Association where he was to become President.

66 See Girouard, *Sweetness and Light*, pp 53–5.

67 E.W. Godwin, 'Architectura vulgata', *The Architect*, 10 July 1875, p.17.

68 'Alterations to Old Front, no.109 Fleet-Street', *The Building News*, 1 October 1875, p.364.

69 Part of the Holland Park estate developed by William and Francis Radford from 1859.

70 The Paris Gang was a group of young artists which also included Edward Poynter and Thomas Lamont, who had trained in France in the 1850s.

71 Pevsner says: 'His church at Hautbois (1864) is of no interest, his Methodist church at Holt (1862) and his church at Thorpe outside Norwich (1866) are terrible.' See Nikolaus Pevsner, *The Buildings of England: North-West and South Norfolk* (Harmondsworth: Penguin Books, 1962), p.67.

72 The painter Thomas Armstrong CB (1832–1911) was later Director for Art, Department of Science & Art, Victoria and Albert Museum.

73 Daphne du Maurier (ed.), *The Young George du Maurier: A Selection of His Letters, 1860–67* (London: Peter Davies, 1951), p.139.

74 This was probably the architect Arthur Billing. See Susan Weber Soros and Catherine Arbuthnott, *Thomas Jeckyll: Architect and Designer, 1827–1881* (London and New Haven: Yale University Press, 2003), p.32.

75 Terracotta panels, incorporating roundels, were used at both High House, Thorpe St Andrew, Norwich (1871) and the lodge at Framington Pigot, Norfolk (1872). The elaborate dining room ceiling at 62 St Andrew's Street, Cambridge, which he built for the Mayor of Cambridge, Henry Rance, in 1874, also incorporated roundels.

76 Lewis F. Day, 'Notes on English Decorative Art in Paris. XII.– Metal Work', *The British Architect and Northern Engineer*, 1 November 1878, p.171.

77 Greenacombe, *The Survey of London*, p.199.

78 For a detailed analysis of the leather, see Linda Merrill, *The Peacock Room: A Cultural Biography* (London and New Haven: Yale University Press, 1998), pp 193–4.

79 ibid., pp 192–3.

80 See Soros and Arbuthnott, *Thomas Jeckyll*. They also suggest that Jeckyll might have been influenced by the wooden-rib ceiling in the Oak Parlour at Heath Old Hall, Heath, Yorkshire, which he restored and extended in 1865–72. See also Merrill, *The Peacock Room*, p.196; Elizabeth Aslin, *The Aesthetic Movement: Prelude to Art Nouveau* (London: Ferndale Editions, 1981), p.94.

81 This is the wording Whistler used in a letter to Jeckyll's brother, Henry, dated 17 February 1877. See the Correspondence of James McNeill Whistler, University of Glasgow Library, system no.02407, call no. MS Whistler J28.

82 See Correspondence of James McNeill Whistler, University of Glasgow Library, system no.00431, call no. MS Whistler B207 and system no.13692, call no. GUL Copies A48.

83 See the Correspondence of James McNeill Whistler, University of Glasgow Library, system no.02407, call no. MS Whistler J28.

84 James McNeill Whistler, 'A Red Rag', *The World*, 22 May 1878, contained in James McNeill Whistler, *The Gentle Art of Making Enemies* (London: William Heinemann, 1890), pp 127–8.

85 Whistler met Algernon Mitford in about 1873, not long before the Mitfords moved into Lindsey Row, Chelsea. The Mitfords later moved to Cheyne Walk, near to both Whistler and Dante Gabriel Rossetti. Mitford shared Whistler's enthusiasm for Japanese art and Whistler painted both him and his wife, Clementine, the latter 'in draperies of Chinese blue silk'. Whistler later destroyed the paintings to avoid them being taken by creditors.

86 See Girouard, *Sweetness and Light*, p.189.

87 It was the third version of the street elevation, approved by the Works and General Purposes Committee of the Metropolitan Board of Works on 18 March 1878, which first showed the name, The White House, inscribed over the door. In this proposal, the whole street elevation was rendered white. See Girouard, *Sweetness and Light*, p.180.

88 ibid.

89 See handwritten note by Godwin, dated 9 March 1878, on p.2 of letter from Vulliamy to Godwin, 8 March 1878. The Correspondence of James McNeill Whistler, University of Glasgow Library, system no.01051, call no. MS Whistler M322.

90 Vulliamy to Godwin, 8 March 1878. The Correspondence of James McNeill Whistler, University of Glasgow Library, system no.01051, call no. MS Whistler M322.

91 Whistler's bankruptcy followed his financially disastrous libel action against John Ruskin, in which he was awarded one farthing in damages but had to pay half the costs.

92 See Whistler to Godwin, [23/25 May 1878?]. The Correspondence of James McNeill Whistler, University of Glasgow Library, system no.01754, call no. MS Whistler G111.

93 See Vulliamy to Godwin, 15 May 1878. The Correspondence of James McNeill Whistler, University of Glasgow Library, system no.04057, call no. MS Whistler M328.

94 Quoted in Girouard, *Sweetness and Light*, p.181.

95 'Studios and Mouldings', *The Building News*, 7 March 1879, p.261.

96 Painted in 1884, the inscription on the reverse of the portrait reads 'Model and Mistress'.

97 See the 1881–1882 design for a house for Lillie Langtry in Godwin's sketchbook at the Victoria and Albert Museum, E.255-1963.

98 16 Tite Street, 1884–85.

99 Wilde in 1882 and Langtry in 1901.

100 Morse, *Japanese Homes*, p.xxvii.

101 'Cremorne Gardens', *The Illustrated London News*, 30 May 1857, p.516, illus. p.515.

102 James McNeill Whistler, *Cremorne Gardens no.2* (1872–77), Metropolitan Museum of Art, New York; Walter Greaves, *Whistler in the Cremorne Gardens Chelsea* (1869).

103 du Maurier visited the Exposition with Emanuel Oscar Manahem Deutsch (1829–1873): 'We went to the Exposition and chiefly confined ourselves to the outer buildings which are most delightful; especially the Algerian and Japanese women so like the pictures we know.' See du Maurier, *The Young George du Maurier*, p.267.

104 Humbert was Envoy Extraordinary and Minister Plenipotentiary of the Swiss Republic in Japan in 1863–1864.

105 Aimé Humbert, 'Le Japon', in Edouard Charton (ed.), *Le Tour du monde: Nouveau journal des voyages* (London: Librairie Hachette, 1869), pp 353–416.

106 Aimé Humbert (trans. Mrs Cashel Hoey, ed. H.W. Bates), *Japan and the Japanese* (New York: D. Appleton and Co., 1874), p.249.

107 Lewis F. Day, 'Notes on English Decorative Art in Paris. XII. – Metal Work', *The British Architect and Northern Engineer*, 1 November 1878, p.170.

108 ibid.

109 ibid., p.171.

110 ibid., p.172.

111 See 'Gates to Heigham Park', *Recording Archive for Public Sculpture in Norfolk & Suffolk*, at http://www.racns.co.uk/sculptures.asp?action=getsurvey&id=51, accessed 9 February 2018.

112 'Japan in New-York. Japanese Art Treasures and Household Goods Collected by an English Ph.D. – The Dresser Collection', *New York Times*, 6 May 1877, p.10.

113 ibid.

114 ibid.

115 ibid.

116 Quoted in Dorothy Gondos Beer, 'The Centennial City, 1865–1876', in Barra Foundation, *Philadelphia: A 300-Year History* (New York: W.W. Norton & Co., 1982), p.470.

117 See Westcott, *Centennial Portfolio*, p.22, quoted in Clay Lancaster, *The Japanese Influence in America* (New York: W.H. Rawls, 1963), p.48.

118 Hannah Sigur, *The Influence of Japanese Art on Design* (Layton, UT: Gibbs Smith, 2008), p.85.

119 *The American Architect and Building News*, 12 February 1876, pp 55–6; 2 April 1876, p.136; 18 November 1876, p.376.

120 'Japanese Houses', *The American Architect and Building News*, 22 January 1876, pp 26–27.

121 E.W. Godwin, 'Woodwork. – V. Japanese Wood Construction', *The Building News*, 12 February 1875, pp 173–4, 181; 'Woodwork. – VI. Japanese Woodwork Construction', 19 February 1875, pp 200–201, 210.

122 E.W. Godwin, 'Woodwork. – V. Japanese Wood Construction', *The Building News*, 12 February 1875, p.173.

123 ibid., p.174.

124 Alexander Jackson Downing, *The Architecture of Country Houses* (New York: Dover Publications Inc., 1969), p.163. This is what Scully, writing in the book of that name, dubbed 'The Stick Style.' See Scully, *The Shingle Style*, 1971, p.xlvii.

125 'Japanese Houses', *The American Architect and Building News*, 22 January 1876, p.27.

126 ibid.

127 Only 210 copies were printed, 160 being for advance subscribers.

128 Mariana Griswold van Rensselaer, *Henry Hobson Richardson and His Works* (Boston: Houghton and Mifflin, 1888), facing p.122.

129 Richardson to White, 22 February 1878. Quoted in Lelend M. Roth, *McKim, Mead & White, Architects* (London: Thames & Hudson, 1984), p.33.

130 For White in Richardson's office, see Roth, *McKim*, pp 29–34.

131 See Roth, *McKim*, p.27.

132 See *American Architect and Building News*, 10 September 1881, p.120, illus. after p.122.

133 See Scully, *The Shingle Style*; Henry-Russell Hitchcock, *The Architecture of H.H. Richardson and His Times* (Boston: MIT Press, 1966); Jeffrey Karl Ochsner and Thomas C. Hubka, 'H.H. Richardson: The Design of the William Watts Sherman House', *Journal of the Society of Architectural Historians*, vol.51, June 1992, pp 121–45; Jeffrey Karl Ochsner and Thomas C. Hubka, 'The East Elevation of the Sherman House, Newport, Rhode Island', *Journal of the Society of Architectural Historians*, vol.52, March 1993, pp 88–90.

134 See Ochsner and Hubka, 'H.H.Richardson', pp 132–3.

135 For these houses, see ibid., p.123, figs 2, 3.

136 See Scully, *The Shingle Style*, p.26, fig.15; Ochsner and Hubka, 'H.H. Richardson', pp 136–7, fig.24. The Bishop Berkeley House had been published in *The New York Sketch Book* in December 1874.

137 See Ochsner and Hubka, 'H.H. Richardson', p.132, fig.14.

138 Published in *The Building News*, 8 May 1874, p.498, pp 506–7.

139 See Ochsner and Hubka, 'H.H. Richardson', p.133, fig.15.

140 Located in Church Preen, Shropshire, and published in *The Building News*, 11 August 1871, pp 100, 102–3.

141 Located in Holmbury St Mary, Surrey and published in *The Building News*, 6 September 1872, pp 182, 184–5.

142 Located near Groombridge, Sussex, and published alongside Nesfield's Cloverley Manor in *The Building News*, 3 June 1881, pp 642, 648. Saint writes, 'only the finials at Glen Andred are Japanese ...' See Saint, *Richard Norman Shaw*, p.38.

143 The Exposition opened on 10 May 1876, and the Watts Sherman House was occupied early that month. See Ochsner and Hubka, 'H.H. Richardson', p.125.

144 A report in *The Builder*, 25 March 1876, p.299, says that there was a dinner held at the house to celebrate its completion. Since the Watts Sherman House was ready for occupation in May 1876, it is unlikely that Shaw's house was the source of this particular detail. See Ochsner and Hubka, 'H.H. Richardson', p.125.

145 See Ochsner and Hubka, 'H.H. Richardson' and 'The East Elevation'.

146 See Hitchcock, *The Architecture of H.H. Richardson*, p.156.

147 This is Ochsner and Hubka's argument. See Ochsner and Hubka, 'H.H. Richardson' and 'The East Elevation'.

148 Townsend writes: '... towards the apex of the gables there is a row of jagged-edged shingles marking the line where, on a thatched roof, the top layer of reeds would have been woven together and fixed to the rafters; and towards the bottom of the roof the shingles change pattern again, as if to indicate an area where a straw roof might flare.' See Gavin E. Townsend, 'The Tudor Revival in America, 1890–1930', PhD, University of California, Santa Barbara, 1986, pp 58–9.

149 See Charles Price, 'Henry Hobson Richardson: Some Unpublished Drawings', *Perspecta*, 1965, pp 199–210.

150 See Hitchcock, *The Architecture of H.H. Richardson*, p.156, fig.42.

151 Located near Groombridge, Sussex, and published in *The Building News*, 31 March 1871, pp 244, 246–7.

152 Hitchcock, *The Architecture of H.H. Richardson*, pp 156, 161.

153 For the Rush Cheney House, see *The New York Sketch Book of Architecture*, September 1876, p.3, pl.36; for the James Cheney House, see *The American Architect and Building News*, 25 May 1878, p.183.

154 In Paris they spent 'afternoons visiting the International Exposition'. See Roth, *McKim*, p.52.

155 Hitchcock, *The Architecture of H.H. Richardson*, p.156. Ochsner and Hubka point out that this could not have been Annie Sherman, the building's original client. See Ochsner and Hubka, 'H.H. Richardson', p.140, n.50.

156 The detail of the stairs does not correspond with the design shown in the perspective drawing, probably by White, published in the *New York Sketch Book* in May 1875.

See Ochsner and Hubka, 'H.H. Richardson', p.130, figs 11 and 27.

157 White to Whistler, 20 September 1895. The Correspondence of James McNeill Whistler, University of Glasgow Library, system no.03724, call no. MS Whistler M58.

158 See Sargent to Whistler, 1 November [1895], The Correspondence of James McNeill Whistler, University of Glasgow Library, system no.05390, call no. MS Whistler S34.

159 'Japanese Houses', *The American Architect and Building News*, 1876, p.277.

160 ibid.

161 See Scully, *The Shingle Style*, figs 67, 73, 74, 79, 82, 89, 91.

162 ibid., figs 93, 94.

6 The Manners of the West

1 'Building and Civil Engineering in Japan', *The Builder*, 27 March 1875, p.283.

2 Brunton built 26 stone lighthouses, referred to as 'Brunton's children'. His unpublished memoir, *Pioneer Engineering in Japan: A Record of Work in Helping to Re-Lay the Foundations of Japanese Empire (1868–1876)*, was eventually published by two separate publishers, one with an introduction by Sir Hugh Cortazzi, as Richard Henry Brunton, *Building Japan 1868–76* (Folkestone: Japan Library Ltd, 1991), and the other, edited by Edward R. Beauchamp, as *Schoolmaster to an Empire* (Westport, CN: Greenwood Press, 1991).

3 'Constructive Art in Japan', *The American Architect and Building News*, 15 April 1876, p.124. For the original paper, see Brunton, *Building Japan*, pp 227–32.

4 In 1858, the *bakumatsu* government signed the five Treaties of Amity and Commerce, known collectively as the Ansei Treaties, as follows: the United States of America on 29 July; the Netherlands on 18 August; Russia on 19 August; Britain on 26 August; and France on 9 October.

5 Kanagawa was absorbed into neighbouring Yokohama in 1901.

6 British traders were to be allowed to live in Yedo (Tokyo) from 1 January 1862 and in Osaka from 1 January 1863, the date from which Hyōgo (Kobe) would be open. See Article III of the 'Treaty of Peace, Friendship, and Commerce, between Her Majesty and the Tycoon of Japan. Signed in the English, Japanese, and Dutch languages, at Yedo, August 26, 1858'.

7 See Burke-Gaffney, *Nagasaki*, pp 24–8.

8 On 9 August 1945, the atomic bomb was detonated about 4.5 kilometres (2.8 miles) further up the Urakami river estuary. The Glover and other houses were sheltered from the blast by headlands.

9 For the Glover House attribution, see Burke-Gaffney, *Nagasaki*, p.37. Burke-Gaffney advises that the attribution and dates for the other two houses are assumptions.

10 The national ban on Christianity was lifted in 1873.

11 The 26 Martyrs of Japan included six European Franciscan missionaries, three Japanese Jesuits and 17 Japanese laymen. The executions were ordered by the *daimyo* Toyotomi Hideyoshi.

12 Shimizu, Shigeatsu, *Giyōfū Kenchiku* [Pseudo-western-style Architecture], *Nihon no bijutsu* [Arts of Japan], no.446, July 2003 (Tokyo: Shibundo, 2003), p.41.

13 See both McKay, *Scottish Samurai* and Gardiner, *At the Edge of Empire*.

14 See Plate IV, 'A Cottage of Two Rooms for a Park', in Joseph Gandy, *Designs for Cottages, Cottage Farms, and Other Rural Buildings …* (London: John Harding, 1805). The drawing shows a distyle-in-antis colonnade to the verandah comprising simple square columns with flat (i.e. wall plate) capitals and no bases. There are fan lights above niches on either side of the central door with lattice-work infill. There is also lattice-work in the window above the door. See also Joseph Gandy, *The Rural Architect: Consisting of Various Designes for Country Buildings …* (London: John Harding, 1805).

15 See John B. Papworth, *Rural Residences* (London: Ackerman, 1818), p.52, pl.XIII.

16 There is no further information on Ansell.

17 Amakusa is on Shimoshima Island, about 30 kilometres to the south of Nagasaki.

18 This building, the Fujian Hall, was rebuilt in 1897.

19 The lowest monthly average temperature in Nagasaki is 3ºC in January; the highest is 31º; the average annual rainfall is 1,958 millimetres.

20 The bricks were made at Hardes's direction by the Japanese tilers.

21 *Konnyaku*, which refers to the shape, is a jelly made from the starch of devils' tongue; *renga* means Dutch.

22 See Neil Jackson, 'Thomas James Waters (1842–98): Bibles and Bricks in *Bakumatsu* and Early-Meiji Japan', in Hugh Cortazzi (ed.), *Britain and Japan: Biographical Portraits*, 7 (Folkestone: Global Oriental and the Japan Society, 2010), pp 469–86. Other writers have credited Waters with buildings he did not design, such as the Glover House. His letters to his sister Lucy, referred to in this article, provide an accurate account of his early years in Japan.

23 Tom Waters to Lucy Waters, 4 July 1867.

24 Hori, Takeyoshi, *Gaikokujin kenchikuka no keifu* [The Legacy of Foreign Architects], *Nihon no bijutsu* (Arts of Japan), no.447, August 2003 (Tokyo: Shibundo, 2003), p.22.

25 See ibid., pp 21–2. See also John B. Black, *Young Japan: Yokohama and Edo, A Narrative, vol. II* (Yokohama: Kelly and Co., 1881), p.226.

26 Gary Saxonhouse, 'A Tale of Japanese Technology Diffusion in the Meiji Period', *The Journal of Economic History*, vol.34, no.1, March 1974, p.160. See also Kanji Tamagawa, 'The Role of Cotton Spinning Books in the Developments of the Cotton Spinning Industry in Japan', www.jsme.or.jp/tsd/ICBTT/conference02/KanjiTAMAGAWA. html, 19 February 2011.

27 Stewart suggests that Bridgens might have been British. His railway stations certainly imply a knowledge of British railway station buildings. See Stewart, *The Making of Modern Japanese Architecture*, p.27.

28 See the San Francisco Directory for the years commencing 1 October 1863 and 1 October 1864. The former has Bridgens as a draughtsman at 238 Clay Street (room 14), and the latter, both as an artist and lithographer at the same address, and also as a clerk, Office of US Engineers, at 532 Pine Street.

29 For the Schoyers, see Ellen P. Conant (ed.), *Challenging Past and Present: The Metamorphosis of Nineteenth-Century Japanese Art* (Honolulu: University of Hawai'i Press, 2006), p.86, and Leonard Hammersmith, *Spoilsmen in a 'Flowery Fairyland': The Development of the U.S. Legation in Japan, 1859–1906* (Kent, OH: Kent State University Press, 1998), p.55.

30 For Roches, see Dana Irwin, 'Sheiks and Samurai: Leon Roches and the French Imperial Project', *Southeast Review of Asian Studies*, vol.30, 2008, pp 23–30.

31 See Hori, *Gaikokujin kenchikuka*, p.26.

32 Verny was actually instrumental in implementing the first French Military Mission to Japan which, in 1867–1868, helped train and re-equip the Tokugawa army.

33 For this analysis, see Dallas Finn, *Meiji Visited: The Sites of Victorian Japan* (New York and Tokyo: Weatherhill, 1995), p.21; Black, *Young Japan*, p.21.

34 The coining factory at the Imperial Mint at Osaka was, by comparison, 67.5 metres long.

35 See Morton S. Schmorleitz, *Castles in Japan* (Tokyo: Charles E. Tuttle Co., 1974), p.144.

36 See Article III of the 'Treaty of Peace, Friendship, and Commerce, between Her Majesty and the Tycoon of Japan. Signed in the English, Japanese, and Dutch languages, at Yedo, August 26, 1858'.

37 Finn, *Meiji Visited*, p.14. Finn suggests that these towers were designed by Katsu Kaishū.

38 From 1854 to 1868 the currency used in Tokugawa Japan was the Mexican dollar while local *daimyo* issued their own currency anarchically.

39 The Hong Kong Mint operated from February 1864 to May 1866.

40 On 29 May 1868, Waters wrote from Kagoshima to his sister Lucy: 'Shillingford who was down here is on his way home.'

41 See the Palazzo Chiericati, Vicenza (1551) and also Inigo Jones's portico at old St Paul's Cathedral, London, 1634.

42 Waters had stopped at Shanghai on his way to the Loo Choos in 1865.

43 The Sempukan is open to visitors for only two or three days a year. Therefore, see Finn, *Meiji Visited*, pp 19–20.

44 Amy Waters to Lucy Waters, 30 January 1869, W/G 9.6.

45 See Roy S. Hanashiro, *Thomas Kinder and the Japanese Imperial Mint 1868–75* (Leiden, Boston and Cologne: Brill, 1999), pp 48–50.

46 For the manufacture of glass, see Martha Chaiklin, 'A Miracle of Industry: The Struggle to Produce Sheet Glass in Modernizing Japan', in Low (ed.), *Building a Modern Japan*, pp 161–81.

47 Black, *Young Japan*, vol.2, pp 307–8.

48 The following dates relating to the Ginza rebuilding use the Gregorian calendar.

49 André Sorensen, *The Making of Urban Japan: Cities and Planning from the Edo to the Twenty-first Century* (London and New York: Routledge, 2002), p.61.

50 See Hanashiro, *Thomas Kinder*, p.50.

51 See copy of estimate dated 18 April 1872. Meg Vivers, *An Irish Engineer* (Brisbane: Copyright Publishing, 2013), p.112.

52 See Vivers, *An Irish Engineer*, p.112.

53 ibid., pp 111–12.

54 For these dates and movements, see ibid., pp 110–34.

55 Kume, *The Iwakura Embassy*, vol.2, p.402.

56 Hiromichi Ishizuka, *Methodological Introduction to the History of the City of Tokyo*, Japanese Experience of the UNU Human and Social Development Programme, Bk 2 (Tokyo: United Nations University, 1981), p.18.

57 James Elmes, *Metropolitan Improvements; or London in the Nineteenth Century* (London: Jones & Co., 1827), pls facing pp 58, 101 (The Quadrant), and p.92 (Park Crescent).

58 Friedrich Hoffmann patented the Hoffmann brick kiln in 1858. See Finn, *Meiji Visited*, p.20; although not stated, it is likely to have been at Kosuge.

59 Botsman, *Punishment and Power*, pp 174–5.

60 Ishizuka, *Methodological Introduction*, pp 16–17.

61 These required a down-payment of one third of the construction cost and the balance in instalments over seven years. See Ishizuka, *Methodological Introduction*, p.18.

62 *The Building News*, 21 April 1876, p.411.

63 Ishizuka, *Methodological Introduction*, pp 12–13, 17.

64 Shimizu, *Giyōfū Kenchiku*, p.42.

65 Stewart says that Tateishi Seijyū had seen and sketched the Kaisei Gakkō. See Stewart, *The Making of Modern Japanese Architecture*, p.23.

66 *Nichinichi Shinbun* was first published in Tokyo in March 1872 by John Reddie Black.

67 Japan was represented by the chemist and industrialist Takamine Jōkichi (1854–1922) at the exposition.

68 This building is now at Meiji-mura where there are many other examples of Classical-style buildings from the Meiji period.

69 Variations on the Orders were drawn up principally by Serlio, Vigmola, Palladio, Scamozzi, Perrault, Gibbs and Chambers.

70 Both buildings are now at Meiji-mura.

71 This literally means the separation of Shintoism and Buddhism. The introduction of State Shintoism, which was not a religion but an *allegiance*, resulted in the abolition of many Buddhist temples and the return of the land to the government for the building of schools. Here State Shintoism could be taught without fear of criticism from other Occidental countries. See Ruth Benedict,

The Chrysanthemum and the Sword (London: Secker and Warburg, 1947), pp 87–8.

7 The Western Architects

1 *University College, London: College Calendar*, 1880. Information kindly supplied by Professor Alan Powers.

2 *Report of the Senate on the Chair of Architecture and Construction*, 2 March 1903. Information kindly supplied by Professor Alan Powers.

3 Smith was the founder and first editor of *The Architect* in 1869.

4 *Kenchiku Zasshi*, quoted in Toshio Watanabe, 'Vernacular Expression or Western Style? Josiah Conder and the Beginning of Modern Architectural Design in Japan', in Nicola Gordon Bowe (ed.), *Art and the National Dream* (Dublin: Irish Academic Press, 1993), p.45. See Toshio Watanabe, 'Japanese Imperial Architecture from Thomas Roger Smith to Itō Chūta', in Ellen P. Conant (ed.), *Challenging Past and Present*, p.251.

5 Walter Millard, 'The Late Josiah Conder (F)', *RIBA Journal*, 25 September 1920, p.474.

6 Ernest Claude Lee (1845–1900) also won the Soane Medallion in 1870. Conder's younger brother, Roger Thomas Conder (1855–1906), won it in 1881.

7 See 'The Institute Prizes: The Soane Medallion Competition', *Building News*, 10 March 1876, p.240, and 'RIBA Soane Medallion Prize Drawings, 1876 – Design for a Country House, by J. Conder', *Building News*, 21 April 1876, p.394 and illus.

8 From 1864 onwards, Japanese students had studied at University College, London as had William Ayrton, who became the Professor of Natural Philosophy and Telegraphy at the Imperial College of Engineering in 1873.

9 T. Roger Smith, 'Architectural Art in India', *Journal of the Society of Arts*, vol.21, 1873, p.286. See also T. Roger Smith, 'On Buildings for European Occupation in Tropical Climates. Especially India', *Transactions of the Royal Institute of British Architects*, 1st series, vol.18, 1867–68, pp 197–208.

10 The title page reads: *A Lecture Upon Architecture Addressed to the Architectural Students. Kobu-dai-gakko, Tokei, Japan. March 1878. Josiah Conder – Professor.* See Josiah Conder, *A Few Remarks Upon Architecture* (Tokyo: Kobu-dai-gakko, 1878).

11 See publications by Josiah Conder: 'Notes on Japanese Architecture', pp 179–92; 'Further Notes on Japanese Architecture', *Transactions of the Royal Institute of British Architects*, new series, vol.2, 1886, pp 185–209; 'Domestic Architecture in Japan', pp 103–27; *Supplement to Landscape Gardening in Japan* (Hong Kong, Singapore, Shanghai and Yokohama: Kelly and Walsh Ltd, 1893).

12 Conder, *A Few Remarks*, p.14.

13 ibid., p.13.

14 ibid., p.14.

15 ibid., p.8.

16 Rosengarten's *Die Architektonischen Stilarten*, first published in Germany in 1857, was translated into English as *Handbook of Architectural Styles* by William Collett Sandars. See Watanabe, 'Japanese Imperial Architecture from Thomas Roger Smith to Itō Chūta', in Conant (ed.), *Challenging Past and Present*, p.245 and p.252, n.25.

17 Questions from the 'Lectures on Styles of Architecture Examination Paper', March 1888. See Kusumi Kawanabe, Nobuo Aoki, Mitsuyuki Tago, Takeo Inada and Aya Yuzuhana (eds), *Josiah Conder* (Tokyo: East Japan Railway Culture Foundation, 1997), p.171.

18 Imperial College of Engineering, *Calendar*, 1881, C, quoted in Don Hoon Choi, *Domestic Modern: Hybrid Houses in Meiji Japan, 1870–1900*, PhD University of California, Berkeley, 2003, p.51.

19 Question from the Architecture Final Examination: History and Design paper, February 1884. See Kawanabe, et al. (eds), *Josiah Conder*.

20 Tatsuzō Sone, 'Nihon Syōrai no Jyūtaku ni tsuite (The Future Domestic Architecture in Japan)', cited by Watanabe in 'Japanese Imperial Architecture from Thomas Roger Smith to Itō Chūa' in Conant, *Challenging Past and Present*, p. 245, p. 252 n. 26.

21 See Watanabe, 'Japanese Imperial Architecture from Thomas Roger Smith to Itō Chūa' in Conant (ed.), *Challenging Past and Present*, p.245.

22 'Tokio University, Japan', *The Builder*, 13 December 1884, pp 790, 792–3, 796.

23 The caption 'Dr Conder … drew up a couple of plans. Our drawings constitute one of them' appears with the aerial perspective drawing and a plan in Josiah Conder, *Collection of the Posthumous Works of Dr Josiah Conder, F.R.I.B.A.* (Tokyo, 1931), figs 18, 19.

24 'Tokio University, Japan', *The Builder*, 13 December 1884, p.790.

25 See W. Burges, 'Proposed School of Art at Bombay', *RIBA Session Papers*, 1868, pp 79, 83–5.

26 W. Burges, 'Proposed School of Art at Bombay', *RIBA Session Papers*, 1868, p.83.

27 T. Roger Smith, 'Architectural Art in India', p.286.

28 T. Roger Smith, 'On Buildings for European Occupation in Tropical Climates. Especially India', p.208.

29 ibid., p.208. For a similar recommendation, see T. Roger Smith, 'Architectural Art in India', p.286.

30 Completed in 1884.

31 From 1882 it was the Bank of Japan. See Hanna Lerski, 'Josiah Conder's Bank of Japan, Tokyo', *Journal of the Society of Architectural Historians*, vol.38, no.3, October 1979, pp 271–4.

32 Conder to the *Kenchiku Gakkai* (Japanese Institute of Architects), quoted in Watanabe, 'Japanese Imperial Architecture from Thomas Roger Smith to Itō Chūta', in Conant (ed.), *Challenging Past and Present*, p.243. See also Tojio Watanabe, 'Josiah Conder's Rokumeikan: Architecture and National Representation in Meiji Japan', *Art Journal*, Fall 1996, pp 25–7.

33 Conder to the *Kenchiku Gakkai* (Japanese Institute of Architects), quoted in Watanabe, 'Japanese Imperial Architecture from Thomas Roger Smith to Itō Chūta', in Conant (ed.), *Challenging Past and Present*, p.243.

34 For the Second National Industrial Exhibition.

35 For late nineteenth-century Anglo-Mughal buildings, see J.W. Brassington's Law Courts in Madras (1888–1892), Frederick William Steven's Municipal Buildings (1888–1893) and Churchgate Station (1894–1896) in Bombay, and John Begg's Central Post Office in Bombay (1903–1809).

36 For late-nineteenth-century Islamic architecture, see Michael Darby, *The Islamic Perspective* (London: The World of Islam Festival Trust, 1983), pp 122–37.

37 Alice Tseng notes that the plans might have been drawn up by Giovanni Vincenzo Cappelletti or Antonio Fontanesi, Italian art instructors employed by the Ministry of Public Works at the Technical Fine Arts School. See Alice Y. Tseng, 'Styling Japan: The Case of Josiah Conder and the Museum at Ueno, Tokyo', *The Journal of the Society of Architectural Historians*, December 2004, p.484, p.495, n.40.

38 Conder had taken drawing classes at the South Kensington Art School and also the Slade School of Art, as well as working with and studying stained glass under Burges's friend, Walter Lonsdale, and it is inconceivable that he would not have been familiar with the galleries in and around central London.

39 Conder to the *Kenchiku Gakkai* (Japanese Institute of Architects), quoted in Watanabe, 'Japanese Imperial Architecture from Thomas Roger Smith to Itō Chūta', in Conant (ed.), *Challenging Past and Present*, p.243. See also Watanabe, 'Josiah Conder's Rokumeikan', pp 25–26; and also Tseng, 'Styling Japan, p.487.

40 See Watanabe, 'Josiah Conder's Rokumeikan', p.26, and also Ian Buruma, *Inventing Japan, 1853–1964* (New York: Modern Library Chronicles, 2004), p.47.

41 The *Dajōkan* was the Council of State of the Japanese government between 1871 and 1885.

42 See Dallas Finn, 'Josiah Conder (1852–1920) and Meiji Architecture', in Hugh Cortazzi and Gordon Daniels (eds), *Britain and Japan 1859–1991: Themes and Personalities* (London and New York: Routledge, 1991), p.89, and also Finn, *Meiji Revisited*, pp 93, 95.

43 Tokuzo Hara, 'Josiah Conder and His Patrons', in Kawanabe et al. (eds), *Josiah Conder*, p.45.

44 Morse, *Japanese Homes*, pp 319–20.

45 Robert Kerr, *The Gentleman's House; or How to Plan English Residences from the Parsonage to the Palace* (London: J. Murray, 1864 [later editions 1865, 1871]). The later editions in 1865 and 1871 illustrate and describe Bear Wood.

46 Bear Wood was also described in 'Bearwood, Berkshire', *The Architect*, 9 July 1870, p.21, and 'Bearwood, Berkshire', *The Architect*, 14 January 1871, pp 26–7.

47 For the Iwasaki Yanosuke mansion at Takanawa, see Suzuki, Hiroyuki, *Iwasaki Yanosuke Takanawa Tei: Kaitōkaku* [Architectural References of Yanosuke Iwasaki

Takanawa Residence: Kaitōkaku] (Tokyo: Kaitōkaku Iinkai, Mitsubishi, 2008).

48 Osborne House is shown on the title page of Kerr's *The Gentleman's House*, which also contains a plan and a description.

49 The *cortile* at Bear Wood was used as a picture gallery. For *cortile*, see Kerr, *The Gentleman's House*, pp 170–73.

50 At Bear Wood, there is a billiard room/gentleman's room and a gentleman's room/library. But there is also a library.

51 On 15 February 1902, Conder wrote to Iwasaki: 'Since I left you today I have been reflecting over our conversation regarding control of building work. Having your best interests in mind, I think that ... it would be better if I were employed professionally only.' See Suzuki, *Kaitōkaku*, pp 178–9. See also Hiroyuki Suzuki, 'The Business Practices of the Architect Josiah Conder – Focussing on the Takanawa Residence of Iwasaki Yanosuke', in Kawanabe et al. (eds), *Josiah Conder*, p.39.

52 Conder, *Collection of the Posthumous Works*, facing pl.34.

53 This building was brought over from Iwasaki's Surugadai estate in 1905.

54 See *The Builder*, 9 February 1895, p.98, and 'The New Turkish Bath', *The Building News*, 8 February 1895, p.191.

55 For the Surugadai house, see Tokuzo Hara, 'Josiah Conder and His Patrons', in Kawanabe et al. (eds), *Josiah Conder*, p.46.

56 The *Zaibatsu* were financial and industrial combines, of which Mitsubishi was one. They were largely broken up following the Second World War.

57 The balcony originally had bronze railings which were removed to assist in the war effort.

58 Conder, *Collection of the Posthumous Works*, fig.37.

59 Josiah Conder, *Landscape Gardening in Japan* (Hong Kong, Singapore, Shanghai and Yokohama: Kelly and Walsh Ltd, 1893), pp 1, 11.

60 Here too is the Japanese gate and the probable location of the Japanese residence.

61 This withdrawal began in 1894 when Great Britain agreed to accept the authority of the Japanese courts following a five-year transition period.

62 See Jonathan M. Reynolds, 'Japan's Imperial Diet Building: Debate Over Construction of a National Identity', *Art Journal*, vol.55, no.3, Autumn 1996, p.39.

63 See ibid., p. 40, p.47. ns 12, 13 and 14.

64 See ibid., pp.39–40.

65 Josiah Conder, 'The Condition of Architecture in Japan', *Proceedings of the Twenty-Seventh Annual Convention of the American Institute of Architects, Supplement: World's Congress of Architects*, Chicago, 1893, pp 365–81, quoted in Tseng, 'Styling Japan', p.491.

66 Muthesius arrived in Japan in July 1887 and left in January 1890. Construction work on the Ministry of Justice started in 1888.

67 Seel had arrived in Japan in October 1888 but was dismissed by the Japanese government in March 1893. By this date the design of the building and much of the building work would have been completed. See 'The Imperial Law Courts, Tokio', *The Builder*, 15 April 1893, p.288.

68 'The Imperial Law Courts, Tokio', *The Builder*, 15 April 1893, p.288.

69 Evarts Boutell Greene, *A New-Englander in Japan: Daniel Crosby Greene* (Boston and New York: Houghton Mifflin Company, 1927), p.102.

70 ibid., p.4.

71 ibid., p.200.

72 ibid., p.200.

73 Alexander Nelson Hansell, FRIBA Nomination Paper, dated 1891. *Hansell, Alexander Nelson, Biography File*, RIBA, London.

74 For St Paul's College, see Margaret Jeffreys Hobart (compiler), *Institutions Connected with the Japan Mission of the American Church* (New York: The Domestic and Foreign Missionary Society, 1912), pp 6–7.

75 William Merrell Vories, quoted in *Omi Brotherhood and William Merrell Vories* (Shiga: Omi Brotherhood Company Ltd., n.d), p.4.

76 See 'An Eye for the World: photographs by Shotaro Shimomura 1934–35', www.photographymuseum.com/shimo.html, accessed 10 February 2018.

77 Shimomura Shotaro, *Chudo-Ken: Views Within and Outside, Chewdoh-Ken* (*Tudor House*) (Kyoto: Matsuzaki & Co., 1932), n.p.

78 ibid., pls 16, 25, 2.

8 The Japanese Architects

1 *The American Architect and Building News*, 4 March 1876, p.73.

2 'Foreign Gossip', *St. Louis Globe-Democrat*, St Louis, MO, 23 April 1876, p.3.

3 *The American Architect and Building News*, 4 March 1876, p.74.

4 The other two Italians were the painter Antonio Fontanesi (1818–1881) and the sculptor Vincenzo Ragusa (1841–1928). See Alice Y. Tseng, 'Kuroda Seiki's *Morning Toilette* on Exhibition in Modern Kyoto', *The Art Bulletin*, vol.90, no.3, 1 September 2008, p.420.

5 Imperial College of Engineering, *Calendar*, 1877, pl.ii. I am grateful to Don Hoon Choi for bringing to my attention this and other information regarding the Imperial College of Engineering.

6 William Gray Dixon, *The Land of the Morning: An Account of Japan and Its People Based on Four Years' Residence in That Country* (Edinburgh: James Gemmel, 1882), p.170, quoted in W.H. Brock, 'The Japanese Connexion: Engineering in Tokyo, London and Glasgow at the End of the Nineteenth Century. Presidential Address, 1980', *The British Journal for the History of Science*, vol.14, no.3, November 1981, p.233.

7 Dyer, from Bellshill near Glasgow, had studied at Anderson College and was about to graduate from Glasgow University when appointed.

8 McVean to the Chief of the Japanese Lighthouse Department, 19 August 1869, quoted in Hideo Izumida, 'Colin Alexander McVean and the Meiji Japan: His Contribution to Establish Engineering Institution and Survey Departments', unpublished manuscript, 2017, revised July 2018, n.p.

9 Mary Wood Cowan (b.1837) was the eighth daughter of the Penicuick papermaker and philanthropist Alexander Cowan (1775–1859) who, by two wives, had 20 children. His eldest daughter Helen (1806–1875) married the Edinburgh Professor of Law, Allan Menzies (1805–1856), and their daughter Elizabeth (1837–1923) married the Glasgow architect Campbell Douglas. Cowan's fourth daughter, Lucia Anne Cowan (1818–1901) married the Edinburgh printer and publisher Thomas Constable (1812–1881), the supporter and biographer of Revd. Charles A. Chastel de Boinville (1819–1878), the father of the architect of the same name who, in 1874, married Agnes Cowan (1846–1897), daughter of William Cowan (1797–1886), a banker from Ayr, at the French Legation in Yokohama. See, in association with other sources, Hideo Izumida, 'Reconsideration of Scottish Connection in Civil Engineering and Architecture in Meiji Japan: Alexander Cowan's Relatives Engaged in Engineering Practice in the Modern Japan', unpublished conference paper given at the International Symposium of Succession of Cultural Heritages in East Asia, at Institute of Industrial Engineering, University of Tokyo, Tokyo, June 2009.

10 'The Late Charles Alfred Chastel de Boinville', RIBAJ, 1897, pp 359–60. Izumida quotes McVean as writing to Douglas on 23 April 1872: 'Cam. Douglas – asking him to appt one Teacher of Surveying, one Architect and a Draftsman.' See Izumida, 'Colin Alexander McVean and the Meiji Japan', n.p.

11 See Thomas Constable, Memoir of the Reverend Charles A. Chastel de Boinville Compiled from His Journals and His Letters (London: James Nisbet & Co., 1880).

12 Revd. de Boinville's connections with the Cowan family were through the Edinburgh printer and publisher, Thomas Constable (1812–1881), later his biographer and also the husband of Lucia Anne Cowan, another aunt of Campbell Douglas's wife, Elizabeth.

13 Dixon, The Land of the Morning, p.170, quoted in Brock, 'The Japanese Connexion, p.233.

14 For part-plans and interior details, see 'Imperial College of Engineering, Yedo, Japan', The Builder, 10 April 1880, after p.440, and 17 April 1880, after p.442. For a perspective view of the building, see Imperial College of Engineering Tokei, General Report by the Principal for the Period 1873–77, and for the plan see Imperial College of Engineering Tokei, Calendar, Session MDCCCLXXVII–LXXVIII, Tokyo, 1877.

15 Dixon, The Land of the Morning, p.170, quoted in Brock, 'The Japanese Connexion', p.233.

16 Sone Tatsuzō, 'Kondory Sensei Hyōshō Yoteki' (Some Remarks on the Occasion of Professor Conder's Commendation), quoted in Toshio Watanabe, 'Japanese Imperial Architecture from Thomas Roger Smith to Itō Chūa', in Conant (ed.), Challenging Past and Present, pp 244–5.

17 ibid., p.245.

18 For the diploma schemes, see Kawanabe et al. (eds), Josiah Conder, pp 172–87.

19 Ian Ruxton, 'Tatsuno Kingo (1854–1919): "A Leading Architect" of the Meiji Era', in Hugh Cortazzi (ed.), Britain and Japan: Biographical Portraits, 7 (Folkestone: Global Oriental and the Japan Society, 2010), pp 443–55. See also Checkland, Japan and Britain, p.78. Checkland also says that Tatsuno registered at University College, London, where he is believed to have studied engineering, and from where he graduated in 1882.

20 See Watanabe, 'Josiah Conder's Rokumeikan', p.27, and also Crook, William Burges, p.82, n. 32.

21 For Tatsuno's technical specification, see AIJ Journal of Architecture and Building Science, 25 April 1897, pp 121–6.

22 See Ruxton, 'Tatsuno Kingo', pp 446–7.

23 Renamed Kenchiku Gakkai in 1897.

24 These sketches are included in Tatsuno's biography, Shiratori, Shōgo (ed.), Kōgaku Hakashi Tatsuno Kingo Den (Tokyo: Tatsuno Kasai Jimusho, 1927). See also Ruxton, 'Tatsuno Kingo'.

25 The trip took in Boston, New York, Liverpool, London, Brussels, Antwerp, Paris and Marseilles.

26 John W. Root (ed.), Convention Proceedings of the American Institute of Architects, The Western Association of Architects, and Consolidation of the American Institute and the Western Association held at the Burnet House, Cincinnati, Ohio, November 20 and 21, 1889 (Chicago: Inland Architect Press, 1890), p.23.

27 Bowes was appointed Honorary Consul for Japan in 1888.

28 See Christina Baird, 'Japan and Liverpool: James Lord Bowes and His Legacy', Journal of the History of Collections, vol.12, no.1, 2000, pp 27–137.

29 Audsley was the author of The Ornamental Arts of Japan, Vols I and II (London: Sampson, Low, Marston, Searle and Rivington, 1882–84), and, with Bowes, of Keramic Arts of Japan (London: Henry Sotheran & Co., 1881).

30 The museum opened on 19 June 1890 and was visited by 11,229 people in its first five days.

31 The Ocean Steam Ship Company, owned by Alfred and Philip Holt, was part of the Blue Funnel Line.

32 This was the Ajax.

33 'Men of note by themselves, J-m-s L B-w-s', Liverpool Citizen, 8 April 1891, pp 6–7, quoted in Baird, 'Japan and Liverpool', p.129.

34 The Palais de Luxembourg (1615–24) in Paris, designed by Salomon de Brosse (1571–1626), has also been mooted as a source for the plan of the Bank of Japan. However, that building has just one enclosed court whereas

Tatsuno's design has courts on both sides of the central range.

35 It is worth noting, perhaps, that the Bank of England displayed similar porticoes designed by Sir Robert Taylor (1714–88) in 1783–86, but neither Beyaert and Janssens nor Tatsuno are likely to have known of them, for they were removed by Soane.

36 The Hôtel des Fermes was located on the rue de Bouloir, Paris, but only one wing was built. See Alan Braham, *The Architecture of the French Enlightenment* (Berkeley: University of California Press, 1980), p.191, illus. 251. Ledoux published a folio of his designs in 1804 as *L'Architecture Considerée sous le Rapport de l'Art, des Moeurs et de la Législation*. A second volume, edited by Daniel Ramée (1806–87), was published in 1847.

37 See Kayser & Groszheim's villas at Am Sandwerder 5, Wannsee, Berlin (1885), Bleichstrasse 22, Düsseldorf (1895) and Arcisstrasse 12, Munich (1895).

38 The Daiichi Bank, which had been built with timber rather than steel and without reinforcements in the brickwork, was demolished in 1999, only to be rebuilt in replica on the same site in 2003.

39 Jonathan M. Reynolds, 'The Bunriha and the Problem of "Tradition" for Modernist Architecture in Japan, 1920–1928', in Sharon Minichiello (ed.), *Japan's Competing Modernities: Issues in Culture and Democracy, 1900–1930* (Honolulu: University of Hawai'i Press, 1998), p.235.

40 'A World-Style in Architecture', *The Builder*, 21 September 1907, p.306. See Kawamichi Rintaro, 'On Uheiji Nagano's Theory Stated in the Debates on Architectural Style Held in 1910: Discourses on World Style in Architecture', Part 1, *AIJ Journal of Architecture, Planning and Environmental Engineering*, no.460, June 1994, p.156, n.20.

41 The Yokohama Specie Bank had branches in London, New York, Lyons, Bombay, Shanghai and Beijing. See Finn, *Meiji Visited*, p.192.

42 For Endō, Tsumaki and the Yokohama buildings, see Hiroshi Watanabe, *The Architecture of Tokyo* (Stuttgart and London: Edition Axel Menges, 2001), pp 68, 71.

43 See Nishimura Yoshitoki's Aichi Prefecture administrative building in Nagoya, 1938.

44 Toshio Watanabe (ed.), *Ruskin in Japan 1890–1940: Nature for Art, Art for Life* (Japan: Cogito, 1997), p.300.

45 Checkland says this was at 4939 Lake Street and Finn has it as Daniel Burnham's Monadnock Building. See Checkland, *Japan and Britain*, p.83; Finn, *Meiji Revisited*, p.72.

46 For Shimoda, see Checkland, *Japan and Britain*, pp 83–4.

47 Jonathan M. Reynolds, *Maekawa Kunio and the Emergence of Japanese Modernist Architecture* (Berkeley, Los Angeles, London: University of California Press, 2001), p.13.

48 *Annuary of the American Institute of Architects*, 1910, p.44.

49 See Finn, *Meiji Revisited*, p.184.

50 Root, *Convention Proceedings*, p.23.

51 A similar comparison could be made with the church of Ss Paul and Louis, Paris (1625–34) by François Derand (1588–1644), but the proliferation of columns and its use of the Corinthian Order preclude that: it should be argued that both Derand and Katayama are borrowing equally from de Brosse.

52 He was to become the Taishō Emperor (1912–26).

53 'For a Ruler Whose Spirit Will Be Worshipped: Tokio Preparations', *Illustrated London News*, 7 September 1912, p.345.

54 Katayama, as quoted in *Nippon shimbun*, 17 May 1907. See Finn, *Meiji Revisited*, p.235 and p.240, n. 10.

55 See Finn, *Meiji Revisited*, pp 238–9, 240, n.21.

56 Sullivan, *The Autobiography of an Idea*, p.321.

57 Gaston Migeon (trans. Florence Simmonds), *In Japan: Pilgrimages to the Shrines of Art* (London: William Heinemann, 1908), pp 7–8.

58 See Finn, *Meiji Revisited*, p.239, p.241, n.27.

59 See Reynolds, 'Japan's Imperial Diet Building', p.41, fig.3.

60 Ralph Adams Cram, *Impressions of Japanese Architecture and the Allied Arts* (London: The Bodley Head, 1906), p.208.

61 'Modern Japan', *The Builder*, 10 April 1880, p.436.

62 Cram, *Impressions of Japanese Architecture*, p.22.

63 ibid., p.204.

64 ibid., pp 206–8.

65 For *shajiyō*, see Wendelken, 'The Tectonics of Japanese Style', pp 28–30.

66 For this argument, see ibid., p.29.

67 The Nihon Kangyō Bank has since been moved three times and now serves as a Toyota car showroom in Chiba. Rebuilt with a concrete frame, it bears little resemblance to its original appearance.

68 See Wendelken, 'The Tectonics of Japanese Style', p.30; and also Jonathan M. Reynolds, 'Teaching Architectural History in Japan: Building a Context for Contemporary Practice', *Journal of the Society of Architectural Historians*, vol.61, no.4, 2002, p.531.

69 See Wendelken, 'The Tectonics of Japanese Style', p.31, p.37, n.19; and also Watanabe, 'Josiah Conder's Rokumeikan', p.27.

70 Watanabe, 'Japanese Imperial Architecture from Thomas Roger Smith to Itō Chūta', in Conant (ed.), *Challenging Past and Present*, p.247.

71 Josiah Conder, an address given to the Association of Japanese Architects on 14 July 1886 and reported in *The Japan Weekly Mail*, 28 August 1886, p.214, quoted in Watanabe, 'Japanese Imperial Architecture from Thomas Roger Smith to Itō Chūta', in Conant (ed.), *Challenging Past and Present*, pp 246–7.

72 This became the first Bank of Japan building in 1882. See Lerski, 'Josiah Conder's Bank of Japan'; see also, Watanabe, *Ruskin in Japan*, pp 43, 298, pl.170.

73 Ruskin was introduced by the journalist Tokutomi
Soho, writing in *Kokumin no Tomo* (Friend of the Nation),
and Morris, by the novelist Shibue Tamotsu, in *Eikoku
Bungakushi* (The History of English Literature).

74 The teaching of architecture at Cambridge
University did not start until 1911, although there were the
Slade Lectures as well as extramural classes which would
have touched upon architecture.

75 In 'The Nature of Gothic', Ruskin identifies these
'characteristic or moral elements' as being: Savageness,
Changefulness, Naturalism, Grotesqueness, Rigidity and
Redundance. See John Ruskin, *The Stones of Venice*, vol.2
(Orpington: George Allen, 1853), chapter VI, para. vi.

76 Jordan Sand, *House and Home in Modern Japan:
Architecture, Domestic Space and Bourgeois Culture 1880–1930*
(Cambridge, MA and London: Harvard University Asia
Centre, 2003), pp 113–14.

77 Itō Chūta, 'Secessionni tsuite', *Kenchiku to
sōshoku*, July 1912, pp 1–2, quoted in Ken Tadisha Oshima,
*International Architecture in Interwar Japan: Constructing
Kokusai Kenchiku* (Seattle: University of Washington Press,
2009), p.17.

78 Tsukamoto was later to be Professor of Architecture
at Tokyo University and, during the Japanese occupation
of Manchuria, the architect of the very grand Gyeongseong
(Seoul) Railway Station (1925).

79 Hiroyasu Fujioka, 'A Report from Japan', *Museum
International*, no.167, vol.XLII, no.3 (Paris: UNESCO, 1990),
p.176.

80 See www.mackintosh-architecture.gla.ac.uk/
catalogue/browse/display/?sysnum=s400, accessed 21
February 2018.

81 See 'National Competitions Work of the Schools
of Art', *The Building News*, 25 July 1902, p.107. See Takeda
Hakushi Kanreki Kinen Jigyoukai [Special Committee for
Dr Takeda's 60 Years Old Celebration], *Takeda Hakushi
Sakuhinsyu* (The Works of Dr Takeda) (Kyoto, 1933),
p.1.

82 Notes on Takeda's itinerary are taken from Hiroshi
Adachi, 'Takeda Goichi To Aru Nubo: Takeda Goichi
Kenkyu' (Art Nouveau and Modern Architecture in Japan:
A Study of Goichi Takeda), part 2, *Journal of Architecture
Planning (AIJ)*, 357, November 1985, pp 97–111.

83 Takeda Goichi, 'Sekai ni okerukenchikukai no
shinkiun', *Kenchiku sekai*, April 1912, pp 5–8.

84 Sand, *House and Home*, pp 114–15.

85 See Watanabe, *Ruskin in Japan*, p.303; Shun-ichi
Watanabe, 'The Japanese Garden City', in Stephen V. Ward
(ed.), *The Garden City: Past, Present and Future* (Oxford: E. &
F.N. Spon, 1992), p.74.

86 Ōsawa was also a founder of the Department of
Architecture at the Tokyo School of Art.

87 First published in 1898 as *To-morrow: A Peaceful Path
to Real Reform.*

88 See Watanabe, 'The Japanese Garden City', in Ward
(ed.), *The Garden City*, p.74.

9 The Winds of Heaven

1 'Japanese Houses', *The American Architect and
Building News*, 22 January 1876, p.27.

2 Frank Lloyd Wright, tape transcript, Taliesin, 5
February 1956, quoted in Nute, *Frank Lloyd Wright and
Japan*, p.7, n.1. The authority and usefulness, for this
chapter in particular, of Dr Nute's book must here be
acknowledged.

3 Frank Lloyd Wright, *Ausgeführte Bauten und
Entwürfe von Frank Lloyd Wright* (Berlin: Ernst Wasmuth,
1910), republished as *Studies and Executed Buildings by
Frank Lloyd Wright* (New York: Rizzoli, 1986), p.16.

4 For the correct dates of this trip, see Masami
Tanigawa, 'The Wright's 1905 Itinerary', in Melanie
Birk (ed.) and Frank Lloyd Wright Home and Studio
Foundation, *Frank Lloyd Wright's Fifty Views of Japan*
(Rohnert Park: Pomeranate Artbooks, 1996).

5 The passport is reproduced in Birk, *Frank Lloyd
Wright's Fifty Views of Japan*, p.14. Dated 9 February 1905, it
gives his age as 37. Wright's birthday was 8 June: therefore,
he was born in 1867. For Wright's date of birth, see also
Thomas S. Hines Jr., 'Frank Lloyd Wright – The Madison
Years: Records versus Recollections', *The Journal of the
Society of Architectural Historians*, vol.26, no.4, pp 227–33.

6 The World's Columbian Exposition opened on 1
May 1893.

7 See Manson, *Frank Lloyd Wright to 1910*, p.39.

8 Ashbee's introduction was not to the first folio
edition of Wright's work, *Ausgeführte Bauten und Entwürfe
von Frank Lloyd Wright*, published by Wasmuth in 1910, but
to the book edition of the following year.

9 Charles Robert Ashbee, 'Frank Lloyd Wright: Ein
studie zu seiner würdigung von C.R. Ashbee FRIBA', in
Frank Lloyd Wright, Chicago, published as *8. Sonderheft der
Architektur des XX. Jahrhunderts* (Berlin: Wasmuth AG, 1911),
as quoted in Nute, *Frank Lloyd Wright and Japan*, p.3.

10 Alan Crawford, 'Ten Letters from Frank Lloyd
Wright to Charles Robert Ashbee', *Architectural History*,
vol.13, 1970, p.69.

11 From C.R. Ashbee's journals held at King's College,
Cambridge, quoted in Alan Crawford, *C.R. Ashbee: Architect,
Designer and Romantic Socialist* (New Haven and London:
Yale University Press, 1985), p.154.

12 Robert C. Spencer Jr., 'The Work of Frank Lloyd
Wright', *The Architectural Review* (Boston), vol.7, no.5, May
1900, p.69.

13 ibid., p.72.

14 See Frank Lloyd Wright, *An Autobiography* (New
York: Duell, Sloan and Pearce, 1943), p.13.

15 Wright had briefly worked for Silsbee in 1885. See
Nute, *Frank Lloyd Wright and Japan*, p.32, n.68.

16 See ibid., pp 23–6.

17 'His work was a picturesque combination of gable,
turret and hip, with broad porches quietly domestic and
gracefully picturesque.' Wright, *An Autobiography*, p.70.

18 See ibid., p.75.

19 Manson, *Frank Lloyd Wright to 1910*, pp 16–17. For the 'Unitarian Chapel for Sioux City, Iowa', see the *Inland Architect & News Record*, vol.9, June 1887.

20 Nute states that the Cheney House was also designed in 1893. See Nute, *Frank Lloyd Wright and Japan*, p.140, n.72 and p.62, fig.3.31a.

21 'Bootleg' was the term Wright used to describe the houses he designed outwith the Adler and Sullivan office. See Manson, *Frank Lloyd Wright to 1910*, p.34, and Hitchcock, *In the Nature of Materials*, p.21.

22 Frank Lloyd Wright, 'Recollections – United States, 1893–1920', *Architects' Journal*, July 1936, p.78, quoted in Manson, *Frank Lloyd Wright to 1910*, pp 35–7.

23 Wright, *An Autobiography*, p.143.

24 'After the first terrible anguish, a kind of black despair seemed to paralyze my imagination in her direction and numbed my sensibilities. The blow was too severe.' Wright, *An Autobiography*, p.187.

25 ibid., p.193.

26 For this and details of Wright's travels to Japan, see Kathryn Smith, 'Frank Lloyd Wright and the Imperial Hotel: A Postscript', *Art Bulletin*, vol.67, no.2, June 1985, pp 297–9.

27 Brendan Gill, *Many Masks: A Life of Frank Lloyd Wright* (London: William Heinemann, 1988), p.264.

28 *The New York Times*, 3 September 1923, p.1.

29 See Smith, 'Frank Lloyd Wright and the Imperial Hotel', p.308.

30 That was this author's experience following the Loma Prieta Earthquake in San Francisco in 1989. He telephoned his daughter in San Francisco within an hour of the earthquake but then could not connect for days following.

31 Smith, 'Frank Lloyd Wright and the Imperial Hotel', p.310.

32 Antonin Raymond, *An Autobiography* (Rutland, VT, and Tokyo: Charles E. Tuttle, 1973), p.96.

33 Quoted in Henry-Russell Hitchcock, 'Frank Lloyd Wright and the "Academic" of the Early Eighteen-Nineties', *Journal of the Warburg and Courtauld Institutes*, vol.7, 1944, p.46.

34 Frank Lloyd Wright, *The Future of Architecture* (New York: Bramhall House, 1953), p.300.

35 ibid.

36 See Wright, *An Autobiography*, pp 213–23, and also Wright, *The Future of Architecture*, pp 299–313.

37 Wright, *An Autobiography*, p.214.

38 Wright, *The Future of Architecture*, p.306.

39 ibid., p.300.

40 Wright, *An Autobiography*, p.215.

41 Wright, *The Future of Architecture*, p.308.

42 Wright, *An Autobiography*, p.216.

43 Wright designed 14 buildings for Japan of which eight remained as projects: US Embassy, Tokyo (1914); Odawara Hotel, Odawara (1917); Ginza Motion Picture Theatre, Tokyo (1918); Mihara House, Tokyo (1918); Tadashiro Inoue House, Tokyo (1918); Shimpei Goto House, Tokyo (1921); Prime Minister's Residence, Tokyo (1922); Hobiya Triangle Building, Tokyo (1922).

44 See Smith, 'Frank Lloyd Wright and the Imperial Hotel', pp 303–5, figs 8–17.

45 Tanigawa, Masami, *Jiyu Gakuen: School of the Free Spirit* (Tokyo: Banana Books, 2009), p.55.

46 Itō, Midori, 'Hani Motoko and the Spread of Time Discipline into the Household', *Japan Review*, vol.14, 2002, pp 135–47. See also Michiko Yamaguchi Aoki and Margaret B. Dardess (eds), *As the Japanese See It: Past and Present* (Honolulu: University of Hawai'i Press, 1981), pp 136–46.

47 Wright, *An Autobiography*, p.204.

48 See the Millard, Storer, Ennis and Freeman Houses of 1923.

49 Tanigawa, Masami, *Yamamura House* (Tokyo: Banana Books, 2008), p.47.

50 Wright had panelled the ceilings in a similar way at the Arthur Heurtley House, Oak Park, Illinois (1902) and the Avery Coonley House, Riverside, Illinois (1908).

51 Olive Hill was purchased on 23 June 1919. See Kathryn Smith, 'Frank Lloyd Wright, Hollyhock House, and Olive Hill, 1914–24', *Journal of the Society of Architectural Historians*, vol.38, no.1, March 1979, pp 15–33, and also Alice T. Friedman, 'A House Is Not a Home: Hollyhock House as "Art-theatre Garden"', *Journal of the Society of Architectural Historians*, vol.51, no.3, September 1992, p.242.

52 Smith, 'Frank Lloyd Wright, Hollyhock House', p.18, n.12 and p.19, n.17.

53 The complex was to include a theatre and entrance pavilion, a cinema, a row of 16 terraced shop-houses, an apartment building and six houses of various sizes including Barnsdall's own residence. See Smith, 'Frank Lloyd Wright, Hollyhock House', p.22.

54 ibid., p.22.

55 F. Lawrence, 'Eminence to be Made Rare Beauty Spot', *Los Angeles Examiner*, 6 July 1919, quoted in ibid., p.20.

56 Wright, *An Autobiography*, p.226.

57 Louise Aline Barnsdall, also known as Elizabeth, was born in Seattle on 19 August 1917. Her father, whom Barnsdall did not marry, was the Polish actor, Ryszard or Richard Ordynski (1878–1953).

58 See Smith, 'Frank Lloyd Wright, Hollyhock House', p.27, n.34.

59 ibid., p.24, n.32.

60 David Gebhard, *Schindler* (San Francisco: William Stout Publishers, 1997), p.48.

61 Morse, *Japanese Homes*, pp 54–5.

62 ibid., p.111.

63 R.M. Schindler, 'Care of the Body – Shelter or Playground', *Los Angeles Times*, 2 May 1926, quoted in David Leclerc, 'Schindler Guide: Complete Listing of All Existing Buildings by R.M. Schindler', in Peter Noever (ed.), *MAK Center for Art and Architecture: R.M. Schindler* (Munich and New York: Prestel Verlag, 1995), p.58.

64 Hotel brochure, Koshien Hyogoken, Japan, n.d. Here a single room with a bath was advertised for 18 Yen, and luncheon for 2 Yen.

65 ‡ A double cross or cross of Lorraine.

66 Pfeiffer (ed.), *Frank Lloyd Wright: Letters to Architects* (London: Architectural Press, 1987), p.60.

67 See Makinson, *Greene and Greene*, pp 28–32.

68 Bradley, who was often compared to Aubrey Beardsley (1872–98), was very much influenced by Japanese wood-block printing.

69 See Will Bradley, 'A Bradley House …', *Ladies' Home Journal*, November 1901, p.7; December 1901, p.17; January 1902, p.11; February 1902, p.13; March 1902, p.15; May 1902, p.13; July 1902, p.15; August 1902, p.11.

70 See Manson, *Frank Lloyd Wright to 1910*, p.60.

71 Frank Lloyd Wright, 'A Home in a Prairie Town', *Ladies' Home Journal*, vol.18, no.3, February 1901, p.18.

72 See Manson, *Frank Lloyd Wright to 1910*, p.103.

73 The term 'parlour' is used on the drawings for the Pasadena Security Investment Co. houses (1894), the Theodore Gordon House (1897), and the George Hull House (1897). The James Swan House (1895) has both a parlour and a sitting room. The Edward Hosmer House (1896), the Howard Longley House (1897) and the William Tomkins House (1898) have both a parlour and a living room. The Charles Hollister and William Bolton Houses (1899) have only living rooms. All these houses were designed for Pasadena. The more British term 'drawing room' is used for the Green House in Vancouver, the client being a barrister from Ireland. See Makinson, *Greene and Greene*, pp 38–53.

74 Charles Greene to Lucretia Garfield, n.d., quoted in ibid., p.92.

75 Adelaide Tichenor to Charles Greene, 10 June 1904, quoted in ibid., p.98.

76 Adelaide Tichenor to Charles Greene, 27 September 1905, quoted in ibid., p.99.

77 Aymar Embury II, *One Hundred Country Houses: Modern American Examples* (New York: The Century Company, 1909), p.218.

78 Henrietta P. Keith, 'The Train of Japanese Influence in Our Modern American Architecture', *The Craftsman*, vol.xii, no.4, July 1907, p.451.

79 ibid., p.446.

80 ibid., p.446.

81 Had Greene and Greene missed this, a very similar plan for 'A Shingled Farmhouse for $2700', drawn up by Wright's friend Robert Spencer, was printed by the *Ladies' Home Journal* that April. See H. Allen Brooks, *The Prairie School: Frank Lloyd Wright and His Midwest Contemporaries* (London and New York: W.W. Norton and Co., 1972), p.58, figs 1, 6.

82 See the Warren Hickox House, Kinkakee, Illinois (1900), the F.B. Henderson House, Elmhurst, Illinois (1901), the Darwin D. Martin House, Buffalo, New York (1904) and the Thomas P. Hardy House, Racine, Wisconsin (1905).

83 The Hickox House was published in *Architectural Record*, March 1908, pp 179–81. The ground-floor plan of the Gamble House (NYDA.1960.001.01259) is dated 19 February 1908 and work started on site in March. However, it is possible that the journal was available before the publication month.

84 Although the inglenook fireplace had appeared in the Tichenor House and other houses and projects of this time, it was never again used, like this, in association with a cruciform plan. See the Hollister House, Hollywood (1904), the second and third van Rossem Houses, Pasadena (1904 and 1905) and the project for the Ford House, Pasadena (1907).

85 From C.R. Ashbee's journals held at Kings College, Cambridge, quoted in Crawford, *C.R. Ashbee*, p.152. Also quoted in Makinson, *Greene and Greene*, p.168.

86 Embury, *One Hundred Country Houses*, p.220.

87 On 28 January 1929 Charles wrote to the Japan Society, enclosing a draft for 10s 6d, to renew his membership for 1929. See Greene & Greene Archives, University of Southern California, Huntington Library.

88 Kume, *The Iwakura Embassy*, vol.5, p.75.

89 See Morse, *Japanese Homes*, p.21.

90 Bucknall also translated Viollet-le-Duc's two-volume *Entretiens sur l'architecture* in 1877 and 1881.

91 Translated as *Style in the Technical and Tectonic Arts; or, Practical Aesthetics: A Handbook for Technicians; Artists and Friends of the Arts*.

92 See Richard Longstreth, *On the Edge of the World: Four Architects in San Francisco at the Turn of the Century* (New York: The Architectural History Foundation and Cambridge, MA: MIT Press, 1983), pp 61, 92. It is Longstreth who first explores the connection between Maybeck and Semper: see pp 322–4, 338, 343–4, 347–8.

93 Gottfried Semper (trans. Harry Francis Mallgrave and Michael Robinson), *Style in the Technical and Tectonic Arts; or, Practical Aesthetics* (Los Angeles: Getty Research Institute, 2004), p.666.

94 ibid., pp 685–688.

95 See Kume, *The Iwakura Embassy*, vol.5, pp 52, 75.

96 Semper, *Style in the Technical and Tectonic Arts*, p.688.

97 Phoebe Hearst, a philanthropist, feminist and suffragist, was the widow of US Senator George Hearst (1820–91) and the mother of the newspaper tycoon, William Randolph Hearst (1863–1951). She was the first woman Regent of the University of California, Berkeley.

98 The International Competition for the Phoebe Hearst Architectural Plan for the University of California, 1909.

99 The scrapbooks were assembled by his daughter-in-law, Jacomena Maybeck, and are held in the Design Archives at the University of California, Berkeley.

100 Although unaccredited, the drawings which accompany the article can be attributed to Batchelder due to his monograph. Furthermore, references in the text to

the positioning of a piano and the English appreciation of the garden suggest his authorship: Batchelder's wife was a professional pianist and he studied in England at the Birmingham School of Arts and Crafts. Batchelder was soon to be famous for manufacturing decorative tiles. See 'A Five-room Bungalow, No.747', *The Bungalow Magazine*, vol.II, no.2, April 1910, p.49.

101 Named after the magazine's proprietor, Henry L. Wilson.

102 'A Five-room Bungalow, No.747', *The Bungalow Magazine*, vol.II, no.2, April 1910, pp 46–51.

103 In the plan accompanying the article, the house is inexplicably shown as being L-shaped, there being no wing extending to the rear as in the aerial view. See ibid., p.50.

104 ibid., pp 47–9.

105 'Berkeley', Bernard Maybeck Collection, First Church of Christ, Scientist (Collection no.1956-1), College of Environmental Design Archive, University of California, Berkeley.

106 It is likely that Maybeck knew, or knew of, Batchelder at this time for he had used tiles designed by Batchelder in the fireplace at the second house he built for J.B. Tufts, in San Rafael, in 1908. I am grateful to John Arthur for this information.

107 See Esther McCoy, *Five California Architects* (New York: Praeger Publishers, 1975), p.24.

108 Quoted in Kenneth H. Cardwell, *Bernard Maybeck: Artisan, Architect, Artist* (Santa Barbara and Salt Lake City: Peregrine Smith Inc., 1977), p.122.

109 See Eugène Viollet-le-Duc (trans. Benjamin Bucknall), *The Habitations of Man in All Ages* (London: Simpson Low, Marston, Searle & Rivington, 1876), p.30.

110 Maybeck vertically divided each pane of the factory windows with leading. See William H. Jordy, *American Buildings and Their Architects: Progressive and Academic Ideals at the Turn of the Twentieth Century*, vol.4 (Oxford and New York: Oxford University Press, 1972), p.305.

111 Mary Baker Eddy (1821–1910) was the founder of Christian Science.

112 This comparison was probably first made by Jordy in *American Buildings and Their Architects*, vol.4, pp 311–12. Unity Temple and its relationship to Japanese architecture is discussed by Nute in *Frank Lloyd Wright and Japan*.

113 Frank Lloyd Wright, 'In the Cause of Architecture', *Architectural Record*, vol.23, no.3, March 1908, pp 155–221. The plan of Unity Temple is shown on p.213.

114 Thomas E. Tallmadge, 'The Chicago School', *The Architectural Review* (Boston), vol.15, no.4, April 1908, pp 69–74.

115 Nute explains that the *gongen*-style plan consists of three elements: the *honden* or sanctuary; the *haiden* or worship hall; and the connecting corridor, the *ainoma*. See Nute, *Frank Lloyd Wright and Japan*, p.167.

116 ibid., pp 149–50, 167–70.

117 e-mails to the author from John Archer, 1 and 7 July 2010.

118 Jacomena Maybeck's interview by Mark Anthony Wilson, Berkeley, September 1980, quoted in Mark Anthony Wilson and Joel Puliatti, *Bernard Maybeck: Architect of Elegance* (Layton, UT: Gibbs Smith, 2011), p.220.

10 The Shaken Reed

1 See Brock, 'The Japanese Connexion', pp 227–43; Cobbing, *The Satsuma Students*, pp 64–6; and Hideo Izumida, 'Inquiry in Organization and Campus Buildings for *the Imperial College of Engineering*', 21st IAHA Conference, River View Hotel, Singapore, June 2010, DOI: 10.13140/RG.2.1.1560.5208.

2 See Colin Latimer, 'Kelvin and the Development of Science in Meiji Japan', in Raymond Flood, Mark McCartney and Andrew Whittaker (eds), *Kelvin: Life, Labours and Legacy* (Oxford: Oxford University Press, 2008), p.214.

3 For the early development of the Imperial College of Engineering, see Henry Dyer, *Dai Nippon: The Britain of the East: A Study in National Evolution* (London: Blackie and Son, 1904), pp 1–6. See also Hideo Izumida, 'Reconsideration of Foundation of the Imperial College of Engineering', *Journal of Architecture Planning (AIJ)*, vol.82, no.739, September 2017, pp 2401–10.

4 See Brock, 'The Japanese Connexion', p.240, n.18. Here Brock also states that some 20 Japanese students' names appear in the *Calendars* of the University of Glasgow between 1865 and 1870.

5 Kelvin himself never went to Japan.

6 The Scotsman Richard Henry Brunton (1841–1901) designed and supervised the building in Japan of 26 lighthouses, known as Brunton's 'children', between 1868 and 1876.

7 Antonia Lovelace, *Art for Industry: The Glasgow Japan Exchange of 1878* (Glasgow Museums, 1991), p.9.

8 Horoaki Kimura, 'Japanese Influence on Mackintosh's Architecture', in Horoaki Kimura (ed.), *Process Architecture: Charles Rennie Mackintosh* (Tokyo: Process Architecture Publishing Co., 1984), p.116.

9 Lovelace, *Art for Industry*, p.40.

10 Olive Checkland, *Britain's Encounter With Meiji Japan, 1868–1912* (London: The Macmillan Press Ltd, 1989), p.165.

11 See Checkland, *Japan and Britain*, p.xiii.

12 See ibid., pp 136–7.

13 See Ayako Ono, *Japonisme in Britain: Whistler, Menpes, Henry, Hornel and Nineteenth-century Japan* (London and New York: RoutledgeCurzon, 2003), p 21.

14 See Checkland, *Japan and Britain*.

15 The Science and Art Department of the South Kensington Museum lent Japanese lacquered work consisting of cabinets, medicine chests, bowls, trays, etc., and porcelain and earthen-ware, consisting of vases, flower and incense holders, cups and saucers, etc.; Messrs Liberty & Co lent, among other items, Satsuma and Shigayaki

vases; one of the larger private contributors was the civil engineer Colin Alexander McVean (discussed in chapters 6 and 8). See the catalogue *Oriental Art Loan Exhibition*, pp 29–31, 41–2, 58–8, *et seq.*

16 John Ure was Lord Provost of Glasgow in 1880–83.

17 Reported in *The Glasgow Herald*, 2 March 1882, p.4.

18 Robert Crawford was a partner in Burns, Crawford & Co., fancy goods, china and toy merchants, the sort of firm which might well have sold Japanese wares. His portrait was painted by George Henry in 1901.

19 Robert Crawford to James McNeill Whistler, 2 May 1891. The Correspondence of James McNeill Whistler, University of Glasgow Library, system no.00760, call no. MS Whistler C261.

20 See Bill Smith, *Hornel: The Life and Work of Edward Atkinson Hornel* (Edinburgh: Atelier Books, 1997), p.89.

21 See Toni Huberman, Somnia Ashmore and Yasuko Suga (eds), *The Diary of Charles Holme's 1889 Visit to Japan and North America with Mrs Lasenby Liberty's Japan: A Pictorial Record* (Folkestone: Global Oriental, 2008).

22 Lecture by Hornel delivered at the Corporation Art Galleries, Glasgow, 9 February 1895, quoted in Ono, *Japonisme in Britain*, p.192.

23 The third edition of *A Handbook for Travellers in Japan*, revised and for the most part re-written by Basil Hall Chamberlain and W.B. Mason, was published by John Murray of London in 1891. Hornel includes an extract from *Murray's Guide to Japan* in his lecture delivered at the Corporation Art Galleries, Glasgow, 9 February 1895. This is quoted in Ono, *Japonisme in Britain*, pp 186–7.

24 See William Buchanan, *Mr Henry and Mr Hornel Visit Japan* (Edinburgh: The Scottish Arts Council, 1978), p.12.

25 Smith, *Hornel*, p.91; also quoted in Frances Scott, 'A Singer in Paint', in Ciaran Murray and Charles M. De Wolf (eds), *The Transactions of the Asiatic Society of Japan*, 4th series, vol.13, 1998, p.122.

26 See 'Two Glasgow Artists in Japan – An interview with Mr George Henry', *Castle-Douglas*, 20 July 1894, quoted in Ono, *Japonisme in Britain*, p.196.

27 Lecture by Hornel delivered at the Corporation Art Galleries, Glasgow, 9 February 1895, quoted in ibid., pp 190–91.

28 'Hornel found that in Japan interior space was appreciated as part of art, and this tradition made Japanese life artistic.' See ibid., p.120.

29 Lecture by Hornel delivered at the Corporation Art Galleries, Glasgow, 9 February 1895, quoted in ibid., p.188.

30 Lecture by Hornel delivered at the Corporation Art Galleries, Glasgow, 9 February 1895, quoted in ibid., p.184.

31 Founded in 1889, its first Secretary was the Edinburgh-trained sanitary engineer and Professor at Tokyo Imperial University, William Kinnimond Burton.

32 They were elected members of the Photographic Society in May 1893. Hornel's photographic collection, many of which were purchased, comprised 140 loose prints and an album containing a further 43 photographs of Japan. See Ono, *Japonisme in Britain*, pp 116–17, 122.

33 *Salutations* (1894) is in the Kelvingrove Museum and Art Gallery, Glasgow; the *Yokohama shashin* is in the National Trust for Scotland's Hornel Library, Broughton House, Kirkcudbright.

34 See Ono, *Japonisme in Britain*, pp 127–8.

35 At the exhibition Mackintosh exhibited his *Design for Diploma, Glasgow School of Art Club* and *A Railway Terminus – Longitudinal Section*. *A Railway Terminus* had been his entry for the RIBA Soane Medallion competition 1892–93 and was published in *The British Architect*, 17 February 1893, pp 112, 118–19, and 24 February 1893, pp 136–7. See William Buchanan, 'Glasgow Art, Glasgow Craft, Glasgow International', in William Buchanan (ed.), *Mackintosh's Masterwork: The Glasgow School of Art* (London: Glasgow School of Art Press in association with A. & C. Black, 2004), p.141; and Thomas Howarth, *Charles Rennie Mackintosh and the Modern Movement* (London: Routledge and Kegan Paul, 1977), pp 15–16 and pl.3.

36 Smith, *Hornel*, p.90.

37 Crawford identifies this as 27 Regent Park Square, Strathbungo (after 1895). See Alan Crawford, *Charles Rennie Mackintosh* (London: Thames and Hudson, 2002), p.19. Howarth, however, identifies it as 2 Firpark Terrace, Denistoun (1891–92), and illustrates it thus. See Howarth, *Charles Rennie Mackintosh*, p.21 and pl.5A.

38 'Scottish Baronial Architecture', 1891; 'A Tour in Italy', 1892; 'Elizabethan Architecture', *c.* 1892; untitled paper on architecture, *c.* 1892; 'Architecture', 1893; 'Seemliness', 1902, all reproduced in Pamela Robertson (ed.), *Charles Rennie Mackintosh: The Architectural Papers* (Wendlebury: White Cockade and Glasgow: Hunterian Art Gallery, 1990).

39 See Buchanan (ed.), *Mackintosh's Masterwork*, p.11, illus.2.7. Mackintosh had used such a device as early as 1890 in the competition drawing for the Public Hall: see Kimura, *Process Architecture*, p.124.

40 See Buchanan, 'Glasgow Art, Glasgow Craft, Glasgow International', in Buchanan, *Mackintosh's Masterwork*, fig.2.11, p.14.

41 Morse, *Japanese Homes*, p.51, fig.33, and p.75, fig.57.

42 The drawing for this is inscribed 'CRM April 1899'.

43 See Yūko Ikeda, 'Hermann Muthesius und Japan', in Yūko Ikeda (ed.), *Vom Sofakissen zum Städtebau: Hermann Muthesius und der Deutsche Werkbund: Modern Design in Deutschland 1900–1927* (Kyoto: National Museum of Modern Art, 2002), p.389.

44 Anon, 'Die schottischen Künstler: Margaret Macdonald, Frances Macdonald, Chas. R. Mackintosh, T. Morris und J. Herbert McNair', *Dekorative Kunst*, 3, November 1898, pp 48–9, 69–76.

45 Horoaki Kimura writes that the Japanese prints on the bookshelves and mantelpiece include Shigenobu Yanagawa, *The Girl Playing Shiyamisen* (*c.* 1825) and Kunisada Ototai, *Asahina Saburo no Ojigi* (*c.* 1825). See Horoaki Kimura, 'Japanese Collection in Mackintosh's 120

Mains Street Flat', in Kimura (ed.), *Process Architecture*, pp 122–3.

46 Mackintosh to Muthesius, 19 December 1900. Nachlass Hermann Muthesius, Charles R. Mackintosh 19 December 1900, Deutscher Werkbund Archiv, Berlin.

47 Hermann Muthesius, *Das englische Haus*, edited by Dennis Sharp (London: Crosby Lockwood Staples, 1979), p.52.

48 See Smith, *Hornel*, p.96.

49 See L.L. Ardern, 'Henry and Hornel: Their Friendship as Shown in Henry's Letters', in Buchanan, *Mr Henry and Mr Hornel Visit Japan*, p.17.

50 See Smith, *Hornel*, p.96.

51 Lecture by Hornel delivered at the Corporation Art Galleries, Glasgow, 9 February 1895, quoted in Ono, *Japonisme in Britain*, p.184.

52 Josiah Conder, *The Theory of Japanese Flower Arrangements*, J.L. Thompson & Co. (Retail) Ltd, 1935, p.1.

53 Muthesius, *Das englische Haus*, pp 51–2.

54 Blanche-Ernest Kalas, née Blanche Honorine Truchon, is often incorrectly given as E.B. Kalas and referred to as a man.

55 B-E. Kalas (trans. John Dunlop), 'The Art of Glasgow', in *De la Tamise à la Sprée: L'essor des industries d'art* (Rheims: L. Michaud, 1905), reprinted in *Charles Rennie Mackintosh, Margaret Macdonald Mackintosh, Memorial Exhibition Catalogue*, pp 3–5. Maurice Maeterlinck (1862–1949) was a francophone Belgian playwright, poet and essayist who was important in the Symbolist movement.

56 ibid., p.4.

57 ibid.

58 The lengthy quote given by B-E. Kalas is from Hermann Muthesius, 'Die Glasgower Kunstbewegung: Charles R. Mackintosh und Margaret Macdonald-Mackintosh', *Dekorative Kunst*, 9, 1902, pp 193–221.

59 Kalas (trans. John Dunlop), 'The Art of Glasgow', p.5.

60 W. Fred, 'Art Centres: Vienna', *Artist: An Illustrated Monthly Record of Arts, Crafts and Industries,* January 1901, p.92. Fred was the pseudonym for Alfred Wechsler (1879–1922).

61 Margaret Macdonald Mackintosh to Hermann Muthesius, 25 January 1902, Herman Muthesius Estate, Werkbund Archiv, Berlin, ref: *Margret [sic] M. Mackintosh, 25 January 1902.*

62 Muthesius, 'Die Glasgower Kunstbewegung: Charles Rennie Mackintosh und Margaret Macdonald-Mackintosh', *Dekorative Kunst*, 9, March 1902, pp 193–222.

63 See Dresser, *Japan*, figs 41, 46, 47.

64 Morse, *Japanese Homes*, pp 161–2.

65 See Dresser, *Japan*, figs 17, 60, 84, 102.

66 Mackintosh to Muthesius, 13 March 1903, Nachlass Hermann Muthesius, Charles R. Mackintosh 13 März 1903, Deutscher Werkbund Archiv, Berlin.

67 Muthesius, *Das englische Haus*. For Munstead Wood, see 2, pp 167–9, 203; for Orchards, see 1, pp 192–5 and 2, 112.

68 Charles Rennie Mackintosh, 'Scottish Baronial Architecture', 1891, in Robertson, *Charles Rennie Mackintosh*, pp 49–63.

69 Morse, *Japanese Homes*, p.159.

70 ibid., p.28, fig.20.

71 Mortimer Menpes, *Japan: A Record in Colour* (London: Adam & Charles Black, 1901), p.153.

72 ibid., p.158.

73 ibid., p.159.

74 ibid., p.177.

75 ibid., p.196.

76 See Gleeson White, 'Some Glasgow Designers and Their Work (Part 1)', *The Studio*, vol.11, July 1897, pp 86–100; (Part 2), September 1897, pp 225–36; (Part 3), October 1897, pp 47–51.

77 Mackintosh became a favourite of *The Studio*, so much so that in 1903 it could say of the Ingram Street Tea Room that 'The work of Mr Charles R. Mackintosh is so well known and appreciated by readers of *The Studio* that it is unnecessary to describe at length the decorations, here illustrated, which he has recently completed for one of Miss Cranston's tea-rooms in this city. Suffice it to say that the work more than maintains the high reputation of this talented and imaginative designer.' 'Studio Talk. Glasgow', *The Studio*, vol.28, May 1903, pp 286–7. It can probably be safely argued that Mackintosh was a frequent, if not regular, reader of the magazine.

78 Anon, 'An Experiment in the Application of Japanese Ornament to the Decoration of an English House', *The Studio*, vol.17, 1899, p.170.

79 Charles Rennie Mackintosh, 'Scottish Baronial Architecture', 1891, p.30, quoted in Robertson, *Charles Rennie Mackintosh*, p.60.

80 The 1891 tour of Italy was the result of winning the Alexander Thomson Memorial Travelling Studentship.

81 Robertson, *Charles Rennie Mackintosh*, p.196 (p.33 of Mackintosh's text).

82 Eckart Muthesius, 'Thoughts on My Godfather', in Buchanan, *Mackintosh's Masterwork*, p.3.

83 Denys Lasdun, 'Charles Rennie Mackintosh: A Personal View', in Patrick Nutgens (ed.), *Mackintosh and His Contemporaries in Europe and America* (London: John Murray, 1988), p.153.

84 Murray Grigor and Richard Murphy (eds), *The Architect's Architect: Charles Rennie Mackintosh* (London: Bellew Publishing and the Charles Rennie Mackintosh Society, 1993), p.77.

85 Andrew MacMillan, 'Mackintosh in Context', in Nutgens (ed.), *Mackintosh and His Contemporaries*, p.30.

86 Crawford, *Charles Rennie Mackintosh*, p.154.

87 Shingo Morita, 'Geniuses without Glory: New Series, 8: C.R. Mackintosh, The Young Architect Ahead of His Time', *Young Jump*, 2, *c.* 1993, pp 5–31.

88 Kyoko Tajima, 'Letters from Japan', *Charles Rennie Mackintosh Society Journal*, no.85, Winter 2003, p.24.

11 The Principle of Evolution

1 In March 1888, Conder set an examination paper on 'Lectures on Styles of Architecture'. See Kawanabe et al., *Josiah Conder*, p.171.

2 Hiroyuki Suzuki, 'Itō Chūta's Private Personality', in Hiroyuki Suzuki (ed.), *Itō Chauta o Shitteimasuka* [Do You Know Itō Chūta?] (Chiba: Okokusha 2003), chapter 1.

3 Toshio Watanabe, 'Japanese Imperial Architecture from Thomas Roger Smith to Itō Chūta', in Conant (ed.), *Challenging Past and Present*, p.248; Watanabe, *Ruskin in Japan*, p.298.

4 Taki Uichi, 'The World Trip of Itō Chūta: Turkey and Europe', in Suzuki, *Itō Chauta*, chapter 4.

5 ibid.

6 Itō Chūta, 'Horyū-ji Kenchikuron' ['The Architecture of the Temple of Horyūji'], *Kenchiku zasshi*, vol.7, no.83, November 1893, pp 317–350.

7 See Wendelken, 'The Tectonics of Japanese Style', p.33.

8 Toshio Watanabe wrote: '"Hōryū-ji Kenchikuron" has several versions. First one came out in 1893 (*Kenchiku zasshi*), then 1896 (*Kōkogaku Gakkai Zasshi*) and 1898 (*Tōkyō Teikoku Daigaku Kiyō*). The last one is the Doctoral thesis. The foremost Itō scholar Kurakata Shunsuke regards them all as unfinished.' E-mail to Neil Jackson, 19 February 2018.

9 Itō Chūta, 'Hōryū-ji Kenchikuron', pp 317–50. See also See Wendelken, 'The Tectonics of Japanese Style', pp 32, 37, n.26.

10 Itō Chūta, Kingo Tatsuno and Tsukamoto Yasushi, 'On the Method of Parliament Architecture', *Kenchiku zasshi*, 225, March 1908, pp 102–4.

11 Itō Chūta, 'A Personal Opinion on the Parliament Design Competition', *Kenchiku zasshi*, 396, December 1919, pp 561–5.

12 Itō Chūta, 'The Significance of the Parliament Building', *Kenchiku zasshi*, 289, January 1911, pp 22–7.

13 Itō Chūta, 'A Personal Opinion on the Parliament Design Competition', pp 561–5.

14 Itō Chūta, 'The Prospect of Japanese Architecture Seen From the Principles of Architectural Evolution', *Kenchiku zasshi*, 265, January 1909, pp 4–36.

15 ibid., chapter 5, pp 25–31.

16 ibid.

17 ibid.

18 ibid., illus. p.28.

19 ibid., chapter 5, pp 25–31.

20 ibid., p.20.

21 See Reynolds, 'Teaching Architectural History in Japan', p.531.

22 It was renamed Hitotsubashi University in 1949.

23 Itō Chūta, 'The Prospect of Japanese Architecture Seen From the Principles of Architectural Evolution', *Kenchiku zasshi*, no.265, January 1909, chapter 5, pp 25–31.

24 See Yoshiaki Sato, 'Architect Karo Obi'.

25 See *Kokusai kenchiku*, 5, January 1929, pp 2–33.

26 Reynolds, *Maekawa Kunio*, p.91.

27 'Tokyō teishitsu hakubutsukan sekkei zuan kenshō bioshū' [Tokyo Imperial Museum architectural design competition], *Kenchiku zasshi*, 540, 1930, p. 2213, and quoted in Reynolds, *Maekawa Kunio*, p.92.

28 See 'Tokio Imperial Museum', *Shinkenchiku*, 14, 1938, pp. 199–206.

29 Makino Masami, 'Nationalistic Architecture or Architecture of National Disgrace?', *Kokusai kenchiku*, February 1931, pp 1–5.

30 Compare, for example, with Rettorato della Città Universitaria, Rome, by Marcello Piacentini, 1936. See 'Daiiti-sōgo Life Insurance Co. Bldg., Tokyo', *Kokusai kenchiku*, 15, December 1938, pp 408–13.

31 For *Bunriha*, see Reynolds, 'The Bunriha and the Problem of "Tradition" for Modernist Architecture in Japan, 1920–1928', in Minichiello (ed.), *Japan's Competing Modernities*, pp 228–46; Oshima, *International Architecture in Interwar Japan*, pp 39–67.

32 *Bunriha kenchikukai sakuhinshū*, 1920, n.p., translated and quoted in Reynolds, 'The Bunriha and the Problem of "Tradition" for Modernist Architecture in Japan, 1920–1928', in Minichiello (ed.), *Japan's Competing Modernities*, p. 229.

33 Mendelsohn later observed that Yamada's design for a public hall included in a *Bunriha* publication was a copy of his Einstein Tower. See Oshima, *International Architecture in Interwar Japan*, p.64. For a contemporaneous publication on the Einstein Tower, see Jean Badovici, 'Entretiens sur l'Architecture vivante', *L'Architecture vivante*, Spring, 1925, p.16 and also pp 23–25.

34 Oshima, *International Architecture in Interwar Japan*, p.263, n.107.

35 ibid., p.64.

36 For the following record and interpretation of Horiguchi's travels in Europe, I am indebted in many parts to Oshima, *International Architecture in Interwar Japan*, pp 52–62.

37 The other architects involved were Cornelis Blaauw (1885–1947) and Guillaume la Croix (1877–1923).

38 Horiguchi Sutemi, in an interview given to Jindai Yūichirō in 1956, translated and quoted in Oshima, *International Architecture in Interwar Japan*, p.59.

39 Horiguchi Sutemi, as given by Isozaki Arata, translated and quoted in Oshima, *International Architecture in Interwar Japan*, p.61.

40 Ishimoto Kikuji, *Kenchiku-fu* (Osaka: Bunhira kenchiku kai, 1924).

41 Jeff Cody, '"Erecting Monuments to the God of Business and Trade": The Fuller Construction Company of the Orient, 1919–1926', *Construction History*, 12, 1996, p.69.

42 This is often referred to as a department store.

43 Okada Takeo had published a lengthy article on Poelzig in *Shinkenchiku* in 1928.

44 Okamura Bunzō, 'Saisaku suru kokoro', *Bunriha kenchikukai sakuhinshū*, 3, pp 27–8; Iwanami Shoten, 1924, translated and quoted in Reynolds, 'The Bunriha and

the Problem of "Tradition" for Modernist Architecture in Japan, 1920–1928', in Minichiello (ed.), *Japan's Competing Modernities*, p. 232.

45 See Yamawaki Iwao, 'Reminiscences of Dessau', *Design Issues*, vol.2, no.2, Autumn 1985, p.56; Leah Hsiao and Michael White, 'The Bauhaus and China: Present, Past, and Future', *West 86th*, vol.22, no.2, Fall–Winter 2013, p.182.

46 Iwao, 'Reminiscences of Dessau', p.56.

47 Okada Takeo, 'The Current State of Walter Gropius and the Bauhaus', *Shinkenchiku*, part 1, August 1927, pp 12–23; part 2, September 1927, pp 12–23.

48 Horiguchi Sutemi, 'Bauhaus', *Kenchiku gahō*, October 1926, p.28.

49 Anon, *Buahausu Waimāru hen*, in the series *Kenchiku jidai* (Era of Architecture), 1929, pl.5.

50 ibid., pls 8, 9, 10.

51 Iwao, 'Reminiscences of Dessau', p.56.

52 ibid.

53 'Report A: 9 August 1930', in ibid., p.59.

54 'Letter c: 2 March 1931', in ibid., p.64.

55 *Weihnachtsfest* is Christmas. 'Letter A: 19 December 1930', in ibid., pp 62–3.

56 'Report C, 4 September 1932', in ibid., pp 62–3.

57 The website www.wiw.net/pages.php?CDpath= 3_5_1358_1360_1729_1822 (accessed 7 August 2013) calls this *Shin Kenchiku Kōgei Kenkyūjo* (the Institute of New Architecture and Technology) and gives the date as 1932.

58 Iwao, 'Reminiscences of Dessau', p.58.

12 The Artist-Samurai

1 Walter Gropius, *Internationale Architektur*, 2nd edn, Weimar, 1927, pp 6–7, quoted in Richard Pommer and Christian F. Otto, *Weissenhof 1927 and the Modern Movement in Architecture* (Chicago and London: University of Chicago Press, 1991), p.161.

2 *Kokusai kenchiku* printed captions and indexes in English and German (and even Esperanto), as well as in Japanese.

3 Although Reynolds does give Ishimoto's name, Oshima does not list him as a founding member. See Reynolds, *Maekawa Kunio*, p.34, and Oshima, *International Architecture in Interwar Japan*, p.254, n.38.

4 International Architecture Association of Japan Manifesto, translated and quoted in Reynolds, *Maekawa Kunio*, p.35.

5 For Neutra in Japan, see Barbara Lamprecht, 'From Neutra in Japan, 1930, to his European Audiences and Southern California Work', *Southern California Quarterly*, vol.92, no.3, 2010, pp 215–44. It is likely that Neutra arrived at Yokohama on 9 June and departed on 22 or 23 June.

6 Neutra worked for Wright from October 1924 to January 1925, and the Tsuchiuras worked for Wright between April 1923 and October 1925. See Lamprecht, 'From Neutra in Japan', p.224.

7 *Kenchiku zasshi*, June 1930, p.1353.

8 Richard Neutra, 'Shinkenchiku no igi to jissai', *Kokusai kenchiku*, July 1930, pp 2–3; Tsuchiura Kameki, 'Rihyato Noitra shi', *Kokusai kenchiku*, July 1930, p.1; Kishida Hideto, 'Amerika no kenchiku to Noitora shi', *Kokusai kenchiku*, July 1930, pp 4–9.

9 The same lecture was to be delivered to CIAM in Brussels.

10 Richard Neutra, *Life and Shape* (New York: Appleton-Century-Crofts, 1962) p.227.

11 Richard Neutra, 'An Abstract of Modern Architecture as an Idea and in Practice', *Kokusai kenchiku*, July 1930, translated and quoted by Atsuko Tanaka in 'The Way to the International Style: Tsuchiura Kameki's Residential Design and the Correspondence with Richard Neutra', an unpublished paper dated 13 July 2013, p.3.

12 Neutra, *Life and Shape*, p.228.

13 Thomas S. Hines, *Richard Neutra and the Search for Modern Architecture* (New York and Oxford: Oxford University Press, 1982), p.93; see also Lamprecht, 'From Neutra in Japan', p.226. Lamprecht here quotes Maekawa as saying: 'I've the deepest conscience that the architecture should never be the work of some individual, and I believe so deeply that all the failures of the so-called modern architecture is [*sic*] always due to the lack of this convenience.' (Richard Neutra Archives, California State Polytechnic University, Pomona.) *Kenchiku zasshi*, June 1930, p.1353.

14 Atsuko Tanaka, 'Kameki Tshchiura's Prewar Residential Designs: Adapting the International Style to Japanese Traditional Living', an unpublished paper presented at the 60th Annual Meeting of the Society of Architectural Historians, Toronto, 11–15 April 2007, p.2.

15 Lamprecht, 'From Neutra in Japan', p.224.

16 Atsuko Tanaka, 'Kameki Tshchiura's Prewar Residential Designs', p.8, n.4.

17 Atsuko Tanaka, 'The Way to the International Style', p.2.

18 ibid.

19 Letter from Richard Neutra to Dione Neutra, 10 June 1930 (Richard Neutra Archives, California State Polytechnic University, Pomona). Quoted in Lamprecht, 'From Neutra in Japan', p.226.

20 Ueno had worked for Josef Hoffman in Vienna, where he met and married Rix in 1925.

21 Hiroyuki Tamada, 'Modernity and Tradition: Richard Neutra's Discourse on Japan', *International Conference of East Asian Architectural Culture, Kyoto 2006: Reassessing East Asia in the Light of Urban and Architectural History*, Proceedings 1, Executive Committee of the International Conference on East Asian Architectural Culture, Kyoto, 2006, p.6.

22 Letter from Richard Neutra, 22 June 1930 (Richard Neutra Archives, California State Polytechnic University, Pomona). Quoted in Lamprecht, 'From Neutra in Japan', p.227.

23 Richard Neutra, 'Gegenwärtige bauarbeit in japan', *Die Form*, 1 January 1931, p.22.

24 The French-language caption says 'Ministère des Communications'; the English-language caption says 'Traffic Ministry'.

25 Horiguchi received commissions for seven meteorological stations through his brother, Yoshimi, who was a meteorologist. See Oshima, *International Architecture in Interwar Japan*, p.219, p.282, n.83.

26 The three volumes, and a fourth, published in 1934, are held in the archives of the Japan Institute of Architects.

27 Philip Johnson had seen the Deutsche Werkbund exhibition. See Alan Powers, '*Exhibition 58*: Modern Architecture in England, *Museum of Modern Art, 1937*', *Architectural History*, vol.56, 2013, p.284; Terence Riley, 'Portrait of the Curator as a Young Man', in John Elderfield (ed.), *Philip Johnson and the Museum of Modern Art* (New York: The Museum of Modern Art, 1998), p.42.

28 See Norbert Becker, *Gonkuro Kume (1895–1965)*, University Archives Stuttgart, www.uni-stuttgart.de/archiv/alumni/kume_gonkuro.html, accessed 18 February 2018.

29 Richard Neutra, 'Japanese Dwellings, Developments, Difficulties', *Die Form*, heft 3, 15 March 1931, p.92, translated and quoted by Lamprecht, 'From Neutra in Japan', p.229.

30 Neutra, 'Japanese Dwellings, Developments, Difficulties', p.97.

31 Letter from Richard Neutra to his mother-in-law Lilly Niedermann, 22 June 1930 (Richard Neutra Archives, California State Polytechnic University, Pomona). Quoted in Lamprecht, 'From Neutra in Japan', p.225.

32 Richard Neutra, 'Neue Architektur in Japan', *Die Form*, September 1931, p.340, translated and quoted by Lamprecht in 'From Neutra in Japan', p.231.

33 In this context, he also mentions an 'institute building' by Yamada but does not illustrate it. See Neutra, 'Neue Architektur in Japan', pp 335, 340.

34 Neutra, *Life and Shape*, p.227.

35 ibid., p.228.

36 Wells Coates, 'Inspiration from Japan', *Architects' Journal*, 4 November 1931, p.586.

37 Wells Coates, letter to M.B., commenced 30 September 1927 and finished and sent 13 July 1928, quoted in Farouk Hafiz Elgohary, *Wells Coates, and His Position in the Beginning of the Modern Movement in England*, PhD, University College London, 1966, p.328.

38 Wells Coates, 'Autobiographical Description', 1931, Canadian Centre for Architecture, Montreal, Wells Coates Papers: WCA Box 04-D, quoted in Anna Elizabeth Basham, *From Victorian to Modernist: The Changing Perception of Japanese Architecture Encapsulated in Wells Coates' Japonisme Dovetailing East and West*, PhD University of the Arts, London, 2007, p.118.

39 See Laura Cohn, *The Door to a Secret Room: A Portrait of Wells Coates* (Aldershot: Scolar Press, 1999), p.11, and also Fiona MacCarthy, 'Coates, Wells Wintemute (1895–1958)', *Oxford Dictionary of National Biography* (Oxford: Oxford University Press, 2004–13), online version published 21 May 2009.

40 Canadian Centre for Architecture, Montreal, Wells Coates Papers: Box 05, Diaries 1909, 'Sights and Experiences of Japan', diary 1908–1909, illustrated in Cohn, *The Door to a Secret Room*, p.15.

41 Agnes Coates to Wells Coates, quoted in Elgohary, *Wells Coates*, p.11.

42 Cohn, *The Door to a Secret Room*, p.21.

43 Wells Coates, 'Planning in Section', *The Architectural Review*, August 1937, p.53.

44 Patrick Gwynne, 'Wells Coates', April 1979, in Denys Lasdun Papers, RIBA Drawings Collection, LaD/1/2, quoted in Elizabeth Darling, *Wells Coates* (London: RIBA Publishing, 2012), p.46.

45 Wells Coates, 'Planning in Section', *The Architectural Review*, August 1937, p.55.

46 Their proper names were John Craven Pritchard and Rosemary Pritchard, née Cooke.

47 The other directors were the lawyer Frederick Graham-Maw and the economist Robert S. Spicer.

48 Coates used isometric projection to draw the kitchens at Embassy Court. It was also favoured by Modernist architects at this time.

49 Wells Coates to the students of the University of British Columbia, 1957, Canadian Centre for Architecture, Montreal, Wells Coates Papers: WCA Box 06-29, quoted in Basham, *From Victorian to Modernist*, vol.1, p.119.

50 See 'One Room London Flats', *The Architectural Review*, February 1934, p.43.

51 Wells Coates, 'Furniture Today – Furniture Tomorrow. Leaves from a Meta-Technical Notebook', *The Architectural Review* (*The Architectural Review Supplement*, 'Decoration & Craftsmanship'), July 1932, pp 33–4.

52 ibid., p.34.

53 See Simon Callow, *Charles Laughton: A Difficult Actor* (London: Mandarin, 1990), p.106, referenced in Basham, *From Victorian to Modernist*, vol.1, p.186.

54 See 'Embassy Court, Brighton', *The Architectural Review*, November 1935, pp 167–73. Sherban Cantacuzino refers to their 'inadequate two feet nine inches width'. See Sherban Cantacuzino, *Wells Coates, a Monograph* (London: Gordon Fraser, 1978), p.83.

55 Although most of the discussions were done on board the ship, the official opening of the Congress was held in Athens where the Parthenon was floodlit in their honour.

56 This important document was eventually published by Le Corbusier in 1943. The other British delegates, representing the MARS Group, were Philip Morton Shand, G. Boumphrey, H. Elvin, Godfrey Samuel and F.R.S Yorke. See Eric Mumford, *The CIAM Discourse on Urbanism, 1928–1960* (Cambridge, MA and London: The MIT Press, 2000), p.293, n.65.

57 See John R. Gold, 'Creating the Charter of Athens: CIAM and the Functional City, 1933–43', *Town Planning Review*, vol.69, no.3, 1998, pp 225–47. Gold says that Max Fry attended (p.227) and that Ernö Goldfinger was a member of the French delegation (p.226). See also Sigfried Giedion, 'CIAM at Sea: The Background to the Fourth Charter', in Trevor Dannatt (ed.), *Architects Yearbook 3* (London: Paul Elek, 1949), pp 36–9.

58 20th Century Group, 'Statement of Aims and Objectives or Constitution'. See Elgohary, *Wells Coates*, Appendix III, p.352.

59 Wells Coates, 'Notes for the Sketch Plan of a New Aesthetic', February 1931, quoted in Elgohary, *Wells Coates*, Appendix II, p.338.

60 Wells Coates, 'Autobiographical Description', 1931, Canadian Centre for Architecture, Montreal, Wells Coates Papers: WCA Box 04-D, quoted in Basham, *From Victorian to Modernist*, vol.1, p.122. See also Elgohary, *Wells Coates*, Appendix II, p.338, for this phrase contained in Coates's 'Notes for the Sketch Plan of a New Aesthetic'.

61 Chermayeff applied successfully for Fellowship of the RIBA in 1932 and Coates in 1938.

62 20th Century Group, 'Statement of Aims and Objectives or Constitution'. See Elgohary, *Wells Coates*, Appendix III, p.352.

63 Joseph Peter Thorp, 'Scenario for a National Exhibition', *The Architectural Review*, July 1933, p.21.

64 See 'At the B.I.A. The Minimum Flat and Other Exhibits', *The Architects' Journal*, 29 June 1933, pp 866–7.

65 Thorp, 'Scenario for a National Exhibition', p.23.

66 'The Weekend House at the Exhibition of British Industrial Art, Dorland Hall, Regent Street. Architect Serge Chermayeff', *The Architectural Review*, July 1933, p.20.

67 Thorp, 'Scenario for a National Exhibition', p.23.

68 For Bentley Wood, see Alan Powers, *Serge Chermayeff: Designer, Architect, Teacher* (London: RIBA Publications, 2001), pp 118–41; see also 'House Near Halland, Sussex', *The Architectural Review*, January 1939, pp 64, 70.

69 Robert Ferneaux Jordan, 'Modern Building in Timber', *RIBA Journal*, 4 January 1936, p.238.

70 Quoted in Powers, *Serge Chermayeff*, p.69.

71 Tetsurō Yoshida, *Das Japanische Wohnhaus* (Berlin: Verlag Ernst Wasmuth, 1935).

72 Jirō Harada, *The Lesson of Japanese Architecture*, edited by Geoffrey Holme (London: The Studio, 1936).

73 C.G. Holme, in Harada, *The Lesson of Japanese Architecture*, pp 9, 11.

74 See Hyon-Sob Kim, 'Tetsuro Yoshida (1894–1956) and Architectural Interchange Between East and West', *Architectural Research Quarterly*, vol.12, no.1, March 2008, p.48.

75 See Yoshida, *Das Japanische Wohnhaus*, p.31. This plan came, in turn, from Kawakami Kunimoto, *Photographs*

and *Survey Drawings of the Katsura Imperial Retreat, Nijo Palace, and Shūgakuin Imperial Retreat* (Tokyo: Society for Research in Old Architecture and Gardens, 1928–32), fol.2. See Dana Buntrock, 'Katsura Imperial Villa: A Brief Descriptive Bibliography, with Illustrations', *Cross-currents: East Asian History and Cultural Review*, E-Journal no.3, June 2012, pp 4–5.

76 Bruno Taut, 'Architecture Nouvelle au Japon', *L'Architecture d'aujourd'hui*, April 1935, pp 46–83.

77 Chermayeff had studied at the École des Beaux-Arts in Paris and 'attended lectures and studios in Germany'. See Powers, *Serge Chermayeff*, p.13.

78 Howard Robertson, 'The Paris Exhibition: A Review', *The Architects' Journal*, 26 August 1937, p.330.

79 Serge Chermayeff, 'Circulation: Design: Display. The Architect at the Exhibition', *The Architectural Review*, September 1937, p.95.

80 'Allied Societies', *Journal of the Royal Institute of British Architects*, 13 April 1929, pp 443–7.

81 'The terrace is protected by a brick wall which is yellow in colour … All the living interiors are designed as a simple background, sober in colour …' See 'House Near Halland, Sussex', *The Architectural Review*, January 1939, pp 64, 70. However, at the Week End House, there had been a suggestion of red-and-black lacquers: 'The desk, cupboards and bookcases are of dark oak. The interior of the desk is cellulosed red.' See 'The Weekend House at the Exhibition of British Industrial Art, Dorland Hall, Regent Street. Architect Serge Chermayeff', *The Architectural Review*, July 1933, p.20.

82 Tunnard was in the MARS Group Town Planning Committee formed in December 1936.

83 Christopher Tunnard, *Gardens in the Modern Landscape* (London: The Architectural Press, 1938), p.88.

84 ibid., pp 89–90.

85 ibid., p.90.

86 Charles Reilly, 'Professor Reilly Speaking', *The Architects' Journal*, 22 September 1938, p.479.

87 Compare Wells Coates, 'Inspiration from Japan', *Architects' Journal*, 4 November 1931, p.586 with Wells Coates, 'Planning in Section', *The Architectural Review*, August 1937, p.53.

88 Manfred Speidel, 'Bruno Taut in Japan', in Winfried Nerdinger, Kristiana Hartmann, Matthias Schirren and Manfred Speidel, *Bruno Taut 1880–1938: Architekt zwischen Tradition und Avantgarde* (Stuttgart and Munich: Deutsche Verlags-Anstalt, 2001), p.174.

89 In the next two weeks some 10,000 were arrested.

90 General Kurt von Hammerstein-Equord was an ardent opponent of Hitler and the Nazis. His daughter Marie-Therese or 'Esi' (1909–2000) had met Taut's daughter Elisabeth (1908–99) in Spain and because she, Marie-Therese, was not politically active, unlike her sisters Marie-Louise or 'Butsi' (1908–1999) and Helga (1913–2001), who were both Communists, her father used her to convey warning messages to Communists and others at risk of

imminent arrest. (I am grateful to Marie-Therese's son, Emeritus Professor Gottfried Paasche of York University, Canada, for providing this information on which he has corroborative material.) Two of their brothers, Ludwig and Kunrat, were later involved in the July 1944 plot to assassinate Hitler. Although the General died of cancer in 1943, the whole family survived the war.

91 For an account of these events, see Manfred Speidel, 'Bruno Taut in Japan', in Nerdinger et al., *Bruno Taut*, pp 174–5.

92 For Taut's travel itinerary, see Manfred Speidel, *Bruno Taut: Natur und Fantasie 1880–1938* (Berlin: Ernst & Sohn, 1995), p.270; and also Speidel, 'Bruno Taut in Japan', in Nerdinger et al., *Bruno Taut*, pp 175–6.

93 The Anti-Comintern Pact was concluded in Berlin between Nazi Germany and the Empire of Japan on 25 November 1936.

94 I am grateful to David Stewart and Hiro Fujioka for this and information regarding Taut's journey to Japan.

95 Bruno Taut's *Diary*, quoted in Kengo Kuma, *Anti-object: The Dissolution and Disintegration of Architecture* (London: Architectural Association, 2008), p.21.

96 Kawakami, *Photographs and Survey Drawings*.

97 Bruno Taut, *Houses and People of Japan* (London: John Gifford Ltd, 1938), p.272.

98 ibid., p.291.

99 Bruno Taut, *Katsura Imperial Retreat* (trans. Hideo Shinoda) (Tokyo: Ikuseishakōdōkaku, 1942), p.213, quoted in Buntrock, 'Katsura Imperial Villa', p.2.

100 Bruno Taut, *Grundlinien der Architektur Japans* [Fundamentals of Japanese Architecture] (Tokyo: Kokusai Bunka Shinkokai, 1936), p.3.

101 ibid., p.25.

102 Taut, *Houses and People*, p.2.

103 ibid.

104 ibid.

105 See ibid., pp 29–37. See also Sandra Kaji-O'Grady, 'Authentic Japanese Architecture after Bruno Taut: The Problem of Eclecticism', *Fabrications*, vol.11, no.2, September 2001, p.1.

106 Taut, *Grundlinien der Architektur*, p.9.

107 ibid.

108 Taut, *Houses and People*, p.261.

109 Hideto Kishida, *Japanese Architecture* (Japan Travel Bureau, 1948 [1936]), pp 50, 104, quoted in Kaji-O'Grady, 'Authentic Japanese Architecture After Bruno Taut', p.6.

110 For Taut's publications on Japan, see Manfred Speidel, 'Japanese Traditional Architecture in the Face of Its Modernisation: Bruno Taut in Japan', *Questioning Oriental Aesthetics and Thinking: Conflicting Visions of "Asia" under the Colonial Empires* (Kyoto: International Research Center for Japanese Studies, 2011), pp. 93–111.

111 Bruno Taut, 'Architecture Nouvelle au Japon', *L'Architecture d'aujourd'hui*, April 1935, pp 46–83.

112 ibid., p.66.

113 ibid., p.66.

114 Taut, *Houses and People*, p.303.

115 ibid., p.39.

116 ibid., p.258.

117 ibid., p.258.

118 ibid., p.258.

119 For Kume's thoughts, see 'On a House Designed by Prof. B. Taut in Tokyo', *Kokusai kenchiku*, 12, December 1936, p.457.

120 See 'Ōkura's Residence, Tokyo', *Kokusai kenchiku*, 12, December 1936, pp 322–8. See also Speidel, *Bruno Taut*, pp 263, 332; Catalogue no.158 in Nerdinger et al., *Bruno Taut*, pp 388–9; and also Willi Weber and Simos Yannas, *Lessons from Vernacular Architecture* (London and New York: Routledge, 2013), p.149.

121 See Susie Harries, *Nikolaus Pevsner: The Life* (London: Random House, 2011), p.149.

122 Nikolaus Pevsner, 'Bruno Taut's Japanese Modern', *The Architectural Review*, June 1941, p.135.

123 ibid.

124 Heinrich Taut, 'Bruno Taut in und uber Japan', in Achim Wendschuh, Barbara Volkmann, Akademie der Künst, *Bruno Taut 1880–1938* (Berlin: Akademie der Künst, 1980), p.133.

125 See Speidel, *Bruno Taut*, pp 232–5; Wendschuh and Volkmann, *Bruno Taut*, cat. no.173; Kurt Junghanns, *Bruno Taut 1880–1938: Architektur und sozialer Gedanke* (Leipzig: E.A. Seemann, 1998), illus. 342; Anon, 'Para Observations on Ginza's Crystal Palace', *Art-IT*, www.art-it.asia/u/maisonhermes/?ca1=3&lang=en, accessed 16 April 2014.

126 Nerdinger et al., *Bruno Taut*, p.388.

127 ibid., pp 387–8.

128 Bruno Taut, *Die neue Wohnung*, p.29, quoted in Manfred Speidel, 'Japanese Traditional Architecture in the Face of Its Modernisation: Bruno Taut in Japan', in Shigemi Inaga (ed.), *Questioning Oriental Aesthetics and Thinking: Conflicting Visions of Asia Under the Colonial Empires: The 38th International Research Symposium* (International Research Center for Japanese Studies, 2010), p.100.

129 The four buildings at the *shoin* are, from east to west, *ko-shoin*, *chu-shoin*, *gakki-no-ma* and *shin-goten*, and were built in that order between *c.* 1619 and 1662. These names translate as Old Shoin, Middle Shoin, Room of Musical Instruments and New Palace. *Shoin*, being a Japanese type of room, does not translate well into English. It could be understood as a drawing room or reception space. Taut believed that the *shoin* had been built by Kobori Enshū in a single operation when, in fact, it had developed incrementally as four distinct yet conjoined buildings.

130 Taut, *Houses and People*, p.303.

131 Pevsner, 'Bruno Taut's Japanese Modern', p.135.

132 'Hyuga's Villa at Atami', and T. Yoshida, 'Hyuga's Villa at Atami by Prof. B. Taut', *Kokusai kenchiku*, 12, December 1936, pp 313–21, pp 451–3. R.M. Schindler's McAlmon House in Los Angeles was illustrated in the same issue.

13 The Presence of Le Corbusier

1 The English-language title was 'Seven Houses'. See *Shinkenchiku*, July 1953, p.24.

2 Antonin Raymond, 'No Place for Personality', in William Whitaker and Kurt G.F. Helfrich (eds), 'Selected Writings by Antonin and Noémi Raymond', in Kurt G.F. Helfrich and William Whitaker (eds), *Crafting a Modern World: The Architecture and Design of Antonin and Noémi Raymond* (New York: Princeton Architectural Press, 2006), p.304.

3 See William Whitaker, 'List of Buildings and Projects, 1917–73', in Helfrich and Whitaker (eds), *Crafting a Modern World*, pp 330–32.

4 Raymond, *An Autobiography*, p.249.

5 Antonin Raymond to Noémi (New York, 4 November 1935), quoted in Anne Lutun (ed.), '"Your letters fire my soul", Selected Correspondence of Antonin and Noémi Raymond', in Helfrich and Whitaker (eds), *Crafting a Modern World*, p.334.

6 Le Corbusier had, in fact, briefly met Raymond three years earlier in his studio at 35 rue de Sèvres, Paris. See Noémi Raymond to Jeannette (Geneva, 2 December 1932), quoted in Lutun (ed.), '"Your letters fire my soul"', in Helfrich and Whitaker (eds), *Crafting a Modern World*, p.331.

7 Le C. et P.J., 'Errazuriz Maison en Amerique du Sud 1930', in 'Rapport sur les parcellement du sol des villes par Le Corbusier', *L'Architecture vivante*, Spring and Summer 1931, pp 37–9.

8 Anon, 'Architect's Summer Quarters, Karuizawa, Japan – 1933. Antonin Raymond, Architect', *Architectural Record*, May 1934, pp 432–7.

9 ibid., p.434.

10 This can be translated as 'No need to be shy!' Le Corbusier, *Le Corbusier et Pierre Jeanneret, Oeuvre complète de 1929–1934*, 3rd edn, edited by W. Boesiger (Erlenbach-Zurich: Les Editions d'Architecture 1946), pp 49, 51–2.

11 ibid., p.52.

12 Raymond, *An Autobiography*, p.130.

13 This translation appears in Raymond's own book. An alternative translation is in Helfrich and Whitaker. See Raymond, *An Autobiography*, p.131. See also Le Corbusier to Antonin Raymond (Paris, 7 May 1935), quoted in Lutun (ed.), '"Your letters fire my soul"', in Helfrich and Whitaker, (eds), *Crafting a Modern World*, pp 332–3.

14 Raymond, *An Autobiography*, p.131.

15 The separate residence for the draughtsmen comprised a studio, kitchen, bathroom and 10-mat *tatami* room.

16 Ichiura Ken, 'Reemondo shi karuizawa bettei' [The second home of Raymond in Karuizawa], *Shinkenchiku*, vol.9, no.10, October 1933, p.185, translated and quoted in Oshima, *International Architecture in Interwar Japan*, p.127.

17 See Junzo Yoshimura, House at Karuizawa in 'Modern Houses', *Japan Architect*, Summer 1996, pp 78–82.

18 See Antonin Raymond to Noémi (New York, 9 November 1935), quoted in Lutun (ed.), '"Your letters fire my soul"', in Helfrich and Whitaker (eds), *Crafting a Modern World*, pp 336–7.

19 ibid., p.336.

20 Antonin Raymond to Noémi (New York, 14 November 1935), quoted in Lutun (ed.), '"Your letters fire my soul"', in Helfrich and Whitaker (eds), *Crafting a Modern World*, p.337.

21 Raymond, *An Autobiography*, p.102.

22 ibid., p.248.

23 Here is a conundrum. If the Lipchitz-Miestchaninoff villas were the source for Raymond's own house, as seems very likely, how did he know about them? They were published as 'Atelièrs, Allée des Pins, à Boulogne-sur-Seine, 1926' in *L'Architecture vivante*, Autumn 1926, pp 14–15, pl.19–21. But this was after *L'Architecture vivante* had shown the maquette and design drawings for Raymond's Reinanzaka house in Tokyo: see 'La maison d'aujourd'hui à Tokio (Japon), par Antonin Raymond', *L'Architecture vivante*, Winter 1925, pp 29–30, 34–5. One suggestion is that the magazine's editor, Jean Badovici, sent Raymond images of the Lipchitz-Miestchaninoff villas in 1923 or 1924.

24 Chaim Jacob Lipschitz (1891–1973) and Oscar Miestchaninoff (1886–1956).

25 See Le Corbusier's Mass Production House project of 1921.

26 See the construction drawing no.8 in William Whitaker, with Ken Tadashi Oshima, 'Portfolio', in Helfrich and Whitaker (eds), *Crafting a Modern World*, p.98.

27 'La maison d'aujourd'hui à Tokio (Japon), par Antonin Raymond', *L'Architecture vivante*, Autumn and Winter 1925, p.29.

28 Antonin Raymond to Noémi (on the train to Tokyo, 14 May 1926), quoted in Lutun (ed.), '"Your letters fire my soul"', in Helfrich and Whitaker (eds), *Crafting a Modern World*, p.327.

29 See 'Auditorium and Chapel of Tokyo Joshidaigaku', and M. Sugiyama, 'Auditorium and Chapel of Tokyo Joshidaigaku', *Kokusai kenchiku*, 14, May 1938, pp 157–71, 173–6.

30 Raymond, *An Autobiography*, p.140. Auguste Perret's church of Notre Dame at Raincy had been published in *L'Architecture vivante* in 1923. See Jean Badovici, 'Entretiens sur l'Architecture vivante', in *L'Architecture vivante*, Autumn 1923, pp 11–16, pl.1–12.

31 Raymond, *An Autobiography*, p.248.

32 ibid.

33 Noémi Raymond to Jeannette (Geneva, 2 December 1932), quoted in Lutun (ed.), '"Your letters fire my soul"', in Helfrich and Whitaker (eds), *Crafting a Modern World*, pp 331, 332.

34 The job numbers were, respectively, 1298, 1299 and 1303. All date from 1933. See Whitaker, 'List of Buildings and Projects, 1917–73', in Helfrich and Whitaker (eds), *Crafting a Modern World*, p.347.

35 See Stewart, *The Making of Modern Japanese Architecture*, p.136.

36 Kazue Yakushiji, 'Travelling in the West', *Kenchiku sekai*, August 1923, p.53.

37 Hiroshi Sasaki, 'Le Corbusier et les architectes japonais', in Monnier, *Le Corbusier*, p. 76.

38 See ibid., pp 75–85; and also Hiroyasu Fujioka, 'L'influence corbuséenne chez les architectes japonais et l'intérêt pour l'oeuvre de Le Corbusier dans le Japon d'avant-guerre', in Monnier, *Le Corbusier*, pp 87–97.

39 See Hiroshi Sasaki, 'Le Corbusier et les architects japonais', in Monnier (ed.), *Le Corbusier*, pp 75–7.

40 (ed.), *Ru Korubyujie sakuhinshū* (Tokyo: Koyosha, 1929), pp 50–52.

41 *Yamato-e* means 'Japanese'-style painting, to distinguish it from Chinese, whereas *fukinuki-yatai* means, literally, *'blown off roof'* technique, as in an interior axonometric projection.

42 See Hiroyasu Fujioka, 'L'influence corbuséenne chez les architectes japonais et l'intérêt pour l'oeuvre de Le Corbusier dans le Japon d'avant-guerre', in Monnier (ed.), *Le Corbusier*, pp 91–2.

43 Ichiura graduated in 1928 and went on to develop a pre-fabricated housing programme during the Second World War. Maekawa was his classmate (Reynolds, *Maekawa Kunio*, p.271, n.4) and also graduated in 1928.

44 Ichiura Ken, 'Look at Him, Le Corbusier', *Kokusai kenchiku*, May 1929, pp 6–13.

45 The publisher was Kōseisha Shobō of Tokyo. In the introduction Miyazaki notes that a year earlier he could not get the translation published. See Reynolds, *Maekawa Kunio*, p.72.

46 Nakamura Junpei, 'Le Corbusier', *Kokusai kenchiku*, May 1929, p.23.

47 Kishida Hideto, 'The Contemporary and Le Corbusier', *Kokusai kenchiku*, May 1929, p.15.

48 This was, in fact, a translation of a letter from Le Corbusier to 'H.L.', in all probability Hubert Lagardelle (1874–1958), the French Syndicalist thinker who, like Le Corbusier, sat on the editorial board of the avant-garde magazine *Plans*. The magazine, which advocated a technically orientated fascism, was founded in 1930 by the French fascist Philippe Lamour (1903–92) and was, until 1933, the mouthpiece of the Ordre nouveau group.

49 Kimiji Mizuki, 'City and Houses', *Kenchiku*, May 1929, pp 1–10.

50 Hisashi Kido, 'Flag of Japan: Rising Sun or Setting Sun?', *Kenchiku*, October 1929, p.7.

51 The uncle was Satō Naotake, a diplomat with the League of Nations who was to be the Japanese Ambassador to France in 1933–37. Satō supported and housed Maekawa on the condition that he stayed no longer than two years and did not take 'a blue-eyed fiancée'. See Hiroshi Sasaki, 'Le Corbusier et les architects japonais', in Monnier (ed.), *Le Corbusier*, p.79.

52 Le Corbusier, *Le Corbusier et Pierre Jeanneret, Oeuvre complète de 1910–1929*, 4th edn (Erlenbach-Zurich: Les Editions d'Architecture, 1946), pp 204–5.

53 Maekawa Kunio, translated and quoted in Reynolds, *Maekawa Kunio*, p.59.

54 Le Corbusier, *Oeuvre complète de 1929–1934*, p.52.

55 Le Corbusier, *Oeuvre complète de 1910–1929*, p.198.

56 Tsutsui Shinsaku, 'Kenchikuteki jun' [Architectural Purity], *Kokusai kenchiku*, May 1929, p.26; Makino Masami, 'Ru Korubyujie o katari Nihon ni oyobu' [Talking About Le Corbusier and Expanding (The Discussion) to Japan], *Kokusai kenchiku*, May 1929, pp 67–75.

57 Maekawa Kunio to Le Corbusier, 1 June 1930, p.2, Fondation Le Corbusier, Paris, no. E2-15-173-002.

58 For the guests, see Reynolds, *Maekawa Kunio*, p.271, n.4.

59 Maekawa Kunio to Le Corbusier, 1 June 1930, p.2, Fondation Le Corbusier, Paris, no. E2-15-173-002.

60 Sakakura Junzō to Le Corbusier, 16 June 1931, pp 1–2, Fondation Le Corbusier, Paris, no. R3-2-65-001 and R3-2-65-002.

61 Le Corbusier handwritten note, Fondation Le Corbusier, Paris, no. R3-2-65-003.

62 Yasuto Ota, 'Le Corbusier, Charlotte Perriand et Junzō Sakakura', in Monnier (ed.), *Le Corbusier*, p.62.

63 The other three were Maeda Kenjirō, Taniguchi Yoshirō and Yoshida Tetsurō.

64 See Reynolds, *Maekawa Kunio*, p.275, n.73.

65 Half of the design fee also went to Le Corbusier. See Museum of Modern Art, Kanagawa and Hayama, *Kenchikuka Sakakura Junzo Modanizumu o ikiru* [Junzo Sakakura, Architect] Exh.cat. (Kanagawa: Museum of Modern Art, Kanagawa and Hayama, 2009), p.42.

66 'Paris, 1937', *RIBA Journal*, 17 July 1937, p.910.

67 Talbot F. Hamlin, 'Paris 1937: A Critique by Talbot F. Hamlin', *American Architect and Architecture*, November 1937, pp 25–6.

68 The architect was Oliver Hill (1887–1968).

69 'Paris, 1937', *RIBA Journal*, 17 July 1937, pp 910–11.

70 The architects were Paul Lester Wiener (1895–1967), Julian Clarence Levi (1874–1971) and Charles H. Higgins.

71 Talbot F. Hamlin, 'Paris 1937: A Critique by Talbot F. Hamlin', *American Architect and Architecture*, November 1937, p.30.

72 *L'Architecture d'Aujourd'hui*'s first published illustration of the building credits it to Danis and Sakakura; later, Danis is listed as the 'architecte Français adjoint'. See Maurice Barret, 'Les expositions de Paris', *L'Architecture d'Aujourd'hui*, May, June 1937, p. 113, and A.H., 'Pavilion du Japon', *L'Architecture d'Aujourd'hui*, September 1937, p.40.

73 Talbot F. Hamlin, 'Paris 1937: A Critique by Talbot F. Hamlin', *American Architect and Architecture*, November 1937, p.27.

74 Anon, 'The 1937 International Exhibition, Paris', *Architectural Record*, October 1937, p.82.

75 Anon, 'Paris, 1937', *RIBA Journal*, 17 July 1937, p.910.

76 Anon, *The Architect and Building News*, 23 July 1937, p.99.

77 Anon, 'Pavilion du Japon', *L'Architecture d'Aujourd'hui*, September 1937, pp 40–41; Howard Robertson, 'The Paris Exhibition: A Review', *The Architects' Journal*, 26 August 1937, pp 324–33; Anon, 'The 1937 International Exhibition, Paris', *Architectural Record*, October 1937, pp 81–93; Anon, 'Pariisin Maailmannäyttely 1937', *Arkkitehti*, 1937, pp 132–6; Reidar Lund, 'Fremmede lands paviljonger', *Bygge Kunst*, 1938, pp 6–16; Anon, 'Weltausstellung Paris 1937', *Das Werk*, 11 November, pp 321–52.

78 Serge Chermayeff, 'Circulation: Design: Display. The Architect at the Exhibition', *The Architectural Review*, September 1937, pp 91–104.

79 A.H., 'Pavilion du Japon', *L'Architecture d'Aujourd'hui*, September 1937, p.40.

80 Serge Chermayeff, 'Circulation: Design: Display. The Architect at the Exhibition', *The Architectural Review*, September 1937, p.97.

81 ibid., p.95.

82 ibid., p.92.

83 Quoted in ibid., p.93.

84 José Luis Sert, in the Introduction to an exhibition catalogue of Sakakura's work, 1975, n.p.

85 Sakakura Junzō to Charlotte Perriand, 10 February 1940, reproduced in Museum of Modern Art, *Kenchikuka Sakakura Junzo*, p.50. Two days earlier, on 8 February, Sakakura had sent Perriand a telegram with the news.

86 Jacques Barsac, *Charlotte Perriand, Complete Works Vol. 1, 1903–1940* (Paris: Archives Charlotte Perriand; and Zurich: Scheidegger & Spiess, 2014), p.482.

87 ibid., p.483.

88 Mary McLeod (ed.), *Charlotte Perriand: An Art of Living* (New York: Harry N. Abrams Inc., 2003), p. 277, n.1.

89 Mary McLeod, 'Charlotte Perriand's *L'Art de vivre*', in ibid., p.15.

90 Okakura, Kakuzō, *The Book of Tea* (Rutland, VT, Tokyo and Singapore: Tuttle Publishing, 1956), p.81.

91 Sakakura Junzō to Charlotte Perriand, 10 February 1940, reproduced in Museum of Modern Art, *Kenchikuka Sakakura Junzo*, p.50.

92 The exhibition was subsequently presented at the Takashimaya store in Osaka from 13 to 18 May 1941.

93 1941 was the year 2601 in the Japanese Imperial calendar.

94 Yasushi Zeno, 'Fortuitous Encounters: Charlotte Perriand in Japan 1940–1', in McLeod (ed.), *Charlotte Perriand*, p.96.

95 See Charlotte Perriand, *Une vie de creation* (Paris: Odile Jacob, 1998), p.188.

96 'L'Art d'habiter', *Techniques et architecture*, vol.9, nos 9–10, August 1950, p.33, quoted in McLeod (ed.), *Charlotte Perriand*, p.262.

97 See Perriand, *Une vie de creation*, pp 189–90.

98 Gorozō Iizuka, 'High-floor House with Lightweight Steel Frame', *Shinkenchiku*, September 1958, pp 61–9.

99 See Rem Koolhaas and Hans Ulrich Obrist, *Project Japan: Metabolism Talks* (Cologne: Taschen GmbH, 2011), pp 72, 83 nos 8, 9.

100 See Le Corbusier and P. Jeanneret, *Oeuvre complete 1934–1938*, 2nd edn, edited by Max Bill (Zurich: Erlenbach-Zurich: Les Editions d'Architecture 1947), p.54.

101 See drawings SN003 (plans) and SN004 (elevations and section) in Museum of Modern Art, *Kenchikuka Sakakura Junzo*, p.49.

102 The elevations of both these Le Corbusier buildings have since been altered.

103 Yasuto Ota, 'Le Corbusier, Charlette Perriand et Junzō Sakakura', in Monnier (ed.), *Le Corbusier*, p.65. The actual wording is: 'J'ai remarqué le même principe de spatialité que chez Le Corbusier.'

104 Tōkyū Dentetsu (or Corporation) is a private railway company and land developer, not to be confused with the city of Tokyo.

105 For this observation and discussion of Maekawa's early public buildings, see Reynolds, *Maekawa Kunio*, pp 60, 67–72.

106 Watanabe Jin was not averse to designing in the Modern style, as his Hara House (1938) in Shinagawa, Tokyo, shows.

107 Maekawa, in an essay published in December 1937 in *Mokuyōkai zasshi*, his school of architecture alumni magazine, translated and quoted in Reynolds, *Maekawa Kunio*, p.73.

108 Maekawa Kunio to Le Corbusier and Pierre Jeanneret, 9 January 1947. Fondation Le Corbusier, Paris, no. E2-15-183-001.

109 PRE for pre-fabricates; M for Maekawa; O for One Kauru, the structural engineer; S for the Sani'in Manufacturing Company. See Reynolds, *Maekawa Kunio*, p.146.

110 Maekawa Kunio to Le Corbusier and Pierre Jeanneret, 9 January 1947. Fondation Le Corbusier, E2-15-183-001.

111 See Reynolds, *Maekawa Kunio*, p.165.

112 See Norie Fukuda and Shin-Ichiro Ohnishi, 'do.co,mo.mo_japan: the 100 selections', *Architecture and Urbanism*, April 2005, p.83.

113 A close examination of the side railings of the L-shaped balconies will show that they were not like those at the earlier Villa Cook or the Maison Guiette (1926).

114 See Reynolds, *Maekawa Kunio*, pp 165–7.

115 *Manière de Penser L'urbanisme* was translated as *Kagauaku toshi* (which confusingly means 'The Radiant City') and *L'Unité d'habitation de Marseille* was translated as *Maruseiyo no jyukyo ynni*. Le Corbusier's *Vers une architecture* (1923) was eventually translated into Japanese by Yosjizaka in 1967, with the title *Kenchiku wo mezashite*.

116 Tange was placed second. There was no first prize. The building was not built.

117 Established in 1947, MID was a collective which allowed Maekawa to take a less prominent place in the firm.

118 Tange was the first non-Western architect to present at a CIAM meeting.

119 Yamashita Hisao and Arai Ryuzo were joint second.

120 Tange worked for Maekawa between 1938 and 1942.

121 Tange Kenzō (trans. Robin Thompson), 'A Eulogy to Michelangelo: A Preliminary Study of Le Corbusier', *Art in Translation*, vol.4, no.4, 2012, p.393.

122 ibid., p.404.

123 See Carola Hein, 'Visionary Plans and Planners: Japanese Traditions and Western Influences', in Nicolas Fiévé and Paul Waley (eds), *Japanese Capitals in Historical Perspective: Place, Power and Memory in Kyoto, Edo and Tokyo* (London: RoutledgeCurzon, 2003), p.328.

124 Le Corbusier's version of the Athens Charter was initially published with CIAM–France shown as the author. The actual findings of the conference were published in J.L. Sert (ed.), *Can Our Cities Survive?* (Cambridge, MA: Harvard University Press, 1941).

125 See Ishimaru Norioki, 'Reconstructing Hiroshima and Preserving the Reconstructed City', in Carola Hein, Jeffry M. Diefendorf and Ishida Yorifusa (eds), *Rebuilding Urban Japan After 1945* (New York: Palgrave Macmillan, 2003), p.88.

126 Le Corbusier, *La Chartre d'Athèns* (Paris: Editions de Menuit, 1957), p. 28, translated and reproduced in Stewart, *The Making of Modern Japanese Architecture*, pp 173, 286, n.19.

127 It is thought that it was Miles Born, the vice-president of United Press, who in July 1947 first suggested Nakajima as a location for the memorial park. See Ishimaru Norioki, 'Reconstructing Hiroshima and Preserving the Reconstructed City', in Hein et al. (eds), *Rebuilding Urban Japan*, p.96.

128 See Hein, 'Visionary Plans and Planners: Japanese Traditions and Western Influences', in Fiévé and Waley (eds), *Japanese Capitals*, p.330.

129 Robin Boyd, *Kenzo Tange* (New York: George Brazillier, 1962), p.9.

130 See 'Harumi Apartment House', *The Japan Architect*, January 1957, pp 15–26.

131 Masato Ōtaka, 'Floor Plans in the Harumi Apartments', *The Japan Architect*, March 1959, p.27.

132 Tange Kanzō, writing in *Shinkenchiku*, June 1956, and quoted in Nōboru Kawazoe, 'A Step Towards the Future', *The Japan Architect*, March 1959, p.26.

133 Masato Ōtaka, 'Floor Plans in the Harumi Apartments', *The Japan Architect*, March 1959, p.27.

134 Located in Geneva, the International Labour Organization was established in 1919 and Japan was a member.

135 Yasutada Watanabe, 'Comments on Mr M's Residence', *Sinkentiku*, March 1957, p.21.

136 'Villa CouCou, Yoyogi, Tokyo', *Sinkentiku, The New Architecture of Japan*, December 1957, p.23.

137 Muramatsu, 'Humanity and Architecture: Dialogue 4 with Takamasa Yoshizaka', *Japan Architect*, November 1973, p.90.

138 'Il padiglione del Giappone alla Biennale', *Domus*, September 1956, pp 6–7.

139 ibid., p.6.

140 ibid., p.7.

141 The Museum at Chandigarh, which has a similar plan, was completed posthumously in 1968.

142 J.M. Richards, 'Japan 1962', *The Architectural Review*, September 1962, p.169.

143 For this background, see Yoko Terashima, 'The Construction of the National Museum of Western Art Recounted', in Shin-Ichiro Ohnishi (ed.), *Le Corbusier and the National Museum of Western Art* (Tokyo: The National Museum of Western Art/The Western Art Foundation, 2009), English text, pp 10–15, Japanese text, pp 58–65.

144 *Asahi Shimbun*, 3 November 1955, n.p., quoted in Hirochi Matsukuma, 'Le Corbusier's Visit to Japan: What He Saw on His Trip', in Ohnishi (ed.), *Le Corbusier*, English text, p. 5, Japanese text, p.32.

145 Noriaki Okabe, 'Réflexions autour du "cabanon sur la Méditeranée"', in Monnier (ed.), *Le Corbusier*, p.155.

146 For this background, see Hirochi Matsukuma, 'Le Corbusier's Visit to Japan: What He Saw on His Trip', in Ohnishi (ed.), *Le Corbusier*, English text, pp 10–15, Japanese text, pp 58–65.

147 Miracle Box.

148 Sakakura later said: '... I wanted him to make sure to include an expanded, comprehensive site plan design for the area surrounding the museum anyway (even though that may be outside the contract with the Japan side) as a suggestion for future development.' Quoted in Yoko Terashima, 'The Construction of the National Museum of Western Art Recounted', in Ohnishi (ed.), *Le Corbusier*, English text, p. 13, Japanese text, p.62.

149 See Fondation Le Corbusier drawings no. Mu.To.5400, Mu.To.5401 and Mu.To.5402 reproduced in Ohnishi (ed.), *Le Corbusier*, Japanese text, pp 120–21; English text, p.13.

150 See Fondation Le Corbusier drawings no. Mu.To.5481, Mu.To.5482, Mu.To.5483, Mu.To.5484, Mu.To.5485, Mu.To.5486, Mu.To.5487, Mu.To.5488 and Mu.To.5489 reproduced in Ohnishi (ed.), *Le Corbusier*, Japanese text, pp 122–4; English text, p.14.

151 See Fondation Le Corbusier drawings no. Mu.To.5509 and Mu.To.5510 reproduced in Ohnishi (ed.), *Le Corbusier*, Japanese text, p.124; English text, p.14.

152 For the drawings, see Yoko Terashima, 'The Construction of the National Museum of Western Art Recounted', in Ohnishi (ed.), *Le Corbusier*, English text, pp 13–14, Japanese text, pp 62–3.

153 Tadayoshi Fujiki, 'Un réceptacle d'oeuvres d'art conçu par un cubiste: le musée national d'Art occidental

à Tokyo, ou Le Corbusier et ses disciples Japonais', in Monnier (ed.), *Le Corbusier*, p. 15.

154 J.M. Richards, 'Japan 1962', *The Architectural Review*, September 1962, p.169.

155 ibid.

156 See Yoko Terashima, 'The Construction of the National Museum of Western Art Recounted', in Ohnishi (ed.), *Le Corbusier*, English text, p.14, Japanese text, p.63.

157 Maekawa, in 1979, and Maekawa Associates (who removed Sakakura's auditorium) in 1997, made additions to the north and west of the Museum on the only space available.

158 J.M. Richards, *An Architectural Journey in Japan* (London: The Architectural Press, 1963).

159 J.M. Richards, 'Japan 1962', *The Architectural Review*, September 1962, p.157.

160 ibid., p.162.

161 ibid., p.178.

162 ibid., p.197.

163 ibid., p.212.

164 ibid., p.215.

165 ibid., p.220.

166 ibid.

167 ibid., p.218.

168 Raymond, *An Autobiography*, p.248.

169 ibid.

170 ibid., pp 248–9.

171 Matthew Hunter (trans. and ed.), *Tadao Andō: Conversations with Students* (New York: Princeton Architectural Press, 2012), p.47.

172 ibid., p.14.

173 ibid., p.47.

174 ibid., pp 49–50.

175 Tadao Andō, 'The Agony of Sustained Thought: The Difficulty of Persevering', *GA Document* 39, April 1994, p.23.

176 Hunter, *Tadao Andō*, p.50.

177 Tadao Andō, 'The Agony of Sustained Thought: The Difficulty of Persevering', *GA Document* 39, April 1994, p.23.

178 Tadao Andō, 'Materials, Geometry and Nature', in *Tadao Andō Architectural Monographs 14* (London: Academy Editions, 1990), p.13.

179 Le Corbusier, *Towards a New Architecture* (London: The Architectural Press, 1946), pp 32–3. See also Le Corbusier, *Vers une architecture* (Paris: Editions G. Crès et Cie, 1923), p.19.

180 Le Corbusier, *Towards a New Architecture*, p.31. See also Le Corbusier, *Vers une architecture*, p.16.

181 Tadao Andō, 'Materials, Geometry and Nature', in *Tadao Andō Architectural Monographs 14*, p.13.

182 The Church on the Water is located near Tomamu, Hokkaido, and was completed in 1988.

183 Andō wrote that Ronchamp was the inspiration. See Tadao Andō, *Le Corbusier Yūki Aru Jūtaku* [Courageous Housing by Le Corbusier] (Tokyo: Shinchōsha, 2004), p.76.

184 Tadao Andō, 'Materials, Geometry and Nature', in *Tadao Andō Architectural Monographs 14*, p.13.

185 ibid.

186 'News and Comment – Survey', *The Japan Architect*, January 1961, p.7.

187 ibid., p.7. The survey, sent to about 200 leading architects and critics, found that the three best buildings completed in 1960 were: 1. Kyoto Kaikan (Maekawa); 2. Kurashiki City Hall (Tange); 3. Osaka Dentsu Building (Tange).

188 Toyo Itō, *Toyo Ito 1971–2001* (Tokyo: TOTO Publishing, 2013), p.39.

189 ibid., p.23.

190 Organised by Peter Eisenman and Kenneth Frampton.

191 Richards observes how 'Professors at Waseda have office-space in the school, and the assistants working there are largely post-graduate students.' J.M. Richards, 'Japan 1962', *The Architectural Review*, September 1962, p.216.

192 Itō, *Toyo Ito*, p.11.

14 The Pacific Rim

1 Johnson resigned for the second time in 1954.

2 Ishimoto was born in San Francisco and studied photography at the Chicago Institute of Design in 1948–52, following internment during the war. In 1924–39 he had been raised in Japan and had returned to live there in 1953.

3 See Yasufumi Nakamori, *Katsura: Picturing Modernism in Japanese Architecture: Photographs by Ishimoto Yasuhiro* (Houston: The Museum of Fine Arts, 2010), p.20, p.160.

4 See Kurt G.F. Helfrich, 'Antonin Raymond in America, 1938–49', in Helfrich and Whitaker (eds), *Crafting a Modern World*, pp 50–51, p.62, n.28.

5 See 'Japan House', *The Japan Architect*, Autumn (15 October) 2005, pp 84–7.

6 Arthur Drexler, *The Architecture of Japan* (New York: Museum of Modern Art, 1955), p.262.

7 After the exhibition closed, the building was dismantled and relocated to Fairmount Park, Philadelphia, in 1958.

8 Drexler, *The Architecture of Japan*, p.262.

9 ibid., p.262.

10 Earthquakes in eastern Australia almost never exceed a magnitude of 6.0; those in New Zealand, California, Oregon and Washington more frequently do. In Japan they often exceed a magnitude of 7.0, if not 8.0.

11 See: http://museumvictoria.com.au/origins/history.aspx?pid=33, accessed 4 August 2015.

12 Lewis Mumford, 'The Sky Line: Status Quo', *The New Yorker*, 11 October 1947, p.110. See also 'Bay Region Domestic', *The Architectural Review*, October 1948, p.164.

13 'Do We Have an Indigenous Northwest Architecture?', *Architectural Record*, April 1953, pp 140–46.

14 ibid., p.140.

15 ibid., p.141.

16 ibid.

17 For Tange's house, see 'A Japanese Architect Seeks a New Expression', *Architectural Record*, July 1958, p.137.

18 See 'Architects' Offices', *Architectural Record*, January 1953, pp 140–66.

19 Oral history interview with Paul Thiry, 15–16 September 1983, Archives of American Art, Smithsonian Institution. Interview conducted by Meredith Clausen.

20 ibid.

21 'Crowding Puts Dormitories on Difficult Sites', *Architectural Record*, August 1957, pp 210–11.

22 Oral history interview with Paul Thiry, 15–16 September 1983, Archives of American Art, Smithsonian Institution. Interview conducted by Meredith Clausen.

23 For Pries, see Jeffrey Karl Ochsner, *Lionel H. Pries, Architect, Artist, Educator: From Arts and Crafts to Modern Architecture* (Seattle: University of Washington Press, 2007).

24 Emily Post, *By Motor to the Golden Gate* (New York and London: D. Appleton, 1916), pp 221–3.

25 See Kanō Sanraku, *Bamboo Grove in Spring and Autumn*, Seattle Art Museum (91.235.1).

26 See Jeffrey Karl Ochsner, 'Seattle, the Pacific Basin, and the Sources of Regional Modernism', *Fabrications: The Journal of the Society of Architectural Historians, Australia and New Zealand*, vol.26, no.3, 2017, p.322.

27 See ibid., p.322; see also Ochsner, *Lionel H. Pries*, pp 255–61.

28 Grant Hildebrand, *Gene Zema: Architect, Craftsman* (Seattle and London: University of Washington Press, 2011), p.60.

29 See Gail Dubrow and Donna Graves, *Sento at Sixth and Main* (Washington, DC: Smithsonian Books, 2004), pp 1, 62–79.

30 Paul Kirk and Eugene Sternberg, *Doctors' Offices and Clinics* (New York: Reinhold Publishing Corporation, 1955).

31 See Ochsner, 'Seattle', p.323.

32 See Anon, 'Sunset and AIA Pick the Seven Best Houses in the West', *House and Home*, October 1957, pp 95–9.

33 For Haag, Thiel, Steinbrueck and the influence of educators at the University of Washington, see Ochsner, 'Seattle', pp 324–8.

34 See Teiji Itō, *The Classical Tradition in Japanese Architecture; Modern Versions of the Sukiya Style; The Elegant Japanese House; Traditional Sukiya Architecture;* and *Traditional Domestic Architecture of Japan*. All were published by Weatherhill, New York, 1972. See also Teiji Itō, *Kura: Design and Tradition of the Japanese Storehouse* (Tokyo, New York and San Francisco: Kodansha International Ltd, 1973); and Kawazoe and Itō, *Kura: Design of the Japanese Storehouse*.

35 For Zema, see Hildebrand, *Zema*.

36 ibid., p.65.

37 Richard Neutra, Foreword, in David H. Engel, *Japanese Gardens for Today* (Rutland, VT and Tokyo: Charles E. Tuttle Company, 1959), p.xii.

38 Dresser, *Japan*, p.23.

39 Editorial, 'At the Beginning of 1957', *Shinkenchiku*, January 1957, p.2.

40 *Shinkenchiku*, February 1958, p.1.

41 *Shinkenchiku*, yellow insert, November 1957, pp 52/53 and December 1957, before p.1.

42 ibid.

43 'Publisher's Message on the Third Anniversary of Publication', *The Japan Architect*, June 1959, n.p. (insert before p.1).

44 For example: 'Tatami Floor Mats (I)', *The Japan Architect*, November 1958, pp 77–9; 'Tatami Floor Mats (II)', *Shinkenchiku*, December 1958, pp 72–3; 'Tatami (III)', *The Japan Architect*, January–February 1959, pp 125–8; 'Fittings in Japanese-style Houses', *The Japan Architect*, March 1959, pp 78–81; 'Fittings in Japanese-Style Houses (II)', *The Japan Architect*, April 1959, pp 78–81; 'Tokanoma', *The Japan Architect*, May 1959, pp 80–82; 'Tokanoma (II)', *The Japan Architect*, June 1959, pp 91–4; 'Japanese Roofing (I)', *The Japan Architect*, July 1959, pp 84–7; 'Japanese Roofing (II)', *The Japan Architect*, August 1959, pp 84–7; 'Japanese Roof (III)', *The Japan Architect*, September 1959, pp 84–7; 'Wooden Posts (I)', *The Japan Architect*, October 1959, pp 76–9; 'Bamboo', *The Japan Architect*, November 1959, pp 100–103; 'Wooden Rain Shutters', *The Japan Architect*, December 1959, pp 88–91; 'Transoms', *The Japan Architect*, April 1960, pp 73–5; 'Grilles for Doors and Windows', *The Japan Architect*, May 1960, pp 87–90; 'Engawa', *The Japan Architect*, June 1960, pp 89–91.

45 'Note from the Publisher', *The Japan Architect*, June/July 1961, p.9.

46 ibid., p.9. It was, in fact, circulating in 56 countries (see p.10).

47 'Note from the Publisher', *The Japan Architect*, June/July 1961, p.10.

48 ibid.

49 ibid.

50 ibid., p.11.

51 ibid.

52 For Belluschi, the Sutor House and Harada, see Meredith Clausen, *Pietro Belluschi, Modern American Architect* (Cambridge, MA: MIT Press, 1994), pp 97–101, p.430, n.30.

53 On the first Saturday 17,000 people 'streamed through the turnstiles' and emergency staff were brought in to handle the crowds. *The Argus*, 21 February 1955, p.6.

54 *The Argus*, 15 February 1955, p.8.

55 Anon, 'The Ideal Home', *Architecture and Arts and the Modern Home*, March 1955, p.27.

56 ibid.

57 This was an argument which the magazine made again six years later: 'If Australia is to develop a special way of building for the hot north … We could learn quite

a deal, too, from the ancient and modern architecture of Japan, for the modern house in Japan was derived from two simple facts – hot summers and heavy rains.' See 'Post War Domestic Architecture', *Architecture and Arts*, 92, June 1961, p.44.

58 Anon, 'The Ideal Home', *Architecture and Arts and the Modern Home*, March 1955, p.27.

59 See Jennifer Taylor, *An Australian Identity: Houses for Sydney 1953–63*, University of Sydney, Department of Architecture, 1972, p.32.

60 See 'House at Neutral Bay, NSW', *Architecture and Arts*, June–July 1958, pp 38–9.

61 *Architecture and Arts*, 71, September 1959, p.25; *Architecture and Arts*, 73, November 1959, p.26.

62 'House at Turramurra', NSW, *Architecture and Arts*, 98, December 1961, pp 24–5.

63 Horiguchi, Sutemi and Kōjiro, Yūichirō, *Architectural Beauty in Japan* (Tokyo: Kokusai Bunka Shinkokai, 1955).

64 '10 Best Houses', *Architecture and Arts*, November 1959, p.41.

65 ibid.

66 Neville Gruzman, 'An Approach to Architecture', *Architecture and Arts*, October 1962, p.29.

67 See 'Timber Frame Homes Most Popular', *Architecture and Arts*, 80, June 1960, p.28.

68 See 'Spacious Living Oriental Style', *Australian Home Beautiful*, June 1955, p.15.

69 See Jennifer Mitchelhill, 'Popular Journals, Japan and the Post-war Australian House', Panorama to Paradise, XXIV International Conference of the Society of Architectural Historians, Australia and New Zealand, Adelaide, Australia, 21–24 September 2007.

70 'Old and New Art Forms in Japanese Culture', *Architecture and Arts*, 66, April 1959, p.15.

71 For a discussion of the attitude of the Australian architectural and home-improvement press towards Japan, see Mitchelhill, 'Popular Journals'.

72 These were: 'Mr U's House', *The Japan Architect*, November 1959, pp 16–20; 'The Ikeda House', *The Japan Architect*, November 1959, pp 21–8; 'The Kobayashi House', *The Japan Architect*, November 1959, pp 29–35; 'A House in the Suburbs of Nagoya', *The Japan Architect*, November 1959, pp 36–43.

73 'Japanese Houses for Australia?', *Architecture and Arts*, 75, January 1960, p.22.

74 'Ten Years of Architecture and Arts', *Architecture and Arts*, January 1962, p.22.

75 Kenneth McDonald (ed.), 'A Beach House at Carrum', *Architecture and Arts*, 75, January 1960, between pp 24 and 25.

76 ibid., p.26.

77 ibid.

78 'The Ten Best Houses for 1959–60', *Architecture and Arts*, 83, September 1960, p.32.

79 See ibid.

80 'Grenville Spencer Residence, Red Hill, Victoria', *Architecture and Arts*, 78, April 1960, pp 42–3.

81 James Pearce Mockridge (1916–94), James Rossiter Stahle (1917–2010) and George Finlay Mitchell (1916–2006) formed their practice in 1948. Mockridge was the principal designer.

82 See Mitchelhill, 'Popular Journals'.

83 See 'House at Turramurra', NSW, *Architecture and Arts*, 98, December 1961, p.25.

84 See http://pmi.viewbook.com/album/influences, accessed 13 August 2015.

85 Peter Muller, *1963 Trip to Kyoto*, p.2, n.d. Personal account sent by Peter Muller to Neil Jackson, May 2017.

86 Boyd, *Tange*, p.9.

87 Walter Gropius, 'Architecture in Japan', in Gropius, Tange and Ishimoto, *Katsura*, p.2.

88 For the background to the book's production, see Yasufumi Nakamori, 'Ishimoto Yasuhiro's Katsura – Reexamined and Revisited', in Nakamori, *Katsura*, pp 11–58.

89 Bayer agreed in a letter dated 4 August 1955 and Gropius in one dated the next day. See Nakamori, *Katsura*, p.37 (Bayer) and p.36 (Gropius).

90 See Nakamori, *Katsura*, p.57, n.81.

91 Letter, Kenzō Tange and Yasuhiro Ishimoto to Walter Gropius, 27 July 1955, reproduced in facsimile in Nakamori, *Katsura*, p.60.

92 Tange acknowledged the receipt of Gropius's essay on Katsura in a letter dated 31 January 1956 in which he admitted that he had not yet written his own text. See letter, Kenzō Tange to Walter Gropius, 31 January 1956, reproduced in facsimile in Nakamori, *Katsura*, p.62.

93 Mori Minoru, 'Guropiusu hakaseno Nihon-kan: Kyōto no kokenchiku teien ni tsuite (Dr Gropius's views on Japan: regarding old architectural gardens in Kyoto), quoted in Nakamori, *Katsura*, p.33.

94 Gropius, 'Architecture in Japan', in Gropius, Tange and Ishimoto, *Katsura*, p.5.

95 ibid., pp 5–6.

96 ibid., p.11.

97 *Katsura* was first published in Tokyo in the spring of 1960 by Zōkeisha, who took on the project following the closure of David-sha in 1958; it was published in America by Yale University Press towards the end of the year. See Nakamori, *Katsura*, pp 43, 57, ns 103, 104. The Yale edition of the book was advertised in *The Japan Architect*, December 1960, p.100.

98 Walter Gropius, 'Architecture in Japan', in Gropius, Tange and Ishimoto, *Katsura*, n.p.

99 Gropius, Tange and Ishimoto, *Katsura*, p.vii.

100 The effect is similar to that of Charles and Ray Eames's film, *House After Five Years of Living*, produced in 1955.

101 Kenzō Tange, 'Creation in Present-day Architecture and the Japanese Architectural Tradition', *Shinkenchiku*, June 1956, pp 25–33.

102 Kenzō Tange, 'Tradition and Creation in Japanese Architecture', in Gropius, Tange and Ishimoto, *Katsura*, p.35.

103 ibid.

104 ibid.

105 From Elizabeth Gordon, 'The Threat to the Next America', *House Beautiful*, April 1953, pp 126–30, 250–51, quoted in Alice T. Friedman, *Women and the Making of the Modern House: A Social and Architectural History* (New York: Harry H. Abrams, 1998), p.141.

106 From Gordon, 'The Threat to the Next America', *House Beautiful*, April 1953, pp.126–30, 250–51, quoted in Friedman, *Women and the Making of the Modern House*, p.141.

107 Elizabeth Gordon's obituary in *The Economist* suggests that her close friend Frank Lloyd Wright might have written some of this essay and, if not, that it was certainly written under his influence. See 'Elizabeth Gordon', *The Economist* (UK edition), 30 September 2000, p.153; *The Economist* (US edition), vol.356, no.8190, p.93. Wright's book, *The Japanese Print, An Interpretation*, was listed as recommended reading in the August 1960 issue of *House Beautiful*, p.47.

108 See Friedman, *Women and the Making of the Modern House*, pp 140–41.

109 *Shibui* is an adjective meaning 'beautiful': *shibusa*, meaning 'beauty', is the noun. See Elizabeth Gordon, 'We Invite You to Enter a New Dimension: Shibui', *House Beautiful*, August 1960, p.88.

110 ibid.

111 'Recommended Reading on Japan', *House Beautiful*, August 1960, p.47.

112 It is described as 'One of the most influential issues ever by a design magazine' by The Smithsonian Institution (The Elizabeth Gordon Papers, Freer Gallery of Art and Arthur M. Sackler Gallery Archives).

113 Monica Penick, *Tastemaker: Elizabeth Gordon, House Beautiful, and the Postwar American Home* (New Haven and London: Yale University Press, 2017) p.208.

114 Gordon, 'We Invite You to Enter a New Dimension', p.120.

115 ibid., p.95.

116 ibid.

117 'The Most Flexible House in the World', *House Beautiful*, August 1960, p.58.

118 See Dean Sakamoto (with Karla Britton and Diana Murphy) (ed.), *Hawaiian Modern: The Architecture of Vladimir Ossipoff* (New Haven and London: Honolulu Academy of Arts in association with Yale University Press, 2007), p.118. For Ossipoff, see Astrid M.B. Liverman, Review of 'Hawaiian Modern: The Architecture of Vladimir Ossipoff', *Journal of the Society of Architectural Historians*, December 2008, pp 595–7; Layla Dawson, 'Hawaiian Modern: The Architecture of Vladimir Ossipoff', *The Architectural Review*, April 2009, p.104.

119 'What Japan can contribute to your way of life', *House Beautiful*, August 1960, p.55.

120 Hill had worked with Frank Lloyd Wright, first as an apprentice from 1938, and going on to be Wright's chief architect. He was the architectural editor at *House Beautiful* from 1953 to 1963 and in 1964 became its editorial director. He later became Treasurer of the Taliesin Fellowship and Honorary Chairman of the Frank Lloyd Wright Foundation.

121 Much to Yale University Press's annoyance, Ishimoto sent Japanese-language copies of the book to American reviewers before the English-language edition was published. See Nakamori, *Katsura*, p. 43, p.57, n.103.

122 Bruno Zevi, 'Concerning "Shibui"', *Architecture and Arts*, March 1963, p.25.

123 ibid.

124 ibid.

125 ibid.

126 ibid., p.26.

127 Kenzo Tange, 'Architecture and Urbanism', *The Japan Architect*, October 1960, p.10. This is rewritten and reprinted, in part, in Oscar Newman, *New Frontiers in Architecture: CIAM '59 in Otterlo* (New York: Universal Books, 1961), p.220. Here he refers to 'the progressive form in the case of Team X and the past form in the case of the Italian group ...'

128 ibid. Here he says that 'Creative drive today is an association of technology and humanity.'

129 'Tokyo Seen from the Sky: Foreign Urban Planners Say "It's Like a Big Village"', *Asahi Shimbun*, 16 May 1960, quoted in Koolhaas and Obrist, *Project Japan*, p.202.

130 All quoted in Koolhaas and Obrist, *Project Japan*, pp 194–6.

131 'World Design Conference', *The Japan Architect*, July 1960, p.7.

132 This explanation is given by Nōboru Kawazoe whose choice of word it was. See Koolhaas and Obrist, *Project Japan*, pp 234–5.

133 Alison and Peter Smithson, 'Whatever Happened to Metabolism? – A Summons to the Fourth Generation', *The Japan Architect*, April 1988, p.5.

15 The West and Japan

1 Anon, 'The New Brutalism', *Architectural Design*, January 1955, p.1.

2 Alison and Peter Smithson, 'The New Brutalism', *Architectural Design*, January 1955, p.1.

3 See Dargan Bullivant, 'Hunstanton Secondary Modern School', *Architectural Design*, September 1953, pp 238–48; Anon, 'Secondary School at Hunstanton, Norfolk', *The Architects' Journal*, 16 September 1954, pp 341–52.

4 Alison and Peter Smithson, 'The New Brutalism', p.1.

5 ibid. This analysis, as Irénée Scalbert argues, might be seen to exclude many later buildings from the Brutalist canon: 'While Le Corbusier's Maisons Jaoul

might conceivably fall within its compass, buildings once thought seminal to the movement, for example the Yale Art Gallery by Louis Kahn, the Ham Common flats by Stirling and Gowan and the Halen Siedlung by Atelier 5, should be excluded: these all testify to a keen interest in form, order and symmetry which were fundamentally at odds with the Brutalist sensibility.' Irénée Scalbert, 'Architecture as a Way of Life: The New Brutalism 1953–56', in *CIAM Team 10: The English Context* (Delft: TU-Delft, 2002), p.82. See also Irénée Scalbert, 'Parallel of Life and Art', *Daidalos*, 75, May 2000, pp 52–65.

6 Alison and Peter Smithson, 'The New Brutalism', p.1.

7 ibid.

8 For a discussion of the significance of concrete in Japan, see Adrian Forty, *Concrete and Culture: A Material History* (London: Reaktion Books, 2012), pp 129–43.

9 See Reynolds, *Maekawa Kunio*, p.167.

10 Board-marked concrete was a significant innovation at the Unité d'habitation at Marseilles which was completed in 1952.

11 Tange Kenzō, in a debate held at the Nakamura-ya Restaurant, Shinjuku, on 5 October 1951. 'Western Society and Current of Modern Architecture', *Kokusai-Kentiku*, vol.18, no.12, December 1951, pp 2–13.

12 For Takamatsu, see Forty, *Concrete and Culture*, p.137.

13 The Villa Giulia was built for Pope Julius III in 1551–53.

14 Alison and Peter Smithson, 'The New Brutalism', p.1.

15 See 'Prize-winners', *Architects' Journal*, 3 July 1958, p.8.

16 Alison and Peter Smithson, *The Charged Void: Architecture* (New York: The Monacelli Press, 2001), p.230.

17 *Megastructure* can be defined as, 'very large multi-functional urban complexes containing transient smaller units adaptable to changing needs'. See Reyner Banham, 'Megastructure', *Architectural Design*, July 1975, p.400.

18 Fumihiko Maki with Masato Ōtaka, 'Towards the Group Form', in Noboru Kawazoe (ed.), *Metabolism 1960: Proposals for a New Urbanism* (Tokyo: Bijutsu Shuppan-sha, 1960), p.59.

19 Alison and Peter Smithson, Statement accompanying competition entry for the University of Sheffield, 1953.

20 Reyner Banham, 'The New Brutalism', *The Architectural Review*, December 1955, illus. p.360.

21 ibid., p.361, illus. p.60.

22 Maki worked for SOM in 1954–55; for Sert in 1955–56; as an assistant professor of Architecture at Washington University, St Louis in 1956–58; then as a Graham Foundation Travelling Fellow in 1958–60.

23 'Peter Smithson, Bakema, van Eyck, and Giancarlo De Carlo befriended me, particularly in my later years.' Quoted in Koolhaas and Obrist, *Project Japan*, p.303.

24 Peter Smithson, quoted in ibid., p.126.

25 Smithson, quoted in ibid., p.126.

26 Alison and Peter Smithson (guest eds), 'The Rebirth of Japanese Architecture', *Architectural Design*, February 1961, p.55.

27 Maki's first building was not in Japan but in America: Steinberg Hall at Washington University, St Louis (1958–60).

28 Fumihiko Maki, *Fumihiko Maki* (London and New York: Phaidon, 2009), p.20.

29 The following buildings were shown: by Tange, Tokyo Prefectural Offices, Imabari City Hall and Auditorium, Kagawa Prefectural Office, Kurashiki City Hall; and by Maekawa, Harumi Apartment Houses, Kyoto City Hall, Gakushuin University, Tokyo.

30 Alison and Peter Smithson (guest eds), 'The Rebirth of Japanese Architecture', *Architectural Design*, February 1961, p.66.

31 ibid.

32 ibid.

33 ibid.

34 ibid.

35 Peter Smithson, 'Form Above All': The Michael Ventris Memorial Award Lecture 1963, *Architectural Association Journal*, March 1963, p.281.

36 Teiji Itoh, *Nature and Thought in Japanese Design*, quoted in Koolhaas and Obrist, *Project Japan*, p.200.

37 ibid., p.201.

38 Smithson, 'Form Above All', p.276.

39 Itō Chūta, 'On the Quality of Curve in Japanese Architecture', *Kenchiku Zasshi*, no.96, 1894, pp 346–50.

40 Smithson, 'Form Above All', p.285.

41 ibid., p.285.

42 ibid., p.285, n. 55.

43 Vincent Scully, 'New British Buildings', *Architectural Design*, June 1964, p.266.

44 Vol.1, Architecture (2001); vol.2, Urbanism (2005).

45 Alison and Peter Smithson, *The Charged Void*, p.66. See also A. and P. Smithson, 'The Pavilion and the Route', *Architectural Design*, March 1965, pp 143–6.

46 A. and P. Smithson, 'The Pavilion and the Route', pp 143–6.

47 ibid., p.144.

48 The essay is dated 15 May 1962. P. Smithson, 'Reflections on Kenzo Tange's Tokyo Bay Plan', *Architectural Design*, October 1964, p.479.

49 I Chippendale [Alison Smithson], 'Japan', *Architectural Design*, July 1969, p.356.

50 ibid., p.356.

51 Peter Smithson, 'The Emperor's New Clothes', *Architectural Design*, February 1972, pp 119–20.

52 e-mail from David Stewart to Neil Jackson, 28 May 2018.

53 Alison and Peter Smithson, *The Charged Void*, p.398.

54 ibid., p.453.

55 Designed by Edward Durell Stone.

56 Designed by Alexander Boretskii, Iurii Abramov, Victor Dubov and Anatole Polianskii.

57 'Expo '58. The Foreign Pavilions', *The Architectural Review*, August 1958, p.94.

58 'Brussels 1958', *The Architects' Journal*, 29 May 1958, p.821.

59 News and Comment, 'Japanese Pavilion at Brussels', *Shinkenchiku*, June 1958, p.3.

60 ibid., p.3.

61 See 'Pavillon du Japon', *L'Architecture d'aujourd'hui*, June 1958, pp 28–9.

62 'Brussels Universal Exhibition 1958', *Architectural Design*, August 1958, p.314.

63 ibid.

64 News and Comment, 'The Japanese Pavilion (continued)', *Shinkenchiku*, September 1958, pp 95–7.

65 For this debate and the following quotations, see News and Comment, 'Japanese', *Shinkenchiku*, August 1958, p.85.

66 See Ishida Yorifusa, 'Japanese Cities and Planning in the Reconstruction Period: 1945–55', in Hein et al., *Rebuilding Urban Japan*, p.23.

67 For these innovations, see Koolhaas and Obrist, *Project Japan*, pp 701–2.

68 See 'Brussels Universal Exhibition 1958', p.331.

69 The US pavilion, a 76-metre diameter geodesic dome, was designed by Richard Buckminster Fuller; the West German pavilion, a sweeping tent structure, was by Frei Otto and Rolf Gutbrod; and Habitat 67, a 12-storey stack of pre-cast concrete apartments, was by the Canadian Moshe Safdie.

70 'Expo '67', *The Japan Architect*, August 1967, p.29.

71 Kenzō Tange, 'Some Thoughts About EXPO '70', *The Japan Architect*, May–June 1970, p.31.

72 Motoo Take, 'A Proposal for Expo '70', *The Japan Architect*, August 1967, pp 100–101.

73 Koolhaas and Obrist, *Project Japan*, p.511.

74 J.M. Richards, 'Expo 70', *The Architectural Review*, August 1970, p.69.

75 ibid., pp 69–70.

76 Robin Boyd, 'EXPO and Exhibitionism', *The Architectural Review*, August 1970, p.99.

77 ibid., p.109.

78 'Britain at Expo', *The Architects' Journal*, 22 April 1970, p.970.

79 Peter Blake, 'Impressions of Expo '70', *The Japan Architect*, May–June 1970, p.180.

80 ibid., p.182.

81 Pieter van Wesemael, *Architecture of Instruction and Delight: A Socio-historical Analysis of World Exhibitions as a Didactic Phenomenon (1798–1851–1970)* (Rotterdam: 010 Publishers, 2001), p.600.

82 ibid., p.626.

83 ibid., p.639.

84 The date of publication and the good condition of the book suggests that Stirling bought it following his visit to Japan. However, the fact that the book contains no reference to Expo '70 might indicate that it was available before the printed publication date. The book and the enclosed notes are in a private collection.

85 Stirling worked on the Olivetti Training School at Haslemere, Surrey from 1968 to 1972.

86 In his library, Stirling had a copy of Harada Jirō's *The Lessons of Japanese Architecture* (1936). It bears his signature and the price of 10s/6d, but no purchase date.

87 The building was designed with his partner Michael Wilford. See James Stirling, *Buildings & Projects 1950–1974* (London: Thames and Hudson, 1975), p.179.

88 The clustering of columns on a grid in a tight, internal space appears later in Stirling's work at the Wallraf-Richartz-Museum, Cologne (1975).

89 See Anthony Vidler, *James Frazer Stirling: Notes from the Archive* (New Haven and London: Yale University Press, 2010), fig. 308, p.253.

90 These are the eight named above: Otaka (b. 1923), Kawazoe (b. 1926), Kamiya, Kikutaki and Maki (b. 1928), Ekuan (b. 1929), Isozaki (b. 1931) and Kurokawa (b. 1934).

91 Although Maekawa Kunio and Sakakura Junzō designed architecturally progressive pavilions – Maekawa, the Steel Pavilion and the Automobile Pavilion and Sakakura, the Electric Power Pavilion – they were both of the older generation and were not involved with the design of the infrastructure which held Expo '70 together.

92 It should be remembered that Hugh Casson, the Director of Architecture at the 1951 Festival of Britain, was still just 40 when the Festival opened on 4 May: Casson's 41st birthday was 23 May.

93 *Time*, 2 March 1970, quoted in Koolhaas and Obrist, *Project Japan*, p.506.

94 Archigram originally comprised Warren Chalk, Peter Cook, Dennis Crompton, David Greene, Ron Herron and Michael Webb.

95 See Koolhaas and Obrist, *Project Japan*, pp 330–31.

96 *Archigram* 5 (London: Archigram, 1964), p.8.

97 ibid., p.13.

98 ibid., p.20.

99 *Archigram* 4 (London: Archigram, 1964), p.17.

100 *Archigram* 5 (London: Archigram, 1964), p.13.

101 Reyner Banham, 'Megastructure', *Architectural Design*, July 1975, p.401.

102 *Archigram* 5 (London: Archigram, 1964), p.5.

103 *Archigram* 1 (London: Archigram, 1964), p.2.

104 ibid., p.2.

105 P. Smithson, 'Reflections on Kenzo Tange's Tokyo Bay Plan', *Architectural Design*, October 1964, p.479.

106 For Folkestone, see Simon Sadler, *Archigram: Architecture Without Architecture* (Cambridge, MA: MIT Press, 2005), p.155.

107 *Archigram* 7 (London: Archigram, 1966), p.8.

108 *Archigram* 9 (London: Archigram, 1970), p.19.

109 Peter Blake, 'The Secret Scrapbook of an Architectural Scavenger', *Architectural Forum*, 8 September 1964, pp 82, 114.

110 'An Interview with Peter Cook by Arata Isozaki', *Archigram: Experimental Architecture, 1961–74* (Tokyo: PIE Books, Tokyo, 2005) p.101.

111 Terence Bendixson, 'Palaces Are for Fun', *Architectural Design*, November 1964, p.533.

112 Anon, 'Archigram Group, London', *Architectural Design*, November 1965, pp 559–72.

113 'An Interview with Peter Cook by Arata Isozaki', p.101.

114 ibid., p.102.

115 Robert Venturi, *Complexity and Contradiction in Architecture* (New York: The Museum of Modern Art, 1966), p.25.

116 ibid., pp 40–41.

117 Maki, in fact, gets quite a lot of attention, either because of his recently published paper, *Investigations in Collective Form* (Washington University, St Louis, 1964), or because, since 1961, he had been teaching architecture in America, first at Washington University, St Louis (1961–62) and then at the Harvard Graduate School of Design (1962–65). It is likely, therefore, that Venturi, who at this time was teaching at the University of Pennsylvania, Philadelphia, had come across him.

118 The Group Form is here referred to as 'collective form'. Venturi, *Complexity and Contradiction*, p.39. For the usage of 'group form', see also pp 97–8, 102.

119 ibid., p.102.

120 Many of the following observations regarding Jencks's change of direction have been made by Florian Urban in 'Talking Japan', in Peter Herrle and Erik Wegerhoff (eds), *Architecture and Identity* (Münster: LIT Verlag, 2008), pp 91–102.

121 Charles Jencks, *The Language of Post-Modern Architecture* (London: Academy Editions, 1977), pp 21, 22, and (1981), pp 21–2.

122 ibid., pp 4, 40, and (1981), pp 40, 41.

123 C. Ray Smith, *Supermannerism: New Attitudes in Post-Modern Architecture* (New York: Dutton, 1977), p.269 *et seq.*

124 Robert Venturi, Denise Scott Brown and Steven Izenour, *Learning From Las Vegas*, rev. edn (Cambridge, MA and London: MIT Press, 1972), p.20.

125 'The duck is the special building that *is* a symbol; the decorated shed is the conventional shelter that *applies* symbols', ibid., p.87.

126 ibid.

127 'What Is Supergraphics?' *Unit Editions*, 23 May 2011, https://uniteditions.com/blog/1-supergraphics, accessed 4 January 2016.

128 'Colori a Parigi: un Auditorium', *Domus*, vol.459, no.2, February 1968, pp 19–23. See Andrew Santa Lucia, 'Superthickness: A Genealogy of Architectural Control from Surface to Volume', in John Stuart and Mabel Wilson (eds), *102nd ACSA Annual Meeting Proceedings, Globalizing Architecture/Flows and Disruptions*, pp 351–2.

129 'Supergraphics: Jean Philippe Lenclos', *Unit Editions*, 26 May 2011, https://uniteditions.com/blog/supergraphics-jean-philippe-lenclos/, accessed 4 January 2016.

130 In *Learning From Las Vegas*, Venturi contrasts a decorated shed with a duck. While the former, as described above, is symbolic or representational art, the duck, by comparison, is the architecture of abstract expressionism, functional and ultimately boring – such as factory chimneys.

131 This ski lodge was designed by architects James Volney Righter, Paul Rose and Peter Lanken.

132 Jencks, *The Language of Post-Modern Architecture*, (1977), p.40; see also 'Post-Modernism', *Architectural Design*, April 1977 (special issue), p.264.

133 Botond Bognar, *Kengo Kuma: Selected Works* (New York: Princeton Architectural Press, 2005), p.28.

134 Charles Jencks, *AD Profile: 28. Post-Modern Classicism: The New Synthesis* (London: Architectural Design, 1980).

135 Zhongjie Lin, *Kenzo Tange and the Metabolist Movement: Urban Utopias of Modern Japan* (London and New York: Routledge, 2010), p.123.

136 Geoffrey Broadbent, 'The Language of Post-Modern Architecture: A Summary', in 'Post-Modernism', *Architectural Design*, April 1977, p.267.

137 Kurokawa Kishō, *Metabolism in Architecture* (London: Studio Vista, 1977), p.10.

138 Quoted in Jonathan Glancey, *Nigel Coates: Body, Buildings and City Scapes* (London: Thames & Hudson, 1999), p.10. As a style guru, Peter York published, with Ann Barr, the bestselling *The Official Sloane Ranger's Handbook* (1982).

139 See Nigel Coates, 'Branson Coates, The Metropole Restaurant and Current Work', *AA Files*, Summer 1986, p.19.

140 ibid.

141 ibid., p.19.

142 ibid., p.20.

143 Glancey, *Nigel Coates*, p.11.

144 Thomas Weaver, Chapter 54, in Dan Cruickshank (ed.), *Sir Banister Fletcher's A History of Architecture*, 20th edn (Oxford: Architectural Press, 1996), p.1592.

145 It is possible that this epilogue might have been written by the editor, Monica Pidgeon. However, she rarely contributed words towards the magazine whereas Middleton did, as on p.108 of this issue.

146 Gunter Nitschke, 'MA – The Japanese Sense of "Place" in Old and New Architecture and Planning', *Architectural Design*, April 1966, p.156.

147 See Arata Isozaki, *Japan-ness in Architecture* (Cambridge, MA and London: MIT Press, 2011), p.124.

148 Taut, *Grundlinien der Architektur Japans*, p.15.

149 ibid.

150 Sutemi Horiguchi, *Japan-ness in Architecture* (1934), quoted in Isozaki, *Japan-ness in Architecture*, p.48. A similar but not identical version of this text is quoted on p.123. Whereas the first is referenced to p.239 of *The Collected Works of Sutemi Horiguchi* (Tokyo: Kajima Shuppan Kai, 1978), vol.3, p.239, the second is referenced to p.230.

151 Hirotarō Ōta, *Japanese Architecture: History and Tradition* (Tokyo: Chikuma Shobō, 1968), p.50, quoted in Isozaki, *Japan-ness in Architecture*, p.126.

152 Isozaki, *Japan-ness in Architecture*, p.27.

153 Arata Isozaki, 'Space of Darkness', *Kenchiku Bunka*, May 1964, quoted in Stewart, *The Making of Modern Japanese Architecture*, p.234.

154 Okakura, *The Book of Tea*, p.45.

155 Tanizaki, *In Praise of Shadows*, p.32.

156 ibid., p.29.

157 ibid.

158 ibid., p.28.

159 ibid., p.33.

160 Isozaki, *Japan-ness in Architecture*, p.95. Shadows, or darkness, which for Tanizaki comprised both space and time, were symptomatic of *ma*.

161 Nitschke, 'MA – The Japanese Sense of "Place"', p.155.

162 ibid.

163 ibid., p.156.

164 Peter Smithson, writing in 1992, in Alison and Peter Smithson, *The Charged Void*, p.11.

165 A. and P. Smithson, 'The Pavilion and the Route', pp 144–5.

166 Much of the following information on Scarpa's 1969 visit to Japan is taken from J.K. Mauro Pierconti, *Carlo Scarpa e il Giappone* (Milan: Mondadori Electa, 2007).

167 Brionvega produced the Doney 14, the first portable transistor TV made in Europe, in 1962. It was designed by Marco Zanuso (1916–2001) and Richard Sapper (1932–2015).

168 The group included the architects and designers Vico Magistretti (1920–2006), Gaetano Pesco (b.1939), Virgilio Vercelloni (1930–95) as well as Sergio Gandini (1933–1999), the founder of Flos, and Aldo Businaro (1929–2006) of Cassina.

169 Pound had a great interest in the *haiku* and had edited Ernest Fennolosa's works on the *noh* plays.

170 Jirō Harada, *The Gardens of Japan*, edited by Geoffrey Holme (London: The Studio, 1928); Norman F. Carver, *Form and Space of Japanese Architecture* (Tokyo: Shokokusha, 1955).

171 See Pierconti, *Carlo Scarpa e il Giappone*, p.35, illus. Scarpa did visit Katsura and in Kyoto saw the Kinkaku-ji (Golden Temple) and the Ryōan-ji, among other sights.

172 Foscari Maraini (trans. Eric Mosbacher), *Meeting with Japan* (London: Hutchinson, 1959), p.138.

173 See Pierconti, *Carlo Scarpa e il Giappone*, p.31, illus.

174 Carlo Scarpa to Nini Scarpa Lazzart, August 1969, displayed at the exhibition *Carlo Scarpa et il Giappone*, MAXXI, Rome, 9 November 2016 to 26 February 2017.

175 *Space Design* to Carlo Scarpa, 31 March 1977, displayed at the exhibition *Carlo Scarpa et il Giappone*, MAXXI, Rome, 9 November 2016 to 26 February 2017.

176 Carlo Scarpa, interviewed by Barbara Radice, 31 October 1978, displayed at the exhibition *Carlo Scarpa et il Giappone*, MAXXI, Rome, 9 November 2016 to 26 February 2017.

177 Scarpa died on 28 November 1978.

178 Guido Guidi, Nicholas Olsberg, Carlo Scarpa et al., *Carlo Scarpa Architect: Intervening with History* (New York: The Monacelli Press and Montreal: Canadian Centre for Architecture, 1999), p.128, illus.

179 Dresser, *Japan*, p.255.

180 See George Perkin, 'The Royal Gold Medal for Architecture for Maxwell Fry', *Concrete Quarterly*, April–June 1964, p.2.

181 See Elizabeth Walder, *The Royal Institute of British Architects' Royal Gold Medal*, PhD, University of Liverpool, 2013, p.68. The Royal Gold Medal Committee in 1964 comprised Sir Hugh Casson, Peter Chamberlin, Thomas Cordiner, Sir William (later Baron) Holford (Royal Gold Medallist for 1963 and Past-President of the RIBA), William Howell and James Richards, with Sir Robert Matthew, President of the RIBA, as chairman. Richards had published *An Architectural Journey in Japan* the previous year and, as editor of *The Architectural Review*, was to write enthusiastically about Japan, as was Casson who, some years later, published *Japan Observed: A Sketch Book* (1991) following a tour of 1983. Chamberlin was an admirer of Tange's work, and he of his; and Howell, who was 'nuts about Japanese architecture' (Steve Osgood in an email to the author, 21 November 2018), had built a house in 1958 at Ravensbourne, London, described as 'the apotheosis of the Japanese-inspired style of the day': Bridget Cherry and Nikolaus Pevsner, *London 2: South* (Harmondsworth: Penguin, 1983), p.187. Whichever way the voting went cannot be easily determined, but the casting vote, which was for Maekawa, was made by Matthew.

182 Ryūichi Hamaguchi, 'Japanese Architecture and the West', *Architectural Forum*, January 1953, p.138.

BIBLIOGRAPHY

Japanese Sources

Andō Tadao, *Le Corbusier Yūki Aru Jūtaku* [Courageous Housing by Le Corbusier] (Tokyo: Shinchōsha, 2004)

Fujimori Terunobu (ed.), *Nihon Kindai Shisō Taikei, 19, Toshi Kenchiku* [The Compendium of Modern Japanese Thought, vol.19, Urbanism and Architecture] (Tokyo: Iwanami Shoten, 1990)

Hinago Motoo, *Japanese Castles*, translated and adapted by William H. Coaldrake (New York: Kodansha International Ltd, 1986); originally published as *Shiro*, vol.54 in the series *Nihon no bijutsu* (Tokyo: Shibundo, 1970)

Hori Takeyoshi, *Gaikokujin kenchikuka no keifu* [The Legacy of Foreign Architects], *Nihon no bijutsu* (Arts of Japan), no.447, August 2003 (Tokyo: Shibundo, 2003)

Horiguchi Sutemi and Kojirō Yūichirō, *Architectural Beauty in Japan* (Tokyo: Kokusai Bunka Shinkokai, 1955)

Hoshu Katsuragawa [trans. Gérard Siary], *Naufrage & tribulations d'un japonais dans la Russie de Catherine II (1782–1792)* (Paris: Editions Chandeigne, 2004)

Ishimoto Kikuji, *Kenchiku-fu* (Osaka: Bunhira kenchiku kai, 1924)

Museum of Modern Art, Kanagawa and Hayama, *Kenchikuka Sakkara Junzo Modanizumu o ikiru* [Junzo Sakakura, Architect] Exh.cat. (Kanagawa: Museum of Modern Art, Kanagawa and Hayama, 2009)

Shimizu Shigeatsu, *Giyōfū Kenchiku* [Pseudo-western-style Architecture], *Nihon no bijutsu* [Arts of Japan], no.446, July 2003 (Tokyo: Shibundo, 2003)

Shiratori Shōgo (ed.), *Kōgaku Hakashi Tatsuno Kingo Den* (Tokyo: Tatsuno Kasai Jimusho, 1927)

Suzuki Hiroyuki (ed.), *Itō Chauta o Shitteimasuka* [Do You Know Itō Chūta?] (Chiba: Okokusha 2003)

Suzuki Hiroyuki, *Iwasaki Yanosuke Takanawa Tei: Kaitōkaku* [Architectural References of Yanosuke Iwasaki Takanawa Residence: Kaitōkaku] (Tokyo: Kaitōkaku Iinkai, Mitsubishi, 2008)

Yoshitaro Takanashi (ed.), *Ru Korubyujie sakuhinshū* (Tokyo: Koyosha, 1929)

Takeda Goichi, 'Sekai ni okerukenchikukai no shinkiun', *Kenchiku sekai*, April 1912, pp 5–8

Takeda Hakushi Kanreki Kinen Jigyyoukai [Special Committee for Dr Takeda's 60 Years Old Celebration], *Takeda Hakushi Sakuhinsyu* (The Works of Dr Takeda) (Kyoto, 1933)

Tanaka Sadahik, *Nihonjin kenchikuka no kiseki* [Modern Japanese Architects], *Nihon no bijutsu* [Arts of Japan], no.448, September 2003 (Tokyo: Shibundo, 2003)

Tanaka Yoshio and Hirayama Shigenobu (eds), *Oukokuhakurankai sandou kiyou* (Tokyo, 1897)

Tanigawa Masami, *Yamamura House* (Tokyo: Banana Books, 2008)

Tanigawa Masami, *Jiyu Gakuen: School of the Free Spirit* (Tokyo: Banana Books, 2009)

Tanizaki Jun'ichirō, *In Praise of Shadows* (London: Vintage Books, 2001)

Yoshimura Junzō, *Junzō Yoshimura*, Japan Architect series no.59 (Tokyo: Shinkenchiku-sha, 2005)

Western Sources – Books

Rutherford Alcock, *International Exhibition, 1862: Catalogue of the Works of Industry and Art, Sent from Japan* (London: William Clowes and Sons, 1862)

Rutherford Alcock, *The Capital of the Tycoon: A Narrative of Three Years' Residence in Japan*, 2 vols (London: Longman, Green, Longman, Roberts & Green, 1863)

Tadao Andō, 'Materials, Geometry and Nature', in *Tadao Andō Architectural Monographs 14* (London: Academy Editions, 1990)

Tadao Andō, *Le Corbusier: Houses* (Tokyo: Toto, 2001)

David Thomas Ansted (ed.), *Black's Guide to Paris and the International Exhibition of 1867* (Edinburgh: Adam and Charles Black, 1867)

Michiko Yamaguchi Aoki and Margaret B. Dardess (eds), *As the Japanese See It: Past and Present* (Honolulu: University of Hawai'i Press, 1981)

L.L. Ardern, 'Henry and Hornel: Their Friendship as Shown in Henry's Letters', in William Buchanan, *Mr Henry and Mr Hornel Visit Japan* (Edinburgh: The Scottish Arts Council, 1978)

Elizabeth Aslin, *The Aesthetic Movement: Prelude to Art Nouveau* (London: Ferndale Editions, 1981)

George Ashdown Audsley, *The Ornamental Arts of Japan, Vols I and II* (London: Sampson, Low, Marston, Searle and Rivington, 1882–84)

George Ashdown Audsley and James Lord Bowes, *Keramic Arts of Japan* (London: Henry Sotheran & Co., 1881)

Reyner Banham and Hiryoyuki Suzuki, *Contemporary Architecture of Japan, 1958–1984* (London: The Architectural Press, 1985)

Barra Foundation, *Philadelphia: A 300-Year History* (New York: W.W. Norton & Co., 1982)

Jacques Barsac, *Charlotte Perriand, Complete Works vol.1, 1903–1940* (Paris: Archives Charlotte Perriand and Zurich: Scheidegger & Spiess, 2014)

Ruth Benedict, *The Chrysanthemum and the Sword* (London: Secker and Warburg, 1947)

Christopher Benfey, *The Great Wave* (New York: Random House, 2003)

Mary Bennett, *Ford Madox Brown: A Catalogue Raisonné*, 2 vols (London and New Haven: Yale University Press, 2010)

Albert Berg, *Die preusiusche Expedition nach Ost-Asien: Ansichten aus Japan China und Siam* (Berlin: Königliche Geheime Ober-Hofbuchdruckerei, 1864–1873)

Roger Billcliffe, *Edward Atkinson Hornel 1864–1933* (Glasgow: The Fine Art Society, 1982)

Isabella L. Bird, *Unbeaten Tracks in Japan: An account of travels in the interior including visits to the aborigines of Yezo and the shrine of Nikko*, 4th edn (London: John Murray, 1893)

Melanie Birk (ed.) and Frank Lloyd Wright Home and Studio Foundation, *Frank Lloyd Wright's Fifty Views of Japan* (Rohnert Park: Pomegranate Artbooks, 1996)

John B. Black, *Young Japan: Yokohama and Edo, A Narrative, vol.II* (Yokohama: Kelly and Co., 1881)

Leonard Blussé, 'Dutch Settlements and Trading Centres', in Anna Jackson and Amin Jaffer (eds), *Encounters: The Meeting of Asia and Europe 1500–1800* (London: V&A Publications, 2004)

Beatrice Bodart-Bailey (ed.), *Kaempfer's Japan: Tokugawa Culture Observed* (Honolulu: University of Hawaii Press, 1999)

Beatrice Bodart-Bailey and Derek Massarella (eds), *The Furthest Goal: Engelbert Kaempfer's Encounter with Tokugawa Japan* (London: Routledge, 2012)

Botond Bognar, *Contemporary Japanese Architecture: Its Development and Challenge* (New York: Van Nostrand Reinhold, 1985)

Botond Bognar, *Togo Murano: Master Architect of Japan* (New York: Rizzoli International Publications, 1996)

Botond Bognar, *Kengo Kuma: Selected Works* (New York: Princeton Architectural Press, 2005)

Daniel V. Botsman, *Punishment and Power in the Making of Modern Japan* (Princeton: Princeton University Press, 2005)

Nicola Gordon Bowe (ed.), *Art and the National Dream* (Dublin: Irish Academic Press, 1993)

C.R. Boxer, *Jan Compagnie in Japan, 1600–1850* (The Hague: Martinus Nijhoff, 1950)

C.R. Boxer, *The Christian Century in Japan, 1549–1650* (Berkeley and Los Angeles: University of California Press; and London: Cambridge University Press, 1951)

Robin Boyd, *Kenzo Tange* (New York: George Brazillier, 1962)

Robin Boyd, *New Directions in Japanese Architecture* (London: Studio Vista, 1968)

Alan Braham, *The Architecture of the French Enlightenment* (Berkeley: University of California Press, 1980)

Mrs Annie Brassey, *A Voyage in the 'Sunbeam', Our Home on the Ocean for Eleven Months* (Chicago: Belford, Clarke & Co., 1881)

H. Allen Brooks, *The Prairie School: Frank Lloyd Wright and His Midwest Contemporaries* (London and New York: W.W. Norton and Co., 1972)

Richard Henry Brunton, *Building Japan 1868–76* (Folkestone: Japan Library Ltd, 1991)

William Buchanan (ed.), *Mackintosh's Masterwork: The Glasgow School of Art* (London: Glasgow School of Art Press in association with A. & C. Black, 2004)

William Buchanan, *Mr Henry and Mr Hornel Visit Japan* (Edinburgh: The Scottish Arts Council, 1978)

Brian Burke-Gaffney, *Nagasaki: The British Experience, 1854–1945* (Folkestone: Global Oriental, 2009)

Ian Buruma, *Inventing Japan, 1853–1964* (New York: Modern Library Chronicles, 2004)

Ian Buruma and Avishai Margalit, *Occidentalism: A Short History of Anti-Westernism* (London: Atlantic Books, 2004)

Simon Callow, *Charles Laughton: A Difficult Actor* (London: Mandarin Books, 1990)

Colen Campbell, *Andrea Palladio's First Book of Architecture* (London: S. Harding, 1728)

Sherban Cantacuzino, *Wells Coates, a Monograph* (London: Gordon Fraser, 1978)

Kenneth H. Cardwell, *Bernard Maybeck: Artisan, Architect, Artist* (Santa Barbara and Salt Lake City: Peregrine Smith Inc., 1977)

Vincenzo Cartari, *Imagini delli Dei de gl'antichi* (Venice: Presso il Tomasini, 1647)

Norman F. Carver, *Form and Space of Japanese Architecture* (Tokyo: Shokokusha, 1955)

Zeynep Çelik, *Displaying the Orient: Architecture of Islam at Nineteenth-century World's Fairs* (Berkeley: University of California Press, 1992)

Martha Chaiklin, 'A Miracle of Industry: The Struggle to Produce Sheet Glass in Modernizing Japan', in Morris Low (ed.), *Building a Modern Japan: Science, Technology and Medicine in the Meiji Era and Beyond* (Basingstoke: Macmillan, 2005)

Arthur Chandler and Marvin Nathan, *The Story of the California Midwinter International Exposition, San Francisco, California, 1894* (St Paul, Minnesota: Pogo Press, 1994)

Edouard Charton (ed.), *Le Tour du monde: Nouveau journal des voyages* (London: Librairie Hachette, 1869)

Olive Checkland, *Britain's Encounter With Meiji Japan, 1868–1912* (London: The Macmillan Press Ltd, 1989)

Olive Checkland, *Japan and Britain after 1859: Creating Cultural Bridges* (London: RoutledgeCurzon, 2003)

Bridget Cherry and Nikolaus Pevsner, *London 2: South* (Harmondsworth: Penguin, 1983)

Pippo Ciorra and Florence Ostende (eds), *The Japanese House: Architecture and Life after 1945* (Venice: Marsilio Editori, Rome: MAXXI, and London: Barbican Art Gallery, 2016)

Meredith Clausen, *Pietro Belluschi, Modern American Architect* (Cambridge, MA: MIT Press, 1994)

William H. Coaldrake (1990), *The Way of the Carpenter* (New York: Weatherhill, 1990)

Andrew Cobbing, *The Japanese Discovery of Victorian Britain: Early Travel Encounters in the Far West* (London: Routledge, 1998)

Andrew Cobbing, *The Satsuma Students in Britain: Japan's Early Search for the 'Essence of the West'* (London: Routledge, 2000)

Laura Cohn, *The Door to a Secret Room: A Portrait of Wells Coates* (Aldershot: Scolar Press, 1999)

Ellen P. Conant (ed.), *Challenging Past and Present: The Metamorphosis of Nineteenth-Century Japanese Art* (Honolulu: University of Hawai'i Press, 2006)

Josiah Conder, *A Few Remarks Upon Architecture* (Tokyo: Kobu-dai-gakko, 1878)

Josiah Conder, *Landscape Gardening in Japan* (Hong Kong, Singapore, Shanghai and Yokohama: Kelly and Walsh Ltd, 1893)

Josiah Conder, *Supplement to Landscape Gardening in Japan* (Hong Kong, Singapore, Shanghai and Yokohama: Kelly and Walsh Ltd, 1893)

Josiah Conder, *Collection of the Posthumous Works of Dr Josiah Conder, F.R.I.B.A.* (Tokyo, 1931)

Thomas Constable, *Memoir of the Reverend Charles A. Chastel de Boinville Compiled from His Journals and His Letters* (London: James Nisbet & Co., 1880)

Michael Cooper, *They Came to Japan: An Anthology of European Reports on Japan, 1543–1640* (Berkeley and Los Angeles: University of California Press, 1965)

Michael Cooper, *The Japanese Mission to Europe, 1582–1590: The Journey of Four Samurai Boys Through Portugal, Spain and Italy* (Folkestone: Global Oriental, 2005)

Kinahan Cornwallis, *Two Journeys to Japan, 1856–57, vol.1* (London: Thomas Cautley Newby, 1859)

Hugh Cortazzi (ed.), *Mitford's Japan: The Memoirs and Recollections, 1866–1906, of Algernon Bertram Mitford, the first Lord Redesdale* (London and Dover, NH: The Athlone Press, 1985)

Hugh Cortazzi, *Victorians in Japan: In and Around the Treaty Ports* (London and Atlantic Heights, NJ: The Athlone Press, 1987)

Hugh Cortazzi, *Japan in Late Victorian London: The Japanese Village in Knightsbridge and the Mikado, 1885* (Norwich: Sainsbury Institute for the Study of Japanese Arts and Culture, 2009)

Hugh Cortazzi and Gordon Daniels (eds), *Britain and Japan 1859–1991: Themes and Personalities* (London and New York: Routledge, 1991)

Ralph Adams Cram, *Impressions of Japanese Architecture and the Allied Arts* (London: The Bodley Head, 1906)

Alan Crawford, *C.R. Ashbee: Architect, Designer and Romantic Socialist* (New Haven and London: Yale University Press, 1985)

Alan Crawford, *Charles Rennie Mackintosh* (London: Thames & Hudson, 2002)

J. Mordaunt Crook, *William Burges and the High Victorian Dream* (London: John Murray, 1981)

Dan Cruickshank (ed.), *Sir Banister Fletcher's A History of Architecture, 20th edn* (Oxford: Architectural Press, 1996)

Francesco Dal Co, *Tadao Andō: Complete Works* (London: Phaidon, 1995)

Thomas Daniell, *After the Crash: Architecture in Post-Bubble Japan* (New York: Princeton Architectural Press, 2008)

Rebecca Daniels and Geoff Brandwood (eds), *Ruskin & Architecture* (Reading: Spire Books, 2003)

Trevor Dannatt (ed.), *Architects Yearbook 3* (London: Paul Elek, 1949)

Michael Darby, *The Islamic Perspective* (London: The World of Islam Festival Trust, 1983)

Elizabeth Darling, *Wells Coates* (London: RIBA Publishing, 2012)

William Gray Dixon, *The Land of the Morning: An Account of Japan and Its People Based on Four Years' Residence in That Country* (Edinburgh: James Gemmel, 1882)

William Dobson and John Harland, *History of the Preston Guild, the Ordinances of Various Guilds of Preston, the Charters of the Borough, the Incorporated Companies, List of Mayors from 1327 &c.* (Preston: W. & J. Dobson, 1862)

Sebastian Dobson and Sven Saaler, *Under Eagle Eyes: Lithographs, Drawings & Photographs from the Prussian Expedition to Japan, 1860–61* (Munich: Iudicium VerlagGmbH, 2011)

Alexander Jackson Downing, *The Architecture of Country Houses* (New York: Dover Publications Inc., 1969)

Christopher Dresser, *Japan: Its Architecture, Art, and Art Manufactures* (London: Longmans, Green, and Co., 1882)

Arthur Drexler, *The Architecture of Japan* (New York: Museum of Modern Art, 1955)

Gail Dubrow and Donna Graves, *Sento at Sixth and Main* (Washington, DC: Smithsonian Books, 2004)

François Ducuing, *L'Exposition Universelle de 1867* (Paris: Bureaux d'Abonnements, 1867)

Daphne du Maurier (ed.), *The Young George du Maurier: A Selection of His Letters, 1860–67* (London: Peter Davies, 1951)

Henry Dyer, *Dai Nippon: The Britain of the East: A Study in National Evolution* (London: Blackie and Son, 1904)

Charles L. Eastlake, *A History of the Gothic Revival* (London: John Murray, 1872)

Charles Eastlake, *Hints on Household Taste* (London: Longmans, Green and Co., 1878)

John Elderfield (ed.), *Philip Johnson and the Museum of Modern Art* (New York: The Museum of Modern Art, 1998)

John Eliot, *Ortho-epia Gallica: Eliots Fruits for the French: Enterlaced with a double new Invention, which teacheth to speake truely, speedily and volubly the French-tongue*, Book 1 (London: John Wolfe, 1593)

James Elmes, *Metropolitan Improvements; or London in the Nineteenth Century* (London: Jones & Co., 1827)

Aymar Embury II, *One Hundred Country Houses: Modern American Examples* (New York: The Century Company, 1909)

David H. Engel, *Japanese Gardens for Today* (Rutland, VT and Tokyo: Charles E. Tuttle Company, 1959)

Henry Faulds, *Nine Years in Nipon: Sketches of Japanese Life and Manners* (London and Paisley: Alexander Gardner, 1885)

Rupert Faulkner, 'Personal Encounters: Europeans in East Asia', in Anna Jackson and Amin Jaffer (eds), *Encounters: The Meeting of Asia and Europe 1500–1800* (London: V&A Publications, 2004)

Nicolas Fiévé and Paul Waley (eds), *Japanese Capitals in Historical Perspective: Place, Power and Memory in Kyoto, Edo and Tokyo* (London: RoutledgeCurzon, 2003)

Dallas Finn, 'Josiah Conder (1852–1920) and Meiji Architecture', in Hugh Cortazzi and Gordon Daniels (eds), *Britain and Japan 1859–1991: Themes and Personalities* (London and New York: Routledge, 1991), pp 86–93

Dallas Finn, *Meiji Visited: The Sites of Victorian Japan* (New York and Tokyo: Weatherhill, 1995)

Raymond Flood, Mark McCartney and Andrew Whittaker (eds), *Kelvin: Life, Labours and Legacy* (Oxford: Oxford University Press, 2008)

Robert Fortune, *Yedo and Peking: A Narrative of a Journey to the Capitals of Japan and China* (London: John Murray, 1863)

Adrian Forty, *Concrete and Culture: A Material History* (London: Reaktion Books, 2012)

Calvin French, *Shiba Kōkan: Artist, Illustrator, and Pioneer in the Westernization of Japan* (New York: Weatherhill, 1974)

Alice T. Friedman, *Women and the Making of the Modern House: A Social and Architectural History* (New York: Harry H. Abrams, 1998)

Luís Fróis SJ, *Tradado doa Embaixadores Iapões que Forão de Iapão à Roma no Anno de 1582*, published by Yoshimoto Okamoto and Henri Bernard SJ in J.A. Abranches Pinto (ed.), *Monumenta Niponica* Monograph 6 (Tokyo: Sophia University, 1942)

Tadayoshi Fujiki, 'Un réceptacle d'oeuvres d'art conçu par un cubiste: le musée national d'Art occidental à Tokyo, ou Le Corbusier et ses disciples Japonais', in Gérard Monnier (ed.), *Le Corbusier et le japon* (Paris: Éditions A. et J. Picard, 2007)

Hiroyasu Fujioka, 'A Report from Japan', *Museum International*, no.167, vol.XLII, no.3 (Paris: UNESCO, 1990)

Hiroyasu Fujioka, 'L'influence corbuséenne chez les architectes japonais et l'intérêt pour l'oeuvre de Le Corbusier dans le Japon d'avant-guerre', in Gérard Monnier (ed.), *Le Corbusier et le japon* (Paris: Éditions A. et J. Picard, 2007)

Joseph Gandy, *Designs for Cottages, Cottage Farms, and Other Rural Buildings ...* (London: John Harding, 1805)

Joseph Gandy, *The Rural Architect: Consisting of Various Designs for Country Buildings ...* (London: John Harding, 1805)

Michael Gardiner, *At the Edge of Empire: The Life of Thomas Blake Glover* (Edinburgh: Birlinn, 2007)

Charles Garnier, *L'Habitation Humaine* (Paris: Hachette, 1892)

David Gebhard, *Schindler* (San Francisco: William Stout Publishers, 1997)

Sigfried Giedion, 'CIAM at Sea: The Background to the Fourth Charter', in Trevor Dannatt (ed.), *Architects Yearbook 3* (London: Paul Elek, 1949)

Brendan Gill, *Many Masks: A Life of Frank Lloyd Wright* (London: William Heinemann, 1988)

Mark Girouard, *Sweetness and Light: The 'Queen Anne' Movement 1860–1900* (Oxford: Oxford University Press, 1977)

Mark Girouard, *The Victorian Country House* (New Haven and London: Yale University Press, 1979)

Jonathan Glancey, *Nigel Coates: Body, Buildings and City Scapes* (London: Thames & Hudson, 1999)

R. Goadby, *A New Display of the Beauties of England* (London, 1776)

Grant K. Goodman, *Japan and the Dutch, 1600–1853* (Richmond: Curzon Press, 2000)

John Greenacombe (ed.), *The Survey of London, vol.45, Knightsbridge* (London: Athlone Press, 2000)

Evarts Boutell Greene, *A New-Englander in Japan: Daniel Crosby Greene* (Boston and New York: Houghton Mifflin Company, 1927)

Paul Greenhalgh (ed), *Art Nouveau 1890–1914* (London: V&A Publications, 2000)

Murray Grigor and Richard Murphy (eds), *The Architect's Architect: Charles Rennie Mackintosh* (London: Bellew Publishing and the Charles Rennie Mackintosh Society, 1993)

Walter Gropius and Kenzō Tange; photographs by Yasuhiro Ishimoto, *Katsura: Tradition and Creation in Japanese Architecture* (Tokyo: Zōkeisha Publications, and Tokyo and New Haven: Yale University Press, 1960)

Guido Gualtieri, *Relationi della Venuta degli Ambasciatori Giaponesi a Roma fino alla partita di Lisbona* (Rome: Francesco Zannetti, 1586)

Guido Guidi, Nicholas Olsberg, Carlo Scarpa et al., *Carlo Scarpa Architect: Intervening with History* (New York: The Monacelli Press and Montreal: Canadian Centre for Architecture, 1999)

Hoshi Hajime, *Handbook of Japan and Japanese Exhibits at World's Fair, St. Louis, 1904* (St Louis: Woodward and Tieman Print Company, 1904)

Walter Hamilton, *The Aesthetic Movement in England* (London: Reeves and Turner, 1882)

Leonard Hammersmith, *Spoilsmen in a 'Flowery Fairyland': The Development of the U.S. Legation in Japan, 1859–1906* (Kent, OH: Kent State University Press, 1998)

447

Roy S. Hanashiro, *Thomas Kinder and the Japanese Imperial Mint 1868–75* (Leiden, Boston and Cologne: Brill, 1999)

David Hanks, *The Decorative Designs of Frank Lloyd Wright* (London: Studio Vista, 1979)

Jirō Harada, *The Gardens of Japan*, edited by Geoffrey Holme (London: The Studio, 1928)

Jirō Harada, *The Lesson of Japanese Architecture*, edited by Geoffrey Holme (London: The Studio, 1936)

Susie Harries, *Nikolaus Pevsner: The Life* (London: Random House, 2011)

Francis L. Hawks, *Narrative of the Expedition of an American Squadron to the China Seas and Japan Performed in the Years 1852, 1853, and 1854, Under the Command of Commodore M.C. Perry, United States Navy, By Order of the Government of the United States, vol.1* (Washington: Beverley Tucker, Senate Printer, 1856)

Carola Hein, 'Visionary Plans and Planners: Japanese Traditions and Western Influences', in Nicolas Fiévé and Paul Waley (eds), *Japanese Capitals in Historical Perspective: Place, Power and Memory in Kyoto, Edo and Tokyo* (London: RoutledgeCurzon, 2003)

Carola Hein, Jeffry M. Diefendorf and Ishida Yorifusa (eds), *Rebuilding Urban Japan After 1945* (New York: Palgrave Macmillan, 2003)

Kurt G.F. Helfrich and William Whitaker (eds), *Crafting a Modern World: The Architecture and Design of Antonin and Noémi Raymond* (New York: Princeton Architectural Press, 2006)

Peter Herrle and Erik Wegerhoff (eds), *Architecture and Identity* (Münster: LIT Verlag, 2008)

George Hersey, *High Victorian Gothic: A Study in Association* (Baltimore and London: The Johns Hopkins University Press, 1972)

Grant Hildebrand, *Gene Zema: Architect, Craftsman* (Seattle and London: University of Washington Press, 2011)

Thomas S. Hines, *Richard Neutra and the Search for Modern Architecture* (New York and Oxford: Oxford University Press, 1982)

Henry-Russell Hitchcock, *The Architecture of H.H. Richardson and His Times* (Boston: MIT Press, 1966)

Henry-Russell Hitchcock, *In the Nature of Materials: The Buildings of Frank Lloyd Wright, 1887–1941* (New York: Da Capo Press, 1975)

James E. Hoare, *Embassies in the East: The Story of the British Embassies in Japan, China and Korea from 1859 to the Present* (Richmond: Curzon Press, 1999)

Margaret Jeffreys Hobart (compiler), *Institutions Connected with the Japan Mission of the American Church* (New York: The Domestic and Foreign Missionary Society, 1912)

Ayako Hotta-Lister and Ian Nish, *Commerce and Culture at the 1910 Japan-British Exhibition: Centenary Perspectives* (Leiden and Boston: Global Oriental, 2013)

Thomas Howarth, *Charles Rennie Mackintosh and the Modern Movement* (London: Routledge and Kegan Paul, 1977)

Toni Huberman, Somnia Ashmore and Yasuko Suga (eds), *The Diary of Charles Holme's 1889 Visit to Japan and North America with Mrs Lasenby Liberty's Japan: A Pictorial Record* (Folkestone: Global Oriental, 2008)

Aimé Humbert (trans. Mrs Cashel Hoey, ed. H.W. Bates), *Japan and the Japanese* (New York: D. Appleton and Co., 1874)

Matthew Hunter (trans. and ed.), *Tadao Andō: Conversations with Students* (New York: Princeton Architectural Press, 2012)

Yūko Ikeda (ed.), *Vom Sofakissen zum Städtebau: Hermann Muthesius und der Deutsche Werkbund: Modern Design in Deutschland 1900–1927* (Kyoto: National Museum of Modern Art, 2002)

Shigemi Inaga (ed.) *Questioning Oriental Aesthetics and Thinking: Conflicting Visions of Asia Under the Colonial Empires: The 38th International Research Symposium* (International Research Center for Japanese Studies, 2010)

Hiromichi Ishizuka, *Methodological Introduction to the History of the City of Tokyo*, Japanese Experience of the UNU Human and Social Development Programme, Bk 2 (Tokyo: United Nations University, 1981)

Arata Isozaki, *Japan-ness in Architecture* (Cambridge, MA and London: MIT Press, 2011)

Teiji Itō, *Kura: Design and Tradition of the Japanese Storehouse* (Tokyo, New York and San Francisco: Kodansha International Ltd, 1973)

Toyo Itō, *Toyo Ito 1971–2001* (Tokyo: TOTO Publishing, 2013)

Anna Jackson, 'Visual Responses: Depicting Europeans in East Asia', in Anna Jackson and Amin Jaffer (eds), *Encounters: The Meeting of Asia and Europe 1500–1800* (London: V&A Publications, 2004)

Neil Jackson, 'Thomas James Waters (1842–98): Bibles and Bricks in *Bakumatsu* and Early-Meiji Japan', in Hugh Cortazzi (ed.), *Britain and Japan: Biographical Portraits, 7* (Folkestone: Global Oriental and the Japan Society, 2010), pp 469–86

Cary James, *Frank Lloyd Wright's Imperial Hotel* (Mineola, NY: Dover Publications, 1968)

Charles Jencks, *The Language of Post-Modern Architecture* (London: Academy Editions, 1977)

Charles Jencks, *AD Profile: 28. Post-Modern Classicism: The New Synthesis* (London: Architectural Design, 1980)

Charles Jencks, *The Language of Post-Modern Architecture* (London: Academy Editions, 1981)

R. Mounteney Jephson and Edward Pennell Elmhirst, *Our Life in Japan* (London: Chapman and Hall, 1869)

Owen Jones, *The Grammar of Ornament* (London: Day and Sons, 1856)

William H. Jordy, *American Buildings and Their Architects: Progressive and Academic Ideals at the Turn of the Twentieth Century*, vol.4 (Oxford and New York: Oxford University Press, 1972)

Kurt Junghanns, *Bruno Taut 1880–1938: Architektur und sozialer Gedanke* (Leipzig: E.A. Seemann, 1998)

Engelbert Kaempfer (trans. and ed. J.G. Scheuchzer), *The History of Japan*, vol.2 (London: printed for the translator, 1727)

B-E. Kalas (trans. John Dunlop), 'The Art of Glasgow', in *De la Tamise à la Sprée: L'essor des industries d'art* (Rheims: L. Michaud, 1905)

Kusumi Kawanabe, Nobuo Aoki, Mitsuyuki Tago, Takeo Inada and Aya Yuzuhana (eds), *Josiah Conder* (Tokyo: East Japan Railway Culture Foundation, 1997)

Nishi Kazuo and Hozumi Kazuo, *What Is Japanese Architecture?* (Tokyo, New York and London: Kodansha International, 1983)

Donald Keene, *The Japanese Discovery of Europe, 1720–1830* (Stanford: Stanford University Press, 1969)

Robert Kerr, *The Gentleman's House; or How to Plan English Residences from the Parsonage to the Palace* (London: J. Murray, 1864 [later editions 1865, 1871])

Horoaki Kimura (ed.), *Process Architecture: Charles Rennie Mackintosh* (Tokyo: Process Architecture Publishing Co., 1984)

Rudyard Kipling, *From Sea to Sea and Other Sketches*, 1, *Letters of Travel*, 2 vols (London: Macmillan, 1917)

Paul Kirk and Eugene Sternberg, *Doctors' Offices and Clinics* (New York: Reinhold Publishing Corporation, 1955)

Rem Koolhaas and Hans Ulrich Obrist, *Project Japan: Metabolism Talks* (Cologne: Taschen GmbH, 2011)

Kengo Kuma, *Anti-object: The Dissolution and Disintegration of Architecture* (London: Architectural Association, 2008)

Kawakami Kunimoto, *Photographs and Survey Drawings of the Katsura Imperial Retreat, Nijo Palace, and Shūgakuin Imperial Retreat* (Tokyo: Society for Research in Old Architecture and Gardens, 1928–32)

Kume Kunitake, *The Iwakura Embassy 1871–73: A True Account of the Ambassador Extraordinary & Plenipotentiary's Journey of Observation through the United States of America and Europe, Great Britain* (trans., vol.1, Martin Collcutt; vol.2, Graham Healy; vol.3, Andrew Cobbing; vol.4, P.F. Kornicki; vol.5, Graham Healey, Eugene Soviak and Chushichi Tsuzuki) (Matsudo, Chiba: The Japan Documents, 2002)

Kawazoe Noburo, Itoh Teiji et al. *Kura: The Japanese Storehouse: the 100th Anniversary of the Tokio Marine & Fire Insurance Co., Ltd* (Tokyo: Tōkyō Kaijō Kasai Hoken Kabushiki Gaisha, 1979).

Kurokawa Kishō, *Metabolism in Architecture* (London: Studio Vista, 1977)

Donald F. Lach, *Asia in the Making of Europe, Vol.1, Bk 2* (Chicago: University of Chicago Press, 1970)

John La Farge, *An Artist's Letters From Japan* (London: Waterstone; and New York: Hippocrene Books, 1986 [1897])

Lionel Lambourne, *Japonisme: Cultural Crossings Between Japan and the West* (London: Phaidon, 2005)

Clay Lancaster, *The Japanese Influence in America* (New York: W.H. Rawls, 1963)

Denys Lasdun, 'Charles Rennie Mackintosh: A Personal View', in Patrick Nutgens (ed.), *Mackintosh and His Contemporaries in Europe and America* (London: John Murray, 1988)

Colin Latimer, 'Kelvin and the Development of Science in Meiji Japan', in Raymond Flood, Mark McCartney and Andrew Whittaker (eds), *Kelvin: Life, Labours and Legacy* (Oxford: Oxford University Press, 2008)

Marc-Antoine Laugier, *Essai sur l'architecture*, 2nd edn (Paris: Duchesne, 1755)

Le Corbusier, *Le Corbusier et Pierre Jeanneret, Oeuvre complète de 1910–1929*, 4th edn (Erlenbach-Zurich: Les Editions d'Architecture, 1946)

Le Corbusier, *Le Corbusier et Pierre Jeanneret, Oeuvre complète de 1929–1934*, 3rd edn, edited by W. Boesiger (Erlenbach-Zurich: Les Editions d'Architecture 1946)

Le Corbusier, *Towards a New Architecture* (London: The Architectural Press, 1946)

Le Corbusier, *Vers une architecture* (Paris: Editions G. Crès et Cie, 1923)

Le Corbusier and P. Jeanneret, *Oeuvre complete 1934–1938*, 2nd edn, edited by Max Bill (Erlenbach-Zurich: Les Editions d'Architecture 1947)

Zhongjie Lin, *Kenzo Tange and the Metabolist Movement: Urban Utopias of Modern Japan* (London and New York: Routledge, 2010)

Richard Longstreth, *On the Edge of the World: Four Architects in San Francisco at the Turn of the Century* (New York: The Architectural History Foundation and Cambridge, MA: MIT Press, 1983)

Antonia Lovelace, *Art for Industry: The Glasgow Japan Exchange of 1878* (Glasgow Museums, 1991)

Morris Low (ed.), *Building a Modern Japan: Science, Technology and Medicine in the Meiji Era and Beyond* (Basingstoke: Macmillan, 2005)

Anne Lutun (ed.), '"Your letters fire my soul", Selected Correspondence of Antonin and Noémi Raymond', in Kurt G.F. Helfrich and William Whitaker (eds), *Crafting a Modern World: The Architecture and Design of Antonin and Noémi Raymond* (New York: Princeton Architectural Press, 2006)

Fiona MacCarthy, 'Coates, Wells Wintemute (1895–1958)', *Oxford Dictionary of National Biography* (Oxford: Oxford University Press, 2004–13)

Margaret F. MacDonald and Patricia de Montfort *An American in London: Whistler and the Thames* (London: Dulwich Picture Gallery, 2013)

Charles MacFarlane, *Japan: An Account Geographical and Historical ...* (New York: George P. Putnam, 1852)

John M. MacKenzie, *Orientalism: History, Theory and the Arts* (Manchester: Manchester University Press, 1995)

Andrew MacMillan, 'Mackintosh in Context', in Patrick Nutgens (ed.), *Mackintosh and His Contemporaries in Europe and America* (London: John Murray, 1988)

Fumihiko Maki, *Fumihiko Maki* (London and New York: Phaidon, 2009)

Fumihiko Maki with Masato Ōtaka, 'Towards the Group Form', in Noboru Kawazoe (ed.), *Metabolism 1960: Proposals for a New Urbanism* (Tokyo: Bijutsu Shuppan-sha, 1960)

Randell L. Makinson, *Greene and Greene: Architecture as Fine Art* (Salt Lake City and Santa Barbara: Peregrine Smith Inc., 1977)

Grant Carpenter Manson, *Frank Lloyd Wright to 1910: The First Golden Age* (New York: Reinhold Publishing Corporation, 1958)

Foscari Maraini (trans. Eric Mosbacher), *Meeting with Japan* (London: Hutchinson, 1959)

Henry Stacy Marks, *Pen and Pencil Sketches, vol.1* (London: Chatto and Windus, 1894)

Hirochi Matsukuma, 'Le Corbusier's Visit to Japan: What He Saw on His Trip', in Shin-Ichiro Ohnishi (ed.), *Le Corbusier and the National Museum of Western Art* (Tokyo: The National Museum of Western Art/The Western Art Foundation, 2009)

James D. McCabe, *The Illustrated History of the Centennial Exhibition Held in Commemoration of the One Hundredth Anniversary of American Independence* (Philadelphia: The National Publishing Company, 1876)

Esther McCoy, *Five California Architects* (New York: Praeger Publishers, 1975)

Raymond McGrath, *Twentieth-century Houses* (London: Faber & Faber, 1934)

Alexander McKay, *Scottish Samurai: Thomas Blake Glover, 1838–1911* (Aberdeen: Canongate Press, 1993)

Mary McLeod (ed.), *Charlotte Perriand: An Art of Living* (New York: Harry N. Abrams Inc., 2003)

Mortimer Menpes, *Japan: A Record in Colour* (London: Adam & Charles Black, 1901)

Linda Merrill, *The Peacock Room: A Cultural Biography* (London and New Haven: Yale University Press, 1998)

Gaston Migeon (trans. Florence Simmonds), *In Japan: Pilgrimages to the Shrines of Art* (London: William Heinemann, 1908)

Sharon Minichiello (ed.), *Japan's Competing Modernities: Issues in Culture and Democracy, 1900–1930* (Honolulu: University of Hawai'i Press, 1998)

Gérard Monnier (ed.), *Le Corbusier et le Japon* (Paris: Éditions A. et J. Picard, 2007)

Arnoldus Montanus, *Atlas Japannensis Being the Remarkable Addresses by way of Embassy from the East-India Company of the United Provinces to the Emperor of Japan...*, edited by John Ogilby (London: Thomas Johnson, 1670)

Shingo Morita, 'Geniuses without Glory: New Series, 8: C.R. Mackintosh, The Young Architect Ahead of His Time', *Young Jump*, 2, *c.* 1993

Edward S. Morse, *Japanese Homes and Their Surroundings* (Boston: Ticknor and Company, 1886) [1st edn, 1885]

Eric Mumford, *The CIAM Discourse on Urbanism, 1928–1960* (Cambridge, MA and London: The MIT Press, 2000)

Norimasa Muragaki, *The First Japanese Embassy to the United States of America: Sent to Washington in 1860 as the first of the series of Embassies specially sent abroad by the Tokugawa shogunate* (Tokyo: The America-Japan Society, 1920)

James Murdoch, *A History of Japan, Vol.III, The Tokugawa Epoch, 1652–1868* (London: Kegan Paul, Trench, Trubner and Co., 1926)

Hermann Muthesius, *Das englische Haus: Entwicklung, Bedingungen, Anlage, Aufbau, Einrichtung unf Innenraum* (Berlin: Ernst Wasmuth, 1 and 2, 1904; 3, 1905)

Hermann Muthesius, *Das englische Haus*, edited by Dennis Sharp (London: Crosby Lockwood Staples, 1979)

Stefan Muthesius, *The High Victorian Movement in Architecture 1850–1870* (London and Boston: Routledge and Kegan Paul, 1972)

Yasufumi Nakamori, *Katsura: Picturing Modernism in Japanese Architecture: Photographs by Ishimoto Yasuhiro* (Houston: The Museum of Fine Arts, 2010)

Winfried Nerdinger, Kristiana Hartmann, Matthias Schirren and Manfred Speidel, *Bruno Taut 1880–1938: Architekt zwischen Tradition und Avantgarde* (Stuttgart and Munich: Deutsche Verlags-Ansalt, 2001)

Richard Neutra, *Life and Shape* (New York: Appleton-Century-Crofts, 1962)

Oscar Newman, *New Frontiers in Architecture: CIAM '59 in Otterlo* (New York: Universal Books, 1961)

Peter Noever (ed.), *MAK Center for Art and Architecture: R.M. Schindler* (Munich and New York: Prestel Verlag, 1995)

Ishimaru Norioki, 'Reconstructing Hiroshima and Preserving the Reconstructed City', in Carola Hein, Jeffry M. Diefendorf and Ishida Yorifusa (eds), *Rebuilding Urban Japan After 1945* (New York: Palgrave Macmillan, 2003)

Kevin Nute, *Frank Lloyd Wright and Japan: The Role of Traditional Japanese Art and Architecture in the Work of Frank Lloyd Wright* (Abingdon: Routledge, 2000 [1992])

Patrick Nutgens (ed.), *Mackintosh and His Contemporaries in Europe and America* (London: John Murray, 1988)

Jeffrey Karl Ochsner, *Lionel H. Pries, Architect, Artist, Educator: From Arts and Crafts to Modern Architecture* (Seattle: University of Washington Press, 2007)

John Ogilby (trans.), *Gedenkwaerdige Gesantschappen der Oost-Indische Maatschappy in't Vereenigde Nederland aan de Kaisaren van Japan* (London: Thomas Johnson, 1670)

Shin-Ichiro Ohnishi (ed.), *Le Corbusier and the National Museum of Western Art* (Tokyo: The National Museum of Western Art/The Western Art Foundation, 2009)

Noriaki Okabe, 'Réflexions autour du "cabanon sur la Méditeranée"', in Gérard Monnier (ed.), *Le Corbusier et le Japon* (Paris: Éditions A. et J. Picard, 2007)

Okakura, Kakuzō, *The Book of Tea* (Rutland, VT, Tokyo and Singapore: Tuttle Publishing, 1956)

Yoshimoto Okamoto and Henri Bernard SJ, *La Première Ambassade du Japon au Europe, 1582–1592; Première Partie, La traité du Père Frois*, in J.A. Abranches Pinto (ed.), *Monumenta Niponica,* Monograph 6 (Tokyo: Sophia University, 1942)

Laurence Oliphant, *Narrative of the Earl of Elgin's Mission to China and Japan in the Years 1857, '58, '59,* 2 vols (Edinburgh and London: William Blackwood and Sons, 1859)

Ayako Ono, *Japonisme in Britain: Whistler, Menpes, Henry, Hornel and Nineteenth-century Japan* (London and New York: RoutledgeCurzon, 2003)

Ken Tadisha Oshima, *International Architecture in Interwar Japan: Constructing Kokusai Kenchiku* (Seattle: University of Washington Press, 2009)

Yasuto Ota, 'Le Corbusier, Charlotte Perriand et Junzō Sakakura', in Gérard Monnier (ed.), *Le Corbusier et le Japon* (Paris: Éditions A. et J. Picard, 2007)

John B. Papworth, *Rural Residences* (London: Ackerman, 1818)

Neil Pedlar, *Imported Pioneers: Westerners who Helped Build Modern Japan* (Folkestone: Japan Library Ltd, 1990)

Monica Penick, *Tastemaker: Elizabeth Gordon, House Beautiful, and the Postwar American Home* (New Haven and London: Yale University Press, 2017)

Charlotte Perriand, *Une vie de creation* (Paris: Odile Jacob, 1998)

José Joaquín Pesada (ed.), *La Ilustracion Mexicana* (Mexico City: Ignacio Cumplido, 1855)

Nikolaus Pevsner, *The Buildings of England: North-East Norfolk and Norwich* (Harmondsworth: Penguin Books, 1962)

Nikolaus Pevsner, *The Buildings of England: North-West and South Norfolk* (Harmondsworth: Penguin Books, 1962)

Nikolaus Pevsner, *Studies in Art, Architecture and Design: Victorian and After* (Princeton, NJ: Princeton University Press, 1968)

Bruce Brooks Pfeiffer (ed.), *Frank Lloyd Wright: Letters to Architects* (London: Architectural Press, 1987)

Bruce Brooks Pfeiffer (ed.), *Frank Lloyd Wright: Collected Writings* (New York: Rizzoli, 1995)

George Phillips, *Rudiments of Curvilinear Design* (London: Shaw and Sons, 1839)

J.K. Mauro Pierconti, *Carlo Scarpa e il Giappone* (Milan: Mondadori Electa, 2007)

Herbert Plutschow, *Philipp Franz von Siebold and the Opening of Japan: A Re-evaluation* (Folkestone: Global Oriental, 2007)

Christian Polak, *Soie et lumières: L'âge d'or des échanges franco-japonais (des origines aux années 1950)* (Tokyo: Chambre de Commerce et d'Industrie Française du Japon, 2001)

Richard Pommer and Christian F. Otto, *Weissenhof 1927 and the Modern Movement in Architecture* (Chicago and London: University of Chicago Press, 1991)

Emily Post, *By Motor to the Golden Gate* (New York and London: D. Appleton, 1916)

Alan Powers, *Serge Chermayeff: Designer, Architect, Teacher* (London: RIBA Publications, 2001)

Antonin Raymond, *An Autobiography* (Rutland, VT, and Tokyo: Charles E. Tuttle, 1973)

Johannes Justus Rein, *Japan: Travels and Researches, Undertaken at the Cost of the Prussian Government* (New York: A.C. Armstrong and Son, 1884)

Mariana Griswold van Rensselaer, *Henry Hobson Richardson and His Works* (Boston: Houghton and Mifflin, 1888)

Jonathan M. Reynolds, 'The Bunriha and the Problem of "Tradition" for Modernist Architecture in Japan, 1920–1928', in Sharon Minichiello (ed.), *Japan's Competing Modernities: Issues in Culture and Democracy, 1900–1930* (Honolulu: University of Hawai'i Press, 1998)

Jonathan M. Reynolds, *Maekawa Kunio and the Emergence of Japanese Modernist Architecture* (Berkeley, Los Angeles and London: University of California Press, 2001)

J.M. Richards, *An Architectural Journey in Japan* (London: The Architectural Press, 1963)

Terence Riley, 'Portrait of the Curator as a Young Man', in John Elderfield (ed.), *Philip Johnson and the Museum of Modern Art* (New York: The Museum of Modern Art, 1998)

Eugene Rimmel, *Recollections of the Paris Exposition of 1867* (Philadelphia: J.P. Lippincott, 1868)

Pamela Robertson (ed.), *Charles Rennie Mackintosh: The Architectural Papers* (Wendlebury: White Cockade and Glasgow: Hunterian Art Gallery, 1990)

G.A.F. Rogers, *The Arts Club and Its Members* (London: Truslove and Hanson Ltd, 1920)

John W. Root (ed.), *Convention Proceedings of the American Institute of Architects, The Western Association of Architects, and Consolidation of the American Institute and the Western Association held at the Burnet House, Cincinnati, Ohio, November 20 and 21, 1889* (Chicago: Inland Architect Press, 1890)

Lelend M. Roth, *McKim, Mead & White, Architects* (London: Thames & Hudson, 1984)

John Ruskin, *The Stones of Venice*, vol.2 (Orpington: George Allen, 1853)

Ian Ruxton, 'Tatsuno Kingo (1854–1919): "A Leading Architect" of the Meiji Era', in Hugh Cortazzi (ed.), *Britain and Japan: Biographical Portraits, 7* (Folkestone: Global Oriental and the Japan Society, 2010), pp 443–55

Simon Sadler, *Archigram: Architecture Without Architecture* (Cambridge, MA: MIT Press, 2005)

Andrew Saint, *Richard Norman Shaw* (New Haven and London: Yale University Press, 1976)

Dean Sakamoto (with Karla Britton and Diana Murphy) (ed.), *Hawaiian Modern: The Architecture of Vladimir Ossipoff* (New Haven and London: Honolulu Academy of Arts in association with Yale University Press, 2007)

Jordan Sand, *House and Home in Modern Japan: Architecture, Domestic Space and Bourgeois Culture 1880–1930* (Cambridge, MA and London: Harvard University Asia Centre, 2003)

Hiroshi Sasaki, 'Le Corbusier et les architects japonais', in Gérard Monnier (ed.), *Le Corbusier et le Japon* (Paris: Éditions A. et J. Picard, 2007)

Tomoko Sato and Toshio Watanabe, *Japan and Britain: An Aesthetic Dialogue 1850–1930* (London: Lund Humphries, 1991)

Irénée Scalbert, 'Architecture as a Way of Life: The New Brutalism 1953–56', in *CIAM Team 10: The English Context* (Delft: TU-Delft, 2002), pp 55–84

Morton S. Schmorleitz, *Castles in Japan* (Tokyo: Charles E. Tuttle Co., 1974)

Frances Scott, 'A Singer in Paint', in Ciaran Murray and Charles M. De Wolf (eds), *The Transactions of the Asiatic Society of Japan*, 4th series, vol.13, 1998

Timon Screech, *The Lens Within the Heart: The Western Scientific Gaze and Popular Imagery in Later Edo Japan* (Honolulu: University of Hawai'i Press, 2002)

Timon Screech, 'Europe in Asia: The Impact of Western Art and Technology in Japan', in Anna Jackson and Amin Jaffer (eds), *Encounters: The Meeting of Asia and Europe 1500–1800* (London: V&A Publications, 2004)

Timon Screech (annotated and introduced by), *Secret Memoirs of the Shoguns: Isaac Titsingh and Japan, 1779–1822* (London and New York: Routledge, 2006)

Vincent J. Scully Jr., *The Shingle Style and the Stick Style: Architectural Theory and Design from Downing to the Origins of Wright* (New Haven: Yale University Press, 1971)

Gottfried Semper (trans. Harry Francis Mallgrave and Michael Robinson), *Style in the Technical and Tectonic Arts; or, Practical Aesthetics* (Los Angeles: Getty Research Institute, 2004)

J.L. Sert (ed.), *Can Our Cities Survive?* (Cambridge, MA: Harvard University Press, 1941)

F.H.W. Sheppard, *The Survey of London: North Kensington*, vol.37 (London: London County Council, 1973)

Shimomura Shotaro, *Chudo-Ken: Views Within and Outside, Chewdoh-Ken* (*Tudor House*) (Kyoto: Matsuzaki & Co., 1932)

Hannah Sigur, *The Influence of Japanese Art on Design* (Layton, UT: Gibbs Smith, 2008)

Bill Smith, *Hornel: The Life and Work of Edward Atkinson Hornel* (Edinburgh: Atelier Books, 1997)

C. Ray Smith, *Supermannerism: New Attitudes in Post-Modern Architecture* (New York: Dutton, 1977)

George Smith, *Lewchew and the Lewchewans: Being a Narrative of a Visit to Lewchew, or Loo Choo, in October, 1850* (London: T. Hatchard, 1853)

George Smith, *Ten Weeks in Japan* (London: Longman, Green, Longman and Roberts, 1861)

Alison and Peter Smithson, *The Charged Void: Architecture* (New York: The Monacelli Press, 2001)

André Sorensen, *The Making of Urban Japan: Cities and Planning from the Edo to the Twenty-first Century* (London and New York: Routledge, 2002)

Susan Weber Soros and Catherine Arbuthnott, *Thomas Jeckyll: Architect and Designer, 1827–1881* (London and New Haven: Yale University Press, 2003)

J. Willett Spalding, *Japan and Around the World: An Account of Three Visits to the Japanese Empire, with Sketches of Madeira, St Helena, Cape of Good Hope, Ceylon, Singapore, China and Loo-Choo* (New York: Redfield, 1855)

Manfred Speidel, *Japanische Architektur Geschichte und Gegenwart* (Düsseldorf: Akademie der Architektenkammer Nordrhein-Westfalen, 1983)

Manfred Speidel, *Bruno Taut: Natur und Fantasie 1880–1938* (Berlin: Ernst & Sohn, 1995)

Manfred Speidel, 'Japanese Traditional Architecture in the Face of Its Modernisation: Bruno Taut in Japan', *Questioning Oriental Aesthetics and Thinking: Conflicting Visions of "Asia" under the Colonial Empires* (Kyoto: International Research Center for Japanese Studies, 2011) pp. 93-111

James Steele, *R.M. Schindler 1887–1953: An Exploration of Space* (Cologne: Taschen, 2005)

David B. Stewart, *The Making of Modern Japanese Architecture from the Founders to Shinohara and Isozaki* (Tokyo, New York and London: Kodansha International, 2002)

James Stirling, *Buildings & Projects 1950–1974* (London: Thames and Hudson, 1975)

William Allin Storrer, *The Architecture of Frank Lloyd Wright: A Complete Catalog* (Cambridge, MA: MIT Press, 1982)

G.E. Street, *Brick and Marble in the Middle Age: Notes of a Tour in the North of Italy* (London: John Murray, 1855)

Louis Sullivan, *The Autobiography of an Idea* (New York: Dover Publications Inc., 1956)

Michael Sullivan, *The Meeting of Eastern and Western Art: From the Sixteenth Century to the Present Day* (London: Thames & Hudson, 1973)

Yuki Sumner, Naomi Pollock and David Littlefield, *New Architecture in Japan* (London: Merrell Publishers Ltd, 2010)

Hiroyuki Suzuki (ed.), *Itō Chauta o Shilteumasuka* [Do You Know Itō Chūta] (Chiba: Okokusha, 2003)

Bruno Taut, *Grundlinien der Architektur Japans* [Fundamentals of Japanese Architecture] (Tokyo: Kokusai Bunka Shinkokai, 1936)

Bruno Taut, *Houses and People of Japan* (London: John Gifford Ltd, 1938)

Bruno Taut (trans. Hideo Shinoda), *Katsura Imperial Retreat* (Tokyo: Ikuseishakōdōkaku, 1942)

Heinrich Taut, 'Bruno Taut in und uber Japan', in Achim Wendschuh, Barbara Volkmann, Akademie der Künst, *Bruno Taut 1880–1938* (Berlin: Akademie der Künst, 1980)

Bayard Taylor, *A Visit to India, China and Japan in the Year 1853* (London: Sampson, Low and Son, 1855)

Egon Tempel, *New Japanese Architecture* (London: Thames & Hudson, 1969)

Yoko Terashima, 'The Construction of the National Museum of Western Art Recounted', in Shin-Ichiro Ohnishi (ed.), *Le Corbusier and the National Museum of Western Art* (Tokyo: The National Museum of Western Art/The Western Art Foundation, 2009)

Edward Maunde Thompson (ed.), *The Diary of Richard Cocks, Cape Merchant in the English Factory in Japan, 1615–1622, with Correspondence*, 2 vols (London: Hakluyt Society, 1883)

Isaac Titsingh, *Illustrations of Japan; Consisting of Private Memoirs and Anecdotes of the Reigning Dynasty of the Djogouns, or Sovereigns of Japan*, trans. from the French by Frederic Schoberl (London: R. Ackerman, 1822)

Isaac Titsingh, *Bijzonderheden over Japan behelzende een verslag van de Huwelijks Plegtigheden; Begrafenissen en Feesten der Japanezen...*, 2 vols (The Hague: J. Allart, 1824)

J.M. Tronson, *Personal Narrative of a Voyage to Japan, Kamtschatka, Siberia, Tartary, and various parts of the coast of China, in HMS 'Barracouta'* (London: Smith, Elder and Co., 1859)

Christopher Tunnard, *Gardens in the Modern Landscape* (London: The Architectural Press, 1938)

Florian Urban, 'Talking Japan', in Peter Herrle and Erik Wegerhoff (eds), *Architecture and Identity* (Münster: LIT Verlag, 2008)

Robert Venturi, *Complexity and Contradiction in Architecture* (New York: The Museum of Modern Art, 1966)

Robert Venturi, Denise Scott Brown and Steven Izenour, *Learning From Las Vegas*, rev. edn (Cambridge, MA and London: MIT Press, 1972)

Anthony Vidler, *James Frazer Stirling: Notes from the Archive* (New Haven and London: Yale University Press, 2010)

Eugène Viollet-le-Duc, *Entretiens sur l'architecture* (Paris: A. Morel et cie, 1863)

Eugène Viollet-le-Duc (trans. Benjamin Bucknall), *The Habitations of Man in All Ages* (London: Simpson Low, Marston, Searle & Rivington, 1876)

Rodrigo de Vivero y Velasco, *Relacion y noticias del reino del Japon*, in José Joaquín Pesado (ed.), *La Ilustracion Mexicana* (Mexico City: Ignacio Cumplido, 1855)

Meg Vivers, *An Irish Engineer* (Brisbane: Copyright Publishing, 2013)

Edward Walford, *Old and New London: A Narrative of Its History, Its People, and Its Places. The Western and Northern Suburbs, vol.5* (London, Paris and New York: Cassell, Petter & Galpin, 1878)

Stephen V. Ward (ed.), *The Garden City: Past, Present and Future* (Oxford: E. & F.N. Spon, 1992)

Isaac Ware, *The Four Books of Andrea Palladio's Architecture* (London: Isaac Ware, 1738)

John Burley Waring, *Masterpieces of Industrial Art and Sculpture at the International Exhibition 1862* (London: Day and Son, 1863)

Hiroshi Watanabe, *The Architecture of Tokyo* (Stuttgart and London: Edition Axel Menges, 2001)

Shun-ichi Watanabe, 'The Japanese Garden City', in Stephen V. Ward (ed.), *The Garden City: Past, Present and Future* (Oxford: E. & F.N. Spon, 1992)

Toshio Watanabe, *High Victorian Japonisme* (Bern: Peter Lang, 1991)

Toshio Watanabe, 'Vernacular Expression or Western Style? Josiah Conder and the Beginning of Modern Architectural Design in Japan', in Nicola Gordon Bowe (ed.), *Art and the National Dream* (Dublin: Irish Academic Press, 1993)

Toshio Watanabe (ed.), *Ruskin in Japan 1890–1940: Nature for Art, Art for Life* (Japan: Cogito, 1997)

Toshio Watanabe, 'Japanese Imperial Architecture from Thomas Roger Smith to Itō Chūta', in Ellen P. Conant (ed.), *Challenging Past and Present: The Metamorphosis of Nineteenth-Century Japanese Art* (Honolulu: University of Hawai'i Press, 2006)

William Watt, *Art Furniture From Designs by E.W. Godwin FSA, and Others, with Hints and Suggestions on Domestic Furniture and Decoration* (London: Batsford, 1877)

Willi Weber and Simos Yannas, *Lessons from Vernacular Architecture* (London and New York: Routledge, 2013)

Russell Frank Weigley, *Philadelphia: A 300-Year History* (New York: W.W. Norton & Co., 1982)

Achim Wendschuh, Barbara Volkmann, Akademie der Künst, *Bruno Taut 1880–1938* (Berlin: Akademie der Künst, 1980)

Pieter van Wesemael, *Architecture of Instruction and Delight: A Socio-historical Analysis of World Exhibitions as a Didactic Phenomenon (1798–1851–1970)* (Rotterdam: 010 Publishers, 2001)

Thompson Westcott, *Centennial Portfolio: A Souvenir of the International Exhibition at Philadelphia* (Philadelphia: Thomas Hunter, 1876)

Thomas Clark Westfield, *The Japanese: Their Manners and Customs* (London: Photographic News Office, 1862)

James Abbott McNeill Whistler, *The Gentle Art of Making Enemies* (London: William Heinemann, 1890)

Captain Bernard Whittingham, *Notes on the Late Expedition Against the Russian Settlements in Eastern Siberia; and of a Visit to Japan and to the Shores of Tartary and of the Sea of Okhostk* (London: Longman, Brown, Green, and Longmans, 1856)

Mark Anthony Wilson and Joel Puliatti, *Bernard Maybeck: Architect of Elegance* (Layton, UT: Gibbs Smith, 2011)

Robert Winter, *Towards a Simpler Way of Life: The Arts & Crafts Architects of California* (Berkeley, Los Angeles and London: University of California Press, 1997)

Frank Lloyd Wright, *Ausgeführte Bauten und Entwürfe von Frank Lloyd Wright* (Berlin: Ernst Wasmuth, 1910), republished as *Studies and Executed Buildings by Frank Lloyd Wright* (New York: Rizzoli, 1986)

Frank Lloyd Wright, *An Autobiography* (New York: Duell, Sloan and Pearce, 1943)

Frank Lloyd Wright, *The Future of Architecture* (New York: Bramhall House, 1953)

Tetsurō Yoshida, *Das Japanische Wohnhaus* (Berlin: Verlag Ernst Wasmuth, 1935)

Yasushi Zeno, 'Fortuitous Encounters: Charlotte Perriand in Japan 1940–41', in Mary McLeod (ed.), *Charlotte Perriand: An Art of Living* (New York: Harry N. Abrams Inc., 2003)

Journal Articles

K. Abe, 'Early Western Architecture in Japan', *The Journal of the Society of Architectural Historians*, vol.13, no.2, May 1954, pp 13–18

Hiroshi Adachi, 'Takeda Goichi To Aru Nubo: Takeda Goichi Kenkyu' (Art Nouveau and Modern Architecture in Japan: A Study of Goichi Takeda), part 2, *Journal of Architecture Planning (AIJ)*, 357, November 1985, pp 97–111

Christina Baird, 'Japan and Liverpool: James Lord Bowes and His Legacy', *Journal of the History of Collections*, vol.12, no.1, 2000, pp 27–137

Léonce Bénédite, 'Felix Bracquemond, l'animalier', *Art et Décoration*, 17, February 1905, pp 37–47

Terry Bennett, 'Meiji Japan Through the Eyes of the Illustrated London News', *Proceedings of the Japan Society*, no.142, 2004, pp 92–101

W.H. Brock, 'The Japanese Connexion: Engineering in Tokyo, London and Glasgow at the End of the Nineteenth Century. Presidential Address, 1980', *The British Journal for the History of Science*, vol.14, no.3, November 1981, pp 227–44

Dana Buntrock, 'Katsura Imperial Villa: A Brief Descriptive Bibliography, with Illustrations', *Cross-currents: East Asian History and Cultural Review*, E-Journal no.3, June 2012

William Burges, 'The International Exhibition', *The Gentleman's Magazine and Historical Review*, June 1862, p.664.

Philippe Burty, 'Le Mobilier moderne', *Gazette des Beaux-Arts*, January 1868, pp 26–45

Philippe Burty, 'Le Japon ancien et le Japon moderne', in *L'Art*, 4^ième année, vol.4, bk.15, 1878, pp 242–3

Jeff Cody, '"Erecting Monuments to the God of Business and Trade": The Fuller Construction Company of the Orient, 1919–1926', *Construction History*, 12, 1996, p.69

Josiah Conder, 'Notes on Japanese Architecture', *Transactions of the Royal Institute of British Architects*, series 1, vol.28, 1877–78, pp 179–92

Josiah Conder, 'Further Notes on Japanese Architecture', *Transactions of the Royal Institute of British Architects*, new series, vol.2, 1886, pp 185–209

Josiah Conder, 'Domestic Architecture in Japan', *RIBA Transactions*, new series, vol.3, 1887, pp 103–27

Josiah Conder, 'The Condition of Architecture in Japan', *Proceedings of the Twenty-Seventh Annual Convention of the American Institute of Architects, Suppl.*, World's Congress of Architects, Chicago, 1893, pp 365–81

Alan Crawford, 'Ten Letters from Frank Lloyd Wright to Charles Robert Ashbee', *Architectural History*, vol.13, 1970, pp 64–76

Nandini Das, 'Encounter as Process: England and Japan in the Late Sixteenth Century', *Renaissance Quarterly*, vol.69, no.4, 2016, pp 1343–68

William Farish, 'On Isometrical Perspective', *Transactions of the Cambridge Philosophical Society*, vol.1, 1822, pp 1–20

Peter Ferriday, 'The Peacock Room', *The Architectural Review*, June 1959, pp 407–14

W. Fred, 'Art Centres: Vienna', *Artist: An Illustrated Monthly Record of Arts, Crafts and Industries*, January 1901, p.92

Alice T. Friedman, 'A House Is Not a Home: Hollyhock House as "Art-theatre Garden"', *Journal of the Society of Architectural Historians*, vol.51, no.3, September 1992, pp 239–60

John R. Gold, 'Creating the Charter of Athens: CIAM and the Functional City, 1933–43', *Town Planning Review*, vol.69, no.3, 1998, pp 221–43

Louis Gonse, 'L'Architecture à l'Exposition universelle', *Gazette des Beaux-Arts*, November 1889, pp 465–86

Dudley Harbron, 'Queen Anne Taste and Aestheticism', *The Architectural Review*, July 1943, pp 15–18

Ernest Hart, 'Abstract of a Lecture of the International Health Exhibition of 1884: Its Influences and Possible Sequels', *British Medical Journal*, 6 December 1884, p.1121

Thomas S. Hines Jr., 'Frank Lloyd Wright – The Madison Years: Records versus Recollections', *The Journal of the Society of Architectural Historians*, vol.26, no.4, pp 227–33

Henry-Russell Hitchcock, 'Frank Lloyd Wright and the "Academic" of the Early Eighteen-Nineties', *Journal of the Warburg and Courtauld Institutes*, vol.7, 1944, p.46

Leah Hsiao and Michael White, 'The Bauhaus and China: Present, Past, and Future', *West 86th*, vol.22, no.2, Fall–Winter 2013, pp 176–89

Marcus B. Huish, 'England's Appreciation of Japanese Art', *Transactions and Proceedings of the Japan Society*, vol.7, 1906, pp 120–39

Dana Irwin, 'Sheiks and Samurai: Leon Roches and the French Imperial Project', *Southeast Review of Asian Studies*, vol.30, 2008, pp 23–30

Hiroshi Itani, Takeshi Koshino and Yukihiro Kado, 'Building Construction in Southern Sakhalin During the Japanese Colonial Period (1905-1945)', *Acta Slavica Iaponica*, vol.17, 2000, pp 130–60

Itō, Midori, 'Hani Motoko and the Spread of Time Discipline into the Household', *Japan Review*, vol.14, 2002, pp 135–47

Yamawaki Iwao, 'Reminiscences of Dessau', *Design Issues*, vol.2, no.2, Autumn 1985, pp 56–8

Hideo Izumida, 'Inquiry in Organization and Campus Buildings for *the Imperial College of Engineering*', 21st IAHA Conference, River View Hotel, Singapore, June 2010, DOI: 10.13140/RG.2.1.1560.5208

Hideo Izumida, 'Reconsideration of Foundation of the Imperial College of Engineering', *Journal of Architecture Planning (AIJ)*, vol.82, no.739, September 2017, pp 2401–10

Sandra Kaji-O'Grady, 'Authentic Japanese Architecture After Bruno Taut: The Problem of Eclecticism', *Fabrications*, vol.11, no.2, September 2001, pp 1–12

Eileen Kane, 'John Henry Newman's Catholic University Church Revisited', *Artefact* I (Autumn, 2007), pp 6–27

Henrietta P. Keith, 'The Train of Japanese Influence in Our Modern American Architecture', *The Craftsman*, vol.xii, no.4, July 1907, p.451

Tange Kenzō (trans. Robin Thompson), 'A Eulogy to Michelangelo: A Preliminary Study of Le Corbusier', *Art in Translation*, vol.4, no.4, 2012

Hyon-Sob Kim, 'Tetsuro Yoshida (1894–1956) and Architectural Interchange Between East and West', *Architectural Research Quarterly*, vol.12, no.1, March 2008, pp 43–57

P.F. Kornicki, 'Japan at the Australian Exhibitions', *Australian Studies*, vol.8, 1994, pp 15–60

P.F. Kornicki, 'Public Display and Changing Values: Early Meiji Exhibitions and Their Precursors', *Monumenta Nipponica*, vol.49, no.2, Summer 1994, pp 167–96

Wybe Kuitert, 'Japonaiserie in London and The Hague: A History of the Japanese Gardens at Shepherd's Bush (1910) and Clingendael (*c.* 1915)', *Garden History*, Winter 2002, vol.30, no.2, pp 221–38

Barbara Lamprecht, 'From Neutra in Japan, 1930, to his European Audiences and Southern California Work', *Southern California Quarterly*, vol.92, no.3, 2010, pp 215–44

Clay Lancaster, 'Japanese Buildings in the United States Before 1900: Their Influence Upon American Domestic Architecture', *The Art Bulletin*, vol.35, no.3, September 1953, pp 217–24

John Leighton, 'On Japanese Art', *The Journal of the Society of Arts*, 24 July 1863

Hanna Lerski, 'Josiah Conder's Bank of Japan, Tokyo', *Journal of the Society of Architectural Historians*, vol.38, no.3, October 1979, pp 271–4

Astrid M.B. Liverman, Review of 'Hawaiian Modern: The Architecture of Vladimir Ossipoff', *Journal of the Society of Architectural Historians*, December 2008, pp 595–7

Jennifer Mitchelhill, 'Popular Journals, Japan and the Post-war Australian House', Panorama to Paradise, XXIV International Conference of the Society of Architectural Historians, Australia and New Zealand, Adelaide, Australia, 21–24 September 2007

Hermann Muthesius, 'Die Glasgower Kunstbewegung: Charles R. Mackintosh und Margaret Macdonald-Mackintosh', *Dekorative Kunst*, 9, 1902, pp 193–221

Jeffrey Karl Ochsner, 'Seattle, the Pacific Basin, and the Sources of Regional Modernism', *Fabrications: The Journal of the Society of Architectural Historians, Australia and New Zealand*, vol.26, no.3, 2017, pp 312–36

Jeffrey Karl Ochsner and Thomas C. Hubka, 'H.H. Richardson: The Design of the William Watts Sherman House', *Journal of the Society of Architectural Historians*, vol.51, June 1992, pp 121–45

Jeffrey Karl Ochsner and Thomas C. Hubka, 'The East Elevation of the Sherman House, Newport, Rhode Island', *Journal of the Society of Architectural Historians*, vol.52, March 1993, pp 88–90

Alan Powers, '*Exhibition 58*: Modern Architecture in England, *Museum of Modern Art, 1937*', *Architectural History*, vol.56, 2013, pp 277–98

Janice Pregliasco, 'The Life and Work of Marion Mahony Griffin', *Art Institute of Chicago Museum Studies*, vol.21, no.2, 'The Prairie School: Design Vision for the Midwest', 1995, p.173.

Charles Price, 'Henry Hobson Richardson: Some Unpublished Drawings', *Perspecta*, vols 9/10, 1965, pp 199–210

Jonathan M. Reynolds, 'Japan's Imperial Diet Building: Debate Over Construction of a National Identity', *Art Journal*, vol.55, no.3, Autumn 1996, pp 38–47

Jonathan M. Reynolds, 'Teaching Architectural History in Japan: Building a Context for Contemporary Practice', *Journal of the Society of Architectural Historians*, vol.61, no.4, 2002, pp 530–36

Jonathan M. Reynolds, 'The International House and the Struggle to Reconcile Tradition with Modernism in Japanese Architecture', *International House of Japan Bulletin*, vol.26, no.2, 2006, pp 27–39

Yoshiaki Sato, 'Architect Karo Obi, His Career and Architectural Activities', *Journal of Architecture and Planning*, vol.70, issue 587, 2005, pp 199–206

Gary Saxonhouse, 'A Tale of Japanese Technology Diffusion in the Meiji Period', *The Journal of Economic History*, vol.34, no.1, March 1974, pp 149–65

Timon Screech, review of Mary Elizabeth Berry, *Japan in Print: Information and Nation in the Early Modern Period*, Reviews in History no.537, available at www.history.ac.uk/reviews/review/537, 2006, accessed 5 April 2010

Paul Sédille, 'L'Architecture au Champ de Mars et au Trocadéro – 2: L'Architecture étrangère', *Gazette des Beaux-Arts*, July to December 1878, pp 732–52

Kathryn Smith, 'Frank Lloyd Wright, Hollyhock House, and Olive Hill, 1914–24', *Journal of the Society of Architectural Historians*, vol.38, no.1, March 1979, pp 15–33

Kathryn Smith, 'Frank Lloyd Wright and the Imperial Hotel: A Postscript', *Art Bulletin*, vol.67, no.2, June 1985, pp 297–9

T. Roger Smith, 'On Buildings for European Occupation in Tropical Climates. Especially India', *Transactions of the Royal Institute of British Architects*, first series, vol.18, 1867–68, pp 197–208

T. Roger Smith, 'Architectural Art in India', *Journal of the Society of Arts*, vol.21, 1873, pp 278–87

Robert C. Spencer Jr., 'The Work of Frank Lloyd Wright', *The Architectural Review* (Boston), vol.7, no.5, May 1900

Kyoko Tajima, 'Letters from Japan', *Charles Rennie Mackintosh Society Journal*, no.85, Winter 2003, pp 24–5

Thomas E. Tallmadge, 'The Chicago School', *The Architectural Review* (Boston), vol.15, no.4, April 1908, pp 69–74

Toru Nomura, 'Magotaro: An Eighteenth Century Japanese Sailor's Record of Insular Southeast Asia', *Sari*, vol.27, 2009, pp 45–66

Alice Y. Tseng, 'Styling Japan: The Case of Josiah Conder and the Museum at Ueno, Tokyo', *The Journal of the Society of Architectural Historians*, December 2004, pp 472–97

Alice Y. Tseng, 'Kuroda Seiki's *Morning Toilette* on Exhibition in Modern Kyoto', *The Art Bulletin*, vol.90, no.3, 1 September 2008, pp 418–41

Tojio Watanabe, 'Josiah Conder's Rokumeikan: Architecture and National Representation in Meiji Japan', *Art Journal*, Fall 1996, p.27

Cherie Wendelken, 'The Tectonics of Japanese Style: Architect and Carpenter in the Late Meiji Period', *Art Journal*, vol.55, no.3, 'Japan 1868–1945: Art, Architecture and National Identity', Autumn 1996

Frank Lloyd Wright, 'In the Cause of Architecture', *The Architectural Record*, vol.23, no.3, March 1908, pp 155–221

Unpublished Theses and Other Manuscripts

Anna Elizabeth Basham, *From Victorian to Modernist: The Changing Perception of Japanese Architecture Encapsulated in Wells Coates' Japonisme Dovetailing East and West*, PhD, University of the Arts, London, 2007

Don Hoon Choi, *Domestic Modern: Hybrid Houses in Meiji Japan, 1870–1900*, PhD, University of California, Berkeley, 2003

Farouk Hafiz Elgohary, *Wells Coates, and His Position in the Beginning of the Modern Movement in England*, PhD, University College London, 1966

Widar Halén, *Christopher Dresser (1834–1904) and the Cult of Japan*, University of Oxford, 1988

Hideo Izumida, 'Reconsideration of Scottish Connection in Civil Engineering and Architecture in Meiji Japan: Alexander Cowan's Relatives Engaged in Engineering Practice in the Modern Japan', unpublished conference paper given at the International Symposium of Succession of Cultural Heritages in East Asia, at Institute of Industrial Engineering, University of Tokyo, Tokyo, June 2009

Hideo Izumida, 'Colin Alexander McVean and the Meiji Japan: His Contribution to Establish Engineering Institution and Survey Departments', unpublished manuscript, 2017, revised July 2018

Laura MacCulloch, *The Influence of Japan on Dante Gabriel Rossetti 1854–1872*, MPhil thesis, University of Birmingham, 2005

Richard Neutra, 'An Abstract of Modern Architecture as an Idea and in Practice', *Kokusai kenchiku*, July 1930, translated and quoted by Atsuko Tanaka in 'The Way to the International Style: Tsuchiura Kameki's Residential Design and the Correspondence with Richard Neutra', an unpublished paper dated 13 July 2013, p.3

Atsuko Tanaka, 'Kameki Tshchiura's Prewar Residential Designs: Adapting the International Style to Japanese Traditional Living', an unpublished paper presented at the 60th Annual Meeting of the Society of Architectural Historians, Toronto, 11–15 April 2007

Atsuko Tanaka, 'The Way to the International Style: Tsuchiura Kameki's Residential Design and the Correspondence with Richard Neutra', paper, 13 July 2013

Jennifer Taylor, *An Australian Identity: Houses for Sydney 1953–63*, University of Sydney, Department of Architecture, 1972

Gavin E. Townsend, 'The Tudor Revival in America, 1890–1930', PhD, University of California, Santa Barbara, 1986

Elizabeth Walder, *The Royal Institute of British Architects' Royal Gold Medal*, PhD, University of Liverpool, 2013

Other Sources

Charles Rennie Mackintosh, Margaret Macdonald Mackintosh, Memorial Exhibition Catalogue (Glasgow: McLellan Galleries, 1933)

A Guide to Japanese Architecture with an Appendix of Important Traditional Buildings (Tokyo: Shinkenchiku-sha Co. Ltd, 1971)

The Imperial Almanac and Paris Exhibition Guide for 1867 (London: Clayton and Co., 1866)

'An Interview with Peter Cook by Arata Isozaki', in *Archigram: Experimental Architecture, 1961–74*, (Tokyo: PIE Books, 2005)

Official Catalogue of the Japanese Section, and Descriptive Notes on the Industry and Agriculture of Japan (Philadelphia: The Japanese Commission, 1876)

Omi Brotherhood and William Merrell Vories (Shiga: Omi Brotherhood Company Ltd., n.d)

Oriental Art Loan Exhibition, Comprising Principally the Decorative Arts of Japan and Persia, Corporation Galleries, Glasgow, December 1881–May 1882 (Glasgow: Robert Anderson, 1881)

The Paris Universal Exhibition Album (London: W. Stiassny and E. Rasetti, 1889)

INDEX OF WESTERN PERSONALITIES

Note: *italic* page numbers indicate illustrations.

INDEX OF JAPANESE PERSONALITIES

Note: *italic* page numbers indicate illustrations.

INDEX OF BUILDINGS AND THEMES

Note: *italic* page numbers indicate illustrations.

ILLUSTRATION CREDITS

Reproduction of the illustrations listed below (by figure number) is courtesy of the following copyright holders. All other illustrations are courtesy of Neil Jackson.

Alison and Peter Smithson Archive, Courtesy of the Frances Loeb Library, Harvard Graduate School of Design Plate 4
Arata Isozaki and Associates 15.10, 15.11
Archigram Archives 2018: 100-507-PM02, The Molehill and the Cluster page, Archigram 5, © Archigram 1964; 100-917-PM01, Osakagram page, Archigram 9, © Archigram 1970 15.07, 15.08
Architectural Press Archive/RIBA Collections 12.01, 15.05, 15.06
Archives Nationales, Paris, F12 12557 Plate 21

Bernard Maybeck Collection, Environmental Design Archives, University of California, Berkeley Plate 16, Plate 17
Brian Burke-Gaffney 6.01
British Library, London, UK/Bridgeman Images 1.01, 1.02, 1.04, 1.05, 1.06, 3.01, 4.05, 4.06, 4.07, 4.08, 4.11, 5.08

Christian Polak 4.01
Cornell University 5.09
Creative commons, Urbipedia 13.08

© FLC/ADAGP, Paris and DACS, London 2017 Plate 19, Plate 20
Freer Gallery of Art and Arthur M. Sackler Gallery, Smithsonian Institution, Washington, DC: Robert O. Muller Collection, S2003.8.212 Plate 13

Gene Zema/Grant Hildebrand 14.05
George Plunkett (© Jonathan Plunkett) 5.07

Reproduced by permission of Historic England Archive 5.04, 5.05

Illustrated London News Ltd/Mary Evans Picture Library 2.01, 2.02, 4.03

Ken McCown 14.04
Kjeld Duits 6.10, 6.12

London Metropolitan Archive, City of London 4.04

Marc Treib 11.11
Marco Capitanio 12.05
Max Dupain/Peter Muller 14.08
Mitsubishi Heavy Industries Ltd, Kobe 6.09

National Records for Scotland, RHP93855 Plate 18

Paul Thiry Collection/Meredith Clausen 14.02
Pictures Collection, State Library of Victoria/Mark Strizic 14.10

RIBA Collections 3.05, 4.09, 5.03, 7.01, 7.08, 12.03, 12.04, 13.02
RIBA Collections, courtesy Gordon Cullen Estate 12.02
RMN-Grand Palais (musée Guimet, Paris)/Harry Bréjat Plate 6

The Lavenberg Collection of Japanese Prints Plate 12, Plate 14, Plate 15
The Smithson Family Collection 15.03, 15.04, Plate 4
Tim Benton 13.16
Timon Screech Plate 7
Toyo Ito & Associates, Architects 13.18, Plate 22

University of California, Berkeley 1.03
University of Glasgow Library, Special Collections 4.10
University of Washington Libraries, PH Coll 191 American Institute of Architects Photographs, UW 38509/Charles Pearson 14.01

© Victoria and Albert Museum, London 4.12, 4.13, 4.14, 5.01, 5.02, 5.06, Plate 3, Plate 5, Plate 8, Plate 9, Plate 10, Plate 11

Werkbundarchiv – museum der dinge, Berlin 10.02, 10.03
Wikimedia commons 4.02, 5.10, 11.12, Plate 1, Plate 2